EARLY ENGLISH WATERCOLOURS

TO MY WIFE

*who has borne with all the litter
which the writing of this
book has entailed*

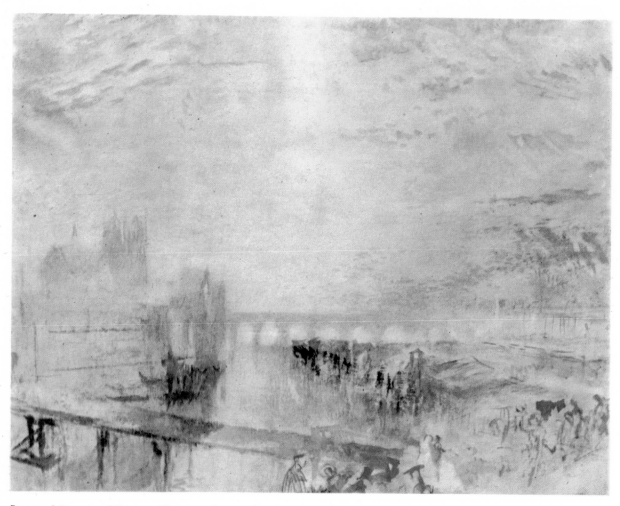

Joseph Mallord William Turner. *Lyons.* $9\frac{1}{2} \times 12$ inches. Ex Coll. H. Vaughan

Victoria and Albert Museum

IOLO A. WILLIAMS

EARLY ENGLISH WATERCOLOURS

AND SOME COGNATE DRAWINGS

BY ARTISTS BORN NOT LATER

THAN 1785

With an Introduction to the Reprint
by Edward Croft-Murray and Malcolm Cormack

KINGSMEAD REPRINTS

BATH

First Published 1952
Reprinted 1970
SBN 901571 36 9

Reproduced and Printed in Great Britain by
Redwood Press Limited
Trowbridge & London

INTRODUCTION TO THE REPRINT

Everyone interested in the history of English watercolours will welcome a reprint of Iolo Williams's book. It has long been out of print and had become a very rare item, securing high prices in the book trade. Justifiably so, for his modest hope that it might prove useful has been well fulfilled, for connoisseurs and amateurs alike.

He was of that older generation of "fully untrained" experts and collectors, such as Paul Oppé, Randall Davies, Sir Hickman Bacon, Sidney Kitson, L. G. Duke, C. F. Bell, Martin Hardie, and others, whose tastes and energies revitalised the study of English draughtsmanship. They rediscovered many major and minor artists about whom new facts were zealously researched, lost drawings and whole *oeuvres* were brought to light, and above all they put together important collections for very little which fully vindicated their new knowledge. Iolo Williams, in his study of English watercolours, "and some cognate drawings", enabled a further generation to benefit from his generation's patiently acquired learning. And, in passing, let us not forget the dealers who so materially helped in the formation of these collections: Agnew, Colnaghi and the Fine Art Society, of course; but also those better remembered by an earlier generation—Palser (in King Street, St James's), Walker (in Bond Street, who put out those excellent little publications on English watercolour, *Walker's Quarterly* and *Monthly*), Parsons (in the Brompton Road), Meatyard (in Museum Street), Bernard Squire (in Baker Street) and—a glorious scrap-yard for the treasure-seeker—Mendelsohn (in the Tottenham Court Road) who displayed a banner beside his door encouraging his visitor to 'Buy More Pictures'. One of the present writers well remembers going with Iolo to Mendelsohn's, about 1936, and there wading through a pile, near shoulder-high, of drawings out of which turned up—among other nice things—a typically misty-grey naval battle by the younger Van de Velde and Robert Adam's original design of 1777 for the plate of Lord Derby's Drawing Room in the Adam's *Works*. Then there were those happy lunch-hours spent—indeed as now—in the Sale Rooms: not only those still with us, but also in two in the St James's area no longer alas extant, Robinson and Fisher in King Street and Forster in Pall Mall.

It seems typical of that circle that Williams's volume should have been written in the spare time from his other wide interests, such as botany, bibliography, folk song and Welsh, in the intervals, as it were, of "entering Printing House Square and the Athenaeum and strolling through museums, picture galleries and the Zoo". Other books have since been written, greater professional industry has been employed, with numerous recent articles on further stylistic problems and watercolours are now seen more in relation to the painting of the period than as isolated phenomena in their own right, but it was his very personal approach, reflecting very much his own taste as a collector, which gives the book its special flavour and quality. To write five lines, say on Copplestone Warre

Bampfylde (1720-1791) is easily possible with the aid of *Early English Watercolours* and rather difficult to do without it, and the depth of his interest in the minor artist and the apt reproduction of their works is perhaps the book's greatest strength. His predilection was for the eighteenth century and he pursued there even the minor practitioners and amateurs with the same delight that he found in the better-known personalities of the period. This had its counterpart in his earlier researches into the works of the less familiar Georgian writers. But his fortunate acquisition—which he shared with Leonard Duke and Sir Bruce Ingram—of part of the Patrick Allan Fraser Collection, consisting of a rare assemblage of drawings by Hollar, Francis Place and the hitherto obscure Thomas Manby, stimulated him also to push his researches back into the seventeenth century and even Anthonis van den Wynegaerde in the sixteenth century. Easily read and used, with plates that successfully solved his problem, as he admitted, of what to reproduce, *Early English Watercolours* deserves to be reissued. His dream of a revised and improved edition was unfortunately prevented by his death in 1962, but it is a fitting memorial to his labours and enthusiasms that the demand from the ever-expanding interest in the subject, with which he had so much to do, should give the opportunity here to reprint his book as it was written.

EDWARD CROFT-MURRAY
Keeper of Prints and Drawings,
British Museum

MALCOLM CORMACK
Keeper of Paintings and Drawings,
Fitzwilliam Museum, Cambridge

August 1970

Publisher's Acknowledgement

Kingsmead Reprints wish to thank Mr D. F. Snelgrove
for the revised list of the owners of the pictures.

As stated in the introduction, the drawings illustrated with no acknowledgment in the caption were chosen from Iolo Williams' own collection. Since his death in 1962, many have changed hands, and the list below is the result of an attempt to give their present owners.

7 : Mr. and Mrs. Paul Mellon

9 : Mr. and Mrs. Paul Mellon

12 : The family of the late Iolo Williams

19 : Mr. D. L. T. Oppe

21 : British Museum

22 : The family of the late Iolo Williams

24 : British Museum

27 : The family of the late Iolo Williams

29 : Mr. and Mrs. Paul Mellon

30 : The family of the late Iolo Williams

32 : Bought by Colnaghi's at the Ingram Sale

33 : Ashmolean Museum, Oxford

34 : Mr. D. L. T. Oppe

35 : Mr. and Mrs. Paul Mellon

36 : Mr. and Mrs. Paul Mellon

41 : Mr. and Mrs. Paul Mellon

42 : British Museum

43 : Mr. and Mrs. Paul Mellon

44 : Mr. D. L. T. Oppe

46 : Not traced

47 : The family of the late Iolo Williams

48 : Mr. and Mrs. Paul Mellon

49 : The family of the late Iolo Williams

50 : Mr. D. L. T. Oppe

51 : Not traced

53 : The family of the late Iolo Williams

58–60 : Mr. D. L. T. Oppe

61–63 : The family of the late Iolo Williams

66 : The family of the late Iolo Williams

67 : Mr. D. L. T. Oppe

69 : Mr. and Mrs. Paul Mellon

74 : Mr. and Mrs. Paul Mellon

76 : The family of the late Iolo Williams

78 : Mr. and Mrs. Paul Mellon

80 : Mr. and Mrs. Paul Mellon

81 : Not traced

83 : Mr. Luke Herrmann

87–89 : The family of the late Iolo Williams

94 : The family of the late Iolo Williams

101 : The family of the late Iolo Williams

104 : Mr. and Mrs. Paul Mellon

105 : Stolen

107 : The family of the late Iolo Williams

109 : The family of the late Iolo Williams

111, 112 : The family of the late Iolo Williams

114–116 : The family of the late Iolo Williams

117 : Mr. and Mrs. Paul Mellon

118 : The family of the late Iolo Williams

120 : The family of the late Iolo Williams

121 : Not traced

122 : The family of the late Iolo Williams

123 : Not traced

124 : Not traced

127 : The family of the late Iolo Williams

132 : Mr. D. L. T. Oppe

133 : British Museum

134, 135 : The family of the late Iolo Williams

136 : Mr. and Mrs. Paul Mellon

138, 139 : Mr. D. L. T. Oppe

141 : Mr. and Mrs. Paul Mellon

142 : Mr. D. L. T. Oppe

143 : Miss A. Scott-Elliot

146 : Mr. and Mrs. Paul Mellon

148 : Not traced

150 : The family of the late Iolo Williams

151 : Miss A. Scott-Elliot

154 : Mr. Leonard G. Duke

156 : Mr. Ian Fleming-Williams

157–160 : The family of the late Iolo Williams

161 : Not traced

165 : Not traced

166 : Mr. and Mrs. Paul Mellon

168 : The family of the late Iolo Williams

170 : The family of the late Iolo Williams

172 : BRITISH MUSEUM

175 : THE FAMILY OF THE LATE IOLO WILLIAMS

178 : MR. AND MRS. PAUL MELLON

198, 199 : THE FAMILY OF THE LATE IOLO WILLIAMS

204 : THE FAMILY OF THE LATE IOLO WILLIAMS

207 : THE FAMILY OF THE LATE IOLO WILLIAMS

208 : MR. AND MRS. PAUL MELLON

211 : THE FAMILY OF THE LATE IOLO WILLIAMS

212 : MR. AND MRS. PAUL MELLON

215, 216 : THE FAMILY OF THE LATE IOLO WILLIAMS

221 : MR. AND MRS. PAUL MELLON

222 : THE FAMILY OF THE LATE IOLO WILLIAMS

225 : HENRY E. HUNTINGTON ART GALLERY, SAN MARINO

226 : MR. AND MRS. PAUL MELLON

227 : BRITISH MUSEUM

231 : MR. AND MRS. PAUL MELLON

232 : THE FAMILY OF THE LATE IOLO WILLIAMS

233 : MR. AND MRS. PAUL MELLON

239 : MR. AND MRS. PAUL MELLON

240 : THE FAMILY OF THE LATE IOLO WILLIAMS

241 : MR. AND MRS. PAUL MELLON

243 : THE FAMILY OF THE LATE IOLO WILLIAMS

253, 254 : THE FAMILY OF THE LATE IOLO WILLIAMS

258 : MR. AND MRS. PAUL MELLON

268 : BRITISH MUSEUM

279 : BOUGHT BY AGNEW'S AT THE INGRAM SALE

283 : MR. AND MRS. CYRIL FRY

287 : THE FAMILY OF THE LATE IOLO WILLIAMS

289 : NOT TRACED

293 : MR. AND MRS. PAUL MELLON

294, 295 : THE FAMILY OF THE LATE IOLO WILLIAMS

297 : THE FAMILY OF THE LATE IOLO WILLIAMS

298 : MR. AND MRS. PAUL MELLON

299, 300 : THE FAMILY OF THE LATE IOLO WILLIAMS

306 : BOUGHT BY COCKETT AT THE INGRAM SALE

311 : THE FAMILY OF THE LATE IOLO WILLIAMS

318 : COURTAULD INSTITUTE, WITT COLLECTION

325 : BRITISH MUSEUM

326 : THE FAMILY OF THE LATE IOLO WILLIAMS

328 : THE FAMILY OF THE LATE IOLO WILLIAMS

332, 333 : THE FAMILY OF THE LATE IOLO WILLIAMS

334 : NOT TRACED

335 : THE FAMILY OF THE LATE IOLO WILLIAMS

337 : THE FAMILY OF THE LATE IOLO WILLIAMS

340 : NOT TRACED

341 : MR. AND MRS. PAUL MELLON

343 : THE FAMILY OF THE LATE IOLO WILLIAMS

346 : THE FAMILY OF THE LATE IOLO WILLIAMS

347 : MR. AND MRS. PAUL MELLON

348 : NOT TRACED

350 : THE FAMILY OF THE LATE IOLO WILLIAMS

352, 353 : THE FAMILY OF THE LATE IOLO WILLIAMS

355, 356 : THE FAMILY OF THE LATE IOLO WILLIAMS

358 : THE FAMILY OF THE LATE IOLO WILLIAMS

361 : MR. AND MRS. PAUL MELLON

366 : MR. AND MRS. PAUL MELLON

368 : THE FAMILY OF THE LATE IOLO WILLIAMS

370 : BRITISH MUSEUM

371–373 : THE FAMILY OF THE LATE IOLO WILLIAMS

375–376 : MR. D. L. T. OPPE

379–388 : THE FAMILY OF THE LATE IOLO WILLIAMS

389 : MR. AND MRS. PAUL MELLON

391, 392 : THE FAMILY OF THE LATE IOLO WILLIAMS

394 : THE FAMILY OF THE LATE IOLO WILLIAMS

397 : THE FAMILY OF THE LATE IOLO WILLIAMS

399–403 : THE FAMILY OF THE LATE IOLO WILLIAMS

407–410 : THE FAMILY OF THE LATE IOLO WILLIAMS

CONTENTS

LIST OF ILLUSTRATIONS

xiv

XV

PREFACE

IN THE pages which follow I have aimed at giving a rather fuller general survey of the matter in hand than has previously been written. Though there is no attempt to include every known painter who used watercolour, much attention is nevertheless paid to the minor artists, partly because many of them are delightful subjects of study, partly because I believe that only by knowing them can one appreciate the true character and stature of the greater men, and partly also in order to do something to correct the common error of attributing any good, or even passable, early drawing to one of the small number of artists whose names are, for one reason or another, well known. In fact the number of men and women capable, at least occasionally, of doing a creditable drawing was, after about the middle of the Eighteenth Century, very large, and I hope that my text and illustrations may help in the identification of some of them. In particular the amateur artists played a part which has never been properly realized in the development of English watercolour. It would not be difficult to write a book about them alone, but I do not know that they have previously been allotted even as much as the single chapter given to them here. I have tried, too, to suggest something of the charm and interest of such specialists as the book illustrators, the marine artists, the botanical and zoological draughtsmen, and the caricaturists. Naturally, however, these minor categories, engaging though they may be, have to take rank after the main battalions of the landscape, topographical, and figure draughtsmen.

There are many acknowledgments which must be made, and first of all I must offer my thanks to His Majesty the King, HRH the Duke of Gloucester, and all those others, whether private owners or custodians of public collections, who have allowed me to reproduce drawings in their possession or care.

Next comes the debt to previous writers, which in a work of wide scope such as this one must clearly be heavy. I have tried, throughout the text, to acknowledge in the proper places the work of those scholars whose studies of one artist or another have been specially helpful to me. But a general acknowledgment is also due in this place, and I should wish, too, to refer in particular to the writings of Mr Paul Oppé which, by their combination of a keen and sure aesthetic perception with a highly critical examination of the available historical evidence, have altered the accepted story of the English watercolour school at many points. There are several important artists of whom it is impossible to write today without treading in Mr Oppé's footsteps, and there are certain sections of this book, especially Chapter III and parts of Chapter V, which I hope may be regarded as in some degree a tribute to his work. I also owe him thanks for allowing me to make use of drawings in his collection and to consult him upon many points.

To Mr Edward Croft-Murray and Mr Leonard Duke I owe my warmest thanks for undertaking the heavy task of reading the manuscript of my book and for making, each of them, many valuable corrections and suggestions. They have also been generous in allowing me to consult drawings in their collections and to reproduce some of them. I owe thanks, too, for similar or other kindnesses to Sir Edmund Bacon, Sir Robert Witt, Sir Bruce Ingram, Mr Thomas Girtin, Mr H. C. Green, Mr Brinsley Ford, Miss R. M. Clay, Mrs Russell Colman, Dr Eric Millar, the Rev Francis Smythe, Mr Ralph Edwards, Mr Gilbert Davis, Mr H. Clifford Smith, and others.

From museum officials I have received much help, and I should like to express my gratitude especially to Mr A. E. Popham and Mr Croft-Murray of the Department of Prints and Drawings at the British Museum, where also Mr D. F. Snelgrove has checked certain facts for me. At the Print Room of the Victoria and Albert Museum, too, I have received constant help equally from Mr Martin Hardie and the late Basil Long, and from their successors Mr James Laver, Mr Carl Winter (now transferred to the Fitzwilliam Museum, Cambridge), Mr Graham Reynolds, Mr Brian Reade and Mr Jonathan Mayne. I also wish to thank Sir Owen Morshead and Miss A. H. Scott-Elliot of the Royal Library, Windsor Castle; Miss Margaret Pilkington of the Whitworth Art Gallery, Manchester; Dr K. T. Parker and Mr John Woodward of the Ashmolean Museum, Oxford; Miss G. V. Barnard of the Castle Museum, Norwich; Mr Trenchard Cox and Miss Mary Woodall of the City Art Gallery, Birmingham; Mr John Steegman of the National Museum of Wales; Mr M. S. Robinson of the National Maritime Museum; and Mr H. Hess of the City of York Art Gallery. In the matter of natural history illustrators I must acknowledge the help of Mr A. C. Townsend, Mr N. B. Riley, Dr John Ramsbottom and Mr T. C. S. Morrison-Scott, all of the British Museum (Natural History), and of Dr W. B. Turrill, of the Herbarium, Royal Botanic Gardens, Kew.

No writer on the history of art could get far without the co-operation of members of the fine art trade. Here I have to acknowledge much assistance ungrudgingly given, and I should like to thank particularly Mr D. C. T. Baskett, of Messrs P. & D. Colnaghi, who has been a constant help; Mr Augustus Walker; Mr Gerald Agnew; Mr E. P. Dawbarn of the Fine Art Society; Mr Bernard Milling of the Squire Gallery; Mr F. R. Meatyard; and Mr M. Bernard. To this list I must add Mr Arthur Appleby and his brother the late Richard Appleby, in whose shop, during twenty years of frequent visits, I have picked up a good part of what knowledge I possess, especially about the minor English draughtsmen.

I must also thank Mr H. Granville Fell for all the work he has put into the proper display of the illustrations, and my daughter Elizabeth Williams for help in checking dates and facts.

The purpose of this book is not primarily biographical, though it contains a good deal of incidental biography. For this I have followed, in each case, the best authorities known to me, and have tried to give references to any specialized writings of which I have made use. These references, I trust, may serve both to express my indebtedness and to indicate to the reader where he may find further information. For the most part, however, the biographical element in the text is founded upon what one may call the accepted story of English watercolour art as told in a number of standard works and summarized, most

notably, for the principal artists, in the *Dictionary of National Biography*. That story is inaccurate at many points, as various modern authors have shown, and I have corrected such errors as I could either from their writings or, more rarely, from my own knowledge. But there is much research still to be done on the lives, as well as the work, of the English artists, and it is inevitable that what I have written, in the chapters that follow, should contain many errors of fact. I can only say that I shall be most grateful to receive corrections of any mistakes, whether they be my own or copied from other writers, for use in the preparation of a revised and improved edition—that dream of every author— should one be called for.

Perhaps it would be well to name here some of the principal books in which the story of English art, and with the later volumes particularly of watercolour, is recorded. The earliest is the anonymous *An Essay towards an English School of Painters* (a series of short biographies) which is appended to early eighteenth century editions of Roger De Piles's *The Art of Painting*. According to the title-page of an undated edition (subsequent to the death of Kneller) this was chiefly the work of a certain B. Buckeridge; but the book, I fancy, is one that needs bibliographical and critical investigation. The main authority for the earlier period is Horace Walpole's *Anecdotes of Painting in England*, five volumes (with the engravers), 1762–1771 [1780], and later editions. This is founded upon the notes compiled by the engraver George Vertue, and bought from his widow in 1758 by Walpole. Almost the whole of Vertue's original manuscripts have now been published and indexed by the Walpole Society in its volumes 18, 20, 22, 24, 26 and 29. A continuation of Walpole, very valuable for the later Eighteenth Century, is *Anecdotes of Painters who have resided or been born in England; with critical remarks on their productions*, compiled by Edward Edwards, ARA, and published posthumously in 1808.

In the early Nineteenth Century there came such chiefly reminiscent writers as J. T. Smith and W. H. Pyne, but the main task of carrying on what Vertue, Walpole, and Edwards had begun was shouldered rather later by the brothers Samuel and Richard Redgrave. In 1866 they published their *A Century of Painters of the British School* (new edition 1947) and the elder brother, Samuel, in 1874 issued his *Dictionary of Artists of the English School*, of which a new and revised edition appeared in 1878. Six years later— in 1884—there was published the first edition of another valuable tool of the student, Algernon Graves's *A Dictionary of Artists who have exhibited Works in the Principal London Exhibitions*, of which a 'new and enlarged edition', 1895, covered all exhibitors down to 1893. A third edition appeared in 1901. Graves also did extremely useful work in compiling, from the original catalogues, more detailed lists of exhibitors and exhibits. His *Royal Academy Exhibitors* (1769–1904)—to give it the name by which it is generally known— was published in eight volumes during 1905 and 1906, and his similar compilations relating to the Society of Artists and Free Society of Artists (1760–1791) and to the British Institution (1806–1867) appeared in 1907 and 1908 respectively.

Books dealing specifically with the English watercolour were slow to appear. The first I know of was *The Earlier English Water-Colour Painters*, 1890 (second edition 1897), by William Cosmo Monkhouse, who wrote many of the notices of artists for the *Dictionary of National Biography*. A year later came a most important work, J. L. Roget's *A History of the 'Old Water-Colour' Society*, two volumes, 1891. Another pioneer book, G. R. Redgrave's

A History of Water-Colour Painting in England, first appeared in 1892. Later books on the subject have been: A. J. Finberg, *The English Water Colour Painters* [1906]; H. M. Cundall, *A History of British Water Colour Painting*, 1908, second edition 1929; C. E. Hughes, *Early English Water-Colour*, 1913; and Laurence Binyon, *English Water-Colours*, 1933. Randall Davies's *Chats on Old English Drawings*, 1923, and M. T. Ritchie's *English Drawings*, 1935 (a collection of 96 monochrome reproductions) may also be mentioned. Two catalogues that are indispensable, even though more or less out of date, are the Victoria and Albert Museum's *Catalogue of Water Colour Paintings*, 1927 edition, and the British Museum's *Catalogue of Drawings by British Artists and Artists of Foreign Origin Working in Britain*, by Laurence Binyon, 4 volumes, 1898, 1900, 1902 and 1907. Another catalogue which is useful is the well-illustrated *Commemorative Catalogue of the Exhibition of British Art . . . 1934*, 1935. Of more general character are three works by W. T. Whitley, *Artists and their Friends in England 1700–1799*, two volumes, 1928, *Art In England 1800–1820*, 1928, and *Art in England 1821–1837*, 1930; and Colonel M. H. Grant's *A Chronological History of the Old English Landscape Painters (in oil)*, volumes I and II [1926], volume III, 1947.

The reader should perhaps be warned that, in the text, I have not always allotted space strictly according to the comparative artistic or historical importance of the artists concerned. On the whole I have tried to do so, but occasionally a minor draughtsman has been given rather more than his fair share because information about him, which I happened to have, was not easily accessible elsewhere. Other points to be made clear are that terms like Indian ink, sepia, or bistre are not used to mean particular pigments, but as general indications of colour; and that numbers inserted in brackets refer to illustrations at the end of the book. As regards measurements, I have given a good many of these in my text (as well as beneath every illustration), because I believe it is important for the reader to realize the approximate size of a drawing which is discussed or reproduced. Where I have taken measurements myself they have usually been taken to about $\frac{1}{8}$ of an inch. When smaller fractions are given they are extracted from existing catalogues.

The choice of illustrations I have found very troublesome, chiefly because of the several conflicting guiding principles of selection open to the selector. Ought he to choose always the finest available example of a particular artist, even though it is already familiar in a score of reproductions, or is it better to give something less familiar even if less good? Ought he, again, to select the best examples artistically, or those most characteristic of their authors? Yet again, should he always choose the small drawing, which loses less in reduction, and the monochrome, which can be reproduced in black and white without sacrificing so much of the artist's intention, in preference to large, fully coloured, and possibly finer drawings? These conflicts of principle are insoluble, and as regards this book I can only say that I have borne them all in mind and tried to reach a common-sense accommodation between them. I have also tried to select examples that would be generally accepted as authentic; but it has not always been possible to find suitable signed drawings, and no doubt the attribution of some, though I hope not many, of the drawings chosen will be challenged. I would add that the number of reproductions allotted to an artist is not to be taken as an exact measure of his importance. A minor draughtsman may be much more variable, and so in need of fuller illustration, than one artistically his superior. The owner, by whose kind permission each drawing is reproduced, is named

in the caption. Drawings belonging to museums and galleries are reproduced by kind permission of the appropriate trustees and directors, many of whom have waived, or greatly reduced, any reproduction fees normally charged by them. Drawings not acknowledged to any owner are in my own collection. Where no medium is named in the caption, the drawing is in watercolour, with or without various admixtures of bodycolour, pen, pencil and so on.

Though my theme is watercolour and its use in England, no subject can be treated satisfactorily in a vacuum. I have therefore included, both in the text and among the illustrations, some drawings which are not watercolours but which are helpful in understanding the setting, so to speak, in which watercolour was used. I make no excuse for the inclusion of such things which, as anyone who has had much to do with watercolours will agree, are inseparable from the main subject.

I hope this book may prove useful. It is the fruit of a long enjoyment of early English drawings and of twenty years' intensive collecting of examples and facts. For six years its writing has occupied almost all my spare time, and the result is now proffered with trepidation and a full realization that it has many imperfections. However, in this world one can only do a certain amount in a given time, and such as it is the book must now go forth.

EARLY ENGLISH
WATERCOLOURS

The Sixteenth and Seventeenth Centuries

THIS BOOK is concerned with English drawings in watercolour from their first production in this country (what and when that may have been will be considered in a moment or two) up to about the time of those artists who were born in the early eighties of the eighteenth century—John Sell Cotman in 1782, David Cox in 1783, and Peter De Wint in 1784. Since Cotman died in 1842, Cox in 1859 and De Wint in 1849, the last dates in this account will be in the middle of the nineteenth century, but the final fifty years will be more selectively treated (because only the older artists then practising will figure in it) than the eighteenth century, to which the greater part of the volume must be devoted.

Watercolour is a method of painting in which the colours or pigments which the artist uses are transferred to the substance on which the painting is done (usually, with watercolour, a sheet of paper) by mixing them with water so that they may be in a fluid enough condition to be applied as the painter wishes. The water evaporates, and the paint remains as a stain upon the paper. Water is the watercolourist's 'vehicle', just as oil is that of the oil painter. There are two kinds of watercolour, clear and opaque. In clear watercolour the paint is laid on in transparent washes, and the lights are obtained from the whiteness of the paper behind the paint and can be varied by varying the thickness of the washes or by leaving certain parts of the paper bare. This is the method *par excellence* of the watercolourist. With opaque colour—which in its various forms is known by the names of body-colour, gouache, tempera, or distemper—the lights are produced by mixing with the colours an opaque white pigment, and the spectator does not see through the colour to the paper behind it. This is a very ancient method of painting—older than oil-colour to which it is, essentially, more nearly allied than to transparent colour. Body-colour has a rather chalky look, and lacks both the delicacy of transparent colours and the juicy richness of oils. When used in works of comparatively small size, and especially for landscape, it often seems to me to obscure the individual touch of the artist, so that, as someone once remarked, 'every eighteenth century gouache appears to be by the same painter'. But for certain purposes it is very effective—for rendering the texture of a bird's plumage, for example. It will, however, not figure very largely in this book. Naturally not all watercolours are entirely in one medium; a mixture of transparent and opaque colour has often been used, and many drawings which are mainly in clear watercolour have passages, or small touches, of body-colour also. This, however, is not always a successful device artistically.

Normally, when people speak of a watercolour, they mean one in full colour, one in

which the subject is represented in something approaching its natural range and variety of hue. But it must be remembered that there are also many watercolours in monochrome washes—whether of Indian ink, sepia, bistre, blue, grey or whatnot—and, especially in landscape and topography, it would be absurd to exclude them from a book on English watercolour. At the same time it would be equally absurd to class as a watercolour any drawing which had a few touches of sepia wash about it. Evidently, therefore, no rigid definition need be adhered to, and I hope that a commonsense compromise may reveal itself as the book proceeds.

Opaque colour was the medium of the illuminators of medieval manuscripts, and it was also used by the painters of portrait miniatures in Tudor times. Each of these subjects is outside the scope of this book; but it is possible to see the beginning of 'early English watercolour', in the usual sense of the phrase, in the sixteenth century. The British Museum has, among the Cottonian manuscripts, a number of elaborate military 'platts' or 'plotts', which are half plans, half bird's-eye views, coloured in clear watercolour and dating from Henry VIII's reign. They do not appear to be by English artists, and the finest of them, a large view of Dover from the south-east, measuring about 31×75 inches, is from the drawing of the ships clearly by some Flemish artist of the school of Breughel. It belongs to the year 1538, and tells one a good deal about the appearance of Dover when it was a waterside village separated from the castle by fields. This 'platt' is not signed, but things of the kind are rather vaguely associated with the name of one Vincent Volpe, Voulpe or Wolfe, 'Vincent the King's painter'. Another view of about the same date, but much inferior, is signed by John Luckas, presumably also a Fleming. Both were on view in an important exhibition of the origins of English topography and landscape which opened in the British Museum Print Room in December 1949, and which made one realize how large a share in their development was taken by the military draughtsman, drawing camps and fortifications for purely professional purposes. The influence of military drawing continued, indeed, at least until the end of the eighteenth century.

About 1557 there came to England, in the suite of Philip II of Spain, a Flemish artist, Anthonis van den Wyngaerde, who made a series of drawings, slightly tinted with colour, of London and the surrounding area, which are in the Bodleian Library at Oxford. Amongst them are views of Richmond Palace (1). The drawings bear dates up to 1562, but those dated in that year must have been worked up after Wyngaerde's return to Spain in 1561. Again, the British Museum has a very pretty drawing of Nonsuch Palace, near Ewell, Surrey, in pen and brown ink, with brown wash and slight watercolour, by George Hoefnagel (1542–1600), which is signed and dated 1582. A reference (which I owe to Sir Thomas Kendrick) may be made to the small, naïve, watercolours of antiquities, such as castles and so forth, with which scholars like the topographer John Norden (1548–1625) and the herald William Smith (1550?–1618) decorated their manuscript descriptions of various parts of England. The Victoria and Albert Museum, again, possesses 35 sheets of charmingly fresh drawings in watercolour of flowers (2) and fruits by Jacques le Moyne de Morgues,* a French Protestant cartographer and artist who came to London at the time of the massacre of St Bartholomew, became a friend of Sir Walter Raleigh, Sir Philip

* See articles by Mr S. Savage in the *Gardeners' Chronicle*, January 28, 1922, and March 17, 1923. Also *Times Literary Supplement*, February 9, 1922.

Sidney and Hakluyt, and died in London in 1588. The English school of watercolour has, throughout its existence, owed much to men of foreign birth, whom it has constantly absorbed and—very often—entirely Anglicized in the process. And here it may be convenient to refer to the statement, sometimes carelessly made, that watercolour is a peculiarly English art, or even an art of English origin. To refute such a notion, it is perhaps enough to recall Dürer's use of clear colour on his drawings, including landscape and topographical subjects, and the Dutch draughtsmen of the seventeenth century, many of whom employed watercolour for their drawings. To regard the medium as essentially English is foolish—but we may claim that for a century from the middle of the eighteenth century onwards there flourished in England an exceptionally numerous, accomplished, sincere and delightful school of watercolourists. And—to return—even in the sixteenth century there were Englishmen using the medium, about at any rate one of whom—John White—we know something, though we do not know when or where he was born, or died. Our only glimpses of him are between 1585, when he was already a married man with a marriageable daughter, and 1593, when he was living in Ireland.

White's known original drawings* were all contained in a volume which, since 1866, has been in the British Museum, having been sold in June of the previous year at Sotheby's with the library of Lord Charlemont, an Irish peer. The volume has now been broken up and the drawings are mounted separately. An illustrated account of them was contributed to the XIIIth volume of the Walpole Society, in 1925, by the late Laurence Binyon. The great interest, from the point of view of general history, is that among the drawings in the book are the originals of twenty-three which were used to illustrate Theodore de Bry's *America*, published at Frankfort in 1590, and which continued to be the basis of illustrations of American Indian life published up to the end of the eighteenth century or later. They were done when White went in 1585 (it was probably not his first voyage across the Atlantic) with the second expedition sent by Raleigh to America, under the command of Sir Richard Grenville. One of White's drawings shows Grenville riding among his men on the island of St John. Others show native villages on the mainland, the Indians' religious dances, manners of fishing, husbandry and so on, as well as American animals and plants. The book also contains subjects which are not West Indian or Virginian, but represent Eskimos, Orientals, and Caucasians, and seem to prove that White had travelled widely—though little is known of him apart from his American voyages. There are some imaginary portraits of Ancient Britons in their woad. The drawings are done in rather thick watercolour with a full range of colours. Though they may be unsophisticated in approach, yet they are far from unpractised: they are observant and lively, and there is, as Binyon pointed out, much feeling and beauty in such a drawing as that inscribed *One of their Religious men* ($10\frac{3}{8} \times 6$ inches), which is chiefly in brown flesh tints with black for the hair (4). The drawing inscribed *The Flyer*, showing an Indian throwing his hands up in the air, standing on one leg, and wearing a small black bird in his hair, is also strangely effective. The animal drawings, such as those of an iguana and a loggerhead turtle, the latter richly coloured in purple-brown for the carapace and lightish red-brown for the legs, are observant and competent records of fact, firmly and vigorously drawn. White, indeed, has the honour of being the first (since medieval times) of the long race of English

* There is also in the British Museum a volume containing copies after White.

artist-naturalists, and his drawings include watercolours of at least two European birds, the hoopoe and the roller.

The next figure to be noticed is that of the great architect Inigo Jones (1573–1652). As a young man he had the advantage of going, at Lord Pembroke's expense, to 'Italy and the politer parts of Europe', returning by way of Denmark in 1604. He was in Italy again in 1613–1614, when he visited Vicenza, Rome, Naples and Venice. These foreign, and especially Italian, experiences were of great value to him and his work. Between 1605 and 1640 Jones designed the scenery, dresses, and so forth for a long series of masques by Ben Jonson, George Chapman, Thomas Campion, Sir William Davenant, and others. In such productions Inigo Jones was no mere journeyman called in to fulfil other people's orders. He was, and regarded himself as, a collaborator in the creation of a work of art, which was every bit as much his as it was the poet's or the musician's. Drawings by Jones for such entertainments survive in the British Museum, and the library of the RIBA, as well as in the great collection at Chatsworth, which is the principal treasure-house of his work. These drawings formed the subject of the Walpole Society's twelfth volume (1924) which contained a study of them by Mr C. F. Bell, together with a catalogue by him, based on a hand-list made by Mr Percy Simpson, and a large number of reproductions. The great majority of the drawings are in pen and ink with a wash of ink or sepia. Mr Bell, however, says that the usual phrase 'pen and wash' here 'inverts the order of the processes employed, the ink lines having been usually added over the tint'—though there was generally an earlier black lead outline which was by Jones himself even when the later stages of the drawing were done by an assistant. Nine drawings only are completed in colour, all of them designs for dresses, and these include the vigorous and splendidly poetic *A Page like a Fiery Spirit* ($11\frac{3}{8} \times 6\frac{1}{4}$ in.), a tall figure, with wings and kilt of flame red feathers, carrying a lighted torch over one shoulder, which was done for Campion's *The Lords Masque*, performed on February 14, 1613. It is in pen and ink, very freely and incisively handled, with washes of red, pink, blue, grey and olive grey (5).

Not all of Inigo Jones's drawings are costume designs. Very many of them represent the settings against which the actors were to perform. Some of these are mainly architectural in character, but others are landscapes, sometimes of a highly imaginative kind, and this is specially true of some of the later stage settings, such as a beautiful 'Night' scene (309 in catalogue, $6\frac{3}{8} \times 8\frac{3}{4}$ inches), in pen and black ink washed with grey, designed for *Luminalia, or the Festival of Light*, probably by Davenant, which was produced in 1638. This drawing, a composition of boldly massed clumps of trees, reflected in a curving river by moonlight, with some others, entitles Inigo Jones to be considered the first English-born draughtsman to attempt imaginative landscape (3). He did not do so in colour—and it is of interest that some of the greatest English landscape draughtsmen of the next century—Alexander Cozens, Wilson, and Gainsborough for instance—most often worked in monochrome, which suits the English temperament remarkably well. Mr Bell, in discussing this 'Night', draws attention to 'the influence of Rubens, which is noticeable as gradually eclipsing that of Titian and the Carracci in Inigo's designs for woodland scenes', and to the fact that Rubens was in London in 1629 and 1630; but what will perhaps strike the average person most readily is the kinship with certain of Claude Lorrain's most broadly handled landscape drawings.

4

This is possibly the right moment to introduce a point which is vital to the discussion of English drawings—the often stated distinction between landscape and topography. Topography has been defined as the portraiture of places—and since the definition is not mine I may be allowed to say that it seems to me admirably clear. The topographer's job is to produce a drawing which will be recognized as representing a certain place—whether it be a group of mountains, a stretch of pastoral country, a street in a town, or a gentleman's country seat—and will record its features for posterity. Landscape is the imaginative manipulation of natural features such as hills, trees, rivers, fields, clouds, and so forth, into a composition which will be aesthetically pleasing or otherwise impressive. The distinction is one of aim, and in theory it is sharply defined. In practice it is not always so easy to make. Both elements may exist in the same artist, even in the same drawing; many of the topographers notoriously played tricks with their facts in order to improve the look of their pictures; nevertheless the distinction is a real one, and one which is extremely useful in considering English drawings and their qualities.

Inigo Jones, so far as he comes into this particular argument, was a landscape draughtsman, and most definitely not a topographer. It does not, however, seem possible to trace any direct connection between him and the men who made landscape drawings in the eighteenth and nineteenth centuries. That there are a few extremely beautiful landscape drawings by Sir Anthony Van Dyck (1599–1641), and that some of these may well have been made in England (where he was in 1620–1 and again most of the time from 1632 to 1641), is another isolated fact which seems to have little bearing upon any development of a landscape style in England. These Van Dyck drawings are chiefly studies of trees, pollarded willows for instance, grouped perhaps at the turn of a lane, and are done in bodycolour* on grey paper (6). They are beautiful, free things, chiefly blue-green in colour, sketched with the eye upon nature, and might have appealed very keenly to Gainsborough in his early days in Suffolk, or some years later to Crome in Norfolk. But to say that is to relate them immediately to a later phase in English art, and to connect them instinctively with two artists upon whom Dutch landscape art, and particularly Hobbema, had a strong influence. But for the most part, and especially in the earlier years, it was Italian rather than Dutch influence that made itself felt whenever English drawing broke out of topography and into imaginative landscape. At such moments the artists who influenced us chiefly were seventeenth century Italians, or Italianized Frenchmen, such as Salvator Rosa, Claude Lorrain and the Poussins. One sees their influence in Taverner, Wilson, Gainsborough (excluding the early drawings), Alexander and J. R. Cozens and many others—even in men like Paul Sandby and Anthony Devis who, though primarily topographers, sometimes produced romantic imaginary landscapes. Is there perhaps any line of approach along which we may find a connection in the seventeenth century itself?

A possible link is that, even in that century, a number of English artists studied in, or visited, Rome. Inigo Jones's visits have been mentioned already. Salvator Rosa had at any rate one English pupil, Henry Cook (1642–1700). He was employed, on his return to England, chiefly in decorative work at great houses, such as Ranelagh House and Lord Carlisle's in Soho Square, but it would be strange if he had never attempted landscape in his master's manner. I have only seen four drawings by Cook—three small details of

* Some of Van Dyck's landscapes at Chatsworth appear to be in clear watercolour.

decoration in the British Museum, and a wash drawing of a monkey looking at its own reflection in a pool. But one day some landscape drawings by Cook, more or less in the style of Salvator, may turn up and establish a new link in the development of the story we are trying to trace.

Another English artist who worked in Italy was Thomas Manby,* and here we are on rather firmer ground, since eleven topographical or landscape drawings apparently by him are known. They are in grey wash, generally with some pen work, and they were sold at Sotheby's in 1931 in the remarkable collection of English drawings, chiefly of the seventeenth century, which had belonged to Patrick Allan Fraser, of Hospitalfield, Arbroath. They were catalogued without attribution as 'Various views in Italy, including two views of the Ponte Lucano, near Tivoli'. Several of them have the name Manby written on them in a very old hand, and there seems little reasonable doubt that they are the work of this English landscape painter, of whom it is recorded that he 'had been several times in Italy, and consequently painted much after the Italian manner'. He is known to have executed landscape backgrounds in oils for Mrs Beale, including one to a portrait now at Welbeck. He died in 1695 and there were probably two sales of pictures by or belonging to him. The best of the extant group of drawings is one representing a bridge over a river, with part of a castle to the right and figures in the foreground. It measures $9\frac{1}{4} \times 14\frac{1}{2}$ inches and is not undecorative (7). These wash drawings, though they are chiefly concerned with ruins, sometimes go beyond topography, and search out, not very effectively perhaps, towards imaginative landscape, as, for example, in one (an upright, measuring $12\frac{1}{4} \times 9\frac{1}{4}$ inches) which shows a tree rather to the left of the foreground, below and beyond which an expanse of mountainous country is seen. It is to be noted that Manby's drawings are a good deal like certain grey wash drawings by his younger contemporary Francis Place (of whom more in a few moments), and they also resemble an anonymous and apparently English seventeenth century drawing, in the same medium, inscribed 'Ye Remains of ye Temple of Concord behind ye Campidoglio', which was once in the collection of Jonathan Richardson, and which I now have. These similarities suggest that there may have been something more like a school of English landscape draughtsmen of this sort than we know at present. As regards Cook and Manby in particular, I do not suppose that either of them is likely to have been a main agent in transmitting to England the Italian influence in landscape. I merely wish to draw attention to the fact that here are two Englishmen who worked in Italy in the seventeenth century. We know, moreover, that there were others such as Hugh Howard (1675–1737), who was in Italy from 1697 to 1700, and Henry Trench (d. 1726), who was there about 1700. There may well have been more English artists than we know of in Italy making more or less imaginative drawings of natural objects in wash—and perhaps even in colour—and these may have helped to lay the foundations of the strong Italian influences visible in mid-eighteenth century English landscape. I do not put this theory forward as established; but at least it seems to be a possible line of investigation.

The story of English landscape drawing in the seventeenth and early eighteenth centuries remains a matter of scanty and largely unrelated scraps. By contrast, English topography—that is the more factual drawing of the appearance of places—had a more

* See I. A. Williams, 'Thomas Manby, a 17th Century Landscape Painter'. *Apollo*. May 1936.

continuous development, and the controlling influences were from the Low Countries and Central Europe rather than from Italy. Undeniably the most important single fact was the arrival of Hollar in 1637; but the more the subject is examined the more evident it becomes that there were many more foreign topographers here in the middle and later seventeenth century than has been generally realized. Most of them did not come until Charles II's reign, but at least one, Claude de Jongh (died 1663) was here before Hollar, for among a number of English drawings in very crisp and careful pen and wash in the British Museum, which quite recently have been indentified as by de Jongh, is one of mediaeval ruins dated April 26, 1627. He was back in his native Utrecht in 1633, but may have returned to England by 1650.

None of this, however, detracts from the fact that it is possible to trace something like a connected development from the year 1637, when in January there came to London, as one of the train of Thomas Howard, Earl of Arundel, the Bohemian draughtsman and engraver Wenceslaus (or Vaclav) Hollar (1607–1677), a native of Prague and one of the greatest men who have practised the arts in Britain. Arundel, while passing through Cologne in 1636 on a diplomatic journey to the Imperial Court, noticed Hollar's work and engaged him as draughtsman in his suite. In the course of that journey Hollar made a series of exquisite little topographical drawings in pen and watercolour, which are now at Chatsworth, and he continued to practise the art of pen and ink topographical drawing, tinted in watercolour, after he came to England. This country became Hollar's home for the rest of his life, with the exception of the years 1644 to 1652 when, as a result of his associations with the Royalist party in England, he was in exile at Antwerp. But even while he was there he was occupied to some extent with English scenes, for it was in 1647 that one of his most important engravings, the *Long Bird's-eye View of London from Bankside*, was published in seven sheets at Amsterdam. In making this great print Hollar worked from his own drawings, which he must have carried with him when he fled from England. Some of them, in pencil inked over, still survive, and turned up in the Patrick Allan Fraser sale to which reference was made a page or so back (9). It is largely from Hollar's many etchings and drawings that we know what England looked like in the middle of the seventeenth century—what sort of clothes its people wore, the appearance of many of its most famous buildings, and even the aspect of some of its quietest rural retreats, such as that shown in the exquisite little etching inscribed *bey Alburye in Surrey*, and also produced during his exile, in 1645. One may feel a little proud that the quiet beauty of rural England should have so impressed the mind of this great artist that he could produce in recollection and from afar so exquisite and glowing a representation of a typical English scene. It is, however, with Hollar's watercolours that we are primarily concerned here, though their relation to his other work is not beside the point, for such an etching as that of Albury is very nearly allied to his topographical watercolours. The quality of the drawing—the etched line in the one case, the beautifully firm and neat pen and ink in the other—the horizontal panoramic arrangement of the subject, the remarkable sense of depth, distance, and atmosphere conveyed in little, are the same in both etching and watercolour. The difference lies merely in that the quality of warmth and glow which both possess is produced in the one case by the black lines of the etcher's ink, and in the other by basic washes of Indian ink or sepia with local colour lightly added over them.

There are many beautiful examples of Hollar's tinted watercolours of this type in the Royal Library at Windsor, for example (8) the delightfully crisp and precise, yet delicate, *Windsor Castle, from the North-East* ($4\frac{5}{8} \times 10\frac{7}{8}$ inches), which has only the slightest washes of colour, and there are others in the Print Room at the British Museum. Windsor, Richmond, Whitehall, the Tower of London from the Thames, Gravesend—of how many an English scene do we not get our first, or almost our first, glimpse in the drawings of Hollar? Nor did he stick to English scenes, for in addition to his early work on the Continent there are the drawings of Tangier which he made in 1669 as draughtsman in the suite of Lord Henry Howard, some of which are in the British Museum and others in the collection of Sir Bruce Ingram. In these late drawings, however, Hollar occasionally seems to have lost something of his earlier delicacy and to have become just a little heavy in touch. I have referred to the horizontal, panoramic, way in which Hollar laid out his subjects so as to cover a wide area on a rather small scale. Most of his drawings are very shallow for their width, and this fondness for the 'strip-picture' (if I may use a modernism in an unorthodox sense) remained characteristic of the English school, persisting in such topographers as Place, Lens, the Bucks and Thomas Sandby, and cropping up again regularly at intervals—for example not infrequently in the landscapes of Peter De Wint.

In his English topographical productions Hollar did not work in entire isolation. His engravings were sometimes done after drawings (some of which have survived) by anonymous and presumably English artists—much as, a century and a half later, such an artist as Francis Nicholson occasionally based his work on sketches by Sir Richard Colt Hoare, Sir Thomas Acland and other amateurs. At other times Hollar engraved after such named artists as Daniel King and Thomas Johnson. By King I only remember seeing (in the British Museum) an architectural drawing of the east end of York Minster, in pencil and grey wash, and in the British Museum (Natural History) a monochrome drawing of the Great Auk—which has the distinction of being the earliest known representation of a famous bird now extinct. By Johnson, who made drawings of Canterbury churches, which were etched by King, there is in the British Museum a highly curious, amusing, and rather primitive drawing ($13\frac{1}{4} \times 18\frac{5}{8}$ inches), in Indian ink wash and pen, of people taking the baths at Bath. It is dated 1675. There is also in my own collection a panoramic view of Canterbury, in pen and black chalk, signed 'Tho. Johnson Delin', and measuring $5 \times 31\frac{1}{2}$ inches, which was engraved by Hollar. This, too, came from the Patrick Allan Fraser collection. It may well be that somewhere there exist drawings in watercolour by these two artists, done in imitation of Hollar—but they remain things which the collector dreams about finding some day.

Much more important were Hollar's connection with, and influence upon, the amateur artist Francis Place* (1647–1728). He was born at Dinsdale in County Durham, and came to London to study law, but left on the outbreak of the Great Plague in 1665. He was not Hollar's pupil in the formal sense of the word, but he was his friend and certainly his disciple, as a glance at their drawings will show. Place lived for many years at York, where he was one of a group of artists and antiquaries, which included William Lodge (1649–1689), another English artist, though not a professional or one highly skilled, of that period who visited Italy. He is represented in the British Museum by three pen-and-ink sketches of

* See Sir H. M. Hake, 'Some Contemporary Records relating to Francis Place', etc. Walpole Society, Volume X, 1922.

London scenes, but they are slight and amateurish affairs. Others in the circle were the antiquary Ralph Thoresby, and the glass-painter Henry Gyles, whose house was the meeting place of all those interested in the arts in York. Two other amateur artists among Place's friends and correspondents were John Lambert, son of the General, and Sir Ralph Coll, Baronet, of Brancepeth Castle.

Place was a man of many artistic talents—he etched, drew portraits (including one of William Penn) in crayons, was one of the first English mezzotinters, experimented in making pottery, and made many combined sketching and fishing tours in company with his friend Lodge. One of these tours was that of 1678 in the course of which Place made drawings of Salisbury, Bath, Bristol, Plymouth, Swansea, Cardiff, Pembroke and Tenby. His topographical drawings are more or less in the manner of Hollar, though both freer and less firm and certain in touch. Place drew in many mediums, e.g. pencil, pen and sepia wash, grey wash with little or no pen (the style which, as I have already said, is like that of the Manby drawings), and pen and watercolour. A large number of his drawings came to light in the already mentioned Patrick Allan Fraser sale in 1931—a sale which, indeed, added very greatly to our knowledge of seventeenth century drawing in England, since it contained also examples of Hollar, Thomas Johnson, Francis Barlow, Manby and Thomas Wyck (1616–1677), a Dutch artist who settled in England at the Restoration and drew, among other things, harbour scenes (and occasional landscapes) in broadly handled grey wash. It is a misfortune that the importance of this collection, which must, I think, have descended from Place himself, was not grasped before the sale and an effort made to keep it intact—it would not have been a very expensive matter to do so, since the twenty-two lots into which it was divided fetched an average of not quite £10 each, and a great deal might have been learnt from a careful study of the collection as a whole. However two important lots, which included two sketch-books, were acquired for the Victoria and Albert Museum, and these have added greatly to what was to be learnt about Place's drawings from the examples which had been in the British Museum since about 1850. Other drawings from the sale went to provincial galleries, such as Cardiff, and still others into well-known private collections. As a general result we now know a good many additional facts both about Place's style of drawing and about his movements. Scarcely any of the British Museum drawings represent other than North of England views, few are dated, and of those few the majority are dated late in Place's life, i.e. after 1700. Moreover all of them are in monochrome. From the material which turned up in 1931 we now know, for example, of drawings—in colour—done by him in the Isle of Wight in 1677, in London in 1683, in Ireland in 1698, in Chester, North Wales and again Ireland in 1699 (perhaps there is some confusion in the dates of the Irish drawings), and in Scotland in 1701—as well as the West Country and South Wales drawings of 1678 already mentioned.

Place is a less exact and masterly draughtsman than Hollar, upon whom for the most part he modelled his style, but he can achieve a very pretty and delicate result for all that. Some of his coast scenes, in pen and wash, or pen and watercolour, with little ships neatly and surely drawn with a fine line, and pleasant small figures in the foreground, have great charm. He drew ruins well, and also panoramic views of towns. One of the Victoria and Albert sketch-books contains, for example, a double-page watercolour inscribed *Chester Castle with the Bridge* (1689), which is admirably crisp and solid, and the same Museum also

has some notable watercolour views of Millbank (10) and adjacent parts of Westminster as they were in 1683. It is to be remembered that when these drawings are spoken of as water-colours it is in the sense that they are drawings done first in pen or pencil, the lights and shadows next being added by monochrome washes, perhaps of sepia or Indian ink, and finally the local colour applied in thin washes of other colours. This method—that of the 'tinted drawing'—was used in most coloured topographical work until towards the end of the eighteenth century. But to return to Place, devoted though he was to Hollar, yet he was a typical Englishman, who often has an inclination to rebel from unvarying neatness. In some of his drawings we find Place trying to get added poetry by drawing his forms with the brush, rather than by drawing them with the pen and then filling them in with a watercolour wash. This is seen, for example, in the tree and rock forms of his monochrome *The Dropping Well, Knaresborough* ($12\frac{7}{8} \times 16$ inches) in the British Museum, where the impulse seems more strongly aesthetic than in the strictly topographical drawings (11). The artist here is more interested in the beauty of light and shade than in portraying a particular spot. The same is true of a little sketch in my own possession, *Near Bishop Auckland* ($5\frac{7}{8} \times 7\frac{3}{4}$ inches), slightly and rapidly done in pen and wash, of a cottage on the brow of a hill, with smoke streaming away from the chimney in the wind (12). It is purely the flowing lines of the composition which have inspired Place here. And because of such occasional sketches as these one may perhaps see in Place the beginnings of a painter of imaginative landscape.

Another amateur artist who followed the topographical tradition of Hollar was John Talman, son of the architect William Talman. He also made antiquarian and architectural drawings—he was the first Director of the Society of Antiquaries, which possesses some of his work—and sometimes tinted them. As a topographer he was less sensitive and charming than Place, and far less skilled than Hollar, whose convention of the broad shallow panorama he followed. A pen drawing of this type by him, dated 1699, represents a view on the Rhine, and later he was in Italy. He lived from 1677 to 1726. Of the two men, David Loggan (1635–1700?), a Scot born in Danzig, and the Dutchman Michael Burghers (1653?–1727), who recorded for us the topography and architecture of Oxford (and in the case of Loggan of Cambridge also), I do not know that any original drawings of this sort survive. Certain things of the same school do, however, exist, and in 1948 the British Museum acquired two large drawings (about 11×32 or 33 inches) of Badminton in pen and wash, with just a little blue on the roofs. They are by Hendrik Danckerts, a Dutch artist who came to England soon after the Restoration. He lived from about 1630 to after 1679. The same museum also has a drawing of Whitehall and Westminster Abbey by Danckerts. It is in pen and brown ink, with grey wash and watercolour. Other topographical draughtsmen who came to England in Charles II's time were Willem Schellinks (1627–1678) by whom the British Museum has a drawing of Stonehenge, in pen and brown wash over pencil, and a panorama of Canterbury; Adam Colonia (1634–1685), a native of Rotterdam, who lived here from soon after 1670 until his death, there is a study of trees in brown wash by him in the Print Room; and Sir Martin Beckman (died 1702), a Swedish-born military engineer, whose drawing owed a debt to Hollar.

Another use of the topographical watercolour in the seventeenth century is seen in a volume now at the National Maritime Museum, Greenwich. This is a survey of the Channel Islands undertaken by George Legge, as Master General of Ordnance, in 1680.

It is fully illustrated with large watercolour views, competent if formal, by Thomas Phillips (1635?–1693), military engineer of the expedition. The volume was recovered from the wreck of the *Gloucester* in 1682. There are other examples of Phillips's work at the British Museum. He went to Tangier with Pepys and Beckman in 1683 and was in Ireland in 1685 (15).

One of the things which Place did was to make etched plates after drawings of birds and animals by Francis Barlow (1626?–1702), who has the credit of being the first English sporting painter whose name we know. He is said to have been born in Lincolnshire, and certainly he shows a fondness for marshland birds and vegetation very proper to a native of that county. Barlow painted in oils (some of the most important examples belong to Lord Onslow) and also made many drawings of sporting and natural history subjects, and illustrations for *Aesop's Fables*. He drew with a very firm rather broad pen line, with monochrome wash added (14). The late Laurence Binyon suggested that he may well have worked in watercolour, but I know of no coloured drawing by Barlow except a design for a decorative panel which Sir Bruce Ingram lent to the Burlington Fine Arts Club in 1938. And here it may be worth noting that the British Museum has some studies of poultry in watercolour by Marmaduke Cradock (1660–1716), who had a considerable reputation in his day as a painter of decorative bird-groups.

An event of much importance to the development of English art was the arrival in this country in the year 1675 of the Dutch marine painter William Van de Velde the elder (1611–1693), a native of Leyden. He had previously been employed by the Dutch Government, who supplied him with a boat of his own, to paint sea-fights, and after he came here he did similar work for the English court. He worked, however, entirely in monochrome, both in his drawings and in his paintings. He probably brought with him to England his son, William Van de Velde the younger (1633–1707), at any rate the younger artist was here by 1677, acting as his father's assistant. Both Van de Veldes made many drawings, and it is often a matter of much difficulty to distinguish their hands. Like his father, the younger man drew in monochrome—pencil or pen with Indian ink or sepia wash—though in oils he worked in colour. His drawings of ships are very numerous—it is said that more than 8,000 were sold by auction in the late eighteenth century—and are often of great beauty, the ships being drawn with freedom and spirit combined with accurate understanding. The effects of light on sails, and so forth, are often extremely delicate and poetical. Neither of the Van de Veldes was a watercolourist in the full sense, but their work very largely inspired the eighteenth century marine watercolour artists, of whom something will be said in a later chapter. Important collections of drawings by both father and son are in the British Museum and the National Maritime Museum, as well as in the possession of Sir Bruce Ingram. Both artists were fond of the wide shallow panorama, and their drawings are frequently annotated in Dutch with the names of ships and other details (16 and 17).

Another seventeenth century artist who must be mentioned, if briefly, is Marcellus Lauron, or Laroon, the elder (1653–1702). He was born at The Hague, of French extraction, came early to England, and lived first in Yorkshire and later in London. He drew smallish figure-subjects—usually single figures—and about 1688 a series of *The Cryes of the City of London* after his designs was engraved and published by P. Tempest. One drawing of

his ($9 \times 6\frac{3}{4}$ inches) which is before me as I write represents a Salzburger merchant in London, attended by his page-boy who holds a horse. It is carefully, but rather stiffly, drawn in brown ink, with the light and shade indicated by washes of blue-grey. It is not one of the engraved series (if the British Museum copy is complete), but it agrees pretty well in general style with some of the engravings—such for example as *The Squire of Alsatia*. In the British Museum are an illustration to a book on fencing, in pen and sepia, and a series of characters of Italian comedy most of which are very gaily and clearly coloured (18). His second son, Marcellus Laroon the younger (1679–1772), was a much better known artist, whose style of drawing conversation pieces, often humorous, in a rather rough, broad, broken pen-line, or in pencil, varied scarcely at all throughout his very long career; but I do not know that he ever worked in watercolour The charming example (32) which I reproduce from Sir Bruce Ingram's collection is not altogether typical, being more delicately drawn than is usual with Laroon; but though unsigned it must be, I think, by him.

A few more names of the seventeenth century perhaps call for mention. Isaac Fuller (1606–1672) was a painter of portraits, altar pieces and house decorations, a few of whose designs upon mythological scenes are known, and one of these (in Sir Robert Witt's collection) is loosely drawn in pen and wash. In the same collection are some elegant little studies of draped female figures by the miniaturist Isaac Oliver (*circa* 1556–1617?), drawn with a fine pen and delicately washed with blue or sepia. Mr Paul Oppé has two attractive signed pen and wash drawings of a woman with braided hair by Oliver (19). Another early artist was Alexander Marshal (working about 1660 to 1690). There are watercolours of flowers* on vellum by him at the British Museum, and he also did the fine coloured drawings in a *Florilegium* (or album of flower-paintings) of two folio volumes, in the Royal Library, Windsor. In this connection, too, it must be mentioned that the Royal Society possesses a number of delightfully fresh signed drawings of English wild flowers, in clear colour, by Richard Waller (1650?–1715), who became secretary of the Society in 1687. They include many grasses, and there is also, with them, a drawing of a chameleon, dated 1686. But it would be straining things to allot to any of these four men an important position in the history and development of English watercolours.

Lastly, it may be recorded that there are in the British Museum two prim and stiff little drawings in body colour on vellum, signed by the engraver John Dunstall, who was working from about the middle of the seventeenth century and died in 1693. They represent a curious survival of the old limner's technique. One represents a pollarded oak with a town (perhaps Chichester) in the background, and the other the front of the Bethlehem Hospital. Unless he was almost a centenarian when he died this artist cannot have been the John Dunstall who in 1612 signed a military 'platt' of Carrickfergus (also in the British Museum).

* For the whole subject of drawings of flowers see Mr Wilfrid Blunt's excellent *The Art of Botanical Illustration*. Collins. 1950. 21*s*.

CHAPTER TWO

The Early Eighteenth Century

WE MAY most conveniently begin the story of English watercolour in the eighteenth century by continuing for a little to trace the development of topography. A glance may, however, be given first at the somewhat isolated figure of the Flemish painter Peter Tillemans, who was born at Antwerp in 1684, settled in England in 1708, and remained here till his death in Suffolk in 1734. He did hunting scenes, views of country houses, and portraits, and his drawings are now rare. He saw landscape in a neat, formal way, though not quite with the matter-of-fact eye of the pure topographer. A very good example of his watercolours ($7 \times 8\frac{3}{4}$ inches) is in the Victoria and Albert Museum (20); it shows a stream in the foreground, beyond which are two horsemen with their dogs, while still further in the distance is a stretch of park land studded with clumps of trees and grazing and running deer—a very pretty rendering of an English country scene, such as one may still find today. Mr Oppé has a sheet of small costume studies, in pencil and clear watercolour, for a group of the Duke of Kent's family. Tillemans probably had some influence on such early sporting painters as John Wootton (1678?–1765)—though he was a little older than Tillemans, and was the pupil of John Wyck (1652–1700), son of the Thomas Wyck mentioned in the previous chapter—and James Seymour (1702–1752). Seymour, besides his well-known oil portraits of horses and their riders, did a few small body-colour drawings of horses and so forth, which seem very stilted in comparison with his vigorous and spirited pen or pencil drawings of sporting subjects.

A much more considerable figure—though landscape and watercolour were only very slight elements in his output—was Sir James Thornhill (1675–1734), a member of an old Dorset family and the first English painter to receive a knighthood—which he did in 1720 on his appointment as sergeant-painter to the King in succession to his old master and relative, Thomas Highmore. Thornhill as a young man travelled on the Continent, visiting Rome, and eventually became the chief painter of wall and ceiling decorations in England, a branch of art previously almost a monopoly of foreigners such as Verrio and Laguerre. His work of this kind in the dome of St Paul's and at Greenwich is familiar. When an academy of painting was opened in Great Queen Street in 1711, with Kneller as Governor, Thornhill was one of the twelve directors, and later he led the secession which started a rival academy in James Street, Covent Garden. Here one of his pupils was William Hogarth, who in 1729 clandestinely married his daughter Jane. Thornhill was thus one of the chief founders of the English eighteenth century school of painting. A very great number of his drawings survive—usually allegorical or classical subjects, with a strong architectural element in the setting, done in pen, pencil and wash, generally

13

bistre, sepia or grey. They are often extremely stylish and attractive, with a pleasant free-
dom of touch about them, plenty of movement in the figures, and warmth and richness in
the washes. They frequently carry annotations in Thornhill's hand, and they have certain
characteristic tricks, such as the suggestion of a full face by a cross within an oval, and the
very sharp noses Thornhill often gave to faces seen in profile (22).

Thornhill only very rarely used colour in his drawings, but in an album of them which
he himself made (dating the title page 1699) and which is now in the British Museum there
are (amongst much else) two elaborate allegorical subjects rather highly coloured, another
with slight traces of watercolour (pink, yellow, brown and grey), and another in pen and
red wash. This volume also contains a number of classical landscapes in pen, pencil, etc.,
as well as a series of small monochrome views, formal but clearly done from nature, of
places in Derbyshire—Mam Tor, Castleton, Buxton amongst others—in pen, pencil and
bistre. These are very early things of their kind. A late example of Thornhill's topo-
graphical work (it is inscribed *From my lodgings, Ap.* 20, 1731) is the *View of Hampton Court
Ferry* (11 × 18½ inches), in the Whitworth Institution, Manchester (25). This is in pen and
wash and is much freer, as well as much larger, than his earlier drawings of this sort. A
similar drawing, of the same size, but dated 1730, is the *View of the River at Hampton Court*,
also in the Whitworth gallery.

Among Thornhill's imitators was a certain Thomas Carwitham, who worked about
1720, and did a number of pen and wash drawings of classical myths, often taken from
Ovid's *Metamorphoses* (24). He is a very obscure figure, but there is a signed drawing by him
in the Victoria and Albert Museum. I have never seen coloured drawings by him. Another
decorative artist of the same time and school was John Devoto, by whom the British
Museum has an album of drawings, including designs for wall-paintings and stage scenery,
mostly strongly architectural and done in pen and monochrome wash, but including also a
drawing of a fountain in pen and watercolour. Other coloured drawings by Devoto exist.
Mr Edward Croft-Murray, for example, has a lively watercolour of the deformed dwarf
artist, Matthew Buckinger, who had neither hands nor feet, dancing on his stumps (23).
He is clad in a costume reminiscent both of Highland tartan and of the Italian *Comedia del
Arte*, and is shown inside a design for a golden frame which, as usual with such designs,
shows alternatives on either side—the right being of one pattern and the left of another.
I myself have a design for a marble and gilt tomb with a figure of a man leaning
against it, which is rather shakily drawn in pen and tinted with yellow, blue, brick-red,
brown and grey (9½×6¼ inches). Like most of his work it is signed, the signature here
reading 'Jo. Devoto in de'. It is a much less spirited performance than Mr Croft-Murray's
example.

Thornhill's chief rival, however, was William Kent (1684–1748), an artistic jack-of-all-
trades who won much distinction as an architect and landscape gardener, and rather less
as a book-illustrator and painter. There is a certain landscape element in his illustrations
for *The Faerie Queen* at the Victoria and Albert Museum, and in some of his designs for the
lay-out of gardens (26), but I have not seen any such things of his in colour. There
are, however, some touches of colour about monumental or decorative designs by
Kent in the British Museum, and at Windsor there is a pen and watercolour design for
a boathouse, dated 1754, by one of his principal assistants, John Vardy (died 1765).

At Chatsworth there is a folio volume containing drawings in pencil, chalk or water-colour, chiefly by Kent's amateur pupil, Dorothy, Lady Burlington (1699–1758), wife of the third Earl of Burlington, the celebrated patron of the arts and architect, but I have not seen them.

Among topographers, in the strict sense, the first considerable figures of the century were the Dutchmen Leonard Knyff (1650–1721) and Johannes Kip (1655–1722), the first volume of whose *Britannia Illustrata, or Views of several of the Queen's Palaces, as also of the principal Seats of the Nobility and Gentry of Great Britain* appeared in 1708. It contained a series of stiff and artificial bird's-eye views drawn by Knyff and etched by Kip. In later volumes Kip etched after his own designs and after those of some other artists, including one Thomas Badeslade. The British Museum has a pleasant view of Berkeley Castle from the South by Knyff in grey wash over pencil, but I have never seen anything by Kip or Badeslade. One would expect the original drawings of this group of artists to be in pen and Indian ink like most other topographical drawings of their period, notably the majority of those of Samuel Buck (1696–1779), and his younger brother Nathaniel, who assisted him during the years 1727 to 1753. Samuel Buck was both draughtsman and engraver, and he and his brother produced more than five hundred views of ruined abbeys and castles, and of cities and towns. This extensive series began in 1720,* and started with Yorkshire. It was his custom to travel during the summer making drawings and to work on the plates during the winter. A few of his drawings are said to have been coloured, but all that I have seen have been in monochrome. Two examples of Buck's drawings are before me as I write. They vary a good deal, though both are in Indian ink. The earlier ($5\frac{3}{4} \times 13\frac{3}{4}$ inches) is the more elaborate and highly finished, and is inscribed across the top in careful lettering, *The South View of the Ruins of Fountains Abbey, in Skeldale, three Miles from Rippon* (27). It probably dates from between 1720† and 1726. The view is not a bird's-eye, but yet the angle at which we look down upon the abbey is somewhat exaggerated. There is a great deal of rather fine pen outline—in the building itself, the cliff-face and hills beyond, and in some of the trees in the foreground. Other trees, however, are done with the brush only (there are a few very slight traces of underlying pencil), the foliage being put in with small horizontal, more-or-less elliptical, strokes, and throughout the drawing the way the washes are varied in intensity to suggest light and shade is not without a pleasant degree of modulation and warmth. The broken tops of the walls, and the tower, are crowned with strag-gling and drooping vegetation (even including a few small trees) which always seems to have taken Buck's fancy, and which he employed to give an agreeably Chinese, willow-patternish, decorative trimming to his drawings and prints. The second drawing ($5 \times 14\frac{1}{2}$ inches) is much looser and sketchier, though it, too, has a formally lettered inscription at the top—*The east view of St Briavel's Castle, in the County of Gloucester*—and so can scarcely be regarded as a mere preliminary sketch. Save on one part of the building there is hardly any pen-work, and the handling of foliage and so forth is much broader. There is also much less 'bird's-eye' feeling in this drawing, which probably belongs to the year 1732. A comparison with the print shows that Buck tightened up this drawing a good deal in

* There is one print in the British Museum set dated 1711, but that is apparently the date of the original drawing which, in this case as in a few others, was by another hand.

† The print of this drawing is not dated. But it is number 7 of the series of 24 Yorkshire views, published in 1726. Other prints in the same series range from 1720 to 1726.

transferring it to the copperplate. The Duke of Northumberland has a view of Sion House, signed N. B. and dated 1736, which can be taken as a genuinely signed example of Nathaniel Buck's work (28). The British Museum also has an important series of drawings by the Bucks.

Buck's Fountains Abbey drawing has in the lower right-hand corner the signature 'Samuel Buck', but that is almost certainly a forgery, though the drawing is genuine. This, therefore, is the most convenient place to introduce a short digression about a group of forged signatures to which I believe this particular forgery belongs, and which is a real nuisance to collectors of English eighteenth century drawings. The signatures—for which a London dealer now dead is generally supposed to be responsible, certainly many of them passed through his hands—generally give themselves away, to anyone who has seen a number of them, by being too roundly and smoothly written in a copybook hand. This applies less evidently to the 'Buck' signatures, though even here there is the lack of underlying individuality, of the personal character of the artist, which declares the thing false. In the signatures supposed to be those of later artists—Richard Wilson, Paul Sandby, P. S. Munn, H. W. Bunbury, and David Cox are frequent forgeries of this group—the falsity should be obvious to anyone with half-an-eye; yet these spurious signatures have caused a great deal of confusion. This forger's favourite method was to buy up parcels of unsigned eighteenth-century drawings, and sign them without any regard to style. For example, one frequently finds monochrome drawings by the accomplished amateur Thomas Sunderland bearing spurious signatures of Paul Sandby, and I have a watercolour by Anthony Devis which bears in one corner the obtrusive signature 'Rich Wilson, 1770' and in another corner, very unobtrusively, the scribbled monogram of its real author. A large number of small caricature drawings, a few of them genuinely by H. W. Bunbury, and many of them possibly coming from his family though not by him, bear his supposed signature. A great many Gillray and Woodward signatures also, I believe, come from the same source—in the case of Woodward (though not so far as I have seen of Gillray) often on drawings which are really his; many little monochrome sketches by Glover bear the name 'P. S. Munn'; and the work of an obscure drawing master called J. Robertson is frequently signed 'David Cox'. In addition there are good eighteenth century landscape sketches by unidentified hands (probably in most cases those of talented amateurs) which are marred by these unsightly and preposterous attempts to father them upon well-known artists. But this—for the most part—is to get ahead of our story, and we must return to the early topographers.

Bernard Lens was another artist who practised topography in the first third of the eighteenth century. The unravelling of the Lens family is a matter of some difficulty, and it is therefore perhaps worth while to set it out as follows:

(1) Bernard Lens I
 1631–1708
Enamel painter, 'apparently of Netherlandish origin'. (D.N.B.)

(2) Bernard Lens II
 1659–1725
Mezzotint-engraver and drawing master.
Son of (1).

16

(3) Bernard Lens III
　　1682*–1740
'The best miniature painter of his day' (*BM Catalogue*).
Son of (2).

(4) Bernard Lens IV
　　17　–17
Studied art, but became a clerk in the Exchequer office.
Eldest son of (3).

(5) Peter Paul Lens
　　17　–17
Miniature painter.
Second son of (3).

(6) Andrew Benjamin Lens
　　17　–17
Miniature painter. Exhibited 1765–1770.
Third son of (3). This must, I think, be the disreputable '. . . B. Lens' of whom
Vertue (*Walpole Society*, Vol XXII, p. 106) records an amusingly Bob Sawyerish
experiment in self-advertisement.

According to both the British Museum *Catalogue of Drawings by British Artists* and the
Dictionary of National Biography, it was Bernard Lens II who did the topographical drawings
which I shall discuss in a few moments. This, however, seems to be incompatible with the
statement, contained in the BM Catalogue itself, that the preliminary cartouche of one
series of the drawings supposed to be by him reads 'Severall Prospects taken by the Life
and Drawn by Bernard Lens Senr in ye Years 1730 and 1731'—i.e. five and six years after
the death of their alleged author. I suggest that these thirty drawings, at least, must be
the work of number (3) of the family—Bernard Lens III, the celebrated miniaturist, who
lived from 1682 to 1740 and might well, since his eldest son was also a Bernard, be de-
scribed as 'senior' in 1730-1. His authorship of the topographical drawings is, indeed,
stated by George Vertue (*Walpole Society*, Vol. XXII, p. 100). The BM Catalogue does
tentatively attribute to him four topographical drawings in the Crace collection of London
views—though here again there is something wrong since one of these is dated 1746! Re-
cently, however, I saw a drawing, much in the family manner, but inferior in the figures
especially, and generally much woollier in treatment, which was signed by number (6) of
my list—Andrew Benjamin Lens—and I think this may help to solve the problem. Material
in private hands, and in the Royal Collection at Windsor, also seems to suggest that
Bernard Lens III, the miniaturist, did the best of the topographical drawings, and that the
inferior examples are copies, or imitations, of his work by his son Andrew Benjamin Lens,
and perhaps by Bernard Lens IV also. But it is, of course, possible that three, and not only
two, generations of the Lens family were concerned in making these views. Since, more-
over, some of the subjects are repeated, and do not look like copies by another hand, I
presume that Bernard Lens III produced replicas of his own work. But clearly the pro-
duction of these views was a business in which several members of the family had a share.

* Vertue says 1681.

The great majority of the Bernard Lens topographical drawings are neatly and rather stiffly drawn in pen and ink, and washed in blackish, or grey, monochrome—probably Indian ink—or occasionally in brown. The figures, which decorate the foregrounds, are charming, often amusing, and sometimes include one of the artist himself seated sketching the scene. The subjects are chiefly either buildings and other things of antiquarian interest, or 'prospects' (for which Lens had a good eye) of towns, and in this he follows the same utilitarian approach as the Bucks. Occasionally (as in a few of the British Museum drawings) he seems to have been more interested in a stretch of country, than in any antiquarian object. One delightful sequence of (if I have seen them all) ten drawings* represents a trip through *Ochie Hole*, otherwise Wookie Hole in Somerset; the best of these, an exceptionally pleasing and interesting view of the entrance to the Hole, belongs to Mr Leonard Duke (29). Some of the smaller interior views show the party being taken round the caves by the light of torches held in the hand. Vertue (if I understand his note correctly) records that these drawings were done in 1719; and certain of the artist's drawings of Bristol and Bath which are in the British Museum date from 1718 or 1719. The 1730–31 series (already referred to) also contains some Somerset views, in addition to others of London, Portsmouth, Shropshire, and Worcester. As I have said, most of Lens's topographical work is in monochrome, but I have seen two drawings by him which were tinted with light washes of colour and, supposing the colouring to be original (which I see no reason to doubt), Lens may therefore be classed as a watercolourist in the full sense. It is perhaps worth noting that he was drawing master to the young Horace Walpole, as well as being 'limner' to George I and George II. Lens's architectural draughtsmanship is stilted and often faulty in perspective, but his little figures, his horsemen admiring the view, such incidentals as boats being towed along rivers, the miniature trees neatly out-lined with small loops of the pen and dappled with wash, and the general sense of a scene well laid out in a simple and rather primitive way, give his work of this type a certain attractiveness, apart from its antiquarian interest.

One exceptionally large Indian ink monochrome, inscribed *A View of the Castle [and?] Town of Arundel*, signed 'Bern^d Lens Sen^r delin', and marked with the serial number 13, used to belong to Randall Davies, though it was not in his sale. I saw it again at Messrs Appleby's in 1948. It measures $15\frac{1}{8} \times 36\frac{3}{8}$ inches, and is without the pen outline which is present in the smaller drawings. Possibly this may be the work of Bernard Lens II—but unhappily it is not dated, so that one cannot be sure.

A minor artist who seems to have been both topographer and architect was John Donowell, about whom there was some correspondence in *Country Life* in the early weeks of 1948. Unless there were two draughtsmen of that name he had a long career, for there are prints of St Giles's-in-the-Fields, dated 1735, after his drawings, and he was exhibiting at the Royal Academy as late as the years 1778 to 1786. He also showed at the Free Society of Artists in 1761 and at the Society of Artists from 1762 to 1770. He contributed to volume IV of *Vitruvius Britannicus*, 1771. So far as my limited experience goes Donowell worked in rather thin pen and Indian ink wash and not in colour. Many of his drawings are largely architectural in character. Mr L. G. Duke has a signed drawing of a garden

* They are part of a numbered series of West Country drawings of which I have noted numbers from 7 to 30. They vary in size but are all on sheets 10×14 inches which have clearly been cut from the same sketch-book and are gilt round three edges.

with a cascade which has on the back this revealing tradesmanlike note of the artist's charges for it:

	£	s.	d.
View	2	2	0
Figures		10	6

With the possible exception of those by Thornhill, none of the topographical drawings so far mentioned in this chapter has been inspired by what we should nowadays consider a love of beautiful scenery. Lakes, mountains, picturesque cottages, even stretches of lowland river or agricultural land, are absent, and the subjects have been towns, great houses, ruins or other antiquities. The aim has been intellectual rather than aesthetic. It was therefore interesting when, a year or two ago, there turned up unexpectedly a group of four large watercolours, three of which depicted Lake District scenes, done in the thirties of the eighteenth century. The artist was one Stephen Penn, of whom nothing is known save what these drawings reveal. Take, for example, his drawing *The S. West Prospect of the Country from Peelnears* ($13\frac{1}{8} \times 19\frac{1}{4}$ inches), signed and dated 1732. It is a wide view over Coniston—or Thurston Water as it was then called—outlined in pen and tinted in a rather timid range of colour, chiefly pale greys, greens, and blues, with some pinky lights on the trees. In many ways it is crude—the figures in the boats on the lake are wildly out of proportion—and it is strictly topographical in that the various hilltops and so on are numbered clearly in ink and their names given in a table of reference. But the thing that is really striking is that the artist (presumably an amateur) had an eye for a picture, and that he has obviously made this drawing as a record of a place which he loved to look at. His impulse was aesthetic, and he has here been moved by the beauty of a lake and mountain scene, long before lakes and mountains were generally fashionable (30).

Better things, however, than this were already happening. That same year, 1732, saw a *Five Days' Peregrination* down the Thames by boat, undertaken by five friends, of which a famous record survives in a manuscript volume preserved in the British Museum. Among the friends were Hogarth, his brother-in-law John Thornhill, and Samuel Scott, and the record of the trip is illustrated by seven drawings by Hogarth and two by Scott. If the term watercolour be restricted to drawings in full colours, and if the accent be put on landscape, William Hogarth (1697–1764)* scarcely comes into our picture at all. Though his illustrations in the *Peregrination* have some washes of colour, yet he is primarily a painter in oils and an engraver, and his drawings, such as the British Museum's great series of designs for his prints of the story of the industrious and idle apprentices, are normally in pen or pencil with Indian ink (or other monochrome) washes. So far as I know the only Hogarth drawings in colour are those in the manuscript *Peregrination* just referred to, and a fine study for a painting of a large family seated on a terrace, in pen with washes of black, red, grey and blue to indicate the colour of the clothes ($12\frac{3}{4} \times 17\frac{1}{4}$ inches). This too is in the British Museum (31). It is much to be regretted that we have not from him a series of sketches of London street characters such as those done about 1740 by Louis Philippe (or Pierre?) Boitard. He was born in France early in the eighteenth century and was brought to England by his father François Boitard, who also was an artist and whose rather scratchy

* See A. P. Oppé, *The Drawings of William Hogarth*. Phaidon. 1948. 25s.

drawings of religious subjects in the manner of La Farge are not infrequent. L. P. Boitard was a far inferior draughtsman to Hogarth but his pen drawings, rather stilted and yet with a trace of French elegance, of beggars, ragged seafaring men, flower-women and the like, some of them made in preparation for such prints as the *Covent Garden Morning Frolic*, are washed in pale colours, and so qualify him for a place in a book on watercolour. A large album of his work, now to some extent at least broken up, passed through the London salerooms a few years ago (35).

Samuel Scott (1710?–1772), however, who was with Hogarth on the tour of 1732, has an undoubted claim to a place in any book on watercolour, though he too was primarily a painter in oils and his watercolours are not at all common. Such topographical examples as I have seen are rather lightly coloured, with a good deal of white paper showing, and often unfinished. Scott had, too, a distinctive way of rendering brickwork in a very pale red. His subjects were usually views on or alongside the Thames. The Whitworth Gallery Manchester, for example, has a view of Twickenham (where he lived for some time) in watercolour, with touches of pen in the trees, but it is so faded as to give little idea of his colour. Another view of Twickenham belongs to Sir Bruce Ingram. It is a drawing ($10\frac{1}{8}\times19\frac{3}{8}$ inches) of the church, which was then under repair, done from the windows of Scott's house opposite, and (having been kept in a book until recently and not hung) is in beautifully fresh condition. Parts of the drawing are unfinished. There is very neat pen-work, with small sharp loops and angles, in the row of churchyard trees, coloured rather dark green and brownish, and Scott's characteristic pinky-red appears on the roof of the house to the right, the walls of which are of an iron-grey of which he was also fond. The small figures of the men on the scaffolding to the left are lively and vigorous. One also occasionally sees charming and lively single figures. Mr Oppé has two, of ladies in billowing pink or mauve dresses, which belonged to Horace Walpole. Others representing perhaps an ostler sitting drinking, which are similarly tinted with clear soft colours, are sometimes said to be by Scott, though I do not know the authority for the attribution and I have also heard it suggested, with more probability, that they may be by his pupil Marlow. As a topographer of the Thames, and a recorder of its shipping, Scott has real importance, and artistically he is miles in advance of Buck, Lens, and such-like primitives (33 and 34).

About the same time there appeared on the scene two exceptionally interesting watercolourists, whose work had a much more imaginative quality than anything yet mentioned—Taverner and Skelton. William Taverner (1703–1772) was the son of a lawyer and minor dramatist of the same name, and like his father became procurator-general of the Court of Arches at Canterbury. As a painter he was an amateur but, according to an obituary notice in *The Gentleman's Magazine*, was reputed 'One of the best landscape-painters England ever produced'. As, however, he was notoriously shy of allowing his pictures to be seen by strangers, his reputation cannot have been very widespread. Walpole in the *Anecdotes of Painting* obviously confuses him with his father. He seems to have done both oils and watercolours, but I have seen only the latter. Three examples are before me as I write, two landscapes and a head and shoulders of Diana. The last-named is in a mixture of watercolour and black and red chalk; the drawing is weak, and the thing is not much more than a curiosity (though he could at times use classical figures effectively, as

in the British Museum's *Aglauros discovering Ericthonius*). The landscapes, however, are a different matter. They are both strongly romantic—or if you will classical, for in this connection these contrasted words seem to mean almost the same thing—in feeling, and are clearly the work of an artist with a strong poetical instinct, working under Italian influence which may have reached him through the English artists who visited Italy (as I tried to suggest in the previous chapter), or through prints or paintings in private houses, or perhaps through such an Italian artist as Marco Ricci (1676–1729?) who came to England in 1710 and did oils, as well as watercolours, wash drawings and more especially gouaches (such as the long series, done on leather, at Windsor), of classical ruins. Of the two Taverner watercolours now under discussion one ($13 \times 18\frac{3}{4}$ inches) represents a street with classical buildings at the end and to the left, and on the right a wall with trees behind it. There is also a group of trees to the left foreground, and two men, in loose semi-classical clothes, are talking in front of a fountain. The light comes in diagonally from the left distance, so that one side of the scene is cloaked in translucent shadow. Most of the picture is in warm grey monochrome, but there are some brown washes on the ground and the pink and buff clothes of one of the figures have the effect, somehow, of suggesting colour throughout. There are some very sketchy traces of soft pencil, but the great bulk of the work is drawn with a full brush very loosely used, and though it is not very solid in effect the whole thing is full of atmosphere and the suggestion of poetry. The second landscape ($12\frac{1}{2} \times 15\frac{1}{2}$ inches) has a good deal more colour in it, though still in very soft and quiet tones. It represents a bushy hollow in broken, sandy, ground, with a group of pink-roofed buildings at the far end, and three figures in classical robes of red or black—two in the foreground and one in the middle distance. Here again the general impression is soft and poetical, and the light which suffuses the distance and middle distance is delicate and lovely. Both drawings show Taverner's characteristic method of suggesting foliage by means of a flat wash of grey, grey-green, or yellow-green, incised diagonally at the edges with broad strokes of a darker colour, thus creating a very pretty dappled effect which, since things a good deal like it are to be found in other artists of the same time, notably Skelton, forms a recognizable mannerism of the mid-eighteenth century.

These drawings represent what is, perhaps, Taverner's best-known style—if anything of his can be said to be well known except to the initiate—but he also worked more naturalistically. I do not here refer to such things as the exquisite group of trees on Hampstead Heath, in Mr L. G. Duke's collection, which was seen in the English Exhibition at Burlington House in 1934, for this perhaps comes midway between Taverner's two extremes, but to the broad, sober, almost literal, renderings of sweeps of English country which he occasionally did, and of which the *Sand Pits, Woolwich* ($14\frac{1}{4} \times 27\frac{5}{8}$ inches, largely done in bodycolour), in the British Museum, is the most famous example. Like another Taverner in the same manner, which I have, it was once in Paul Sandby's collection, as was also a calm and peaceful view from Richmond Hill, now in the Whitworth Institute at Manchester. In this mood Taverner's work is much more than mere topography, and suggests the richly realistic approach to landscape of the Dutch seventeenth century masters, rather than the influence of Italy (37).

In 1947 there came to light several large English landscapes in watercolour by Taverner. One of the best of these, a view looking diagonally across the Thames near Richmond

($12\frac{1}{8}\times 37$ inches), now belongs to Mr Paul Oppé. It is beautifully freely—and for so large a drawing slightly—done in the artist's most characteristic manner. The far bank of the river is dotted with trees and bushes. On the near bank, to the lower right-hand of the picture, is a shepherd in a red cloak with his flock. The predominating colours are soft greys and yellow-browns. The whole effect is tenderly poetical—but the poetry is that, not of classical Italy, but of the English countryside.

John Skelton, who was Taverner's perhaps rather younger contemporary, is an unsubstantial figure as a man. He was quite forgotten until this century, when some drawings of his attracted attention in the auction rooms—at Hodgson's in 1909 and at Sotheby's in 1925—and led to his representation in the British Museum and Victoria and Albert collections. I do not know that anything is known of him beyond what is recorded in the subjects and inscriptions of these watercolours. From them we learn that he was working at Croydon in 1754, at London and Rochester in 1757, and that he died in Rome soon after 1758. He was a more professional watercolourist than Taverner, his buildings, for example, have greater solidity, but he had not, to my mind, Taverner's lyrical quality. Nevertheless he was an extremely accomplished artist, as the large watercolour *View of Rome, with the Tiber, the Castle of St Angelo, and in the background St Peter's* ($14\frac{9}{16}\times 20\frac{7}{8}$ inches, dated 1758), in the Victoria and Albert Museum, well shows (38). The colour is restrained in range, the blues of water and sky are very pale, and the trees are chiefly yellow-green and grey-green. The foliage displays a similar dappled effect to Taverner's, but the pale areas are edged with a sharp dog's-tooth pen line. In other examples the foliage seems less loosely treated, and the darker strokes of the brush are shorter and stumpier than with Taverner. A somewhat more dramatic example of his work, with strong effects of light and shade, is the *Lake Albano* ($14\frac{5}{8}\times 20\frac{15}{16}$ inches), in the Whitworth Gallery, which also has a charming monochrome ($5\frac{5}{8}\times 8\frac{1}{2}$ inches) of an unidentified English subject—a lake among trees. Another English view, but in watercolour—a view of a church—belongs to Mr A. P. Oppé. The British Museum's *The Castle, Canterbury* ($8\frac{1}{4}\times 21\frac{1}{4}$ inches), showing the ruins standing among dark green trees dappled with light, and water to the left, is a very fine specimen of Skelton's English work, of which the museum also has some charming small examples (39).

If it be permissible to judge from a single drawing, another artist who attempted to render the dappled effect of light on the foliage of trees and bushes, which seems to have been a favourite effect of the middle of the eighteenth century, was the amateur, Robert Price (died 1761), of Foxley, Herefordshire. He was the father of Sir Uvedale Price, who became well known as a writer upon the picturesque and as a landscape gardener. The only signed drawing of Robert Price's which I know is drawn with a rather fine pen, and looks at first sight like monochrome, though I think at least two different tints are used in it. It is dated 1744 and represents The Grove at Foxley. Its interest is rather as evidence of contemporary style than for its merits. In 1741 Robert Price was in Switzerland and some of his drawings were used in that year to illustrate a work on glaciers.

Rather more useful in helping us to form our ideas of watercolour styles about the middle of the century is George Lambert (1700?–1765), who painted many oils, often under the influence of Gaspar Poussin or Salvator Rosa, was a successful scene-painter for Covent Garden, and founded the Beefsteak Club. He was one of the leaders of his pro-

fession in his day, and it is strange that his work, and especially his watercolours, should be so little known today. I do not think that either the British Museum or the Victoria and Albert Museum possesses a drawing by him. Mr L. G. Duke, however, has two watercolours bearing his signature, which are valuable key-pieces to a knowledge of Lambert's work in this medium. The first ($9\frac{5}{16} \times 14\frac{1}{8}$ inches) represents a grove of trees, through which, rather to the right, a distant plain, with buildings, is seen (42). To the left a skilfully drawn farmhouse, or perhaps mill, peeps out among the trees, and a stream flows under a foot-bridge and down a small waterfall to spread out into a shallow pool beside which a boy sits with crossed legs. In some respects this drawing is rather a Claudian composition, but the left of the picture—containing the house, the stream and the bridge—impresses one as something really seen in the English countryside. The colour, which has no doubt faded somewhat, is in low tones in which silvery greys and yellowish or brownish greens predominate. There is a good deal of pencil work underlying the watercolour, and the treatment of foliage is fairly close to that of Taverner and of Skelton. The drawing is signed 'G. Lambert pinx'. The 'G' is somewhat rubbed out, and therefore difficult to decipher, but the drawing cannot possibly be by either James Lambert (1725–1788) or his son and namesake, two rather primitive topographers who worked at Lewes in Sussex. Indeed I have not the slightest doubt that in this beautiful and accomplished watercolour we have an authentic example of George Lambert, and one which shows him working in a style which seems to have been characteristic of the middle of the century, which relates closely to that of Taverner and Skelton, and which seems independent of the Sandby tradition, the beginnings of which will be discussed in the next chapter. Mr Duke's second drawing ($7\frac{7}{8} \times 12\frac{1}{2}$ inches) differs considerably from the first, though there are enough similarities to make it quite possible that the two drawings are in fact by one artist, working in different moods, or perhaps at different periods in his career. This second drawing has 'G. Lambert' in the lower right-hand corner, though whether this is a signature or an ascription I do not feel certain. The subject is a mill-pool with trees and mill-buildings, evidently a direct study from nature, naturalistically rendered in very pleasant soft colours —blues and grey-greens among them. There is less pencil work in this drawing, but there is some, and the foliage convention is less like Taverner and Skelton, the dappling of light on the trees being done by smaller and rounder touches of the brush (41). Yet I believe this, too, to be by George Lambert, and if so he may also be the artist responsible for a number of softly and prettily coloured drawings (I have seen six at various times) which have a strong general resemblance to Mr Duke's mill-pond, though they are obviously not studies from nature but compositions. They possibly relate to Lambert's work as a scene-painter. I am the more inclined to think that these drawings may be by Lambert, since one of them seemed to agree very well, especially in its drooping trees, with an oil-painting of Chiswick House and Gardens, by Lambert, which was lent by the Duke of Devonshire to the British Country Life Exhibition in 1937. Mr Christopher Norris has just (May 1950) shown me four Italian landscapes, each about $10\frac{3}{8} \times 18\frac{3}{8}$ inches, in pen and sepia, or Indian ink, monochrome. They are inscribed, in an old hand, 'The outline of this drawing by Lambert, and wash'd by Zucarrelli [sic] for Mr Kent'—a curious piece of evidence about artistic collaboration.

One of Lambert's pupils was the amateur Thomas Theodosius Forrest (1728–1784), son

of Ebenezer Forrest who was a member of the Hogarth-Scott expedition down the Thames in 1732. It is perhaps significant of the affinity one feels between the work of Skelton, Taverner and Lambert, as forming a distinct school, that Laurence Binyon saw a likeness to Skelton (as well as to Sandby, though that is not to the point here) in Theodosius Forrest's *St Botolph's Priory, Colchester* ($13\frac{1}{2} \times 21\frac{7}{8}$ inches) in the British Museum (40).

This drawing is in pen and watercolour, with a rather stiff group of small figures in the foreground. Something of the relation to the Skelton-Taverner-Lambert group appears (especially in the treatment of foliage) in another watercolour (10×14 inches, in my own collection) attributed, I think correctly, to Forrest, a springlike view of a summerhouse among trees seen across an artificial pond in which two swans are swimming. There is no pen in this drawing, which is looser and sketchier than the other. It is done in quietly gay and light tones of blue, yellow-green, grey and pink. As for the likeness to Sandby this is very evident in a large unfinished watercolour by Forrest in the Victoria and Albert Museum, *York Stairs, the Thames, Blackfriars Bridge and St Paul's Cathedral* ($13\frac{7}{8} \times 21\frac{5}{8}$ inches). This is presumably a fairly late work since a finished version of it (still I believe in existence) was shown at the Royal Academy in 1770. The Victoria and Albert Museum version is in watercolour over pencil. It shows a number of figures on a riverside terrace with trees. There are a man leaning on the river-wall, a lady and gentleman with a dog, a nursemaid with two children, one of whom drags a toy horse, and others—all very strongly reminiscent of Sandby, though the unfinished state of the drawing, particularly the fact that no flesh tints have been given to the faces and hands, gives them a queer look. The foliage of the trees is done with rather long strokes, and some rounder blotches and loops, of Indian ink, with tender washes of fawn, pink, yellow and green. The general colouring is very light and pretty.

Some of Lambert's paintings were engraved by the landscape engraver François Vivarès (1709–1780), a native of Montpellier, who settled in London about 1727. With him the student of watercolour has rather more to go upon, for, though his drawings are rare, there are a few undoubted examples available for study and, diverse though they are in subject, they are remarkably uniform in manner. In the Victoria and Albert Museum Vivarès is represented, as a watercolourist, by a *Landscape with Waterfall*. In the sale of drawings from Lord Warwick's collection in 1936, there was a small watercolour of trees and classical buildings, with cattle by the edge of a pool. And in an album which must, I think, have come from the collection of the early nineteenth century East Anglian painter Thomas Churchyard, there is a rocky coast with a tree growing by the waterside and boats racing past in a choppy sea. This last is drawn in a nervous, staccato, line in brownish ink and coloured in brown, grey and blue. The light over the sea has a pleasant glow, and the combination of brown ink, applied in hedgehoggy touches, with russet, blue, and grey washes, is highly individual, if limited in effect (43). Vivarès had 31 children including a son, Thomas Vivarès (born about 1735), who imitated him very closely but, if one may judge from three examples in the Randall Davies sale in 1947, with a harder touch and a tighter pen-line. These three drawings are now in the Royal Library at Windsor.

Another, and much more diverse, landscape watercolourist who worked in England,

and from whom Vivarès is said to have had lessons in drawing, was John Baptist Claude Chatelain (1710–1771), whose real surname was Philippe. His parents were French and, though he was born and died in London, he was enough of a Frenchman to be for a time an officer in the French Army. Chatelain's work varies a good deal. Normally, whether in pen and pale washes of watercolour or in fine black chalk, it is charming in a formal and precise way (44). Occasionally, however, he used a much looser pen line, and, in any case, he tends to be rather more free in the foreground trees, even of compositions in which the background is in his formal manner. In these backgrounds he is fond of 'carved out' looking mountains, with perhaps a church or a castle silhouetted on top of a rocky crag. In the foreground there may be a stream, or a road, with men and horses, rather perfunctorily drawn, watering or passing by, and rocks and trees flanking the whole composition—which, it need hardly be said, is in such drawings entirely imaginary. The colour is extremely limited—the background washed in pale blue or mouse grey, the foreground in bistre or some other brown, and possibly a little pink or blue on the clothes of the figures. Besides these fancy landscapes, however, he did a number of topographical views which were engraved, and it seems usually to have been in the preliminary sketches for these that he drew most freely. Two drawings of London scenes by Chatelain are in the Victoria and Albert Museum. He was also an engraver and as such employed a good deal by Boydell, who paid him by the hour as a method of overcoming his natural idleness. Chatelain was a talented and agreeable artist, but a far greater Frenchman working in England in our period was Hubert François Gravelot (1699–1773), who was here from about 1732 to 1745 and later for a shorter period ending in 1755. He was a most delicate draughtsman, especially of small groups of figures, and—besides being for a time the master of Gainsborough—had an extremely beneficial and refining effect on English book illustration. But he was not a watercolourist and his delicious drawings for the second volume of Gay's *Fables* (45) and for Richardson's *Pamela*, preserved in the British Museum, are in monochrome and pen. The same consideration excludes from our scope the principal English illustrator of the middle of the century—Francis Hayman (1708–1776)—whose admirable and spirited drawings for *Don Quixote* (also in the British Museum for the most part) are in pen and Indian ink or sepia. Obviously it is natural and proper that, in creating something to be reproduced on a copperplate, an artist should conceive his original design in monochrome—and this was the general practice of illustrators up to the time when books were illustrated with coloured etchings or aquatints (46).

Topography, landscape, and book-illustration were not the only kinds of watercolour drawings made in England in the period covered by this chapter. The medium was also used for painting flowers and birds—and more often, in these early years, the latter than the former. The British Museum, however, has two albums, once belonging to Sir Hans Sloane, which contain some 250 watercolours of plants by Jacob van Huysum, who was born about 1687 at Amsterdam, came to England in about 1721, and worked here till his death in 1746. He was the brother of Jan van Huysum, perhaps the most accomplished of Dutch painters of elaborate arrangements of flowers, of whose work in oils the National Gallery has magnificent examples. Jacob copied his brother's style, and I remember that, perhaps twenty-five years ago, a London bookseller had a large number of watercolour flower groups by Jacob van Huysum, which were sold for a very few guineas apiece.

Another foreign flower-painter working in England was Georg Dionysius Ehret* (1708–1770), a native of Erfurt in Germany. He was in England for a short while in 1735. He then went on to Holland where his drawings in the *Hortus Cliffortianus* of Linnaeus were published in 1737. In 1736 he had returned finally to this country, where he worked making drawings of plants for the Duchess of Portland, Dr Mead and Sir Hans Sloane. Many of his drawings passed into the possession of Sir Joseph Banks and are now at the Natural History Museum. Others are in the Victoria and Albert Museum and at Kew. As befitted one who benefited by the advice of Linnaeus himself and who became the brother-in-law of Philip Miller, Ehret was not primarily a decorative artist like van Huysum,† but a scientific draughtsman. Yet he aimed at making a drawing handsome as well as accurate— he disposed his plant to advantage and often added decoration, in the way of a moth or butterfly, to the picture. One Ehret drawing, dated 1756, and measuring $19\frac{1}{4} \times 13\frac{3}{4}$ inches, may serve as an example. It shows a branched sprig of the Bristly Ox-tongue, *Picris hieracioides*, and an American species of hawk-moth, *Pachylia ficus*,‡ to one side. It is done on vellum and the artist has used a certain amount of body-colour—especially in creating an effect of grey bloom on the foliage which is very characteristic of him. The colours of the plant are perhaps a trifle hard, but the quality of the moth's wings is most beautifully and softly rendered. The Bristly Ox-tongue is a common English flower, specially on rough banks near the sea, and Ehret painted both native British and foreign plants among the many hundred which he drew (47).

Of the naturalist artists perhaps those with the widest appeal are those who drew or painted birds. King, Barlow, and Cradock have already been mentioned, and the tradition was continued and developed in the first half of the eighteenth century by George Edwards and Charles Collins. Of these two Edwards (1694–1773) makes the better showing in books of reference. He was an Essex man, travelled in Holland, Norway, and France about 1718–1720, and then began to make coloured drawings of animals. In 1733, on Sir Hans Sloane's recommendation, he was appointed librarian of the Royal College of Physicians. Later he became a Fellow of the Royal Society. The chief work of his life consisted of the four volumes of his *The History of Birds*, which appeared between 1743 and 1751, and the three volumes of *Gleanings of Natural History*, published in 1758, 1760 and 1764.

In these works nearly six hundred species were illustrated for the first time. Edwards's original drawings of birds, which come to light from time to time, are in body-colour, and are a little stiff and formal, but very pretty. He drew many gaily coloured exotic birds in the course of his career, but my heart warms to him particularly because he did not scorn to draw also our familiar little friend 'The Cock Sparrow', and to set out its name in copperplate writing at the top of the picture. This drawing may stand, here, as typical of Edwards's style and of the convention he used. It measures about $11\frac{3}{8} \times 8\frac{3}{4}$ inches, and the bird, which occupies the centre of the sheet, is done on a much larger scale than the rest of

* The account given of Ehret in the *Dictionary of National Biography* is incorrect at several points. What appear to be the true facts are given in a memoir written by himself, a translation of which by Miss E. S. Barton was printed in the *Proceedings* of the Linnean Society of London, 1894–1895, pp. 41–58. I owe this reference to the kindness of Mr Wilfrid Blunt. Moreover, a letter written to Linnaeus, belonging to the Linnean Society, shows that Ehret was back in England by October 3, 1736 (not about 1740, as in the *D.N.B.*).

† Not all Jacob van Huysum's work is purely decorative, some of it is scientific or horticultural in purpose.

‡ This moth was kindly identified for me by Messrs N. D. Riley and W. H. T. Tams of the British Museum (Natural History).

the composition. He is perhaps a little more brightly coloured than in nature, but not much so, and he stands on a tree branch that is on so much smaller a scale that the bird is able to grasp its entire thickness in his claws. Behind are a hedge and fence, a sloping meadow with a cowshed, and beyond those again blue wooded hills, on one of which stands a church. Blue-grey clouds float peacefully across the sky. The whole thing, though it delineates the bird accurately, is extremely artificial in effect, and it represents a convention of bird portraiture—one might call it the Magpie and Stump formula—which was dominant for at least a century (48).

Charles Collins (died 1744), who painted both in oils and watercolour, and of whose work some was engraved, is a much vaguer figure biographically, but a much more considerable artist, than Edwards. Both used body-colour for their bird drawings, and it is only necessary to compare the prim, hard, little lines of white with which Edwards indicated the high lights on plumage, with the delicate, sensitive, almost caressing, quality of similar passages by Collins, to realize the superiority of the latter. His rendering of feathers is, indeed, wonderfully rich, soft, and convincing, and I should be inclined to place him, in this particular, above all other English bird-painters. His drawings are large—say about 19 × 15 inches. The bird may sometimes be shown perched on the conventional tree stump; alternately it may be given just the suggestion of a more natural setting—though Collins did not use the scenic background, as Edwards did, but left the surrounding paper mostly blank, merely brushing in, rather roughly, a hint of a setting at ground level. It was characteristic of him, too, to use clear colour for this purpose, as for painting the tree stump if the bird is shown on one, keeping the body colour for the bird itself. His masterly drawing of a heron—a wonderfully satisfactory thing for the quality of the plumage, the bold pattern of the pose, and the knowing liveliness with which the bird arches its neck and peers down towards the water—represents the heron standing by a pool, which is sketchily indicated by an area of blue fringed by a few long, loose, brush strokes of what was once, perhaps, green to represent reeds (49). Occasionally Collins painted dead birds as an exercise in sheer virtuosity in the rendering of feathers. One of my most exciting experiences as collector (if I may for a moment be reminiscent) was when, one day in, I suppose, 1931, my wife and I got off a bus in the Brompton Road and saw the window of Parsons's shop (now, alas, no longer there) filled entirely with birds by Collins. It was then the worst moment of the slump and the drawings were marked at what were even then fantastically low prices—either £1 1s. and £1 10s. or 15s. and £1 1s. each, I forget which. Even at those prices the family finances would not, at that moment, allow me to buy more than two—but I have never got better value or more pleasure for about 30s. In two or three days the whole lot were gone.

Another bird-painter in watercolour who was working in the middle of the century was Isaac Spackman, of whose personality I know nothing except that he died at Islington in 1771. The late Edward Hudson of *Country Life* owned a set of watercolours of birds by Spackman (about twenty in all, to the best of my recollection) and after Hudson's death these passed into the possession of Messrs Dulau. They included I think both foreign and British birds. Spackman worked both in clear colour and in body colour. A drawing of a *Bittern* 'drawn from nature' is in the former medium, a *Hen large spotted Woodpecker, drawn after nature March* 1765 *by I. Spackman, Bassinghall Street, London,* in the latter, at least in

great part. Both are on vellum. Spackman* was an inferior artist, but his work has much of the decorative quality which is generic in things of this kind (51). More skilful was Peter Paillou, who made many body-colour drawings of birds for Thomas Pennant (1726–1798), the eminent naturalist. Paillou again is an obscure figure. Mr Oppé has a fine drawing of a Golden Pheasant by him dated 1745, and he exhibited pictures of birds in 1763 and 1778. I have a Garganey duck which is inscribed *Drawn & Painted by Paillou, Red Lion Row, Islington, given me by Thomas Pennant Esqr E.K. Ap.* 1780. There are a good many examples of his work in the British Museum. He was unequally successful in his work, but at his best he shows a strong sense of pattern, and rendered the colours of the plumage well, though with nothing like Collins's lustre and subtlety. Presumably he was not the same person as the Peter Paillou who exhibited miniatures from 1786 until 1814 (50).

* Five other bird-drawings by Spackman, including two largish groups of several birds each, were shown at Messrs Walker's Galleries in January 1951.

The First Great Men

THE LAST chapter, in its final section, went off upon a side issue, and the narrative must now return to the main theme—the development of the English watercolour landscape. In this realm two of the most important artists of the school were already at work before the middle of the eighteenth century—Alexander Cozens and Paul Sandby. In their drawings the two main types of eighteenth century landscape find clear expression. Cozens was somewhat the older, but his influence was perhaps rather later in making itself felt, and it will be more convenient to treat of Sandby first in this chapter.

Paul Sandby, like his elder brother Thomas with whose career his own is inextricably intertwined, was, according to family tradition, a native of Nottingham. The actual records of birth have not been traced, but it is said that Thomas was born in 1721 and Paul in 1725 or 1726. They died in 1798 and 1809 respectively, and the chief authority for their lives is the joint biography published in 1892 by their descendant* William Sandby, a work which unfortunately leaves many gaps unfilled. William Sandby, however, did not know the biographical notice of Paul Sandby which appeared in the *Monthly Magazine* of June 1, 1811, signed 'S.T.P.'. Mr Oppé, who has reprinted this memoir, with a valuable introductory examination of it, in the *Burlington Magazine* for June 1946, shows that 'S.T.P.' was none other than Thomas Paul Sandby, the son of Paul. The son's memoir obviously has considerable authority, and corrects the commonly accepted legend at some points. According to one story the brothers were already conducting a drawing school in Nottingham before 1741, in which year they came to London and obtained posts in the 'drawing room' at the Tower of London, where their work would be chiefly, if not entirely, concerned with making maps and plans. T. P. Sandby, however, seems to make 1742 a more likely date for his father's arrival in London. In 1743 Thomas became (though not titually until 1750) draughtsman to the Duke of Cumberland, and was with him in Flanders in 1743 and 1745, then in Scotland where he was stationed at Fort William when the Young Pretender landed, and again in the Low Countries from November 1746 until (probably) October 1748. Several of his drawings done at this period, usually views of towns or camps and some of them very large, survive in the British Museum and elsewhere. They show him to have been a careful and precise craftsman, using the pen with neatness, and having a good understanding of buildings. They are tinted with washes of local colour, in which blues and greens predominate, over an underpainting probably of Indian ink, but are rather flat and lacking in warmth of colour. One drawing of this period

* He was a great-grandson of Thomas Sandby. See A. P. Oppé quoted by E. H. Ramsden, 'The Sandby Brothers in London'. *Burlington Magazine*, January 1947.

(in private hands) is inscribed *Drawn on the spot by Thos Sandby August 3d 1748*, and represents a low, partly ruined and ivy-clad, building surrounded by a garden and a moat, which it would be interesting to identify. This is a curious record of a garden of its time, especially of the grouping of hedges and topiary work, and also illustrates the laborious care with which Thomas Sandby represented the foliage of trees and bushes by means of innumerable very small double or triple loops drawn with a fine pen. One bush about half-an-inch square has some 90 or more of these tiny squiggles. As the drawing measures $10\frac{1}{4} \times 28\frac{1}{2}$ inches, and such foliage occupies a large part of it, one both admires the artist's assiduity and wonders what exact significance is to be attached to the phrase 'drawn on the spot'. He can scarcely have done all this fine detail seated at his drawing board out of doors.

Thomas Sandby's service in Scotland and the Netherlands under Cumberland stood him in good stead, for in 1746 the Duke was appointed Ranger of Windsor Great Park and some time after made Thomas his deputy. As Deputy Ranger Thomas Sandby continued until he died, at the Deputy Ranger's Lodge, on June 25, 1798. During this period of forty or fifty years he worked as architect, landscape gardener, and topographical draughtsman. In the first capacity he enlarged and rebuilt the house afterwards known as Cumberland Lodge, became in 1768 a foundation member of the Royal Academy, and shortly afterwards its first Professor of Architecture; he designed, as apparently his only London building, Freemasons' Hall in Lincoln's Inn Fields. In landscape gardening he was associated with the development of Windsor Park, and especially with that of Virginia Water, which was also the subject of much of his work as a topographical draughtsman. Drawings of Virginia Water by him are in the Victoria and Albert Museum, the Soane Museum and the British Museum, and at Windsor and elsewhere, and a series of eight was engraved in 1754 by his brother Paul and others and republished in 1772. He also made many drawings of London architecture, some of which were engraved. Thomas Sandby's characteristic method of drawing remained throughout his life, I believe, that described in the last paragraph—pen outlines washed with Indian ink and overlaid with watercolour—but there is much confusion between his drawings and those of his brother Paul, and the limits of their work are not well understood. In particular it is not clear how constantly one may assume that the figures introduced into architectural or topographical drawings by Thomas are the work of Paul. Mr A. P. Oppé has recently catalogued, with a notable introduction which stands as the latest and most authoritative treatment of the subject, the Sandby drawings at Windsor,* but even his scholarship has not been able to solve finally all the problems involved—though he has done much to clear away errors and misconceptions. At present, of many drawings, in deciding between the claims of the two brothers to their authorship, all that one feels able to say, apart from the fact that Paul was the more versatile of the two, and that much that was within his range was outside that of Thomas, is that Paul seems to have had the livelier, more poetic, mind, which distinguishes, or may distinguish, his works from the more literal-minded, though extremely competent, productions of Thomas (52).

Paul Sandby's career was, however, closely interwoven with that of his brother, and affected by it at many points. Like him he went in early manhood to Scotland, being ap-

* See A. P. Oppé, *The Drawings of Paul and Thomas Sandby in the Collection of His Majesty the King at Windsor Castle*. Phaidon. 1947. 25s.

pointed in 1746 draughtsman to the survey of the Highlands begun after the suppression of the rebellion of '45, and the British Museum has some drawings (mostly copies of Bloemart) which he gave to the Board of Ordnance as examples of his skill when applying for the post. In the British Museum, too, are many drawings done in Scotland at this early period, notably a series of sketches of people and street scenes in Edinburgh which show his observant eye for picturesque incident and character. From this Scottish time, again, date his first engraved views. In 1751 he quitted the service of the Survey and joined his brother at Windsor, assisting him with his work in the Park, including the construction of Virginia Water, and beginning his long series of drawings and engravings of Windsor, its personalities, and its topography. Like Thomas, he was a foundation member of the Royal Academy, and he exhibited there from 1769 until 1809, missing only nine years out of the 41. From 1768 to 1796 he was drawing master at the Royal Military Academy at Woolwich, and privately had many pupils, both amateur and, apparently less frequently, professional. T. P. Sandby, indeed, alleges that he himself was his father's only professional pupil. Michael 'Angelo' Rooker, P. S. Munn, Jacob Schnebbelie and John Cleveley (all of whom will be mentioned in later chapters) are however generally said to have been Sandby's pupils. The amateurs included (according to one account) Queen Charlotte and the Princesses. Another account says Sandby taught George III's sons but not his daughters. But, as Mr Oppé points out, it is rather remarkable that T. P. Sandby makes no claim that his father received any direct royal patronage, in spite of the numerous and delightful watercolour views of Windsor (many of them now in the Royal Library there) which he did, some at least under the patronage of the Duke of Montagu, Constable of the Castle. Apart from such possible instruction of royalty, Sandby's amateur pupils included Viscount Nuneham, afterwards second Earl of Harcourt, and Sir John Fleming Leicester, afterwards Lord de Tabley. Like other teachers he at times collaborated with a pupil in a drawing. How much he did this I do not know, but I have one drawing which is inscribed on the back in his writing 'Ld Md & P.S.'—the former being presumably the Lord Maynard who is mentioned in William Sandby's biography. With many of his pupils Paul Sandby became on terms of close friendship, and he was in general a man highly respected. His portrait by Francis Cotes shows him to have had a sensitive, intelligent face, and the later likeness of him (by Beechey) in the National Portrait Gallery gives the impression of a singularly kindly and charming old man.

Paul Sandby's drawings have a varied range. He did some caricatures, one amusing example of which, representing the dancer Vestris giving a dancing lesson to a goose, is familiar in an engraving. His early drawings of Edinburgh street characters have already been mentioned, and he continued to make large numbers of small drawings, often coloured in watercolour, of people, either known characters or casually observed individuals or groups. The latter he used to enliven his topographical drawings, and it is sometimes possible to identify one of his small figure sketches as the original note which he afterwards worked up into an incident in a known finished drawing. One day, for example, I found a little pencil study ($2\frac{3}{4} \times 2$ inches) washed with rather pale watercolour, of a man and a girl seated in a small summer house; and Mr Oppé was able at once to relate it to the *View of the Seat near the Terrace with a View of the Adjacent Country* which he describes as 'one of the most attractive and perhaps the most individual' of those of Sandby's watercolours

of Windsor and the neighbourhood which were bought from the artist by Sir Joseph Banks and passed to the Royal Library at Windsor Castle in 1876. This is indeed a remarkable drawing ($10\frac{7}{8} \times 22\frac{1}{2}$ inches) wherein the almost bleak simplicity of the foreground and of the summer house contrasts strongly with the wide panorama of the background, in which the topographical detail of the rich, wooded, plain spreads out in careful miniature under a pale blue sky. Moreover this was not the only occasion on which Sandby used this particular group of two figures, for it reappears in a drawing in the British Museum and, with more alteration, in an aquatint, *Windsor Terrace looking Westward*, published in 1776 (see A. P. Oppé, 'A Drawing by Paul Sandby', *Burlington Magazine*, November 1944). Naturally this tiny sketch is not presented here as an important thing of its kind, but merely as one which illustrates conveniently the use to which such things were put. Large numbers of far more notable figure drawings by Sandby exist, and many of them show his curious mannerism of making the figure seem longer and narrower than it should be. We see this both in the elegant and charming *Kitty Fisher* ($6\frac{1}{2} \times 5\frac{3}{8}$ inches, in the collection at Windsor, 54) and in such a drawing (also belonging to the King) as that representing *Bob Dun one of the Duke's gardeners at the Great Lodge* ($9\frac{1}{4} \times 6$ inches), a figure all gawkiness and awkwardness, in which the aim is almost that of caricature—both drawings being in full watercolour. Sandby was not, in one sense of the phrase, an accomplished figure draughtsman—one suspects that his knowledge of anatomy was not great—but he was able in this *genre* to suggest character, incident, and a surprising variety of mood in a rapid and incisive way. With all their faults these drawings of Sandby's, often very fresh and pretty in colour, stand as something without parallel in English eighteenth century art, recording for us with vividness, elegance, and gaiety a whole range of characters of the time (53).

As a landscape artist Sandby is thought of principally as a topographer. Later I shall try to show that he was by no means only that, but topography certainly formed a large portion of his output. He was, moreover, exceptionally important in the history of English topography in that he was almost the first of the English artists to introduce to his countrymen the beauties and picturesque antiquities of Scotland and, particularly, of Wales. Some predecessors, indeed, he had—we have already seen how Francis Place made Welsh drawings—as did the Bucks also—but broadly speaking it was Sandby who opened the eyes of Englishmen to the pictorial interest of Wales. His son records that Sandby visited Wales (apparently for the first time) with Sir Watkin Williams Wynne (1748-9?–1789)* when the latter went to Wynnstay 'to meet his tenants upon coming of age'—which must have been in 1769 or 1770—and that he afterwards made several Welsh tours with the baronet. The same authority states that Sandby travelled in Wales with Sir Joseph Banks, Daniel Charles Solander and John Lightfoot. The date has not been ascertained, but it was probably in the 'seventies. His first exhibited watercolour of a Welsh subject (not precisely localized) was shown in 1773. Later he published four sets of 12 plates each in aquatint (of which method he was the pioneer in this country) of Welsh views, the first set appearing in 1775, and the others in 1776, 1777, and 1786. He also issued many prints of English subjects. By these publications, as well as by his original drawings, Sandby drew attention to many of the remote beauties of this island, and so holds an important place among those who led the way to the appreciation of the picturesque and eventually to the

* See the obituary notice in the *Gentleman's Magazine*, Vol. LIX, p. 765.

romantic revival. Even in his topographical work, indeed, Sandby often showed a keen eye for the picturesque—which may be defined as that quality of attractiveness which resides in irregular broken surfaces and things seamed and roughened by the dilapidations of time, a quality different from the well-proportioned regularity of beauty. The old witticism that 'The Vicar's horse is beautiful, the Curate's picturesque' points the distinction nicely enough.* It is true that Sandby could be matter of fact, as in *The Old Swan, Bayswater* ($25\frac{1}{4} \times 35$ inches), dated 1790, in the Victoria and Albert Museum. This is a fairly straightforward rendering of a stretch of road outside an inn, pleasantly diversified with trees, carts, men making a bonfire, and other incidents. But he could get away, while still producing the portrait of a place, from such comparative tidiness, as in some of his drawings of Welsh castles and other medieval buildings, where he appreciates, by means of apt placing, the effective contrast between the broken lines of a ruined building and the general structure of the masses of the composition. Of this type of Sandby drawing a good example is the British Museum's *Gate of Coverham Abbey in Coverdale, near Middleham, Yorkshire*, 1752. It is in a mixture of clear and opaque colour and measures $10\frac{3}{8} \times 15\frac{1}{4}$ inches. The main feature is a ruined, but not broken, arch, which crosses the centre of the picture and connects the blocks of brownish grey ruins. On the top of the arch grow bushes of brown and green, while under it play a boy and his dog. Through the arch can be seen a grey-roofed house amid trees and also a patch of blue sky, while above the arch is a larger area of blue sky broken by white clouds. The whole forms a delightful image of picturesquely crumbling antiquity (56).

It was not always topographical or picturesque interest which inspired Sandby's drawings, even when it seems probable that he was reproducing the likeness of something seen by the eye and not only in imagination. This is specially true of his studies of trees, which are among his most notable works, for he was a great lover of huge tree-trunks, twisted boughs, and heavy canopies of foliage, and he had a sharp understanding of them. His trees are seldom purely conventional and often he expresses extremely well the strength and richness of a fine tree. A case in point is that of his *Ancient Beech Tree* ($27\frac{5}{8} \times 41\frac{5}{8}$ inches), signed and dated 1794, which is in the Victoria and Albert Museum. Like many of Sandby's drawings, it is in body-colour, and it is a thoroughly satisfactory, lovingly observed, rendering of the beauty of this most beautiful of English trees. It is illustrated in this book as figure 55. Another very delightful opaque-colour drawing of this type, which also belongs to the Victoria and Albert Museum, though since it is in the Circulation Department, and is therefore less regularly to be seen in London, it is less well known, is that catalogued as *Windsor Forest with Oxen drawing Timber*. Windsor, indeed, may be the location of the scene, but in fact the place means nothing and its character everything in such a picture as this. It represents a hollow glade, with a pale blue glimpse of water at the far end, and a grove of trees which cuts diagonally right across the composition from the right foreground towards the left middle distance. In front of the trees is a grubbed-up tree stump, and a team of four oxen drags a felled tree-trunk. A mounted man in a blue coat directs the work, and other figures are a man leading the team, and a woman with a basket and a child who is talking to a man in a red coat. All these figures are on rather a small scale; and seen through the trees, to the right, are two still smaller figures of men

* For this subject see Christopher Hussey, *The Picturesque*, Putnam, 1927.

riding on horseback down a grassy slope. The lower parts of the trees are mostly bare of foliage, so that the back of the picture appears through them. They are admirably diversified both in colour (some silvery white, some dark brown) and form. The tops of the trees meet in a canopy of foliage, rather dark in tone, but beautifully massed and moulded to the shape of the boughs. One small reddish bush—very typical of Sandby—stands in the further opening of the glade. The ground below the trees is dark, but beyond the blue patch of lake rises a green wooded hill, and above that is a patch of white and leaden grey cloud under a blue sky across which pass a few rooks in flight. The picture, which measures $12\frac{3}{4} \times 18$ inches, is signed and dated 1798, when Sandby was 73. There is nothing of the tiredness of old age in it, but it is the sort of drawing which could hardly have been done by a young man. It contains the accumulation of years of understanding and love of the sights of the English countryside, their colouring, forms and character, rendered, with the polished skill of long practice, into a whole that is richly peaceful and meditative.

In all Sandby's work so far discussed he has his eyes on things actually seen, but there are a number of his drawings which are purely imaginary, though the imagination they show is not of a very original kind and perhaps never achieves anything that could be called real grandeur. It is, indeed, very largely derivative. To some extent, especially in the representation of mountains in the smaller and more conventional of the drawings of this class, he may have been influenced by Chatelain; but the chief influences were certainly Italian, or Italianate. Sandby was a great collector of drawings and no doubt possessed many imaginative landscapes of that school; indeed I remember seeing examples of Marco Ricci and Gaspar Poussin from his collection. Many of Sandby's smaller imaginary landscapes are rather trivial and cut to a pattern. They represent, perhaps, a boatload of horses being ferried across a river, with a church standing on the left bank and a distant suggestion of mountains to the right; or a rocky sea-shore where a cloaked man stands below a round tower watching a boat sail by; or, again, a boat crossing a river between rocky banks, but this time by moonlight. A good many such small drawings exist, sometimes signed, and they are often very pretty trifles—especially as regards colour, their pink-brown or yellow-brown autumn trees, blue skies with faint white clouds drifting across, grey-blue mountains or rocks—but not much more than that. No doubt Sandby found a ready sale for them as decorations. He also did larger and more important imaginative—or at least imaginary—landscapes, but as an example of his work in this manner may be taken a drawing of only medium size—$9\frac{1}{2} \times 11\frac{3}{4}$ inches—the *Castle and Stream* in the British Museum. I choose it, moreover, in that it breaks away from Sandby's more usual blue-green colouring and is on the whole a brown drawing with yellow, white, and reddish high lights. Its subject is a foaming stream which flows down the centre of the picture, while a man with a fishing rod, a woman, and a child sit on the near bank. Beyond this stream stands a romantic castle and beyond that mountains. Over-arching trees complete the composition, which is a typical Anglicization of a romantic Italian theme (57).

Sandby worked in both opaque and clear colour, or in a mixture of the two. Some of his body-colours are very large, and though they are usually handsome rather than beautiful he nevertheless did not allow the medium to swamp his individuality as it did that of so many artists. A Sandby gouache is usually recognizable as his, chiefly because of his

34

characteristic range of colour—the rich blue-greens, the pearly greys (on tree-trunks for instance), accented perhaps by a touch of red in the clothing of a cleverly placed figure. His most ambitious effort in this medium was to paint a whole room in body-colour at Drake-lowe, near Burton-on-Trent. The house is now unfortunately demolished but one end of the painted room is preserved in the Victoria and Albert Museum. It is dated 1793.

With clear colour Sandby used either pencil or pen outlines. His coloured drawings are much more common than his monochromes, though no doubt the latter are often over-looked. They are sometimes initialled on the back by the artist, as for example a little blackish-brown wash drawing of Benton Castle, on grey paper, which I have, and which seems to be drawn entirely with the brush, save possibly for a few touches of what may be broad pen in the tree-forms. Other monochrome wash-drawings of Sandby's are strongly and rather freely accented with the pen. An unusual example of his work is the very Wilsonish *Landscape with Two Horsemen*, in black and white chalk on brown paper, at the British Museum. Paul Sandby's second son, Thomas Paul Sandby (17 –1832), already mentioned for his memoir of his father, was also an artist, succeeded him in 1797 as draw-ing master at Woolwich, and claimed to be the sole 'repository of his discoveries and peculiar methods of working in his art'. I have never seen or heard of a drawing by T. P. Sandby, though it seems hard to believe that none exists. Perhaps they all masquerade as his father's work.

With Alexander Cozens* (1717?–1786) we step into another world, a world almost entirely of the imagination though constructed out of the types of landscape feature existing in reality, a world seen, almost without exception, in monochrome. Appreciation of his art is a comparatively modern thing for, though he exercised great influence in his own day, he became in the nineteenth century little more than a name attached to a misunderstood and much scoffed at system of drawing. He was remembered too as the father of John Robert Cozens, belief in whose surpassing greatness never died among lovers of watercolour. But it was not until the present century that Alexander Cozens began to be treated as a great man in his own right. Herbert Horne began the restoration of his fame and collected the fourteen examples, later belonging to Sir Edward Marsh, which were shown at the Burlington Fine Arts Club in 1916. Mr Oppé has done the great bulk of recent research, and not until he selected and arranged the loan collection shown at Sheffield in 1946, and afterwards at the Tate Gallery, was there held, anywhere, a one-man show of Cozens's work. Unfortunately he remains inadequately represented in the national collections, and most of the finest examples of his work are in private hands.

Alexander Cozens was born in Russia about 1717. In many books of reference he is said to have been an illegitimate son of Peter the Great, but Mr Oppé has shown that this seems to be a mere fable and that, according to all the real evidence, the artist's father was Richard Cozens (1676–1736), an English shipbuilder who went to Russia to work for the Czar about 1700. The mother's maiden name was Mary Davenport. Practically nothing is known of Alexander Cozens's early life. He was in England in or before 1742, in which year is dated an engraving of Eton after a drawing by him, and he may have visited Italy

* The greater part of what is known of Alexander Cozens is due to the research and writings of Mr A. P. Oppé. His introduction to the *Catalogue of an Exhibition of Drawings and Paintings by Alexander Cozens* (Graves Art Gallery, Sheffield, 1946) summarizes his study of this artist. But references should also be made to other writings by Mr Oppé.

before then. He certainly was in Rome in 1746, and he was on the Continent again in 1764. In 1749 he became drawing master at Christ's Hospital, but apparently he was a poor disciplinarian (he was a man of mild disposition) and he resigned in 1754. Later, however, he taught drawing at Eton with more success, at least so far as concerned his better pupils there, who included many who afterwards passed on to Oxford to be taught by John Baptist Malchair (see Chapter V). Among these were Lord Aylesford and Sir George Beaumont, two of the most distinguished amateur artists of their day (see Chapter XII). Another pupil was William Beckford. Cozens showed oils and drawings from 1760 to 1781, sending 18 exhibits to the Society of Artists, 7 to the Free Society, and 8 to the Royal Academy. He made two unsuccessful attempts to become an ARA. Cozens also taught in Bath and London, and from 1781 he was Instructor in Drawing to the young Princes. He married the daughter of John Pine the engraver, and had, beside his famous son, a daughter Juliet Ann, who married Charles Roberts and whose descendants survive today. In 1786 he died.

Cozens showed remarkable variety, as well as great power of expression, within his own set limits, the chief of which was an almost complete self-denial in the matter of colour. That this was a deliberate aesthetic choice there can be no doubt. Plenty of colours were available, and that he was capable of the effective use of colour is shown by four small oil paintings belonging to Mr Oppé. Yet he scarcely ever used colour in his drawings, one of the few exceptions being one in the Victoria and Albert Museum, which has a striking red flush over the sky. In the British Museum there is a remarkable collection of about 50 early drawings made by Cozens in Italy, a very few of which have some tinting in colour. There are also some drawings containing watercolour in the sketch-book (belonging to the same period as the Museum's drawings) which was described by Mr Oppé in the Walpole Society's sixteenth volume, 1928, and which then belonged to Mr Norwood Young, a descendant of Cozens's daughter. Otherwise colour hardly exists in Cozens's known work. A memorandum which accompanies the British Museum drawings states that they were done by Cozens and lost with many more by falling from his saddle, when he was returning through Germany from Italy in 1746, and that they were found and bought in Florence, thirty years later, by his son, John, who when he got back to England in 1779 restored them to his father. It is a point worth noting that in this series are included some views in Elba, which makes one wonder whether John Robert Cozens's famous *View in the Island of Elba*, in the Victoria and Albert Museum (see Chapter V), may not have been done from one of his father's sketches.

Alexander Cozens's early Italian sketches—of which there are also a few examples in private hands—are not finished works. They are studies of things seen, ruins, trees, and so forth, noted down for his own use, and, I think, for his own training in the technique of drawing. They show him in a much more literal and topographical mood than he after-wards used. Many of them are of identifiable places at Rome and elsewhere, and one of these, *In the Farnese Gardens*, *Mount Palatine*, *Rome*, of which there are versions both in the British Museum and in Mr Oppé's collection, was copied by J. R. Cozens. Mr Oppé's version is signed 'Alexr. Cozens 1746 Roma', and is in pen and grey wash on grey paper; it is formal, and to some extent stiff, in a manner quite foreign to his later work. Many of these early Italian sketches are in similar pen and wash, others are in pencil, with or without

wash. They are sometimes squared for enlargement. Occasionally there are underlying traces of red chalk. This Italian group of 1746 contains almost the only known drawings of definite localities by Cozens, with the exception of some half-dozen views on the Rhone, in brown and black wash on varnished paper that gives the drawing a rich orange-red glow out of which the forms loom obscurely. These Rhone views however are much less precisely localized than those of Rome. There are examples in the collections of Mr Thomas Girtin, the late E. H. Coles and Mr Oppé. It is not known on what journey they were done —apparently not that of 1746.

Another type of Cozens drawing consists of small drawings in brownish pen—usually very freely handled, though in a few examples the pen-work is more formal—washed with purplish-black upon rather thin white paper. The drawings of this group are never, I think, signed but bear Cozens's characteristic scrawled numbering in a corner. There is a specimen in the Victoria and Albert Museum, Mr Martin Hardie has an admirable example, and there are a few others in this manner, in which Cozens achieved in a very small space most effective suggestions of mountain, tree and river, with telling contrasts of the bare white paper in the lights with the black wash in the shadows (61). A still rarer type is represented by two drawings in pencil and grey wash on varnished paper, very curiously Chinese in effect, which were lent (with much else) to the Sheffield Exhibition by Mr Oppé. They are not signed, but like many other examples in his collection came from a volume of *Designs by Cozens*, bought by Sergeant W. M. Praed, father of the poet and a pupil of Alexander Cozens, in 1820, which had previously been sold in 1794 among the possessions of J. R. Cozens. It passed to Mr Oppé in 1926 and contained 83 drawings and four small oils.

Cozens's characteristic medium, however, is brown wash deepening to black in the darkest shadows, and generally used upon paper toned to a delicate coffee-colour. Sometimes there are grey washes combined with the brown, and more rarely a touch of Chinese white. The amount of pen outline varies very greatly and sometimes there is none. In two drawings belonging to Mr Oppé, each containing a ship, Cozens uses a very unexpectedly effective trick of drawing the rigging, masts, etc., firmly and precisely with the pen though the rest of the composition is entirely, or almost, without pen. In this connection it is to be noted that what looks like pen in a Cozens drawing is not necessarily so. Mr John Wheatley, ARA, who organized the Sheffield Exhibition and is himself a distinguished watercolourist, has expressed the opinion that some small outline landscapes in, apparently, black ink and pen upon Chinese tissue paper were in fact drawn with a fine brush.

The wonder of Cozens lies in the grandeur, the breadth and depth, the rich luminosity, of landscape which he could achieve with monochrome wash, and the variety of scale upon which he could do so. He could sustain his effects in a large drawing, and a number of his most impressive works measure approximately 18 or 19 inches by 24 or 25. Of this size are such noble things as the *Bare Landscape with High Hill, Water in Foreground*, belonging to Mrs Walter Sedgwick and once in the collection of Thomas Sunderland (see Chapter XII), who seems to have been a friend or pupil of both Alexander and J. R. Cozens. This drawing, of a deeply satisfying warm brown, represents a craggy mountain range in the right distance, on which the light falls, while the whole of the middle distance and foreground (though there is no real foreground, since the entire drawing is like a vast distant

view seen as it were through a window) is occupied with an undulating plain broken with occasional hills and water. The sweep of the thing is tremendous. In this instance the sky is left blank, save for an even wash over the whole; but often Cozens's skies are of great beauty and subtlety, as for example in another drawing of about the same size, belonging to Mr Oppé, the *Classical Landscape*, which he lent to the British Exhibition at the Royal Academy in 1934. Here we look across a bushy foreground and a lake to a rocky cliff on the left, the right edge of which rises parallel to a clump of cypresses on the near bank of the lake so as to form a gap through which the eye is led, across a bright patch of water, to the furthest point of a plain hedged in to the right by a line of distant hills, over which towers an exquisitely dappled bank of cloud (58). A more bizarre note is struck by another of Mr Oppé's drawings of similar size, the *Rocky Landscape with Lion*. Here a rocky eminence in the left middle distance is answered by a huge dead tree-trunk which sticks starkly out from the very dark lower right-hand corner of the picture where a lion lies half descried in the gloom. This shows Cozens carrying out one of his most violent and uncompromising designs on a large scale; but he can be equally uncompromising and bold in a small draw-ing, *Dead Trees in a Landscape*, measuring $6\frac{1}{8} \times 7\frac{3}{4}$ inches, in the same collection. Here most of the drawing is occupied with two blasted tree-trunks, one ivy-clad, but the extreme of boldness is reached by the introduction of a slender, quite bare, tree, drooping its tip and few boughs like hanging whip-lashes in a sort of dreary cascade—altogether a most fan-tastic and macabre thing, which I find fascinating (60). As for the luminous glow which is to be seen in similar small works, many examples could be cited, some of them extremely simple things, consisting merely of the main lines of a subject—say, a clump of trees by the water's edge, or a distant headland with a ship in the foreground forcefully blocked in with a broad brush. The very great brilliance of Cozens's sky-studies, above all one representing a succession of bright-edged cumulus clouds above a black line of cliff (again belonging to Mr Oppé and seen at Burlington House in 1934), is also to be noted. It seems certain that Constable (who made a number of copies after Cozens) learnt much from this phase of his work (59).

Cozens was a great systematizer, with an ever-active, inquiring brain. He invented, or projected, systems for drawing trees, clouds, and human countenances. He even seems to have played with the idea of a vast system of morality to be illustrated both by a whole series of epic poems, dealing with the various moral qualities, good and bad, and by paint-ings. But that system of his which has aroused the widest and most lasting interest is his method of 'blot-drawing', which he taught to some, at least, of his pupils, and which he set forth in an excessively rare publication, *A New Method for Assisting the Invention in the Composition of Landscape*, an undated pamphlet, though its 28 accompanying mezzotints are dated 1784 and 1785. Cozens found that his pupils were apt to pay too much attention to detail and thereby to lose the main features of a composition. He therefore devised the method which is briefly as follows: Taking some very general idea—say a mountain or a clump of trees—and holding it firmly in his mind, he brushed about, with a full brush, making every conceivable type of stroke, upon a piece of paper, paying no heed to any-thing more than the vague general form which this basic idea conveyed to him. Over this 'blot' he would put tracing paper, pick out the features which the 'blot' suggested to him, and work them up into a composition. It is to be noted that this was not, as has often scorn-

fully been said, a method of pure chance. There must be a general, guiding idea, the development of which was stimulated by the chance marks of the brush, and even sometimes by crumpling the paper before 'blotting' on it. But the stimulation of the creative imagination was never more than semi-fortuitous. A good many drawings by Cozens exist which are based upon 'blots'. It is to be imagined that the dashingly executed *Tigers* (if that is what the beasts are) in Mr Oppé's collection is such a one, and there are others in the British Museum and elsewhere upon landscape themes. About 1930, in a suburban auction-room, Sir Henry Hake happened upon five pairs of drawings by Cozens, each consisting of a 'blot' and the finished drawing evolved from it—a most interesting find. Occasionally there are found 'blots', perhaps the work of Cozens himself, with amateur drawings, evolved from them, pasted on top. Mr Oppé has one such pair of an oval composition, and the Rev Francis Smythe, lately Archdeacon of Lewes, has a similar oval pair inscribed *A drawing found at Hartwell among some papers of the late Lady Elizabeth Lee. There are several similar at Hartwell framed.* As a pendant it may be added that Mr Martin Hardie has experimented with Cozens's method and has produced a most satisfactory 'blot', which he has published as illustration to an article.*

But it is a mistake, in considering Alexander Cozens, to think too much of his method of 'blotting'—ingenious and effective though it was. He was much more than what Dayes calls 'blotmaster to the town'. He was on all grounds a very fine master of watercolour, and of the imaginative landscape in particular. The days when he was thought of as a mere curiosity of art are long gone by, and he has every right to be considered, with Sandby, as one of the two first great watercolourists of the eighteenth century.

* See Martin Hardie. 'Early Artists of the British Watercolour School—Alexander Cozens.' *The Collector*. November and December 1930.

The Topographical Tradition

IT IS not possible to distinguish rigidly between artists who practised topography and those who drew imaginative landscapes, since the two categories overlap—as we have seen that they overlapped in the person of Paul Sandby himself. Yet roughly, and for the sake of convenience, the artists who took for their theme the face of nature may be classified upon these lines, and the present chapter will be devoted to the topographical tradition as pursued by the contemporaries and followers of Sandby. It will, however, be possible to deal only with some of the more important and regular practitioners among them—for they were very numerous. Moreover artists of other kinds were always liable to produce occasional topographical drawings—for example the Sandby-like watercolour view of a house, signed and dated 1750, in the Victoria and Albert Museum, by the well-known portraitist Francis Cotes, RA (1725-1770). There come to mind, too, the neat and charming small views of parks, buildings, etc., some of them done for Dodsley's *London and its Environs Described*, 1761, in pen and wash by Samuel Wale, RA (1720?-1786), who is chiefly remembered as a book-illustrator, specializing in historical subjects (62). Again there are the artists of whom, though they are known to have done topographical work, scarcely any examples survive—such artists, for instance, as Gainsborough's friend John Joshua Kirby (1716-1774), by whom I remember to have seen only a single drawing, the tidy and efficient pen and watercolour *View of St Alban's Abbey*, signed and dated 1767, in the British Museum (65).

Sandby has often been referred to as the 'father' of topographical watercolour, but, as this book has already shown, there was a long line of English topographers before him, and he had contemporaries who derived their practice of the art from the same sources independently and, so far as we know, without inspiration from him. Two such were John Inigo Richards* and Anthony Devis—though the former was well acquainted with Sandby and the latter must at least have known his work. The date of Richards's birth is not recorded in any of the books of reference I have consulted, but it was probably some time in the seventeen-twenties. There is, indeed, very little known about him. He has been claimed as a Welshman (there is an oil by him in the National Museum of Wales), and he was an original member of the Royal Academy, of which in succession to Newton he became, in 1788, Secretary, holding the post, which then carried with it living accommodation, until his death in 1810. He was poor and in debt when he died. In 1791 the Academy paid him twelve guineas for repairing its famous cartoon by Leonardo da Vinci. Richards at one time worked as a scene-painter. As a watercolourist he was active at least as early as

* See figures 66 and 67.

1752, when he did a rather primitive little sketch of the Castle Gate, Taunton. Other dates which I have noted on drawings which look as if they had been done on the spot are Carisbrooke Castle, 1758; Corfe Castle, 1763, and Oakhampton, 1768. A view of Ton-bridge Castle is dated 1798, but this may well be a studio drawing. He often inscribed his drawings on the back of the mount in a bold handwriting in ink, and signed 'J. Richards', sometimes with RA after the signature, fairly frequently on the front of the drawing. He had a favourite mount of pale brown washes and black ink lines upon a white or cream card. He was fond of strong blue skies, sometimes with mauve-red lights on the clouds, and he used a good deal of pen, especially in indicating foliage. His trees are sometimes a little like those of William Marlow both in their colour and in their thick, rather knotty, pen outlines. Ruins were his favourite subject, and he liked to get a strong light on the stone-work of the building, so that it contrasts sometimes rather too sharply with the deep blue of the sky and with the dark greens of the trees. Though it showed no great range his colour did not by any means lack strength (as it is so often said that of the early water-colourists did); indeed, I think he is preferable when he modified his style in this respect, and used less intense tones, as in an undated *Eagle Tower, Carnarvon Castle*, which has a pale sky and soft greys, yellowish greens, and blues upon the building and foreground. This drawing, which is without pen lines and has only slight indications of pencil in certain parts (notably the tower itself), is much more poetical, loosely handled, and softly luminous than most of Richards's work. On the whole, however, his restricted but rather individual palette varied little throughout his long career. One sometimes sees small body-colour drawings, rather dark with pearly high lights, signed J. R. or (I believe, but cannot quite trust my memory) J. Richards, which are commonly attributed to John Inigo Richards, but I remember the late Basil Long telling me he thought them to be by some other J. Richards.

Of the biography of Anthony Devis, too, comparatively little is known.* He was the younger half-brother of Arthur Devis, whose conversation pieces are now fashionable, and was born at Preston in Lancashire on March 18, 1729. He is said to have been already working as a painter in London in 1742, but later returned for a time to Preston. His name is sometimes given as Anthony Thomas Devis, but Mr Pavière tells us that this is a mistake, probably due to confusion with his nephew Thomas Anthony Devis (1756–1810). Anthony Devis exhibited a few times, between 1761 and 1781, at the Free Society of Artists and the Royal Academy, but then seems to have retired from professional practice (though not from practice of the art itself). From 1780 until his death in 1816 he lived at Albury House near Guildford, and the country round there furnishes the subject of many of his later watercolours, which are often very charming with their glimpses of St Martha's or St Catherine's Chapel peeping up in the distance across a stretch of the Wey or above the wooded slopes of the Surrey hills (63). He died a bachelor and left Albury House (a water-colour of which is in the British Museum) to his niece, Ellin Devis, from whom it passed to her niece and adopted daughter, Ellin Devis Marris, who became the mother of Martin Farquhar Tupper, the author of *Proverbial Philosophy*. Through the kindness of my friend, Mr Derek Hudson, the biographer of Tupper, I have seen, in the latter's common-place albums, views of the Albury district which were probably mid-nineteenth century

* See 'Biographical Notes on the Devis Family of Painters'. By Sydney H. Pavière. Walpole Society. Vol. XXV. 1937.

copies of Anthony Devis, or, if not actual copies, at least showed that his influence continued for many years in a family tradition of drawing. This would no doubt descend not only through original Devis drawings in family possession but from the work of Robert Marris, grandfather of Tupper and nephew-in-law of Anthony Devis, whose style, as Mr Pavière points out, he very closely imitated. There are examples of Marris's work in the Harris Art Gallery at Preston. They lack the fluency and grace of Devis's best drawings. Mr Pavière also states that Italian landscapes by William Assheton, of Cuerdale Hall, show similarities in the drawing of trees to the work of Devis, who may have accompanied him to Italy in 1783-1784. I am not familiar with Assheton's work, but I have two large drawings in watercolour, crayon and pen, which though rather clumsy are pure Devis in style, and of which one is inscribed *Cascade du Tessin dans le Canton d'Uri. WL pinx* 1780. I do not know who WL was, but it seems possible that he, or she, may have been a Lister and related to the T. Lister, of Mallam-Waterhouse, in Craven, Yorkshire, a view of whose house Devis (as Mr Pavière notes) exhibited at the Academy in 1781. The only importance of the matter is that it suggests that Devis, like other artists with strong mannerisms, could teach his pupils to imitate him very closely, and that unsigned, and slightly inferior, examples should be regarded with a certain suspicion and not attributed positively to him. He occasionally signed his drawings 'Anthony Devis' or 'A. Devis', either on the back or the front. More frequently (in my experience) he scribbled on them a small monogram of his initials, which is very easily overlooked. The majority of his drawings are, however, unsigned. One can sometimes confirm an attribution from there being an inscription, with perhaps a number, in his writing, either on the mount or on the back of the drawing. Often he drew a black line round the edge of his drawings and hinged them on to a sheet of white paper stained buff on the upper side.

Devis's chief mannerism lies in his trick of rendering foliage by a series of triple or quadruple loops, rather like bunches of bananas. Sometimes the loops are a little more elongated and less rounded than usual, but it was only rarely that he omitted them entirely from a drawing. He used many mediums. His oils I am not here concerned with, but he drew in pen, pencil, crayon, Indian ink, monochrome wash or full watercolour, sometimes with some body-colour. In a mixture of pen, Indian ink, and crayon, he could be darkly effective and show a certain strength. So much of his work is undated that it is difficult to arrange his styles chronologically, but my impression is that his small, pretty, pen sketches, washed with Indian ink and softly tinted with grey-blues, yellowish-greens, and pinky browns, are late works. One such, *Looking across Ride Lane to St Martha's Chapel*, is dated 1798, and a view of Gomshall Mill almost in monochrome has the date 1812. In these sketches— and indeed in much of his work—Devis was fond of introducing sheep, and his manner of drawing them in pen, with rather long stick-like legs, is characteristic. A good many of the late drawings are circular in shape. In early and middle life he attempted stronger and more imaginative effects. A drawing ($9 \times 12\frac{1}{2}$ inches) inscribed *Hellsglen—in Argile Shire*— unhappily not dated but probably fairly early—is a study of wild mountains half hidden in mists with a torrent pouring through rocks in the foreground. It is carried out in greys for the distance, with some areas of pale brown on the rocks, and is strengthened with some freely drawn pen-lines. It is a most unexpected thing for Devis to have done. Occasionally, again, there is a strong classical Italianate influence, though whether he ever went to

Italy is not known. If so, it was probably long before the Continental tour of 1783–4 which Mr Pavière thinks possible, for a pen and wash drawing of classical ruins by a river, bold but mannered in treatment, is inscribed 'Ap. 1765'. I remember seeing also, at a dealer's, a fine pen and wash drawing of classical buildings, but do not remember whether it was dated or not, though it too must have been fairly early. About 1770, in his finished English topographical work he employed very heavy shadows (probably of Indian ink) in his underpainting and also strengthened the drawing with pen and, apparently, crayon or charcoal, applying his local colour above this. An example is the *Landscape with Church and Cattle*, dated 1772—probably his most familiar drawing—in the Victoria and Albert Museum (64). To the same year belongs a view *Near Lime in Dorsetshire* ($10\frac{1}{8} \times 15\frac{1}{2}$ inches), which shows much the same technique, and is rather strongly coloured, particularly in the greens of the foreground foliage and the leaden blues of the sky. It is an effective composition of a diagonally receding line of rocks and grassy slopes on which boys scramble and sheep feed. I prefer Devis, however, in a mood intermediate between this and his later rather too pretty style, especially when he handles a large stretch of hilly, or mountainous, country simply, and without too much detail, on a large scale. An undated view of a *Hill at the head of Semerwater*, for example, measuring $12 \times 17\frac{1}{4}$ inches, is to me a satisfying rendering of a wide stretch of Yorkshire dale country, the lines of the hills drawn in flowing pen lines, the light and shade delicately suggested by the underpainting, and the whole only very slightly coloured. Some well drawn, if conventional, bushes and two figures placed at the turn of a rough track add interest to the foreground.

About contemporary with Devis was Richard Bernard Godfrey (1728–). He was an engraver of antiquities, views, sea-pieces, portraits, etc. His topographical engravings are often after his own drawings. Examples of his work appear in Grose's *Antiquarian Repertory*, 1775; Bell's *British Theatre*, 1776–1781, and other publications. The British Museum has two competent if undistinguished watercolours by Godfrey, one of *Pontefract Church*, the other of *Ely Palace, Holborn*.

To introduce, at this point, such an artist as George Barret the elder, who was born in Dublin in 1732 (or as other accounts say 1728), is to stray, perhaps, a little from the bounds of strict topography, for his drawings (68) so far as I know them (they are not common) are not portraits of named places. It would seem, however, out of place to rank him with the more imaginative landscape artists, even though his drawings were made to give aesthetic pleasure, rather than for the interest which attaches to the careful representation of places. His most typical works consist of rather large watercolours of groups of trees under which stand two or three horses added by his frequent collaborator, Sawrey Gilpin, RA (1733–1807), a very lively draughtsman of animals. I remember seeing at least three collaborations of this type, one being in the Circulation Department of the Victoria and Albert Museum, another a thing met with casually at a dealer's, and the third in the collection of the Rev Francis Smythe, lately Archdeacon of Lewes. This last example shows very well the strongly drawn spiky foliage which is characteristic of Barret, and which I have also occasionally seen in monochrome drawings of trees and rocks by or attributed to him. There is an agreeable small watercolour of trees by him in the Soane Museum. The *Landscape with Figures* in the British Museum seems a little difficult to reconcile with such other drawings of his as I have seen. Barret came to London in

1762. He became a fashionable painter here, and in 1768 he was one of the foundation members of the Royal Academy, but in spite of this when he died in 1784 he left his family destitute.* His son George Barret junior is mentioned in a later chapter. Another son, James, who exhibited between 1785 and 1819 at the Academy, also did some watercolours.

If George Barret, who so far as is known never went outside these islands, showed some slight inclination towards the grander type of landscape which seems to spring more easily from an acquaintance with Swiss or Italian mountain scenery, it is curious that his contemporary, Samuel Hieronymus Grimm (1733–1794), who was born among the Alps of Switzerland, appears to have reversed the process. Though he was never a very powerful artist, his early work, done before he left his native land, displays the beginnings of an appreciation of scenic grandeur, and a sense of the sculptural quality, and strong lines, of great mountain masses. But after he settled in England he became one of the most typical of English topographers, almost completely taken up with the quiet rustic charms of old houses and village streets, ruined abbeys, pleasant riverside willow-banks, and peacefully undulating, half-wooded, country accented by nothing more dramatic than 'the taper spire that points to heaven'. It is only on rare occasions that, in his English watercolours, as for example in one Cumbrian drawing, so uncouth an object as a mountain obtrudes itself. He was completely tamed by the English landscape—and it was not for nothing that Gilbert White chose him, with much anxious thought, to illustrate his *Selborne*.

The facts of Grimm's life have been collected, with copious illustrations, by Miss R. M. Clay in a book which should be read by those interested in his work.† He was a pupil of J. L. Aberli in Berne, and made some early attempts in oils, a medium which he afterwards seems to have given up. In 1762 he published at Berne a small volume of poems, and in 1765 he migrated to Paris, staying in France until he left for England—his home for the rest of his life—in February, 1768. While in France, in the year 1766, he went on a tour of Normandy with Philipp Hackert and Nicholas Pérignon. In England Grimm seems to have established himself immediately—there are drawings of Canterbury dated 1768 and in the following year he contributed to the first exhibition of the Royal Academy, where he continued to show, with only one break, until 1784. He also showed at the Society of Artists and the Free Society. His works included caricatures, illustrations of Shakespeare, and groups containing many carefully drawn figures (such as those of the Eton 'Montem' ceremony in the British Museum), besides his topographical work. He did many drawings of buildings, but his perspective is not always impeccable, at any rate in his slighter works of this sort. A very pleasant type of his drawings is that of the rather freely drawn pen and monochrome wash studies of places that are now swallowed up in London—such as one, which I have, of an inn, *The Queen's Head and Artichoke near Marybone turnpike*, with hedges and open fields all round. Dr Jacob Isaacs has a sketchbook full of similar drawings, and the British Museum another of Thames-side views between Richmond and Fulham. Perhaps the finest of all Grimm's watercolours is the large upright *The Terrace at Richmond*

* Mr Edward Croft-Murray tells me that an interesting example of Barret is his decoration of a room at Norbury Park, Surrey. It is painted in distemper and consists of landscapes seen through the arches of a trellis-work arbour. Mr Croft-Murray adds that it strongly recalls Sandby's decorated room, formerly at Drakelowe, of which a fragment is now at the Victoria and Albert Museum.

† See *Samuel Hieronymus Grimm of Burgdorf in Switzerland*. By Rotha Mary Clay. Faber. 1941.

($14\frac{3}{4} \times 11\frac{1}{4}$ inches), which aroused so much admiration when it was sold at Christie's in the A. N. Gilbey collection in 1940. It shows a stretch of the terrace with elegantly dressed ladies and gentlemen passing or leaning against the railings which form a decorative pattern of rectangles and diagonals, while beyond lies the river with boats upon it. This drawing might well have been of the normal shallow shape,* were it not for two tall trees which stretch high up each side of it, arching over a large expanse of sky and almost meeting at the top. A small but extremely lively sketch of about the same period (the early 'seventies) is the monochrome *Footpads attacking a Traveller*, in the Victoria and Albert Museum, which shows very well Grimm's gift of giving life to a quiet uneventful bit of scenery by the introduction of a few small, vigorously drawn, figures, very full of movement. Personally I much prefer this type of Grimm to the same Museum's much more ambitious horizontal oval composition, *Fairlop Fair*, in full watercolour, in which large numbers of figures are crowded together under the shade of a vast and ancient oak.

In 1776 Gilbert White engaged Grimm, at two-and-a-half guineas a week, to make drawings of Selborne. He stayed there twenty-seven days, 'twenty-four of which he worked very hard, and displayed great tokens of genius and assiduity'. White, in a letter to his brother John dated August 9, 1776, thus described Grimm's method:

> 'He first of all sketches his scapes with a lead-pencil; then he pens them all over, as he calls it, with Indian ink, rubbing out the superfluous pencil-strokes; then he gives a charming shading with a brush dipped in Indian ink; and last he throws a light tinge of watercolours over the whole.'

For Gilbert White Grimm worked only for a short period, but with other patrons he found more frequent, or even prolonged, employment. In 1777 the antiquary Henry Penruddocke Wyndham (1736–1819) took him for a tour of Wales, and (apparently over a number of years in the 'seventies and 'eighties) he was employed by Cornelius Heathcote Rodes (1755–1825) of Barlborough Hall, Derbyshire, to make drawings of that house and countryside, of which he did many important, and for Grimm large, watercolours. Of this group Miss Clay herself gave a fine example, *Whitwell Hall, Church and Crag* ($14\frac{1}{4} \times 20\frac{7}{16}$ inches), dated 1785, to the Victoria and Albert Museum. It is rather sombre in colour, with browns and greys predominating save for blue-greens of the distant landscape and trees. Its chief feature is a group of ancient buildings, but as ever with Grimm the scene is enlivened with various small figures—a rustic with a pitchfork leaning against a gate, another carrying a mug of beer and climbing a wall, and in the foreground three gentlemen in red and blue coats surveying the scene together with Grimm's favourite type of rather long lean-bodied dog with a slender curling tail (70). For another antiquary, Sir William Burrell (1732–1796), he did many views of Sussex now in the British Museum, where also is the bulk of the vast collection of drawings which, during the years 1773 to 1794, Grimm made for Richard Kaye (1736–1809), an antiquary and clergyman who in 1783 became Dean of Lincoln and in 1789 a baronet. A delightful relic of the association of Grimm and Kaye is the Indian ink drawing of Kaye and his family picnicking on Pinnacle Island in the Farne Islands, with Grimm sketching, and the dogs, and a great concourse of

* Which, incidentally, is that of the preliminary sketch, in grey wash, in the British Museum sketch-book, just referred to.

seafowl perched on neighbouring rocks, looking on. In the Bodleian at Oxford are a number of drawings done by Grimm for Richard Gough. He also made copies of ancient paintings and drawings for the Society of Antiquaries. On occasion he made replicas of his work, and one small watercolour of *Alnwick Abby, Northumberland*, dated 1773, which I have, is inscribed on the back 'To have a duplicate'. Miss Clay states that in such cases he always varied the incidental figures. She has also come to the conclusion that the arrow which sometimes occurs on the drawings is an indication of the direction of the light. A very large proportion of Grimm's work is signed and dated, as well as inscribed with the name of the place, either on the front or the back, or on both. In his early Swiss drawings his name is often written with a single m and a contraction mark above it. He is well represented in most collections, and at his best, with his extremely neat pen-work, like minute hemstitching round the outlines of his trees, and the pearly quality of his pale washes over Indian ink underpainting, he is delightful. A good example is the *Roche Abbey Lake and Laughton-en-le-Morthen Church, Yorkshire* ($14\frac{3}{4} \times 21\frac{1}{2}$ inches), in the Whitworth Gallery, Manchester, where the red, blue, and white figures in a boat in the right foreground make the whole scene gay. His Thames-side watercolours can be very fresh and pretty (69).

Grimm's long years of work making topographical and antiquarian drawings for various private patrons might be uncongenial to some artists of today, with their high claims for independence and the importance of aesthetic inspiration, but they were typical of eighteenth century conditions, and one can think of several parallel cases, for example that of John Smith who did so much work for the Earl of Warwick that he became known as Warwick Smith. He will be considered in the next chapter. An extreme instance was that of Moses Griffith* (1747–1819), some 1,500 or 2,000 of whose drawings turned up when the library of Thomas Pennant (1726–1798) was sold at Christie's in 1938. Almost the whole of Griffith's career and artistic output was bound up with Pennant and his family, and little was known of him until these drawings came to light. Then, in going through them, I found a slip of paper which gave a few biographical details, which amplify the scanty facts given elsewhere by Pennant. Griffith was born of very poor parents at Trygrainhouse in the parish of Bryn Groer, in Lein or Lleyn, a peninsula on the coast of Caernarvonshire, on March 25, 1747. He had 'no other instruction than that of reading and writing' at the free school of Bottwnog. He was apparently self-taught as an artist. Pennant speaks of him, in so many words, as a personal servant—'a worthy servant, whom I keep for that purpose', i.e. to make drawings for him—and says that it was in 1769 that he 'acquired that treasure'. Griffith, writes Pennant in 1791, 'early took to the use of his pencil, and during his long service with me, has distinguished himself as a good and faithful servant, and an able artist: he can engrave, and he is tolerably skilled in music. He accompanied me in all my journeys, excepting that of the present year', which is interesting not only from the artistic point of view, but also from that of social history. Captain Grose also employed his manservant to make drawings. Thomas Pennant died in 1798, and Griffith is said to have left the household at Downing then to practise as an engraver near Holyhead. However between 1805 and 1813 he was making Welsh views for David Pennant, but,

* See 'Thomas Pennant and Moses Griffith', by I. A. Williams. *Country Life*, July 2, 1938; also 'Moses Griffith', *Walker's Monthly*, August and September 1938.

though in these he could sometimes produce fine broad mountain effects, his colour had lost its early freshness and charm. He died on November 11, 1819. With Thomas Pennant Griffith visited Scotland in 1769, Cumberland and Yorkshire in 1773, the Isle of Man in 1774, when Captain Grose (who used several of Griffith's drawings in his publications) was one of the party, the Midlands in 1776, Yorkshire and Derbyshire in 1777, when he did some of his best work, Staffordshire, where he drew a particularly delightful set of views of Shugborough House, at some time before 1782, and Shrewsbury and the Severn Valley in 1783. Griffith's work, all done for one patron and his son, includes antiquarian details, natural history illustrations, small portraits in watercolours, and landscape views. He was a real primitive, a sort of untaught rustic Sandby, and the tinted drawings of his early period are fresh and charming (71).

Grimm was by no means the only Swiss artist to settle in England. One who worked in this country for a few years from about the same time as Grimm arrived here was Charles Brandoin, but such few drawings of his as I have seen have been of Continental subjects, and I do not know that he ever practised English topography. He was, however, no doubt one of the links between the English and Swiss watercolour schools of the period. These show certain affinities, and Mr C. F. Bell has drawn attention (*Walpole Society*, Volume XXIII, 1935) to the influence of the Swiss artist Abraham Louis Rodolphe Ducros (1748–1810), who settled in Rome about 1770, upon J. R. Cozens, who may have met him there in 1777–1779—but this can scarcely have had any direct result so far as English eighteenth century topography is concerned. It is perhaps worth noting—in this brief note on Anglo-Swiss links—that at least four English topographers were the sons of Swiss fathers. One was Francis Grose (see Chapter XII). Another was John Alexander Gresse (1741–1794), a very successful drawing master, and a collector who left a large collection which was sold in the year of his death. His own work is, however, scarcely known to us today, the most important extant example being the unfinished *Llangollen Bridge* in the Victoria and Albert Museum, which also has a pretty little pen and wash, *Landscape with a Ferry*, tentatively attributed to him. At the British Museum there is a pen and wash drawing, touched with red and green, of a river view with water-wheel and so forth, by Gresse. He seems to have been a very neat workman, his pen outlines being particularly clean and taking, but in spite of his celebrity in his own time he is now an insubstantial figure as an artist. Two slight pencil drawings from the Ford collection, which were sold at Sotheby's in March 1947, were very different from such works of his as I had previously seen. They are now in the Royal Library at Windsor. Even more unexpected were two imposing gouache landscapes, shown at Messrs Spink's in 1949. They measured 19 × 25 inches each, and were fully signed and dated 1780. They bore no detectable likeness to such clear colour drawings as the *Llangollen Bridge* (73) being more like rather ponderous exercises in the style of Zuccarelli. Another topographer of Swiss descent was Jacob Schnebbelie (1760–1792), whose father was a Swiss confectioner in London, and who was a pupil of Paul Sandby. He became draughtsman to the Society of Antiquaries. His son Robert Blemme Schnebbelie (died 1849) did many drawings of London buildings. Last, in this Anglo-Swiss group was John Webber, RA (1750?–1793), who, incidentally, was a friend of Grimm's, and who though born in London studied at Berne (under Grimm's master Aberli) and in Paris before entering the Academy schools in 1775. His father was a Swiss

sculptor named Weber. Young Webber accompanied Captain Cook on his third and last voyage in 1776, was present at his death, of which he made a drawing, and returned to London in 1780. Webber is best known, in the sale-room at least, for his South Sea scenes, often crowded with figures of natives and so forth. These seem to me rather stiff and lifeless things, but his English topographical drawings are pleasant, though they are often only in grey or blue monochrome. A very good example is *Near Dolgelly*, dated 1790, in the Victoria and Albert Museum (72). Webber visited Switzerland and North Italy in 1787. He did a number of views of Derbyshire rock-scenery in 1789. They are in grey or brownish-grey wash over delicate and fairly copious soft pencil used with a fine point, and there are sometimes washes of primrose yellow on the foliage and of pale blue in the sky—but the colour is slighter even than that of Edwards, Hearne, or Pouncy. This however is to get ahead of our main theme, since Webber belongs, chronologically, to a rather later part of this chapter.

The Edwards just mentioned is Edward Edwards, ARA (1738–1806),* who was born in London and died there after a life of continuous struggle against adversity. His is a name blessed by all students of English art, since he was the author of a most valuable book, *Anecdotes of Painters who have resided or been born in England; with Critical Remarks on their Productions*, posthumously published in 1808. In 1775–1776, with the help of Robert Udney, he was enabled to visit Italy. In 1787 he became scene-painter to a theatre in Newcastle on-Tyne, and some of the best of his rather rare topographical drawings are of places in that neighbourhood, notably the fine view of Durham Cathedral ($11\frac{1}{2} \times 18\frac{3}{4}$ inches), dated 1788, in the Victoria and Albert Museum. It is vigorously and surely drawn with the pen, and the colour is very light in tone. Another drawing of the same period is inscribed on the back, *In Jesmond Dean near Newcastle Tyne*, 1788. *E.E.* It is in pen with the shadows washed in, apparently in Indian ink, and with only very slight colouring added—a little blue in the sky and on the water below the wooden foot-bridge, and some pale pink on the roofs of the mill to the right. The foliage of the central tree is done with much the same running series of loops or undulations as in the Durham drawing, but another tree has a convention which is near to the 'bunch-of-banana' foliage of Anthony Devis. Edwards also did full-length portrait drawings—Mr Ralph Edwards has a charming watercolour, $8\frac{7}{8} \times 7\frac{3}{8}$ inches, very simply drawn in pen and lightly coloured, of a girl seated at a table, wearing a flowing blue dress and a picture hat with ostrich feathers, and I have an uncoloured pencil drawing of the artist's mother seated. In addition he did monochrome compositions of classical figures, sometimes very elegant, in pen and wash—presumably as book illustrations—and drawings of furniture, architectural detail, etc. One would say that his initials form a most individual signature, but apparently an almost identical E.E. was used by a certain Edward Eyre, who exhibited landscapes at the Academy from 1771 to 1786. I have a Bristol view signed 'E.E.' which I believe to be by Eyre and not Edwards. In 1788 Edwards became Teacher of Perspective to the Academy, a post he held until his death. By all accounts he was an admirable, likeable, and modest man (74, 75, and 76).†

* See Ralph Edwards. 'Edward Edwards . . . and the Furniture of an Earlier Age.' *Country Life*, June 7, 1930.
† Edwards for a period worked for Horace Walpole at Strawberry Hill, but fell out with him in 1784. Other draughtsmen employed by Walpole at various times were Richard Bentley (1708–1782), John Henry Muntz (a Swiss working in England, *c.*1755–1775), and J. C. Barrow (see p. 225). Of these three, so far as I know their work, only Barrow was a topographer. Muntz did some watercolour classical landscapes—tame in general effect, rather pale in colour, and finicky in touch.

Thomas Malton the elder (1726–1801), who was born in London, was a writer on geometry, a lecturer on perspective, and an architectural draughtsman; originally he is reputed to have kept an upholsterer's shop in the Strand. He exhibited a few architectural drawings at London exhibitions, and in 1785, being it is said in money difficulties, he settled in Dublin where he died. He was, however, eclipsed as an architectural draughtsman by his two sons, Thomas the younger (1748–1804) and James (1766?–1803), the former famous especially for his London views (which sometimes have etched outlines), the latter for similar views of Dublin—though in neither case are these categories exclusive. Both sons spent some time with their father in Dublin, but both came back to England, and Thomas's stay in Ireland seems to have been comparatively short. He studied for three years under the architect James Gandon (1743–1823), and after his return from Ireland he seems to have lived in London with intervals at Bath. He held an evening drawing class at which (probably about 1789) Turner took lessons in perspective. During Malton's last years, from 1796 to 1804, he lived in Long Acre, and at the time of his death was engaged upon producing a series of views of Oxford. At the Academy he was represented by 128 exhibits (his brother James by 50), and they both occasionally showed elsewhere. Much of his work was reproduced in aquatint, and 100 such plates were published as illustrations to *A Picturesque Tour through the Cities of London and Westminster*, which began to appear in 1792, and by which he is best known. A typical example of his watercolours, and one which was used in that publication, is *The Strand, with Somerset House and St Mary's Church* (13 × 19½ inches), now in the Victoria and Albert Museum—it is a very able piece of architectural drawing, showing the view looking to the east at a slight southward diagonal across the street. It is much enlivened by the figures—coaches, gentlemen in red and blue coats, a woman with a child crossing the road, a dog capering in front of a horse, and so on—and the general perspective is as good as the way in which the character and materials of the individual buildings are conveyed. Other drawings for the same series are in the British Museum. My own taste, however, is for a less purely architectural example, such as the *North Parade, Bath* (13 × 18⅞ inches, also in the Victoria and Albert Museum), where the stretch of blue-green open country visible to the right adds greatly, by its contrast with the grey stone buildings and the abbey, to the pleasure which the drawing gives. Here too there are some admirable figures in the foreground, and there is a pleasantly modulated sky of grey, white and pale blue (77). Malton normally worked with an Indian ink under-painting over which he put his local colour—the traditional technique of the 'tinted drawing' in fact. It is said that Francis Wheatley sometimes helped him with the figures in his drawings. As a footnote to this brief account of the Maltons may be added a reference to Thomas Richard Underwood (died 1836) since the excellent drawing by which he is best known, *Queen Eleanor's Cross, Waltham Cross, Herts*, in the Victoria and Albert Museum, was at one time thought to be by Thomas Malton, junior. It is a very sound and solid piece of architectural drawing. Underwood was one of the young men who worked at Dr Monro's, and was on May 20, 1799, one of the party of artists, headed by Girtin and Francia, who met and formed themselves into 'a small and select society of Young Painters' which they name 'the Brothers' (see p. 102). Underwood had private means and his later years were spent chiefly in France, where he died. Mr Thomas Girtin has an admirable example (78) of his work, which is rare.

There were many other architectural topographers, but it will be possible to mention only some of them—and that very briefly. One who was a pupil of the younger Thomas Malton was Charles Wild (1781–1835), who became a devotee of Gothic architecture and did many views of cathedrals both in this country and abroad. He made drawings of the Coronation of George IV which are in the Victoria and Albert Museum, as are two drawings of the same event (with figures by James Stephanoff) by Augustus Charles Pugin (1762–1832), a Frenchman who settled in England during the revolution and was an important figure in the Gothic revival here. The municipal gallery at Brighton has an important series of pencil and watercolour drawings by Pugin of the Pavilion. They were engraved. Two drawings were necessary for each print, a pencil drawing to give the details of decoration, a watercolour to give a rough guide to the colour and general effect. Both Wild and Pugin became members of the old Water-Colour Society, as did Frederick Nash (1782–1856), another highly successful watercolourist of architectural subjects. Of a rather earlier generation—in fact an exact contemporary of the younger Thomas Malton—was John Carter (1748–1817), archaeologist, musician, and draughtsman to the Society of Antiquaries. Presumably of about the same age as Carter was James Miller—though I do not think his dates of birth and death are known. He specialized in views of London, and exhibited between 1773 and 1791. He was a more interesting (though not more accomplished) watercolourist than most of those recorded in this paragraph, who seem to me to concern the history of architectural taste rather than that of watercolour. A fine example of Miller's work is the *Cheyne Walk, Chelsea* ($16\frac{1}{8} \times 24\frac{7}{8}$ inches), signed and dated 1776, in the Victoria and Albert Museum, in which he is clearly as much interested in the effect of the trees against the buildings, and in the life of the waterside, as in the buildings themselves (79). He was less skilled than Paul Sandby, and his figures are somewhat gauche, but his art relates rather to Sandby than to those who were primarily architectural watercolourists, though Sandby was that too, among many other things. A minor and rather later purveyor of London views, often of bridges over the river, was a certain G. Yates, of whom I know nothing but his name. He does not appear in lists of exhibitors nor in any of the books of reference, but his watercolours, done about the end of the eighteenth century, occur not infrequently. A longish series, chiefly of London bridges, varying in date between 1790 and 1837, was in the Arthur Honey sale at Sotheby's in October 1947.

Other topographers with a special interest in London buildings were William Capon (1757–1827) and C. John M. Whichelo (died 1865). Both are represented in the Crace collection of London views at the British Museum. Capon, a native of Norwich, was an architect and also worked for John Kemble as a scene-painter at Drury Lane, where he helped greatly in staging plays with historical accuracy. A good example of Capon's work in watercolour is 'Ancient Houses in Chancery Lane', signed and dated 1798, at Guildhall. Whichelo was working at least as early as 1806; his early monochromes of old buildings, in pencil and Indian ink wash, can show a pleasantly warm touch.

Humphry Repton (1752–1818), a Suffolk man who from about 1790 achieved a great reputation as a landscape-gardener, in his earlier drawings (which he drew presumably as an amateur) showed himself as a rather pleasing formal topographer, more or less of the School of Sandby. Two charming panoramic views in a park, each measuring $5\frac{3}{4} \times 16\frac{1}{4}$ inches, are in the Castle Museum, Norwich. They are signed and dated 1788.

But later he changed his style greatly, and the architectural element increased in his drawings, which then tended to be characteristic early-nineteenth-century designs for summer-houses, lodges, gates, greenhouses, and other estate improvements, shown picturesquely in their setting of trees. They may be either in colour or monochrome.

These brief remarks on the architectural watercolourists have, however, once again led us ahead of the main story of the topographical tradition, to which, in the person of the watercolourists born in the seventeen-forties, it is time to return. The oldest, and one of the most successful, of the men of this generation was Michael 'Angelo' Rooker (1743–1801), whose second name was not his by baptism, but was a joke of Paul Sandby's which stuck so effectively that Rooker frequently signed 'M. A. Rooker', the three initial letters being in monogram. He was the son of the engraver Edward Rooker (1712?–1774), and studied engraving under his father and drawing under Sandby, whose first distinguished pupil he was. He was elected ARA as early as 1770, did book-illustrations and topographical drawing and engraving, and—as 'Signor Rookerini'—was for a good many years chief scene-painter at the Haymarket Theatre. In 1788 he began a series of walking and sketching tours through the country, gathering material for his watercolours. He did not date his drawings, and I do not know if his various tours have ever been traced, but among the counties he drew in were Essex, Norfolk, Suffolk, Warwickshire, Somerset, Worcestershire, Monmouthshire, and Kent. He sometimes worked in monochrome, and did a very pleasant series of wash drawings of Kenilworth, which came on the market a few years ago. Presumably there must have been some pencil basis for these, with their solid architectural drawing and lively figures of boys scrambling upon the grassy slopes round the ruins, but upon examination of one of the series with a magnifying glass I find it impossible to be sure of this. Such outlines as can be made out—they are mostly very fine—appear to be in ink, and the great bulk of the work (in the foliage everything) seems to be done with a brush (80). Rooker* was a very suave watercolourist, there is no roughness anywhere—and by the same token there are no strong effects. His colour is often very pretty, especially in his delicate tones of yellow-green and pinky-brown in the foliage. He was fond of ruins, but—though he occasionally did urban street views—he usually took a great deal of trouble to place his building picturesquely in its setting, and the surrounding banks of tenderly coloured trees, oaks or weeping willows or what-not, often constitute the greater part of the effect—occasionally almost all of it. Rooker died suddenly on March 3, 1801, and his drawings, sold the next May by auction, fetched £1,240. A first-rate Rooker is an attractive, though hardly thrilling, thing; they do not come very often upon the market now, but most museums have good examples. A very pretty one is *The Bowling Green* ($8\frac{3}{8} \times 10\frac{3}{4}$ inches), lent to the British Exhibition at the Royal Academy in 1934 by Mr L. G. Duke. The groups of players and spectators are really animated, and the diagonal recession of the inn and the distant church is admirably managed. A younger artist whose early work is rather like Rooker's in its soft suavity, as well as in colour, is Joseph Powell† (born about 1780, died 1834?). The Victoria and Albert Museum catalogue says he 'was probably a pupil of B. T. Pouncy', but I have sometimes thought that Rooker may have been his master. A large signed watercolour of Willesden Church, by Powell, which cannot

* Mr Edward Croft-Murray points out that Rooker's minute and highly finished technique was much like that of such contemporary Dutch watercolourists as Jacob Cats, Hendrick Schrouten and J. H. Prins.

† Not, as often stated, John. See Jonathan Mayne. 'Joseph Powell.' *Burlington Magazine*. September 1948.

be much later than 1800, and may be earlier, is certainly nearer to Rooker, or even to Hearne, than to Pouncy (81). His *Close Gate, Wells*, in the National Museum of Wales, also suggests Rooker, though the figures are poor. Powell, who was a drawing master, did some pleasing, but not very robust, brown or grey monochrome views at Brighton, Eastbourne, the Isle of Wight and other places on the South Coast. He also worked on the Welsh border, in the Lake District, and elsewhere. He exhibited at the Royal Academy from 1797 to 1833, and at the Associated Artists from 1808 to 1812. In 1832 he became the first President of the New Society of Painters in Watercolours, with whom he exhibited up to 1834.

Benjamin Thomas Pouncy, mentioned incidentally in the last paragraph, was a brother-in-law and pupil of the engraver William Woollett, and was himself also an engraver. The books do not say when he was born, but he exhibited from 1772 to 1789. From 1780 or earlier he was deputy librarian at Lambeth Palace. To judge by his drawings (which are rare) his connections must have been with Kent—there are views of Broadstairs and Canterbury, the latter dated 1795, in the Victoria and Albert Museum, and there are two more Canterbury subjects (one dated 1782) in the Whitworth Gallery at Manchester. One of these last—they are little more than monochromes—is slightly suggestive of Anthony Devis, and such timid colour as there is is chiefly upon the cattle and horses. There is an agreeable exactitude, showing an observant eye, about the drawing of the plant-forms in the foreground. *On the Coast at Broadstairs* (in the Victoria and Albert collection) has rather more colour. Pouncy was clearly an artist of talent, but it is not easy to learn much about him or his work except as an engraver (82).

Another of Woollett's pupils, Thomas Hearne (1744–1817), who worked with him from 1765 to 1771, was a much more important figure in the watercolour school and left a large amount of work as a basis for the judgment of posterity. He was a native of Brinkworth, near Malmesbury, and came while still young to London. In 1763 he was awarded a premium by the Society of Arts. In 1771, having completed his apprenticeship with Woollett, he went to the Leeward Islands with the newly appointed Governor-General, Sir Ralph Payne (1738?–1807), who in 1795 was created Baron Lavington. Payne was recalled in 1775. Hearne stayed with him for three-and-a-half years in the West Indies, making drawings of the topography and life of the islands. Some of these were large and 'important' and contained many figures. Evidently Hearne continued to produce drawings of West Indian subjects, at least occasionally, after he returned home, for one such drawing in the British Museum is dated 1779. He also made drawings for Richard Payne Knight after sketches done in Sicily by Charles Gore (see p. 246) in the course of a three months' visit paid to the island with Knight and J. P. Hackert in 1777.

Hearne himself was apparently never in Italy, indeed he does not seem to have visited the Continent at all. His great work in topography was upon British themes, and from 1777 to 1781 he was chiefly engaged in making the fifty-two drawings of *The Antiquities of Great Britain*, which were engraved by William Byrne (1743–1805). The title-page of the first edition is dated 1786, a later edition appeared in 1807, and the plates vary in date from 1778 to 1806. This series was the most important work of Hearne's life. He did not disdain to draw from the sketches of others. Byrne's engraving of *Dunstable Church*, dated 1803, one of the plates of his *Britannia Depicta*, issued in six parts, 1806–1818,* describes the

* The plates vary in dating from 1803 to 1817. Not all are by Hearne, and later ones are not engraved by Byrne.

subject as *Drawn by T. Hearne F.S.A. from an outline by H. Edridge*. Hearne's original water-colour ($13\frac{1}{4} \times 9\frac{1}{4}$ inches) for this plate is in gradations of colour from grey to reddish brown with a little blue in the cloudy sky and in the solitary figure seated by the church door (in the print a second figure is introduced in the foreground). There are traces of pencil out-line, but most of the work is done with the brush, and the architectural drawing is admir-ably firm and solid in effect, yet soft and graceful in touch. Hearne used more colour than this on occasion, for instance, in his charming *Richmond, Surrey*, in the Victoria and Albert Museum (84), but generally speaking his colour, like that of several of his contemporaries, is timid. A very fine example of his work, also at South Kensington, is the *Durham Cathedral from the opposite bank of the Wear* ($14\frac{5}{8} \times 21\frac{1}{4}$ inches), which is signed and dated 1783. The composition is one of big trees to the left foreground, below which two men point across the river (the width of which seems exaggerated) more or less in the direction of the cathedral and castle perched high up in the middle distance. The foliage in this drawing is gracefully done with pen outlines in the shape of rather shallow spreading lobes. This is a convention he sometimes used—but very often there is no pen work. The colour is severely limited, being little beyond blue and grey, with fawn or pinkish lights. The grey clouds, with white edges, trailing diagonally over a blue sky, and the reflections in the water, are very prettily done. The whole is not ambitious, or grand, but within its own terms of reference it is completely successful and, for the moment, one asks nothing more.

Many of Hearne's best drawings are without colour altogether (83 and 85), being in grey monochrome, sometimes on paper previously tinted with a pale coffee-coloured wash. The basic outline is usually in pencil, but occasionally there seems little or no pencil, and usually the greater part of the drawing is with the brush. His monochromes have more warmth than Rooker's—indeed Hearne was one of the most successful artists in this medium, and his small views of a ruined castle, or a picturesque stone bridge over a stream, with a child leaning on the parapet, show how much can be done, without colour, to suggest the glow of light and the varying quality of rough and broken surfaces. He sometimes also drew in pencil only—but his work in this kind is little known to collectors. There is an authenticated example in the British Museum. Though Hearne was not, so far as is known, a pupil of Paul Sandby's, yet he was sometimes—probably early in his career—influenced by him. Mr Oppé has a view of Linlithgow Palace by Hearne which is very much in Sandby's manner. With Dr Thomas Monro (see Chapters VI and XII) Hearne was a special favourite, and Monro owned many drawings by him which were copied by Girtin and Turner, upon whose early style Hearne had considerable influence. When he died he was buried at Bushey where Monro lived. The Whitworth Gallery, Manchester, has an able watercolour, *View in Cumberland*, which clearly shows the influence of Hearne. It is by John Emes (working 1786–1810), an artist of whom I know little. Two further water-colours by him, *Greenwich Park* and *Wynnstay Park*, are in the Victoria and Albert Museum. They too are closely modelled on Hearne, particularly in the foliage and in the colour, notably the reddish brown trees contrasting with the blue sky and distance. Emes, though unoriginal, is accomplished, graceful and delicate (86).

A minor artist, who can hardly have been born later than the 'forties (a Suffolk drawing by him in the British Museum is dated 1767) was a certain Job Bulman. The British Museum catalogue says he was a friend of Paul Sandby—but I know nothing of him,

though his drawings are not very uncommon. He varies a good deal in quality; some of his work is crude, but there is a good example in the Christchurch Manor Museum at Ipswich. It represents one of the town gateways and is strongly influenced by Sandby's topographical style. Bulman's subjects also include scenes in Scotland, Cumberland, the Isle of Man, Sussex, Cornwall, the Wye Valley, Northumberland (1774 and 1779), Durham (1774) and Yorkshire. He had a heavy touch, and was possibly an amateur since he is described as 'Esquire' in Grose's *Antiquities*.

William Burgess (1749?–1812) was another who did a number of conventional topographical views, rather scratchily drawn with a fine pen, and timidly tinted chiefly in greys and blues. They include some done in South Wales and the Wye country in 1785, which have the attraction of things typical of their period—but no more (87). He was the father of H. W. Burgess (exhibiting 1809 to 1844), watercolour painter to William IV, who produced some watercolours rather heavily outlined in brown ink with the reed pen and also many very ponderous pencil drawings, which are probably drawing copies. The Burgesses became a numerous minor artistic clan in the nineteenth century.

Joseph Farington,* one of the most notable figures in English eighteenth century topography, was of the same generation as Rooker and Hearne, being born on November 21, 1747. He was the son of the Rev William Farington, Vicar of Leigh in Lancashire, and descended from an ancient family which still survives in that county. In 1763 he came to London and became a pupil of Richard Wilson, remaining with him for some years. While still in his 'teens he was three times awarded premiums for landscape drawings by the Society of Arts, and in 1765 became a member of the Society of Artists. In 1769 he became a student at the newly founded Royal Academy, of which Wilson was a foundation member. In the later 'seventies he returned to the north of England, remaining there till 1781, during which time he made drawings of the Lake District. A small monochrome of Lake Windermere at Bowness is signed 'Joseph Farington 1780'. It is neatly drawn in pen, with grey wash sensitively graded to suggest the lights and shades (88). It reminds one more of Chatelain than of Wilson—to whom indeed Farington's style seems to owe scarcely anything save an appreciation of mountain forms. In 1781 he came back to London and settled at 35 Upper Charlotte Street, Fitzroy Square, which continued to be his home until his death on December 30, 1821, when he was succeeded in occupation by John Constable. In 1783 (a year after Wilson's death) Farington became an Associate of the Academy and in 1785 a full Academician. In the affairs of the Royal Academy Farington was a very prominent and dignified figure, and it is to his credit that he early recognized the merit of younger men such as Lawrence and Constable. In spite of the fact that Farington was himself an old-fashioned and (in his exhibited work) unadventurous artist, he very soon predicted that the landscapes of Constable (whom he met first in 1795) would eventually 'form a distinct feature in the art'. In 1793 Farington began to keep a diary, a selection from which, in eight volumes, edited by the late James Greig, appeared in 1922–1928. The whole diary (still unpublished) is in the Royal Library at Windsor. This is one of the great sources of knowledge of the arts during the period it covers, and it is to be hoped that one day a complete edition will be printed.

* See F. Gordon Roe's 'Dictator of the Royal Academy.' *Walker's Quarterly*, October 1921. Unfortunately Mr Roe completed this essay before the publication of Farington's Diary.

Though Farington was Wilson's most distinguished pupil and had an abiding reverence for his master, his own bent was more and more away from imaginative landscape towards formal topography. A volume of *Views of the Lakes*, with twenty coloured plates after his drawings, appeared in 1789, and an enlarged edition with forty-three plates in 1816. *Views of Cities and Towns in England and Wales* was published in 1790. His most famous topographical illustrations, however, were the seventy-six Thames valley aquatints done by J. C. Stadler after Farington for the *History of the River Thames*, published by Boydell, in two volumes, folio, 1794, with text by William Combe. In these Farington has recorded for posterity, with great faithfulness both to the facts of the scene and to the spirit of the locality, the appearance and character of perhaps the most highly civilized tract of urban, suburban, and rural England as it was in the late eighteenth century.

Farington's diaries and sketchbooks were sold at Puttick & Simpson's in 1921, and many of the latter are now at the Victoria and Albert Museum and elsewhere. They contain drawings which revealed a quite unsuspected aspect of his work—really free and dashing studies of rocks and trees, for example, in pen or pencil and wash, which no one (on the evidence of Farington's exhibited or engraved drawings) would have thought of attributing to him (89). His finished work, indeed, is self-controlled in the extreme—often almost to the point of frigidity. Yet even here he has great merits, especially when he is dealing with a wide sweep of country, in which he is able to contrast the simplified lines of the distance with a more detailed area—perhaps a woodland slope—in the foreground. A good example is the *Lancaster, N.E. View* in the Victoria and Albert Museum (90). The Thames valley gave him many excellent opportunities of this sort. He was fond also of subjects in which the centre of interest takes up practically all the forefront of the picture and, if there is a distant vista, it is away to one side—as in *An Old Manor House* in the same museum. One large and elaborate drawing of this kind represents an old mill house half-hidden by trees, with a stretch of mill stream in the foreground. But in such drawings I often feel that the breadth of effect is lost and that the thing becomes too much a study of rather conventionalized detail.

To judge from a number of Farington's drawings in various stages of execution, his method was first to sketch the subject somewhat slightly in pencil. Second, to add careful ink outlines with the reed pen, using sometimes black, sometimes rusty brown, ink—and sometimes both, black for the distance, brown for the foreground. His nubbly pen line, incidentally, owes a good deal to Canaletto. Third, Farington added wash (blackish grey, presumably Indian ink, or sometimes sepia) to give the light and shade. The vast majority of his drawings were left at this stage—without any local colour.

George Robertson* (1748–1788), who may conveniently come next on our list, might almost as well have been dealt with in the next chapter, for he was as much an imaginative landscape artist as a topographer. His topographical work, however, forms a fair proportion of his rather small known output, and includes two well-known oval views of Windsor, the originals of which are in the Royal Library there. A purely topographical example is the pen and monochrome wash *View of Wanstead House, Essex* ($11\frac{7}{16} \times 17\frac{7}{16}$ inches), in the Victoria and Albert Museum (91), engraved in 1781. It has a row of figures across the foreground, trees to right and left, and the house behind in the centre. The foliage is

* See C. F. Bell. Walpole Society. Vol. 5. 1917.

done with pinnate strokes of the brush, rather like the broad, blunt frond of a fern, and this is a characteristic trick, which recurs (for example) both in a small body-colour view of Ben Lomond which I have (this is signed, which is quite exceptional with Robertson), and to a modified degree in the delightful and delicate *Landscape with Cattle* in the Victoria and Albert Museum (92). This last, which in certain effects of dappled light on trees resembles Taverner, shows Robertson's quiet pastoral mood. The same mood is delightfully seen, too, in a *Landscape Composition: Evening* ($11\frac{5}{8} \times 16\frac{3}{8}$ inches), belonging to the Ashmolean Museum at Oxford, a drawing which represents a winding, rutty lane, along which comes a team of horses dragging a timber cart, with great leaning beeches spreading their boughs above. Also in the same museum is a *Landscape Composition with a Stormy Sky* ($11\frac{3}{8} \times 16\frac{1}{4}$ inches), which shows a man and woman driving a donkey along a road, with a castle-crowned crag in the background, storm-twisted trees and a distant plain (93). It is notable that this pair of drawings exhibits exactly the same dichotomy of style that we see in Sandby—the one calm and intensely English, the other wildly romantic and Italianate in the Salvator Rosa manner. Indeed the drawings might almost be taken—at a first glance—to be a contrasting pair of Sandbys. The similarity to Sandby, however, is in feeling and general manner, and to some extent in colour, not in touch, which (for example, in the pen-work on the trees of the evening landscape) is quite different. There is some opaque white used on both these drawings. The Ashmolean also has a sketchbook of Robertson's containing forty-three drawings in pen or pencil, mostly with blue, or blue and brownish-grey, wash. Several of them represent animals, and one of two bulls fighting while a cow looks on is especially spirited. The amateur James Moore (see Chapter VI) owned a number of drawings by Robertson, who redrew some of Moore's work for him, and from that collection come the examples at the Ashmolean and also most of those in the British Museum. Robertson apparently had no great success in his lifetime, in spite of having been taken by William Beckford to Rome and to Jamaica, where he offered to settle him, and he is said to have fallen back on teaching for a livelihood. Mr Charles Bell is inclined to allow Robertson, in spite of the comparative fewness of his works, a considerable influence on the English school, and draws attention to the fact that Robertson appears to have been the originator of the trick scratching out the high-lights. He exhibited 84 works at the Society of Artists and three at the Academy.

The collector of English topographical drawings will not infrequently come across examples of Hendrick Frans de Cort (1742–1810), a native of Antwerp who settled in England in middle life (he first exhibited at the Royal Academy in 1790) and remained here till his death. He was principally an oil-painter, and as such his work was bought by Beckford amongst others. Contemporary collectors are said also to have admired his monochrome drawings, which are not without picturesque qualities, but tend to be too large for their content and rather flaccid in construction. The subjects are chiefly ruins, and I have noted views by him of Devon (1794), Somerset (1794), Carmarthenshire, Glamorgan, Denbighshire (1802), Herefordshire, Middlesex (Islington, 1799), Kent (1807) and Berkshire (Windsor). He worked in sepia or Indian ink, or sometimes both together, over a basis of somewhat fuzzy pencil which shows some diagonal movement, though this is much more timid than (for instance) in Gainsborough. I have seen only one drawing of de Cort's in colour—and it amounts only to some pale washes of green, red and slate-grey

added to what is essentially a sepia sketch. Many of his drawings bear a heavy ink signature 'H. de Cort' in the lower right-hand corner—but I distrust this as it differs very considerably from the much more genuine-looking signature 'Henry de Cort', often to be found, usually with details of place and sometimes of date, on the backs of de Cort's drawings (94).

The seventeen-forties saw the birth of two artists who are more widely known for their topographical work in India than in this country. William Hodges (1744–1797), who became an RA in 1787, had in 1772 been appointed draughtsman on Captain Cook's second voyage. The British Museum has a *View of the Island Otaheite* (14¼×21¼ inches), in Indian ink wash and pen, partially tinted in colour, which is dated 1773. This is a rather good drawing, incisive in design and pleasing in colour, with a taking freedom of movement about the wind-stirred leaves of the palms (95). In 1780 he again left England—this time for India, where he remained until 1783. After his return in 1784 he published his *Select Views of India*, 1786, and painted theatrical scenery, amongst other things. I have seen few of his original drawings, some large gouaches of Indian scenes in the Soane Museum being the chief. These have little beyond a certain broad posterish effectiveness to recommend them. Much more agreeable—though much quieter—is the work of Thomas Daniell* (1749–1840), who became an RA in 1799. Not all his work is Indian in subject—the Victoria and Albert Museum, for example, has an unfinished watercolour, *Sketch of a Common, with Houses* (96), which is certainly English in theme, and there are other English subjects in the British Museum. Moreover, several large, rather formal, unsigned watercolours (recently on the market) of Brimham Crags, etc., near Ripon, are certainly early works by Thomas Daniell, who exhibited views of the district at the Royal Academy in 1778 and 1781. But he made his chief mark as a result of the nine or ten years—1785 to 1794—which he spent in India, accompanied by his nephew William Daniell (1769–1837), who also became an RA—in 1822. Mr Hardie and Miss Clayton express the view that William's position during this period was principally that of assistant to his uncle, and that the large number of drawings which were shown at Walker's Gallery in 1933 were in the main the work of Thomas.† They also make the interesting point that the Daniells, to aid them in collecting material rapidly, made considerable use of the *Camera Obscura*—a contraption of lens and mirror by which an image, which can be traced in outline by a skilled hand, is thrown on a sheet of paper. The difference in the styles of Thomas and William Daniell is, at any rate when we consider William's more characteristic mature work, I think quite clear. Thomas adhered to the crisp, calligraphic drawing tradition of the older topographers, setting out his subject cleanly, simply and without much arrangement. William was addicted to a very soft pencil line—or rather in many cases lines, for when one looks at certain of his drawings it is to find that almost every outline consists of a multiplicity of fine threads. He liked soft and restrained colours, and his compositions have a rather feminine elegance, with pretty arrangements of—for example—tall, slender, leaning, palm trees, and Indian hump-back cattle. On their return to England the Daniells set about the preparation of the 144 plates of their *Oriental Scenery*, and allied works, issued between 1795 and 1808. William Daniell, who was a first-rate engraver in several processes, later

* See *Walker's Quarterly*, nos. 35-36, by Martin Hardie and Muriel Clayton. 1932. This double number is devoted to the work of Thomas and William Daniell, and to extracts from William Daniell's diary in India.
† See figures 97 and 98 for Indian examples of each artist.

made a considerable reputation for his views, issued as coloured aquatints, of London, of Eton and Windsor, and of coast scenes all round Great Britain. The original drawings—whether pencil sketches or finished watercolours—for some of these prints are in the British and Victoria and Albert Museums. One would be inclined to dismiss William Daniell as a pleasantly stylized, slightly oriental, not very exciting minor watercolourist, were it not for such an occasional picture as the sombrely impressive *Durham Cathedral*, dated 1805, in the Victoria and Albert Museum, which shows him capable of a much grander type of composition (99).

Two other names have to be associated with those of Thomas and William Daniell. One is that of William's younger brother, Samuel Daniell (1775–1811), who travelled in South Africa, and later in Ceylon, where he died. Some of his work was engraved by his brother. He was more than a topographer, being also an observant draughtsman of native life and a decorative watercolourist of birds and animals (100). The second name is that of Samuel Davis, who was born in the West Indies in 1757, went to India in 1780, and was for some years Accountant-General in Bengal. He returned to England in 1806. The Daniells visited him in India, and William aquatinted some *Views of Bootan*, which were published in 1813, after his drawings. Davis was a skilled amateur watercolourist, whose style a good deal resembles that of Thomas Daniell—though whether he was actually a pupil of his or not I do not know. His Indian mountain scenes are poetically conceived and delicate in colour (101). Incidentally the two views (one of St Helena, the other of Cape Town) tentatively attributed to Davis in the Victoria and Albert Museum catalogue are certainly not his. Another British artist who—though he was chiefly a painter of portraits and animal pictures—did Indian views was Robert Home (1751?–1834). I only recollect seeing one topographical drawing by him—a strongly drawn monochrome, now in the Victoria and Albert Museum—but according to the *Dictionary of National Biography* he did 'numerous' drawings of this kind. He published *Select Views in Mysore*, 1794.

Not much older than William Daniell was another artist who travelled in the East—William Alexander (1767–1816), the son of a coachmaker at Maidstone. He studied under Pars and Ibbetson, and also at the Royal Academy, and in 1792 went to China as an artist attached to Lord Macartney's embassy. He made many drawings on this expedition, whence he returned to England in 1794, and some of them were used to illustrate Sir George Staunton's account of it, published in 1797. He also illustrated a number of other books on China. Alexander's Chinese watercolours show much accomplishment, of a steady-going kind, particularly in the grouping of the numerous figures which he often introduced into them. In 1802 he became Professor of Drawing at the military college at Great Marlow, a post which he retained until in 1808 he was appointed Keeper of Prints and Drawings at the British Museum where, very properly, many examples of his work are to be seen. He is also well represented at South Kensington (103). His later work consists largely of factual drawings of antiquities, and also of antiquarian or architectural topography. He showed a nice delicate touch, somewhat in the manner of early Turner or Girtin, in pencil and wash studies of church doorways and the like. More exciting was George Chinnery* (1774–1852), whom Colonel Newcome so much admired (perhaps because he painted a portrait

* See *Notes and Queries*, 1927, for a series of articles by W. H. Welply. Also I. A. Williams. 'Indian Drawings by George Chinnery.' *Country Life*, May 30, 1936.

of W. M. Thackeray at the age of three), but he was not a topographer and if he is mentioned at this point it is merely as a matter of convenience, and because, after a few years in Dublin, he worked in India from 1802 to 1825, and in China from then until his death. He used all sorts of media, and did many kinds of subject. His watercolours, which are usually small and of a satisfying rich quality of colour, include landscapes, illustrations of Fielding's *Amelia*, Indian boatmen on the seashore or Indian girls fetching water from the well, and Chinese coolies at work or at play. Most of the watercolours of his which I have seen have been sketches rather than finished works, and often contain very fluent and lively pen drawing. His figures are animated and admirably observed. I like especially his sketches done in Madras between 1802 and 1807 when he went to Calcutta—but his much later Chinese drawings are often delightful too. Like Ward and Hills he frequently annotated his rough sketches in shorthand (104).

One more name must be added to this list of English watercolourists who visited the Far East—that of William Westall (1781–1850), who became ARA in 1812. He was a pupil of his elder brother Richard Westall, RA (see p. 133), but whereas Richard specialized in figure subjects, William was principally a topographer. In 1801 he became draughtsman to Matthew Flinders's expedition to Australia, where he was shipwrecked—and the Victoria and Albert Museum has a view of *Port Jackson, Sydney*, signed and dated 1804 (this date does not represent that at which he visited Port Jackson, but that at which he finished the drawing). From Australia he went to China in 1803 and India in 1804, came back to England early in 1805, and almost immediately set out again for a voyage to Madeira and Jamaica. He did many topographical views of the north of England, of the Thames, and elsewhere which were engraved, in many cases by himself. Some small watercolour views in the Victoria and Albert Museum, for example one of Lancaster Castle, are extremely pretty in colour and neat, and in them Westall uses numerous minute figures with skill and vivacity. Mr H. C. Green has a large landscape, *St Helena—Lot and his Daughters*, signed and dated 'W. Westall 1804'. The foreground is chiefly in greeny-browns, while the distant mountains are whitish and suffused with misty light. It is a more ambitious and imaginative work than one usually associates with Westall's name (102).

A brief mention may conveniently be made here of another topographical traveller— George Heriot* (1766–1844), a Scot whose father was sheriff-clerk of East Lothian. He was born at Haddington and educated at Edinburgh High School and University. He became a cadet at Woolwich, but was afterwards a civil servant. From 1799 to 1816 he was Deputy Postmaster-General of Canada, but seems to have been a somewhat obstructive official. His travels took him through a great part of Quebec and Ontario. He returned to England in 1816 and died here, unmarried, in 1844. His earlier drawings are often marked by a neat penmanship, but his later work was less crisp and good. Some of Heriot's Canadian watercolours were exhibited in London in 1797, and in 1807 he published *Travels Through the Canadas*, 4to., illustrated with plates after his own drawings. The British Museum has some views of Salzburg by him dated 1818, and I have at various times seen, or seen reference to, drawings by him of Spain, France, the Channel Islands, Wales, Scotland, and the Thames estuary. In 1824 he began to publish

* See 'George Heriot, Author-Artist', by J. C. A. Heriot. *Americana*, Vol. 5, 1910, pp. 888–892. I owe this reference, which contains, so far as I know, the only account of Heriot, to the kindness of my friend Mr C. R. Sanderson, Chief Librarian, Toronto Public Library, who has sent me a photostat of the article.

A Picturesque Tour, in eight parts, with illustrations after his drawings in France and Spain, but only two parts appeared, containing twelve French views. Sir Bruce Ingram has one of his English sketch-books, containing some very Sandby-like views of Greenwich and North Kent (105). A large collection of his work was sold at Sotheby's in 1943. He was a younger brother of John Heriot (1760–1833), of whom there is an account in the *Dictionary of National Biography*. English topographers who worked on the American continent were rare in the eighteenth century, but another, and rather earlier, such artist was the amateur Archibald Robertson (1745?–1813), a Royal Engineer who eventually rose to the rank of lieutenant-general. He was a first cousin of Robert Adam, the architect. I have not seen the originals of any of Robertson's American drawings, but a number of them are reproduced in Mr H. M. Lydenberg's *Archibald Robertson, Lieutenant-General Royal Engineers, His Diaries and Sketches in America*, 1762–1780, published by the New York Public Library in 1930. The plates in that volume are in monochrome, but they show that Robertson had at least a good eye for a scene, though his figures are poor and conventional and his treatment of foliage is rather mechanically repetitive. He sometimes reminds one a little of Devis. The National Museum of Wales has five large topographical Welsh views, with semi-classical figures, done in Indian ink and pen by Robertson (106).

It is time, however, to turn to the later topographers—those, that is, born after the great generation of the 'forties—who worked in Britain. Some of these, such as John 'Warwick' Smith and Edward Dayes, are reserved for treatment in other chapters, but there are others (and they are only a small selection from a very large number of artists who might be included) who call for comment here. If they are rather briefly dealt with, it is because on the whole the strictly topographical artists born between 1750 and 1785 are worthy plodders, following a track already beaten, and not men of great sensitiveness or imagination. How many such performers there were is not generally realized—and least of all by those collectors and dealers who try to attribute all the fairly competent drawings of the period to a few well-known names. It will check any tendency to over-confident attribution to look through the plates in such topographical publications as Britton and Brayley's *The Beauties of England and Wales*, 1801–1816, and to notice how many artists of whose original drawings the average student knows nothing are there represented by engravings.

Some of these minor performers were local artists, either provincial teachers of drawing or men who exploited a growing interest in the picturesque or romantic beauty of their own locality. Such a one, for example, was William Green (1760 or 61–1823), a Manchester man by birth who, after a short period in London, returned to the north to make one Lake District view after another. He died at Ambleside. Some of his work was engraved. He is one of those artists who always seem to paint the same picture—and his favourite subject is a view across a lake, with mountains behind and in the foreground a group of rather wooden-looking cows (107). There is an absence of sunlight in his drawings, which always appear to have been done on a cloudy day, and the colours are chiefly greyish or brownish purple and dull green, but possibly the examples I have seen have suffered from exposure to the light, for I never remember coming across a really fresh specimen—save for one unsigned drawing which may possibly not be Green's. His pencil sketches are well and firmly drawn. Another local artist was J. Roe of Warwick (exhibiting

1771–1790, and apparently still living in 1812) who specialized in views of ancient buildings and ruins in the Midlands (108). He was a stilted performer with a tiresome trick of using a lifeless brick-red for foliage*; but a costume drawing of one of the Brothers of Lord Leicester's Hospital at Warwick, wearing his long blue cloak and broad-brimmed hat, shows a more capable side of Roe's work. A better artist was John William Upham (1772–1828), who lived for many years at Weymouth and specialized in views of Dorset and Devon—though he also visited North Wales and Switzerland. John Marten, senior, of Canterbury (exhibited 1793–1802) may also be mentioned among topographical water-colourists of local reputation (109). Whether Daniel Harris was purely a local Oxford artist, I do not know, but he certainly lived there when he exhibited his only picture at the Royal Academy in 1799, and the very few drawings of his which are known are of Oxford subjects. One, representing *The Original Entrance to the Cloisters at Magdalen College* (110), which belongs to Mr Croft-Murray, shows Harris to have been a competent draughtsman in the topographical-architectural tradition. It was engraved for the *Oxford Almanac* of 1787. *A Western View of All Souls' College*, by Harris, in the Victoria and Albert Museum, dated 1789, was engraved for the *Oxford Almanac* of 1790. A competent provincial topo-graphical watercolourist was Robert Noyes (*c.* 1780–1843), who worked chiefly in Stafford-shire and the Midlands.† His drawings are somewhat in the style of Francis Nicholson. His great-grandson, Mr Alfred Noyes the poet, has several examples. Yet another local topographer was Henry Cave (1779–1836) of York by whom there are many drawings in the Art Gallery of that city. He worked skilfully, sometimes rather in the manner of T. M. Richardson, senior.

John Laporte‡ (1761–1839) did much topographical work, and most of his exhibited drawings were of named places, though doubtless many of them were primarily pictorial in intention. He also did much work of other sorts, including the series of soft-ground etch-ings after Gainsborough, in which he collaborated with W. F. Wells (see p. 215) and a number of studies of trees, rocks, castles and so forth which he published as aids for learners. I have referred elsewhere (see p. 218) to his occasional habit of combining soft-ground etching with watercolour. He was a pupil of John Melchior Barralet (fl. 1774–1787), a drawing master and landscape painter who was born in Dublin of Huguenot parents. John James Barralet (1747–1815), an inept and heavy-handed if ambitious artist, was the latter's brother, and in 1773 opened a drawing school in James Street, Golden Square, but did not stay long in England. Some of Laporte's most accomplished drawings are in body-colour, for example the Isle of Wight woodland scene, dated 1790, in the Victoria and Albert Museum. This perhaps shows him at his best and is a handsome and effective thing, relating rather, *mutatis mutandis*, to Hobbema and the Dutch masters than to Sandby. Another of Laporte's gouache drawings, also signed and dated 1790, shows, however, strong Sandby influence (111) and is completely Italianate in manner—and in subject, for it represents a little red-roofed village perched on a hill top with a waterfall in the left fore-ground and a wide plain, lavender purple in colour, stretching out to the horizon beyond a winding river. Both these drawings contain Laporte's favourite compositional form in

* Some of the worst of the supposed 'Roe of Warwick' drawings may, however, be the work of pupils.
† See 'Robert Noyes: A Forgotten English Artist', by I. A. Williams, *Country Life*, June 30, 1950. Noyes did much work also in Shropshire, Wales and the Welsh Border. He did a few London drawings between 1811 and 1814.
‡ See the account of him by B. S. Long in *Walker's Quarterly*, number 8, July 1922.

which the eye is led along the line of some high object (in one case the side of a wood, in the other an almost precipitous hill) diagonally across the picture to the skyline. I have a little drawing in clear colour, initialled and dated 36 years later—in 1826—which, though a very unassuming English country sketch, retains this element, but with the added complexity that, while the line of a fence and a building leads the eye off to the left this direction is cut across by a receding road which seems to wish to deflect one to the right. At one time—in 1792–3—Laporte lived at 4 Gresse Street with John Hassell (died 1825), a topographical artist whose rather dull, matter of fact, little sketches of buildings and so forth often have a good deal of interest for local historians and are therefore prized, as documents, by provincial museums—for example, the Educational Museum at Haslemere. A more distinguished contact was with Dr Thomas Monro, to whom Laporte gave some lessons, and to whom he sold drawings to the value of £500 or £600. I do not know of any direct evidence that Laporte and Turner met at Monro's house, or indeed that they were ever personally acquainted—though there is much that makes this probable, particularly the fact that they were both friends of W. F. Wells. But, however that may be, one of the prettiest drawings I know by Laporte is a pencil sketch of Knockholt Church, with the sky washed with grey and blue (112), which is much in the style of one of Turner's early studies of buildings. Indeed, I recently saw a watercolour by Laporte, dated as late at 1822, which still showed the influence of early Turner.

From the last fifteen years of the period covered by this book the names of perhaps half-a-dozen topographers may be chosen as representative, and as artists whose work every collector is likely to come across. Of these the eldest was John Buckler (1770–1851), who worked in London as an architect until 1826, but is best known for his drawings of cathedrals, country houses, and other buildings, many of which were published as aquatints. He had a smooth, painstaking style, and a characteristic and narrowly restricted range of colour in which browns, brownish-greens, and grey-blues predominate. When his drawings have been hung, they have usually faded badly, and gone very red. He was a dull artist, though skilful in the representation of buildings, particularly those of stone. His most taking quality was a knack of showing a house in relation to its surrounding grounds and of placing aptly the rather pretty figures with which he decorated his views (113). His son, John Chessell Buckler, lived an immensely long life—from 1793 to 1894—and his work is pretty well indistinguishable from his father's. Another prolific, but on the whole dull, watercolourist was James Bourne (1773–1854), who was born at Dalby, near Spilsby in Lincolnshire, worked in London early in the nineteenth century, and died at Sutton Coldfield. He must have travelled very widely in Britain, and his subjects include views in Wales, Yorkshire, and Cornwall, besides many in Surrey and on the north coast of Kent. He was fond of old cottages in a setting of trees, and worked a good deal in brown or grey monochrome (114). He had a fuzzy and usually clumsy touch—his work is without crispness or firm outline, though he had an eye for the picturesque and in his drawings in full colour could sometimes attain an agreeable warmth expressed in low rich tones. Bourne's style is unmistakable—but there are no limits to the attributions which certain owners will make, and I have seen drawings apparently by him called Girtin, and even Cozens, for no reason discernible by the human eye. Luckily, however, Bourne often signed his drawings on the back, usually giving also the name of the place represented and his own

address. A mannerist such as he was is easily imitated, and I have seen drawings in his style signed 'E. Bourne' and 'E. Lee'—the former being a daughter of the artist. In 1945 several portfolios of James Bourne's drawings were presented by his grand-daughter, Dr Annette Benson,* through the National Art-Collection Fund to the galleries at Birmingham, Lincoln, Swansea and York.

Three topographical watercolourists who, in much of their work, showed an almost ladylike restraint of colour and gentleness of touch were P. S. Munn, W. Delamotte, and J. C. Smith. The first of these, however, Paul Sandby Munn (1773–1845), a godson of Paul Sandby, who is said to have given him his first lessons in watercolour, at one time showed signs of rather greater strength. A very early drawing of Munn's of Shanklin Chine, dated 1797, is a gouache in the Sandby-Laporte tradition. He was an early friend of Cotman's, and with him visited Wales in 1802 and Yorkshire in 1803. Under Cotman's influence—which superseded that of Sandby—Munn in a few drawings achieved something of Cotman's harmonious and rich gradations of colour, and Cotman's strong sense of pattern is occasionally reflected by Munn, even as late as a monochrome of a waterfall signed and dated 1814 (117). Usually he attempted nothing so bold, contenting himself chiefly with delicate little drawings of ruins, towns, houses, farmyards and so on, many of them in pencil and wash. Occasionally he strayed from the strictly topographical, as in a pretty watercolour, very soft in colour, of an oak, with two ladies and a child beneath it, signed 'P.S.M. 1805' (116). Munn had a way of doing foliage in rounded shapes which, at their worst, become a trifle cotton-woolly. Indeed his delicacy of touch at times eluded him and left his work flat and clumsy. He contributed many plates to *The Beauties of England and Wales*. Francis Stevens (1781–1823), who became an Associate of the Old Water Colour Society in 1805 and a member in 1809, was a pupil of Munn.

William Delamotte (1775–1863) was born—at Weymouth—in the same year as Turner and Girtin, and the books of reference say that his early drawings were in Girtin's manner. This must, I think, mean in the manner of Girtin's early topographical work, and though I have not seen any well authenticated Delamotte drawings of this type, I have come across watercolours, chiefly in blue and grey, with attributions to Delamotte, which are certainly reminiscent of early Turner and Girtin. Delamotte became a drawing master at Oxford, and in 1803 was appointed to a similar post at the Royal Military Academy, Great Marlow. I have seen slight drawings done by him in collaboration with William Crotch (see Chapter XII). Besides views of many parts of England and Wales he did many of Swiss scenery. His most characteristic work, as I know it, is drawn with the pen in reddish-brown ink and tinted in not very strong colour—chiefly blue and grey and a washed-out red. At his best he has a certain firmness which, combined with restraint, is not unattractive, and he had an eye for a picturesque building or bit of country (118). But he could be sadly uninspired, especially in later life—say about 1830. He was an attractive and fairly bold etcher.

The third of the three artists just mentioned as making almost a trio in style—though so far as I know there was no contact between them—was Joseph Clarendon Smith, who was

* This lady, who died in 1948, was also the great-granddaughter of the Rev William Gilpin. She left a number of miscellaneous drawings to the Victoria and Albert Museum. A sister, Miss Mary K. Benson, of Hertford, died in 1949 and the sale of her effects included many drawings by Bourne and a few by Gilpin. These ladies were the daughters of Edmunda Bourne (born 1820), afterwards Mrs William Benson.

born in 1778 in London, and died of tuberculosis in 1810 on his way back from Madeira, whither he had gone in a vain attempt to get well. He was originally an engraver. The basis of his style as a draughtsman is a very neat, elegant, and delicate pencil line, lightly treated with sepia or blue-grey wash, but sometimes also with local colour. He used rather prim, regular, pencil hatching for the shadows. J. C. Smith was a topographical artist of much taste, though not of great force (119). He did many pleasing drawings of the Thames valley (*cf.* a sketch book of 1807 in the Victoria and Albert Museum) and the home counties, and also worked farther afield, as for example, in Warwickshire, Devon (1805) and Cornwall (1806).

A minor general-utility watercolourist, a topographer among other things, of whom little is known, though his work is not very rare, is a certain J. de Fleury, who exhibited pretty regularly, chiefly at the Royal Academy, from 1799 to 1822, and was active at least as late as 1825, which is the date on a view of Salisbury in the Victoria and Albert Museum. Up to 1801 his exhibits appear from their titles to have been sentimental subject pictures, one of which, 'The Gleaners', is presumably the large watercolour in the Whitworth Gallery, Manchester. It is a rather feeble piece, in a Wheatley-cum-Westall manner. Later his exhibits were principally topographical, and included subjects in Wales (from 1802), Yorkshire (from 1806), the South Coast, Scotland (1814) and Worcester and Hereford (1817). To judge from the few examples I have seen, he was a pretty enough, sometimes mildly poetical, watercolourist, but weak in drawing. I have a sepia monochrome of a ruined castle in a landscape. He lived in London.

Finally, in this chapter, a short paragraph or two may be given to a few Scottish artists who devoted their talents largely to depicting the scenery of Scotland. The eldest of them was Alexander Nasmyth (1758–1840), but he was principally an oil-painter, and is hardly known in watercolour. There are, however, some small drawings by him in the British Museum, and I have come across two others, one a theatrical caricature in watercolour signed 'Al.N' (he was a scene-painter at one time) and the other a pen and wash landscape signed 'A.N.', which I think to be his (120). These form too frail a basis for an assessment of Nasmyth's powers, and a large and striking watercolour of Ben Lomond, which carries an old attribution to him on the back of the frame, is so much in the manner of H. W. Williams (of whom more in a moment) that it cannot be treated as a reliable document. If indeed this drawing (which is in my own collection) is by Nasmyth, then Williams must have been his pupil—but Mr Stanley Cursiter, lately Director of the National Gallery of Scotland, tells me that he thinks it is unlikely, and that so far as he can ascertain Williams was a pupil of David Allan. One who was certainly a pupil of Nasmyth was Andrew Wilson (1780–1848), who was born and died in Edinburgh, though he spent long portions of his life in London and, especially, in Italy. Nasmyth was Wilson's master before at the age of 17 he left to work at the Royal Academy Schools in London, and afterwards in Italy. In 1808 he was one of the original members of the Associated Artists in Watercolours, a short-lived rival to the Society of Painters in Watercolours (see Chapter XI). H. W. Williams also belonged to the Associated Artists, which held its final exhibition in 1812. For a time Wilson taught at Sandhurst, and from 1818 to 1826 at the Trustee's Academy, Edinburgh. In 1826, however, he returned to Italy permanently, and he was merely on a visit to his native island when he died. His watercolours of Scottish scenery are often very

large, and he showed extreme precocity, so far as technical accomplishment is concerned. A watercolour of a Highland valley, with a herd of cattle being driven along a road in the foreground, and some extremely well-observed trees, measures $16\frac{1}{2} \times 24\frac{1}{2}$ inches and is carried out with very great skill (which is not to say that it is a great work of art). It is signed and dated 1799, when the artist was 18 or 19 (121). The Victoria and Albert Museum has some sketches which illustrate his late work, including a view of Rome in clear fresh washes over soft, fine, pencil, and a somewhat Crome-like study of sandhills at St Andrews. In 1946 I saw a slight and delicate signed watercolour portrait by Andrew Wilson in a shop at Colchester—a fact which may be worth noting as he is not generally known as a portrait draughtsman. During his later years in Italy he acted as adviser to a number of wealthy collectors of Old Masters.

Another pupil of Alexander Nasmyth's was Patrick Gibson (1782?–1829), though I only remember seeing one Scottish topographical subject by him. The British Museum has an album of 26 watercolour views of the Faröe Islands, made by Gibson in 1812; and quite effective and bold London views in Indian ink monochrome occasionally occur (122). A rough but vigorous watercolour of Linlithgow Palace, signed with a monogram of his initials (which the cataloguer pardonably misread as 'I.G.') and dated 1802, was in the sale of the Randall Davies collection at Sotheby's in February 1947. A more amusing misreading of this monogram, in which the tops of the P and G are combined, recently led to the attribution to Girtin of a watercolour of Caernarvon Castle initialled by Gibson.

Hugh William Williams (1773–1829) was born on board his father's ship during a voyage to the West Indies. He was early orphaned and brought up in Edinburgh by his maternal grandmother, who had married, as her second husband, an Italian named Ruffini, who encouraged him to become a painter. His early works are chiefly Scottish landscapes, but he sometimes did Welsh or North of England subjects—a view of Bangor Cathedral in the Victoria and Albert Museum is dated 1806. He made a tour of Italy and Greece, from which he returned in 1818, and in 1820 published an account of his travels with engravings after his own drawings. His watercolours of Greece attracted considerable attention when he exhibited them in 1822, and between 1827 and 1829 he issued his *Select Views in Greece*. Eventually his Greek work became so well known as to earn him the nickname of Grecian Williams. There is a view on the Acropolis, Athens, in the British Museum (and there are other Greek watercolours by him in the National Gallery of Scotland), but his Scottish drawings are now more familiar in English collections (e.g. the Victoria and Albert Museum, and the British Museum). H. W. Williams was a surprisingly varied artist, and I once acquired a small bundle of sketches by him which, had they not been signed (mostly on the back), would have defied attribution. One pen and wash drawing looks like Farington, and a watercolour of Caerphilly Castle is in purple-browns and dark greens that almost suggest De Wint! Williams could be boldly dramatic at times—as in a watercolour of a rocky gorge, dotted with ancient wind-torn trees, and overhung with a dark storm-ridden sky, which is signed and inscribed 'Edinr 1801'. This, which is carried out in a colour scheme of grey, dull green, and fawn-brown reminiscent of J. R. Cozens, would have entitled Williams to be classed among the creators of imaginative landscape had he done others like it (124). But usually he was content with more conven-

tional aspects of Highland scenery and ruins, and his colour, when it attempts a wider range, is apt to lapse into rather unpleasant blue-greens and hot passages of high light in brownish-red and yellow. One of the finest drawings I remember seeing by H. W. Williams was a large monochrome (in Indian ink I believe) of trees with a group of horses standing below them, which was shown at the Beaux Arts gallery in 1945. It was bold and striking.

These Scottish artists, however, probably from the character of their native scenery, had a foot in both camps; and they may therefore perhaps fittingly be the last to be considered, in a chapter on topographers, before passing to those who practised pure landscape, chiefly under the influence of Italy and the Alps.

Imaginative Landscape

AFTER DEVOTING so long a chapter as the last to topography, it is time to turn again to the other great division of those graphic arts which take the face of the earth for their subject—imaginative landscape, particularly as it was practised under the influence of Rome and of Italian and Alpine scenery. The first grand watercolourist of this school in England, Alexander Cozens, has already been discussed, but great as his influence was it was eclipsed by that of two other men, Richard Wilson and Thomas Gainsborough. Wilson, however, worked scarcely at all in watercolour, and Gainsborough, though he did so at times, resembled Cozens in most often confining himself to monochrome wash.

Richard Wilson (1714–1782) was born at Penegoes, Montgomeryshire, where his father was parson. The family soon moved to Mold, where Wilson's boyhood was spent, and where, long years after, he was buried. In 1729 he was sent to London, worked under a portrait-painter called Thomas Wright, and it was as a portrait-painter that he began his artistic career. In 1750 he went to Italy, visiting Rome and Venice, and at the latter place, as Edward Edwards recounts, 'he painted a small landscape, which being seen by Zuccarelli*, that artist was so much struck by the merit of the piece, that he strongly urged Wilson to pursue that branch of art, which advice Wilson followed, and became one of the finest landscape painters in Europe. His studies in landscape must have been attended with rapid success, for he had some pupils in that line of art while at Rome', which was Wilson's chief place of residence during the six years or so which he passed in Italy. The Victoria and Albert Museum has a sketchbook of chalk or crayon drawings done by Wilson at this time, many of which were afterwards very ably engraved by John Whessell. Duplicates, or sometimes enlargements, of these drawings not infrequently occur which are very troublesome, and it is often hard to decide whether they are replicas done by Wilson himself, copies made by pupils, or copies made from Whessell's reproductions.

After Wilson's return to England in 1756 or 7 he practised as a landscape painter. Italy continued to be one of his main sources of inspiration, though he also painted many English scenes and some of his noblest work was inspired by the mountains of his native Wales. From 1760 to 1768 he exhibited with the Society of Artists, and in the latter year became a foundation member of the Royal Academy, to which in 1776 he was appointed Librarian

* Francesco Zuccarelli (1702-1788) was, with Canaletto and Marco Ricci in their different styles, one of the contemporary Italian artists who most influenced the development of landscape painting in 18th century England. All three visited this country. Zuccarelli spent five years in London (apparently in the forties of the century) being largely employed as a scene-painter. A second visit lasted from 1752 to 1773, in the course of which he became a foundation member of the Royal Academy. He worked in oils, body colour, to some extent in clear colour, and in sepia wash. His drawings are picturesquely romantic scenes, with peasants, perhaps accompanied by goats and cattle, among rocks and trees, or beside humble cottages, all done with a considerable decorative flourish. He occasionally signed with a monogram, but more often a gourd, lying on the ground by one of his peasant girls, acts as a signature—an allusion to his name which means 'Little Gourd'.

EARLY ENGLISH WATERCOLOURS

in succession to Francis Hayman. Apparently landscape-painting brought him in so little that he was glad of the small salary attached to the post. Eventually, however, he inherited a small estate at Llanberis from his brother, and there he spent the end of his life. His last exhibit at the Academy was in 1780. He died on May 15, 1782.

Wilson is one of the grandest of British artists—the glow and richness of his colour, the strength with which he could seize the essential forms of mountain scenery, are in their own way unequalled. But he scarcely touched watercolour. The bulk of his drawings—and he did many—are in black chalk, often worked with a stump and sometimes heightened with white chalk. They are often on blue or grey paper—but he also used brown or white paper on occasion. They are usually of Italian scenes, frequently Roman classical buildings; and their importance for the student of watercolour lies in their general influence, and that of Wilson's art as a whole, upon landscape. He was not the first of British artists to go to Rome. We have seen that they were doing that in the seventeenth century, and since then there had been a continuous, if thin, stream—for example a certain John Alexander (who worked about 1715 to 1752) was in Italy early in the eighteenth century, and the British Museum has a Roman view by him, in pen with Indian ink and sepia wash, dated 1715. But with the possible exception of Alexander Cozens (who for all his importance as a draughtsman never had Wilson's reputation nor his all-round artistic achievement) Wilson was the first English painter of the highest rank to go to Italy and to import thence a whole new way of looking at landscape, a way in which appreciation of the natural scene was combined with nobility of expression and a pervasive sense of both history and legend. Well might Edward Edwards describe his style as 'classical, grand, and original'. One of the very few drawings of Wilson's which are in colour is the celebrated study, now in the Victoria and Albert Museum, for his painting of *The Destruction of the Children of Niobe*, a technically curious drawing which seems to contain elements of both oil and body-colour. It is a very fine and dramatic thing, carried out chiefly in dark chocolate browns and greys. From the right there comes down a diagonal mass of rocks cleft by the white foam of a waterfall. In the lower left corner is a bridge, beyond which appears a sombre landscape, in which a tower, with lightning flashing behind it, is prominent, and above which is heaped a pile of dark clouds to balance the rocks to the right. But though this is catalogued at South Kensington with the watercolours, it is scarcely to be counted such in any ordinary sense of the word (125 and 126).

Of Wilson's pupils* the most important were Joseph Farington and William Hodges, who were discussed in the last chapter. Neither of them was closely influenced in his drawings by Wilson. A pupil who came nearer to his master was Robert Crone (17 –1799), an Irishman by birth. His drawings (which are rare) are in black and white chalk, and are much like Wilson's in general effect save that they are more obviously painstaking, and entirely lacking in Wilson's freedom and spirit (127). Crone was in Rome in 1755 (see A. J. Finberg, *Times Literary Supplement*, December 26, 1918, who quotes part of a list of artists

* A note may be added on drawings by certain other Wilson pupils. Mr Brinsley Ford (*Burlington Magazine*, December 1948) has recently identified a monochrome London view, very much in Wilson's manner, in Sir Bruce Ingram's collection, as by Johnson Carr, of whom Edward Edwards tells that he died of consumption in 1765, aged 22. Edwards also mentions 'Mr Plimer, said to have been a native of Blandford, in Dorsetshire. He died young in Italy, before 1770'. This was doubtless the 'Plimer' whose name is on the back of some pen and grey or brown wash Italian landscapes (from Paul Sandby's collection) also belonging to Sir Bruce Ingram. There are also in existence some sketch-books (one is in the National Museum of Wales) of Thomas Jones (1742–1803), another pupil of Wilson. Jones's diary, edited by Mr Hesketh Hubbard and Mr Paul Oppé, is to be published soon by the Walpole Society.

in Rome between 1753 and 1775), in which year James Forrester, also from Dublin, was there too. Forrester is an obscure figure. He was still in Rome in 1760, when an etching by him is dated. I have seen monochrome landscape wash drawings, rather dark and heavy in manner, attributed to him, and there is a romantic 'Italian Landscape', signed on the back, in the Victoria and Albert Museum. It is in brown and grey with white and some pen on brown paper.

In an album, from the collection of the Duke of Northumberland, sold in London in 1949, were some half-dozen drawings in Indian ink, wash and chalk, attributed in an old hand to 'Oram the Elder'. They measured about $8\frac{3}{4} \times 12\frac{1}{4}$ inches each, and were obviously pastiches of Wilson. The attribution is to William Oram (died 1777) and seems not unreasonable, though these drawings are not like the only other drawing I remember attributed to him. He was a landscape painter much employed for decorating houses, and is clearly an artist whose drawings should be looked for. His son, Henry Oram (flourishing 1770–1800), was also an artist, and there is a small watercolour by him in the Victoria and Albert Museum.

A minor artist who was in Rome at about the same time as Wilson, and stayed there much longer, was James Russel. Indeed when he died there in 1763 he was said to have lived more than twenty years in Rome, where he acted as guide and agent for English travellers interested in antiquities and works of art (see W. T. Whitley, *Artists and their Friends in England*, 1700-1799, 1928). According to the same authority he was the son of a non-juring clergyman schoolmaster in Westminster and was the author of the anonymous *Letters from a Young Painter Abroad to his Friends in England*, 1748, which has been attributed erroneously to Allan Ramsay. Russel is today forgotten as an artist, but I have four small landscapes in watercolour, a little reminiscent of Taverner, which are signed on the back 'J. Russel del' and may be presumed to be by him.

The second towering figure in English eighteenth century landscape was Thomas Gainsborough (1727-1788).* But, in contrast to Wilson, he never went to Italy—nor indeed anywhere abroad. His first inspiration was from his own Suffolk countryside, aided, no doubt, by sight of examples of some of the Dutch seventeenth century landscape painters. He was born at Sudbury and himself said that 'there was not a picturesque clump of trees, nor a single tree of any beauty, no, nor hedgerow, stem or post' in the district that was not firmly fixed in his memory. At fifteen he was sent to London, to the care of a silversmith, and became a pupil of Gravelot, from whom, perhaps, he acquired that almost French elegance which appears in some of his paintings. He then worked under Francis Hayman for three years, after which he was on his own in London for about a year, before returning to Sudbury in 1745. He soon married and with his wife set up house in Ipswich, where he first made the acquaintance of his lifelong friend Joshua Kirby. In 1760 Gainsborough moved to Bath, and there he quickly made a reputation as a portrait painter. He exhibited with the Society of Artists from 1761 and in 1768 became a foundation member of the Royal Academy, but it was not until 1774 that he settled in London, where he remained for the rest of his life.

We are not here concerned with Gainsborough's work as a whole, merely with his

* See especially W. T. Whitley, *Thomas Gainsborough*, Smith, Elder, 1915, and Mary Woodall, *Gainsborough's Landscape Drawings*, Faber, 1939.

watercolours. But it is worth observing that medium seems to make less essential difference in Gainsborough's art than in that of any other great artist. The same method of expression runs through his work in pencil, chalk, wash or watercolour—or even in many cases in oil. With most artists one sees different styles in—at least—their drawings and their paintings. Not so with Gainsborough, with whom the same mind and hand are immediately apparent in every medium—and indeed it is often easier to remember that one has seen a Gainsborough of a particular subject than to remember precisely the medium used.

There is a considerable difference between the drawings of Gainsborough's Suffolk period, and those which he did at Bath; but beween the Bath and the London drawings the distinction is less clear. In this Suffolk period Gainsborough worked chiefly in pencil, or black chalk, on white paper, and his subjects are very close to nature—a man ploughing beside a wood, a clump of trees, or a bend in the road between bushes. He is taking his inspiration at first hand from nature, and setting his reaction down in the most direct manner possible. Drawings of this type must have remained behind in Suffolk after Gainsborough's departure, for they very clearly influenced other East Anglian artists—the amateur George Frost for example (see Chapter XII), or, more importantly, Crome and Constable. After the move to Bath new themes arise in Gainsborough's drawings—studies of rocky glades, based presumably on Wick Rocks, and a definite Italianization (showing itself for example in the placing of a white building among gloomy trees) which must have come from the study of prints and paintings rather than from direct observation of nature—though much that was still seen with the eye of the countryman, as the cows which he touched in, however sketchily, yet so convincingly, or the farm carts or the cottage children, remained to the end of his career. There also appears in the Bath period a great increase in that strong, diagonal, vibratory movement which had scarcely been felt in much of his early work, but which entirely dominates many later drawings, not only in dark shapes, or areas of shadow, strongly blocked in with free thick strokes sloping up from left to right, but in the tilt of the main lines of the composition, and in the general set of the tree forms.

These Bath and later drawings are more strikingly effective than the earlier ones, but they are also more artificial, more composed. It is not surprising to know that Gainsborough worked often by candle-light, and that, as Reynolds reports, 'he framed a kind of model of landscapes upon his table, composed of broken stones, dried herbs, and pieces of looking glass, which he magnified and improved into rocks, trees and water'. Edward Edwards says the same thing in rather different words, and adds, of Gainsborough's later drawings, 'Many of these were in black and white, which colours were applied in the following manner: a small bit of sponge tied to a bit of stick, served as a pencil [i.e. brush] for the shadows, and a small lump of whiting, held by a pair of tea-tongs was the instrument by which the high lights were applied; beside these, there were others in black and white chalks, India ink, bister, and some in a slight tint of oil colours; with these various materials, he struck out a vast number of bold, free sketches of landscape and cattle, all of which have a most captivating effect to the eye of an artist, or connoisseur of real taste.'

It will be gathered from that passage that the ordinary type of watercolour drawing

figured not, or scarcely, in Gainsborough's output. Nevertheless, as well as a great bulk of work in black chalk or various monochrome washes, sometimes with a touch of colour, there is a small proportion of things which are rather more fully coloured. One of the most beautiful of such drawings is *A Woodland Road* in the British Museum. It represents a cart and horses advancing along a curve of a road flanked by rather tall trees. The colour is not strong—the trees are of grey, reddish-brown and yellow-brown, the horses are white and brown and there is a pinkish light on the road—but it is soft and delicately rich and the effect of light is exquisite and tender (128). On the whole, however, it is as an artist in monochrome wash or in chalk or pencil that we think of Gainsborough the draughtsman. How varied, yet intensely and revealingly individual, he could be in such mediums, is seen not only by the bold massing of his dark groups of trees and rocks, but also in such more delicate and ethereal effects as those achieved in the *Landscape with a Sailing Boat*, which the late Laurence Binyon lent to the British Exhibition in 1934—a thing poetical and insubstantial in a way one is apt (quite wrongly) to think of as the sole invention of Steer and the watercolourists of the New English Art Club. Equally poetical are two drawings in the British Museum, *Wayfarers Resting near a Ruinous Building*, which is slightly reminiscent of Wilson and might be called a monochrome subtly suffused with brown and grey blue, and *Travelling West*, a brilliant evening study of trees and figures against a blue-grey sky (129).

Since Gainsborough stood outside the normal use of watercolour it is not surprising that he had comparatively little direct effect on watercolour methods and styles—though his indirect effect may have been great. His influence is most obvious in the work of such artists as the amateur Dr Thomas Monro (see Chapter XII) and John Hoppner, RA (1758–1810), who was a portrait painter but nevertheless did a number of landscape studies, somewhat in Gainsborough's manner. Several of them, in black, or black and white, chalk, generally on bluish paper, are in the British Museum (130). There are rather similar drawings, but in brown wash, which are also called Hoppner—fairly convincingly to the eye, though I do not know what formal evidence there may be. Nicholas Thomas Dall, ARA (died 1776),* a Dane who settled in London and was employed as a scene-painter at Covent Garden, may also have been influenced by Gainsborough. He is usually said to have settled here about 1760, but he was in London at least four years earlier than that, for in 1947 Messrs Colnaghi acquired four drawings of architectural details (an unexpected subject for Dall),† signed and inscribed as done in London, the earliest of which, now in my collection, is dated November 1756. His drawings are rather rare, but I have seen a few which seem to have some genuine affinity to both Gainsborough and Wilson. Such for example is the *Rocky Landscape* (probably a stage design) in the British Museum, a composition which shows a rocky gorge, with dead tree-trunks in the foreground, and a waterfall coming off a distant mountain-side. There is a good deal of body colour in this drawing. Mr Paul Oppé, however, has three good watercolours by Dall which are much more realistic in approach. They all represent scenes at Hackfall, Yorkshire, and two are dated 1766. They show, between trees in the foreground, spreading

* The date usually given is 1777. But *The London Magazine*, 1776, p. 761, records Dall's death as having occurred on December 10th, 1776. His name is moreover there spelt Dahl, which is presumably its original Danish form. He himself signed Dall as early as 1756. I cannot find that anything is known of Dall in Denmark.

† Mr Croft-Murray tells me he regards these as designs for decorative wall-paintings, and so quite consistent with Dall's work as a scene-painter.

landscapes falling away. One is a small upright, mostly in greys, but the others are large drawings (the biggest measures 21×28 inches) in which soft greens and blues predominate. There is some underlying pencil, but most of the drawing is done with the brush. Dall also did Indian ink wash drawings, including more than one view at Richmond, Surrey, and others unlocalized (and perhaps imaginary), which are fairly broad in handling and provide an effective mixture of picturesque topography and scene-painting (132 and 133).

It may also be worth noting here that in 1944 the British Museum bought two landscapes, in black chalk touched with white and a little colour, by the Edinburgh drawing-master, Alexander Runciman (1736-1785). One at least is strongly reminiscent of Gainsborough. It is signed with the monogram of his initials which Runciman commonly used. The subject is a lion drinking at an ancient well among trees while a woman runs terrified away. It measures $8\frac{7}{8} \times 12\frac{1}{2}$ inches. The other drawing, of a man with a pack-horse and sheep crossing a bridge, is unsigned and, though it recalls Gainsborough in a general way, is rather nearer to the work of Dr Monro. One usually associates Runciman with figure drawings in various mediums, notably red chalk.

Wilson, as we have seen, was in Italy from 1750 to 1757, and his stay there overlapped for a year or two with that of another famous British artist—though of a very different kind—the architect Robert Adam (1728-1792), who from 1754 to 1758 was travelling in France, Italy, Dalmatia and Germany. We normally think of Adam in connection with a sober, perfectly balanced, type of architecture, and of elegant classical decorations; but while in Dalmatia he made many drawings of the ruins of Diocletian's palace at Spalatro, drawings which were something more spectacular than mere architectural studies, and which were engraved and published in 1764. Perhaps it was partly a memory of these splendid ruins that haunted Adam's imagination and led him to produce, no doubt mainly for his own amusement and apparently late in life (Mr Oppé* has noted dates from 1777 to 1787), a number of picturesque watercolours, often wildly fantastic, in which architecture and romantic landscape are mingled in varying proportions. The examples in the Print Cabinet at Copenhagen are, Mr Oppé tells us, all architectural fantasies in black monochrome, dated 1777, and in his article he reproduces two such examples. But other drawings are purely scenic, notably a pen and watercolour *River in a Gorge* in Mr Oppé's own collection, and the steep cliffs which form the chief feature of this drawing are entirely uncrowned by even the smallest castle. Castles perched high on hill-tops, often with a river or lake below, are however a usual feature of Adam drawings of this type—an extravagant example of which is the *Rocky Landscape with Castle* in the Victoria and Albert Museum, in which a gigantic, serpentine, natural ramp, sheer on both sides, leads up to a castle standing at the top of a conical hill, while an extensive landscape spreads beyond to the right (131). In colour these drawings vary from deep rich hues, chiefly of blue and green, sometimes with a patch of yellow sunlight beating upon part of the scene, to Indian ink monochrome. They form a curious episode in the story of eighteenth century imaginative landscape, but they were no more than an episode, were not, in Adam's lifetime, known to any but his friends, and exercised, so far as I am aware, no influence on other artists. It is perhaps worth noting that I have one drawing in this

* See A. P. Oppé. 'Robert Adam's Picturesque Compositions'. *Burlington Magazine*. March 1942.

style, a monochrome, which represents a real place—the old Fishergate at Sandwich, Kent. It is inscribed on the mount, in a modern hand, with the name of James Adam (one of Robert's brothers), but it appears very like Robert's work and has the same type of figures and horses, rather heavily drawn in pen, in the foreground. It also has a mount of the kind characteristic of other Adam drawings, which usually consists of clear washes of blue, grey and yellow.

While Adam was in Italy he made the acquaintance of, and travelled with, Charles Louis Clérisseau (1722-1820), a distinguished draughtsman of classical ruins in body colour as well as in clear monochrome. Adam later persuaded him to come to England, where he stayed from 1771 to about 1778—and so is entitled to a brief mention in a work on English watercolour. Adam and Clérisseau were accompanied in Italy and Dalmatia by Antonio Pietro Zucchi (1726-1795), who was in England from 1766 to 1781, assisting Adam in the decoration of houses, became an ARA in 1770, and in 1781 married Angelica Kauffmann, RA, and returned to Italy with her. He, too, did drawings of classical ruins with figures, as well as portrait or conversation groups, which Mr Croft-Murray thinks were probably studies for decorative paintings (like those in the Music Room at Harewood) rather than for actual portraits or groups. His characteristic medium was either sepia monochrome or a combination of sepia and Indian ink wash, sometimes over pen outlines. He used opaque white for high lights on his figures. It may be added, here, that Robert Adam sent the young William Hamilton (1751-1801) to Italy, where he had lessons from Zucchi. This must have been before 1766, so it seems doubtful whether two large drawings of classical ruins and figures in brown and black, heightened with white, done by Hamilton very much in Zucchi's manner, could have been drawn then. If so, he must have been extremely precocious. It is more likely that he did them, in imitation of Zucchi, after he returned to England. He became RA in 1789, having specialized in portraits and historical paintings. As a watercolourist he is most familiar for his prettily coloured, but rather mannered and insipid, mythological and rustic subjects (see Chapter VII).

A much more notable artist than Hamilton went to Italy about the same time as he and derived far greater benefit from his visit. This was William Marlow (1740-1813), a Londoner, born in Southwark, and a pupil of Samuel Scott, to whose work some of Marlow's Thames-side drawings have a close affinity. He began exhibiting with the Society of Artists in 1762, and painted many views of country seats. In 1765, on the advice of the Duchess of Northumberland, he went abroad and travelled in France and Italy until 1768, when he returned home. Places with which his work is specially connected are the neighbourhood of Paris, Avignon, Nimes, Florence, Rome, Naples and Venice. He always remained much of a topographer—he might almost have been treated of in the last chapter—but with a strong sense of the picturesque, if not of something more than that. After his return he worked in many parts of England and Wales, and much of his most characteristic work was of the Thames, especially in the neighbourhood of Twickenham whither, after living for some years in Leicester Square, he removed in 1778, continuing there until his death. His London views are also notable, particularly the British Museum's *Fish Street Hill and the Monument* ($19\frac{3}{4} \times 15\frac{3}{4}$ inches), which is strong and effective, if rather too coarse in touch to be altogether pleasing.

Marlow worked in many kinds of medium—oils, body colour, clear watercolour, monochrome wash, pen and pencil. He liked strong rich effects of colour, but there is sometimes a heaviness about his watercolours which I dislike, and he was fond of a slightly acid blue that occasionally makes an unfaded Marlow watercolour less pleasant than one might expect. At the same time there is generally a sense of quality, a feeling of being in contact with an able mind, about Marlow's drawings. He has a knotty, twisted, way of drawing boughs and leaves with a broad pen that has great character. His small figures are successful both in giving life to a scene by their actions—a man punting vigorously on the river or a couple being rowed easily down stream—and in relieving the general blue and green colour scheme with a red coat here or a white shirt there. I do, however, really prefer Marlow's monochromes, such as a masterly and assured pen drawing ($8\frac{3}{4} \times 16\frac{3}{4}$ inches) of the bridge at Avignon which has the shadows very beautifully put in with a thin wash of (I presume) Indian ink. In monochrome Marlow can sometimes spring a real surprise, and I remember some years ago finding a grey wash drawing of a sailing-boat coming into a rock-bound bay over a choppy sea, with a man standing on the shore and others hauling up a small rowing-boat. It was very freely and forcefully dashed in, and quite defeated my powers of attribution, though some of my bolder friends were inclined to see Gainsborough in it. Mr Oppé, when faced with this conundrum, remarked that, though he had never seen one like it, if he had to guess, he would guess Marlow. This has always seemed to me a most brilliant bit of attribution, for within a year a finished version in full watercolour, signed by Marlow, turned up at Christie's. To my mind the monochrome is—artistically—the better drawing (134, 135 and 136).

Two years younger than Marlow was another London-born watercolourist, William Pars (1742-1782), who had he lived more than forty years might well have become one of the greatest names in the English watercolour school. As it is his work is very highly regarded by the comparatively few who know it in its full freshness and beauty—a point which it is important to make, for the most familiar gallery examples have grown a little pale from long hanging and give only a restricted idea of his achievement and range of colour. Pars was a younger son of a chaser, and received his first artistic training at the drawing school founded by William Shipley at 10 Strand, a school afterwards conducted by Pars's elder brother Henry Pars (1734-1806)—who, incidentally, is a striking example of the way in which the work of certain artists of position in their day has disappeared, for in a good many years of collecting I have never seen, or heard of, a single drawing by him, though he must have done many. William Pars afterwards studied in the Duke of Richmond's private gallery and at the Academy in St Martin's Lane. In the early 'sixties he exhibited with the Society of Artists and the Free Society, and in 1764 he obtained a Society of Arts premium for historic painting. He also practised portraiture. It is, however, as a draughtsman that he is best known. In 1764 he was selected by the Society of Dilettanti to accompany Dr Richard Chandler and Nicholas Revett* to Greece, for which country he left England in that year, returning home again in 1766.

* Nicholas Revett (1720–1804), architect and draughtsman, went to Rome in 1742, where he made the acquaintance of James Stuart (1713–1788). They formed a plan for visiting Greece and were in Athens together from 1751 to 1754, returning to England in 1755. The first volume of their 'Antiquities of Athens' appeared in 1762, and had a very great effect on architectural taste. Public opinion gave by far the greater share of credit to Stuart, who became known as 'Athenian Stuart', and this caused a breach between them. Stuart exhibited Greek subjects with the Free Society of Artists from 1765 to 1783, but in his later years worked chiefly as an architect.

In the course of this voyage he also visited Asia Minor—being one of the very few early English artists to do so. Pars's Greek drawings, of which there are many examples in the British Museum, were used to illustrate the 2nd and 3rd volumes, 1789 and 1795, of Stuart and Revett's *Antiquities of Athens* and the first and second parts, 1769 and 1797, of the Society of Dilettanti's *Ionian Antiquities*. Those in the British Museum show that Pars could handle a large subject efficiently, and his colour is often attractive, as in *The Temple of Minerva at Sunium* (137). In this view ($9\frac{1}{4} \times 18\frac{5}{8}$ inches), the figures introduced are very small, but they make themselves felt effectively, for instance those standing in the ruined temple, which crowns the gently rising slope stretching back from the foreground to the left, while beyond to the right lies a calm sea broken with rocky islands. There is much delicate and precise pen-work, and also rather heavier pen outlining of the dark blue-green bushes in the foreground. It is worth noting in this, as even more in other drawings of the series, that Pars used a convention like a letter *m*, or sometimes several *m*'s run together, to indicate roughness of the ground. He also at times uses another conventional form, rather like a small group of the petals of a daisy. Though Pars had a high opinion of himself as a figure draughtsman, the figures in these Greek subjects do not always seem to merge properly in their surroundings, and especially when they are comparatively large are not always equally well drawn. In particular some of the figures in the drawing which represents Chandler, Revett and the artist himself getting into a horse ferry to cross a river near the Theatre at Miletus are distinctly poor.

At some time before 1771, Pars went again to the Continent, visiting Switzerland and the Tyrol with Lord Palmerston, who employed him to make drawings. Pars also visited Wales and Ireland, and there are three Irish drawings by him in the Victoria and Albert Museum, and others in Mr Oppé's collection. In 1770 he became an ARA. In 1774 the Society of Dilettanti decided to send a painter to Rome at their expense to study, and they once more selected Pars, who accordingly went there the following year. From that journey he never returned, for in November 1782 he died as a result of a chill caught by standing in the water at Tivoli to make a drawing (see W. T. Whitley, *Artists and Their Friends in England*, 1700-1799, 1928, vol. ii, p. 344). Some particularly fine examples of Pars's drawings of Italian subjects, in quite unfaded condition, belong to Mr Oppé. Perhaps the most remarkable of them is that inscribed *On the Tessin, near Poleggio* ($9\frac{3}{4} \times 13\frac{3}{4}$ inches), a bold composition (138) of a foaming torrent, almost a waterfall, flowing towards the spectator under a single span bridge and between rocks which are done chiefly in grey and purplish brown and clad with vegetation rendered by a strong green that has a striking colour effect. By contrast the patch of sky above is rather palely coloured. Some of the brown shadows are (as in certain others of Pars's drawings) deepened with gum or some such substance. Though Pars drew so many landscapes he fancied himself most as a figure-draughtsman, and he introduced large numbers of figures into some of his drawings, particularly those of an architectural character. Mr Oppé has a *Civita Lavinia* ($15 \times 20\frac{3}{4}$ inches), which has several lively and well-drawn groups in the foreground, and he also has two admirable watercolour costume studies of Spanish women, made after drawings by 'Mr Waddilove Lord Grantham's Chaplain', which illustrate Pars's virtuosity in this sort of thing at its best. As unfaded examples of Pars's lower-toned, greyer, water-colours of Irish and English subjects, there may be mentioned, from the same rich collec-

tion, the *Valle Crucis* (10×14¼ inches) (once Dr Percy's), chiefly in grey and fawn, with a pretty group of a youth walking by a girl on horseback (139), and *The Salmon Leap on the Liffey* (10½×14¾ inches), a beautiful drawing principally in greys, soft greens and browns.

Italy, particularly Rome, was visited by many English artists in the seventies and eighties of the eighteenth century. The late Basil Long, for example, listed eighteen* who were there between 1776 and 1781—and no doubt there were others. It will not be possible to deal with them all here—and in any case they were not all watercolourists; but at least J. R. Cozens, Francis Towne, John Smith, John Downman, Joseph Wright, Jacob More and Richard Cooper—all of whom were in Rome in the 'seventies—must be discussed, some at length, others more briefly. Of these, two—Cozens and Towne—are incomparably greater than the rest.

But to continue the outline of the story of British landscape draughtsmen in their relation to Italian travel it will be better to take these artists in order not of greatness, but of their visits to Italy. Of the seven just mentioned Richard Cooper (1740-1814 or later) is said (I do not know on what authority) to have gone there about 1770. He was a native of Edinburgh where his father, Richard Cooper the elder (died 1764), an engraver, who in his day had also visited Italy, had settled. The elder Cooper, by whom there is a watercolour of a flower in the Victoria and Albert Museum, was a pupil of John Pine, whose daughter married Alexander Cozens. I do not know of any direct link between the younger Richard Cooper and Cozens, but I suspect there may have been one, since certain of Cooper's drawings suggest Cozens a little. It is perhaps worth noting in this connection that Cooper and Cozens were both drawing masters at Eton, whether at the same time or not is not clear. Mr R. A. Austen Leigh's *Eton College Lists*, 1907, quotes a manuscript of about 1766 as giving 'Cozens' as the drawing master then at Eton. He also quotes a list of masters of 1788 (in which year Cooper showed two drawings of Windsor at the Academy) as giving 'Mr Cooper, drawing'. Cozens was dead at this latter date, but there may have been some overlap.

Cooper studied under his father, and in Paris under the engraver L. P. Le Bas. He began to exhibit in 1761 at the Society of Artists and between 1787, when he lived in Charles Street, St James's Square, and 1808 he showed twenty-four pictures (presumably drawings?) at the Royal Academy. To Italy he is said to have gone about 1770, but as with many artists of the period exact biographical facts are scanty and I do not remember to have seen a dated drawing by him, though he signed his work very often. How long he stayed in Italy is not clear, but it is said to have been some years, and Basil Long apparently had evidence that he was there at least as late as 1776. Possibly the fact that Cooper showed seven drawings, including copies of old masters and Roman and other landscapes, at the Academy in 1778, may mark his recent return from Rome. After he returned to England he clearly had a fondness for the Kew and Richmond district, for I have seen slight sketches done by him in Kew Gardens, and Mr Edward Croft-Murray has a very large view from Richmond Hill, in Indian ink, which is probably that which Cooper exhibited at the Royal Academy in 1789. It measures 23⅜×36 inches. The Richmond Borough Library owns the pencil sketch for it.

Cooper's drawings are in various mediums, pen and wash, pencil and wash, or more

* See B. S. Long. 'John (Warwick) Smith'. *Walker's Quarterly*, No. 24, 1927. P. 4.

rarely watercolour or pencil alone. He particularly loved rocky valleys, with torrents down the middle, clumps of bushes, and a classical figure or two. He could sometimes do elaborate and well-sustained pen and sepia drawings of Roman ruins, and these can be handsome things. His masterpiece is the *Rocky Landscape* ($13 \times 19\frac{1}{2}$ inches), in the Victoria and Albert Museum (140), a striking and beautiful drawing in pen and watercolour, in which a shallow valley zig-zags through the centre of the picture towards a low distance, the slope on each side of the picture being crowned with trees. A boat with three figures lies on the water in the lower centre of the picture. The colour is extremely effective. There is a grey and blue sky, with a slight suffusion of brownish red over the sky-line. There is some blue on the water and on the farther slopes, but the nearer rocky slopes are fawn-grey and brown and the trees mostly brownish yellow. The only touches of strong colour—red and blue—are on the figures in the boat, and a great part of the general effect lies in the varying tones of the Indian ink underpainting. The British Museum also has an admirable example, a large *Interior of the Colosseum* ($14\frac{1}{8} \times 19$ inches), in watercolour with some pen and ink. The soft and gracious colours of this drawing —pinks, lilacs, yellow-greens and greens—make it especially beautiful. Another fine *Interior of the Colosseum* ($14\frac{3}{8} \times 20$ inches), also in the British Museum, has more pen work, and is more monochromatic in effect. The character which almost always reveals Cooper's authorship of a drawing is his trick of strongly contrasted small areas of light and shade, outlined with running pen-strokes, sometimes broadly looping, sometimes more acutely digitate, so as to give an effect of mottled, sparkling, sunlight over the whole. The lightest areas leave the paper bare and the shaded areas are in graded tones of wash, often sepia or bistre, with characteristic darker blotches of the same colour superimposed. The effect seems imitated from Canaletto, especially from his etchings. At its best Cooper's work has sparkle and richness; at its worst it is tired, mechanical and heavy.

The drawings of Jacob More, or Moore (1740-1793), have a certain relation to those both of Cooper and of William Pars. He was born in Edinburgh, was a pupil of Runciman, and in 1771 showed Scottish landscapes at the Society of Artists. In 1773 he went to Rome where he remained until his death and built up a considerable reputation for his now forgotten oil-paintings in the manner of Claude. Some of his work was engraved. He was employed by Prince Borghese in the decoration of his villa. I have not seen many drawings by More—who was known somewhat grandiosely as 'More of Rome'—but I remember coming across some large brown wash drawings of Roman ruins (if I remember them rightly), and he also occasionally worked in a somewhat restricted range of watercolours in which a dull green and grey predominate, with touches of washed-out red on roofs and on the rather clumsy and heavy figures. The outlines are drawn in pen and the underpainting is probably Indian ink. The British Museum has a good example, *Horace's Villa*, which measures $14 \times 19\frac{1}{2}$ inches. I have a different, rather smaller view of the same locality (141) which was one of three drawings by More seen in a shop during the war of 1939-45—the other two were bought by someone else and I later saw them attributed, in perfect good faith, to William Pars, though More is really rather closer to Cooper than to Pars. The British Museum also has an Indian ink landscape. I have a sheet of not very good pen and ink caricatures, apparently of actors, which bears his name, but I do not know upon what authority. More's watercolours, in spite of the clumsy figures and the

heavy treatment of foliage, have a rather attractive, melancholy air of their own; the mountains, which are outlined in a thin, flowing pen-line, have solidity and form; and the sense of distance is good.

In November 1773 two English artists and their wives sailed for Italy. They were Joseph Wright of Derby* (1734-1797) and John Downman (1750-1824), neither of whom is generally known as a landscape watercolourist, though each of them did a limited number of drawings of this kind. Wright is remembered for his oil-paintings, principally firelight or candlelight scenes, but also landscapes and portraits, whilst Downman's reputation lies in his portraits, occasionally in oils, but more generally in watercolour. These latter are extremely accomplished and graceful, though they suffer from being very much done to a formula—a sort of large-size miniature painting—if this is not a bull. They will be mentioned in a later chapter. The Wrights and the Downmans were accompanied by a third artist, one Richard Hurlestone, who died young. Drawings in Mr Oppé's collection show that both Wright and Downman were in Nice in December 1773. They had apparently arrived in Rome by March 28, 1774, and other drawings of Mr Oppé's show that Downman was 'near Albano' on August 27, at Marino on September 1, again 'near lake of Albano' on September 3, and at L'Ariccia on September 10. In October 1774 both Wright and Downman seem to have been at Naples. From letters quoted by Bemrose we know that Wright was still there in the next month, and that in May 1775 he was back in Rome; and on July 24, 1775, a letter from him to Ozias Humphry (1742-1810), another English artist in Italy, who was at that moment at Florence, shows that Wright was then at Parma. He seems to have returned home to Derby in September 1775, having travelled from Rome by way of Florence, Bologna, Venice, Padua, Verona, Mantua, Parma, Turin and Lyons. Landscape drawings by Wright are rare, but besides the two in Mr Oppé's collection there are about forty in the Derby Corporation Art Gallery, one of which is a watercolour catalogued as *The Falls of Tivoli*. This is painted, over soft and rather slight pencil, chiefly in greys and olive greens, with occasional yellows and pinks (in the buildings to the right) and a little blue in the sky and in one other passage. A rather starkly stylized tree stands in the left foreground. The general tone is restrained and gracious, and the cascade of white water falling over rocks from the right is vigorous and effective. A few years ago I found, among a number of sketches by Marlow, two rather uninteresting pen drawings of the Bay of Naples and Vesuvius, one on each side of the same sheet of paper. One is signed (or inscribed) in pencil 'Jos. Wright', and the other bears, besides other notes, the inscription 'I painted this View last Year an Eruption is now sent to England'. Presumably this drawing dates from 1774 and the inscription was added in 1775. There are two chalk drawings of Vesuvius in eruption at Derby, and Wright exhibited paintings of the subject at the Society of Artists in 1776 and at the Academy in 1778, 1780 and 1794. Wright's drawing of 'Nice Decr 15 [1773]', already referred to, is a grey brush drawing of a ruined tower on a bushy hill. As it is numbered 244 he presumably did many more drawings than are now known (142).

There were no numbers, however, in a big portfolio of Wright's drawings which Miss N. K. Wood lent to the City Art Gallery, Derby, in October 1947, when a loan exhibition

* See *The Life and Works of Joseph Wright, ARA*, by William Bemrose. 1885.
Wright of Derby, by S. C. Kaines Smith and H. Cheyney Bemrose. Philip Allan. 1922.

of his work was held there. These drawings were of various sizes and were tipped in, perhaps by the artist himself, on to guards. One was a monochrome inscribed on the back 'Nice 25 Dec. 1773', and very close to Mr Oppé's Nice drawing in style. Most of the drawings seem to relate to the Italian journey, and a large study of trees growing on an outcrop of rock in grey wash with areas of yellow, yellow-green, and dull pink was somewhat reminiscent of Downman's studies of trees. Another similar drawing by Wright is in the Derby Gallery's own collection and is signed (or inscribed?) 'J. Wright'. Also in Miss Wood's portfolio were a very pleasant rough watercolour showing, between flanking foreground trees, a low hill in the middle distance capped with trees and sunlight; various monochrome brush landscapes, some of them, particularly one of a volcano in eruption, comparable to Malchair's latest work in the bold treatment of grey-black wash; and a number of rather stiff figure studies in pen and wash. The same exhibition also contained a sketch book (lent by a descendant of the artist, Mr W. L. Bemrose) containing a number of landscapes, apparently of Italian scenes, in grey wash. Sometimes the paper was tinted yellow. There are also in this sketch book some slight figure and anatomical drawings and some cloud studies.

Downman's Italian drawings, all of which (so far as they are known) belong to Mr Oppé, are of more importance (143), and show him to have been a remarkable draughtsman, especially in his studies of trees in pen and watercolour, and in his drawings of ruined buildings, such as the interior view of the ruins of Hadrian's Villa at Tivoli ($14\frac{3}{4} \times 21$ inches), in pen and grey wash. In this drawing the freely sketched trees seen in the sunlight outside the building form a pleasant incident and show well the very attractive loose small flourishes of the pen which Downman sometimes used to indicate foliage. In other drawings he employed rather more formal oval or almost diamond shapes for the same purpose. Most of these drawings are large, and many have light washes of colour, chiefly pale greys and yellow-greens. None of them is highly finished, so that they have all the vigour of first-rate sketches and of a very individual use of the pen. The most powerful of them, though not the most characteristic, is a study, measuring 15×21 inches, of large grey tree-trunks growing from an outcrop of pinkish-grey rock.

Another collection of Downman's landscape drawings is an album in the Victoria and Albert Museum. This is inscribed by the artist 'A Series of Sketches on the spot made by Jᵒ Downman when he took a Tour to the Lakes of Westmoreland and Cummerland [sic] 1812'. The tour seems to have taken place in September and early October, with perhaps a few days of August to begin with. The sketches, which are in grey wash, usually with pen, sometimes with a pinkish or brownish background to create an effect of glow, are comparatively small and much less free and forceful than the Roman drawings. Yet they give the impression of misty Lake District scenery fairly well, and in some, for example a view near Keswick inscribed *The Sun Broke Through a Storm of Rain*, a somewhat complex and subtle atmospheric effect is attempted not unsuccessfully. It is curious that in this drawing, and in one or two others, Downman gets in monochrome that soft velvety texture which is so striking a feature of the watercolour portraits for which he is chiefly known.

Downman, like Wright, seems to have returned to England in 1775, and it appears therefore that Long was wrong in including him and Wright among the artists whom Smith might have met in Italy between 1776 and 1781.

The year after the return home of Wright and Downman saw the arrival in Italy of John Robert Cozens (1752?-1797),* the son of Alexander Cozens, whose work was considered in Chapter III. He was born in London, about the year 1752. Scarcely anything is known about his life, which is strange, considering his great eminence in his art. He exhibited from 1767 to 1776—eight drawings with the Society of Artists, and one oil-painting at the Academy—and in the latter year was an unsuccessful candidate for Associateship. He visited the Continent, especially Italy, from 1776 to 1779 and again in 1782-3. Apparently he married, perhaps about the year 1787, and had one daughter, Sophia. In 1794 he became insane and was cared for by Dr Thomas Monro, the necessary money being subscribed by a distinguished group of professional artists, amateurs, and connoisseurs which included, notably, Sir George Beaumont, Sir Charles Long, Sir Abraham Hume, Richard Payne Knight, Charles Townley, the Rev C. M. Cracherode, Benjamin West and Joseph Farington. Cozens died on, or shortly before, December 14, 1797. Mr Bell was not able to trace where his death took place or where he was buried. In an article, 'A Famous Artist's Last Days,' in the *Morning Post* of December 29, 1936, the art critic of that journal, the late James Greig, brought evidence to suggest that Cozens died at 'Northampton House—end of St John Street, Smithfield' and showed that a 'John Cousins', of John Street Road, age 45, was buried on January 1, 1798, at St James's Church, Clerkenwell. The interval between death and burial seems a long one (more than a fortnight) but this 'John Cousins' may well have been John Robert Cozens, of whom Constable said that he was 'all poetry, the greatest genius that ever touched landscape'.

J. R. Cozens has always ranked, among connoisseurs, as one of the chief English watercolourists, but to the general public he has been less familiar than many inferior artists, and abroad he must be almost completely unknown. This is probably because, like many other artists of his time he worked primarily not for public exhibition, nor even in order that his drawings should be hung on the walls of private houses, but for collectors who kept their purchases in portfolios. But there is an added reason for the limitation of his public—the extremely narrow range of his colour. It is true, as we have seen, that Wilson and Gainsborough drew either almost entirely or chiefly in monochrome—but their reputations were built primarily upon their oil-paintings. Cozens is only known to have painted one oil, *Hannibal Crossing the Alps*, which has now disappeared, though a few others have been tentatively attributed to him, and in watercolour his range seldom goes beyond grey and blue, with a certain amount of fawn and dark green and occasional touches of restrained red. The marvel of the man is the grandeur, the sweep and variety of valley and mountain, the extraordinary sense of distance and atmosphere, he was able to suggest by the gradations of this simple palette.

Two visits to the Continent seem to have been made by Cozens, the first from 1776 to 1779, in company with Richard Payne Knight, the second in 1782-3 with William Beckford. On the first tour Cozens was in Switzerland in August and September 1776, visiting among other places Geneva, Bern, the Lake of Lucerne and the Falls of the Reichenbach, and in the same year he travelled on into Italy, where it is recorded that he then visited

* Students are fortunate in possessing the Walpole Society's 23rd volume, 1935, consisting entirely of a most valuable illustrated catalogue of J. R. Cozens's drawings and sketches, by Messrs C. F. Bell and Thomas Girtin, with an introduction by the former. I gratefully acknowledge my obligations to this book, which contains almost all the known facts about Cozens. W. T. Whitley's 'Artists and their Friends in England' and the Farington Diary are other valuable sources.

Florence. Little else is known positively about the order of his movements in Italy during this first visit, save that he was working in Rome in 1778–1779. The Swiss drawings of 1776 are in little more than monochrome, Mr Bell describes them as 'extremely primitive in handling', and says that three copies of Sicilian views by Charles Gore (see Chapter XII) made by Cozens in 1777 are his first known works in colour, but that finished work done by him in the middle eighteen months of this visit has not yet been traced. As regards Cozens's second voyage, he and Beckford left Dover in May 1782 and went by way of Ostend, Brussels, Cologne and Augsburg to the Tyrol, where Cozens was sketching on June 4. They crossed by the Brenner Pass into Italy, and were in Verona on June 10. Mr Bell gives the itinerary, which included a visit to Naples (where they stayed with Sir William Hamilton) from July onwards. In September, Beckford set out for England, but Cozens remained in Italy, and was probably in Rome for the first nine months of 1783, leaving for England in September and making the journey home by way of Switzerland, where he seems to have seen Beckford, who was then staying near Geneva, again. Of Cozens's later life in England, save for his madness and death, practically nothing is known, and drawings by him of English subjects are very rare. There is a *Windermere* in the collection formed by the late Sir Hickman Bacon, there is another Westmorland landscape in the Victoria and Albert Museum, and Mr Edward Croft-Murray has a Richmond Hill view, notable for the glowing light of the broad bend of the river, across which are seen Little Marble Hill—the home of the sculptress Mrs Damer—and a wide richly wooded panorama (146). In all only about half-a-dozen identifiable English subjects are known, and it is upon Cozens's Continental work, particularly in Italy, Switzerland and the Tyrol, that his great reputation is founded.

Happily this side of Cozens is well represented in the national collections. The Victoria and Albert Museum has almost thirty examples and the British Museum thirty-seven. Unlike many artists who went to Italy, Cozens showed little interest in architecture. It is seldom that he treats a building so architecturally as that, with archway and terrace, which occupies the left hand of *The Campagna, Rome,* in the Victoria and Albert Museum. Incidentally, it is to be noted that the composition, though not the colour, of this drawing is almost identical with Paul Sandby's gouache *North Terrace at Windsor* in the same museum. Usually when buildings play a part in Cozens's compositions they are vast and massive constructions, often ruins, such as the Colosseum, seen from angles at which they appear almost like mountains, cliffs, and such natural features of the landscape. The type of subject he loved best was a prospect across a low flat valley, through which a stream winds, to distant mountains; or a glimpse through a densely wooded ravine to a snow-capped peak; or perhaps above all a view down into one of the volcanic lakes to the south of Rome—Albano or more particularly Nemi, of which he did many drawings and by which he was inspired to some of his noblest efforts. He was fascinated, too, by leaning tree-trunks and interlaced leafy boughs, of which a number of studies exist, one of the most beautiful being the unfinished, and exquisitely fresh, *View on the Galleria di Sopra above the Lake of Albano* in Mr Paul Oppé's collection. An exceptional subject, also belonging to Mr Oppé, is a lovely sky study, showing red and grey clouds over a low dark landscape—evidently, one would say, an effect seen and set down at the same time. Cozens while in Rome made at least three drawings from the interior of a cave, in which

the main interest is the effect of light from the far end filtering in through the darkness which occupies the bulk of the picture; and it is perhaps worth noting that Francis Towne, as another of Mr Oppé's drawings shows, once tackled a very similar subject.

One of the finest of Cozens's drawings seems to have been done from the sketch of some other artist (possibly his father)—at any rate it represents a *View in the Island of Elba* and there is no evidence that John Cozens was ever there. This drawing, which is at South Kensington, is apparently dated 1789 (the last numeral is damaged) and so may be taken to show his work in its maturity. It measures $14\frac{1}{2} \times 21\frac{1}{8}$ inches and the sombre foreground is in dark-blue, purplish-brown, and black, with loosely indicated foliage. Behind, to the right centre of the picture, is a deep valley between two abrupt mountains, the rocky quality of whose peaks and steep upper slopes is magnificently suggested. All the mountain-side passages are carried out in grey-blue and fawn with wriggles of blue-black supplying the accents and breaking up the surfaces. Above are white clouds, which partly veil one of the peaks, and blue sky, while far away in the deep hollow between the hills there is a small white building surrounded by cypresses. The whole thing has immense majesty and solidity, achieved without going beyond Cozens's characteristic range of colour (144). He is seen, however, using a rather wider range in certain other drawings in the Victoria and Albert Museum, notably some of those in the Dyce bequest. For instance, in the *Coast Scene between Vietri and Salerno*, there is a beautiful pink light in the sky and figures in the boat are clothed in dull red. This is one of a number of existing drawings for which the original sketches (in this case dated September 27, 1782) are in seven sketch-books belonging to the Duke of Hamilton. This series, which once belonged to William Beckford, is dated from June 4, 1782, to October 24, 1783. The sketches, which are in pencil washed with ink, were later copied by Turner, Girtin and others at the house of Dr Monro (see Chapter VI). Another of the Victoria and Albert Museum drawings, which has sky effects of yellow-orange and lavender as well as pale blue and grey, is *Santa Giustina at Padua*, and yet others are *Coast Scene between Vietri and Salerno: Storm Effect*, which has pretty touches of pink in the foreground and is not unlike a Dayes or early Girtin, and the exceptionally beautiful *View between Bolzano and Trent, North Italy*, showing a castle perched on a diagonally sloping, bushy, hillside which is rendered in complex gradations of brown, olive green, red and grey. The sketches for these three watercolours also exist in the Beckford sketch-books.

Two more examples, in the same museum, may perhaps be described, before we finish with Cozens, as they are different in style from those I have previously chosen. Both date from 1776. One is a rather primitive monochrome *Geneva from the North-West*, in brown wash, with fine pen used on the distant hills and to outline the trees. This must be one of the earliest drawings made by Cozens on his first Continental tour. It is a little reminiscent of Richard Cooper, though this likeness is probably fortuitous. The other can be little later, but is infinitely more taking and accomplished. It is a *View between Lauterbrunnen and Grindelwald* ($9\frac{1}{8} \times 13\frac{11}{12}$ inches), and is in essence a pen drawing washed with a combination of monochrome tints—by which I mean that, though more than one colour is used in the drawing, each of them is confined to a particular area, or particular areas, of the picture. In this drawing Cozens employs a formula which he also uses elsewhere—a mountain view seen beneath the sloping bough of a tree which stands on one side or the other of the

composition. In this case the tree, fluently drawn in pen with blackish wash, stands to the left, and the bough droops down from top left to middle right of the paper. The central foreground is occupied by water beyond which to the right is a little lawn in grey tinged with olive-green. Beyond this lawn is a blue-grey hill clad with conifers, which slopes down steeply from right to left. The trees here are indicated by sharp up-and-down pen strokes. Another hill slopes down left to right, but more gently, and its surface is partly tree-clad and partly open. Between the two converging slopes is a distant snow-covered mountain. Wild and rough though the scene is, an exquisite gentleness of mood pervades the whole of this beautiful drawing (145). A later version, in Cozens's more familiar manner, is in the Ashmolean Museum at Oxford—for he often repeated his subjects, sometimes more than once.

A less notable, but still historically important, watercolourist whose visit to Italy began in 1776 was John Smith* (1749-1831), commonly known as Warwick Smith from his having been extensively patronized by the second Earl of Warwick (1746-1816), who was himself an amateur artist. Smith was born at Irthington, Cumberland, and was the son of a gardener to a certain Mrs Appleby, who was sister to Captain John Bernard Gilpin (1701–1776), an amateur artist (a drawing of Carlisle Cathedral, dated 1763, by him turned up in the Lowther Castle sale in 1947 and is now in my own collection) and father of the Rev William Gilpin (see Chapter XII) and of Sawrey Gilpin, RA (see William Gilpin's *Memoirs*, edited by W. Jackson, 1879, a reference which has escaped most writers on the subject). Captain Gilpin gave Smith his first lessons in drawing, then recommended him as drawing-master at a school near Whitehaven, and lastly sent him to his son Sawrey as a pupil. No evidence of Sawrey Gilpin's influence is to be found in any drawing of Smith's that I have seen. About 1775 Smith and Gilpin were at Sir Harry Harpur's house in Derbyshire, where also was staying Lord Warwick, Harpur's brother-in-law, who was impressed with some sketches of Matlock which Smith had done and offered to send him to Italy. Gilpin generously released his pupil and in 1776 Smith went to Italy where he was supported by Warwick until 1781, when he returned to England and settled at Warwick. It is often said that a few years later Smith travelled with Lord Warwick in Italy, but I believe this to be a misunderstanding, since I cannot find any evidence that Warwick was ever in Italy at all, or that Smith ever paid a second visit to that country. Many of Smith's Italian drawings are dated later than 1781, but these are undoubtedly worked up from his early sketches, or sometimes perhaps, like a few drawings of Greece and Spain, from the sketches of others—another instance of the danger of trying to establish an artist's movements from the dates on, and subjects of, his finished work. In later life Smith settled in London, where he was apparently living in Bryanston Street as early as 1797. After some hesitation—due, no doubt, to his being already an established artist, whose work was well known in engravings, though he had never exhibited—he joined the Society of Painters in Water-Colours as an Associate in 1805 and a full member in 1806. His first exhibits with the Society were in the next year, and until 1823, when he resigned, he remained an active member, showing 159 drawings and holding various offices. During his early years of membership he lived at 7 St George's Row, Oxford Street, moving about

* See *Walker's Quarterly*, number 24, 1927, 'John (Warwick) Smith', by Basil S. Long. Also Iolo A. Williams, 'John "Warwick" Smith'. Old Water-Colour Society's Club. Vol. XXIV. 1946.

1816 to 25 Bryanston Street, Portman Square. He died in Middlesex Place, Marylebone Road, on March 22, 1831.

Smith's work is very much more various than was realized until comparatively recently. He has been principally known for a number of very pretty, but perhaps rather tame, views of Italy, full of sunlight and rather brightly, yet softly, coloured, particularly in the blues of sky and water, and the pinkish-brown or ochre lights on cliff or rock surfaces. They are diversified with flat-topped pines, frequently tilted gracefully to one side, buildings with low-pitched dull-red roofs, and a small figure or two—perhaps a man in a blue cloak seated on a white horse at the turn of a road. A good example (149) of this type of drawing is the Victoria and Albert's *Terracina* ($6\frac{5}{8} \times 9\frac{3}{4}$ inches). Most of these drawings were, I imagine, done in the studio after he came back to England, and not out of doors in Italy. Many indeed are dated after his return. The work which he did in Italy is much more interesting, but comparatively little known. Mr Paul Oppé has an important series of twenty-four views of Naples and the surrounding district which once belonged to Lord Northwick, most of which seem to be originals done in Italy and not later revisions of Italian scenes. Among them is a view of Vietri in which a house perched on a cliff-top is identified as 'My Residence for Two Successive Summers'. Some of these drawings have free and vigorous pen-work in them, and notes of colour and so forth written on them, which are similar to the notes written on a drawing in my collection (148) which is signed and inscribed on the back of the mount 'View towards Porta Pia towards Tivoli. J. Smith', and on a drawing, very like this in style, which was recently shown, in a famous Bond Street gallery, as by Towne. In this series of drawings of Mr Oppé's the most elaborate is a large view of Capri, measuring $12 \times 18\frac{1}{2}$ inches, which represents a town, in the middle distance, lying among trees at the foot of tall cliffs, while in the foreground is a herd of cattle to the left, and to the right, below a tall tree, some classical figures a little reminiscent of those of Taverner. There is a good deal of body colour in parts of this drawing, which, though it may well have been done in Italy, is a studio production. Others of the series, however, give the effect of being direct studies from nature and this is true of another of Mr Oppé's drawings (though not one coming from the Northwick collection) which is inscribed on the face at the top *A Convent at Surrentum*, 1778. This measures $5\frac{1}{2} \times 10\frac{1}{2}$ inches and is the most delicately poetical drawing of Smith's that is known to me. The left of the picture is occupied by a rocky, tree-topped shore, with a long, red-roofed, white building on top of the cliff. To the right is an expanse of calm, lavender-blue sea, with a low coast-line in the far distance and above a sky glowing with orange light, altogether a most beautiful thing. Also belonging to Mr Oppé is a pair of monochrome drawings in pen and ink-wash, inscribed and signed on the back 'Chestnut Trees, Morning, Frascati, J. Smith'. They are very freely and rhythmically drawn and, like a drawing mentioned a few lines back, strongly suggest Towne and are completely unlike the common idea of a Warwick Smith.

How insufficient that common idea was appeared in June 1936, when drawings from Lord Warwick's collection were sold at Sotheby's. Among them were a very large number by Smith which greatly increased our knowledge of his range and also made more intelligible Farington's statement that Smith influenced Towne. Stylistic connections with Towne appeared in two categories of drawings. First there was an album (lot 147)

acquired by the British Museum and described briefly by Mr Edward Croft-Murray in the *British Museum Quarterly* for October 1936. This contained, besides other things, twenty-two large views of Rome which Mr Croft-Murray believes to have been drawn direct from nature, probably in 1780 and 1781, and which he compares with the series of Roman views by Towne which the latter bequeathed to the Museum in 1816. Mr Croft-Murray writes:

> 'One is struck immediately by the similarity not only of the actual subject-matter but also of the approach to it, notably in the portrayal of the hot Italian sun striking on stone-work, and the sharp contrasts of light and shade. Towne's interpretations, however, appear more formal and decorative than Smith's, whose work here, at all events, is in a far more gentle and naturalistic vein. Quite a fair number of Smith's drawings are taken from almost the same point of view as Towne's. . . . It is just possible that they may have been seated near each other, when they took some of these views.'

Smith and Towne were indeed acquainted in Italy, and in 1781 they returned home through the Alps together. The second surprise in the Warwick sale consisted of a large number of big watercolours by Smith of a type previously almost unknown and certainly unrecognized as his, for a solitary example which I had acquired a few years earlier was sold to me, and generally accepted, as a Towne mountain landscape of an unusual type without any pen in it. It is however certainly by Smith, and drawings of this type passed, after the Warwick sale, into the hands of some of the leading dealers and have since been a regular feature of Bond Street exhibitions. They are in their way attractive things, being often spacious mountain landscapes, full of luminous soft greys and blues, but without Towne's extraordinary sculptural quality in the drawing of mountains and lacking his vigorous outlining with the pen. Two of Smith's best drawings of this type (though not actually Alpine subjects) are now in public collections. One is *The Temple of the Sibyl, Tivoli*, in the National Gallery of Canada, Ottawa (147); the other is of the waterfall and villa of Maecenas at Tivoli and was given by a body of subscribers to the Victoria and Albert Museum as part of a memorial to the late Basil Long. In the latter (and my recollection of the former is that it is similar in these respects) one admires the strong and effective general presentation of the subject, the tender pink and primrose and green lights upon the foliage, and the free drawing of the trees in the foreground.

Smith did drawings of many other kinds. Mr Oppé has one in pencil and another almost entirely in pen. I have a view of La Cava in brown wash, the modulations of which are full of light and warmth. This drawing, which was in the Warwick collection and relates somewhat to the work of Alexander Cozens, is signed with the monogram of I over S, which Smith occasionally used. Monochromes by Smith are, however, rare, and usually he worked in colour. His Italian watercolours are of more than one other type, including one group less strongly coloured than is usual with Smith, and somewhat powdery looking, of which the dealer Samuel (now deceased) in Petty France had a number. One of these, which I acquired, a small view of Nisida and Ischia in the Bay of Naples, has proved to be a copy of a sketch by J. R. Cozens in volume IV of the Beckford sketch-books in the British Museum—a proof, if any were needed, that Smith occasionally worked after drawings by others. Other drawings of this group (not apparently copies) belong to Mr Oppé

and Mr Hesketh Hubbard. Another group of Smith drawings is rather different in palette and woollier than usual in texture. It consists for the most part of views in the Italian Lakes (but Mr Oppé's several examples include one Devonshire view) and at one time, until Mr Oppé persuaded me to the contrary, I thought that these were the work of a pupil. They are very frequently, but not always, mounted on white paper ruled, like an account book, with red lines. Duplicates of the same subject seem frequent in this group.

Smith did not confine himself to Italian views (though he was known sometimes as Italian Smith) but did also many English and Welsh watercolours. One English subject of his is a view of High Tor, Derbyshire, signed and dated 1784, very delicately drawn in pencil and lightly washed in blue, grey changing to mauve, and a little yellowish-green. It clearly relates to the rather different view of the same hill which he did for Middiman's *Select Views* in 1785. Generally Smith used a stronger palette, as in his long series of Welsh views. Most of these measure about $5\frac{1}{4} \times 9\frac{1}{2}$ inches and are mounted on cream cards measuring about $12 \times 16\frac{1}{2}$ inches with a broad line round the drawing (150). The name of the place is written at the bottom of the card, and the date is sometimes also given, both on the front and the back of it. These dates are apparently those at which the original sketch (perhaps the drawings were themselves begun in the field) was made. Long, who had access to more than 300 of these drawings,* worked out Smith's Welsh tours in detail, and showed that he visited Wales in 1784, 1785, 1786, 1787, 1788, 1790, 1792, 1793, 1795, 1797, 1798, 1801 and 1806. On one tour, that of 1792, he was accompanied by Lord Warwick's brother Robert Fulke Greville (1751-1824) and by Julius Caesar Ibbetson (see Chapter X). Some of Smith's Welsh views were engraved by S. Alken for the 1794 edition of William Sotheby's poem 'A Tour through Parts of Wales', and by J. C. Stadler in Sir J. E. Smith's 'Tour of Hafod', 1810.

The accuracy of Smith's British topographical work is open to doubt—he seems to have altered views fairly freely to suit his picture; but his drawings are often very pretty. In them such points of contact with the style of Towne as we noticed earlier have quite disappeared, and the relation is rather to Sandby—especially in the little pinkish-red trees with which Smith loved to decorate his scenes. But he was not a slavish imitator, and his rather dark green, grey and brown landscapes, with occasional small figures, have an individuality of their own. When they are somewhat larger than usual, as for example the *Entrance to Borrowdale*, measuring $13\frac{3}{4} \times 20\frac{1}{4}$ inches, lent to the British Exhibition in 1934 by Mrs Chance of Carlisle, they can be handsome things—though rather in the English topographical tradition than in the more imaginative landscape school to which some of Smith's Italian and Alpine drawings belonged. He never achieved anything like greatness, but he is historically one of the more interesting men of his time and, though it is hard to understand the position given him by some of the earlier writers as one of the great technical pioneers, especially in the matter of strong colour, he was far from deserving the mere scornful passing reference allotted him by Binyon in his *English Watercolours*.

With Francis Towne (1739?-1816) we soar to higher things. Thirty years ago he was, in spite of the long series of drawings which he bequeathed to the British Museum, almost unknown; now, thanks to the research and advocacy of Mr Oppé, who in 1920 contributed an important article on 'Francis Towne, Landscape Painter' to the Walpole

* There are 120 in the National Library of Wales.

Society's eighth volume, he is regarded as among the most notable and original of the English watercolourists. Little or nothing has been added to our knowledge of Towne's life since the publication of that article, save for a few details given in Farington's Diary.*

It is not known exactly when, or where, or of what parents, Francis Towne was born. He himself said that he started to paint in oils at the age of 14, and this was probably at the school which William Shipley founded in London about 1754, where he seems to have been a pupil with Williams Pars, Richard Cosway and Ozias Humphry either under Shipley himself or his successor Henry Pars. In 1759 he gained a premium from the Society of Arts for an 'original design for Cabinet makers, Coachmakers, Manufacturers in Metals, China and Earthenware'. This may have been a landscape, and he exhibited landscapes with the Society of Artists from 1762 to 1773, and with the Free Society in 1763 and 1766. He first showed at the Academy in 1775, and it is worth noting that all these exhibits were in oils. Indeed in 1803, with a misconceived pride, he wrote, 'I never in my life exhibited a *Drawing*'—which largely explains why his watercolours exerted no influence except upon his own pupils, of whom the chief was the Exeter doctor John White Abbott (see Chapter XII).† Up to 1780 Towne's home seems to have been in Exeter, and he stayed in London (after his student days) only as a visitor. In 1777 he made a tour in Wales, and in 1780 occurred the great event of his life, his visit to Italy, whence he returned with Warwick Smith in 1781. Of the next twenty-two years Towne spent fourteen in London, only wintering in Exeter. Mr Oppé thinks that the balance of seven or eight years was probably passed entirely in Exeter, and it is notable that Towne's chief artist friends were Devon men, for example, Cosway, Humphry and above all Downman, one of whose portraits of Towne, showing him as an almost femininely sensitive young man, is reproduced in the Walpole Society article.‡ In 1786 Towne, with two Exeter friends, James White and John Merivale, made a tour of the Lake District. In 1800 he married, at Exeter, a young French dancer, Jeannette Hillisberg. They seem to have lived at times in London, at times in Exeter. Mrs Towne died in 1808. His last years, in the course of which he made various sketching tours, were passed chiefly in London, where he died on July 7, 1816. Both he and his wife were buried in Heavitree Churchyard, Exeter.

In Towne's artistic career there are three peaks—Wales in 1777, Italy and Switzerland in 1780 and 1781, and the English Lakes in 1786—and it was the central peak of these three that wakened his genius to its highest expression. Nevertheless, it is true that before he left this country Towne was already a highly original artist, with an individual style marked by a neatly fluent pen used for outlining shapes, and a perception of the value of large undisturbed areas of flat, translucent colour, which even at this stage in his development showed a marked affinity—all the stranger because it must have been unconscious—to the work of Japanese artists in coloured wood-engraving. His earliest Devonshire drawings already show the essence of Towne's style; but the tidiness and calmness, which might have degenerated into mere suavity, were instead disturbed and inspired to something bold

* But on the critical side see also Martin Hardie, 'Early Artists of the British Watercolour School: Francis Towne'. *The Collector*, September–October 1930.

† Another pupil was W. Mackinnon, by whom there are two drawings in the British Museum and one in the Victoria and Albert. Nothing is known of his life.

‡ This portrait now belongs to Mr C. H. Merivale, of Welham House, Castle Cary, Somerset.

and grand by the sight of the Welsh mountains in 1777. The finest of the Welsh drawings is *The Salmon Leap*, formerly in the collection of the Misses Merivale, to whom descended a rich store of Towne's drawings, and now in that of Mr Oppé. It is an upright, measuring 11×8½ inches, and consists principally of a great expanse of precipitous rock, at the foot of which runs a river with a broad pool above the fall which gives the drawing its name. The way in which the pen lines break the subject up into areas formalized, yet interpreting the reality of the natural shapes, is very remarkable. The colour is not particularly strong, even for this period of Towne's work, but it is all that is wanted and has the most exquisite delicacy. The great rock face is in grey and brown, with fawn lights at the top where it touches the sky. The water is pale grey-blue, and the slope to the left of it is yellowish brown. Three years later he was to create effects much more powerful, especially as regards colour. But in delicacy and subtlety he could hardly be expected to excel this lovely drawing (151).

Apparently, however, it needed Italy and above all the Alps to liberate the full force of Towne's genius, and it is to the years 1780 and 1781 that almost all his best work belongs, for he seems never to have been able, after his return home, to reproduce quite the full power to which Italy inspired him. It is true that such a drawing as the British Museum's *Banks of the Tiber*, done in October 1780, soon after his arrival in Italy, a calm and peaceful panorama, full of trees and their reflection in the shining surface of the river, can be matched by some of the best of the Lake District drawings of 1786. But that drawing is essentially in Towne's earlier manner and very soon there is an enrichment and brightening of colour, which marks almost all his finished Italian and Swiss watercolours, and which he never attempted later for English subjects. Moreover there is often in these two years an extreme boldness of pattern, especially in his contrasts of simplified masses of colour, which enabled him to achieve grand and tremendous effects which he never afterwards equalled—or even attempted. Something of this force and brilliance is often to be found in comparatively unimportant Italian drawings by Towne, such for example as *A View Looking Towards the Appenines* (6¼×8½ inches), signed and dated August 11, 1781 (154). It bears the number 6 and the note (on the back of the mount) 'Light from the right hand'. Towne was almost always careful to document his drawings, and this example is (1) signed, dated and numbered in the left lower corner of the face of the drawing; (2) fully inscribed with place and date and signed on the back of the drawing, as can be seen by holding it to the light; and (3) similarly inscribed and signed on the back of the mount, which may therefore be presumed to be Towne's own work, or at least done to his order. Such triple authentication is frequent with his drawings. In this instance the subject is a distant range of blue hills, with blue and white sky above and a red-roofed village below in the middle distance, all this part of the picture being seen through the gaps in a screen of trees of which those to the left grow on a bank in the foreground and those to the right stand, a little further away from the spectator, by a stream. There is in fact no very bright colour. Even the blue of the distant hills and sky is softened, the foliage of the trees is chiefly in brownish green, most of the foreground in brownish yellow. Yet the whole has an effect of brilliance which is due, I think, to the clean-cut edges of the various elements—green-brown foliage silhouetted over blue hill and so on—and to the decisive and fluent outlining with the pen. No doubt there was originally some preliminary pencil, but this is not

visible in the finished drawing. The pen work is typical and notably individual, especially in the unbroken series of loops outlining each area of foliage. Except to a limited extent on the tree-trunks the pen is used only for outlines, and there is nothing in the nature of cross-hatching. Shadows are obtained chiefly by the grey under-painting showing through the washes of local colour, but partly also (for the heaviest shadows) by superimposing dabs of darker colour loaded apparently with some sort of gum to give depth and glow.

Probably the finest watercolours done by Towne during this voyage are two views of *The Source of the Arveiron*, both drawn in September 1781, and both remarkable for the almost geometrical boldness with which the main lines of a highly dramatic scene, full of sharp contrasts of form and colour, are seized and rendered. The smaller of the two drawings, that in Mr Oppé's collection, measures $12\frac{1}{4} \times 8\frac{1}{2}$ inches. Here again—as in the less important drawing analysed in the last paragraph—though the colour effect as a whole is striking and brilliant there is no extreme brightness (let alone stridency) of any particular passage of colour. The composition is one of contrasting diagonals and triangles—though to say that is to oversimply, for the main lines of the forms are none of them straight, but grandly arching or undulating. The scene is divided from a third down the right side of the picture to a fifth of the way up from the lower left hand corner by a vast chasm, above and to the left of which stand two rounded mountain forms, both grey blue but the lighter outlined in front of the darker, which curve majestically and sharply down to the central hollow. Above them stand more jagged peaks, the light catching their edges against the sky. Below the diagonal chasm comes a sequence of slopes gradually decreasing in steepness, one below another, and flattening out to the lower left corner of the picture. First there is a dark area, which forms almost all the lower edge of the chasm. Below this comes an area of white snow with a gleaming pale blue tongue of ice splitting its centre, and below the snow comes an area of brownish slopes, filling most of the lower right corner. Near the very bottom of the picture a jagged line of pines astonishes one by their smallness and insignificance, which Towne cunningly throws in, as it were at the last minute, to suggest the vast scale of that which lies above. Small as it is, it is one of the most remarkable of mountain landscapes in watercolour, and the rather larger ($16\frac{3}{4} \times 12\frac{1}{4}$), *The Source of the Arveiron with the part of Mont Blanc*, dated September 17, 1781, in the Victoria and Albert Museum, is of the same rare quality (152). This again is a composition of bold undulating diagonals capped with a towering blue-grey peak, the pen outlines of which are put in with almost the incisiveness of etched lines. Below and to the left of the peak spreads a dark blue-green wooded hill; while diagonally from the right cut in sharp tongues of white snow and pale-blue ice with a more broadly based triangular chasm of deep brown, below which again are snowfields and a patch of river to the left. Some of the lines and transitions are almost brutally abrupt, but the whole drawing has an intense sculptural quality which was then quite new in English landscape art.

By no means all Towne's drawings of 1780–1781 are in full watercolour. Many are in grey monochrome. These were probably not regarded by him as finished drawings, but as material either to make replicas from or to be coloured at some later time, and they were, I think, usually (though not invariably) left unmounted by the artist and signed and inscribed only on the back of the drawing. But they can be very fine things, and a 1781 drawing of Lake Geneva shows admirably Towne's power of as it were carving out with

his pen the main forms of a great mountain mass and indicating the effects of light by gradations of a single hue. There are also—and to me this is perhaps his most attractive medium—a number of drawings of this period done in a convention halfway between those of monochrome and of full colour. I refer to the drawings in which he uses a range of black, brown, reddish brown, palest mauve, pale blue-grey, and (for the sky) pale blue. The glow, depth and intensity which Towne could create with this limited palette washed delicately yet powerfully over a pen drawing seems to me one of the most remarkable achievements in watercolour (153).

Towne never again reached such heights of expression, though there are some excellent things, including tree-studies that relate somewhat to those of Downman, among the Lake District drawings of 1786. Yet of most of the work of that expedition it is true to say that it sees Towne more or less back where he was in 1777 or even 1776. After 1786 there are no more peaks of endeavour and achievement; there are good drawings, it is true, but there are also, especially from his latest sketchbooks, many very weak ones that have little to recommend them beyond clean cheerful colour and a pen line which, though it has lost its old strength, still has an attractive delicacy. Towne had a number of amateur pupils, whom he taught by the then common method of giving them drawings of his own to copy. Such pupils' copies sometimes turn up, but there is seldom any danger of mistaking them for the master's work. Once, however, I came across a drawing book inscribed, in what seems to be Towne's writing, 'Miss Maingey began Drawing August 14 1790'. Evidently he spelt the lady's name wrongly, for the e is struck through in pencil. The book contains very feeble copies of Towne's drawings, but in one of these copies there is a group of trees which is so much better than the rest that it is evident that Towne did this part himself, just to show his pupil how the pen should be handled.

With Towne has come to an end, for the time being, this tale of the English watercolourists who drew inspiration for their imaginative treatment of landscape from Continental travel, and particularly from visits to Rome, Italy and the Alps. There are, however, a few other artists to be dealt with before this chapter is ended. And first of all there is the case of one who seems to have reversed the process of the draughtsmen we have just been considering, a foreigner who came to this country a topographer, and only later in life was stirred by sight of the Welsh mountains to adopt a grander style. This man was John Baptist Malchair* (1731-1812), who was born at Cologne, where his father was a watchmaker. He is said to have made his first drawing from nature at Nancy, shortly before coming to England about 1754. It is typical of one who seems to have been a particularly nice man, liked by everyone, that he was attracted to England in the first place because the English 'centinels' (he never learnt to spell our language) at Cologne after the battle of Dettingen (1743) had been friendly and allowed him to ride on the guns. In London at first he taught music (presumably his own instrument, the violin) in a small way and played in public houses and so forth. He also taught drawing at a girls' school. He gave music lessons to some officers at Lewes and there met the amateur artist Robert Price of Foxley (see Chapter II) and through him visited Hereford. For a time he lived at Bristol, of which he made sketches in 1758 and 1759, and in the latter year

*See 'John Baptist Malchair of Oxford', by Paul Oppé, *Burlington Magazine*, August 1943, which collects for the first time the known facts. Also 'Drawings by J. B. Malchair in Corpus Christi College' by H. Minn, *Oxoniensia*, Vol. VIII/IX, 1943–1944, p. 159.

and subsequently played at the Three Choirs Festival. In 1759 also he became leader of the band in the Music Room at Oxford. For the remainder of his days Oxford was his home, and it is as an Oxford topographer that such faint artistic reputation as he has until recently had has come to him. A large number of his Oxford topographical drawings are in the Ashmolean Museum. In 1760 Malchair married a Miss Jenner, who died in 1773, the year in which his only exhibited picture was shown at the Royal Academy. He led the band until 1792, but before this had also built up a practice as a drawing master, in which capacity he taught several distinguished amateurs who had previously been taught by Alexander Cozens at Eton. Malchair's Oxford pupils included Lord Aylesford, Sir George Beaumont, Oldfield Bowles and John Skippe, while William Crotch, the musician, was, if not a direct pupil, at least an ardent disciple and a friend of his old age. Most of these amateurs are discussed in Chapter XII. About the time of his retirement from the band his old pupils raised a subscription which provided him with an annuity of £150. By 1797 his eyesight had failed badly, and in 1798 he handed over his drawing-master's practice to William Delamotte (see Chapter IV). Farington visited the old artist in 1800. Malchair died on December 12, 1812, having been for some time completely blind.

In one sense of the word Malchair's Oxford drawings are merely topographical. That is to say they represent definite places and buildings, which are usually carefully noted on the backs. But as Mr Oppé observes Malchair's colleges and spires as a rule 'are not seen from a comprehensive viewpoint or with the detail that a topographer would choose, but from between trees or from an odd angle as elements in the picture. More often he sketches some picturesque corner, without architectural pretension or extrinsic interest, a shed or a hovel'. In other words Malchair had a keen eye for the picturesque, and moreover even when he did a strictly topographical view he showed strong interest in such atmospheric effects as spreading mist, or the impact of sunshine. A great many of his drawings are in pencil, or in grey brown wash, but he also used colour. One of the best of the Oxford Malchairs in the Ashmolean Museum is a view, delicately and softly coloured in grey and pinky-brown, with yellow for foliage, of backs of houses and sloping roofs, with a few trees among them and the sun sloping palely in from the right. It measures $10\frac{1}{2} \times 13\frac{3}{4}$ inches, and is inscribed 'St Barnabas June 11—1782 — 6. From the back window of my parlour—oposite [sic] Baliol Oxon' etc. This drawing has an air of considerable, if quiet, distinction (155). There are also watercolours by him in an album acquired by the British Museum in 1942. Some of these show his favourite primrose-yellow and pink lights and the purple and orange skies which he sometimes overdid. There are a number of ideal compositions in this album, some of which are copies, or adaptations, from other artists. One of these watercolours is a version of one which I have, and the latter is inscribed in pencil on the back (not in the artist's hand) 'From a slight sketch of Wilson's in chalk in the possession of Oldfield Bowles Esqr North Aston Oxfordshire By J. B. Malchair'.* The inscription is very faint, but still legible. An example of Malchair's charmingly coloured naturalistic style is the watercolour of a bridge and trees in the same British Museum album. Other examples exist elsewhere and two are before me as I write.

* Colonel M. H. Grant, *Old English Landscape Painters* [1926], plate 65, reproduces an *Italian Landscape*, by Oldfield Bowles (1739–1810) which, though not identical, seems founded on this same Wilson drawing. I have never seen any drawings indubitably by Bowles.

Malchair only rarely signed his drawings (Mr H. C. Green has a signed example) but usually inscribed them on the back in a highly characteristic handwriting—and I am, in fact, inclined to be hesitant about the attribution to him of any drawing which is not so inscribed, unless there is other than merely stylistic evidence, for I fancy some of his pupils could imitate his manner pretty closely and are probably responsible for many of the Malchairian drawings which turn up. Malchair's inscriptions normally include the place, the day of the month and year, and the hour, which is indicated by an upright stroke preceded (for morning) or followed (for afternoon) by a figure. Thus 10/ is 10 a.m. and /5 is 5 p.m. Noon is written 1/2. The two drawings now on my desk are inscribed in this manner. The earlier ($8\frac{1}{2} \times 13$ inches) is 'Behind the Brew Houses in St Toles Oxon July 3. 1787. /5'. It represents a three-gabled building, with a small bridge in front and trees and bushes to the left. The lowest part of the picture consists of water on which is anchored a punt. The basis of the colouring is a grey wash, but other colours are added— dull red on the bridge, high lights of yellow-brown on the trees and punt, and a little blue in the sky and where the water passes out under the bridge, are the chief, and all are used in very pale tints to produce a soft and gentle effect. The underlying drawing seems to be in soft pencil, but there is also some drawing with the point of the brush. The treatment of the foliage is especially characteristic of Malchair, shape being given to the masses by means of lines drawn with the brush and a fairly plentiful sprinkling of smallish spots of grey or brown. The second drawing ($8\frac{1}{4} \times 10\frac{3}{4}$ inches) is inscribed 'Holy-well Oxon—June 22—1789—/7'. It shows two buildings between which passes the curve of a country road, while the light, coming from behind the left-hand building—a barn— and surrounding it with an orange-pink halo, floods the right side of the picture with a primrose yellow glow. As often with Malchair the architectural drawing is the least accomplished part of the picture, but the buildings have nevertheless a certain simple strength and the effect of light, both in the right foreground and the glimpse of distant landscape, is very vivid.

But Malchair's real explorations of the realm of imaginative landscape came late in his career, in the last years before his eyesight finally failed him in 1799. William Crotch, in a manuscript in the Bodleian, states that Malchair visited Wales in 1789, 1791 and 1795. The experience seems to have given his work the full sweep and scale, the appreciation of massive forms, of which he was capable. The effect is to be seen even in English subjects after the first Welsh journey, for example in wide panoramic views such as one of Bath from Lansdown Hill in the autumn of 1790, and *Oxford in Flood Time, from Shotover Hill* (in the Ashmolean), dated January 10, 1791, which show a distinct broadening of vision. According to Crotch he was given, by Malchair's nephew, 'all the views his uncle took on these three tours'. These were presumably the drawings some of which, along with a large number by Crotch, came on the market about 1941. They had been numbered on the back by Crotch, and Mr Oppé, when he wrote his article, had seen thirty-one, of which the highest number was 70. The bulk of these drawings were acquired either by Mr L. G. Duke or myself, and the most striking examples are those done in 1795. They are of various sizes, one of the largest being *Between Aberglaslyn and Beddgelert*, measuring $15 \times 20\frac{3}{8}$ inches, a very bold drawing of a fold among steep hills, with a river in the fore-ground, done in blackish-grey wash with some pencil underneath. It is dated August 15,

1795. This represents perhaps Malchair's most grandiose effort, but for quality and the remarkable patterning of the ground surface I prefer two of Mr Duke's drawings, *Dinas Mawddwy*, dated July 30, 1795, and *Moel y Fridd*, done in August of the same year, the latter a really remarkable drawing of a long, sharp saddle-back of mountain stretching and rising away from the spectator's eye (156). These two are in similar monochrome to the last, and indeed of the known Welsh drawings of Malchair only two, according to Mr Oppé, have any colour. In 1945 an interesting album of reduced versions, in black or grey wash over pencil, of thirty-nine of Malchair's Welsh subjects, done by himself, with a list in his handwriting, appeared at a dealer's and was acquired by the National Museum of Wales. The frontispiece of this volume is an etching by the Rev W. H. Barnard, done after one of the drawings in it. William Henry Barnard was a talented amateur pupil of Malchair at Oxford and was probably the man of that name who matriculated at Pembroke College on June 22, 1790, at the age of 23, having been born in 1767.* He became a Bachelor of Civil Laws in 1797, and was of an Irish family. In 1947 the Walker Galleries acquired a very large number of drawings by Barnard dating between 1787 and 1818. Many of them, especially those done in the 'nineties, showed the influence of Malchair's Welsh landscapes very strongly, and there were a few drawings by Malchair himself among them. Some of the earliest of Barnard's drawings, done between 1787 and 1795, were of Irish scenes, and those after 1790 included many Oxford subjects and some views in Wales which he visited in 1793 and in early July 1795 (about three weeks before Malchair's last Welsh tour) probably on his way to or from Ireland. He travelled widely on the Continent in the early nineteenth century, being in Italy in 1804 and again in 1815-18. Some of Barnard's work was in watercolour, but more commonly he used a black monochrome wash. His 'dabby' treatment of foliage comes directly from Malchair. The most notable watercolour in this collection of Barnard's work was a large and handsome view of *The Great Sugar Loaf Mountain in the Co. Wicklow* which was dated September 23, 1795. He became rector of Marsh Gibbon and Water Stratford, Buckinghamshire, and died at Stowe on October 13, 1818 (157).

The watercolourists who remain to us in this chapter are principally a few mannerists who can hardly claim to be men of high imagination, and did not draw inspiration directly from Alpine or Italian travel, but nevertheless attempted something far removed, as a general rule, from the portraiture of places. They were not, however, always entirely divorced from topography and the best known of them, William Payne,† first attracted attention with picturesque views of Devon, especially of Plymouth. Indeed Devon and Cornwall views predominate in the titles of his exhibited works throughout his career, though Welsh‡ subjects appear from 1809 and Lake District subjects from 1811. Probably, however, not all his exhibits were, in fact, strongly localized in character, for though Payne drawings are exceedingly common it is now the exception to find one which seems to represent any particular place at all realistically. He did, however, do a number of purely topographical things, some of which were engraved by Middiman and others. In spite of the fact that Payne gave his name to a colour that is still well known, 'Payne's grey' (which he used largely in his own work), that he was one of the most

* Information kindly supplied by the Librarian, Pembroke College, Oxford.
† See Basil Long, 'William Payne, Watercolour Painter', *Walker's Quarterly*, January 1922.
‡ Mr L. G. Duke, however, has a *Vale of Usk*, dated 1792, by Payne.

prolific of watercolourists, and that he exhibited (though not very regularly) over so long a period as from 1776 to 1830, very little is known of his life. His birth and his death are both unrecorded. In the eighties of the eighteenth century he held a post as an engineer in Plymouth Dockyard. In 1790 he seems to have been settled in London, which so far as is known afterwards remained his home. He worked occasionally in oils or bodycolour, and he also etched; but clear watercolour was his principal medium. He must have had a considerable market for decorative landscapes, since one not infrequently comes across sets of several (usually a good deal faded) all of the same size, which were no doubt commissioned to hang in some particular room. That he had an extensive practice as a drawing master is recorded by W. H. Pyne, and it is not unusual to find drawings more or less in Payne's manner signed by other names, no doubt those of pupils, amateur or professional. Among such signatures I have noted are J. M. Perry (1807), J. Williams (1798), J. Burbank, and 'Captain Humphries* who went round the world with Vancouver'. Probably many unsigned drawings by pupils pass as Payne's work. He no doubt supplied his pupils with drawings by himself to copy, and presumably two blue monochromes which I found stitched together in a paper cover bearing Payne's name on it were used for this purpose. Long suggests that the firm of Random and Stainbrook, 17 Old Bond Street, which used to hire out prints and drawings for copying, may have used some of Payne's watercolours in this way. His professional pupils included John Glover.

Some of Payne's early watercolours owe a good deal to Sandby, particularly to his small romantic drawings of the type described on page 34. Such a drawing by Payne is a signed, but unfortunately not dated, watercolour of a man driving a donkey with panniers along a track below an overhanging rock. This is neat and prettily coloured, chiefly with blues, blue-greens, and in the trees reddish-brown. There is much outlining with the pen, which, particularly in the foliage, is vigorously used. This is, however, not Payne's usual style, for his watercolours commonly have no pen outlines, but are apparently drawn with the brush, used coarsely and strongly in the foregrounds but often with considerable delicacy in the distances. He employed blue monochrome, the deepest shadows being strengthened with Indian ink or something of the sort, very effectively. Long draws attention to two features, or tricks of style, the use of 'dragging', to give a dry, granulated texture, especially in the foregrounds, and the 'striations', or long strokes of dark colour, these also being often most noticeable in the foregrounds. Payne was fond of orange-brown for high lights upon cliffs, rocks and so forth, and his general range of colour tends to brown, grey and blue—though there are some drawings in a higher key. His favourite subjects were such things as a rocky cove, seen in strong light across a foreground in deep shade with perhaps a clump of overhanging trees, or a mountain torrent pouring down among rocks. There is often a group of fishermen pulling up a boat or a knot of peasants lighting a fire, and sometimes even a distant procession of monks. Payne's rather angularly drawn figures seem to owe something to Teniers, and Mr L. G. Duke has an admirable sheet of studies of such figures in blue monochrome. Payne had an effective box of romantic and picturesque tricks at his disposal, and he used them with facility and a certain decorative sense—but hardly more than that (159 and 160).

* Mr M. S. Robinson, of the National Maritime Museum, tells me that this artist was Henry Humphrys, who was born in America in 1773 or 4. Two plates from drawings made by him in 1792 (when he was midshipman) and 1794 (midshipman, but acting master's mate) are engraved in Vancouver's *Voyage round the World*, 1798. He was master of the Chatham from November 26, 1794.

Two artists of something the same type were J. H. Campbell and Joseph Barber of Birmingham. John Henry Campbell (1757-1828) is said to have been of Herefordshire parentage. He was educated in Dublin where he practised his art and many of his watercolours are of named Irish subjects. He exhibited at the Royal Hibernian Academy, but not apparently in England. I have a drawing signed 'Caecilia Campbell', which is scarcely distinguishable from his work and is perhaps by a daughter or sister. At his best his little compositions of ruined arch across a stream, or church tower with overarching trees and distant blue hills, and so on, are pretty in colour and pleasing (161). At his worst his touch is intolerably hard and mannered. Joseph Barber (1757 or 8–1811), who was born at Newcastle, settled in Birmingham where he became a drawing master and had the honour of teaching David Cox. Barber does not appear to have exhibited in London, but he had a considerable local reputation as a teacher and taught several good artists beside Cox. A large body of his work came on the market in the nineteen-thirties—most of it consisting of rather small romantic or picturesque landscape watercolours, the subjects—mountains, ruins, ancient cottages—being simplified somewhat in the manner of stage scenery. But a more elaborate signed watercolour of *Moel Shabot on the Lugwy* (13×18 inches), which turned up in Lord Warwick's sale, shows Barber as a much more accomplished painter of mountains, and contains a group of figures—three peasants with ponies—which suggests J. C. Ibbetson in character (158).

Still more reminiscent of theatrical scenery is Thomas Walmsley (1763-1805 or 6) who was born in Dublin and died at Bath. He was indeed a scene painter who was employed at the King's Theatre and Covent Garden, before returning to his native Dublin to paint scenes for the Crow Street Theatre in 1788. He settled finally in England about 1790. He exhibited at the Society of Artists and the Royal Academy from 1790 to 1796. I have seen drawings in clear colour attributed to Walmsley, but nothing that seemed to me convincingly his. His body-colour drawings, which include many Welsh and Anglo-Welsh border views, are however well known and are occasionally signed—so that there can be little doubt about them. Walmsley liked hot orange reds and purples, and his landscapes are much overdramatized—though sometimes posterishly effective. In detail their drawing is very sloppy. A good deal of his work, representing both Welsh and Irish scenes, was engraved, and in print form is decorative enough in a rather heavy-handed way. Walmsley's body colours are occasionally very big (162).

A brief reference must suffice for Richard Sasse (1774-1849), who originally spelt his name Sass. He exhibited from 1791 to 1813, and was appointed teacher of drawing to Princess Charlotte in 1811 and afterwards landscape painter to the Prince Regent. He went abroad about 1815, and from 1825 to his death lived in Paris. He must at times, I think, have been in low water, for one not infrequently sees small, highly coloured landscapes—mountain scenes for the most part—signed by him which are just the sort of thing an out-at-elbows painter might produce to earn a few shillings. They are in rather greasy looking pigment which has a good deal of body-colour in it. More favourable examples of his work are in the Victoria and Albert Museum, particularly a view of Lancaster, signed and dated 1801 (163), a pleasant low-toned landscape, owing something to Girtin. *A Castle on the Liffy, Ireland*, dated 1812, is on the contrary a little like Nicholson in colour, but with rather long brush strokes, somewhat like those of W. F.

Wells, to represent foliage. Both Girtin (e.g. in the spots on the foliage) and Nicholson, and also perhaps Thomas Barker, seem to have inspired (if that is the word) Sasse in a very large and ambitious *The Falls of Powerscourt, Ireland* ($23\frac{1}{2} \times 33\frac{1}{2}$ inches), signed and dated 1818. This, which is the in same museum as the last two, is not unskilled, but essentially commonplace.

A final paragraph may be devoted to the brothers Thomas and Benjamin Barker, the most prominent figures of the Bath school at the end of the eighteenth and the beginning of the nineteenth century. The elder, Thomas (1769-1847), known as Barker of Bath, the son of a spendthrift gentleman who had become a horse painter, was born near Pontypool in Wales. The family settled at Bath, and when Thomas was 21 a generous patron, a rich coachbuilder of the name of Spackman, sent him for four years to Rome— so that he revives again, for a moment, the main theme of this chapter. On his return to Bath he painted oil landscapes and rustic scenes (such as the famous *The Woodman*) as well as a few portraits and scriptural pictures. In 1825 he executed a large fresco on the walls of a house which he built, and this still survives. He was chiefly an oil painter and comes but little into the story of English watercolour. There are, however, some watercolours by him, mostly mountain landscapes, of which examples exist in both the British Museum and the Victoria and Albert. In the latter collection he is chiefly represented by two very large watercolours. One of these, which introduces his celebrated group of figures of a woodman and his dog (of which he made other use also), is really rather a poor thing, the figures very stiffly drawn, and the grove of trees, which takes up most of the picture, very woolly in appearance. Better, though not by any means a favourite of mine, is the somewhat faded *River Scene with Figures*, measuring $17\frac{3}{4} \times 25\frac{1}{2}$ inches. It shows the characteristic Barker wiped-out lights in the trees and also, in the water, scratched out lights. To the right foreground is an area of brown bushes with gummed shadows. To the left are roughly drawn figures, one in a red, the other in a pale blue, jerkin. Beyond the river, to the left, is rocky barren ground in grey, buff, dull green and ruddy brown, with blue-green trees. There is a dull blue distance. The whole is broadly effective, but quite lacking crispness (164). Thomas Barker also did drawings in a variety of other mediums, especially a peculiar dry-looking brown wash, which he used for portrait-studies, fancy subjects, and landscape-sketches, and pen and sepia, in which he did many small drawings of shepherds, horsemen, Italian peasants, cattle and the like, the best of which have some spirit (165 and 166). His brother Benjamin Barker (1776–1838) was also a landscape painter and did a large number of watercolours. A typical example of these will represent a lake among misty mountains, done in a brown-yellow-green-grey sequence of colour, with the lights on the foliage wiped out—a favourite trick of his as of his brother's. He exhibited prolifically from 1800 to 1838, showing in all 246 pictures, 38 of them at the old Water-Colour Society. A good deal of his work was engraved. He was a not disagreeable artist in a muzzy way (167). A minor Bath watercolourist (or so I have been told) of about the same period was a certain J. West, by whom I have very occasionally seen a drawing. A signed example which I possess, *Caldicot Castle, Pembrokeshire*, is a rather Japanesy thing, relying on a few simplified outlines, sharply silhouetted forms, and a strong contrast between Indian ink shadows and areas of pale primrose yellow or blue. I know nothing of him personally, but he seems to have had a recognizable style (168).

Dayes, Girtin and Turner

OF THE three watercolourists whose names stand at the head of this chapter, the first, Edward Dayes, can hardly be set upon a par, artistically, with the other two, but he is of great importance in the history of the English watercolour school, particularly for his influence upon his pupil Girtin, and for the contribution which he made to the style common both to Girtin and to Turner in their early years. Dayes, who was born in 1763, studied under William Pether and was an artist of all-round capabilities (though of uneven quality), producing miniatures, book-illustrations, oil-paintings, mezzotints and watercolours. His chief talent was for the last-named and he was much employed in doing topographical views, some of which continued to be engraved for years after his death, and he also made a number of exceedingly accomplished large watercolours crowded with figures, which he drew with elegance. These, too, were engraved. He began to exhibit at the Academy in 1786 and he continued to do so until he committed suicide in 1804. He also exhibited at the Society of Artists. He was appointed Designer to the Duke of York, and wrote on the art and technique of watercolours. In the late 'eighties Girtin was apprenticed to Dayes, and though—according to the tradition—they did not get on, for Dayes was evidently a harsh and unlikeable man, his influence was great upon Girtin's work. Moreover, it must have been almost as great upon that of the young Turner (though he was the pupil of Thomas Malton), partly no doubt through drawings by Dayes which were in Dr Monro's collection and which Turner copied at the Doctor's house, though probably Dayes's influence over Turner began before that. There are certain drawings which, in style, might equally well be by Dayes, Girtin or Turner.

The finest example of Dayes's watercolours with many figures is *Buckingham House, St James's Park*, signed and dated 1790, which was engraved in 1793 by F. D. Soiron as *Promenade in St James's Park*, and has been often reproduced (169). The house itself (the precursor of the present Buckingham Palace) is seen in the background, painted chiefly in greys, while the foreground is filled with a crowd of persons, fashionable ladies and gentlemen, soldiers and so forth, flanked on each side by brown overhanging trees. There is, it is true, a certain formality, almost stiffness, in the way the figures are massed and grouped in a solid block across the front of the composition. Indeed, if one wished to criticize it adversely, it would be by suggesting that it sees its subject rather too much like a scene upon the stage. But it is nevertheless a very fine drawing, and the figures themselves are exquisitely graceful and elegant, their actions and poses are well diversified and full of life (for example the gentleman picking up a lady's glove) and the colours of their clothing, principally soft pink, blue and white, are harmonious and gay. The draw-

ing, which is in the Victoria and Albert Museum, measures $15\frac{1}{2} \times 25\frac{1}{2}$ inches, and there are other large compositions of architecture and figures, of somewhat the same kind, in the British Museum and the Whitworth Gallery, but none quite so distinguished as this. As examples of Dayes's figure drawing upon a smaller scale there are his book-illustrations, of which the Victoria and Albert Museum has twenty-one, mostly in brown or blue-grey monochrome, but including one in colour. They include Biblical subjects and others drawn from history or fiction. Further specimens of his illustration occasionally turn up in dealers' portfolios, usually unrecognized.

As a landscapist Dayes specialized in topographical subjects, but this does not prevent his work having delightful aesthetic qualities. Often there is a strong architectural interest, and occasionally his drawings are purely architectural as in *Ely Cathedral*, dated 1792, in the Victoria and Albert Museum. He travelled widely in Britain (but not, I think, abroad) and it was the northern counties which called forth the best in him, especially the Lake District, though his finished watercolours of this kind are usually on a small scale and could more properly be called pretty than grand or inspiring. Two charming examples are the *Windermere* measuring $6\frac{7}{8} \times 10$ inches, and *Derwentwater*, which is very little larger. Both are in the Victoria and Albert Museum. Northern subjects first appear among Dayes's Academy exhibits in 1790, when he showed two views of Durham, and his first Lake District scene, *Keswick Lake*, was hung in 1791. Some twenty years ago, or rather less, a long series of Lake District drawings by Dayes was sold in London. These, which were rather larger than the two just mentioned, were freely and boldly drawn sketches and I remember them as in effect blue monochromes, though actually two colours were generally used by Dayes in such works—blue for the clouds and distance, and a brownish-grey for the foreground. In his *Instructions for Drawing and Colouring Landscapes*, published posthumously in 1805, Dayes identifies these two colours as Prussian blue and brown Indian ink. Used over light pencil, they were the basis of his landscape work. Many drawings by Dayes in this medium, without the addition of local colour, must have been mistaken for early blue Turners or Girtins, and A. J. Finberg held the opinion that a well-known group of blue drawings of shipping subjects at Dover and Folkestone, some of which are among the doubtful drawings in the Turner Bequest in the British Museum, are in fact by Dayes (A. J. Finberg, *Life of J. M. W. Turner*, p. 37)— though other possible candidates for the authorship of at least some of them are Girtin and the amateur John Henderson. One type of Dayes landscape which I find particularly delightful, and which has a very close similarity to early Girtin and also to some early Turners, consists of small watercolours chiefly of North Country subjects; happily they are signed, so that there can be no doubt of their authorship. One such, which is before me now, measures $6\frac{5}{8} \times 8\frac{5}{8}$ inches, and represents Warkworth Castle, Northumberland. It is signed 'Edwd Dayes del 1793' on the mount close under the lower left-hand corner of the drawing. It shows a high steep bank going diagonally almost from the right foreground to the left middle distance. To the left of this ridge is a stretch of water with a low wooded bank on the far side. On top of the high bank stand (going from right to left) a clump of trees, the castle (beyond which is something of a break in the bank), cottages, more trees, and at the end a church spire. Two boats lie by the river bank and there are some small figures of men and cows. White clouds pile up against a blue sky and create, as it were, a

second skyline beyond the terrestrial, its highest eminences lying to the left and thus balancing those of the land, which lie to the right of the picture. The drawing gives a first impression of considerable richness of colour, so that it is something of a surprise to find, on looking more carefully, that so large a part of it is done only in Dayes's two basic colours of blue and brownish-grey, with the addition merely of slight touches of pale red, reddish-brown, and yellowish-green. There are Girtin drawings which are almost indistinguishable from such a drawing as this, which has much of that soft cheesy quality—like the inside of a ripe Stilton—which is seen so beautifully in many drawings of Girtin and in the young Turner, and which derived, I think, both from Dayes and from J. R. Cozens (170).

One of the tasks which fell to Dayes in the course of his profession was to strengthen, or redraw entirely, some of the sketches of the antiquary and amateur draughtsman James Moore* (1762–1799). This is therefore probably the most convenient point at which to introduce a brief mention of a curious and rather obscure figure who, though his own un-improved work is extremely feeble, had contacts with several important artists of the time, including those with whom this chapter is specially concerned. Moore, who seems to have been well-off, was a wholesale linen-draper in Cheapside, where he was in partnership with one Lambert. His home was in Stamford Street, Southwark. It may be that, as Mr Bell suggests, his delicate health (he died of tuberculosis) served as an excuse for his frequent absence from business. As a draughtsman he was a pupil of George Robertson (see Chapter IV) and the series of drawings by Robertson now in the Ashmolean Museum at Oxford, one of which is a pencil and watercolour portrait of Moore, derives from the latter's collection. His interest in drawing seems to have been primarily antiquarian—as a means of recording the appearance of ancient buildings—and nine of his drawings, dated between 1784 and 1786, were engraved in Grose's *Antiquities of England and Wales*. Moore compiled several topographical or antiquarian publications: *A List of the Abbies, Priories and other Religious Houses, Castles, etc. in England and Wales*, etc., 1786, and enlarged in 1798; *Monastic Remains and Ancient Castles in England and Wales*, Volume I, 1792; Volume II began to appear (the work was issued in parts) in 1793, but was only completed by George Isham Parkyns, the engraver of the plates, as long afterwards as 1816; and *Twenty-five Views of the Southern Part of Scotland*, of which only one part appeared, in 1794. A few other drawings of his were reproduced elsewhere. Through some confusion his name does not appear in Graves's *Dictionary of Artists who have exhibited*, revised edition, 1895—that most valuable work—but Moore nevertheless showed a few drawings at the Society of Artists. He is known to have made a number of tours to various parts of the country from 1784 onwards, the most important being those to Scotland and the north of England in 1785; the Welsh border in 1787; South-west Wales in 1788; Yorkshire in 1789; East Anglia in 1790; the West of England and North Wales in 1791; Scotland (probably in company with Girtin) in 1792; the Midlands, with Girtin, in 1794; and the Kent coast, possibly again with Girtin, in 1795. He died on May 11, 1799.

There are over fifty of Moore's unaided drawings in an album at the Ashmolean and these show him, in Mr Bell's words, as 'an ambitious but not very accomplished draughtsman with the amateur's usual failing of assimilating in a superficial way the mannerisms of

* The chief authority for the life and work of Moore is Mr C. F. Bell's 'Fresh Light on Some Watercolour Painters of the Old British School, Derived from the Collection and Papers of James Moore, FSA'. Walpole Society, Vol. V, 1917. A convenient summary of the main facts is contained in Mr Hugh Stokes's little book, *Girtin and Bonington*. Philip Allan. 1922.

the master to whose influence he was at the moment subjected'. They are in pen or pencil, with or without wash, or sometimes in colour. On the whole they are weak and amateurish, scratchy in line, and timid in execution. But one drawing in Indian ink monochrome, with pen and pencil, of *Albion Mills, Southwark*, after a fire, shows some idea of how to handle bolder effects. It measures $12 \times 16\frac{1}{2}$ inches and was done apparently in 1791.

Apart from those at Oxford Moore's drawings seem to be rare—at any rate I have myself only found one, a view of Cawdor Castle, which fully bears out Mr Bell's just quoted judgment, for it is like the weakest of weak blue-and-grey over pencil drawings in the manner of Dayes or early Girtin. It is signed and dated '18th Sepr 1792', and its interest is that it was in fact redrawn by Dayes, for the engraving of it which forms the tailpiece of the 1798 edition of Moore's *List of the Principal Castles and Monasteries* is inscribed 'Edwd Dayes del. Sketch'd on the spot by J. Moore Esq. F.A.S. Sept2 18 1792. B. Howlett fect'. Dayes's original redrawing is in the Ashmolean. In truth the interest of Moore lies almost entirely in his relation to other artists and the material he provided for better men than himself to work upon. As already stated, Dayes redrew a number of his sketches, and there is at Oxford a series of 28 drawings signed by both Moore and Dayes which were presumably originally drawn by the former and afterwards touched up and strengthened by the latter. Others who redrew Moore's work were Girtin, Hearne, J. C. Barrow, and Robertson— but not, apparently, Turner, in spite of Roget's statement that he did so (171 and 172).

Thomas Girtin (1775–1802), though his life was tragically short, was one of the richest personalities in the history of English watercolour. He was born at Southwark (hence perhaps his connection with James Moore) on February 18, 1775, the second son of John Girtin, a brush-maker or rope-maker. Girtin the father died in 1778, and his widow afterwards moved to rooms at 2 St Martin's-le-Grand, near St Paul's, and married one Vaughan, a pattern draughtsman. Thomas Girtin is said to have shown early signs of artistic talent; he received some lessons from a drawing-master called Fisher, in Aldersgate Street, and at some time in the late 'eighties, as already noted in this chapter, became apprenticed to Dayes, greatly to the advantage of the boy's art though not of his personal comfort and happiness. What exactly caused the quarrel between them is not clear, and much of the traditional story of it is either doubtful or demonstrably false, as Mr Stokes, in the little book already cited, has shown. Randall Davies suggested that the quarrel can hardly have been a complete break, for they must have had many later contacts through their associations with Moore. The story, told by the engraver J. Pye to Roget, was that Girtin felt that he was employed too constantly at the dull work of colouring prints and refused to continue doing so, with the result that he was sent to prison as a refractory apprentice. There his landscapes attracted the attention of Lord Essex, who secured his release. The date of the incident is uncertain—1789 has been suggested, but the whole story is doubtful in the extreme. Later Girtin was employed by John Raphael Smith (1752–1812), the celebrated mezzotint engraver and portraitist in crayons. It has been said by some of Girtin's biographers that among Smith's other employees was J. M. W. Turner, who was exactly of an age with Girtin, and that the two then became friends. But J. R. Smith is not even mentioned in A. J. Finberg's painstaking and reliable *Life of Turner*, and Mr Thomas Girtin tells me that there is no evidence where his ancestor and Turner first met. That they did so at Smith's is a pure guess on someone's part. Smith—the very oppo-

site in character from the cross-grained Dayes, who was probably responsible for the ill-founded legend of Girtin's youthful dissipation—appears to have been a jovial character, and there exists an amusing pen-and-ink sketch by Girtin of him seated in a chair, smoking a churchwarden pipe, while waiting for the mailcoach.* This was probably done in 1799, long after Girtin had left Smith's employ.

There is a great deal that is unknown, and a great deal that has come down to us only in a fog of uncertainty, about Girtin's life—short though it was. He was closely associated with Turner during these early years, indeed he is said to have been Turner's only real friend. They both made many drawings in and around London, and they worked together at Dr Thomas Monro's house in Adelphi Terrace, as also at the house of his neighbour John Henderson. For one or other of these two amateurs and patrons, Girtin made copies of Hearne, Malton, Morland, Wilson, Piranesi and Canaletto. The last-named exercised a special influence over him.† The drawings made for Henderson are said to date from 1793 or earlier, but the adaptations of Marco Ricci, Piranesi and Canaletto are probably later. Turner and Girtin are reported by Farington to have told him, in 1798, that they had worked at Dr Monro's for about three years (presumably only in the winters). This may have been about 1794–7, as Finberg suggested, or according to Davies perhaps a year later, but the exact date is quite unknown. They drew from 6 to 10 in the evening and 'Girtin drew in outlines and Turner washed in effects'. Farington adds 'Dr Monro allowed Turner 3s. 6d. each night. Girtin did not say what he had'. Probably his pay was the same as Turner's. Most accounts say that the remuneration of the young men was half-a-crown and supper. There is some doubt as to the purpose of this employment. It has often been presumed to have been due to altruism on the Doctor's part—that he conducted a sort of paid drawing school for young artists. This has been doubted by recent scholars; and Davies speculated whether Monro employed Girtin and Turner as the most talented young artists likely to carry on the tradition of J. R. Cozens (who had become mad in 1794) or whether perhaps, as Mr Oppé had suggested, his main object was to obtain copies of Cozens's drawings which he was able to borrow but not to acquire permanently. Probably there was a mixture of motives.

As we have seen, Girtin may have gone to Scotland with James Moore in 1792; Mr Charles Bell believes that he did so, but the fact is not proved, and Randall Davies‡ held that Girtin did not visit Scotland until 1796 and that his earlier Scottish drawings were done in London from Moore's sketches. Certainly in 1794 Girtin accompanied Moore to Peterborough, Lincoln, Warwick and Lichfield. His first exhibit at the Royal Academy, *View of Ely Minster*, based on a sketch by Moore, was shown in this year. It is now in the Ashmolean, where also is a drawing derived from the 1794 tour, *Peterborough Cathedral, West Front*. In 1795 he again exhibited at the Academy, and probably visited the Cinque Ports with Moore. He did not exhibit in 1796, but did so again from 1797 to 1801. The years 1793–1795, when he was from 18 to 20 years old, have been described by Mr Bell as

* See Martin Hardie: 'A Sketch-Book of Thomas Girtin'. Walpole Society. Volume XXVII. 1939.
 † Mr Martin Hardie in his most interesting article 'Thomas Girtin: The Technical Aspect of his Work' (Old Watercolour Society's Club. Vol. XI. 1934) points out that the lines in the shape of 3s or Ss, which are so frequent in Girtin's drawings, were copied from Canaletto.
 ‡ See Randall Davies, *Thomas Girtin's Watercolours*, The Studio, 1924. Attention should also be directed to Laurence Binyon's *Thomas Girtin, His Life and Works*, 1900; to the fine chapter on Girtin in Binyon's *English Watercolours*, Black, 1933; and to Hugh Stokes's book already cited. Recently there has appeared Mr Jonathan Mayne's *Thomas Girtin*, 1949. (F. Lewis. £5 5s.)

'the moment of Girtin's intensest development'. In 1796 he visited the north of England and Scotland (perhaps for the second time), for a pencil sketch in the British Museum, which has every appearance of being a thing done on the spot, is inscribed 'Jedborough, Scotd, T. Girtin 1796'. And here it may be noted that comparatively few of Girtin's drawings are dated, so that it is not easy to follow his journeyings exactly. He seems, however, to have been in the north of England (though not in Scotland) again in 1798 when he probably did the large drawings of Harewood House and Harewood Bridge, in Yorkshire, which were lent to the British Exhibition in 1934 by Lord Harewood and the Princess Royal; and a *Tynemouth*, lent by the artist's descendant and namesake, the distinguished collector, to the same exhibition, is thought probably to have been painted on the spot in 1800—the year of his marriage to Mary Ann Borrett, daughter of a City goldsmith.

From the previous year, 1799, dates a curious and interesting document that discloses Girtin's association with certain other artists (of whom Turner was not one). On the back of a moonlight landscape composition in black monochrome by Louis Francia, now in the Victoria and Albert Museum, is the following memorandum:

> 'This drawing was made on Monday May the 20th 1799 at the room of Robert Ker Porter of No. 16 Great Newport Street, Leicester Square, in the very painting room, that formerly was Sir Josuah Reynolds's, and since has been Dr. Samuel Johnson's; and for the first time on the above day convened a small and select society of Young Painters under the title (as I give it) of the Brothers; met for the purpose of establishing by practice a school of Historic Landscape, the subjects being designs from poetick passages;
>
> <div align="right">Ls. Francia.</div>
>
> The Society consists of — Worthington, J. Cs. Denham — Treasr., Rt. Kr. Porter, Ts. Girtin, Ts. Underwood, Ge. Samuel & Ls. Francia, Secrety.'

This was the sketching club of which Cotman was afterwards president,* and which included in its later membership John Varley, William Alexander, P. S. Munn and Sir Augustus Wall Callcott. Of the foundation members Thomas Richard Underwood has already been mentioned in Chapter IV. John Charles Denham and Worthington were apparently amateurs. Denham had a long career—from 1796 to 1858—as an honorary exhibitor at the Academy. I have seen sketches with his name on them, but they were slight and I do not know the authority for the attributions. Worthington may have been the Richard Worthington whose signature is on a watercolour, dated 1799, which I have. It is a copy from some other artist, whose name has been erased from the inscription. Alternatively this Worthington may have been J. G. Worthington who was an honorary exhibitor at the Royal Academy from 1795 to 1804. I do not know his work.† George Samuel was a professional, and since he received an award from the Society of Arts as early in 1784 was obviously older than his fellow-members. He painted in oils and watercolours, and exhibited at the Royal Academy and the British Intsitution from 1785 to

* That, at least, is the view taken by some authors, notably S. D. Kitson, *Life of J. S. Cotman*, 1937; but the evidence is not conclusive. Other writers consider that the societies of which Girtin, from 1799, and Cotman, from 1802, were the chief figures, were different, though similar, bodies with some overlap of membership. See A. P. Oppé, 'Cotman and the Sketching Society', *Connoisseur*, December 1923. For this society see also Dr Guillemard, 'Girtin's Sketching Club', *Connoisseur*, August 1922.

† Roget suggests a certain Thomas Worthington, a pupil of Girtin living at Halliford. So evidently the identification of this artist yet remains to be established.

1823. Soon after the latter date he was accidentally killed while sketching. There are two watercolours by him in the Victoria and Albert Museum. One, *Pont Aberglaslyn, North Wales* ($12\frac{3}{4} \times 17\frac{5}{8}$ inches), is a view of the celebrated bridge from below. A rather poorly drawn figure of a man, seen through the arch, is spearing salmon below the waterfall, and there are purple hills, quite well modelled, in the background. This drawing is of no great distinction and is moreover a good deal faded. The other, *A Picnic Party* ($13\frac{11}{16} \times 20\frac{1}{2}$ inches), is more attractive and in fresher condition. In the foreground is a low weir across a stream, below which is tied a boat in which two men-servants are seated. Beyond, on a grassy patch under an oak, is a party of six ladies and gentlemen, and the rest of the picture is taken up with trees and sky. The drawing is vaguely Sandbyish in effect, but coarser, and the figures, though the red and blue and other coloured coats of the men, and the white dresses of the ladies, make a pretty effect, are not drawn with any outstanding skill (173).

Robert Ker Porter (1777–1842), painter and traveller, at whose rooms the Brothers met, was a more interesting character. He was born at Durham and was the brother of Jane and Anna Maria Porter, both of whom, and especially the former, achieved some fame as novelists. The father was an army surgeon, who died in 1779, and the family then moved to Edinburgh. Robert early showed ability and in 1790 his mother took him to see Benjamin West, who was impressed by his drawings and had him admitted as a student at the Academy. In 1792 he was awarded a silver palette by the Society of Arts for a historical drawing, and a watercolour dated this year is in the Victoria and Albert Museum. It represents a warrior in armour, leaning on a battle-axe and watching another soldier going away. It is rather in the manner of Mortimer and pretty in colour, for example in the soft pink of the man's breeches and the amber of his cloak, but otherwise weak and insipid. In 1800 Porter was scene-painting at the Lyceum and also produced a panorama, 120 feet long, of *The Siege of Seringapatam*, which he followed with other battle-pictures. He had a brief spell in the army, but in 1804 was appointed historical painter to the Czar and went to Russia. Thereafter his was a wandering life, visiting Finland, Sweden, the Peninsula with Sir John Moore, Persia, and Venezuela (where he was Consul from 1826 to 1841), the whole interspersed with further periods in Russia (where he married a Princess) and occasional visits to England. He acquired various foreign knighthoods and in 1813 an English one. He died in St Petersburg. In spite of his membership of the Brothers we do not think of Porter as a landscape artist, though there is a sketchbook, containing landscape studies done in Spain and Portugal in 1808 and 1809, in the British Museum. His drawings include book illustrations, battle-pieces and costume-studies, and the difficulty about his work— from the critic's point of view—is that every drawing of Porter's one finds seems to be in a different style, and, apart from signature, could scarcely be identified as his. One of the best I know is a little sketch of soldiers, with four horses pulling a gun, in pen and rather dark shades of watercolour, which comes near to Rowlandson in manner and vigour. It measures $4\frac{7}{16} \times 7\frac{7}{8}$ inches and is in the Victoria and Albert Museum (174 and 175).

The last, and from the watercolour aspect the most important, of Girtin's companions in the Brothers is the secretary, François Louis Thomas Francia (1772–1839), a native of Calais whose father, a refugee, brought him in boyhood to London, where he became an assistant to J. C. Barrow, John Varley's master. Francia was teaching drawing in Kensington in 1805. He showed 85 exhibits at the Academy between 1795 and 1821. Various

accounts give him as a member of the Society of Painters in Water-Colours and for some time Secretary, but this is an error; the Society with which he was connected was the rival Associated Artists in Water-Colours, a body which existed from 1807 to 1812. Francia joined it in 1810 and next year became secretary. He showed 116 drawings there. He was for a time painter in watercolours to the Duchess of York. He made a number of soft-ground etchings, some after his own designs, others after Gainsborough, Hoppner and Girtin, a collection of which was published in 1810. These, which are touched by hand with white and signed 'L.F.', may easily be mistaken by the unwary for drawings. In 1817 Francia returned to Calais where he gave lessons to R. P. Bonington, and there, in 1839, he died. His retirement from England may possibly have been due to his having made an unsuccessful attempt to become an ARA in 1816.

Francia's work shows some variety of style; sometimes, as in a black monochrome view in Richmond Park, signed and dated 1807, in Mr Croft-Murray's collection, he seems to be working in the medium and manner of Dr Monro. He is best, however, when most under the influence of Girtin or, as in a monochrome interior of a church in the Victoria and Albert Museum, early Cotman. But the Brothers drawing of 1799 just referred to, *Landscape: Composition—Moonlight*, a romantic blackish monochrome showing an over-hanging cliff, a tower on a hill dimly seen through the mist, and the moon reflected brightly in water, need not perhaps be attributed to Cotman's influence, since though he was in London by 1799, he was then no more than 17. Not that this Francia drawing is very Cotmanesque in quality, but it shows sufficient likeness, in subject and approach, to Cotman's early monochromes to suggest that there was, so to speak, a common pool of such things from which Cotman drew almost as evidently as he contributed to it a few years afterwards. The later influence of Cotman, in his style of the eighteen-twenties, upon Francia is evident, for example, in the latter's *Street, with Bridge and Figures*, also in the Victoria and Albert Museum, a French scene signed and dated 1827, It is somewhat faded, but can never have been a very attractive picture, being carried out chiefly in thin yellow-brown and grey. Such colours suited Francia much less well than deeper, darker tones, which he used in his earlier work. With these, whether in monochrome or colour, he could achieve very strong and rich effects and sometimes get within measurable distance of Girtin. A small *Lambeth Palace and Westminster Bridge* in the Victoria and Albert is somewhat Girtinish, and pleasant enough in its way, but unfortunately this stronger aspect of Francia's art is not well represented in the national collection of watercolours at South Kensington. There is nothing, for instance, to compare with two very richly coloured versions of one subject—a receding track down a valley with a tree-trunk leaning over it—which were shown at Messrs Agnew's Gallery recently, or with a drawing in the British Museum, the *Transports Returning from Spain, February* 1809, *beating into St Helen's Roads*, a moving low-toned watercolour ($11\frac{1}{4} \times 15\frac{3}{4}$ inches) of brown-sailed boats blown across a rough sea, while a storm breaks out of a leaden-grey cloud to the left and the whole forefront of the picture is a turmoil of foaming water. Francia was fond of such sea and seashore subjects, and sometimes signed these, e.g. on a floating spar, with the initials L.F. in monogram. Some of his late work shows kinship with—is even influenced by—that of his most famous pupil Bonington. Mr L. G. Duke has a very beautiful and comparatively early example of Francia, an upright ($12\frac{1}{2} \times 9\frac{3}{16}$ inches) said to represent *Mousehold Heath*,

which is signed L. Francia on the front and on the back is dated 1808. (See also p.107.) It is chiefly in low tones of colour, but rich and glowing in effect, and represents a landscape sloping away as it recedes, with diagonals of light and storm breaking through the clouds on to the middle distance (176, 177 and 178).

These notes on the lesser members of the Brothers have, however, led us away from the greatest of them, to whom it is time to return. In 1799 Girtin had only three years to live. He was now at the height of his greatness, having reached about the middle of those last six years of which Randall Davies wrote that they produced the work upon which Girtin's reputation solely rests, six years in which he was 'a new artist, scarcely to be identified with the author of the earlier works'—which is something of an overstatement, but yet makes a useful point. On his marriage in 1800, Girtin and his wife settled in St George's Row, near the north-east corner of Hyde Park, and there Paul Sandby—then old but not above learning something from the younger man—was a neighbour. The exact dates of the events of Girtin's last three years are not at all clear. At some time in that period he painted a panorama of London, done from somewhere in the Blackfriars area. Certain of the sketches for it are in the British Museum. It was on exhibition in Spring Gardens at the time of his death, and about 1825 is said to have been sent to Russia, but its later fate is unknown. Girtin had many important patrons, such as Lord Essex at Cassiobury, Lord Harewood in Yorkshire, and Sir George Beaumont, but I do not know that the exact dates of his visits to these and others have ever been worked out. In 1801 he sent his first oil-painting, *Bolton Bridge*, to the Academy—and it was his last exhibit there. His health had been growing worse since 1800, and in 1801 he was advised to try a voyage abroad. So in November he set off for Paris, where he remained until May 1802, when he came back to London and lived (the St George's Row house having been given up) with his father-in-law at Islington. He used a room in the Strand to paint in, and there, in the presence of his wife, he died on the evening of November 9, 1802. 'If Girtin had lived, I should have starved', Turner is reported to have said in later years; and though Finberg thought the remark apocryphal, one may surely imagine that Turner, in a moment of generosity, might have said something of the kind without, perhaps, meaning it to be taken literally.

While in Paris Girtin made the set of somewhat topographical drawings of the city and its environs, from which, between June and October 1802, he produced soft ground etchings. One set of these etchings he coloured, and they were aquatinted by J. C. Stadler and others and published in 1803 under the title *A Selection of Twenty of the most Picturesque Views in Paris and its Environs*. There were, however, nobler results than that of Girtin's stay in Paris, notably the large *Rue St Denis* ($15\frac{1}{2} \times 18\frac{3}{4}$ inches) in the collection formed by the late Sir Hickman Bacon. It is a view looking almost straight down a street lined with stone houses and arched over, some way down, by a gateway, beyond which is seen a further recession of street buildings; the whole of the near part of the street is empty of traffic (179). This is a magnificent example of Girtin as an architectural draughtsman, a capacity in which he showed a remarkable gift of rendering in beautiful creamy washes of grey-browns and blues the full solidity and majesty of masses of building, handled with a rich free touch quite different from the neat precision of Malton and his school. Another great drawing of Girtin's Paris period, also representing the Porte St Denis, is in the

Victoria and Albert Museum. It is much faded, 18×23¾ inches, and now appears as a thing chiefly of mauvish-browns—but even thus it shows how noble a thing the wreck of a fine Girtin can remain.

The secret of that power of retaining grandeur even in decay—like the ruins themselves which he often drew—lies perhaps in Girtin's genius for the rendering of broad masses of form, so that though the drawing may fade the essential majesty of the composition remains so long as the fading is more or less equally distributed. Another masterly Girtin in the Bacon collection is *Stanstead Mill*, now seen as chiefly a drawing in deep rich browns. It shows the windmill on a knoll to the left with a group of three thatched buildings alongside, and an old horse crouching between them and a pond in the right foreground. A deep and magnificent melancholy seems to permeate the whole (181).

I spoke just now of Girtin's power of rendering architecture and suggesting all its character without resorting to the prim methods of the architectural topographers. This is seen not only in the Paris drawings just referred to, but in many of his British watercolours, of which the British Museum's *Great Hall, Conway*, may perhaps be cited as an example. It is an upright composition measuring 14½×11½ inches, painted in exquisitely soft browns, greys, and blue-greens. With its rendering of the light coming from the open heaven through the roofless arches of the building, filling the interior and illuminating the stonework, moss-green in parts, this is a watercolour masterpiece of the highest sensitivity and quality (180).

It is, however, not in his own form of architectural watercolour that Girtin is at his greatest but in landscapes, and many of these show what is one of his most remarkable qualities, the suggestion of immense width of vision which he is able to express on a few square inches of paper. Perhaps only De Wint shared this quality to any comparable extent, and he was on the whole a less important artist. Girtin can draw a curving hillside and make one feel not only the width of what one sees but also that the world stretches out almost endlessly on each side of it. A watercolour in which this makes itself especially felt is the *Kirkstall Abbey, Yorkshire—Evening*, in the Victoria and Albert Museum. This is a fairly large drawing—it measures 12×20⅛ inches—but it is its spiritual, rather than physical, proportions that make it so deeply impressive. The range of colour is not great. In the main this is a grey and brown view with a bright streak across the sky behind the massive building that towers in the central distance. The whole foreground is occupied by a curving sweep of grey river, and this giving of the whole foreground to a single wide sweep of surface, undiversified by incidents, is very characteristic of Girtin. Beyond the river there are meadows through which cattle wander and people stroll towards the church, these figures supplying small touches of white, red, and blue to the scene. It can hardly escape observation that the figures are rather larger than true scale demands, but this does not damage the general effect, and it suggests a curious speculation. How much was this done deliberately in imitation of Rubens, who in his landscapes played curious tricks with the scale of his human and animal figures (see, for example, the partridges in the *Château de Steen* in the National Gallery)? Girtin was influenced by Rubens, and it is odd that James Ward, who often painted in avowed emulation of Rubens, also enlarged the scale of some of his introduced figures. In this connection it is perhaps worth noting that Girtin was certainly interested in adapting to his own ends the styles of other artists, as is evidenced not merely

by his many early copies of drawings, already referred to, but more cogently by the fact that even at the height of his powers he did watercolours which, as Randall Davies discovered, were adaptations of etchings by the Dutch artist Hermann Swanevelt (see *Burlington Magazine*, May 1928, 'Thomas Girtin in Paris', by Randall Davies). One of these watercolours, signed and dated 'Girtin, Paris, 1801', is the Victoria and Albert Museum's *Landscape with Hermit*, which is a transformation of a *Repose in Egypt* by Swanevelt (182 and 184).

A trick which Girtin several times employed was to introduce a staring white object—house, patch of smoke, mist or cloud, and so on—into an otherwise sombre-toned drawing. Examples are the celebrated *White House, Chelsea*, in the Tate Gallery, and the *Wharfedale* in the Hickman Bacon collection. In doing this Girtin was often playing a very bold stroke, but he was not, I think, always successful with it, and the distant white object sometimes seems to jump uncomfortably out of its context. But it is possible that the fading which so much of his work has suffered may be partly responsible for this effect. Certainly the commonly faded condition in which his drawings are seen has the result of leading one to underestimate his strength as a colourist as compared with his power of suggesting warmth of tone, mass, and wide sweep. In his mature work he did not, perhaps, attempt much in the light and clear effects of colour, but that he could use very powerful colour is seen in such things as the big *Durham*, full of strong deep blues, in the Victoria and Albert Museum, and (to cite a small example) the British Museum's *Hills and Stream*, measuring $6 \times 10\frac{1}{8}$ inches, which shows a very brilliant and extraordinary colour effect in the contrast between rich blue hills and an adjoining hill that is white with brown shadows (183). One does not generally think of Girtin as a figure draughtsman, and so it is rather a surprise to find in the Victoria and Albert Museum a small and presumably early drawing in pen and grey wash, *Village Fair with Mountebanks*, which contains many spirited little figures.

Girtin was one of the greatest members of the English watercolour school, perhaps indeed the greatest of them all. Certainly none of them excelled, or even equalled, the massive sincerity of his work. He had the widest possible influence upon his contemporaries and successors, but the close imitators of his style were few. One who certainly modelled himself nearly upon Girtin was a certain William Pearson, an obscure artist of whom little is known except that he exhibited 36 landscapes at the Royal Academy and the Associated Artists in Water-Colours between 1798 and 1809. Such few drawings of his as I have seen have been rather weak, though pleasant, imitations of Girtin. Whether there was any direct connection between the two I do not know, but that there was a link between Pearson and the Girtin circle through Francia is clear not only because the two were exhibitors with the Associated Artists, but because of an inscription on the back of Francia's *Mousehold Heath* in Mr Duke's collection, which reads 'Done for his friend Wm. Peirson [*sic*] as a small return for his Imitations of Kobell's Etchings by L. Francia 1808'. The British Museum has a signed *Mountains and Lake* dated 1802, a landscape of blue distant hills and lowering blue clouds, with trees and water in middle distance and a foreground of olive-green and brown. It is pure Girtin, without Girtin's strength (185). The British Museum also has a series of drawings of London churches dated between 1810 and 1813, but these may, from their style, be by some other, unrecorded, artist of the same name. The Victoria and Albert Museum, too, has examples of Pearson, amongst them a sketch-

book of 1808. This shows him as rather like Girtin when he uses a colour scheme of greys, brownish and blueish greens, and brownish and purplish reds. Some of his pencil outlines are also Girtinesque, but his pen line is mean and often thin, his architectural perspective shaky and the general effect really rather feeble.

Another difficult and obscure minor figure is that of a German artist, Franz Joseph Manskirsch (1770–1827), who worked in this country between about 1796 and 1805. His name is usually associated with landscapes with figures—somewhat Morland-like subjects often in pen or pencil and monochrome wash. But in the Whitworth Gallery, Manchester, there is a *Village Church by River* in full watercolour which has passages, especially in the water, which are like Girtin, but cruder (186); and at Messrs Agnew's in 1946 there was shown another watercolour by Manskirsch, *The Ferry*, which might almost have passed as a weak Girtin. The Ashmolean also has examples of Manskirsch in both his manners. So evidently here is yet another artist whose work is not properly understood.

Frederick Wilton Litchfield Stockdale, who was, originally at least, an amateur, did topographical watercolours which, though rather hard in touch, seem at times to show the influence of Girtin. The dates of Stockdale's birth and death are not known, but he began to exhibit in 1808 and is said to have been still alive in 1848. Some of his drawings were engraved in *The Beauties of England and Wales* and other books.

To pass from Girtin to J. M. W. Turner (1775–1851) is to pass to a temperament artistically colder, less generous, more calculating, though possibly to a hand more deft, than Girtin's. I ought, however, perhaps to confess, at this point, that so much of Turner's work (and I am speaking here only of his watercolours) is unsympathetic to me that I cannot feel myself a trustworthy critic of it. His figure, nevertheless, is a commanding one for good or ill (and I think often for ill) in the history of English watercolour, though to a large extent his influence appears in developments of the art later than the period covered by this book.

Joseph Mallord William Turner* was born in London on April 23, 1775, the eldest child of William and Mary Turner. The father, a Devon man by birth, was a barber and wigmaker. The mother's maiden name was Marshall. She is said to have been a woman of violent temper, and she eventually became insane. Apparently the boy was born at 21 Maiden Lane, but the family removed thence almost at once, whither is not known. In 1785 young Turner was sent to stay a while with an uncle at Brentford, where he attended the Free School, and that is the only fact known about his early childhood. His first certainly authentic drawings date from 1787; they are, for the most part at least, copies of prints. His earliest known original drawings are in a sketchbook used in the neighbourhood of Oxford in 1789. Roughly about this period Turner's parents returned to Maiden Lane, to number 26, and there his father exposed some of the boy's drawings for sale in his shop. It must have been about 1789, too, that Turner became a pupil of Thomas Malton, to whose instruction is probably due the fact that Turner very early in his life drew buildings with considerable accomplishment. From 1790 to 1793 he worked at the Royal Academy schools, and in 1790, when he was 15, he began, with a watercolour, his long career as an Academy exhibitor. In the autumn of 1791 Turner visited a friend of his

* Turner is among the very few English watercolourists to be the subject of a really scholarly modern biography. The late A. J. Finberg's *The Life of J. M. W. Turner*, Clarendon Press, Oxford, 1939, from which the biographical facts in this chapter are derived, is one of the most valuable recent studies of its kind.

father's, John Narraway, a fell-monger and glove-maker, at Bristol. In the Turner bequest, most of the drawings in which are now housed at the British Museum, is the sketchbook he used on that occasion, and Mr Edward Croft-Murray has recently described (see *Burlington Magazine*, April 1948) the discovery by Mr T. W. R. Woodman of a finished watercolour of Cote House, Durdham Down, Bristol, made from one of the sketches in it. This is an admirable example of a finished watercolour by the sixteen-year-old Turner—which is not to say that it is more than a rather crude work of art, at least so far as execution goes, for in general conception it is not ineffective. The large neo-Gothic house is seen over a gate and under an arch of trees, very much as in the sketch-book drawing, which is in pencil and brown wash with only a little other colour. The finished product, however, is taller in proportion, being an upright measuring $11\frac{5}{8} \times 10\frac{1}{8}$ inches; some rather inept figures, notably a sportsman with his dogs, have been added in the foreground; and the whole is strongly and rather harshly coloured, with a somewhat violent and acid blue-green prominent in the foliage, in a manner entirely characteristic of Turner at this stage of his developments.

In the summer of 1792 Turner again visited the Narraways, and went on from Bristol to make his first tour in Wales. A. J. Finberg records of a watercolour of Crickhowell, done in this year, that it shows the influence of Dayes, who, though never apparently Turner's master, had a very great influence on his work during the 'nineties—as already noted in this chapter.* Finberg's observation is especially interesting since it demonstrates that Turner was affected by Dayes's style before he copied drawings by him at Dr Monro's, which may have been between 1794 and 1797, or perhaps a little later. Every summer now (except in 1796) Turner made a tour to some part of the country, making sketches of picturesque scenes and buildings which he worked up at home into finished watercolours, and the first engraving of one of his drawings appeared in the *Copper Plate Magazine* for May 1794. It was a view of Rochester, and was followed by many other reproductions of his topographical work. Turner's various tours have been worked out with great care by Finberg, and it will only be necessary in this brief sketch to mention a few of them. In 1797 he went north to Yorkshire, Durham and other counties, and the drawings he made then show some emulation of Girtin's breadth and mass. His last visit to the Narraways at Bristol was in 1798. In 1801 he went to Scotland for the first time, and in 1802 to the Continent, touring in Northern France and Switzerland. The Alpine watercolour studies made during the 1802 tour in a large sketchbook with pages measuring $18\frac{5}{8} \times 12\frac{3}{8}$ inches (now in the British Museum) show an almost complete break with the eighteenth century. They are done with a loose touch, in sombre browns and dark grey-blues, with some body colour, and are very powerful renderings both of mountain forms and of atmosphere. They clearly forecast such things as the great *Fall of the Reichenbach* (see p. 114). The only drawings which at all match them in spirit (and then only partially) that I know are a few of the best and freest of David Cox's mountain sketches of forty or more years afterwards. In the meantime Turner had won much professional advancement. His first oil, a sea-piece, appeared at the Academy in 1796; in 1799 he became an Associate, and in 1802 a full Academician, being then only 27. He did not go abroad again until 1817.

* Mr Croft-Murray points out to me that the British Museum has some etchings by Dayes of military uniforms, coloured by the young Turner—another link between the two men.

In the interval between his first two foreign tours Turner shed, bit by bit, the simplicity and honesty of statement in which he had been bred in the eighteenth century, and began to acquire the skilful, elaborate and artificial style which was to mark the watercolours of his middle life. His professional success continued to grow, and in 1804, having some doubts as to the stability of the Academy, which was going through a difficult period, he built himself a gallery of his own at his house, 64 Harley Street. He seems to have held an exhibition of his work there in that year, and in 1805 he confined his exhibits to his own gallery, sending nothing to the Academy. In several subsequent years he again held exhibitions in his own gallery but not to the exclusion of sending pictures also to the Academy, which he did almost every year for the rest of his life. In 1807 he became Professor of Perspective at the Academy, and in the same year he took a house in Upper Mall, Hammersmith, where he lived for the next three or four years, though without giving up his gallery in Harley Street. This he continued to occupy till 1820, but from 1812 the entrance was from Queen Anne Street. In 1821 he built a new gallery on adjoining land in Queen Anne Street, and it remained in his occupation until his death.

Shortly before his professorial appointment there began to be formed the plans for the first of those series of engravings after Turner which added so much to his contemporary reputation. This was the *Liber Studiorum*, which was suggested to Turner in 1806 by W. F. Wells, more or less on the lines of Claude's *Liber Veritatis*—though with the highly important difference that Turner's drawings were to be specially designed for the purpose, and engraved under his direction, whereas the *Liber Veritatis* was produced long after Claude's death, from drawings not made for reproduction, and by an inferior engraver. Turner's first five plates were published in 1807, etched by the artist and mezzotinted by Charles Turner (a friend but no relation). Other engravers worked on later plates. The aim was to illustrate all types of landscape composition, and to produce something of much higher artistic value than the early commercial prints after Turner, something moreover which did not stress easy topographical appeal. The plan came to an end in 1819 when 70 plates had been issued, and almost all the drawings for them, in sepia sometimes combined with pen, are in the Turner Bequest. Several other series of engravings were published, though all these had more of topographical interest—which was deliberately reduced in the *Liber Studiorum*. The bibliography of these publications is somewhat complicated, and it will perhaps be enough here to mention *Picturesque Views of the Southern Coast of England*, 1814–1827; *Views of the Ports of England*, 1825; *River Scenery of England*, 1827 (partly after Girtin); and *Picturesque Views in England and Wales*, 1827–1832. To this—not exhaustive—list of engravings after the work of Turner's middle period, must be added the three volumes 1833, '34 and '35 of *Turner's Annual Tour, Wanderings by the Rivers Loire and Seine*, with text by Leitch Ritchie, which were intended, as Finberg points out, to be the beginning of a series, representing the river scenery of Europe, which was never carried out.

Turner had given up his Hammersmith home somewhere between 1810 and 1812. In 1812–1813 he built himself a house farther out from town, Sandycombe Lodge (originally Solus Lodge), Twickenham, which he continued to occupy, though he spent little time there, apparently until about 1826.

In the early years of the nineteenth century, though his art met with some opposition and criticism from Sir George Beaumont and others, Turner acquired the patronage of

many private collectors, the most important of whom, from the point of view of water-colour, was Walter Ramsden Fawkes, of Farnley Hall, near Otley in Yorkshire. In 1803 Fawkes bought one of Turner's large Alpine watercolours (worked up from the 1802 studies, already referred to), and in 1804 two more. These were followed by many other purchases by Fawkes, some of them being oils. A friendship grew up, and in 1810 Turner paid the first of many visits to Farnley. After Turner had paid, in 1817, his second visit to the Continent, Fawkes bought fifty of his watercolours of the Rhine from him for, it is said, £500. In 1819 Fawkes held in his town house an exhibition of his collection of English watercolours, which included about forty in clear colour, and twenty or thirty in body-colour, by Turner. In the same year Sir John Leicester exhibited his oil-paintings, of which eight were by Turner, who therefore was much in the public eye that year. Fawkes's collection was seen again in 1820. In November and December 1824, Turner paid his last visit to Farnley, and the following year Fawkes died, being then about 56. Turner sold in all about two hundred drawings (besides oil paintings) to Fawkes, whose son Francis Hawksworth Fawkes continued the friendship and also bought a few of his works. The Farnley Hall drawings have always had a great celebrity; they were not only seen publicly during the collector's life, but Ruskin also (who got to know Turner in 1840, and became the chief apologist of his work) was shown them a year or so before Turner's death and wrote about them with enthusiasm. They are now to a large extent scattered.

As already mentioned, Turner paid his second visit to the Continent in 1817, when he went to Brussels, Waterloo, Liège and Aix, then along the Rhine from Cologne to Mayence, and back home through Holland. In 1819 he went by way of Calais, Paris, Chambéry, and over the Mont Cenis pass to Italy. In Italy he proceeded by way of Turin, Como, Milan, Verona, Venice, Bologna, Rimini, and other places to Rome, which he seems to have reached in October. He made excursions to Naples and elsewhere and before Christmas had left Rome for Florence, having made nearly 1,500 pencil sketches. Apparently he trusted chiefly to his memory and imagination for colour, and made comparatively few coloured drawings on the spot. Some of these, however, including sketches done both in Venice and Rome, which are in the Turner bequest, forecast with their delicate atmospheric blues and yellows the exquisite effects of light and colour of his later Venetian drawings. In the 1819 sketches, for example *From the Giudecca looking East*, Turner remains more precise in the treatment of architectural and other shapes than he afterwards became. He crossed the Mont Cenis, homeward bound, on January 15, 1820, when his coach was upset in the snow, an incident of which he made a drawing, and reached London on February 1. In the autumn of 1821 he made a brief visit to France. He did not go abroad again until 1826, when he toured the Meuse and Moselle rivers, a tour upon which he made a notable group of sketches in bodycolour on blue paper, each measuring about $5\frac{1}{2} \times 7\frac{1}{2}$ inches, but from then until 1845 his foreign tours increased in regularity. It is beyond the scope of this book to detail them all. The most important were in the winter of 1828–9, spent in Rome, and the visit to Venice, by way of Germany and Austria, in 1835. One would like, in passing, to pay a tribute to the daringly successful way in which Turner, in many of his late Swiss sketches, used a pen dipped in colour to accent the drawing. But it was Venice above all which inspired Turner's last and most brilliant phase of loosely handled colour—so much so, indeed, that it is largely through the interpreta-

tions of Turner that English people today think of Venice. After 1845, when he was on the French coast at Dieppe, Eu and Tréport, his powers began to fail. Turner went no more abroad. On December 19, 1851, he died at 119 Cheyne Walk, Chelsea, a small house at which in his last years he lived intermittently and in secrecy under the *alias* of Booth, which was the surname of his housekeeper there. He left an intricate will under which there passed to the nation 282 oil paintings and 19,049 drawings of which some 300 are in colour (according to the official, but inexact, estimate made in 1856).

Even late in his life it was not, however, always a foreign scene which moved Turner to a further advance in his art. A particularly important stage in the development of his latest, most brilliantly impressionist, use of colour is marked by the British Museum's group of about a hundred sketches in body-colour on bluish paper, each measuring $5\frac{1}{2} \times 7\frac{1}{2}$ inches, done while the artist was staying with Lord Egremont at Petworth, probably, as Finberg thought, in the winter of 1830–1831. These include some outdoor scenes but are principally interiors, among which are many extraordinary impressions of light filtering in through windows, or of rooms lit by firelight or lamp-light, in which figures are more or less dimly seen. Among the outdoor sketches are some very rich glowing sunset or sunrise effects, sometimes with clumps of trees strongly and darkly blocked in; a lively impression of a riding party; and a most exquisite and poetic Watteauesque rendering of a picnic party seated under trees with other figures suggested in the distance. In this last drawing the delicate pinks of the dresses and the golden haze of the foliage of the trees combine to form a little picture of great beauty. Yet it is perhaps the interiors which are the most remarkable, primarily for their effects of diffused light and glowing colour, but incidentally also for the way in which the whole series of them records, in a sequence of glimpses, the manner in which life was then lived by a cultivated noble family in one of the great English houses. Some of these interiors give a fairly precise impression (though summary in technique) of the decoration of the rooms, their colour schemes, the hanging of the pictures, the placing of statues; others are beautiful shadowy groups of people, assembling by the drawing-room fire, seated at cards, attending church, and so forth. One is a bedroom scene in which the tall looped curtains of a four-poster bed are used with much the same effect for which James Pryde painted them almost a century later.

Perhaps the most useful way of following Turner's career as a watercolourist will be to describe a few typical examples of his use of watercolour at various periods, choosing for the purpose principally drawings to be found in public galleries. We considered on page 109 a Bristol watercolour done in 1791, when Turner was 16. His colour was then acid and harsh, the drawing of trees crudely formalized, and the whole thing still rather childish, though full of underlying ability. It is, however, to be granted that these early efforts, crude as they are, have a remarkable individuality of their own, so that they are easily recognizable as his. The change that came over his work in the next three years was immense, and by 1794 he had become a fully adult late eighteenth century picturesque topographer. *Tintern Abbey*, now in the Victoria and Albert Museum, was exhibited at the Academy in 1794. The harshness both of touch and of colour has quite gone, and in its place is all the softness and grace of an accomplished follower of Dayes. The drawing is an upright measuring $12\frac{5}{8} \times 9\frac{7}{8}$ inches, and is carried out chiefly in blues and greys with fawn lights and brown shadows. The roofless arches, clad with vegetation, spring lightly across

the sky. There are traces of underlying soft pencil but most of the lines are drawn with the brush. The architectural drawing is excellent but in the picturesque style of Hearne or Dayes rather than that of Turner's own master, Malton. There is considerable likeness to early Girtin. Three small figures, who stand among the ruins, are stiff and commonplace. A still further step forward is evident in the work of about 1795, such for example as the pretty and still Dayesish view of the Founder's Tower, Magdalen College, Oxford, in the British Museum (187). This is another blue and grey drawing, with fawn lights on the building, but it is even more softly accomplished than the Tintern and the man sharpening his scythe and the dog beside him are far livelier than the earlier figures. It is signed W. Turner with his characteristic signature of the 'nineties in which the e in Turner is written taller than the accompanying letters, as if it were a capital. Another good example of about 1795—and one highly characteristic of Turner at 20 or so—is the *Cottage seen through the Arch of a Bridge*, in the Turner Bequest (but as I write on loan to the Victoria and Albert Museum). This is a bold composition in which the bridge comes right across the front of the picture, leaving just a slip of sky, widening to the left, above it. The cottage, seen through the arch, stands on the far bank of the stream and is bowered among pale brown and grey-green trees. Beyond is a blue wooded distance. Grey river-water, broken by brown rocks, passes under the bridge towards the spectator. This has more colour than the two drawings just described, and shows the rather loose crumbly touch that is characteristic of Turner at this period. He often worked in grey, or sometimes creamy brown, mono-chrome at this time, but unless these drawings are in some way attested it is very difficult to say whether they are by Turner, Girtin or Dayes, or even some other member of the Monro or Henderson circle.

The Victoria and Albert Museum contains another drawing which is important as marking a stage in the development of Turner as a watercolourist—the large *Warkworth Castle*, measuring $20\frac{1}{2} \times 29\frac{1}{2}$ inches, and exhibited at the Royal Academy in 1799 (188). It must have been done from studies made on his north country tour of 1797, and it shows very considerably the influence of Girtin, even down to a sprinkling of the 'spots'—little round dabs of dark colour—which are a characteristic of much of Girtin's work. Girtin's influence is also seen in the bold massing of the high ground, surmounted with church, houses and castle, which juts out from the right of the picture above the dark gleaming curve of the river. Very Girtinlike, too, are the figures in the boat and the group of houses between the Castle and the Church. This is in the main a blue and dark red-brown draw-ing, but it is unfortunately a good deal faded. It is curious to compare it with Dayes's pretty, but much less powerful, small version of the same view done in 1793 and described a few pages back. Another very large north country watercolour—it measures $24\frac{3}{4} \times 35$ inches—which shows similar Girtin influence in the placing of fine gloomy masses of hill, rock and ruin, and of the water which cuts across the central foreground, is the *Easby Abbey* in the Whitworth Gallery, Manchester. It is in effect a greenish blue drawing, and dates from about 1800, I suppose. After this there is seldom much of Girtin's influence, nor of the rich and noble simplicity which he loved, to be seen in Turner's work, though it does peep out just occasionally.

If, as I believe, it is the usual mark of the amateur draughtsman that his work looks earlier than it really is, Turner, by contraries, must have been the most professional of all

artists, for his work after about 1800 nearly always seems later than its true date, and in seeing a Turner drawing one's usual inclination, unless one is especially expert in the matter, is to place it mentally too late in his career. Scarcely had the nineteenth century begun before he had shed almost every trace of the eighteenth from his style. For example the huge upright *The Great Fall of the Reichenbach*, measuring $40\frac{1}{2} \times 27$ inches, which was one of the first drawings bought from Turner by Fawkes, is dated 1804 and is based upon the first Continental tour of two years earlier. It is a complete early nineteenth century romantic landscape, which might have been done by any other artist but Turner (supposing another artist could have done it at all, which is unlikely) up to 1840 or later. It is a grand and tremendous thing of its kind, in which the distant fall pours down into a chasm filled with sunlit foam which rises above a rocky, wooded slope in the centre of the middle distance. For sheer imaginative representation of nature in her most overpoweringly impressive mood, this drawing could hardly be excelled. It was lent to the British Exhibition at the Academy in 1934 by Major F. H. Fawkes, and was seen again four years later at Messrs Agnew's. In considering a work of this size and kind, one must remember that Turner, like some of his contemporaries, believed that it was part of the mission of watercolour to rival oil-painting in force and bold effectiveness.

Only three years afterwards, in 1807, Turner was doing very different watercolours in a series of Thames views ($10\frac{1}{2} \times 14\frac{3}{8}$ inches each), which is in the Turner Bequest. There is a late touch of Girtin's influence in at least one of these, *The Thames near Windsor* (189), a rich and calm drawing quite without the bravura, let alone the flashiness, of much of Turner's work. Barges sail along the river, and beyond them is a line of trees in deep blues and browns above which lies a sky of white, blue and yellow. Particularly effective in this drawing are the small figures standing on the near shore casting long shadows on the sand beside them. In this group of sketches, however, it is generally not the influence of Girtin but the affinity to Constable which makes itself felt. This is particularly so in an unlocalized view of the Thames with sailing barges in the foreground, their cargoes covered with red and brown sheets, and freely sketched trees, brown to the left, blue to the right, while a yellow light breaks through the clouds. Some of the pencil landscapes in this series also suggest Constable.

Two typical highly finished middle period watercolours now fall for consideration, both first-rate examples. Watercolours of this type are not very fully represented in the national collections, since Turner found a ready sale for them to collectors and they did not therefore, like the, to my mind, infinitely preferable sketches, drawings and studies, become part of the Turner Bequest. There are however some excellent examples, such as the British Museum's *Weathercote Cave, near Ingleton* ($11\frac{5}{8} \times 16\frac{3}{4}$ inches), a north country drawing dating from about 1816, which is a very good thing of this kind, though it lacks the spontaneity and the clear purity of colour which are among the chief delights of the medium (190). It represents, from close by, a dramatic piece of scenery, in which a wild stream pours down a central chasm in the rocks. Trees, mostly in Turner's favourite but not very attractive yellowish brown, grow on each side of the waterfall and on the rocks above it. In the distance are blue hills glowing in light against a white and blue sky. At each side of the foreground are curious passages in which the details of fern-fronds and flowering plants are emphasized in a way which seems a little out of harmony with the rest

of the drawing. An even finer middle period Turner is the *Hornby Castle, Lancashire* ($11\frac{1}{2}\times$ $16\frac{1}{2}$ inches), of about 1820, in the Sheepshanks gift, at the Victoria and Albert Museum. This seems to me to show Turner's craftsmanship at its very highest, and is a most intricately skilful production. In the left foreground is a road on which are men and women and cattle, much better and more delicately drawn than is often the case with Turner, with effective touches of red in one of the cows and some of the people's clothes. Immediately beyond and to the right is a valley with a stream between trees (again chiefly yellowish-brown) and a bridge, and still farther away is another stretch of valley, in pale brown, with a hill of the same colour to the right and brilliantly modulated blue hills to the left. Between these two hill areas, in the right central distance, stands the castle dramatically crowning a hillock. A group of rather spindly trees in the left foreground very effectively balances the castle which, though it is far away, dominates the scene. The whole thing is done with the greatest delicacy and sureness of touch, and is quite without the blatancy and vulgarity of which Turner was capable—the ill-drawn orange figures in the foreground, the extravagantly castellated city in the background, the flaring colour, and so forth (191).

The extravagance of colour to which Turner sometimes allowed himself to go can be seen by contrasting the *Hornby Castle* with a large watercolour, measuring $14\frac{1}{2}\times 21\frac{1}{4}$ inches, perhaps of about 1840, which possibly represents *The Lake of Brienz*, and which is also in the Victoria and Albert Museum. As it happens this is in some ways similar in composition to *Hornby Castle*, since its focal point is an island crowned by a castle, between mountains to right and left and with a low-lying area (in this case a lake) in front of it. The mountains fade into clouds and the whole scene is wrapped in an intensely glowing mist of light. But to my taste the opposition of strong blue and orange and red is so strident as to give an air of vulgarity to the entire drawing. It is, I believe, essential to our critical understanding of Turner that one should face the fact that there was in him this streak of showiness and stridency which mars a great deal of his middle and late period work. It exists even in such famous drawings as *The Blue Rigi*, done in 1842 after his visit to Switzerland in the previous year. This, when I saw it exhibited with the collection of Mrs Walter Jones at Agnew's in 1942, struck me as somewhat too assertive in colour, in spite of the impressive solidity of the distant mountain and of the way in which the gradations of rich blue clothe it and give it form. I feel the same defect too, in some of the watercolours of Venice, which even more than Switzerland inspired Turner to bathe his very soul, as it were, in colour—and not always with discretion. But happily there are many of his late drawings which are without this stridency, and in which his love of colour is expressed with a delicacy which, combined with his incomparable skill of hand, enabled him to create in them perhaps the highest expressions of his genius. These drawings are often very slight—a mere suggestion of sky, or of mountain, or of sunlit building and water—but they are entirely satisfying. An example, which happens to be on view at the Victoria and Albert Museum as I write, is *Venice—the Dogana and Campanile from the Giudecca*, dating from about 1835 to 1840, in the Turner Bequest. In this lovely drawing a horizontal line of buildings lies, a third of the way up from the bottom, as if floated on to the paper. Below is an expanse of grey water. Above is a pale sky which is pink to the left and blue to the right. The whole effect is far more ethereal than any which Brabazon, or Steer, or any of the others who have followed Turner's example in work of this kind, ever achieved. Some

115

brilliant and freely impressionist Venetian bodycolour sketches of 1839 in the British Museum are astonishing examples of the delicate and luminous effects which Turner could achieve in this often heavy medium. They include night scenes with fireworks and theatre and other interiors with figures, and are clearly connected in style and feeling with the Petworth sketches of about 1830–1831.

Though today we see Turner as, in spite of an opportunism and a touch of vulgarity which marred much of his work, a master of extraordinary power in watercolour as in oils, it has to be remembered that his pre-eminenence was not so clear to all his contemporaries. It is curious to note that J. T. Smith, in his life of Nollekens published in 1828, twice classes Turner in the same category as the almost forgotten Arnald and the seldom remembered Callcott. Of George Arnald a little will be said in Chapter XI. Augustus Wall Callcott (1779–1844) was a brother of the well-known musician. He was a pupil of Hoppner and originally a portrait-painter, but later turned to landscapes, seascapes and other things, both in oils and watercolours. In 1805 Farington wrote that he would 'press hard upon Turner', but he was never more than, in some ways, a friend and disciple. Callcott became ARA in 1806, when Turned voted for him, RA in 1810, and was knighted in 1837. He was an accomplished watercolourist, with no very strong individuality of his own, but his sepia landscapes and coastal scenes with shipping can be attractive in an unexciting way. There are some good examples in the Victoria and Albert Museum, such as the *Seapiece, with* (? Dutch) *Shipping*. It measures $12\frac{3}{4} \times 20\frac{3}{8}$ inches and is in sepia, sometimes strengthened with touches of pen, and with some free drawing in soft pencil rather of the Van de Velde tradition in the boats (192). Another example is a pretty, very slight, coast scene in watercolour, and there is also a large *Landscape—Evening*, measuring $13\frac{1}{2} \times 24\frac{1}{2}$ inches, which shows Callcott doing an exhibition piece in watercolour. It is an able performance, but the colours, owing no doubt to the artist's desire for a strong effect, seem rather muddy and lacking in luminosity. Certain passages, especially the chocolate brown shadows in the foreground (an open common across which goes a track), seem to have been strengthened with a gummy-looking material which gives them an unpleasant shine from some angles. At the same time the long shadows sloping from the left are well done, and there is a pretty effect of light behind the tall trees beyond the common to the right. The sky is rather brown, and has probably faded. It is not a bad drawing, but seems handled without much sensitiveness to the character of watercolour and, indeed, strikes one as conceived rather as if it were an oil-painting. An even larger watercolour in the same museum is the *View in North Wales*, which measures $27 \times 41\frac{1}{2}$ inches. The catalogue dates it about 1820, but in style it is reminiscent of a Turner of almost twenty years earlier, though it is more woolly in touch. It is an immense, and rather faded, landscape with a wide distance of blue mountains, a foreground of brown and yellow-brown (the latter a very Turnerish colour), and water in a hollow in the near centre of the picture. It is the sort of watercolour which shows considerable ability, of a derivative kind, and should be extremely effective—yet gives a modern eye very little pleasure. Lady Callcott (Maria, née Dundas, 1785–1842) was an amateur artist and the author of *Little Arthur's History of England*.

The Figure Draughtsmen

AMONG THE English figure draughtsmen who practised watercolour there are two strangely contrasting, and exactly contemporary, men of genius, William Blake (1757–1827) and Thomas Rowlandson (1757–1827)—Blake, a poet and a visionary of immense spiritual force, Rowlandson a caricaturist of extreme inventiveness, but earthy above all else, and with no nearer approach to poetry than a charming sense of colour and a liking for a pretty landscape or a buxom chambermaid as a change from his usually very ugly human beings. These two, with a number of lesser artists who are most conveniently grouped with one or other of them, will form the subject of the present chapter.

William Blake,* the son of a hosier, was born at 28 Broad Street, Golden Square, on November 28, 1757. At the age of 10 he went to Henry Pars's drawing school in the Strand—at which so many distinguished artists were taught—and remained a pupil there until he was 14. He had by that time begun to write poetry, and in art had already shown a preference for Michelangelo and Raphael, whose works he got to know through prints, as against the later masters, such as the Carracci, who were then fashionable. They were to exercise great influence on his work as an artist. At 14 he was apprenticed to the engraver James Basire, with whom he remained for some years, learning the trade which he was to follow, often as sheer hack-work, throughout his life. Among the tasks he carried out for Basire was to make drawings of monuments in Westminster Abbey and other churches, which he subsequently engraved, and thereby he acquired a love of Gothic architecture which also greatly influenced his art. After his apprenticeship ended in 1778 Blake became, for a while, a student at the Royal Academy, where G. M. Moser, RA, chid him for wasting his time in studying Michelangelo and Raphael. At the Academy he drew from the living figure, but academic naturalism had little appeal, and perhaps not very much to teach, to one who was to develop his own grand but highly artificial conventions for expressing the human form. It is fair to add, however, that the Academy in 1780 accepted a watercolour by Blake, *The Death of Earl Godwin*, which (I have not seen it) is said to show the influence of J. H. Mortimer. In all Blake sent twelve exhibits to the Academy between 1780 and 1808, and four to the Associated Painters in Water-Colours in 1812. Moreover the Academy has to its credit that in 1822 it gave Blake a grant of £25. As an engraver Blake's early employment included the reproduction of many of the designs of Thomas Stothard, with whom he made a friendship which lasted until, about 1806, the sharp practice of the dealer R. H. Cromek caused a

* There are many books about Blake, and I shall not attempt a list of them. The biographical summary which follows is drawn from the usual works of reference. What I have to say of Blake's drawings is based mainly on the examples in the chief London museums and on the exhibition held at the Tate Gallery in 1947.

misunderstanding and breach between them, by inducing Stothard to paint a picture of *The Canterbury Pilgrims*, a subject upon which (though Stothard did not know it) Blake was already working.

In 1782 Blake married Catherine Boucher, daughter of a market gardener, who made him a devoted wife and learnt to take impressions of her husband's prints and to help him with the colouring of them. In 1784 he opened, with a partner, a printseller's shop in Broad Street, and his youngest brother Robert,* to whom he was much attached, lived there with him. In 1787, on Robert's death, the shop was closed, and Blake moved to 28 Poland Street. There he lived six years, producing his *Songs of Innocence* and other works written, illustrated, and printed by himself with the help of his wife. In 1793 the Blakes moved to Hercules Buildings, Lambeth, staying there until 1800. How hard he worked can be judged from the fact that, for an edition of Young's *Night Thoughts* alone, he did 537 drawings, though only 47 of them were actually used and engraved. The whole of this series is in the British Museum's fine collection of Blake's work. The designs are made round the outer parts of large sheets of paper into the centres of which have been inlaid leaves from the 1745 edition of Young's poem. During the Lambeth period, or shortly before it, Blake obtained the friendship and patronage of Thomas Butts of Fitzroy Square, who bought regularly from Blake for about twenty years. The prices he paid were low—from £1 to £1 10s. a drawing—but he bought in quantity and took what Blake gave him without picking and choosing. In 1799 he ordered fifty small pictures at a guinea each. In the six years from 1805 to 1810 Butts paid Blake £339 5s. 6d.—rather more than a pound a week, which must have been very useful to a poor man at a time when money was much more valuable than it is now. Many of the finest Blake drawings come from Butts's collection, for example, *Job Confessing His Presumption to God, Who Answers from the Whirlwind*, which belonged to the late Graham Robertson—a wonderful composition in which God, with arms outstretched and surrounded with a whirling cloud of angels, looks down with immense benevolence upon the kneeling Job below.

Only once during his life did Blake live away from London. In 1800 John Flaxman, the sculptor and draughtsman, introduced him to William Hayley (1745–1820), author of *The Triumphs of Temper* and of other poems, and a friend of Romney, Cowper and Gibbon. Hayley invited Blake and his wife to come to live near him at Felpham, close by what is now Bognor Regis, in Sussex. There the Blakes went in September 1800, and there they stayed in a cottage by the sea for three years during which he did much work both for Hayley and for Butts, besides writing. One of the very few landscape drawings of Blake's that I remember seeing† is a view near Felpham, a slight pencil sketch, washed with blue and dark grey, which belongs to the Tate Gallery. A set of eighteen heads of the poets (including both Homer and Hayley), which Blake did in tempera for Hayley's library at Felpham, is now in the City Art Gallery, Manchester. Eventually the elegant trivialities of Hayley got on the artist's nerves and he returned to London, where he settled at 17 South Molton Street, and entered upon a long period of poverty and obscurity which lasted until about 1818. Events of the earlier years of this period were the publication of his illustrations to Blair's *The Grave*, engraved to his chagrin, not (like the *Night*

* There is a drawing by Robert Blake in the British Museum. It is much influenced by his brother's work.
† There were some other slight landscape drawings by Blake in the sale of the late W. Graham Robertson's collection at Christie's in 1949.

Thoughts) by himself, but by Schiavonetti, in 1808, and the holding of a small exhibition of his works, which attracted the admiration of Charles Lamb, in 1809. After that obscurity gathered even more closely around him until 1818, when he met John Linnell. Thenceforward, until his death, Blake had the satisfaction of having the friendship and admiration of a group of young artists who, besides Linnell, included John Varley, Samuel Palmer, Francis Oliver Finch, George Richmond, Edward Calvert and Frederick Tatham. In 1820 Blake moved from South Molton Street to 3 Fountain Court, Strand. On August 12, 1827, he died.

Blake worked in various mediums, including what he called 'fresco', for which he is said to have mixed his colours with glue. The works in this medium have suffered a good deal from the passage of time. He also made 'printed drawings', or 'monotypes', by a process the details of which are not altogether clear. The essence of their effect seems to lie in the fact that the colours were impressed on to the paper from millboard and that the lifting of the millboard plucked up the tacky pigment a very little to give a slightly puckered, or minutely blotchy, surface quality. By this method Blake achieved very great richness and strength of colour, and created some of his grandest works, such as *Elohim Creating Adam*, and the terrifying *Nebuchadnezzar*, which shows the King going naked on all fours, his beard trailing upon the ground, and a look of wild terror in his eyes. But these things scarcely come within the scope of a book concerned with watercolour and with such pen, pencil, or wash drawings as are, so to speak, inseparable from the consideration of watercolour.

Blake did not attempt quite such strong and dark colour effects in his watercolours as in his printed-drawings, relying in the former chiefly on his highly characteristic line— stiff yet immensely sinuous and flowing—combined with washes of usually not very bright clear colour to give shape to the imaginings of his mind. His is a very literary form of art and in the technique of drawing he had certain limitations. His facial expressions, in particular, were somewhat primitively conceived and limited in range. Mad terror he could express, as we have seen from the *Nebuchadnezzar*, and calm benevolence in the face of the Creator; but for other expressions he relied again and again on a sort of naïve mystic wonder, perhaps repeated many times in a single drawing, and on a mannerism which gives face after face a long straight nose leading up to a receding forehead. Yet for all that Blake is one of the masters—though perhaps rather one of the masters who worked in watercolour than one of the master watercolourists.

Much of the last paragraph, though true in general, requires occasional modification. Sometimes Blake, particularly in late works such as the illustrations to Dante (each measuring about $14\frac{1}{2} \times 20\frac{1}{2}$ inches) commissioned by Linnell in 1824, used strong colour effects in his watercolour, for example in the *Paradise* in the British Museum, and *The Inscription Over Hell Gate*, in the Tate Gallery. In the latter Dante and his guide, clad one in soft red and the other in soft blue, pause in the gateway, on each side of which stand twisting, dark-foliaged trees, while beyond, among the intersecting arcs of the mountains of Hell, there rise pinnacles of blue and red flame. Even stronger and brighter colour occurs in other drawings in the same series, as in the tremendous kidney-shaped purple-red clouds that obscure the sun in *Dante and Virgil Approaching the Angel Who Guards the Entrance to Hell* (Tate Gallery), or in the rich blue sky that peeps through *The Whirlwind*

of Lovers (Birmingham City Art Gallery), or in *The Simoniac Pope* (Tate Gallery). *The Whirlwind of Lovers*, especially, is a marvellous flowing design, highly typical of Blake, which in the top right-hand corner of the composition shows Dante in a swoon, Virgil looking down at him, and Paolo and Francesca being rapt away in a fierce sinuous tongue of flame (193). The remaining three-quarters of the picture are occupied with a vortex of continuous naked human figures, male and female, which rises from a lake of waves varying from deep purple-red to yellowish-pink and makes a complete loop as it floats away to the left. Blake evidently found great inspiration in the idea of human or angelic figures—his own particular brand of elongated sinuous humanity, often covered with flowing, clinging robes—floating and forming patterns in the sky. No doubt he drew the idea from Italian painting, but he made of it something entirely individual and, in spirit, rather mystic in a northern way than Italianately religious. We get similar swirls of inter-locked angels, or other figures, in many of his drawings, for instance *Job Confessing His Presumption to God* (in the Graham Robertson collection), *The Fall of Man* (in Lieut-Colonel William Stirling of Keir's collection), and *A Vision of the Last Judgment* (in Sir James Stirling Maxwell's collection). In *The Assumption of Our Lady* (in the Royal Library, Windsor Castle) the air-borne figures are infant angels. In *The Ascension*, which belonged to Graham Robertson, a magnificently simple design of the eleven apostles standing gazing at the figure of Christ rising heavenward with outstretched arms above them, most effective use is made of two isolated aerial figures of angels who plunge head down-wards through the air, one on each side of the Saviour. To revert, for a moment, to the Dante illustrations, it is interesting to see in one of them, *Homer and the Ancient Poets* (Tate Gallery), trees done in a manner which obviously influenced the early work of Samuel Palmer.

In most of Blake's work, especially his earlier work, however, colour plays a less im-portant part and the effect depends chiefly upon the rhythmically flowing lines. As one looks at his figures they often strike one as modelled entirely in grey monochrome, which seems to make itself felt through the superimposed tints of local colour. This can produce an effect of great power, as in *The Wise and Foolish Virgins* in the Tate Gallery (194). In some of his finest drawings there is much less colour than in this one—indeed sometimes very little colour at all, and as an example I would give *Angels Hovering over the Body of Jesus* in Mr and Mrs Esmond Morse's collection. This, which measures $16\frac{1}{4} \times 11\frac{5}{8}$ inches, is a design of great simplicity, formality and beauty, which shows very clearly the influence of Gothic church architecture upon Blake's mind. Across the base of the composition stretches, like a medieval recumbent effigy, the dead Christ; while rising in an inclined curve, one from His head and one from His feet, hover two angels. Their hands are held as in prayer, their heads, which almost touch, look down, and the tips of their raised wings meet to form a sharply-pointed arch silhouetted against a rounder, darkly looming archway in the architectural background. A diffused light glows behind the angels' heads, and almost the only colour is in their faces and in the light around them. Occasionally Blake worked in pure monochrome—brown or blackish-grey—as in a small drawing of choppy waves and sky, *The Spirit of God Moves Upon the Face of the Waters* (also in Mr and Mrs Morse's collection), or in Sir Edward Marsh's *Har and Heva Bathing and Menetha Looking On*, an illustration of one of Blake's poems, *Tiriel*, probably written about 1788–9,

in which one admires the beautiful effect of translucency in the water—a translucency which one finds repeated in watercolour many years after in the Dante illustration of *The Simoniac Pope*.

The flowing, yet formal, elongated quality of Blake's line, whether with pen or brush, has already been noticed, but he was capable of quite different effects—for example in two of Graham Robertson's drawings, *Satan in His Original Glory*, which has many small figures flying through space which are drawn in pen with an extremely lively, quite distinct, touch, and *The Finding of Moses** in which the pen drawing of such small details as the waterlilies and the crane feeding its young is done with delicious crispness and freshness—even, at least in the case of the waterlilies, with direct observation of nature. Indeed the whole of this drawing, with its charming clear colour, has an innocence and fresh untroubled peace of mind about it that are unusual in Blake—save, naturally, in the Blake of the *Songs of Innocence*. Occasionally Blake did pencil drawings, without wash or colour, and these are delicate and precise in touch. Usually it was his function, as a powerful and original personality, to influence others. But in a few of his late pencil drawings, notably Graham Robertson's *Lais of Corinth*, the head of a courtesan seen by Blake in a vision about 1820, I seem to feel the influence of Fuseli; just as in certain, usually I think fairly early, other drawings of Blake's the influence of Mortimer and his school appears.

Blake very frequently signed his drawings, sometimes 'W. Blake', more often 'W.B.', followed frequently by 'inv.' with or without the year. The W. and the B. are run together and the signature is habitually in the lower left-hand corner of the drawing.

Of the figure watercolourists, apart from the humorous draughtsmen, only one ever comes within measurable distance of Blake. This was Henry Fuseli† (1741–1825), whose original name was Johann Heinrich Fuessli.‡ But though one can see the affinity of the two artists, and though Blake clearly influenced Fuseli (and was occasionally, as I have already suggested, a little influenced by him in return), there is no equality of stature between the two. Blake was by far the greater artist, principally because his was immeasurably the nobler mind. In Fuseli there is never real nobility of inspiration or expression, and when he aims at it he achieves only the theatrical. This appears clearly in his large watercolour *Oedipus Cursing His Son Polynices* ($20\frac{1}{4} \times 18\frac{1}{4}$ inches) in the Victoria and Albert Museum. This is in a way a rather fine thing, a highly stylized almost geometrical arrangement of limbs in parallels and at angles, but completely unreal and, because it fails in producing the effect of terror at which it clearly aims, in the end slightly ludicrous. Moreover there is often an underlying suggestion of evil even in his very best drawings and it is said that there exist some which are of extreme indecency. Stylistically, though there is an obvious superficial resemblance, there are fundamental differences between the two. Fuseli could never have achieved Blake's flowing rhythmic compositions of many figures, and his quality is more sculptural than moving. He was not, however, by any means a negligible artist; he could group figures in a formal, balanced way, as for a piece of decorative or memorial sculpture, very effectively; his single figures of women, also, often have something statuesque about them. He drew many of his most attractive works

* This drawing is now in the Victoria and Albert Museum. See figure 195.
† See 'The Drawings of Henry Fuseli', by Paul Ganz, Max Parrish, 1949, 42*s*.
‡ For a short intermediate period about 1765–8 he spelt his name Fusseli. A little later he occasionally used the form Fuzely.

with a slender foundation of pencil, washed with monochrome or, much more rarely, with slight but softly agreeable colour.

Fuseli was born at Zurich, where his family was distinguished in art, literature and entomology. In all of these he himself had an interest, and up to the age of 27 or so was more of a literary man than of a painter—though he had made a beginning with the art which was to bring him the greater fame. An early friend was the physiognomist J. C. Lavater, who certainly greatly influenced Fuseli's drawing and painting, and in 1761 they both took holy orders. As a result of some local political disturbance they migrated in 1763 to Berlin, where at the house of the British Minister, Sir Andrew Mitchell, Fuseli met the doctor-poet John Armstrong, author of *The Art of Preserving Health*, who became his close friend. At the beginning of 1764 he reached England, where he lived chiefly by his pen until he met Sir Joshua Reynolds who, seeing some of Fuseli's drawings, urged him to become a painter and to try his hand at oils. In 1769, with Dr Armstrong, he set out for Italy, and on February 9, 1770, reached Rome, where he remained eight years, studying especially Michelangelo, and working under Raphael Mengs. He began sending to the Academy in 1774. He visited Venice, Naples and Pompeii, and in 1778 finally left Rome for England, which, by way of Switzerland, he reached again in 1779. Here he worked as a painter of fantastic, historical and romantic subjects, contributing nine pictures to Boydell's Shakespeare Gallery. He was elected ARA in 1788 (in which year also he married) and RA in 1790. In 1799 he succeeded James Barry as Professor of Painting in the Academy, a post which (with one short interval) he held until his death.

With Fuseli's oils we are not here concerned. The most famous of his watercolours is Sir Edward Marsh's *The Chimney-Piece*, which was seen at Burlington House in 1934. It measures $17\frac{1}{8} \times 10\frac{5}{8}$ inches and is an exceptionally bold and striking design, representing a tall, forbidding-looking woman, with a fantastic headdress curving like two great ram's horns above her brow. Wearing a panniered skirt that makes a huge peg-top of the lower part of her, she stands bolt upright before a mantelpiece upon which are two statuettes of nude figures. The main part of the drawing is in Indian ink, or some similar wash, the other colours being very few—dove-grey on the headdress, a rich purple brown between the statuettes, and a little pink on the woman's cheeks. A smaller version of this remarkable drawing is in the Victoria and Albert Museum; it varies in some respects—for example there are no statuettes on the mantelpiece, and there is rather more colour. This museum also possesses a very fine series of portraits of women in flowing high-waisted gowns and with elaborate hairdressing, done in delicate pencil and monochrome wash—grey or brownish. Some are full-length, some half or three-quarters. The full-lengths, especially, have a strange, dominating quality that is most impressive. A curious nude study in broad pen, with many parallel striations, is also worth noting. It relates somewhat to certain of the drawings of the eccentric genius James Barry, RA (1741–1806), who was in Rome for the five years immediately preceding Fuseli's stay. Barry's intentions often outsoared his abilities, but his best drawings, such as some of those in broad pen (198), can be very powerful. He sometimes combined pen with sepia or Indian ink washes, but I have never seen a watercolour by him. The British Museum possesses another very fine head of a woman by Fuseli, in pencil and wash with just the slightest trace of colour, and an album of 96 drawings in pen and wash, or pencil, done while he was in Rome. These last,

which are of very unequal merit, include subjects from Shakespeare, Milton, Dante and the Greek classics. One more drawing by Fuseli may be quoted—Mr Brinsley Ford's study in pencil and wash, with a few small touches of pink and yellow-brown, of a lady standing before her dressing table and mirror, while two attendants adjust her dress. It is an upright, measuring $17\frac{1}{2} \times 11\frac{1}{2}$ inches, and is a first-rate example of Fuseli's billowing, tall, commanding and menacing type of womanhood (197).

Brief mention must be made here of two artists who were in Rome at the same time as Fuseli and were to some extent influenced by him. One of them was John Brown (1752–1787), a native of Edinburgh and a pupil of Alexander Runciman. Brown went to Italy in 1771 and stayed there 'above ten years' before returning to Edinburgh. He visited Sicily with Charles Towneley, the collector of classical antiquities, and Sir William Young. Brown is said to have made 'many highly finished pen-drawings' of Sicilian antiquities, but I have not seen them. He was principally a portrait draughtsman in pencil. Sometimes, however, he worked very much in Fuseli's manner, and a creepily haunting pen and sepia-wash drawing of the back view of two women—a young woman in a most elaborate toilette and an old housekeeper or nurse—which Sir Robert Witt lent to the British Exhibition at Burlington House in 1934 might easily have passed as by Fuseli. It was, however, clearly signed 'John Brown Romae'. Other drawings by Brown crop up from time to time, some of them in a vein of fantastic allegory. They are sometimes initialled with a monogram of J.B. which can look deceptively like 'WB' and then suggests a faked Blake signature. This I had assumed the pencilled initials on a drawing in my own collection (in grey and brown washes with pencil and pen and touches of opaque white) to be (199), but the appearance of some similarly signed drawings in the Randall Davies sale in 1947 put me right. I do not remember seeing a drawing of Brown's in colour. The second artist is Prince Hoare (1755–1834), son of the portrait painter William Hoare, RA, of Bath (1707?–1792). Young Hoare went to Rome in 1776 and studied there under Mengs with Fuseli and the portrait painter James Northcote, later RA. He ceased exhibiting in 1785, and after that was principally a dramatist and miscellaneous writer. I have a black chalk study by him of Prometheus and the Eagle which strongly suggests Fuseli* and is said to have come from a volume of drawings by Prince Hoare and Nathaniel Dance, RA. Other drawings by Prince Hoare are slight sketches in red chalk. The British Museum has a sketch by him of three classical figures in pencil with some rather pretty soft washes of mauve, primrose yellow, blue and other colours.†

A far more distinguished painter than either Brown or Hoare was, however, also in Rome during part of Fuseli's time there, though I do not know what contact, if any, there was between them there. This was George Romney (1734–1802), who is chiefly famous for his portraits, but who nevertheless painted or planned many historical, Shakespearean, and other subject pictures also. He was not a watercolourist in the full sense, but he did a very large number of drawings in pen and sepia or Indian ink wash, which includes studies of groups as well as single figures. Some of these are fine and bold

* It may indeed be a copy of Fuseli, since a pen version of same composition was included in the Fuseli exhibition held in London in 1950.

† Two later artists who show Fuseli's influence may be mentioned. William Young Ottley (1771–1836), who was Keeper of Prints and Drawings at the British Museum from 1833, did many miscellaneous figure drawings, some of which recall Fuseli, others Flaxman or Stothard. Theodor M. von Holst (1810–1844) gets near to Fuseli in some sketches in the British Museum, but his colours are brighter.

in pose. Indeed it may be said that Romney's gift for seizing upon the main lines of a composition, or of a somewhat abruptly stylized attitude, is often seen to better advantage in the freshness and looseness of a drawing than when laboriously, and not always very happily, translated into the more static terms of a finished oil-painting (196).

The group of foreign decorative artists who worked for Robert Adam might claim considerable space in this chapter were it concerned with figure drawings in other mediums and not primarily with watercolours. Most of these, however, worked little in watercolour, preferring, so far as my knowledge of them goes, to make their designs in pen and wash, black chalk, sepia, and so forth. They must, therefore, have but summary treatment here. The most generally famous of them was Maria Anna Angelica Catharina Kauffmann (1741–1807), who was born at Coire, Switzerland, worked at Rome and elsewhere in Italy, and spent from 1766 to 1781 in London, where she became an original member of the Royal Academy. Almost every decoration of classical figures in an English house of the right period is popularly said to be by 'Angelica'—though many of them are in fact by other artists, such as the Italian, Biagio Rebecca, ARA (1734?–1808). There are some watercolour designs by him in the British Museum (201), and in Mr Croft-Murray's collection. They include some charming little figures in Elizabethan costume. I have two small oval pen and Indian ink wash designs, from Dr Percy's collection, also by Rebecca, and there are two others like them in the Victoria and Albert Museum. They are quite fluent and graceful. By Angelica Kauffmann herself there are a few watercolours—the Victoria and Albert Museum, for example, has *Angelica and Medoro*, an illustration to Ariosto, which measures $5\frac{7}{12} \times 7\frac{1}{6}$ inches. It shows three figures, two of them seated, and some sheep, among trees. The figures are quite well drawn with the pen, though their red and yellow and blue draperies stand out rather garishly from the grey and brown background trees. The sheep are feebly drawn. From the Randall Davies sale in 1947 I acquired a large pen drawing of a pensive-looking girl with a characteristic straight forehead running down without a break into a rather large straight nose. She stands in flowing robes, carrying some sort of a beribboned wand over her shoulder. This bears a plausible and fairly old attribution to Angelica. It is washed in pale tints—especially pink and green on the draperies—and measures $15 \times 9\frac{1}{2}$ inches. This drawing, pleasant in a lackadaisical sort of way, is on a more or less contemporary mount on the back of which is written, in ink, 'New or Old Drawings mounted to any pattern by McKenzie No 100 Berwick Street Soho'—a small scrap of information which may possibly be of use to someone some day. No doubt there are other coloured drawings by Angelica elsewhere, but most of those I have seen have been in pen or wash or black chalk. She was particularly fond of a brick-red monochrome wash over pencil. A good example of her monochrome work is *A Sacrifice to Ceres* ($8 \times 13\frac{1}{4}$ inches) in the British Museum. It is in pen and sepia, and is a well-arranged composition of many figures (200). Of Antonio Pietro Zucchi, ARA (1726–1795), whom Angelica Kauffmann married in 1781, retiring to Italy with him in the same year, I only know (save for one exception) monochrome drawings. These are rather heavily, but fairly boldly, done in sepia heightened with white, and are usually half-length portrait groups* or religious subjects. Zucchi, who had

* Mr E. Croft-Murray writes: 'These fit in with the architectural *capricci* in the music room at Harewood House, where the figures in the foregrounds are quite reminiscent of these drawings.'

travelled with Adam in Dalmatia and came to England in 1766, is known to have assisted him in the decoration of houses. The British Museum has a drawing of *Classical Ruins with Figures* and a *Temple of the Sibyl, Tivoli*, which may be designs for house decorations. The figures in the former are very like Angelica's. The latter drawing is the exception referred to above, for it has some touches of watercolour, being in greys and browns with a man in a red robe seated effectively in the lower left-hand corner. The stone of the ruined temple is very agreeably and softly rendered. This pleasing drawing is a fairly large one, measuring $10\frac{1}{4} \times 14\frac{3}{4}$ inches (202).

Yet another, and in his influence more important, figure draughtsman working in England was the Florentine, Giovanni Battista Cipriani, RA (1727–1785), who in 1755 was persuaded to come to this country by the architect Sir William Chambers and the sculptor Joseph Wilton, whom he had met in Rome. He remained here until his death, and exerted an important influence, not perhaps directly on Blake himself, but in creating the atmosphere in which Blake became possible. In 1758 Cipriani was made teacher of drawing in the short-lived free school of design which the Duke of Richmond opened in his private gallery in Privy Garden, Whitehall. He was also a member of the St Martin's Lane Academy and in 1768 was nominated one of the foundation members of the Royal Academy. He painted in oils, engraved, and drew in many mediums. Two of his works which still survive in use, so to speak, are the panels of the King's state coach and the design for the membership diploma of the Royal Academy. He is perhaps, however, most widely known today from the many engravings which Francesco Bartolozzi, RA (1725–1815) did after his designs. Cipriani was primarily a draughtsman, though not a very great one, and very large numbers of his drawings exist. They are in many mediums—black and red chalk, pencil (which he used with precision and delicacy), pen, water-colour, and above all, perhaps, pen and grey wash. They are not infrequently on lined mounts of grey and cream. They can have an air of easy mastery, but it is superficial and the drawing is often feeble or clumsy. They represent the classical Italian tradition in its extreme decadence, but his little cherubs are sometimes pretty (204). His watercolours are not particularly uncommon, but are usually insipid performances. There are one or two examples in the British Museum and half-a-dozen in the Victoria and Albert, some of them on English historical subjects, but mostly classical in theme. A typical example is the *Nymphs Surprised by Satyrs* at South Kensington. This is a largish work ($12\frac{1}{2} \times 17\frac{1}{16}$ inches) in pen and wash, with slight colouring, chiefly in washed out blues and pinks. Four nymphs lie asleep after a hunt, with dogs and a dead hare and boar beside them. Three satyrs break through the bushes from behind. The most vigorous drawing is in the animals—the rest of the composition being mostly pretty tame (203). I prefer a sketchier looser treatment of a rather similar subject—nymphs bathing, while two river gods look on from a rocky and bushy shore, which the British Museum acquired in 1941. It is in pen and pencil with grey wash and some colour, principally pinkish brick-red and blue. Also in the Museum is a drawing in slight watercolour over very loose pencil, bequeathed by Cracherode, in 1799, of an unidentified subject—an old man in a cloak of light magenta, seated, holding a staff, while a woman leans over him, and three men stand in front of him, holding up their hands in horror. It shows Cipriani in a pleasantly free, but not very characteristic, manner.

A mere reference to an obscure pupil of Cipriani's, Mauritius Lowe (1746–1793), who was befriended by Dr Johnson, must suffice. This unfortunate man was an illegitimate son of the second Baron Southwell (see Johnson, Letter 705, a reference which I owe to Dr R. W. Chapman) and not, as various books of reference state, Lord Sunderland or Lord Sutherland. He specialized in elaborate and often ludicrous allegories. But such drawings of his as I have seen are in monochrome wash and pen, not colour.

William Hamilton, RA (1751–1801), who as a boy studied in Italy under Zucchi, and to whom reference has already been made in Chapter V, was a more reputable performer and was much influenced by Cipriani in his classical watercolours. His *Nymphs Adorning the Sleeping Bacchus with Wreaths*, at South Kensington, is, however, rather nearer to Angelica than to Cipriani. This horizontal oval ($11\frac{3}{16} \times 15\frac{3}{8}$ inches) is commonplace in drawing, but pleasantly restrained in colour, and I find it more agreeable, for this reason, than an example of Hamilton's sentimental rustic subjects, *The Gleaners* ($13\frac{3}{4} \times 10\frac{3}{8}$ inches), in the same museum. This group of three figures, father, mother and child, cleverly placed just coming to the top of a rise with a blue distance beyond, suggests movement effectively, but is coloured in too high a key. It is signed and dated 1796. Also at South Kensington are a rather hard and ungracious watercolour portrait of *Mrs Siddons as Jane Shore*, signed and dated 1791, and an album containing a bewildering variety of drawings in various styles and mediums. Much the most attractive—and unexpected—of them is a very loosely handled grey wash group of cattle and men in an agricultural landscape, which suggests Ward or Ibbetson. Other drawings in this album are reminiscent of Mortimer, Cipriani, Angelica Kauffmann and more rarely Fuseli. The pencil drawings are very dull, those in pen a good deal better—there is a spirited pen sketch of a group of people (monk, woman and several men) outside a church. Some of the most characteristic are pen and wash drawings of classical subjects. Hamilton also did Shakespearean and historical scenes, and a good many book illustrations. One of his Shakespearean watercolours, taken from *As You Like It*, Act IV, Scene III, in the British Museum, is quite a favourable example of this sort of thing. It seems once to have belonged to Turner, whose name and address are written on the back. It is a horizontal oval, signed and dated 1796, and shows Rosalind swooning into Celia's arms at the sight of the blood-stained napkin brought by Oliver. There is a pleasant forest vista up the middle of the picture, and Oliver's bright red jerkin contrasts agreeably with the softer colours of the women's clothes. The figures of Rosalind and Celia, too, are gracefully drawn (205). The British Museum also has two small ovals of children playing, which are pretty in a sentimental way.

A draughtsman with a great contemporary reputation, but now comparatively little regarded, was John Hamilton Mortimer, ARA (1741–1779). He studied under a number of masters, Hudson, R. E. Pine and Reynolds, as well as under Cipriani, to whose drawings some of his come very near in style. Mortimer is said to have been an extremely dissipated young man, but in 1775 he married a farmer's daughter, settled near Aylesbury, and became a reformed character. He did not, however, long survive his reformation, for he died early in 1779. He was buried at High Wycombe. In style he varied between insipidity and a flashy, superficial extravagance. He drew in many mediums, and often with a fine pen, with which he achieved a highly niggly manner, shaded by many little

hooks and V's and innumerable dots with the point of the pen. At times a few washes of watercolour were added. In this elaborate pen style he did, for example, the Shakespearean characters (Bardolph, Beatrice and others) of which one occasionally sees engravings. Helmeted soldiers, bandits and so forth were favourite subjects, in which he was possibly inspired by Salvator Rosa, and he frequently illustrated lines from the poets. The numerous examples of his work in the British Museum are mostly in pen-and-ink, but there are a few watercolours among them, and there are others at South Kensington. Both collections include examples of his small monochrome designs for illustrations to Bell's *Poets of Great Britain*, 1777 and 1778. More important—and perhaps Mortimer's best drawings—are the rather larger illustrations to Chaucer, of which there are several examples at South Kensington, measuring roughly 8×6 inches each. Of these *The Sompnour, the Devil and the Widow* is in pen and an underpainting of grey, with light washes of pinky-red and blue; *The Coke and Peterkin* is in pen and grey wash suffused with brown. These drawings have a very nice finish of detail, for example, in such still life incidentals as the jugs in the first-named, achieved without destroying the vigorous movement of the figures (206). Mortimer also painted in oils and etched.

As a pendant to the last paragraph I may perhaps add that a few years ago I acquired eight small drawings in wash or watercolours by an obscure artist, Thomas Stowers, who exhibited forty-nine pictures between 1778 and 1814, most of them at the Academy but a few at the British Institution and the Old Watercolour Society. They were three figure subjects and five landscapes, three of the latter being views at High Wycombe. The dealer who sold them to me told me that he had bought them from a descendant of the artist and that the family tradition was that he was a pupil of Rowlandson. One of the figure subjects—a pleasant little group of a man in a red coat, resting by the roadside, with his wife, children and dog—gave some slight support to this idea. But Stowers must have been about the same age as Rowlandson, and if there was a connection it was probably merely friendship. Mr Oppé suggested to me, however, that from the two other figure subjects (small romantic illustrations in monochrome, very prettily and freely drawn) the chief influence on Stowers seemed to be Mortimer—and the connection of both artists with High Wycombe, as Mr Oppé also pointed out, certainly makes it possible that Stowers may have learnt from Mortimer rather than Rowlandson.* The best of the landscapes are two which capture quite successfully the aspect of the Buckinghamshire beech woods as autumn comes on (207).

To revert, for a moment, to Cipriani, Hamilton, Angelica Kauffmann and Mortimer, the reader may have begun to suspect that they form a confusing and difficult group. That is indeed so—especially in the slighter drawings, which are often well nigh impossible to distinguish with certainty.

Artists who usually work in oils are liable to produce an occasional watercolour, often done as a preliminary study or design, and this is true of the historical and figure painters of the late eighteenth century, as of others. Yet it would not be justifiable to give much space, in this particular book, to such men as Henry Singleton (1766–1839) and Henry Howard, RA (1769–1847). The former produced many historical, mythological, and

* Colonel M. H. Grant, *The Old English Landscape Painters* [1926], p. 100, identifies this Stowers presumptively with an amateur pupil of Wilson. But there is no sign of Wilson's influence in any of the drawings referred to here.

allegorical compositions which were engraved, and large numbers of drawings by him exist. Only a very few, however, are in watercolour, as for example a highly finished, but banal, *Design Commemorative of the Abolition of the Slave Trade*, 1807, in the British Museum, which also has (besides many drawings, mostly rather dull, in other mediums) a water-colour design for one of the plates in Park's *British Poets*, 1804, which is gently agreeable in tone and quality. By Howard, who painted portraits as well as historical and subject pictures, I do not remember seeing anything in full watercolour, the only coloured drawing which I have seen attributed to him being in chalks. Henry Tresham, RA (1751?–1814), and Samuel Woodforde, RA (1763–1817), were other history painters who did at least occasional watercolours, and examples of both are in the Victoria and Albert Museum. By Tresham there is an allegorical subject, of which it is easier to say that it represents something very terrible than to identify the subject exactly. There are figures, one in armour, crouching among rocks, a gigantic head with a hood which extends over them, a large serpent, and lightning striking in from the right. But this 'terrific' subject is carried out chiefly in pretty pinks and blues, with brown, russet and grey for the outer parts of the composition—a rather unhappy emotional contrast. Nevertheless it is greatly preferable to the album of pen and sepia drawings—classical and mythological subjects, illustrations to Shakespeare and Tasso, and so forth—cast in that anatomically exaggerated style in which the body seems made up of a number of individual parts very jerkily and imperfectly put together. These show Tresham to have been on the whole a rather poor performer. By Woodforde, who was the brother of the well-known country parson diarist, South Kensington has an uninspired watercolour *Pan Teaching Apollo to Play on the Pipes*, rather hot in colour in its present condition, but it has suffered from the obvious fading of the blues.

Benjamin West (1738–1820), who succeeded Reynolds as President of the Royal Academy in 1792, is a more important figure, and he used watercolour rather more often —though only as a by-product of his practice. He was an American, who first painted portraits in Philadelphia and New York, worked in Italy in 1760–1763, afterwards settled in London, and was much employed by George III to paint historical and sacred subjects. His occasional watercolours are very various and the British Museum has some in body-colour; one signed 'B. West. 1788. Windsor', representing *Samson Bound*, in a mixture of opaque and clear colour; and others with some degree of clear colour wash, together with many more in pen and Indian ink or sepia wash. At the Academy in 1783 West showed a group of three designs for the East window of St George's Chapel, Windsor, and a few years ago I was lucky enough to acquire the right-hand drawing of this triptych, representing the Three Marys, signed and dated 1783. It is shaped to a point like a Gothic arch, and its extreme measurements are $16\frac{1}{4} \times 8\frac{1}{4}$ inches (208). The women's figures are quite sensitively drawn with the pen and they and the foreground are washed in tones of reddish brown with a sky of rich blue and cream clouds in the background. The Rev A. V. Baillie, lately Dean of Windsor, has the design for another section of this window, which was executed, but unhappily no longer exists. West did occasional watercolour landscapes, but I cannot help being puzzled about four watercolours in the Victoria and Albert Museum—two mountain scenes, and two pastoral landscapes with distant low horizons and attractively luminous skies—which seem very hard to reconcile with a painter of

West's dates. The pastoral landscapes, especially, look much more like work of 1840 or so. They are not signed, but there seems to be some evidence in favour of, at least, the two mountain views, for they came from a batch of fifty-five similar drawings which were accompanied by a certificate from West's great-grandson Albert F. West, written in 1875, and declaring that these drawings were by Benjamin West, PRA. Two landscapes initialled 'B.W.', at the British Museum, are entirely different in feeling and manner, being somewhat in the style of Paul Sandby. One is a rather heavy body-colour with a good group of small figures in the foreground, *Landscape, with the Story of Palemon and Lavinia, from Thomson's 'Seasons'*; the other is a charmingly quiet pen and Indian ink wash drawing of a carpenter's shed and trees in a landscape. From our immediate point of view the most pertinent of the Victoria and Albert's drawings by West is the *Sheepwashing* ($12 \times 19\frac{3}{4}$ inches), signed and dated 1783, in brown wash, with blue on the sky and water (209). It shows two naked rustics in the dipping trough with the sheep, while others, in smocks, look on. It is interesting in subject, and carefully executed, but it must be confessed somewhat tame. I have seen (if I remember aright) three drawings by West's pupil and fellow-American, Mather Brown (1761–1831), one signed one being a group of robbers by a rock, in pen and sepia. None was in colour. He first exhibited at the Academy in 1782. He specialized in historical subjects and portraits.

The reader will have noticed that many of the painters so far mentioned in this chapter did at least occasional book-illustrations. In the later eighteenth century the illustrating of books attracted artists of very various calibre, including some of the most notable men of the time. Of these John Flaxman, RA (1755–1826), eminent equally as sculptor and draughtsman, scarcely qualifies for inclusion in this book, for so far as I am aware he very seldom used any colour and his pen or pencil drawings are only in a minority of cases even washed with Indian ink or sepia (210). He depended principally on the surpassing precision, firmness and purity of his line, as seen, for example, in his celebrated illustrations of Homer, and other Greek poets, which more forcibly than anything else, perhaps, interpreted the classical Greek spirit to several generations of English people. Much more the conventional illustrator, though one of extreme charm and high talent, was Flaxman's friend and contemporary Thomas Stothard, RA (1755–1834), who was the most distinguished and prolific practitioner of this branch of art in the generation succeeding that of Samuel Wale and Francis Hayman. So far as I am aware, both Wale and Hayman always drew their illustrations in monochrome, and Stothard certainly followed this practice in much of his work, especially in his earlier years. But in many, at any rate of his later, drawings he used watercolour freely and with much feeling and delicacy. Stothard's earlier illustrations, such as those he did for *The Novelist's Magazine* from 1780 to 1783, and for *The Lady's Poetical Magazine* in 1781, for which he was paid a guinea each, were romantic pieces rather in the style of Mortimer, though gentler in spirit (211). Later he developed an exquisite, innocent, young world of his own, peopled by tender maidens and beardless lads, with often a cherub and here and there a fairy. Perhaps his masterpiece was the series of decorations* which he designed for the duodecimo edition of Samuel Rogers's *Poems*, first published in 1812 and many times reprinted; these were

* These are not identical with those in the much later editions of Rogers (*Italy*, 1830 and *Poems*, 1834) to which both Stothard and Turner contributed, though the basic design is in some cases the same.

cut in wood by Bewick's pupil, Luke Clennell (1781–1840), himself a figure-draughtsman and watercolourist of some position and talents. Stothard can be one of the collector's chief joys, for he was an indefatigable sketcher, for ever drawing on any bit of paper available, which he would cover, often on both sides, with little sketches in pen of single figures, or groups, of all sorts, trying ideas this way and that way as they occurred to him. Many of these sheets exist, and can be acquired sometimes for very little. They are extremely characteristic of Stothard, and are marked by various little tricks of style, especially the curious wide-open, unseeing eyes which, once you know them, are as good as signatures to his little figure drawings. Incidentally the 'T. Stothard' found written upon so many genuine Stothard drawings (as well as upon some by other artists) is generally, perhaps always, a forgery, attributable to the group of such forgeries discussed on p. 16.

This industrious, kindly, and delicately-talented man* was the son of a London publican. He was weakly as a young child and was sent to live with relatives at York and near Tadcaster, returning to London when he was thirteen. His father died in 1770, and the boy was apprenticed to a draughtsman of patterns for flowered silks in Spitalfields. In 1777, being then 22, he entered the Royal Academy schools, and in the same year exhibited two Welsh landscapes with the Society of Artists, having made an early tour, or tours, in the Principality. He became friends with Samuel Shelley (see Chapter XI) with whom in 1778 he shared lodgings in the Strand, and about this period is said to have been encouraged by Reynolds and Wilson. His regular employment as a book illustrator began in 1779, his work being at first chiefly for Harrison, publisher of the *Novelist's Magazine*, *Poetical Magazine* and *Lady's Poetical Magazine*; and in these and subsequent years he illustrated with graceful sentiment, pretty fancy and gentle humour, but not often with any of the stronger emotions, almost the whole range of English imaginative literature—poetry, drama and prose fiction alike. Outwardly Stothard's life was uneventful. In 1783 he married Rebecca Watkins, who made him an excellent wife. She died in 1825. He was elected ARA in 1791 and RA in 1794, in which latter year he moved his home from Henrietta Street to 28 Newman Street, where he remained until his death. Between 1799 and 1802 he made annual visits to Burleigh, Northamptonshire, where he decorated the walls of the Grand Staircase for Lord Exeter. A watercolour study for one of the walls is in the British Museum. In 1809 he visited the Lake District and Scotland, and some highly unexpected watercolour landscapes, of which there are examples both in the Victoria and Albert and British Museums, date from this tour. In 1810 he stayed with Thomas Johnes at Hafod, giving lessons to Johnes's daughter and decorating the library with scenes from Froissart and Monstrelet. In 1814 he designed the famous silver shield given to the Duke of Wellington by the merchants and bankers of London. In September 1815 he made his only trip abroad, going to Paris with the sculptor Chantrey and others via Calais, Boulogne, Abbeville, Amiens and Chantilly. After his election as ARA his exhibits at the Academy are said to have been for the most part in oils. In the late eighteen-twenties he made designs for important sculptural decorations at Buckingham Palace—but these were never carried out. Stothard died in 1834.

* The chief biographical authority is *Life of Thomas Stothard, RA*, 1851, by Mrs Anna Eliza Bray, whose first husband was one of Stothard's sons.

Stothard's drawings are in many sorts of medium—pen, pencil, wash of various hues, watercolour—and in sundry combinations of them. The influence of a number of artists is evident at various times. J. H. Mortimer, as has already been noted, had a certain general influence on Stothard's earlier monochrome illustrations, and occasional drawings show a shading with dots from the point of the pen which also seems derived from Mortimer. Blake, too, perhaps exerts some general influence at times, but the two men were too different spiritually for anything strongly Blakeian to appear in Stothard's work. Flaxman's influence is often much more evident, and certain Stothard monochrome drawings get very near to him. Others who affected him were Raphael, whom from afar he greatly admired, and Watteau, of whom an anglicized early nineteenth century minor version appears in such late watercolours as the British Museum's *Scene from the Conclusion of the Eighth Day of the Decameron* or the Victoria and Albert Museum's *The Lady's Dream*. The former, which was engraved in an edition of 1825, may be taken as an example of this type of Stothard. It is an upright, measuring $10\frac{3}{4} \times 7\frac{7}{8}$ inches, which is perhaps rather too large for a drawing of this kind. Yet it is very pretty in its formal, doll-like way—which you can call silly if you like to be censorious. It represents seven girls in gaily coloured dresses—blue, purplish pink, pinkish yellow, white—picking roses and lilac, while doves fly around them against a vivid blue sky. Mannered and artificial though such drawings as this are, they yet retain much of Stothard's charm. That could evaporate entirely from such laboured and lifeless compositions as his watercolour *Scene from 'Twelfth Night'*, *Act III, Scene IV* ($12\frac{1}{8} \times 8\frac{7}{8}$ inches, British Museum), even though the latter is a fairly early production, having been engraved by Heath in 1802.

But it is not in these more ambitious and comparatively large watercolours that Stothard appears at his best. His small compositions, even when highly finished, could be delicious, though one might criticize his colour as tending to be pretty-pretty, made up too often of light tones of pink and blue contrasted with soft greys and greenish-yellows. Just occasionally there are touches of opaque white, as in two small illustrations to Pope's *Essay on Man* in the British Museum, which were engraved in 1797. A particularly beautiful example of his small watercolour illustrations is one in the Victoria and Albert Museum of an incident in Shakespeare's *King John*, Act IV, Scene III. The boy Arthur, clad in a pink jacket, is about to throw himself from the top of the wall. The sky behind him is of pale blue and grey, the whole effect is very soft and delicate, and a gentle pathos (rather than any more terrible emotion) permeates the whole.

Some of the strongest and most beautiful of Stothard's drawings are those of single figures, or groups of two or three, freely drawn in pen and washed with greyish or brownish black to give the light and shade, against an almost black background (212). There were some exquisite examples of his work in this manner in an album of his sketches which belonged to Lady Callcott (1785–1842). This album was broken up, and some of the more saleable drawings dispersed, a few years ago, but the greater part of it (including some admirable things) is now in my possession, though the leaves are unfortunately all loose in the covers. A very striking variant of this manner is seen in one drawing in the British Museum, *St John Supporting the Virgin Mary*, in which the two figures, in pen and grey wash, are seen against a rich glowing blue background—the effect being luminous and brilliant in the extreme.

One of the fascinating things about Stothard's drawings, which may be in any medium from pen or pencil to full watercolour, is that it is frequently possible to relate little preliminary sketches to known finished drawings or engravings, and thereby to study the methods by which he worked out his ideas. An example to the point is the British Museum's *Britomart Disarming*, an illustration to *The Faerie Queen* engraved in 1810. It is in watercolour and measures $4\frac{3}{4} \times 3\frac{3}{4}$ inches. Britomart is clad in armour in this finished drawing, and also in some of the studies which accompany it in the Museum. But in others of these studies the figure is in various degrees of nudity, showing that Stothart seems at first to have designed this composition roughly with nude figures, and later elaborated them with the appropriate costumes.

These preliminary drawings are of many kinds. Studies for book-illustrations, or at least for drawings upon literary themes, English or Classical, predominate, and often the freely sketched trial of an idea results in something most delightful and poetic. A very beautiful example is a subject from *The Deserted Village* of Goldsmith, which was previously in the collections of Herbert Horne and Sir Edward Marsh, and is now in that of Mr H. C. Green. It measures $6\frac{3}{4} \times 5\frac{1}{8}$ inches and represents a man and girl dancing, while the old people, with the children and a dog, rest under a tree (213). The drawing is in grey wash over pencil, the figures touched with sepia. But literary illustrations are by no means all Stothard's subjects, which include also designs for sculptured monuments, for silverware and decorative work of various sorts, and for tradesmen's cards, besides very occasional portraits, topographical views, and landscapes such as the Lake District and Scottish sketches already mentioned. Of these last may be instanced, especially, the British Museum's *View of Edinburgh from Duddingston* ($9\frac{3}{4} \times 17\frac{1}{4}$ inches), in pencil and watercolour, the foreground unfinished—a beautiful widely-stretching distant view in greens and blues with a little faintest pink on the buildings of the city. Both the British Museum and the Victoria and Albert contain remarkable watercolour studies of the river valley at Roslin, near Edinburgh, showing bushes against reddish cliffs with a pool of the river below, and other similar things, among which the British Museum's *Landscape Study* seems possessed of something the same spirit and vision as Van Dyck's landscape studies mentioned in the first chapter of this book, though it is highly unlikely that Stothard ever saw them.

A group of other book-illustrators followed fairly closely in the wake of Stothard, though their work seldom has quite his charm. To differentiate the styles of these men in a few words devoted to each is scarcely possible, and anything which might be attempted in that way here could be of little value to the reader, who, if he is interested in them, must learn to recognize their hands by the laborious method of (*a*) studying authentic examples and (*b*) making himself acquainted with their drawings as engraved in the literature of the time. Prominent in this school were Robert Smirke, RA (1752–1845), Richard Corbould (1757–1831), and Edward Francis Burney (1760–1848). Of these Smirke, who was the father of the well-known early nineteenth century architects, scarcely comes into a book devoted primarily to watercolour. Richard Corbould—whose son Henry (1787–1844) was an illustrator too—also did some watercolour landscapes and portraits. He designed illustrations for *Amelia*, *Tom Jones*, *Pamela* and other novels, some of the drawings for which are in the Victoria and Albert Museum. One of the best, in pen and watercolour,

illustrates a scene in Smollett's *Ferdinand, Count Fathom*—an old woman in a pink cloak kneeling before a horseman in a blue coat in a forest (219). This has a richness of colour which is rare in a book illustration and a crispness of line which much of Corbould's work lacks. E. F. Burney had a rather hard, but certainly competent, touch as an illustrator, and some of his work seems to derive more from Wale and Mortimer than from Stothard. Examples in the Victoria and Albert Museum include designs for the poets Langhorne and Young. Some are in monochrome, others lightly coloured over grey underpainting. They are precise and neat, but quite without Stothard's innocent charm. A particularly good circular design is that of Night casting her starry cloak over the sleeping figure of a dog.* Burney, however, deserves more emphatic mention for such things as his large—about 20 × 29 inches—satirical watercolour crowded with figures, *An Elegant Establishment for Young Ladies*, in the Victoria and Albert Museum. It represents a fashionable school for girls, in the first decade of the nineteenth century, and the pupils are being taught dancing, music, drawing and so forth, as well as being drilled, having their necks stretched and backs straightened by various methods of torture. Through a window can be seen one of the young ladies eloping to Gretna Green. It is a very able performance, cynically witty rather than humorous (217). Another large drawing of this sort, *The Walz*, is in the same museum.

Two late but fairly close followers of Stothard were William Henry Brooke (1772?–1860) and John Massey (or Masey) Wright (1777–1866). Brooke, though his name lingered in books of reference, has only lately become known to students, principally through a number of attractive landscape studies, incisively and freely sketched with the pen and coloured in a characteristic range of clear, rather bright, washes in which an acid blue-green for foliage is prominent. But he also did figure drawings, and I have two pretty sketches of a girl holding a hoop above her head, in pen with slight tints of watercolour, which are almost pure Stothard in inspiration. They are initialled by Brooke and dated October 1828 (215 and 216). Brooke exhibited at the Academy between 1810 and 1826; he designed the vignettes for Moore's *Irish Melodies*, 1822, and did other illustrations. Some of Brooke's drawings have on them a mysterious 'S.P.', which has led to their being attributed to Samuel Palmer. Wright is a more generally known artist. When he was 16 he met Stothard and was greatly influenced by him. He worked for a while as a scene-painter, and theatrical subjects, particularly Shakespearean incidents, bulk largely among his watercolours. He did many book-illustrations. At first principally an oil painter, he exhibited from 1808 at the Academy, but in 1824 he became a member of the Old Water-Colour Society, having taken to the medium about 1820. His watercolours can be very feeble, but sometimes they are pretty in colour and graceful in a milk-and-water way. They are best when nearest to Stothard, though inevitably a good deal later in feeling. Both the British and Victoria and Albert Museums have characteristic examples, and there are many in private collections (218).

Another prolific illustrator of the late eighteenth and early nineteenth centuries was Richard Westall, RA (1765–1836), who gave the future Queen Victoria some drawing lessons. He painted historical pictures in oils, and published some poems. He was an

* See also *Edward Burney's Illustrations to Evelina*, by T. C. Duncan Eaves. *Publications of the Modern Language Associaton of America.* December 1947. Burney in 1780 did three stained drawings in miniature of scenes in his cousin's novel, of which one was used in an edition of 1794.

elder brother of William Westall, ARA, who is mentioned in Chapter IV. Richard Westall illustrated editions of Shakespeare, Milton, Gray and many other poets, and he also did, besides portrait drawings, many large, ambitious, and highly finished watercolours upon classical, historical, dramatic and similar themes. In this mood he is usually a flashy and garish artist, whose men were of ludicrously exaggerated physique and his women insipid and sentimental. He affected especially the straight nose and forehead à la Angelica Kauffmann, and unduly elongated arms and legs. In his more ambitious watercolours he tended to give a high degree of finish to the faces, as in two examples in the British Museum, one representing an old shepherd standing with his dog among his flock against a leaden stormy sky, his face and hands being carefully worked up in fine lines done with a brush. This drawing, which measures $13 \times 10\frac{1}{2}$ inches, is signed and dated 1794. To the previous year belongs the other example cited, which is of about the same size and represents a young lady, with cheeks of brilliant pink, and wearing a white dress with plum blue ribbons round her waist and on her hat, who reclines on a grassy bank below an urn. It is really a very foolish and insipid work, the best parts of which are the lively attitude of the spaniel which looks up at his mistress and the blue depths of the woodland background. A good deal of Westall's work has, indeed, a strong element of the ludicrous in it, for instance, a rather overdramatized sleep-walking scene from *Macbeth* (Victoria and Albert Museum, $8\frac{11}{12} \times 7\frac{5}{12}$ inches) and three brightly coloured and (in facial expression) ridiculous illustrations to Beckford's *Vathek* in the same museum. The British Museum's watercolour ($7\frac{1}{8} \times 5$ inches) of Ophelia just as she is about to fall into the stream is rather happier, and in general it is true that Westall is at his best when there is a strong landscape interest in his drawing—and also when he does not finish it too remorselessly. I have a pretty little coloured vignette of children picking apples and in the Victoria and Albert Museum there is, besides a Claudeian wooded landscape in pen and sepia, a nice roughish drawing ($6 \times 8\frac{1}{2}$ inches) in pen and brown wash, with blue-grey for the distant trees and some touches of pink and other colours on clothes and so on, of a rural scene. A man is sowing, his dog by him, and he looks at a girl who carries a wooden pail on her head. In the background a man with a pair of white horses is harrowing. This is a much better thing, artistically, than most of Westall's too sentimental or too theatrical figure subjects (220 and 221).

William Marshall Craig* (*circa* 1765–1834 or later), who is said to have been a nephew, or great-nephew, of James Thomson the poet, also did a number of book-illustrations, and his original designs in pen and wash (e.g. a vignette, dated 1813, for the title-page of an edition of Cowper) can be delicate and pretty (222). He did not, however, confine himself to illustration, but also produced miniatures, oil-paintings, engravings, monochrome landscapes (Mr L. G. Duke has one), and especially watercolours of rustic subjects somewhat in the anecdotal tradition of Richard Westall or Wheatley, though sometimes (for example the British Museum's *The Penalty of Breaking a Hedge* ($14\frac{3}{4} \times 10\frac{1}{4}$ inches), which represents a cow half-way through a gap being beaten by a rustic) more realistic and less sentimental in approach. Yet Craig can be extremely sentimental too on occasion. His watercolours are highly detailed in their treatment, not only of the principal figures but of such incidentals as foliage and wayside flowers. The colour is fairly rich and strong.

* See Ralph Edwards, 'Queen Charlotte's Painter in Watercolours', *The Collector*, December 1930.

Between 1788 and 1828 he showed 259 exhibits, 152 of them at the Royal Academy. He was evidently something of a personality in his day, for he was painter in watercolours to Queen Charlotte, miniaturist to the Duke and Duchess of York, and drawing master to the Princess Charlotte.

A rather later illustrator, who stands in style half-way between Stothard and Westall, is Thomas Uwins (1782–1857), who at the end of his life earned for himself an honourable place in the history of the National Gallery, of which he was appointed Keeper in 1847. He joined the Old Water-Colour Society as Associate in 1809 and full member in 1810, and became ARA in 1833 and RA in 1838. Three small coloured illustrations of his in the Victoria and Albert Museum are soft in touch and come closer to Stothard than to Westall. A watercolour illustration to Goldsmith's *Vicar of Wakefield* (British Museum) is more or less intermediate between the two—Stothard without his happy charm, Westall without his richer colour and meaningless theatricality. There is a good collection of Uwins's drawings in the Print Room of the British Museum, including also pencil portraits, vignettes, pencil groups of people, Italian landscapes in pen and wash, a Sketching Society subject of the usual type (see p. 228), and a large number of costume drawings, including many of dons and undergraduates at Cambridge and Oxford, which show him to have been very skilful at rendering draperies in watercolour. His larger and more elaborate watercolours, such as *The Hop Gatherer* and *Haymakers at Dinner* (both in the Victoria and Albert Museum), are much more genuine things than those of Westall, but still rather on the sentimental side (223). Other members of the conventional school of illustrators at the end of our period were Henry Thomson, RA (1773–1843), John Thurston (1774–1822), and Richard Cook, RA (1784–1857)—and the list might be very greatly extended with artists who either did, or may be presumed to have done, occasional work of this kind in watercolour.

An illustrator of a different kind, since he dealt very largely with real rather than imaginary people, was John Augustus Atkinson (1775–18??). He was born in London and in 1784 was taken to St Petersburg by an uncle. There he was patronized by the Empress Catherine, and did not return to England until 1801. He exhibited at the Academy and elsewhere from 1803 to 1833, specializing in battle scenes, and was a member of the Water-Colour Society from 1808 to 1812. An admirable small battle scene in watercolour is *Two French Officers Taken by a British Soldier* ($8\frac{3}{4} \times 11$ inches), in Mr H. C. Green's collection. The drawing of the figures, in blue and red coats, is crisply done in pen, and the setting is a wooded valley, sketchily suggested (224). An aquatint of this drawing, by Dubourg, was published in 1817. It is not known when Atkinson died. His most notable work lies in the illustrations of Russian life and character done for *A Picturesque Representation of the Manners, Customs and Amusements of the Russians*. This work was published in 1812 in three volumes, but Atkinson, who was his own engraver, is said to have prepared the plates in 1803–1804. Original drawings for these illustrations occasionally turn up. They show Atkinson as master of clear-cut figure drawing in pen, with clear washes of colour. In 1807 he published *A Picturesque Representation, in one hundred coloured plates, of the Naval, Military and Miscellaneous Costumes of Great Britain*. Occasionally Atkinson in his drawings slipped over the border-line so to speak into a freer semi-caricature style, as for example in a spirited series of watercolour illustrations of *Don Quixote* which were shown at the

Beaux Arts Gallery in 1945. He also sometimes drew rustic subjects vaguely in the Morland tradition. There are good examples of Atkinson's work in the British and Victoria and Albert Museums. An amusing caricature of a poet, belonging to Mr Gilbert Davis, is reproduced as figure 225, next to a drawing of a similar subject by Rowlandson (226).

It is now time to turn to the caricaturists who worked in watercolour. But before coming to the remarkable generation born in the fifties of the eighteenth century, with Rowlandson at its head, a word must be said of at least one predecessor, John Collet, who was born about 1725. He was a pupil of George Lambert, worked both in oil and watercolour, and showed forty-seven exhibits at the Free Society of Artists between 1761 and 1783—his last exhibits being posthumous, since he died in Chelsea in 1780. To some extent he was an imitator of Hogarth, chiefly in his oils, but also in watercolours like *The Asylum for the Deaf* (Victoria and Albert Museum, $13\frac{3}{4} \times 21\frac{1}{8}$ inches) or *Night Musicians* (same museum, $10\frac{7}{8} \times 12\frac{1}{2}$ inches), compositions of many grotesque figures which are clearly modelled on such of Hogarth's paintings as *The Sleeping Congregation*. That we think of Collet first as a caricaturist, however, is chiefly due to the prints after his work in this kind, for he did watercolours of many other sorts; and of the original drawings which one sees caricatures form only a small minority. For instance, of the four examples in the British Museum none is a caricature, and of some fifteen or so which I have acquired at various times only one is of that kind (227). It is an amusing watercolour of two ladies, with ostrich plumes in their hair, being chased by the infuriated—and tail-less—birds from which the feathers were taken. This drawing was engraved as *The Feathered Fair in a Fright*, published by Carington Bowles about 1777. Of humorous intention, though not exactly a caricature, is a curious watercolour with apparently a card-playing significance, in Mr L. G. Duke's collection. But Collet also did pastoral landscapes with figures and cattle, horses with their grooms, little illustrations of birds and animals, and even I believe nudes—at any rate I once saw at a dealer's a recumbent nude in pen and watercolour which had every appearance of being his. It was very clumsy and unattractive, however, and may have been by an imitator. A characteristic of Collet's work is the thick black pen outline he used, especially for foliage and so forth. The effect of this, combined with his often rather hard and crude colour, can be very stiff and artificial. But at his best Collet is charming in a trivial, amusing way. The British Museum's watercolours by him include two lively scenes outside rural ale-houses, and especially a prim and formal scene in a stable yard which was formerly attributed to John Wootton (though it is certainly by Collet). It contains a good deal of interesting detail such as the leopard skin (with tail) on the back of a horse which a groom is holding for the inspection of a young gentleman. There is not so much heavy outlining of the trees as usual in this drawing, though the shapes are characteristically the same, and I suspect it may represent Collet's early work, before his mannerism had fixed so firmly upon him. The heavy outlining is also not so noticeable in the larger groups of figures, such as the two drawings, already mentioned, in the Victoria and Albert Museum. Of these *The Asylum for the Deaf* is an especially good and lively piece, the figures including a group of street musicians—cello, fiddle and pipe—a beggar-woman shouting into the ear-trumpet of an old lady at a window, a lady shaking a rattle to amuse a baby, an errand-boy whistling with his fingers in his mouth, and so on. I have sometimes had the idea, suggested by some of the figures in this drawing and the

Night Musicians, that an interesting group of largish single-figure drawings in pen and watercolour—character-drawings, passing at times into caricature—might be by Collet; but I feel no certainty of this—on the whole, indeed, I am disposed to reject the idea—and the drawings also suggest affinities with some such artist as L. P. Boitard—though they are not I believe by him. I know five drawings by this hand, three in Mr H. C. Green's collection, one in Mr L. G. Duke's, and one in my own. They seem to date from roughly 1750 to 1760. Most of them are 'low life' characters (my own drawing represents a lame and ragged elderly man, leaning on a crutch), but Mr Duke's example shows a character of rather higher social status. It is inscribed in pencil 'Mum', and, in a rather later hand on the mount, 'Dr Mum well known at the University of Oxford'. None of the others has any inscription, and the whole group remains a mystery. I have also sometimes wondered —but again without much conviction—whether these drawings might not be attributable to Edward Edwards.

It is a remarkable fact that almost all the chief caricaturists of the eighteenth century were born between 1750 and 1760—H. W. Bunbury (see Chapter XII) in 1750, Robert Dighton in 1752, Isaac Cruikshank in 1756 or 1757, Rowlandson in 1757, Gillray in 1757, G. M. Woodward about 1760, and John Nixon and John Boyne probably also in the same decade. Two of these, Rowlandson and Gillray, were incomparably greater than the others. James Gillray (1757–1815), however, a savage, angry spirit, much like Swift, and by a coincidence—or perhaps from some common inherent quality of mind— like Swift ending his days in imbecility, seems to have left behind him hardly any identifiable watercolour originals of his more than 1,200 published caricatures. Indeed drawings of any kind by Gillray are very rare, and almost all those which seem firmly established as his are slight and fragmentary. This is in strong contrast to Rowlandson, who left innumerable watercolour, pen and, more rarely, pencil drawings, many of them highly finished and elaborate. Such a difference must mean more than merely that Gillray did not make a habit of selling his originals, but must indicate a wide divergence of artistic method, for it seems incredible that, if Gillray habitually made finished drawings of his subjects, so few should have survived. There are six sketches by Gillray for one subject, some of them in a combination of black chalk and red ink, in the Victoria and Albert Museum, and the British Museum has the original of one Napoleonic caricature (228) and about twenty-five of his sketches, chiefly in pen or pencil, as well as twenty amateur drawings from which, according to the custom of the time, Gillray made prints. But there is nothing to justify his treatment at length in a work on watercolour.

Gillray's caricatures were for the most part fiercely political, though some few of his best plates, such as the delightful etching of Lord Derby and Miss Farren (*Tally-Ho and His Nimeney-Pimeney*) looking at the pictures at Christie's or that other amusing picture of the upset caused by a lady getting up to ring the bell at a party,* are social. Thomas Rowlandson† (1757–1827), by contrast, was almost entirely a social satirist and, moreover, of an opposite temperament. He could often be extremely coarse, but he could seldom be

* This latter print, however, is not an original design, but after a drawing by Brownlow North.

† There are several books on Rowlandson. See especially A. P. Oppé, *Thomas Rowlandson, his Drawings and Watercolours*, 1923, and the same writer's article Rowlandson, the Surprising', in *The Studio*, November 1942. Mr Bernard Falk's *Thomas Rowlandson, his Life and Art* (Hutchinson, £3 3s.), 1949, has lately corrected the previously accepted biography in several important particulars. I have here followed his version of the facts of Rowlandson's life, including the date of birth, which has generally been given as 1756. For the arguments involved, the reader is referred to Mr Falk's book.

angry, and he was not, like Gillray, a sort of perverted moralist. When Rowlandson was coarse, it was because he enjoyed coarseness. His was a spirit ebullient above all else, pouring out a vast stream of work done (save when he had repeated the same drawing so often that he was clearly sick of it) with extraordinary gusto and with the most astonishing fluency of hand and richness and variety of conception. This attitude begot in him as a rule a certain tolerance towards his subjects, however odious and ugly they might be. Yet to this generalization there were exceptions, and he could be really cruel in such drawings as *Madam Catalini's Mouth at Full Stretch* and the circular bull-baiting design, both illustrated in Mr Oppé's monograph, and the powerfully horrible head of a judge in his collection. Equally cruel are the drawings in which human and animal heads are juxtaposed, as it were in a competition of hideousness. This type of work is, I think, fairly late in Rowlandson's career—the bull-baiting roundel, which was done for Lord Byron, dates from about 1810. But usually this greatest of English comic draughtsmen was not deliberately cruel.

Thomas Rowlandson was born in the Old Jewry, London, in July 1757, the son of an unsuccessful warehouseman. He went to Dr Barrow's school in Soho Square, which must have been considered a good one, for his fellow-pupils included Edmund Burke's son Richard. Rowlandson studied at the Royal Academy from 1772. Mr Falk disputes the usually quoted story that he interrupted his work there with two years of study in Paris, arguing that though he did visit Paris in 1774 it was only for a few weeks. At the Academy he gained a silver medal for drawing in 1777. About this point in his career Rowlandson, like several others mentioned in this chapter, seems to have felt the influence of J. H. Mortimer, as is shown in a curious drawing of Academy students at work which is in Mr Oppé's collection. Rowlandson was brought up chiefly by a widowed aunt of London Huguenot family, who in 1789 left him (as Mr Falk estimates) about £2,000, which he gambled away.

He began to exhibit at the Academy in 1775, and continued to exhibit there or at the Society of Artists until 1787. Probably all his exhibits were drawings. Why he then stopped exhibiting remains a mystery. He visited various parts of the Continent at different times, and also made British tours which included Wales, the West Country and Yorkshire, though it would be difficult to work out their chronology because of the notorious unreliability of the dates which he sometimes put on his drawings. Occasionally these tours, however, are fixed by events. In 1782, for example, he went with his friend Henry Wigstead* to Spithead, after the foundering of the *Royal George*. There is, also, in the Victoria and Albert Museum a drawing of the prizes being brought into Portsmouth after Lord Howe's famous victory of 'the Glorious First of June' in 1794—a scene the artist may perhaps be presumed to have witnessed. But the same Museum has another

* Henry Wigstead is a mysterious figure. Some fine plates were etched by Rowlandson as after drawings by Wigstead, notably *Poet and Bookseller* and *Box-Lobby Loungers*. But first-rate drawings of both these subjects exist which are indubitably by Rowlandson himself. Moreover what was probably the latter drawing was exhibited at the Academy in 1785 under Wigstead's name. W. T. Whitley (*Artists and their Friends in England 1700-1799* Vol. II, p. 396) quotes the *St James's Chronicle* as saying of this and two other drawings shown by Wigstead in 1785: 'These humorous and excellent drawings we make no doubt to be the production of Mr Rowlandson; and we wonder anyone should exhibit them as his own whose abilities are known to be unequal to the invention or execution of such drawings. And what shall we say of the penetration of the Rulers of the Academy who could not see in them the hand of Rowlandson?' No doubt Wigstead's original drawings were amateurish and Rowlandson merely appropriated the ideas they contained; but it seems going rather far to exhibit the result as by Wigstead. I have never seen an undoubted drawing by the latter. The date of Wigstead's death is usually given as '1793?'; Colonel M. H. Grant, *Old English Landscape Painters*. Vol. III, 1947, states that he died at Margate in 1800. Mr Falk gives the exact date as September 29, 1800.

version of this drawing which is dated—quite impossibly—1780—a fair warning of the chaos into which a strict belief in Rowlandson's dating would lead one. Whether these wrong dates were put on by him with the deliberate intention of deceiving—for example to sell a late drawing as if it were an early one, or a replica as an original—or whether he simply wrote them on casually and without verification in later years is not evident.

By the middle of the seventeen-eighties Rowlandson was at the height of his powers. His large and staggeringly accomplished watercolour of *Vauxhall Gardens* was exhibited at the Academy in 1784. Until comparatively recently this was only known from engravings, but in 1945 the original was found in a small shop and sent by the finder to Christie's where it fetched the astounding price of £2,730. In its way—as a composition of many cleverly grouped, well characterized, and not greatly caricatured figures, in an attractive and effective setting—this is as good a drawing as Rowlandson ever did. The landscape element is confined to the trees, which are strongly and loosely drawn with the brush over slight pencil, but the subject interest, whether of the architecture (which again shows very bold and firm brush drawing) or the figures, is great. The latter—caricatured, but not grossly so—are superb, both individually and in their grouping. The whole thing brings vividly before one a fragment of eighteenth century London life—the woman singer, with the orchestra banked behind her, singing from one of the upper balconies or boxes, the party of elderly gentlemen supping in an alcove below, and the crowd of loungers and strollers of both sexes under the trees of the garden. This great drawing, which measures $18\frac{3}{4} \times 29\frac{1}{2}$ inches, may be taken as representing more than adequately that type of Rowlandson drawing which depicts the fashionable world, and its hangers-on, upon a high social occasion. There are many drawings of this type, their value to the historian of manners is great, and they are from the dealer's point of view the most 'important' and 'desirable' of Rowlandson's watercolours. In this class must also be mentioned two famous drawings, dating from the later 'eighties, *The English Review* and *The French Review*. These were done for the Prince of Wales, afterwards George IV, and are still in the Royal Collection. One of them, *The French Review*, which measures $19\frac{1}{2} \times 35\frac{3}{8}$ inches, was lent to the British exhibition in 1934. It represents a line of troops marching stiffly past a mounted general, and shows Rowlandson's fondness for using occasional almost geometrically formal groupings of men, as in the *Fair at Router* [Roughtor?] *Rocks, Cornwall,* in the Victoria and Albert Museum, where the lines of rustics and beasts form a St Andrew's cross over the whole foreground and more—one arm of the cross consisting of sheep-pens, one of horses, and two of cattle.

I confess to liking best the drawings in which the pen line is not too carefully controlled, and which show the amazing dash and movement of which Rowlandson, at his freest, was capable. These are not necessarily small sketchy things. They can be large and very telling, as for example the *Entrance to the Mall, Spring Gardens,* which Desmond Coke bequeathed to the Victoria and Albert Museum in 1931 along with nineteen other examples of the artist. This measures $13\frac{1}{4} \times 18\frac{9}{16}$ inches, and is a fairly elaborate composition, containing a good many figures. But it retains great vigour and freshness; the trees are put in with strong black shadows and (save that on the extreme right, which is all in black) washed with tender blues and pinks; and the principal figures, especially a stout old man and his wife, with a nubbly dog cavorting ahead of them, are strongly

outlined in black both with pen and brush. The colours of the clothes make a very pretty effect, though in fact they are almost confined to blue, red and white (229).

Yet perhaps the finest drawing Rowlandson ever did is a monochrome—*A Soirée at the Royal Academy*, which the late Henry Tonks lent to the exhibition of 1934 and which he bequeathed to the Slade School. This is a magnificently fluent sketch in pen and wash, and is on a fairly large scale, for it measures $15\frac{1}{2} \times 10\frac{3}{8}$ inches. It shows the curving, rather sharply rising, staircase at Somerset House up which people are climbing, while others (particularly towards the bottom of the stairs) are tumbling head-over-heels down in an indecorous avalanche of ungainly human forms. The drawing is one of tremendous vigour, rhythm, and movement, and is drawn with the utmost freedom of pen. It probably dates from the later nineties of the eighteenth century.

Rowlandson (so Mr Falk demonstrates) never married, though his housekeeper and mistress passed as his wife. He was somewhat dissipated, besides being a gambler. It is recorded, nevertheless, that he was punctilious in paying his debts, and there must have been definite limits to his gambling since, as Mr Oppé has pointed out, when Rowlandson died in 1827 he left something approaching £3,000, which meant more then than it does now.

One of Rowlandson's chief professional employments in later life was the illustration of books, his most conspicuous success being the long series of designs for William Combe's *The Tour of Dr Syntax in Search of the Picturesque*, which first appeared in book-form in 1812, but had previously been printed, from 1809, in Ackermann's *Poetical Magazine*. This was a rhyming burlesque suggested by the writings of William Gilpin. In the lean, hatchet-faced parson, Rowlandson invented the only pictorial character which, as an illustrator, he ever created. Many of the original drawings are in the Victoria and Albert. Later 'Syntax' tours followed in 1820 and 1821, and he illustrated these also, as well as a number of other books, either contemporary or by the classical novelists of the eighteenth century. In such work he was not always successful; his illustrations to *The Vicar of Wakefield*, for example, seem to lack much of the charm of the book itself. Mention must also be made of *The Microcosm of London*, 1808, to which Rowlandson contributed the figures which enliven the topographical and architectural illustrations of Augustus Charles Pugin.

On the whole, Rowlandson's best watercolours were done before the turn of the century, but there was never a period of his career at which he did not produce good drawings. After about 1800, however, the bulk of his pen work tends to be less lively in touch, and his use of watercolour, notably in his treatment of foliage, is less rich, less full of light and variety vigorously conveyed with the brush itself, and consists more often of a mere perfunctory laying of pale conventional washes of colour upon outlines rather formally outlined with the pen. One sees this even in so delightful a watercolour as *The Gardener's Offering* ($11 \times 16\frac{3}{4}$ inches), which was lent by Mr Henry Harris to the 1934 exhibition and is perhaps as near to the idyllic as Rowlandson could get. This picture of the young gardener kneeling to the young lady in a garden of carefully drawn, but completely artificial, flowers dates from somewhere in the first decade of the nineteenth century and is certainly one of Rowlandson's masterpieces, even though it lacks the spirited treatment of the best of the early work.

Rowlandson was an extraordinarily varied draughtsman, attempting far more styles and

subjects than the ordinary conception of his work allows. There are landscapes in soft pencil more or less in imitation of Gainsborough. There are large numbers of pen and watercolour studies of classical and mythological themes—perhaps the least successful or inspired section of his output. There are sheets of pretty little pen-and-wash drawings of statuettes, each an inch or two inches high. There are rather stiff drawings of horses and cattle, as well as such a simple and graceful study of dogs as Mr Leonard Duke's two greyhounds under a tree (231). There is pen and ink work in wide diversity of style, including such an early drawing, with conventional somewhat Mortimer-like hatching of the shadows, as Mr Oppé's *A Bench of Artists: Sketched at the Royal Academy in the Year 1776*, which only a practised eye would quickly detect as by Rowlandson. Almost as deceptive, at a first glance, though at the other extreme of the artist's pen-work, is a tiny drawing (it measures $3\frac{3}{4} \times 5\frac{3}{4}$ inches) in my own collection, representing two men boxing while others look on. It is sketchy in the extreme, and almost without the 'roly-poly' curves usually associated with Rowlandson, but intensely nervous and alive. A larger boxing subject, in rather similar technique, is *A Prize Fight* (British Museum, $7\frac{5}{8} \times 12\frac{1}{4}$ inches)—a very brilliant bit of pen-drawing.

There are—to continue the subject catalogue—a large number of drawings of shipping and Rowlandson's contribution as a watercolour landscape artist, which must not be forgotten either, for it is often of great beauty. Here, too, are unexpected things, such as slight impressions, consisting of loose pale washes of colour over a few very free traces of pencil. I have one such first impression of rocks at Tintagel. But it is more highly finished, and generally more artificial, landscape-drawings that we associate chiefly with Rowlandson. Wales and Devon and Cornwall seem to have moved him to some of his best work of this kind. In Wales he made a tour in 1797. With the West of England his chief ties were through his friend Mathew Michell of Hengar House, St Tudy, Cornwall. Presumably Rowlandson's visits there began about 1800. There is more freshness of vision in these west country scenes than in most of Rowlandson's landscapes, which are in general accomplished rather than genuinely observed. But even in the West, though it called out what there was of the poet in Rowlandson, there is something not quite convincing about his landscape drawings. Delightful though they are, it is hard to believe entirely in these twisted and gnarled oaks, rutty lanes, loaded farm-carts, ivy-clad bridges, and thatched cottages. Rowlandson was a little too evidently, like Dr Syntax, 'in search of the Picturesque'—and yet it is undeniable that what he found was, if not quite real, at any rate something rich and beautiful and altogether pleasurable. A very good example of his powers in landscape is *The Mouths of the Rheidol and Ystwyth at Aberystwyth*, bequeathed by Desmond Coke to the Victoria and Albert Museum. It is a long shallow watercolour, with some pen and pencil, measuring about $6\frac{1}{8} \times 17\frac{1}{4}$ inches, and (besides being very beautiful) is interesting as showing Rowlandson doing without his usual picturesque trees and other similar trappings and depending for his effect almost entirely on the lines of a wide sweeping landscape. The figures, carts, houses and so on are quite small in scale, and the eye is scarcely diverted from the lovely smooth hills—blue, with sunlit areas of pale buff yellow—which make up the background. This is indeed pure landscape of very high quality, rendered in little more than blue, yellow and grey, with occasional touches of red on horses and houses (230).

Rowlandson was also a portrait draughtsman, and many of his early exhibits at the Academy were portraits. Sometimes he did mere heads, sometimes smallish full-lengths. He had not a strong gift of likeness, except for the more rugged types, and his women tend to look either stupid or vicious. It is very seldom indeed that he gives an impression of unspoilt maidenly charm and freshness, such as appears in the face of a delightful slight watercolour in the British Museum, catalogued as *Portrait of a Lady* ($7\frac{1}{2} \times 6\frac{1}{8}$ inches). His best portrait is probably the *Portrait of George Morland* (British Museum. $12\frac{1}{2} \times 8\frac{1}{2}$ inches), a drawing of really masterly grace. Morland is seen as a young man, standing easily with his back to a fireplace, which is drawn in monochrome with the brush over slight pencil. The figure itself is in pen and watercolour, and is very delicately coloured—pale green coat, white waistcoat with blue stripes, cream breeches and buff tops to the boots. Morland is wearing a broad-brimmed black hat, and the colouring of the face is done with little stripes of pink.

It is above all as a figure draughtsman of infinite liveliness and invention that Rowlandson is famous, and it is in this sphere that he has left us his greatest legacy. Even here there are surprises, as in pseudo-medieval subjects, sometimes excellent, or groups of Italian peasants or priests—as also, of course, in the classical drawings already mentioned, and the adaptations of the Old Masters. On the whole, however, his figure subjects are a running commentary upon the life of his own day and country, particularly that of London, as seen by one who could appreciate to the full its bustle, diversity of character, pomp, squalor, lusty high spirits, and broad humour—but one also who seems to have been untouched by the finer thought and feeling of his time (it is strange to remember that he was only fourteen years older than Wordsworth—yet how many worlds apart) and who never, so far as I am aware, drew a single really beautiful face. Indeed the coarseness, or at very least the limitation, of Rowlandson's character appears much more evidently in his representations of human beauty than in those of human depravity. But for all this, one might have thought crippling, restriction of outlook and understanding, Rowlandson could create a beauty of line and of tint that can be nothing less than exquisite, and in even his weariest repetition, his most unlovely grotesque, there smoulders at least a spark of his magic. As for the scene he painted—the crowds at fairs and race-courses, the bruisers, Jew peddlers, soldiers in their barrack-rooms, sailors coming ashore hugging their blowzy wenches, coachmen, gamblers, drinkers, bawds, worn-out Grub-Street poets, young prodigals and elderly sharks, servant-girls, grooms, self-indulgent bewigged parsons, drunken fox-hunters, fish-wives—is there anywhere a gallery of English character comparable to them, save in the pages of Shakespeare and Dickens? But to name those two is immediately to throw Rowlandson, for all his genius and talent, back into a lower—a much lower—rank. For his portrait gallery is one of types, not of living individuals, and of his types there is not one which displays the nobility, or even the subtlety and intricacy, of the human spirit.

It may be added, as a warning to collectors, that there are a good many fake Rowlandsons about. Moreover it is common knowledge that many of the signatures on perfectly genuine drawings are forgeries.

Of the caricaturists who were more or less contemporary with Rowlandson it was George Moutard Woodward (1760?–1809) who was most influenced by him in manner.

The son of a Derbyshire squire he was untrained as an artist and came to London with an allowance from his father. He is said to have been dissipated and was penniless when he died of dropsy in the Brown Bear public house, Bow Street, whose landlord had been charitable enough to give him shelter. As a draughtsman he always remained very much of an amateur in accomplishment, though he worked prolifically as a professional. Much of his drawing was etched by Rowlandson or Isaac Cruikshank. He was the author and illustrator of various satirical works. His drawings lack the charm of those of Bunbury (the chief amateur artist of this type—see Chapter XII) and they have naturally none of the accomplishment of Rowlandson. The latter's work, especially that of about 1785, very much affected the drawings of Woodward, and the dark outlining of figures, which we see in much of Rowlandson's early work, was copied with a heavier and less certain touch by Woodward. His watercolours, though amateurish, nevertheless possess vigour and plenty of amusing ideas. He obviously enjoyed extravagances of costume, and was fond of doing such subjects as *Preparations for the Tragedy of Hamlet; or A Green Room in the Country* ($12\frac{1}{2} \times 18\frac{1}{2}$ inches), signed and dated February 1790, which I have. It shows a number of needy actors, some in full stage rig, others shaving, ironing or drying their shirts, and so on, in a draughty-looking room of *The Theatre in Thatch Row* where, according to a bill on the wall, *Hamlet* will be succeeded on the following Monday by *A New Way to Pay Old Debts*. Woodward has great fun again with eccentricities of costume in the Victoria and Albert Museum's *The Progress of Fashion*, which is the tallest drawing I ever saw, for it measures $85\frac{1}{8} \times 19\frac{7}{8}$ inches. Naturally the paper is not all of one piece, but is made up of a number of sheets pasted one at the top of the other. The subject consists of a series of twelve couples, showing male and female dress from primitive times to the end of the eighteenth century. I suspect that Woodward must have done drawings of this kind (he sometimes made them up into little booklets) largely for his own amusement. He was fond, too, of drawings divided into a number of compartments, in each of which is shown a different facet of the same idea. For instance in *Symptoms of Reform!* we have the wife who 'Lost 1,000 last night, very sorry indeed, truely penitent, declare I'll never touch a card again', the elector who refuses a bribe, and so forth. *A Dearth of Business or Everybody out of Town!* is constructed on similar principles. Both these are in my collection, for I have found Woodward an engaging artist. A considerable amount of his work has been on the market in recent years, owing no doubt to the dispersal of some old collection of it, and I have been unable to resist buying quite a number of his drawings. His style is usually unmistakable—especially his faces with thick, dark unevenly accented outlines and blotchy red complexions. He drew the human countenance much more effectively in profile than full-face—which was a bit beyond his technical powers. His handwriting is also distinctive as an aid to identification. But not all the signatures on his watercolours are genuine—many have been added later, and forged Woodward signatures have also been put on a number of drawings, sometimes very good and more professional than his own, by other artists (232 and 233).

John Nixon (died 1818) always remained an amateur, though there is sometimes confusion of his work with that of the professional James Nixon, ARA (1741?–1812) a miniature-painter who also did book-illustrations. John Nixon was a merchant in Basinghall Street, but must have devoted a good deal of time to art, for he showed forty-one exhibits at the

Royal Academy between 1781 and 1815. He specialized in large humorous watercolours containing many figures, which are well grouped, and have a certain hurly-burly liveliness; but they are not really very skilfully drawn and the faces·are nothing but grotesque masks with little human feeling or reality in them. Sir Robert Witt has an *Interior of the Old Pump Room, Bath* (14½×20 inches), signed and dated 1792, in pen and watercolour; and another Bath subject—*Sydney Gardens* (19⅛×26 inches), signed and dated 1801, which shows the building which is now the Holburne Museum, with Ralph Allen's sham castle on a hill in the distance—is in the British Museum. Several further examples are in the Victoria and Albert Museum, of which *The Cove at Cork* (19 13/16 × 26¾ inches), signed and dated 1794, is in parts a little reminiscent of Isaac Cruikshank, though coarser in touch. The left side of the picture is occupied with sea and shipping rather in the manner of Nicholas Pocock (see Chapter XI). To the right foreground is *The Cove Coffee House,* there are many figures of varying quality, and in the background is a pleasant rounded hill. The general colour effect is blue-green. On the whole the figures in this drawing are rather better than those in a later Nixon in the same Museum, *A Morning View on the Sands at Worthing* (17 15/16 × 28 inches), signed and dated 'John Nixon 1808'. The figures here are in several cases clumsy and inferior, though some of them, e.g. the old parson leading a lady through a pool, and some dogs, are obviously imitated from Rowlandson. A Nixon watercolour of great topographical interest is the British Museum's *Swansea Market*, which is about the same size as the *Sydney Gardens*, and is signed 'J. Nixon. 1799'. It is full of curious detail—the mountebanks on a stage in the background, the red or blue coats, and high-crowned, broad-brimmed, black hats of the market women, and so on. Though many of the figures are individually rather crude, the crowded scene is on the whole well managed. Another, and highly amusing, example of Nixon in the British Museum represents a stout lady reading *Jane Shore* aloud to a party of bored guests (234). It is signed 'John Nixon, 1788', and shows the influence of Woodward rather than of Rowlandson. The same museum exhibits Nixon in a different mood in two pleasant little watercolours of a jaunt taken down the Thames in 1801 by *The Sailing Club*, and Mr L. G. Duke has a similar subject in monochrome, dated 1806, which is rather more accomplished in drawing than usual. Nixon also did some book illustrations.

Our next two caricaturists, Isaac Cruikshank and Robert Dighton, were hard-bitten professionals who ground out their wares for the market without waiting for any very high, or even very humorous, inspiration. Indeed the humour of each of them seems to me hard and mechanical—though each, to give him his due, was a pretty competent tradesman. Isaac Cruikshank (1756?–1811?) was of Lowland Scottish parentage, the son of a minor artist, and the father of two much more successful draughtsmen—George (1792–1878) the celebrated nineteenth century illustrator and Isaac Robert (1789–1856) who was a popular caricaturist, especially of the follies of fashion. Isaac Cruikshank's death is said to have been hastened by drunkenness. He was not merely a comic draughtsman, for he did also such scenes of social drama and sentiment as the two watercolours in the Victoria and Albert Museum, *The Lost Child* and *The Child Found*. The former shows the bellman going off instructed by the distracted family to find the missing child; in the latter the bellman is seen bringing the child back, while in the background are the gipsies, who stole it, under arrest. These two subjects, with an intermediate scene showing

the discovery of the child in the gipsy encampment, were engraved. The facial expressions are somewhat commonplace, but the colour is agreeable, and the drawing, which is both with pen and brush, shows a less scratchy line than in certain other drawings of Isaac Cruikshank's I have seen. His gift for gay and pretty colour is seen also in two other *genre* drawings in the British Museum, *The Sailor's Sweetheart* ($11\frac{1}{2} \times 8\frac{7}{8}$ inches), and a skating scene of about the same dimensions. The former represents a scene on the lower deck of a man-of-war, where the sailors are entertaining their young women; the red jacket and white trousers with pink stripes, and the white bonnet with rich yellow ribbons, of the principal figures form a delightful bit of fresh colour (235). In the latter, besides the chief colour effects in the clothes, it is well worth noting the pretty touches of blue, pink, etc., in the accessories (bow on muff, hat-trimmings and so forth) which are highly characteristic of this artist. Occasionally, however, he worked in monochrome, as in a drawing of lady archers in Mrs Bernard Croft-Murray's collection.

Isaac Cruikshank's purely comic subjects strike me as having no real warmth of humour, but they are quite accomplished, often contain interesting details, and can be pretty in colour. These qualities appear in a drawing which I have, signed and dated 1807 ($6\frac{5}{8} \times 8\frac{1}{8}$ inches). It represents two servant girls at the door of a small shop which shows the sign of a frog (smoking a pipe) and a frying pan. In the distance is a view of St Paul's. To the left a small boy in blue carries a kite on his back. The shopman, of hideous aspect and wearing a red tassel cap, points into his premises where all sorts of oddments, such as a mousetrap, a wig, a bundle of candles and so on, are on sale. But the colours—the green and yellow of the girls' frocks, especially—are very fresh and make the drawing an agreeable one. These comic drawings of Isaac Cruikshank's are not, I think, common, but Mr Ralph Edwards has one of a man being tossed into a ditch by a bull, and Mr L. G. Duke another of a young wife seeing her elderly husband off to the hunt, while her lover peeps from under the bed.*

Robert Dighton (1752?–1814) I find very crude and unlovely as a comic watercolourist, except perhaps in his backgrounds, though his etched caricatures of individual people, lawyers, dons and so forth, show a sense of character and are decorative. He taught drawing, drew portraits, including a number of small theatrical portraits, and apparently also dealt in prints. In 1806 it was discovered that he had stolen and sold some etchings and other prints from the British Museum—an incident which led to the separation of prints and drawings from the manuscripts as an independent department. The chief thing noticeable about his caricature watercolours is the harshly coloured, staring, grinning faces, which are totally devoid of any real human emotion or expression. His *Men of War Bound for the Port of Pleasure* (British Museum. $12\frac{5}{8} \times 9\frac{7}{8}$ inches), a group of newly-landed sailors being robbed of their money by harlots, is a really coarse and ugly thing, though not without a certain accomplishment in the painting of clothes and so on. Less displeasing is the same Museum's *Keep Within Compass* ($12\frac{3}{4} \times 10$ inches), which was engraved in 1785. The centre of this is occupied by a lady (standing between the legs of a pair of compasses) who contemplates a chest, full of gold, jewels and bank notes, which is inscribed *The Reward of Virtue*. In the four corners appear smaller figures of less virtuous and fortunate ladies. There is some pleasant colour and background detail in this too

* See Ralph Edwards, 'Isaac Cruickshank', *Burlington Magazine*, April 1928.

obvious morality. Two very harshly coloured single figures—a French father and an English one—reading news from the Napoleonic Wars, which are catalogued as by Dighton in the British Museum, seem strikingly different from his usual work and are not signed. At the Victoria and Albert Museum, Dighton is represented by another heavy-handed morality, *Fortune Distributing Her Gifts*, and by one of his more amusing compositions *A Windy Day—Scene Outside the Shop of Bowles, the Printseller, in St Paul's Churchyard* ($12\frac{5}{8} \times 9\frac{5}{8}$ inches)—but even here the humour (an old lady whose hat and wig are blown away, a fishmonger's boy sprawling on the ground with his fish, and so on) is obvious and laboured (236). The view of the shop-window is, however, a valuable document. One form Dighton's facetiousness took was in the drawing of watercolour *Caricature Maps*, one at least of which I have seen engraved. I have two of these watercolours—Scotland represented in the form of a grotesque dwarf, and England in that of a man riding a monstrous fish. The quality of the watercolour is fairly high, but I find the drawings dreary in the extreme, and prefer a rather Rowlandsonian monochrome of a fat parson pulling a cork out of a bottle with his teeth. Some of Dighton's caricatures are in a hybrid method, part etching, part drawing and watercolour. Dighton had two sons, Richard (working about 1800–1827), who did semi-caricature likenesses, and Denis (1792–1827), who specialized in military portraits.

A caricaturist whose drawings are, I believe, rare, was John Boyne (*c.* 1750–1810). He was an Irishman, son of a Cork joiner who settled in London when the boy was about nine. He was apprenticed to the engraver Byrne, became a strolling player, but in 1781 returned to London and set up a drawing school. He sent eighteen exhibits to the Royal Academy between 1788 and 1809. There are examples of his work in the Royal collection at Windsor, and there are others in that of Sir Bruce Ingram and in the museums. In the Victoria and Albert Museum there is an amusing *Meeting of the Connoisseurs* ($16\frac{1}{4} \times 21\frac{7}{8}$ inches), signed 'J. Boyne Int & a [?d]'. The title is hardly descriptive enough, for it represents a scene in an artist's garret, lit by a window from the left. Four gentlemen in blue, brown or red coats are grouped round an easel, while a fifth, to the right, poses a huge negro. The artist, holding his palette and sucking his mahlstick, stands by the easel looking anxiously at the youngest of his visitors, a young fop whom an older man is evidently urging to commission a painting. The painter's wife and children, dog and cat, are more slightly indicated. The drawing (which is rather Rowlandsonian, but weaker and less certain) is in fine pen and watercolour, and there is an agreeable softness in the colour (237). A slighter example, *The Quack Doctor*, showing rather flaccid drawing with a fine pen, but pretty colour, is in the British Museum, which also has a Mortimerish head and shoulders of King Lear in black chalk and wash, the face rather highly coloured in watercolours.

Among minor humorous watercolourists may be mentioned Samuel Collings (worked about 1780–1790) who did some caricature illustrations of Boswell and Johnson in the Hebrides which were etched by Rowlandson. His drawings are rare, but a charming watercolour by him of a musical party (238) was shown at Walker's Galleries, New Bond Street, in 1932. There were, again, a few provincial performers, of whom John Collier (1708–1786) was one. For the greater part of his life he was a schoolmaster near Rochdale. He wrote verses, often in the Lancashire dialect, which he published over the pseudonym

Tim Bobbin, and also practised in some degree the arts of music, drawing, painting, modelling and etching. His engraved caricature illustrations are crude in the extreme. A grotesque figure of a ragged man leaning on a crooked stick, in Indian ink, which I have, is signed 'T. Bob. inv. del. 1770', and poor as it is it seems to be an original by him. Comparable in talent with Collier was a Scottish artist, John Kay (1742–1830), by whom Mr L. G. Duke has a small oval caricature group in watercolour—again a crude performance. He was a barber in Edinburgh, before devoting himself to miniature portraits and caricatures, which are said to have shown, in spite of their artlessness, a strong gift for likeness. More pleasing though rather stilted is a little horizontal oval drawing in pen and watercolour, in my own collection, signed 'J. Dunthorne Del in. 1788', which represents half-a-dozen gentlemen seated round a table, while a maid brings one of them a tankard. Pen, ink and books lie on the table, and on the walls hang framed the 'Rules of This Club, 1788'—so doubtless the drawing, which is a mild caricature, depicts a small provincial literary or political society, probably at Colchester. There were two John Dunthornes, father and son, practising in that town in the eighteenth century, and this drawing is presumably by the son, who exhibited at the Academy between 1783 and 1792 a number of subject pictures such as *The Hypochondriac and the Lunatic* and *Rustic Dinner*. The father is described as a portrait-painter.

It has to be remembered that caricatures were often done by artists whose usual productions were of some quite different order. For example I have one by John Downman, the portrait watercolourist, which is dated 1779 and inscribed *The Only Charactura I ever drew*. And there are many other instances, such as that of George Shepheard, a landscape watercolourist who is said to have come of a Herefordshire family. His exact dates I do not know. He was exhibiting at the Academy from 1811 to 1842, but was already working nearly twenty years before the earlier date, for I have an amusing small pen drawing of his father, mother, and others playing whist at East Sheen in 1793, and a little watercolour of a cottage amid trees dated 1795. I have also a number of sketches and two sketchbooks by him, which include Irish (1807) and Welsh (1825) subjects—though whether he was actually in those countries at those dates I do not know. Certainly he was in France in April 1816. His English landscape subjects are chiefly in Surrey, Middlesex, Sussex and Kent. In 1801 his address was 9 East Street, Red Lion Square, and he was still there in 1811. (I record these trifles of information, since little is said about Shepheard in the ordinary books of reference.) In 1814 his address is given by Graves as 17 Great Ormond Street, and in 1821 as 100 Guildford Street, Russell Square. There were several admirable examples of Shepheard's caricatures in the sale of Randall Davies's collection at Sotheby's in 1947, and there are others in various private collections. A specially good type of these caricatures is that consisting of groupings of the same three figures—identified on the drawings as 'Haughton, Field and Shepheard'. One which I have (8⅜×6 inches) shows the three young men struggling in a doorway, a lively composition, vigorously drawn with the pen and tinted with watercolour, chiefly in blue, grey and pink (241). A fourth figure, 'Adam', appears in some drawings. The only one of the four, apart from Shepheard himself, of whom I know anything was Haughton. He was Matthew Haughton, and I have a pen drawing of him dated 1796 inscribed on the back 'By his most intimate friend George Shepheard. They were students together at

Dickensons'. I possess, too, a rather stiff caricature in pen and ink by Haughton, signed and dated 1803, and by a pleasant coincidence I also have his portrait of Shepheard, stripped to the waist and in boxing attitude. He does not appear ever to have exhibited. In 1948 I saw in Messrs Appleby's shop an ambitious watercolour, *L'Allegro* ($14\frac{3}{4} \times 10\frac{3}{4}$ inches), somewhat in Samuel Shelley's allegorical manner, which was signed 'Mathw Haughton pinxt 1794'. A label on the back of the frame stated that he was born at Wednesbury in 1772 and died in 1848. I do not know the authority for this.

Another group of caricatures which were by-products of a quite different artistic career —or careers—is that connected with the name of Dance. Many of these are quite certainly by the architect George Dance, Junior, RA (1741–1825), also known for his long series of portrait drawings of famous contemporaries. But others are by his elder brother Nathaniel, in later life Sir Nathaniel Dance-Holland, RA (1734–1811), painter of portraits and classical subjects. In caricature the work of these brothers seems to me indistinguishable. I have two little grotesques in pen and wash which one would unhesitatingly attribute to a single hand—yet one is inscribed 'G.D.' and the other 'Sr. N.D.', both inscriptions being in the same handwriting. Grotesques are frequent among these Dance drawings—little creatures half mouse half man, heads with jugs for bodies and so forth. At their best (and their quality varies a good deal) the humorous drawings of the Dance group can be delightful. One of the most charming I know is in Mr L. G. Duke's collection and is inscribed *Conquering a Chromatic Passage*. This is in pen and watercolour, and very fresh and pretty in colour. It depicts a party of musicians—a lady singer in a yellow dress over a blue underskirt, a fiddler in a blue coat, a double-bass player and a fourth performer playing a pipe of some sort. The look of eager anxiety on the lady's face is most amusing, and the whole thing is taking and spirited (239).

By chance there are in my own collection two drawings, coming within the scope of this chapter, by artists whose most familiar vein was in theatrical portraiture, James Roberts (working 1766–1800) and Samuel de Wilde (1748–1832). Roberts is best known for the small portraits of actors which he did for Bell's *British Theatre*. More than sixty of these, in watercolour on vellum, dated 1775 to 1788, are in the Burney collection at the British Museum. The example of Roberts to which I referred a few lines back is in pen, partly tinted with watercolour, measures $6\frac{1}{4} \times 10\frac{3}{4}$ inches, and represents, somewhat stiffly, a duel in which one man spears another through the chest (240). It is subscribed 'Drawn from the life by James Roberts. 1779', but is very close in style to the fencing illustrations which John Gwyn did for Domenico Angelo's *L'Ecole des Armes*, 1763, and even closer to those which John McArthur did for his own *Army and Navy Gentlemen's Companion*, 1780.* For some years Roberts taught drawing at Oxford, where he fell under the influence of J. B. Malchair (see Chapter V) as two or three rather unattractive, garishly coloured, watercolour landscapes by Roberts in the British Museum very clearly demonstrate. The example of de Wilde is in watercolour with outlines in reed pen, and is signed 'S D W July 31st 1806'. It measures $8\frac{1}{4} \times 12\frac{7}{8}$ inches and is unhappily a good deal faded. It shows four fat little cherubs, two dressed up as Comedy and Tragedy, while the third sketches them and the fourth looks on (243). It is amusing and charming, and different not only in subject but also in technique from de Wilde's usual work. Of that

* See J. D. Aylward, 'Some XVIII Century Fencing Books', *Connoisseur*, March 1948.

the Victoria and Albert Museum's *George Davies Harley as Kent in 'King Lear'* (14×9 inches) may be taken as a good example (242). It is drawn in very soft pencil or crayon and is coloured in quiet tones of watercolour—pale reddish coat, brownish leggings and so on. The whole, including the face, is done with delicate care, yet with a good deal of spirit. De Wilde worked in a good many other mediums, including oils.

Standing somewhat apart from the other artists discussed in this chapter was the Scot, David Allan (1744–1796). He was born at Alloa, Clackmannan, apprenticed in 1755 to Robert Foulis, one of the famous Glasgow printers of that name, and in 1764, through the help of various gentlemen from his native place, sent to Rome. He stayed there some years, but by 1777,* at least, was in London, where he remained until 1779, when he returned to Scotland, settling for the rest of his life in Edinburgh. In 1786 he succeeded Alexander Runciman as director of the Trustees' Academy there. He painted both in oils and watercolours, and in his homely Scottish subjects was a precursor of Wilkie, Burnet, and their school. Of Allan's watercolours there are examples in the British Museum and elsewhere. Three very good ones are in the Glasgow Art Gallery, and these include a pair, *Evening Amusements, Naples*, signed and dated 1770, and *Evening Amusements, Rome*, signed and dated 1771, each measuring approximately 13⅜×17¾ inches. These are couched in a half-humorous, half-romantic vein, and have a certain stilted elegance which is quite attractive. The colour is rather pale and lacking in force. The Naples drawing shows people sitting, eating and drinking, with Vesuvius in the background. One man in a three-cornered hat smokes a very long pipe, another plays a mandolin, and so forth. In the Roman drawing there is a party of people singing to the left, while to the right a monk reads the words '*Omnia vanitas*'. Also at Glasgow is another watercolour, a Scottish domestic interior, about 12¼×18 inches, in which the figures are pleasurably drawn with the brush and lightly tinted, the effect being scarcely more than monochrome (245). They include the grandfather holding a boy on his knee, a woman at a cooking-pot to the left, a boy playing a pipe, and another eating to the right. Evidently Allan sometimes found it profitable to produce Italian drawings after his return home, for the British Museum has a Neapolitan watercolour (rather similar to that at Glasgow) which is dated 1787. Allan drew illustrations for a number of Scottish songs, and I saw some of these, rather roughly drawn in monochrome, a year or two since at a dealer's. Allan dealt rather in quiet domestic humour and character than in caricature.

Naturally the artists mentioned in this chapter do not exhaust the list of either caricaturists or more solemn draughtsmen in watercolour. A glance, for example, at the catalogue at the Victoria and Albert Museum will reveal such names as those of John Hodges Benwell (1764–1785), who, to judge from a single elegant and accomplished example (244), might have achieved eminence had he lived longer, and Elias Martin, ARA (1739–1818), a Swede, who spent a good many years in England† and whose *Interior, with Family Group* has a rough vigour (246). But on the whole the most important artists in this kind have

* The British Museum catalogue of drawings says Allan was back in England in 1771, but see addenda.
† Martin was in England from 1768 to 1780 and from 1788 to 1791. Among a very large number of his drawings belonging to the National Museum, Stockholm, where a comprehensive exhibition of his work, with illustrated catalogue, was held in April–June 1950, there are several slight and freely sketched English landscapes, besides many portrait and figure drawings, etc., done in England. The British Museum has three classical or religious figure subjects in pen and watercolour. The Victoria and Albert Museum, besides the drawing mentioned above, has a large oval watercolour, 'State Barges approaching Westminster Bridge', signed and dated 1771, of some historical interest.

been considered, and we come back to the general estimate from which we started, the perception of two commanding, sharply contrasted, geniuses, Blake and Rowlandson, who dominate the field of English figure draughtsmanship—with somewhere not far off the sweet and delicate spirit of Thomas Stothard, gently reigning over a fanciful little principality of his own.

The East Anglians

NO SECTION of England has contributed more to English watercolour, and to English landscape painting in general, than East Anglia. We have already seen how Gainsborough hailed from Sudbury in Suffolk, though except during his earliest period the landscape of his native county can hardly be said to have affected his art greatly. He was an East Anglian painter chiefly in the sense that he came from East Anglia. But later artists were to be East Anglians in a much deeper sense and to be strongly affected in their practice by the gently undulating landscape, the broadly billowing tree clumps, and the wide skies with long rolling banks of cloud which, through the comparative flatness of the land, there form so noticeable an ingredient of the scene. Constable's attitude to the visible world was largely fashioned by his love for the Suffolk and Essex borderland in which he was born, where he passed his early years, and where he regularly returned to paint long after he was settled in London—the area round East Bergholt, Dedham, Stoke-by-Nayland and the rest of the villages that form what is still 'the Constable country'.

Even more distinctive, however, is the contribution made to our story by Norwich, since there alone in England during the period covered by this book did a recognizable local school firmly establish itself. There were perhaps the beginnings of such things at Exeter through Towne, and at Bath through the Barkers, but only at Norwich did a really important provincial school come into existence. What the remote causes of this may have been is a matter of speculation beyond the scope of this book. It will be enough to notice that in the eighteenth century, and for a good many years after, Norwich, a flourishing city, was by its geographical position considerably more remote from the main lines of travel and intercourse than the other great cities of England. The immediate cause was that at Norwich artists found it possible to remain and work in their native city.* Crome, the chief master of the school, worked all his life at Norwich, and Cotman, who though he may have come second to Crome in general position was the more important as a water-colourist, did so for many years. The Norwich artists were therefore more than natives of their city, they were part of its daily life. At Norwich alone among English towns was the young painter's first step forward not necessarily along the road to London.

In years the seniors of the Norwich school were two minor artists who were originally heraldic painters, John Ninham (1754–1817), father of the rather better known Henry Ninham (1793–1874), and James Sillett (1764–1840). Watercolours or other drawings by

* There were some exceptions. Charles Catton, RA (1728–1798) was a native of Norwich, but early came to London to be apprenticed to a coachpainter. However his son, Charles Catton, junior (1756–1819), though born in London, seems to have at least retained some interest in Norwich, for a small watercolour view of the city is in the Victoria and Albert Museum. It was engraved in the *Copper-plate Magazine* in 1792. The younger Catton emigrated to America in 1804.

both of these exist, notably flower subjects, skilful if a little stiff, by Sillett, of whose work a watercolour of mallows, signed 'J. S. 1803', and two of tulips, one of which is signed 'Sillett Delt. 1802', all in the British Museum, are good examples (247). There are similar watercolours of grapes in the Castle Museum, Norwich. The latter gallery also contains a not very good gouache landscape, strongly under French influence, signed and dated 1797, by another presumably early Norwich painter, Charles Hodgson. I do not know when he was born, perhaps soon after 1770. He died in 1856. He was the father of David Hodgson (1798–1864), a painter of Norwich topography in oils and watercolour. John Crome,* however, towers high above such dwarfs. He was born on December 23, 1768, the son of the landlord of the Griffin Inn, Norwich. After enough education to teach him to read and write, he became errand boy to Dr Rigby, a physician of some mark, with whom he lodged. In 1783 he was apprenticed for seven years to Francis Whisler, a coach and sign painter, whose shop was close to Dr Rigby's house.

A contemporary Norwich apprentice was Robert Ladbrooke (1768–1842), who also became a painter and who was associated with Crome in the foundation of the Norwich Society of Artists in 1803. He was apprenticed to a printer, and legend has it that the two lads hired a garret in which to paint. Some watercolours by Ladbrooke survive, including a rather pretty little *Old Wall at Carrow Abbey*, in the British Museum, carried out in pleasantly soft and misty colours—but not a great work (248). It comes from James Reeve's collection of drawings, etchings, and so on of the Norwich School, acquired by the Museum in 1902. Another watercolour in this collection, attributed to Ladbrooke, is somewhat in the manner of Robert Dixon, who will be mentioned later in this chapter.

Sign-painting continued to occupy Crome, at least in part, up to 1803, and signs attributed to him still exist. In the meantime, and while still apprenticed to Whisler, he had somehow attracted the notice of Thomas Harvey of Catton, who came of a wealthy Norwich business family, owned a collection of pictures (including a Hobbema and some Wilsons and Gainsboroughs) and was himself an amateur artist, by whom I have seen pencil or crayon drawings of figures and cattle, somewhat in the manner of George Frost of Ipswich. At Catton Crome met the portrait painter Beechey, later Sir William Beechey, RA (1753–1839), and when afterwards Crome visited London he used to call on Beechey and spend the evening with him—but it must be added that though this statement has Beechey's own authority, Mr Mottram does not find it fully credible. In 1790 Crome's apprenticeship came to an end and in 1792 he married Phoebe Berney, by whom he had several children, amongst others John Berney Crome (1794–1842), who also was a painter. Norwich continued to be Crome's home until his death in 1821.

Artistically Crome (often called 'Old Crome' to distinguish him from his son) was slow in developing. He seems to have painted his first landscape about 1796, and did not exhibit in London until 1806, when he had two landscapes at the Academy. As a drawing master he was established in practice before the end of the eighteenth century, charging his pupils a guinea for half a year's instruction, materials extra. Among those he taught were, from 1798, the daughters of the Quaker banker, John Gurney of Earlham, one of whom later became famous as Elizabeth Fry. In 1802 Crome accompanied the Gurney family on a sketching tour in the Lakes, and he made another tour there with them in 1806.

* See *Crome*, by C. H. Collins Baker. Methuen. 1921; and *John Crome of Norwich*, by R. H. Mottram. Lane. 1931.

In 1804 he and his friend Robert Ladbrooke visited Wales. In 1811 it is possible (but not certain) that he went to Derbyshire. It was in 1814 that he made his only trip abroad—to Paris to see the pictures then brought together in the Tuileries before they were dispersed again. Possibly Crome made other tours—but I do not think there is any certain evidence. In the main his inspiration came from his own county of Norfolk.

In 1803 there was founded 'The Norwich Society for the purpose of an inquiry into the rise, progress and present state of painting, architecture, and sculpture with a view to point out the best methods of study to attain to greater perfection in these arts', later known as the Norwich Society of Artists. It seems at first to have been a discussion society, and its meetings, which were fortnightly, were held at a tavern called 'The Hole in the Wall'. The society was sometimes called 'The Hole in the Wall Club'. Its annual exhibitions began in 1805 (when Crome sent 22 exhibits, more than half of them sketches or watercolours) and continued (with some interruptions in the later years) until 1833. The Society ceased to exist after Cotman's final removal to London.

In 1808 Crome* was elected President of the Society with Ladbrooke as Vice-President. The two were not only long-standing friends, but also brothers-in-law, having married sisters. In 1816, however, they appeared to have differed on the question whether the funds of the Society should be spent on suppers (as Crome thought) or plaster casts (as Ladbrooke wished), and Ladbrooke seceded, taking with him Sillett (who had become President in 1815), Thirtle, and some others to found the rival Norfolk and Norwich Society of Artists, which lasted no more than three years. This quarrel was only healed on Crome's death-bed.

Crome was principally an oil-painter. His watercolours are rare—he is indeed the rarest of the great watercolourists, but the nobility of his surviving works in the medium gives him a full right to the title. Unfortunately, the originally most important of his watercolours in the British Museum, a large upright, *Near Caister*, is very seriously faded, as can be seen from an inch or so round the margin which has been covered by a mount and has retained its colour. This unfaded area shows that all the rich blue has gone from the greater part of the drawing and that sombre foliage, with some traces of very dark green about it, has been reduced to a sort of brick red. The subject is trees over a stream, and very free pencil underlies the watercolour. A fine and large Crome watercolour, perhaps unfinished, also in the British Museum, is *The Hollow Road* ($16\frac{1}{4} \times 24\frac{1}{4}$ inches), which shows a very characteristic rendering of oak trees. This again is rather faded, but not so much as to destroy its essential breadth and nobility. A better opinion of Crome's qualities can, however, really be formed from the examples in the Victoria and Albert Museum, though the *Ruined Castle: Evening* ($12 \times 17\frac{1}{2}$ inches) there is also considerably faded, with the result that what was originally a blueish and greenish drawing is now purple and brown. Moreover this drawing has not the exquisite rich softness of some of Crome's watercolours, though it is notable for its fine sense of mass and for the balance between the sweep of the country and the horizontal lines of cloud and light in the sky behind the castle in the centre and the trees to the right. But it is remarkable how with Crome—as often with Girtin—a faded drawing can yet retain and reveal the simple strength of conception which it enshrines. Those who saw the Hickman Bacon collection when it was exhibited at Agnew's

* Crome was President again in 1810, with Cotman as his Vice-President.

and in various provincial towns in 1945 and 1947 will no doubt remember how this quality stood evident in the two examples of Crome—*The River through the Trees* and *The Blasted Oak*—much though they had suffered from time.

But to revert to the drawings at South Kensington. The finest of these is the *Landscape with Cottages*, which is sometimes called *The Shadowed Road* (249). This is a rather broad upright, measuring $20\frac{1}{2} \times 16\frac{3}{4}$ inches. A track leads almost straight up the lower part of the picture, with a perhaps unnaturally bright patch of light striking across it from a break in the tall trees which border it to the right. A little girl in a red skirt crosses the brightly lit patch of road, just beyond which, and still to the right, are some cottages. Bushes and smaller trees, with contrasted surfaces of light and shade, grow to the left of the track. Roughly the upper left quarter of the picture consists of sky. The colours—exquisitely rich and soft—are chiefly reddish and greenish browns and grey-blue. The whole picture speaks of a robust and yet gracious nobility and simplicity of mind. Incidentally it is curious to note a doubtless fortuitous similarity to Taverner in the effects of light on the bushes to the left of the road. Also notable is the *Wood Scene* ($22\frac{1}{4} \times 16\frac{1}{4}$ inches) in the same museum, which represents tall upright trees on a sandy bank with a glimpse of water and sky beyond. In its present somewhat faded condition it is chiefly a thing of purplish browns, dark olive greens and blues. In contrast with certain other Crome drawings no traces of pencil work are noticeable in this, the whole of which seems done—very strongly and with bold touches on the foliage—by the brush. But strong as it is an immense gentleness of spirit pervades the whole.

Some good examples of Crome's watercolours are in the great collection of works of the Norwich School formed by the late Russell J. Colman and bequeathed by him to the City of Norwich. As I write these are mostly still in Mrs Colman's care at Crown Point, pending the possibility of building the special gallery which is to house them. Of the Crome watercolours, which fill a whole room at Crown Point, perhaps the most beautiful is a tall upright, measuring $22\frac{1}{2} \times 16\frac{1}{2}$ inches, *A Lane at Norwich*. The lane, in point of fact, is not what one notices in this drawing, which is primarily concerned with the tall trees flanking and overshadowing it so that it seems a mere break in their midst. They are painted, very freely and loosely, but with a perfect understanding of their form and towering height, chiefly in various tones of grey and brown, and the colours do not strike one as much faded. In any case the effect is majestic and deeply poetic. There is more variety of colour in another drawing in the Colman collection *River and Rocks* ($16 \times 22\frac{3}{8}$ inches). To the right is a rocky bluff, the rocks rendered in grey with reddish lights. Beyond and to the left is a green-blue hill-side, dotted with white, slate-roofed, houses, while between rocks and hill curves a stream that falls over a low broad weir of stones. This has all Crome's sense of breadth and mass, but a little of his occasional clumsiness too. Several other notable drawings show other aspects of his art, especially two largish monochromes in a greyish brown wash. Of these one, *Whitlingham*, a very simple, strong, composition of a church standing in a hill above a quarry, is particularly beautiful and, in spite of its comparative slightness, is most satisfyingly warm, broad, and free (250).

A number of miscellaneous drawings—in watercolour, wash and pencil—attributed to Crome on the authority of James Reeve and coming from his collection, are in the British Museum. Reeve's knowledge of the Norwich School was very great, and one would not

lightly dispute any view of his. But some of these drawings are very difficult—at any rate on a superficial acquaintance—to reconcile with one's conception of Crome's work and abilities. One or two are monochromes reminiscent of early Cotman. One at least of the watercolours seems vastly inferior to Crome's finest work. Others are quite convincing—notably a very beautiful slight grey monochrome of oak trees standing suffused in misty light upon a bank. But I fancy there still remains a great deal to be done in the study of Crome's slighter drawings—including the little landscape notes in soft pencil of which he did a number—probably, if one only knew the truth, a great many. These sometimes show a curious mannerism of suddenly emphasizing small points, say the muzzles or eyes of cattle, with little black digs of the pencil. These pencil scraps can be deeply revealing of Crome's love and understanding of trees, above all of oaks.

The bewilderment into which the student falls in looking at the various drawings to which Crome's name has been attached is by no means dispelled by the collection of his work in the Castle Museum, Norwich. The very large watercolour ($23 \times 28\frac{5}{8}$ inches), *Demolition of the Infirmary Buildings, Norwich Cathedral Priory*, 1804, a powerful and broad rendering of architectural mass, adds convincingly to one's understanding of his range, and a long series of pencil studies of trees, cottages, etc., acquired in 1942, which was previously in the collections of H. S. Theobald and Lord Mancroft, is interesting and at any rate strongly suggestive of Crome. But there are many other things—some Hearne-like and pretty watercolours of cottages, for instance—which are most puzzling. Indeed, the only possible conclusion seems to be that it is high time some serious critical study was attempted of Crome's drawings.

John Thirtle (1777–1839) sometimes came near to Crome in feeling, though he also owed much to Cotman, whose wife's sister he married. The son of a Norwich shoemaker, he was originally a miniaturist and worked for a while in London. He then returned to his native city where he set up as a frame-maker, carver and gilder, and showed examples of his own portraits and miniatures in his shop. He also taught drawing. He exhibited with the Norwich Society from 1805, but only once in London. It is another sign of his, until comparatively recently, chiefly local fame that there is no notice of him in the *Dictionary of National Biography*. I only know his work in watercolour, and if oils exist they must be rare. His subjects are chiefly from Norfolk, London and Wales. According to the catalogue of the Victoria and Albert Museum many of his drawings were copied. A beautiful example of his finished landscapes is at South Kensington. This, which measures $10 \times 14\frac{15}{16}$ inches, is a widely spreading scene, the land rendered chiefly in grey with patches of ochre and pale mauve, with a grey cloudy sky above. Dark trees accent the view, and the contrasting undulations of the fields are most delicately suggested. Generally, however, his finished watercolours are less pleasing than his sketches—a point easily appreciated by looking through the series of his work acquired by the British Museum in 1902 from James Reeve. Here the large river landscape, *Thorpe Watering—A Summer Morning* ($13\frac{1}{4} \times 19\frac{1}{2}$ inches), is entirely lacking in spirit and (having suffered much from fading) is moreover over hot in colouring, as is another highly finished drawing, with wiped-out lights, *Cromer Looking East* (10×14 inches); whereas several small sketches of sailing boats on the river are deliciously spontaneous and fresh in colour. Very charming, too, is a study of old cottages, *St Miles, Norwich* ($10\frac{1}{4} \times 9\frac{1}{4}$ inches), in which some slightly Turnerish pencil work is combined

with delicate washes of colour—beautiful soft reds for the roofs, with pale grey sky above—to give a sensitive and ethereal effect (251). I have two slight sketches very close to this drawing—one of riverside buildings, the other of an old farm and trees. In this mood Thirtle can come near to certain Crome watercolours, such as the *Houses and Wherries on the Yare* reproduced in Mr Collins Baker's monograph. An extremely beautiful outdoor sketch version of this subject came into Messrs Colnaghi's hands a few years ago (it is now in the Whitworth Gallery at Manchester) and caused considerable argument whether it was by Crome or by Thirtle. But to return to the Thirtles at the British Museum, the most Cotman-like of them is *Under Bishop Bridge* ($11\frac{3}{8} \times 15\frac{1}{2}$ inches)—a view under the arch of a bridge, with rowing boats moored in the foreground, and beyond a cottage, green fields, and trees along a receding stretch of river (252). It owes a lot to Cotman's work of about 1805–10 and is much broader in treatment, much fresher, richer and cleaner in colour, than most of Thirtle's more studiously premeditated drawings. Another watercolour which owes much to Cotman, *St Benet's Abbey* ($9\frac{1}{2} \times 13\frac{3}{4}$ inches), is not so solid and convincing as it should be. There is a large and varied collection of Thirtle's work at Norwich. It includes several big watercolours, with very hot red foregrounds, bright blue skies, and perhaps a rainbow, which I find unattractive, though much must be allowed for the effect of time and light upon the colours. There are also some charming slighter sketches; examples of his small, rather stiff, watercolour portraits; and a large, and to me unpleasing, *Susannah and the Elders* somewhat in the manner of Richard Westall.

A minor member of the Norwich School who deserves mention was Robert Dixon (1780–1815). He was born and also died in Norwich, but as a young man studied at the Royal Academy before returning to his native city to work as a drawing-master and scene-painter. He showed at the first exhibition of the Norwich Society in 1805, and became its Vice-President in 1809.

In London the most elaborate example of his work known to me is the *Farmyard, with Figures and Cattle* ($22\frac{1}{2} \times 28$ inches), signed and dated 1809, in the Victoria and Albert Museum, but it is so much and so unequally faded that little can be judged of its original effect. Other and fresher examples show that Dixon's watercolours vary greatly in quality. Often his washes are harsh in colour, his forms crudely simplified. The British Museum has a number of examples from Reeve's collection, which include a weakly Girtinesque watercolour of a cottage and children by a pond; a not unpleasingly Japanesy unfinished watercolour of a house by the waterside, with boats moored, having strong, clean lights on the building, tree, etc.; and a grey monochrome influenced by early Cotman or Munn. With these at best third-rate drawings another watercolour from the same source, which is also said to be by Dixon, contrasts curiously. This is a small open-air sketch, *Fishermen's Cottages, Overstrand, near Cromer: Morning*, very pretty and delicate in its effects of brownish red on the buildings and road contrasted with blue sky and sea in the background. It is hard to understand how the hand that produced this could have produced some of the other things attributed to it, though James Reeve recorded in his manuscript catalogue that it could be traced back to the collection of the artist's son. Dixon's watercolour sketches occasionally turn up, usually unrecognized. I have, I think, found five, at various times, one of which provided one of those curious coincidences which all collectors occasionally experience. In a Birmingham pawnshop I noticed a small watercolour, labelled as

by David Cox (253 and 254). It was clearly not that—and within a month or so I had found, in another Birmingham shop, a soft-ground etching of the same subject—*Cottage at Diss*—signed by Robert Dixon and published at Norwich in 1811, being one of the series of views of Norfolk scenes, drawn and etched by him in 1810–1811. The etching differs somewhat—it has an extra window and a second figure—from the watercolour. The latter, which is chiefly in blue, blue-green, and leaden-grey with reds and browns on the building, is quite a favourable example of this artist, though the single figure is weak and the washes have something of Dixon's habitual harshness of touch and quality. The best Dixon watercolours that I have seen are, however, at Norwich, especially *St Leonard's Priory* ($12\frac{3}{4} \times 17$ inches), signed and dated 1809, which in the massing of the ruin, and the sombre colour, is rather like Crome. There, too, is a very delicate sketch, *City Walls, Magdalen Gates, Norwich* ($7\frac{5}{8} \times 12$ inches), slightly drawn in pencil with pale washes of grey, brick-pink, and so forth, which may be compared in freshness and lightness of touch with the Overstrand sketch at the British Museum. Like that drawing it once belonged to James Reeve. A very large finished version (22×31 inches) of the same subject, also in the Castle Museum, is a competent performance, but misses the charm of the preliminary study done on the spot.

The greatest of the Norwich watercolourists, not even excepting Crome, was undoubtedly John Sell Cotman (1782–1842).* He was not purely a watercolourist, for there are some notable oils by him, and many etchings. Nor was he entirely a Norwich artist, for he worked during many years elsewhere; much of his best work is inspired by Yorkshire or Normandy, and his powerful and highly original style is something quite distinct from that of Crome and his followers. But Norwich was his background, with which he never lost touch; for long periods he practised his art there; he was a leading member of the Norwich Society; and the course of his life and professional career were deeply affected by conditions in his native city.

John Sell Cotman was born on May 16, 1782, the son of Edmund Cotman of Norwich. The *Dictionary of National Biography* describes Edmund as a prosperous silk-mercer and dealer in foreign lace, but Kitson showed that he was originally a barber, became a draper towards the end ot the century, and was probably never prosperous. The boy was educated at the Norwich Grammar School, and on leaving assisted his father for a while. He had, however, begun to sketch and in 1798 went to London to learn to be an artist, remaining there until the end of 1806. His first employment was with Rudolf Ackermann at 101 Strand—probably not to teach in the drawing school but to colour the aquatints which Ackermann published. Cotman, however, did not stay there long. Whether he had any professional master is not known, but in 1799 he was working—like so many other young draughtsmen—under Dr Monro in Adelphi Terrace, and stayed at his house at Fetcham in that summer. It was no doubt through this connection that Cotman felt the influence of Girtin, which is evident in some of his early work, though Girtin and Turner were then no longer working under Monro. This influence is seen very clearly in many of Cotman's drawings up to about 1802. It persisted much later, though in a form transmuted by and

* One of the few English watercolourists of whom a first-rate full-length modern biography exists—*The Life of John Sell Cotman*, by Sydney D. Kitson. Faber. 1937. But the reader should also consult *Crome and Cotman*, by Laurence Binyon, Portfolio Monographs. 1897; *The Watercolour Drawings of John Sell Cotman*, by A. P. Oppé. Studio. 1923; *John Sell Cotman's Letters from Normandy 1817–1820*, edited by H. Isherwood Kay. Walpole Society, Vols. XIV and XV, 1926 and 1927; and *The Burlington Magazine*, July 1942, a special Cotman number with important articles by L. Binyon, A. P. Oppé and Martin Hardie.

absorbed into Cotman's own personal idiom. In the early work, however, it is often so little diluted that the inspiration of Girtin's example makes itself felt immediately, as in *Barmouth River, with Cader Idris*, signed and dated 1801, in the Russell Colman collection at Norwich.

Reference has already been made to 'The Brothers', the drawing society founded by Girtin and others in 1799. This a couple of years later provided for Cotman another contact with Girtin, for at some time in 1801 they both contributed drawings of *An Ancient Castle* to the society. Cotman was then apparently not yet a member, but on June 5, 1802, there is a record that he presided at a meeting and so must have been elected in the interval. Exactly how long his membership continued is not clear, certainly till 1804, probably until he left London in 1806. Kitson suggests that through association at meetings ot this society Cotman greatly influenced John Varley, though the latter was his senior by four years. After Girtin's death in 1802, Cotman seems to have been regarded as the leading spirit in the drawing society.*

In 1800 Cotman obtained an award from the Society of Arts for a drawing of a mill, and in the same year he first exhibited at the Academy, showing six drawings. His address was then 28 Gerrard Street, Soho. In this year, too, he made his first sketching tour, setting out by way of Bristol, where in June he drew ten pencil portraits of the Norton family, relatives of Peter Norton, a printseller of Soho Square, who befriended him about this period. Portrait-drawing was practised by him at various times during his career. From Bristol he travelled northwards through Wales. Kitson suggests, from several parallels of subject, that at Conway Cotman met Girtin (who was probably there with Sir George Beaumont in July), and that they returned to England together through Llangollen to Bridgnorth. After this first Welsh tour Cotman visited his parents for a while in Norwich, before returning to London in the late autumn. In August of 1801 he again visted Norwich, and afterwards went for a while to South Devon. He also on this occasion paid a second visit to Bristol, out of which seems to have arisen the large and very powerful *St Mary Redcliff, Bristol; Dawn* ($14\frac{3}{4} \times 21\frac{1}{4}$ inches) in the British Museum, a remarkable drawing indeed for so young an artist, though I imagine its date to be perhaps a year or so after the visit on which the sketches for it were probably done. It shows the church, and a smoking furnace beyond, looming up amidst the mirk of half-light and city smoke above a misty creek that leads out to the river, where shipping can be discerned, to the left. The colour—restricted to browns, blacks and greys—helps greatly in creating the effect of gloom and grime inherent in the industrialism that was already beginning to engulf so much of nineteenth century England. A second Welsh tour took place in July 1802. Cotman was in this year, and until 1804, living at 107 New Bond Street, the address of the three brothers, William and James Munn, stationers and printsellers, and Paul Sandby Munn, watercolourist (see p. 63). Here Cotman helped P. S. Munn to turn out drawing-copies, and the two went together on the 1802 Welsh tour. It is sometimes possible to pair drawings by Munn and by Cotman which must, from their similarity of subject, have been sketched when the two artists were sitting side by side on this tour. Kitson reproduced one such pair of a *Coal Shaft at Coalbrooke*, which presents a striking contrast between the timid and uninspired prettiness of Munn and the bold sense of design of Cotman, which was al-

* But see footnote on p. 102.

ready beginning to build up towards his individual style. This was Cotman's last visit to Wales, though he afterwards produced Welsh drawings, done from sketches of 1800 and 1802. About 1803 or 1804, for example, he did the very beautiful *Chirk Aqueduct* (sometimes called *Landscape with Viaduct*) in the Victoria and Albert Museum, an upright design, measuring $12\frac{7}{16} \times 9\frac{1}{8}$ inches, which shows him very nearly at the height of his powers—so rapidly did he develop at this time. The tall narrow arches of the aqueduct—greyish-white with a suffusion of ochre—strike boldly across the upper part of the picture and are reflected in water in the foreground, while through them appears a wooded valley land-scape of subdued olive green. The sky above is of a soft blue—quite without the stridency of some of Cotman's later blue skies—and is reflected (through the arches) in the water as patches of dove grey. The colour combines with the complex series of curves, lines and angles of the aqueduct, its reflection and shadows, and the triangular spit of land that stretches out from the left at the foot of the arches, to create a design of great beauty and of almost dramatic effect. There is a fair amount of pencil visible under the water-colour (255).

The turning point of Cotman's career, and indeed the chief and most poetic inspiration of his life, came to him in his visits to Yorkshire, in 1803, 1804 and 1805—above all the last. For the beginning of the 1803 tour P. S. Munn was his companion, but after that Munn, who was then no longer within hailing distance of Cotman artistically, almost fades out of the picture of his life, though there were some later contacts and no doubt they remained friends.

Cotman's hosts on all three Yorkshire visits were Mr and Mrs Francis Cholmeley of Brandsby Hall. Mrs Cholmeley drew a little and was interested in art, and Kitson sur-mised that she may have seen Cotman and Munn sketching at York early in July 1803, and have carried them back to Brandsby. It seems to me more probable that the visit to Brandsby (which began on July 7 and lasted, with periods spent either alone or with the Cholmeleys at Helmsley, Richmond, Durham, Wakefield and elsewhere, until September 22) was prearranged, possibly through Mrs Cholmeley's brother Sir Harry Englefield, who was a friend of Dr Monro, and to whom in 1811 Cotman dedicated his first collection of etchings. In 1804 Cotman joined the Cholmeleys at Scarborough late in the summer and then spent from September 25 to November 13 with them at Brandsby. In 1805—the greatest of his Yorkshire years and the artistic peak of his whole life—he was at Brandsby from July 13 to November 19, though with breaks between July 30 and September 14, during which his host was John Morritt of Rokeby Park, and between October 4 and 11 when he was at Castle Howard. It was while at Rokeby that Cotman, beside visiting Durham, made his celebrated watercolour studies of the river Greta and its surrounding rocks and trees.

Cotman never revisited Yorkshire, but for the next five years or so, at least, the inspira-tion of Yorkshire scenery and especially of the Greta woods flamed in him with only gradu-ally diminishing force. During this period he evolved a style which, in its clear patterning of areas of flat colour, contrasting sharply in tone, has something strangely oriental about it. In British watercolour it can only be compared with the work of Francis Towne, but it is without Towne's firm outlining with the pen and the character of the two men's washes is very different, so that no doubt the spiritual affinity which one senses between the two is

fortuitous. Of great drawings of the period of the Yorkshire visits and the years immediately succeeding the nation is fortunate in owning a number.

One of the most beautiful of these is the *Sarcophagus in a Park* (13×8⅝ inches), once belonging to Dawson Turner and now in the British Museum. Kitson dated it about 1805 or 1806, and, though the catalogue describes it as a composition, I like to think of it as at least constructed out of the memory of something seen in a Yorkshire garden. It is an upright design, and the troughlike sarcophagus of light brown stands upon a white pedestal, carved with figures, in the centre. At the base of the pedestal there are small patches of rich orange-brown and of pinkish-brown-red, and a bank of less vivid brown. Below is a pool of leaden grey water, while above and behind are a fir, and other closely grown trees, in various rather sombre tones of olive-green, blue-green and grey-green. The foliage shapes are beautifully formalized to suggest the several different kinds of tree. The top left corner of the picture is filled with soft blue sky and grey and white cloud, and about the whole there is a warm richness that is intensely satisfying. Only the slightest touches of pencil are perceptible under the watercolour (256). This drawing appears to me to have all the magic quality of touch of some of the slighter open-air studies of foliage or rocks by the Greta, with the added attraction given by the formality of the subject. Another Yorkshire drawing of 1805 in the British Museum is the *Drop Gate at Duncombe Park* (14×9 inches), a study in planes and angles which must surely have been done on the spot. The rickety wooden drop-gate hangs by chains from a beam across the dark brown water of a stream. In the foreground is pale dull-green foliage—rather loosely suggested, but probably representing butter-bur. Beyond is a dark bank of earth with trees above to the right and, to the left, a leaden-black sky. The colour in general is dark, even muddy, relieved by lighter tones in some parts of the drop-gate itself, and by a solitary touch of blue in a tall plant which sticks up from among the leaves in the foreground, adding a vivid flash to the whole. This is a drawing which was clearly never intended for sale or exhibition, but which has a sombre beauty of texture far exceeding that of much of Cotman's more 'finished' work. What is probably another study, or elaboration from a study, in Duncombe Park, is the British Museum's *Pastoral Scene: Composition* (12½×8⅝ inches), which shows, like the *Horses drinking* (11½×8½ inches) of about 1806 in the same collection, the power and depth of Cotman's use of sepia monochrome.

Of the more deliberate watercolours of this period, elaborated in the studio from his outdoor sketches, two may perhaps be selected for mention, the British Museum's *Greta Bridge* (8¾×12¾ inches) and *The New Bridge, Durham* (17×12⅝ inches), in the Sir Hickman Bacon collection. The former is a thing full of the most exquisite pellucid atmosphere. The light whitish grey stone bridge spans the stream in the middle distance, and below it the river widens out towards the spectator into a pool of silvery water broken with rocks of brown and black. A solid, square, stone house stands above and beyond the bridge-end to the left, while to the right of the bridge are grey-brown and dark reddish-brown clumps of trees. A blue-grey line of woodland completes the horizon behind the bridge and the house, while above is a blue sky with patches of brilliant white cloud and, at the very top, a stratum of grey. A dark horse waters in the stream, and a group of light brown cattle by the houses is just sufficiently defined to catch the light. Formal though the presentation is, the drawing is done almost entirely with the brush, few traces of pencil being visible, except on

the house itself. This watercolour, though a studio work, must have been done very soon after the last Yorkshire visit, when the scene it depicts was still fresh in the artist's eye. *The New Bridge, Durham* (257), dating from 1805, is a studio-work of a different kind, in which Cotman was more interested in building up a pattern of form and colour than in recalling a scene. The artist's viewpoint is on an eminence from which he looks down into the wooded river valley along which flows a silvery stream spanned by a gleaming white bridge deep in the heart of the picture. The vista down to this focal point is through a sequence of silhouetted masses of foliage, the tender greens of the foreground being succeeded by darker shades, with still darker ones beyond the bridge. Both these pictures show Cotman at his best, when his preoccupation with pattern, flat areas of colour, and clear-cut form were still fresh and vital, and had not acquired the hardness, the too obvious stylization, which spoils much of his work of this sort even as early as 1810—as shown by the British Museum's *A Draining Mill in Lincolnshire*, which is dated in that year, and is to my eye too hard and mannered to be pleasing. Of Cotman's gifts as an architectural watercolourist in his early period *St Luke's Chapel, Norwich Cathedral* ($13\frac{3}{4} \times 18$ inches) in the Castle Museum, Norwich, is an outstanding example. It was done about 1807 or 1808, and is a broad and noble rendering of English Norman architecture.

Even while Cotman was still visiting Yorkshire, the next phase of his life was preparing. He regularly interspersed his Welsh and northern tours with visits to Norwich and so kept touch with East Anglia. In the summer of 1804 he made the acquaintance of Dawson Turner (1775–1858), a Yarmouth banker who was also a botanist and antiquary of parts, and in July stayed with him and his family at Covehithe, on the Suffolk coast. Turner was to become Cotman's chief patron and employer and to influence very greatly the course of his professional life. In the autumn of 1806, after a summer visit to Lord Stafford at Trentham, Cotman went as usual to see his parents, and then or soon after decided to leave London and settle at Norwich and open there a school of drawing and design. This he did just before Christmas, holding an exhibition of his work to mark his arrival. In the same autumn, too, he painted his first picture in oils, and the greater part of his work in that medium was done in the next four years, though he took the medium up again in the 'twenties. Cotman continued to live at Norwich until 1812, and during that time, on January 6, 1809, he married Ann Miles of Felbrigg. By her he had five children, of whom two sons, Miles Edmund (1810–1858) and Joseph John (1814–1878), became well-known watercolourists.

Cotman was now working primarily as a provincial drawing-master, and etcher, and a draughtsman of architectural and antiquarian subjects. In 1809 he advertised that he had a collection of six hundred drawings available for amateurs to copy for a quarterly subscription of a guinea. He continued throughout his life to produce such drawing copies, which can be told from his other works by their being numbered. Of these he was responsible eventually for more than four thousand, many of the later ones being dull and lifeless things, of which little but the signature can be by J. S. Cotman himself; and in fact it is known that he was helped in producing them by his family, particularly Miles Edmund and his daughter Ann. The earliest copies are much fresher in inspiration than the later, and are presumably entirely Cotman's own work.

Norwich, however, did not bring such success to Cotman as he had hoped. The trade of

the town had begun to decline, and there was thus not too much money available for luxuries like painting and drawing. In April 1812, upon the invitation of Dawson Turner, Cotman moved to Yarmouth, succeeding Crome as drawing-master to Turner's daughters. There he remained for the next twelve years, guided in the employment of his talents very largely by Dawson Turner's predilection for archaeology and architecture. Yet during this period came a second peak—much lower indeed than that of 1805, yet productive of some noble and strikingly original work—in Cotman's visits to Normandy in 1817, 1818 and 1820. The inspiration for these travels—the only three which Cotman ever made outside Britain—certainly came from Dawson Turner, who had visited Paris in September 1815, and had seen something of the architecture of Normandy on his way back. He wished Cotman to make drawings of it for comparison with the architecture of the Norman conquerors in England. The result was a series of the finest architectural sepia wash drawings ever done by an English artist. In fact, these appear to have been made after his return to England, for Kitson states that Cotman does not seem to have taken painting materials with him on any of his three Normandy tours, but to have relied on his memory to amplify the pencil sketches—and they were a vast number—done on the spot. Some of these pencil studies were made with the help of the *Camera Lucida*, or 'Graphic Telescope', an apparatus invented by Cornelius Varley, whereby an object is reflected on to a sheet of paper on which it can be traced.

Cotman's first French tour lasted from June 20, 1817, when he landed in Dieppe from Brighton, until August 10, when he left Havre for Southampton. During these seven weeks he visited Arques, Bolbec, Rouen, Caen, Bayeux, St Lo, Coutances, Granville, Avranches, Mont St Michel, and other places. On the 1818 tour it was originally the plan that Dawson Turner, with his wife and various members of the family including his son-in-law the eminent botanist William Hooker (afterwards knighted), should accompany Cotman, in order that Turner might collect material for his *Letters from Normandy*. But he was prevented from going until the party had been nearly two months there, when he joined them at Rouen for three weeks. Mrs Turner and her family had gone to France early in June and Cotman had followed, leaving Brighton on June 18, and meeting them at Gournay on June 23. He was with the Turners, helping them with their drawings besides making his own, much (though not all) of the time until they returned home in the middle of August. He then remained alone in France for rather less than another month, getting back to Yarmouth before the middle of September. Les Andelys, Rouen, Jumièges, Honfleur, Lisieux, Caen, Valognes (where he stayed with M. de Gerville, an antiquary) and Falaise, were among the places visited by Cotman on this tour. Two years later, there being still gaps to be filled in his pictorial record of Normandy's architecture, Cotman decided to go there again, and on July 26, 1820, reached Havre. This time his tour—the last he ever made abroad—continued until October 10, and in its course he was at Caen, Alençon, Séez, St Lo, Coutances, Valognes (where he stayed again with his friend de Gerville), Cherbourg, Mont St Michel and elsewhere. Above all there were Domfront and Mortain where the rocky and hilly landscape, piling itself into a natural architecture more fantastic even than the most elaborately ornate of the buildings, fired his imagination for the production of what are perhaps the best of all his Norman drawings in sepia. During the last weeks of this tour, while at Caen, Cotman was overcome by a spiritual depression which

for a time incapacitated him from work and was a symptom of the mental instability which grew more marked in his later years and which was inherited by certain of his children to the point of actual insanity.

Cotman's sketches on his three Norman tours were put to many uses. Some of them, engraved by the Miss Turners, were reproduced to illustrate Dawson Turner's two volumes of *Letters from Normandy*, 1820. Cotman's own etchings, done with some assistance from one Joseph Lambert, of whom little is known, were published in *The Architectural Antiquities of Normandy*, 2 volumes, 1822. He made, as already stated, a large number of extremely beautiful pencil and sepia drawings both of architecture and of landscape, which occupy a very special place in his life's work, and which show, equally in his treatment of buildings and of rocks and other natural features, the great delicacy and purity of his monochrome washes, his remarkable feeling for outline, pattern, and form, and his dramatic appreciation of the contrasts offered by surfaces in shade and in brilliant light. The more elaborate watercolours which Cotman did from his Norman sketches I do not usually care for. Their colour I find often garish and they can be vastly overloaded with pseudo-medieval figures and other details which detract from the grand, and very subtle, simplicities which are the glory of his art. Several of the Norman architectural monochromes are among the Cotman drawings bequeathed to the Royal Institute of British Architects by Sydney Kitson. Of the Norman landscape monochromes a splendid example, belonging to Mr Martin Hardie, is *Domfront: Looking to the South East* ($15\frac{15}{16} \times 10\frac{3}{16}$ inches), which was seen at the British Exhibition at Burlington House in 1934. Here the fantastically geometrical rock formations put one in mind of both architecture and sculpture, and Cotman has clearly tackled the problems they set him much as he tackled those of architectural drawing (258). How much more direct and moving his appeal is in such pieces than in the elaborate watercolours which he constructed upon Norman medieval subjects such as the *Maison Abbatiale, or Logis Abbatial, Abbey of St Ouen, Rouen*, of which several versions exist. One of these is the large watercolour—it measures almost $17 \times 23\frac{1}{4}$ inches—now in the Victoria and Albert Museum and originally exhibited by Cotman at Norwich in 1824. It is to be noted that this, and its fellows, must have been done from a sketch, or print, by another artist, since the house was pulled down in 1816—a year before Cotman's first visit to France. To my mind it is a most unpleasing, though skilfully laboured, thing, artificial in feeling and ugly in colour. The great stone building, lavishly ornate with carvings, is rendered in various shades of mustard brown or yellow, with red, purple or blue blinds in the windows. Above is a strong blue sky, overblown in parts with filmy white clouds. In the foreground is a stretch of gravel in rather duller tones of mustard brown, with figures (ladies, monks, gallants, horses, dogs) in brightly coloured archaic costumes, some of which echo the blue of the sky above. But the general effect is the curious and sad one of a Cotman which is almost as dull and insipid as a Prout.

The years between Cotman's return from his third Normandy tour and his death in 1842 were artistically the least rewarding of his life. His touch remained as skilful and brilliant as ever, but the exquisite freshness of his best earlier work seems for the most part to have disappeared, and his colour, striving after ever more striking and powerful effects, often appears sadly vulgarized and garish. Nevertheless the spark within him was always capable of being fanned into a flame, and though these years of much endeavour, interrupted by

163

growing mental strain and ill-health, produced a great deal of uninspired and laboured work, yet there were also many things of great beauty. There was never a time in Cotman's life at which some new visual experience could not stir his mind to the creation of a really fine drawing.

An example to the point is what is perhaps his best drawing of the sea, the *Shipping at Sea after a Storm*, sometime called *A Dismasted Brig* ($7\frac{3}{4} \times 12\frac{1}{8}$ inches), in the British Museum, which was done about 1823. It is in watercolour over slight traces of pencil, and in colour it is almost entirely blue—intense blues for the sky, greenish or greyish blues for the water— with accents of red and brown on a floating spar in the left foreground, and a pink flag flying from the surviving mast of the principal ship. The boats ride on the crest of the wave, the brig in the centre of the picture outlined against a patch of glowing white cloud, the two others smaller and to the right. Three things strike one particularly about this exquisite work—the singular translucency of both sea and sky; the firmness with which the essential shapes are grasped; and the combination of most delicate and precise (though not over-detailed) drawing of the ships with the very free and bold washes in the sky. Though it has not the warmth of the best work of 1805 (perhaps the subject forbids it) it has great freshness of vision. Indeed it is a masterpiece of its kind (259).

The events of this period may be summarized very briefly. In the last month of 1823 Cotman returned from Yarmouth to Norwich, where he remained for ten years. It seemed to him that, now that Crome was dead, there was a first-class opening for him as a teacher in Norwich, and he set up a drawing school in a large house near the Bishop's Palace. To pay the expenses of the move he held a sale of his drawings, including some two hundred studies for his *Architectural Antiquities of Normandy*, at Christie's on May 1, 1824. It was not a success, the total realized being only £196 10s. 0d. The drawing school, also, was unsuccessful, partly because commerce was not then flourishing in Norwich, partly also because other things, especially painting in oils, which he had once again taken up, interested Cotman more deeply. In 1825 he was in serious money difficulties, and the next year saw a period of despair in which he could not work and wrote that 'The sun has set for ever on my career and all is darkness before me.' He gradually roused himself from this mental paralysis and in succeeding years his output increased again in spite of re- curring fits of deep depression. From this life he was rescued in 1834 by his appointment, through the kind agency of Sir Francis Palgrave and Dawson Turner, as Professor of Drawing at King's College, London. This post he held until his death. The salary was £100 a year and £1 for every pupil over the first hundred—initially about £200 in all, a figure which later rose to £300. At first the family was divided—Joseph John coming with his father to live in lodgings in London—while Mrs Cotman and the others remained at Norwich where Miles Edmund attempted to continue his father's teaching practice.* The experiment was not a success, and both establishments were soon in money difficulties. Cotman's wild initial high spirits were followed by depression, and Joseph John began to show signs of mental disturbance. At the end of 1834 the family were reunited and settled, through Lady Palgrave's help, at 42 Hunter Street, Bloomsbury, Cotman's last home, where, on July 24, 1842, he died. In the autumn before his death he had paid his final visit

* Subsequently the positions of the two sons were reversed, Joseph John teaching at Norwich and Miles Edmund helping his father in London.

to Norwich, where his genius was fanned to its last flame in a series of richly impressive black chalk sketches, such as the British Museum's *The World Afloat* ($8\frac{3}{4} \times 14\frac{1}{4}$ inches), a strong and free study of trees amid floods (260).

It has been customary to look upon Cotman as a creative artist condemned to do antiquarian and topographical work, and overloaded to distraction with the production of drawing copies and the other humdrum cares of teaching. Certainly he himself occasionally lamented his plight, and suffered from periods, sometimes prolonged, of melancholy. But Mr Oppé* has challenged the general truth of the picture and has pointed out that Dawson Turner was a considerate patron and that as regards the last eight years of Cotman's life the conditions in which he worked at King's College were very easy. In fact they gave him the independence to pursue his studies as an artist, which he had long desired. He taught on only two days a week and then only in the mornings, or at most until three in the afternoon. His stock of drawing copies was already large, and he had the help of his children in producing others, so that, except perhaps at first, their supply can hardly have been burdensome. He must therefore have had a good deal of time left for original work, and there are references in his letters of this period to the delights of his profession. The conclusion seems inescapable that Cotman's periods of depression, like those of exuberant high spirits, arose not primarily from his material circumstances but from the instability of his temperament.

Cotman's remaining works were sold at Christie's on May 18 and 19, 1843, but fetched only £219 17s. 6d. As there were 375 drawings, as well as paintings, in this sale, it will be seen that the prices they made were grotesquely small in comparison with the values set upon them today.

As an example of Cotman's last period there may be mentioned the *Yarmouth Beach* ($14\frac{1}{2} \times 21$ inches) in the Russell Colman collection. This is probably as fine a watercolour in Cotman's late style as exists. A group of men, with horses and fishing nets, stands on the sand, with a distant windmill to the left and the misty sea to the right, while above them towers the most tremendous and dramatic sky—a brilliant glow of light surmounted by a great swirl of deep blue atmosphere. One cannot help being impressed by its immense force; and one notices that this is one of the drawings in which Cotman, striving to make watercolour vie in strength with oils, used a curious medium which he is said to have made from the liquid derived from rotting flour paste. Mr Martin Hardie, in the Cotman number of the *Burlington Magazine*, thought the recipe was simpler than that, being merely the use of flour or rice paste, not necessarily sour, as a medium to mix with colour, to give a characteristic semi-opaque result. The medium was employed, very effectively, by Cotman in certain drawings smaller and less strongly coloured than *Yarmouth Beach*; notably the pleasant low-toned *A Punt among the Reeds* at Cardiff and the Victoria and Albert Museum's *The Lake*—both drawings of about 1837 to 1839, in which impressive use is made of dark forbidding masses of trees (261).

The last of the East Anglians in this chapter is John Constable (1776–1837).† He was primarily an oil painter, and though he made a very large number of drawings, a good

* In *The Burlington Magazine*, July 1942.
† The leading biographical authority is C. R. Leslie's *Memoirs of the Life of John Constable, RA*, 1843 (2nd edition, augmented, 1845). An edition of this book edited and enlarged by Mr Andrew Shirley appeared in 1937 (Medici Society. 35s.). A useful popular summary of Constable's career is Mr Sydney J. Key's *John Constable, His Life and Work* (Phoenix House. 15s. 1948).

proportion of them in watercolour, his use of this medium was on the whole merely inci-
dental, except perhaps for a period late in his career. For that reason his life and achieve-
ment may be dealt with in this book rather more briefly than his outstanding eminence as
a landscape painter would otherwise demand. More than any of the other East Anglians,
more even than Crome, Constable as an artist was the product of his native countryside,
whose rich agricultural beauty fired him with the ambition to paint and to overcome the
difficulties of circumstance and of a hand not at first very facile which stood in his way.
'It was those scenes', he wrote, 'made me a painter, and I am grateful; that is I had often
thought of pictures of them before I ever touched a pencil'—using the word 'pencil' where
a modern artist would say 'brush'.

John Constable was born at East Bergholt in Suffolk (but very near the Essex boundary)
on June 11, 1776. His father, Golding Constable, owned the watermills at Flatford and
Dedham as well as two windmills at East Bergholt. John was the second son of the family,
and was sent to school, at first some fifteen miles from home (Leslie does not specify the
exact place), next at Lavenham, and finally at the Grammar School at Dedham. He was
not, however, a very bright scholar, and indeed he seems to have been a slow developer
not only in scholarship but also (when compared with such almost exact contemporaries
as Girtin and Turner) artistically. He had, however, become 'devotedly fond of painting'
by the time when, at the age of 16 or 17, he left school, and he had struck up a friendship
with John Dunthorne, a plumber and glazier in East Bergholt, who was an amateur land-
scape painter. Years later Dunthorne's son became Constable's assistant. Golding Con-
stable was at first unwilling to let his son become a professional artist, but suggested he
should go into the Church. John, however, refused, and for a year or so worked in his
father's mills.

Throughout his life Constable was fortunate in his friends, and his first piece of good
fortune of this kind came now. Sir George Beaumont (see p. 236), the eminent amateur
artist, connoisseur and patron, used to visit Dedham to see his mother, the Dowager Lady
Beaumont, who lived there. Mrs Constable arranged an introduction to Sir George, who
showed Constable the famous little Claude (now in the National Gallery) which Beaumont
carried with him wherever he went and about thirty watercolours by Girtin, and so
introduced him to two artists who were greatly to influence him. If this incident happened,
as one gathers from Leslie, at some time between 1792 and 1795, it is to be noted that
Girtin was then still very young—from 17 to 20—and had not yet reached the threshold of
his six short years of mature work. Therefore it seems to me more likely that the Girtin
part of this event did not take place until a few years later, perhaps about 1798 or 1799.

In 1795 Constable, with his father's consent, paid a visit to London 'for the purpose of
ascertaining what might be his chance of success as a painter'. There he met J. T. Smith*
(1766–1833), topographical draughtsman and etcher, antiquary, and subsequently keeper

* John Thomas Smith is most generally remembered as the author of *Nollekens and his Times*, 2 volumes, 1828, an extremely
amusing book, very valuable to art historians; but his antiquarian publications, with their etchings, are also of much interest,
particularly as regards the topography of London and its environs. A number of his original drawings, in pen and watercolour or
more generally pen and monochrome wash, exist in the British Museum and elsewhere. He used a fine pen line, with sharp hooks,
and angles, and his drawings, particularly those of picturesque cottages among trees, and the like, can be quietly charming.
Mr Oppé has a drawing of an artist teaching a pupil outside a cottage door, which is highly characteristic in its treatment of foliage,
tree trunks, etc. It is reproduced in Randall Davies's *Chats on Old English Drawings*. J. T. Smith's father was Nathaniel Smith, who
seems to have been born about 1740. A sculptor, he was principal assistant to Nollekens, but afterwards became a printseller. He did
some topographical views, and was presumably the N. Smith who signed, and dated 1781, two small watercolours, fresh in colour
but stiff in drawing, which I have. They represent two Middlesex churches—Drayton and Harmondsworth.

of prints and drawings in the British Museum. Smith offered to advise and help Constable by letter, and gave him for the next two or three years, after his return to Suffolk, a 'correspondence course' (to use the modern phrase) in art. Smith was not a great painter, but he had a small neat talent of his own, and seems to have given Constable good advice, if one may judge from the fragment quoted by Leslie on the subject of figures in landscape: 'Do not set about inventing figures for a landscape taken from nature; for you cannot remain an hour in any spot, however solitary, without the appearance of some living thing that will in all probability accord better with the scene and time of day than will any invention of your own'—a dictum which fits in with the beliefs of the Lake poets and the dawn of nineteenth century romantic realism. Smith had a considerable influence over Constable's aesthetic faith; but after a couple of years he felt the young man's artistic promise to be still so uncertain that he advised him to go back to his father's mill for a profession, and in 1797 he did so for a period. In February 1799, however, Constable had abandoned milling for ever, and was back again in London with an introduction to Joseph Farington, who helped and advised him most kindly, introducing him to Joseph Wilton, Keeper of the Royal Academy, where (probably on March 4, 1799) he was admitted a student. He occupied himself largely with copying landscapes by acknowledged masters— Claude, Ruysdael, Wilson and Gainsborough. Some of his pencil or crayon drawings, apparently of about this period, much resemble Gainsborough's early drawings or those of George Frost of Ipswich. In August 1801, he visited Derbyshire and some monochrome sketches with Indian ink wash (each about $6\frac{3}{4} \times 10$ or $10\frac{1}{2}$ inches) in the Victoria and Albert Museum* belong to this tour. Of these *On the Dove, near Buxton*, is a rather feeble forecast of Constable's Lake District sketches of 1806; *Edensor*, a crisp and pretty rendering of sunlight on trees and buildings, is more successful (262). In April 1803 he made a sea-trip from London to Deal, and did some loose and attractive pencil and wash drawings of shipping very much in the style of Van de Velde. To the same year belongs *Warehouses and Shipping on the Orwell* (Victoria and Albert Museum, $9\frac{1}{2} \times 13$ inches), which, like many of Constable's drawings, is inscribed on the back. This is a satisfying drawing in soft pencil with washes of quiet colour—brown and pale brick-red. The buildings are solidly drawn, and the whole effect peaceful and charming, though not much like Constable as he was later. On the whole, however, his progress was slow, and though he showed one painting at the Academy in 1802 and four in 1803, in 1804 he felt so depressed and discouraged that he submitted nothing for the exhibition and spent most of his time at East Bergholt where, in the mornings, he painted portraits at three guineas each with a hand included or two guineas without. He also painted an altar-piece for Brantham Church. In 1805 he again sent an oil to the Academy, and in 1806 a large watercolour, *HMS Victory in the Battle of Trafalgar, between two French Ships of the Line* ($20 \times 28\frac{1}{2}$ inches), which is now at South Kensington. It is so badly faded that its original effect cannot be judged. It clearly owes a good deal to Van de Velde, and the grouping of the ships has a certain force, but the draughtsmanship is rather heavy-handed.

The year 1806 was more notable, to the student of Constable's drawings, because of his tour of the Lake District in September and October. Yet in spite of his admiration for J. R. Cozens he was not really in sympathy with such wild scenery—he told Leslie that 'the

* This Museum has a very large collection of Constable's sketches, most of them given in 1888 by Miss Isabel Constable.

solitude of the mountains oppressed his spirits'—and though he exhibited paintings of Lakeland scenes at the Academy in 1807 and at the British Institution in 1809, this tour, which was undertaken at the wish of an uncle, left little permanent mark on his art. Nevertheless the sketches which he then did in a variety of mediums, pencil, mono-chrome, or watercolour from a limited palette of low tones of purple, brown, and green, are of considerable interest. To some extent in these sketches Constable saw the mountains of Cumberland and Westmorland through the glass of Girtin, though those which are in pencil only are more individual, or perhaps it would be better to say more typical of Constable as he was under the influence of Gainsborough's early pencil draw-ings. In those of the Lake District sketches which are in watercolour over loose pencil, though there is nobility of general conception, and a fine misty, cloudy breadth, the mountain forms are really a little lacking in definition and firmness. Yet for all that these drawings form an impressive group, of which a good example is *Mountain Scene, Langdale* (Victoria and Albert Museum, 13½ × 19 inches), in Indian ink monochrome wash over pencil. It represents a valley surrounded by rugged hills, and catches successfully a scene of gloomy magnificence which was really alien to Constable's temperament as it eventu-ally developed (263).

While he was in the Lake District Constable stayed twice—from September 8 to about 16 and for a few days from October 16—with John Harden* (1772–1847) at Brathay Hall, Ambleside. He came of Irish family, and had connections with Edinburgh, where for a time he edited *The Caledonian Mercury*. He occupied successively three houses in the Lake District, first Brathay Hall, then Field Head, Hawkshead, and lastly Miller Bridge, Ambleside. He was an accomplished amateur both in landscape and, most character-istically, in small figure drawings which vividly illustrate the life of cultivated gentlefolk in the country in the early nineteenth century. His indoor groups show mothers and children, ladies sewing or sketching, parties of friends making music, and so on (269). An exhibition of his work was held in Edinburgh in 1939. A large number of his drawings in pen, pencil, brown monochrome, watercolour, etc., belong to his descendants and include several in which Constable figures.

In 1809, at Farington's suggestion, Constable stood for election as an Associate of the Royal Academy, but without success. Indeed, in spite of subsequent attempts, it was not until 1819 that he became ARA, and his election as full RA was delayed until 1829. This in spite of the backing of Farington, who was in some ways a very clear-sighted old man, and of the fact that as early as 1812 Benjamin West told him that he considered he had already achieved 'real excellence'. Two things seem to have stood in the way of official recognition, a feeling that his subjects were mere commonplace scenes of English country, lacking both the dignity of the classical tradition and the associative interest of topography, and the view that his paintings lacked finish. Yet nothing deflected Constable from his now firmly established ideal of a natural style of landscape painting, just as in private life family opposition did not alter his determination during the long period—from 1811 to 1816—of his engagement to Maria Bicknell, whom he married in the latter year. He was one of those who stick doggedly to their purposes.

* I am obliged to Miss R. M. Clay for information about Harden, her great-grandfather. See also Beryl and Noel Clay, 'Con-stable's Visit to the Lakes in 1806', *Country Life*, April 16, 1938.

An important event in Constable's life was his first visit to Salisbury, in September 1811, in the course of which visit he went to see Sir Richard Colt Hoare's seat at Stourhead. Constable's connection with Salisbury began through his friendship with a young clergyman, John Fisher, the son of the Master of the Charter House, and at that time chaplain to his uncle, the Bishop of Salisbury (an amateur watercolourist, see p. 243), who became a most valuable patron. John Fisher was later appointed Archdeacon of Berkshire, and though sixteen years younger than Constable was one of his wisest and most devoted friends. Salisbury and its neighbourhood, where he stayed again in 1820, 1821 and 1829, became, like Hampstead Heath or Sussex, a favourite sketching ground, and provided the subjects of some of his paintings, and of two of his most considerable watercolours, *Old Sarum* and *Stonehenge*, presumably the drawings exhibited in 1834 and 1836 respectively, and now both in the Victoria and Albert Museum. An earlier and smaller sketch of Stonehenge in watercolour over black chalk is in the British Museum.

John Constable and Maria Bicknell were married on October 2, 1816, and in the following May they settled at 1 Keppel Street, Russell Square. Subsequent moves were to 35 Charlottee Street in 1822 and in 1827 to Well Walk, Hampstead, where Mrs Constable died in 1828, some ten months after the birth of their fourth son and seventh child—so that, when at long last Constable's election to the Royal Academy came, he was, in Johnson's phrase, solitary and could not impart it.

Events are not usually many in a landscape painter's life. Constable's routine was varied most notably by a stay with his first patron, Sir George Beaumont, at Coleorton Hall, Leicestershire, in 1823; and by visits to Brighton in each year from 1824 to 1828, and to Arundel in 1834 and 1835. He never went abroad. Between 1830 and 1832 appeared the five parts of his *Various Subjects of Landscape characteristic of English Scenery*, a work originally intended to rival Turner's *Liber Studiorum*. Each part contained four mezzotints by David Lucas after Constable. But the most striking public event of Constable's life was one which he himself did not witness—the exhibition of three of his pictures, one of them being *The Hay Wain*, at the Louvre in 1824, their outstanding success, and subsequent effect on European landscape painting. That, however, belongs primarily to the history of painting in oils, and does not concern us here. Constable died on March 31, 1837.

One or two of Constable's watercolours have already been mentioned, including what are probably the two most notable of his larger works in the medium—*Old Sarum* and *Stonehenge*. These are drawings of his latest period, and show the extraordinary atmospheric effects of which he was master. *Stonehenge* ($15 \times 23\frac{1}{2}$ inches) is the higher in key, the whole of the upper part being taken up by a vivid deep blue sky broken with whitish clouds and traversed by fragments of a double rainbow whose arcs are also in the main whitish. The blue of the sky is picked up by the clothes of two small figures who are seen among the grey stones of the famous monument. In the foreground the grass is of a dried, yellowish tint. *Old Sarum* ($11\frac{1}{2} \times 19$ inches) is in much the same mood of storm and wind, with the end of a rainbow breaking in on the right, but the sky is darker, with more of shadow in the clouds. The mound on which the old city stood is blue green, and dark trees grow along the hollow ground to its left above the brown area of the left foreground, where a shepherd and his sheep are seen. It is amazing how much spontaneity of handling appears

in these two quite large and elaborate watercolours, especially in the *Stonehenge*, though they are undoubtedly studio drawings (264).

Yet I prefer Constable in his smaller sketches, which are frequently of an amazing brilliance—full of sparkle, light, and purity of colour. Incidentally there is often a slightly metallic or acid quality about Constable's colour, especially the blues and greens, which is highly characteristic. The British Museum has many of his drawings, including some of his delightful figure subjects in pencil; but he can best be studied, perhaps, in the very large and rich collection at the Victoria and Albert. These sketches are of all periods, mediums, and subjects. A few only can be picked out here for mention. His pencil figure drawings at Bloomsbury have just been referred to; at South Kensington this side of his art is delightfully seen in a *Figure of a Rustic Girl seated* (266)—a very pretty rapid sketch ($7\frac{3}{8} \times 5\frac{1}{4}$ inches) in watercolour over pencil, which exactly catches the charm of a country child. There are also many studies of trees, in pencil or watercolour, which demonstrate his extraordinary keen eye in distinguishing one species from another, and the close observation he devoted to them. A fairly early drawing in black chalk, but looking much like soft pencil, is the *East Bergholt Church, with Elm Trees*, dated June 29, 1812, which has much of the diagonal movement and bold blocking in of shapes of Gainsborough (265). Many of the most characteristic or otherwise notable things, especially in watercolour, come from Constable's last decade, and this is equally true of a bold sepia splash in the manner of Alexander Cozens or Romney, *On the Stour: Dedham Church in the Distance* ($8 \times 6\frac{5}{8}$ inches), done about 1830, and of a careful and prim little *Brighton Beach, with Fishing Smacks* ($7 \times 10\frac{1}{8}$ inches) in pen and pale washes of watercolour. These later watercolours include one of Constable's exquisite studies of wind-driven clouds ($7\frac{1}{2} \times 9$ inches) carefully annotated on the back, *About 11—Noon—Sp* 15, 1830. *Wind W.* In his devoted and sensitive researches into cloud forms Constable was in some degree the disciple of Alexander Cozens, whose engravings on this theme he copied. These copies now belong to the Courtauld Institute. As pictures, however, I rather prefer Constable's cloud studies when, as in the British Museum's *London from Hampstead Heath* (number L.B.21b. $4\frac{1}{2} \times 7\frac{3}{8}$ inches), the scale of the skyscape is pointed by a low strip of land along the bottom three-quarter inch or so of the composition.

The watercolour catalogued merely as *Landscape Study* ($8\frac{3}{8} \times 7\frac{1}{8}$ inches. Number 203–1888), at the Victoria and Albert Museum, must be a late drawing too, and is certainly one of the most brilliant examples of the use of watercolour for making a rapid note of something seen. Possibly the drawing was produced in the studio—for obviously an old landscape painter of Constable's quality can see very vividly with the mind's eye—but the impression is entirely of something done out of doors. The clouds in grey-blues against the blue sky, the gleam of water in the central foreground, the trees and bushes to the left and the meadows to the right in low tones of brown, yellow green, and a splash of red—all are brushed in freely, with an effect of almost instantaneous rapidity, which may be deceptive but is certainly convincing. The depth and recession of the landscape, too, are admirable within the limits of its kind. It is a very great work (267). With this may be compared, as a forceful and seemingly rapid note of a landscape effect, the British Museum's *Study of Clouds and Trees* ($6\frac{5}{8} \times 10$ inches) which shows a bank of trees in dark grey with lighter areas of yellowish green, outlined against a sky of clear blue broken by dark and ominous

thunder clouds. Equally brilliant, but without quite the same instantaneous quality as the last two, is *Windmill and Cottages*, in the Victoria and Albert Museum, a tiny drawing, measuring only $5\frac{1}{2} \times 5\frac{1}{4}$ inches, which dates probably from 1834. It is in pen and brownish ink, with some underlying pencil, and watercolour. The key on the whole is rather high, and the effect lively and full of light. The group of buildings leads in a diagonal recession from the right towards the centre of the picture, where over a gate there is a view of fields, done with horizontal lines of yellow and red, with a low line of blue trees far beyond. There are figures and poultry in front of the cottages. Above rides a windy blue sky with clouds of grey and white. Miniature as the scene is, it is suggested with a masterly combination of ease and precision that must give the keenest delight to anyone who loves good drawing. Of the freshness of colour and sense of outdoor light and air which Constable could create in quite small drawings, two examples also at South Kensington may be quoted, *Windmill and Sheep* (5×8 inches), which is exceptionally clean and pretty in colour, and *Church, Houses, etc.* (? *Epsom*) ($5\frac{1}{8} \times 8\frac{1}{4}$ inches), another very dainty drawing, pure and brilliant, but not garish, in its colour.

Constable, within the range of dates covered by this book, did not have any very direct and immediate English disciples in watercolour. There are occasional sketches that are reminiscent of his work, for instance some of those of the amateur, Dr William Crotch (see p. 237). It also seems to me possible that an Italian artist, Agostino Aglio (1777–1857), who settled in England in 1803, and worked here as a scene-painter, decorator, lithographer, and landscape painter, may have felt Constable's influence. Certainly some of his quite pleasant, slightly blobby, watercolour landscapes, with a colour scheme in which greys and blue-greens predominate and stumpy, rather clumsy figures, and still more his sketches of boats on Brighton beach, have a faint suggestion of Constable about them. Perhaps Aglio may have met the greater artist at Brighton—but that, so far as I know, is mere speculation, and the only dated Brighton sketch of Aglio's that I know was done in 1830, which is not a year in which Constable is recorded to have been there (268).

Cox and De Wint

THIS CHAPTER, a comparatively brief one, will deal with the latest of the great landscape watercolourists who come within the period covered by this book—David Cox (1783–1859) and Peter De Wint (1784–1849). Both painted to some extent in oils, but watercolour was their principal medium, they exhibited much more often with the Society of Painters in Water-Colours than with the Royal Academy, and their work, more than that of any other artist, came in the second and third quarters of the nineteenth century to be regarded by the public as the classic contemporary expression of English and Welsh scenery in watercolour. In general one would not quarrel with that judgment, though in detail the critical estimation of both artists has changed. It is not now their most highly finished work that gives the greatest pleasure, and it is unlikely that anyone would today bid £2,950 for a watercolour by Cox—yet that price was given at auction in 1875 for *The Hayfield*, and even more had been paid in 1872 for one of his oils. The modest and unassuming Cox himself never received sums of this order; his top price was £100. Today it is his 'rougher', more atmospheric works, done in his last years, that are most admired, things which many of his contemporaries felt to be deficient in execution, a criticism to which he himself replied, with an accurate anticipation of modern judgment, 'They forget they are the work of the mind, which I consider very far before portraits of places (views).' Much the same is true of the drawings of De Wint. But though the nineteenth century and the twentieth put the accent in different places, both agree in believing Cox and De Wint to be artists of great honesty, originality, and feeling as interpreters of English landscape.

Inevitably one thinks of these two contemporaries together.* Yet there were great differences between them. There is not merely the contrast between the broken surfaces, the lighter tones, and the preoccupation with effects of light and atmosphere of Cox, and the solidly massed forms, and rich dark tones of De Wint. It is not merely that Cox found his chief inspiration in the valleys and wild hills of Wales, and on barren windswept heaths and sands, while De Wint was most deeply moved by the lush country beside slow moving rivers, by the old city of Lincoln, and by the quiet rich agricultural scene. There seems to me to be often a complete difference of approach which I can only suggest by saying that in a Cox one often is first conscious of the sky, with its winds and clouds, and works down thence to the land below it; whereas in a De Wint one's eyes are all for the land and seize first upon the foreground, moving upwards and backwards from that.

* They have been treated together in more than one book. See *David Cox and Peter De Wint* by Gilbert R. Redgrave, Sampson Low, 1891, and *The Watercolours of Turner, Cox and De Wint* by A. P. Oppé, 1925.

There are naturally many exceptions. But I believe that, as a generalization, this one is at least as true as most.

David Cox* was born at Deritend, Birmingham, on April 29, 1783. His father was a blacksmith. His mother, an intelligent and rather better educated woman, was the daughter of a farmer and miller. David had little schooling, but was introduced to the use of water-colour, when he was laid up with a broken leg, by a kind cousin, one Allport (possibly Glover's pupil of that name), who gave him a paint-box. With this the boy painted kites for his school-friends and copied prints. He was for a short time in his father's workshop, but as he was not strong enough for the work there it was decided to apprentice him to a toymaker. In order to prepare him for this he was sent to take drawing lessons at a night school kept by the Birmingham watercolourist Joseph Barber (see p. 95), who is said to have been a master who insisted on thoroughness. Cox was apprenticed first to a firm which made buckles, buttons and various enamelled or painted trifles of the kind, and then, at 14, to a locket maker and miniature painter called Fieldler, who, however, committed suicide eighteen months later. Here cousin Allport stepped in once again and got the lad a minor job in the scene-painting loft at the Birmingham theatre, where the father of the famous tragedian Macready was lessee, and the chief scene-painter was James de Maria, for whose work Cox always kept an admiration. De Maria helped and encouraged him, and Cox became one of Macready's leading scene-painters, travelling with his companies to various towns and occasionally helping things along by playing a small part.

Cox's serious nature, however, disliked the life of a touring theatrical company, and after a quarrel with Macready he obtained his release and in 1804, accompanied by his mother, went to London, where he had some hope of scene-painting at Astley's Circus in Lambeth. He did not in fact get employment there, but he did some work for the Surrey Theatre, in the Blackfriars Road, and for other theatres, and he continued to paint scenery occasionally down to 1808, his last commission of the kind being 310 yards of scenery, at 4s. a yard, for the Wolverhampton theatre. In London, Cox lodged at 16 Bridge Row, Lambeth, with a Mrs Ragg (or as Mr Gordon Roe suggests, *Cox the Master*, p. 121, possibly Agg) whose daughter Mary he married in 1808. She made him an excellent wife, though she was eight years older than he and delicate. Their only child, David Cox, Junior (1809–1885), became an artist who modelled his style closely on that of his father.

Scene-painting was clearly only to be a brief stage in David Cox's career, and as soon as he had reached London he set about becoming an artist of another sort. He sold some drawings in sepia or Indian ink to a dealer called Simpson in Greek Street, who bought them at two guineas a dozen for sale as drawing-copies. I do not know that any of these are now identifiable, but the British Museum has a rather formal brown monochrome of *Battersea Marsh*, measuring $6\frac{7}{8} \times 9\frac{1}{2}$ inches, which may be of this period, and some other apparently early, very stiff, monochromes, such as the *Wingfield Castle, Norfolk*, $6\frac{7}{8} \times 10\frac{1}{8}$ inches, in Indian ink. Another early drawing which shows Cox still carrying on the eighteenth century topographical tradition is the watercolour *Old Westminster* (10×15 inches),

* The two comparatively early biographies are *Memoir of the Life of David Cox*, by N. Neal Solly, 1873; and *A Biography of David Cox*, by William Hall, 1881. A useful recent summary and criticism is *David Cox*, by Trenchard Cox. Phoenix House. 1947. (15s.). A more costly modern work is *Cox the Master*, by F. Gordon Roe. Lewis. 1946. (£5 5s.). Mr Roe has also written a smaller book in the British Artists series, published by Philip Allan in 1924.

a soft and delicate study of light and shade on old buildings, in the Birmingham Art Gallery. It is dated 1805, the year of his first two exhibits at the Royal Academy. Some of the monochromes of this period show affinities with the early work of Samuel Prout, whom he got to know about this time.

Soon after Cox came to London he was followed thither by Charles Barber (1784–1854), his close friend and the elder of the two artist sons of his old Birmingham teacher, Joseph Barber. Charles Barber afterwards settled in Liverpool and was President of the Liverpool Academy of Arts from 1847 to 1853. He became an Associate of the Water-Colour Society in 1812, and there are two examples of his work in the medium in the Victoria and Albert Museum. A watercolour interior of a church, $13\frac{1}{4} \times 18\frac{1}{4}$ inches, signed and dated 1816, in Mr H. C. Green's collection, shows that he had some ability (270). Another of Cox's early London friends was Richard Evans (1784–1871), Lawrence's pupil and assistant, and the three young men used to go sketching. In 1805 Barber and Cox visited North Wales.

Early influences on Cox's work may be judged from the facts that he bought prints after Salvator Rosa, Claude, and Gaspar Poussin, that he copied a painting by the last-named, and that in 1807 he was a subscriber to Turner's *Liber Studiorum*. But the chief influence came from John Varley (see p. 224) who took Cox as a pupil (the exact date of this seems uncertain, but Mr Roe puts it very shortly after his arrival in London). The charge was at first ten shillings a lesson, but when Varley discovered that Cox was a struggling young professional he charged him nothing. The effects of Varley's teaching, and particularly of his rather formal method of presenting a scene, are often very noticeable in Cox's early drawings, and indeed are apt to appear in much of his work save that in his latest and freest style. There is a very close approximation to Varley, for example, in the sepia *Windsor Castle* ($6\frac{3}{4} \times 10\frac{1}{4}$ inches) in the Victoria and Albert Museum, which I should have thought was a very early drawing though Mr Trenchard Cox seems to place it about 1829 or 1830. Not only is the subject treated much like one of Varley's river scenes, but the foliage of the pollarded willow on the left of the drawing is almost pure Varley (271). Varley's influence, again, is strongly apparent in two fine watercolours in the Hickman Bacon collection, *Dolbadarn Castle* and *Pembroke Castle*.

London remained Cox's headquarters for some ten years, though on his marriage in 1808 he moved out to the comparatively rural suburb of Dulwich. By 1810 he had evidently begun to make headway in his profession, for in that year he was President of the Associated Artists in Water-Colours, founded in 1807, with which he exhibited from 1809 to 1812. On June 8 of this last year, however, he was elected an Associate of the more famous Society of Painters in Water-Colours in company with his friend Barber and with Luke Clennell (see p. 130), and in 1813 he began a lifelong connection with it as exhibitor. In that year it had begun its short interlude of showing both oils and watercolours. When a return was made to watercolour only in 1821 Cox was among the members of the reconstituted society. When he died in 1859 he had exhibited 849 works with the 'Old Society'—as against about a dozen at the Royal Academy. In 1814 he published his *Treatise on Landscape Painting and Effect in Watercolour*. Later instructional publications of the same sort were *Progressive Lessons in Landscape for Young Beginners*, 1816, and *The Young Artist's Companion*, 16 parts, 1819–1821.

Teaching played a very important part in Cox's life. During his Dulwich period he began to find pupils, including Colonel the Hon Henry Windsor, afterwards 8th Earl of Plymouth, who was attracted to him through a drawing which he saw at Palser's shop. Windsor got him a number of aristocratic ladies as pupils, whom he taught at five shillings, and later half-a-guinea, an hour. But he did not scorn also to teach perspective to artisans such as carpenters and builders. In 1813 he was appointed drawing-master at the Military College at Farnham. But he found the work, particularly the mapping, irksome, soon resigned, and late in 1814 he applied for, and obtained, the post of drawing-master at a girls' school at Hereford, kept by a Miss Croucher. He had to teach twice a week, and the salary was £100 a year.

From 1814 to 1827 Cox lived at Hereford. He continued to teach at Miss Croucher's school until 1819, and also taught at other schools in Hereford and at Leominster and elsewhere, besides taking private pupils. His fees were 7s. 6d. or 10s. 6d. a lesson, and £70 (or guineas) for those who boarded with him. One of his pupils, for three years from 1823, was Joseph Murray Ince (1806–1859), afterwards a well-known watercolourist. The years at Hereford brought Cox much drudgery, but they also brought him increasing prosperity, so that in 1824 he was able to build himself a house. He did a certain amount of topographical work, both as illustrations for books such as the *Graphic Illustrations of Warwickshire* (not published till 1829, though Cox's drawings for it were done in 1826 and 1827) and as watercolours in their own right, such as the neat and brightly coloured *Buckingham House from the Green Park* (8½ × 17 inches), done in 1825, in the Birmingham Art Gallery. During this period, too, he was producing the pretty, highly finished, pastoral scenes and picturesque cottage exteriors which found a ready sale and made pleasant drawing-room decorations—though it is not on them that his reputation rests today. In these the influence of Varley is still often to be seen. Above all, the years at Hereford enabled him to get to know the Welsh border country and Wales itself. Records of his tours at this time seem rather scanty, but in 1816 he went to the valley of the Wye, in 1818 to North Wales and in 1819 to Bath and Devonshire. In 1826, taking his son with him, he accompanied a brother-in-law to Brussels and visited various places in Belgium and Holland. This was his first trip abroad—and he made only two others, to Paris *via* Calais and Amiens in 1829, and to Dieppe and Boulogne in 1832. Continental subjects, particularly coastal scenes near Calais, appear among his exhibits from 1829, and form an attractive sub-section of his achievement.

Perhaps it was his foreign tour of 1826 that led him to break the routine of his existence. At any rate he sold his house—profitably—and in 1827 returned to London, settling with his family at 9 Foxley Road, Kennington, which remained his home until 1841. He was now a fairly successful artist. He had as many rich pupils as he could want, and his fee eventually went up to a guinea a lesson. He continued to exhibit plentifully at the Society of Painters in Water-Colours, and his sketching tours included visits to Yorkshire in 1830, to Derbyshire in 1831, 1834, 1836 and 1839, to Wales in 1837, to Kent in 1838, and to Lancashire in 1840. In this last year also he had a few lessons from W. J. Muller in oil-painting, a medium in which he had tried his hand many years before, in 1811 or so, and had used a little at various times. Cox, however, tired of London, and in 1841 went back to Birmingham, his native place, where in a pleasant old brick building, with a good

garden, Greenfield House, Harborne, he passed the remainder of his life. In 1845 Mrs Cox died and in 1853 he himself had a slight stroke. He continued to paint, however, for some years after that, and on June 7, 1859, he died.

The loosening and broadening of touch which mark Cox's best work, the forsaking of merely pretty subjects for wilder, more elemental effects of scenery, atmosphere and weather, did not begin to appear until about 1830, when he was 47. But his middle and old age were active, prolific and serenely confident, and his final close association with North Wales, and especially with Bettws-y-Coed, which inspired a large proportion of his best drawings, did not begin until after he had moved back to Birmingham. He went to Bettws almost every year from 1844 until 1856, though up to 1846 he also continued to pay visits to Yorkshire and Derbyshire. In 1844 at Bettws he lodged at the Swan, which he had known as a young man, but on later visits he went to a new inn, the Royal Oak, for which in 1847 he painted a sign, showing Charles II hiding in the oak tree. There he became a favourite with hosts, fellow-guests and villagers alike. From 1852 he stayed at a farm when at Bettws.

Cox produced an enormous body of work, and large collections of his drawings are to be seen at the Victoria and Albert Museum, the British Museum and the Birmingham Art Gallery. There is a great deal that is repetitive, a great deal, especially in his middle years, that represents a too easy acceptance of rather commonplace drawing-room standards of picturesque prettiness. But, in part at least, this acceptance was due to his modesty in face of other people's preferences, and it was not until late in life that he seems to have taken the courage to give rein to his own honesty of vision and deep sincerity of feeling. Yet he produced fine things at many periods of his life. The large and comparatively early *In Windsor Park* ($14 \times 19\frac{7}{8}$ inches), bequeathed to the Victoria and Albert Museum in 1948 by Mrs E. C. Turner, is an admirable example of a full-dress water-colour exhibition picture of (I suppose) some time between 1810 and 1820. It is considerably influenced by John Varley, and contains some beautiful rich firm passages of blues and greens in the massed tree-tops below the castle, which catches a softly glowing ochre light upon its masonry; but the sheep which a boy drives across the foreground are too fluffy to be convincing. Of the pretty drawing-room type of middle-period Cox water-colour, the British Museum contains a number of very good examples, of which one may instance *Between Pont Aberglaslyn and Festiniog* (272) ($7\frac{3}{4} \times 10\frac{1}{4}$ inches), which has beautifully modulated distant hills to the right, showing above meadows in which cattle graze, larger and nearer rounded hills to the left, and a man on horseback talking to a woman in a red skirt in the foreground, the whole under a largely clear blue sky; or *Windmill on a Heath* ($6\frac{5}{8} \times 10$ inches), which reminds one in subject of one of Crome's Mousehold Heath paintings. If I seem to speak with moderation of such drawings as these, it is not that they are not works of very high skill and of an exquisitely refined sense of beauty, but that they do not express the full rugged force, the genuine open air quality, of which Cox was capable. For that one has to go to the work of his last twenty-five years.

It would be a mistake to think of Cox's latest work as always full of dark lowering storms, leaden skies, and bleak moorland prospects. He was a master also of the lighter tones, and especially in his seaside pieces could suggest pearly effects of light, bright, clear air and sometimes an almost Boudinesque gaiety. Even though the sky is chiefly leaden

grey, with blue and white peeping in only at the two corners, there is no heaviness of atmosphere or gloom about the Victoria and Albert Museum's *Rhyl Sands* ($10\frac{5}{16} \times 14\frac{1}{4}$ inches), a very good version of a subject which Cox did several times (274). A shower comes down on the flanks of the faint hills beyond the sea, but the sands, yellow-brown with blue lights, dotted with rather distant figures of white, black, brown and red, seem bathed in light. This drawing is not dated, but another version, reproduced by Mr Oppé, is dated 1854, and Cox exhibited drawings of the subject in 1852 and 1853. Seaside and particularly beach scenes were a favourite occasional subject with Cox. His Calais subjects of 1829 onwards have already been mentioned. Hastings (from 1813) and the Lancashire coast (from 1835) also appear frequently among the titles of his exhibits.

Nevertheless it is upon the wild dreary moorlands, among the misty hill-tops and rocks of Wales, that Cox achieves his grandest and most powerful effects. Perhaps his most famous watercolour of this type is *The Challenge, a Bull in a Storm, on a Moor* ($17\frac{1}{2} \times 25\frac{1}{2}$ inches), in the Victoria and Albert Museum, a very late work, which has been variously dated between 1853 and 1856. A tremendous angry sky, ranging from leaden grey to deep grey-blue and almost black, with torrential rain beating down; a deep blue line traversing the picture below the faintly seen hills that rise beyond the dark brown-purple and brown-green moor; in the foreground dead herbage (indicated by broad wiped-out lights), a light brown rock and a pool to the right, and a reddish bull, with dull white horns, to the left, roaring out defiance, perhaps to a rival unseen in the distance, perhaps only to the angry elements. These are the components of the picture. The watercolour is rather thick and muddy when seen from close to, the touches of the brush very broad and almost clumsily coarse. There is a tremendous force about the whole thing, but nevertheless I cannot, personally, feel that it is an entire success. Like nearly all very large watercolours it gives me the feeling that the medium is being strained to produce an effect of power which is really beyond its range.

To me the best of Cox—and that is very good indeed—lies in some of his late, free drawings which, though on a fairly large scale, and carried through a fair way towards full realization, yet retain in them something of the freshness, sensitiveness and immediate observation of the sketch. These are often of great power and beauty. Let me quote three examples from the British Museum. The first is *Snowdon* ($10\frac{3}{8} \times 14\frac{1}{2}$ inches). In this noble drawing grey storm clouds half encircle the deep dull-blue peak of the mountain, which is seen through a gap in dull-green hills which opens out into a broad hollow in which a bridge across a stream is roughly suggested. It is a powerful study of weather, interpreted in watercolour put on thickly and rather roughly. The second, *Between Capel Curig and Bangor* ($10\frac{1}{4} \times 14\frac{1}{8}$ inches), is lighter in tone, and represents a flock of sheep in a dip among stony hills covered with heather and poor grass, with a triangle of blue-grey sky above. This is a drawing of pale purples, dull greens and greys, the watercolour being applied over a little soft pencil. Third is a more richly coloured drawing, carried through rather further towards completion (for example in some of the foreground detail), *Water-mill, Bettws-y-Coed* ($10\frac{3}{8} \times 14\frac{3}{8}$ inches), signed and dated 1849. Here we get the full richness of Cox's colour, especially in the luminous blue rocky precipitous mountain-side, with purple-grey lights, which cuts across the back of the picture, excluding all but a small area of cloudy sky. Deep black-green trees (almost De Wint in their darkness) are out-

lined against the cliff and mark the course of the stream which edges the left of the meadow, dappled with yellow and blue flowers, that takes up most of the foreground.

Cox's smaller landscape sketches are often delightful, especially those in which a few broad washes of colour are put over soft, loosely drawn pencil. He could be very good, too, in black or red chalk, very freely handled. Of his black chalk work a good example is a sketch of a village street, lined on one side with trees, in the Victoria and Albert Museum ($8\frac{5}{8} \times 11\frac{1}{2}$ inches). The best of his red chalk studies that I have seen is Sir Robert Witt's *Romantic Landscape* ($7\frac{3}{4} \times 6\frac{1}{2}$ inches), representing in the freest way some stepping stones across a stream, with trees against a hillside beyond. Cox sometimes also made little watercolour sketches of people or things—such as the very delicate study of thistle leaves (7×6 inches), also in Sir Robert Witt's collection. Most of these slighter sketches, which are often of great beauty, remained in the artist's family until 1904, when many of them came into the possession of the Walker Galleries, in New Bond Street, and were made the subject of a volume of excellent reproductions, with an introductory essay by the late A. J. Finberg,* but unfortunately giving no details of size and so forth.

Peter De Wint† was born at Stone, Staffordshire, on January 21, 1784. His father, Henry De Wint, was a doctor, born in New York of Dutch ancestry, and educated at Leyden and at St Thomas's Hospital, London. His mother, Caroline Watson, was Scotch. Peter was their fourth son. He is said to have shown early delight in birds and other country sights and in drawing, which he taught to his school-fellows. He had a few lessons from a Stafford drawing master called Rogers, but was destined by his father to become a doctor. He disliked the idea, however, and on leaving school was allowed by his parents to adopt art as a career and to that end was apprenticed in April 1802‡ to the engraver and pastellist John Raphael Smith, at whose house in King Street, Covent Garden, he lodged. Here he met William Hilton (1786–1839), afterwards RA, who was to be his intimate friend and brother-in-law. Smith is said to have encouraged the lads to study nature, and took them with him on his excursions to the country so that they might sketch while he fished. A story is told that Hilton, being unhappy at Smith's, ran away home, and that De Wint, refusing to say where he had gone, was brought before a magistrate by Smith and imprisoned. Eventually all was explained and the youths were better treated. I must say, however, that this incident does not strike me as altogether credible. In 1806 the last four years of De Wint's indentures were cancelled, and in lieu he promised to paint eighteen oil pictures for Smith. At this point he went to Lincoln— the city which was to affect his life and work so greatly—for the first time, in company with Hilton, whose home was there. On this occasion he first met his friend's sister, Harriet, then aged 15, whom in 1810 he married. De Wint and his wife settled in London, sharing their house in Percy Street with William Hilton until 1827, when Hilton became Keeper of the Royal Academy; after that the De Wints moved to 40 Upper Gower Street, which remained their home until he died on June 30, 1849.

This, however, is to get ahead of our story. Soon after the cancelling of his indentures

* *Drawings of David Cox.* Newnes. n.d. (1906).

† See the works cited at the beginning of this chapter. Also Old Water-Colour Society's Club. Vol. I. 1924. 'Peter De Wint', by Randall Davies. 'List of Works exhibited by Peter De Wint', compiled by B. S. Long. The volume also reprints Christie's catalogue of the remaining works of De Wint, sold on May 22, 23, 24, 27 and 28, 1850, with buyers and prices. 493 lots fetched £2,364 7s. 6d.

‡ Redgrave says De Wint went to Smith's house in April 1802, but was not apprenticed until June 1806. This does not seem probable and as regards dates I follow the account given in the D.N.B.

in 1806 De Wint began to frequent Dr Monro's house, and it was probably there that he came under the influence of the work of Girtin, reflections of which are evident in such of De Wint's drawings as *View on the Eden, Cumberland* ($4\frac{15}{16} \times 18\frac{9}{16}$ inches), which belongs to the National Gallery but is lent, with twenty-one other drawings by De Wint, to the Victoria and Albert Museum. This is an exquisite sombre panorama of a low dark grey hill, with a brown cornfield in the foreground, and just a touch of lighter colour in the pinkish-red house that stands against the dark wood on the hill. It is very Girtinesque indeed, though I do not know when De Wint painted it, for he seldom if ever dated his work, and only very rarely signed it.* Probably this drawing is fairly late, for De Wint did not exhibit a named view of Cumberland or Westmorland (where his chief connections were with Lord Lonsdale, with whom he used to stay at Lowther Castle) until 1825. If this is indeed a late drawing it shows how lasting was the impression made by Girtin upon an artist whose work is not usually much like his though, in a broader sense, influenced by it. De Wint is also said to have benefited by the advice, if not the actual teaching, of John Varley, and in 1809 he became a student at the Royal Academy.

In 1807 De Wint began his career as an exhibitor, with three Staffordshire or Derbyshire views at the Academy. He showed there again in 1811 and occasionally up till 1828. He also exhibited at the Associated Artists in 1808 and 1809 and with the British Institution at intervals between 1808 and 1824, but the great bulk of his exhibits were at the Water-Colour Society, to which he sent 417 drawings between 1810 and 1849, and of which he became an Associate in 1810 and a full member in 1811. About a year later the Society took to exhibiting oils as well as watercolours and he dropped his membership, though he continued to exhibit there most years up to 1818. When the Society was reorganized again in 1821 he hesitated to rejoin it, and did not resume his membership and exhibits until 1825. At this period he did a certain amount of redrawing of amateur drawings of foreign scenes so as to make them fit for engraving as illustrations; for example, those of Major William Light in *Sicilian Scenery*, 1823, of Thomas Allason in J. S. Stanhope's *Olympia*, 1824, and of John Hughes in *Views in the South of France*, 1825. He did not himself, however, go abroad until 1828, when he went to Normandy with his wife. He was disappointed with the scenery, and made no other foreign tour.

In England De Wint's life was orderly and uneventful. He was successful as a teacher and in 1827 was charging a guinea an hour for lessons. At this time his drawings were selling at from 5 to 50 guineas each. He had many amateur pupils, and often stayed with them, or with other patrons, at their country houses, but most of the year was spent in London and his visits to the country were chiefly in the summer or early autumn. In 1814 he stayed with Walter Ramsden Fawkes at Farnley Hall, Yorkshire, and then had his first view of Bolton Abbey, which became a favourite subject with him, as it was with Cox. Wales he is generally said to have visited for the first time in 1829, when he was taken there by Lady Mary Windsor Clive and her husband, with whom he had been staying near Ludlow, but this must be taken as meaning North Wales, as according to Roget he had been to Glamorganshire in 1824. He returned to Wales again—to Carnar-

* Redgrave draws attention to the scarcity of signed drawings by De Wint. He quotes one signed 'P. Dewint, 1811' and suggests that this spelling of the name, in one word, was probably an early one afterwards abandoned by the artist. I have five letters all signed in this way, the latest of which, though not dated, is on paper water-marked 1827. So for the greater part of his life, at least, he himself used the form 'Dewint'. His wife, however, seems to have written it 'De Wint'.

vonshire and Merionethshire—in 1835. The English side of the Welsh border he knew well. In Norfolk he used to stay with Colonel Greville Howard at Castle Rising. In 1843 he visited Hampshire and Somerset. In 1848 (the year before his death) he went on his last sketching tour—to Devonshire. But his favourite place was Lincoln—both the ancient buildings of the city itself and its surroundings—and in Lincolnshire he had many friends and patrons, including in his later years Richard Ellison, of Sudbrooke Holme, whose widow gave many drawings from his collection to the South Kensington Museum. After Lincoln perhaps the rich valleys of the Trent and the Thames were nearest to De Wint's heart, and he loved the waterside meadows, the barges being loaded with hay, as much as he loved the hay-making and cornfield scenes which fill the foregrounds of many of his most characteristic drawings.

De Wint is very well represented at the Victoria and Albert Museum, though the drawings there, including those on loan from the National Gallery, have been so much hung (and therefore exposed to light) that many of them are badly faded, especially in the skies. How much this is so can be judged by two drawings in each of which a portion has been covered by the mount and remains unfaded—*Burning Weeds, a Sketch*, and *View of Tours, France*. The present state of these two drawings, with what were once delicately painted skies now completely faded out, makes one wonder whether De Wint's drawings ought ever to be hung on the wall, except for occasional short periods. Certainly the watercolours at the British Museum, though for the most part originally less beautiful, have remained in far better condition, since they have been kept for most of their time in boxes. Both museums have admirable collections of De Wint's sketchbooks, showing his work in pencil, pen (in this medium sometimes curiously reminiscent of Thomas Barker's pen work), brown wash with rather feathery Gloverlike treatment of foliage, black and white chalk (often on grey paper), and less frequently watercolour. On the whole I do not find De Wint's pencil, chalk or monochrome drawings particularly interesting. One needs the rich dark massed hues of his watercolours, with their fine plummy bloom, to appreciate his genius as an artist. There is also a good collection of his work at Lincoln.

Though one thinks of De Wint principally in connection with pastoral and riverside landscape, yet it must be remembered that he did other subjects too. He was fond of still life, and was an unusually accomplished user of watercolour for this purpose, as may be seen in, for example, the British Museum's group made up of baskets, two richly patinaed stoneware vases, and so forth ($8\frac{7}{8} \times 9\frac{5}{8}$ inches). Moreover buildings supply the subjects of a number of his very best works, such as the now unhappily rather faded *Old Houses on the High Bridge, Lincoln* ($15\frac{5}{8} \times 20\frac{3}{8}$ inches) in the Victoria and Albert Museum. This is a grand and noble picture with its grouping of the warm red roofs and cream or grey or pinkish-red walls of the old buildings round and above the stretch of grey water on which boats ride and are reflected (275 and 276).

Yet it is the landscapes in which De Wint is most individual and at the same time most typical of the English scene—though naturally buildings have their part in many of these also, but with no monopoly of the interest. *Conisborough Castle, Yorkshire* ($14\frac{3}{8} \times 25\frac{11}{32}$ inches), bequeathed to the Victoria and Albert Museum in 1921 by the artist's grand-daughter, Miss H. H. Tatlock, is perhaps one of the finest of them, in its sombre massing

of form. The square bulk of the castle stands on a densely wooded knoll rising from a valley in the middle distance. On either side of it grey smoke rises from houses. Beyond is a pale yellow sky above a purple moorland hill. To the right the valley spreads out, with rocks on the high foreground. It is a massive and impressive work. Almost as good, in its sombre massing of building and trees, is *Kenilworth Castle* ($10\frac{7}{8} \times 16\frac{3}{8}$ inches), in the same museum.

De Wint was extremely fond of the shallow broad panorama—a shape often used effectively in England from at least the time of Hollar, though in De Wint's hands its purpose was rather aesthetic than topographical. A fine example of this shape, and of the artist's more highly finished, less broad and free, watercolours, is *On the Severn near Newnham* ($3\frac{19}{32} \times 21\frac{11}{16}$ inches), again in the Victoria and Albert Museum. The boats sailing calmly on the broad, gleaming, grey river, the dark wooded bank to the right, the far distance seen away up stream, are deeply satisfying in their impression of peace. Another fine panorama is the *Gloucester* ($5\frac{7}{8} \times 15\frac{1}{8}$ inches), in the British Museum, with long shallow horizontal areas of contrasted light and shade in the foreground, the town, the hill beyond and the sky above.

I have said that De Wint's skies very often lack interest—perhaps sometimes because they have faded right away. But he occasionally painted quite elaborate sky effects, as in a totally unfaded watercolour, part of the Salting bequest, in the British Museum. It measures $10\frac{7}{8} \times 17\frac{1}{2}$ inches and is a wide spreading landscape under a blue stormy sky from which rain descends. Yellow and brown cornfields stretch back from the foreground diagonally to the right. They are dotted with corn-stooks, farm workers, a horse and cart and so forth. There are rich deep blue hills in the distance and between them and the cornland a low-lying blue-green river valley. The effect is on the whole a little hard, but the drawing is nevertheless forceful and brilliant. It will be noticed that some of the lights, especially in the figures of the harvest workers, are scratched out with the knife, which was a common way of De Wint's in doing figures. On the whole, however, I much prefer De Wint in his more broadly handled sketches, of which there are some very good examples in the Hickman Bacon collection, which was exhibited recently in London and in other towns (277 and 278). Those who saw it will remember the magnificent contrast between the profound darks of the river bank and the glowing orange light on the water in *Lincoln from the River*; and, in *Clee Hills, Shropshire*, the loose yet certain strokes with which the trees to the right are brushed in and the shapes of cattle in the meadow suggested by mere dark blotches of paint. In the latter drawing, and in certain others, such as the Victoria and Albert Museum's *View near Oxford, a Sketch*, the feathery touch with which the foliage of the trees is rendered is very different from the firm strong dark masses of the *Conisborough Castle* and *Kenilworth Castle* already mentioned.

De Wint was by no means always successful. His finished work could be very woolly at times—for example, the *Torksey Castle on the Trent* (Victoria and Albert Museum)— and his sketches also could be both flaccid in construction and harsh in touch—both of which faults appear in the same museum's *Haddon Hall*. Moreover light bright tones, such as he uses in a drawing (in the British Museum) of cattle by a rocky stream in a woodland, do not suit him well. His palette, indeed, was limited, and it is noticeable that he seldom uses green, his foliage generally being rendered in blues, purples and almost blacks.

181

But nevertheless he is one of the major English watercolourists, and his deep tones can achieve—particularly in the sketch—effects of tremendous richness.

De Wint's pupils were chiefly, if not entirely, amateurs. In the volume of the Old Water-Colour Society's Club already referred to Randall Davies mentions some of them as being especially skilful, particularly H. Cheney of Badger in Shropshire, and the Rev P. C. Terrot, Rector of Wispington, in Lincolnshire. Mr Edward Croft-Murray, also, tells me that H. M. Heathcote, of Conington Castle, near Peterborough, was a friend and close follower of De Wint. I do not myself know the work of any of these amateur water-colourists, but Mr Croft-Murray has shown me examples of yet another, J. H. Flower of Leicester, which come deceptively close to De Wint.

As a footnote to this chapter there may be added a short notice of an artist who was contemporary with Cox and De Wint, though stylistically he had little connection with them. This was Samuel Prout (1783–1852), who was born at Plymouth and early in life worked with John Britton* (1771–1857), author with G. W. Brayley of *The Beauties of England and Wales*, to which Prout contributed twenty-three views between 1803 and 1813. He became an extremely successful watercolourist, above all after 1818 or 1819, when he paid his first visit to the Continent, going to Havre and Rouen. From about that time, or soon after, he deserted English topography and the production of drawing books, and turned to making large and elaborate watercolours of picturesque Gothic buildings and scenes in old towns, particularly in Normandy but also in the Rhineland and elsewhere. In these drawings he was a close imitator of some of the latest works of Henry Edridge, ARA (1769–1821), done after his visits to France in 1817 and 1819 (280).

Prout was highly praised by Ruskin, and in the nineteenth century he was considered one of the greatest of the English watercolour school. Of the Water-Colour Society, of which he was elected a member in 1819 and to which he contributed in all 560 drawings, he was a main pillar. He acquired great renown for his manner of rendering the effect of ancient crumbling stone, in which he used the reed pen, and his large views of Norman streets, with elaborately carved church fronts, gabled houses and the pavements crowded with not very well-drawn figures dressed in local costumes, are coarsely effective in their way. When one thinks of the delicacy of effect, the purity of tone, which Cotman achieved with similar material, Prout's work of this kind seems heavy and clumsy. Those who want to see an example, fully characteristic of both his merits and his defects, should look at the huge *Porch of Ratisbon (Regensburg) Cathedral* ($25\frac{3}{4} \times 18\frac{1}{4}$ inches) in the Victoria and Albert Museum (281). Personally I dislike this sort of drawing very much, and greatly prefer Prout's early work (279), notably his watercolours of hulks in Plymouth harbour, which, though they too are often a little clumsy, have a fine solidity and depth of colour, especially in the strong blues and dark chocolate browns. Prout's pencil drawings of ruins are rather in the Dayes-Turner-Girtin manner though heavier in touch.

A very brief mention may also be made, at this point, of Thomas Miles Richardson, senior (1784–1848), who was born and died in Newcastle-on-Tyne. He exhibited ninety pictures, chiefly landscapes, at the Royal Academy and elsewhere between 1818 and 1847, and developed into a very able watercolour landscapist, in the typical early Victorian

* If a watercolour which I acquired lately, *A Cromlech on the Marlboro Downs*, is rightly attributed, Britton was himself a skilled watercolourist. It is an effective thing, with pale sunlight breaking through leaden blue clouds on to the distant plain, and the red coat of a shepherd seated by the cromlech adding a clever touch of higher colour to the brown foreground.

manner, somewhat of the same school as Copley Fielding. Richardson's *Ben Lomond, from the Hills between Arrochar and Tarbet* (12¼ × 18⅞ inches), in the Victoria and Albert Museum, is a good spreading scene of mountain and moor, a very agreeable thing of its kind, in spite of having the highlights on clouds, cattle, and so on touched with opaque white. His son, T. M. Richardson, junior (1813–1890), was a prolific and popular water-colourist.

A Miscellany

IN THIS chapter will be considered three or four groups of watercolourists who stand a little apart from the main developments of landscape and figure-drawing with which we have so far been concerned. They are the artists who specialized in rustic figures and cattle in landscape, the sporting and marine artists, the naturalists, and the portraitists. None of these is, naturally enough, completely cut off from the other manifestations of the art in his time. Watercolour portraits, for example, were done occasionally by a vast number of artists who did not devote themselves especially to portraiture. But on the whole the chief figures in these three groups were sufficiently specialized in their work to have made them difficult to fit into the story of English watercolour as it has been told up to this point.

It is the painters of rustic life who form the least clearly defined group. At least six men are most easily classed here—George Morland, James Ward, Julius Caesar Ibbetson, Peter La Cave, Francis Wheatley and Philip James de Loutherbourg; but if one were tempted to speak of them as the school of Morland one would be brought up sharp by the facts that he was, with the exception of Ward (and perhaps La Cave of whose birth we know nothing) the youngest of the six, that he scarcely worked in watercolour at all, and that he had no real connection with either Wheatley or Loutherbourg. The last-named, indeed, fits only very loosely, and by reason of only a part of his work, into this category at all. All the same through him we may begin to approach the more or less realistic representation of English rustic life.

Philip James de Loutherbourg (1740–1812) was born in Germany of Polish ancestry. His father was a miniature painter at Strasbourg, and the young man was originally intended for the Church. He decided, however, to be an artist, and took lessons first from his father and others in Germany, and later in Paris from Vanloo and Casanova. He exhibited in the Salon from 1763 and remained in France until 1771, when he came to England, where he was to spend the rest of his life. On arrival here he became chief designer of scenery to Garrick at Drury Lane, at a salary of £500 a year, and a proportion of his drawings have a theatrical interest. For example he did some theatrical caricature portraits, and one of the most striking of his watercolours is *David Garrick as Don John in his adaptation of 'The Chances' of Beaumont and Fletcher, Act 1, Scene 2* ($11\frac{11}{16} \times 16\frac{1}{8}$ inches, Victoria and Albert Museum), which has a supposed view of Naples in the background. It is signed and dated 1774. He quarrelled with Sheridan, Garrick's successor, but painted scenery elsewhere until 1785. He first exhibited at the Royal Academy in 1772, became ARA in 1780 and RA in 1781. As an oil painter he specialized to some extent in battle pieces, and

the British Museum's very large collection of his drawings contains many pen and water-colour portraits of sailors and soldiers, studies of military equipment, and the like, done in preparation for pictures of this type. A man of curious and ingenious mind he invented in 1782 a form of entertainment called the Eidophusikon, an arrangement of moving pictures on a stage with lighting effects to simulate various times of day. He also went in for various forms of mysticism. There is, however, nothing mystical about his work as a painter.

Loutherbourg's drawings are varied in subject and medium. He drew semi-caricatured theatrical portraits in pencil. He did some book-illustrations. He also made many studies of landscape, shipping, the sea-shore, figures and various objects in pen and brown ink washed with Indian ink—these can be most attractive, their pen-line remarkably combining freedom and precision, as in a little drawing of breaking waves which I have. The British Museum has many very good examples of his work in this medium, mostly done in the Isle of Wight, among which may be mentioned *The Needles* ($5 \times 7\frac{5}{8}$ inches) and *West Cowes* ($5 \times 7\frac{3}{4}$ inches), the latter a very lively harbour scene (282). His most characteristic drawings, however, are landscapes with cattle and figures, somewhat in the manner of Berghem, who had a great influence on him from as early as 1761, as is shown by the dating of one of his drawings in the British Museum. These subjects are usually in sepia or Indian ink monochrome with pen. In most of them the figures are entirely derived from literature and earlier painting. Observation taken more directly from life appears sometimes, however, as in a small drawing ($7\frac{1}{4} \times 6$ inches) in my own collection. It represents two rustics, a man and a girl, one carrying a turkey, the other a cock—and they are real ragged country folk, not a conventional shepherd and shepherdess. It is drawn partly with the pen and partly with the brush, and is chiefly in sepia, with some washes of blue (in the man's clothes, the sky, and certain shadows) and red (on the faces, the girl's skirt, and elsewhere). Two monochromes in Mr L. G. Duke's collection are also to the point here. Both are in sepia wash and pencil. One, measuring $7\frac{7}{8} \times 12$ inches, represents two men watering their horses under an inn sign, while a chaise and pair drives by on the road to the right. It is delicately drawn, especially in the rendering of the small trees in the background, and shows a direct observation of life (283). The other ($8\frac{1}{8} \times 11\frac{7}{8}$ inches) is a drawing of smugglers opening a chest on the sea shore and a boat putting off to sea. This is very brisk and good, and if there is a slight touch of the romantic in the theme, it is nevertheless in the main a realistic treatment of one of the rougher phases of English life in the eighteenth century.

Loutherbourg also did watercolours—rather weak in colour—of picturesque scenery. A collection of aquatints after these was published in 1805.* The Victoria and Albert Museum has one of the watercolours reproduced in that series of plates, *A Cataract on the Llugwy, near Carnarvon*, which was aquatinted in 1808. It contains an animated group of figures on the edge of the ravine into which the river pours, and the brown trees show the artist's characteristic sharp-angled foliage, done with the pen. The colour, however, lacks warmth and force (284).

With Loutherbourg we are only on the outer fringe of our present subject, and only in a small minority of his drawings do we get any realistic interpretation of rural life and

* The dates on the plates vary from 1805 to 1808. A previous publication of 1801 consisted of six seaside town views.

character. The same chiefly literary, yet sometimes partly observational, interest in country folk appears in the drawings of Francis Wheatley (1747–1801), who is however most generally known for his sentimentally charming but, as Edward Edwards pointed out, quite unrealistic portraits of street vendors, so familiar in prints of the 'Cries of London' series. He was indeed a Londoner, born in Wild Court, Covent Garden, the son of a tailor. He studied at Shipley's drawing school, at the Incorporated Society of Artists' drawing academy in Maiden Lane, and, from 1769, at the Royal Academy. He began to exhibit with the Incorporated Society of Artists as early as 1765, In his young days he was a friend of J. H. Mortimer, who certainly influenced his work. Wheatley is said to have been extravagant and to have got into debt. He eloped with the wife of J. A. Gresse (see p. 47) to Dublin, where he remained until he had to leave, 'having'—in Edwards's words— 'introduced his mistress as his wife, the imposture was soon discovered, and he was obliged to return to England'. This episode must, I imagine, have happened some time between 1780 and 1784, for during those four years there is a blank in his London exhibits. 'Soon afterwards' (there are many such vague phrases in the accounts of Wheatley's career) he married Clara Maria Leigh (died 1838), who in 1807 married, as his third wife, Alexander Pope, the actor and miniature painter (1763–1835). Mrs Wheatley, under the instruction of her husband, also became an artist, exhibited at the Academy from 1796, taught drawing, and painted miniatures. In later life she was known especially for her flower pieces. Wheatley was elected ARA in 1790 and RA in 1791. In his last years he was to some extent dependent upon his wife, for (to quote Edwards again) 'youthful irregularity and intemperance had entirely ruined the constitution of her husband, so that for many years he was at intervals unable to employ his pencil, being much afflicted by long and severe paroxysms of the gout'. He died on June 28, 1801.

Wheatley was an artist elegant rather than vigorous, accomplished but not realistic. He could be extremely insipid, especially in his representations of young girls. Yet he came fairly near to reality with rougher types of humanity (particularly male), tinkers and the like, as in his *Donnybrook Fair* (about $15 \times 21\frac{1}{4}$ inches) in the Victoria and Albert Museum. Here the figures, besides being agreeably grouped, suggest something really observed and not subsequently too much prettified (285). Cattle Wheatley drew very well, but he seldom made them the chief feature of a drawing as, for example, did Hills. I have, however, one watercolour of two cows in a landscape ($8\frac{1}{2} \times 11\frac{1}{2}$ inches), initialled and dated 1789, which is primarily a 'cattle piece'. It is very graceful and shows Wheatley's characteristic unemphatic colouring of fawn-browns and greys in the foreground and blues and greys for the distance. The outlines are in pen and those of the cows show more real sense of form than those of the trees and buildings, which are rather perfunctory and nerveless. I have one monochrome landscape, signed and dated 1776, but I do not think Wheatley often worked in monochrome. Some of his landscapes are very large—I remember particularly one or two Lake District views much larger than the average watercolour—and they can be highly accomplished. But their general blueness and unaccented uniformity of tone tend to make them a little insipid and uninspiring. A notable example, in very fresh condition, of this type of Wheatley watercolour is the Victoria and Albert Museum's *Lake Windermere* (24×37 inches). The left of the picture is devoted to a rocky cliff which slopes down diagonally to the right. In the lower right corner is part of the lake. At the foot of the

cliff a boat is moored, and near the waterside are cows (white and ochre, and white and red) and a group of country folk in red and blue clothes. A patch of light soil in the lower left corner also helps to break the general blue and grey effect of a picture in which even the foliage of the windswept trees is rendered in cold blue. As a whole the picture is an extremely suave and talented production—yet to my mind essentially dull. As examples of the conventional Wheatley watercolour two ovals ($13\frac{3}{8} \times 11\frac{1}{4}$ inches) signed and dated 1786 may be given. One, *The Dismissal*, shows the aged father, with long white locks, driving his daughter, with baby in arms and supported by a young man, from the cottage door. In the other, *The Reconciliation*, the young couple kneel before the old man. The girl weeps, the young man holds out a letter. The baby seems to have disappeared. The colours are palely pretty, and there is a graceful fluency about the drawing, which is mainly with the pen; but the expressions are insipid and the gestures theatrical, especially in the first of the pair (286).

Of the remaining artists of this group it will be convenient to consider first George Morland* (1763–1804), since he enjoys by far the greatest celebrity. But I do not propose to treat of him at length because he was scarcely a watercolourist at all, and it is with watercolour that this book is concerned.

The story of his miserable life has often been told, and its outlines are well known. His full name (for which and other family details see Walter Shaw Sparrow, *A Book of Sporting Painters*, 1931) was George Charles Morland. His father was Henry Robert Morland (1716–1797), painter of the two charming Chardin-like *Laundry Maid* pictures in the Tate Gallery. His mother was of French extraction, but the late W. Shaw Sparrow showed that she was not, as often stated, an exhibitor at the Royal Academy. Maria Morland, who showed there in 1785 and 1786, was his sister, afterwards Mrs William Ward. George Morland was precocious and exhibited at the Academy when he was only ten. His father kept him hard at work, but he early began to show the taste for dissipation and low company which ruined him. His life became eventually an extraordinary combination of extreme drunkenness and incessant labour, amounting almost to slavery since he was kept working for a small daily sum by dealers and innkeepers who took the pictures from him as soon as they were done (and sometimes before) and often had them copied, or finished, straight away by other painters. At one period (late in his life) his rate of pay seems to have been four guineas a day and his drink, and in this way he turned out enormous numbers of pictures—not all rural subjects.

Things had not always, of course, been so bad as in the last disastrous years between his first arrest for debt in 1799 and his death in a sponging-house on October 29, 1804. His naturally strong constitution was not immediately broken down, and he seems to have been a dashing and handsome young man. His friendship with the Ward family, through his brother-in-law William Ward, who engraved so many of his pictures, was a restraining influence, and Morland's marriage to Anne Ward in 1786 is said to have brought some reformation. This, however, did not survive the serious illness of his wife after her confinement and the death of their child. He was apparently not altogether a bad man, and one wonders how much the legend of his drunkenness has been exaggerated, for some parts of

* There are many works about George Morland. According to James Ward the most accurate of the early biographies was that by George Dawe.

it are scarcely credible. But there is no revising his own epitaph upon himself—'Here lies a drunken dog.'

Morland's contemporaries admired the 'simplicity and truth' of such pictures as his oil-painting *Interior of a Stable*, shown at the Academy in 1791 and now in the National Gallery; and these qualities are very notable in comparison with, say, the sentimental artificiality of Wheatley. Morland's farm hands and beasts, boys out rabbiting, smugglers, sailors and the like are truly set down from life. The Londoner of today may be inclined to wonder how a townsman like Morland acquired the first-hand country knowledge which he clearly possessed. But London then was a comparatively small place, not cut off from the country as it is today. An afternoon's ramble would take a man to woods and farms and villages. Moreover Morland had on occasion travelled farther afield—to Kent, to the Isle of Wight, and even to France.

Morland's work was mostly in oils, and he is chiefly mentioned here in order to put certain other artists, who used watercolour more frequently, into proper perspective. I can only recall two drawings by him which might be called watercolours, the *Landscape with Figures* ($9\frac{11}{12} \times 13\frac{2}{3}$ inches) and the round portrait, $7\frac{1}{4}$ inches in diameter, of his sister Mrs William Ward, both in the Dyce collection in the Victoria and Albert Museum. The latter, in black chalk tinted with watercolour, is not a typical work. The other is more characteristic and is signed 'G. Morland Del.' It is a pen and brush drawing suffused with pinkish-red and brown washes. A man with a pack-horse and dog passes along a wooded lane from the right, and a man, woman and child are seated on a bank by the lane (288). It is not a very strong or attractive work. Most of Morland's drawings, however, are in other mediums, such as black and red chalk, or pencil and red chalk, or pencil alone. They vary greatly in quality, some being hard and unattractive, others much more sensitive and rich in touch. He drew animals very well. With human beings he was often clumsy; in particular he had a curious lumpy way of drawing the shoulders and upper part of the back. His small pencil drawings of landscape with trees could sometimes have an almost Dutch precision. Very occasionally he drew in monochrome wash. His drawings vary so greatly in merit, and there are so many copies about, mostly done from the soft ground etchings which were published after his sketches, that he provides many problems difficult of solution. He fairly often signed his drawings, sometimes with abbreviations like 'G. Morld' or merely with initials (289).*

Of more direct importance to the student of watercolour was Julius Caesar Ibbetson (1759–1817), a large proportion of whose work was in the medium.† He was a Yorkshire-man, born on December 29, 1759, at Farnley Moor, Leeds, the son of a clothier. The child's Christian names were given him because of the operation which brought him into the world and caused his mother's death. He was educated first by the Moravians and later by the Friends. He had a strong desire to paint, which his father encouraged, and, apparently through a misapprehension, was apprenticed to a ship's painter at Hull. Here he showed aptitude for ornamental design, and in 1775, when he was about 16, painted some scenery for Tate Wilkinson, the actor and theatrical manager. When five of Ibbetson's

* One of the imitators of Morland is reputed to have been J. Harding of Deptford, who exhibited occasionally at the Royal Academy between 1800 and 1807. He was the father of James Duffield Harding (1797–1863) and is described as a drawing master and pupil of Paul Sandby. I have been shown a landscape, with cottage, donkeys, etc., in pencil and brown wash, supposed to be by him, which was highly reminiscent of a Morland monochrome, but I know little of J. Harding or his work.

† See 'Julius Caesar Ibbetson', by Rotha Mary Clay. *Country Life*. 1948. £3 3s.

seven years apprenticeship were done his master retired from business and the boy, not wishing to be handed over to his successor, ran away to London. That was in 1777. He got work with a picture cleaner called Clarke and, by the chance of painting a chest for a servant of Benjamin West, saw the pictures in West's house. It was at this period that he began his long friendship with William Anderson, the marine painter, of whom more will be said later. About 1780 he married. In his spare time he painted, sold some pictures through dealers, especially Panton Betew of Old Compton Street, and in 1785 showed for the first time at the Academy. In 1787 the Ibbetsons were living at Kilburn, and in that year he got the opportunity of accompanying, as artist, what was to have been the first British Mission to the Court of Pekin. The party, led by Colonel Charles Cathcart, sailed on the frigate *Vestal* on December 21 and proceeded by way of Madeira, the Cape of Good Hope, and Java. Unhappily, on June 10, 1788, Cathcart died, the mission was abandoned, and on October 9 Ibbetson found himself back in England. A number of watercolours made on this voyage have been traced by Miss Clay, who illustrates some of them in her book. They show that (so far as one can judge from reproductions) Ibbetson's drawings were then very much what they were in later life, for his manner of presenting a subject remained more or less the same throughout his career.

Ibbetson was now beginning to make headway, and to find influential patrons. In 1789 he visited South Wales and stayed at Cardiff Castle with Lord Bute. In 1791 he was with Mr Wilbraham Tollemache in the Isle of Wight. In 1792 he had eleven exhibits at the Royal Academy, and in this year he made a second and more extensive Welsh tour, in company with the Earl of Warwick's brother, Robert Fulke Greville (1751–1824), himself an amateur painter, and John 'Warwick' Smith (see p. 86). I have a signed pencil drawing of a man with four donkeys ($8\frac{1}{2} \times 11\frac{1}{2}$ inches) which came from the Warwick sale at Sotheby's, in June 1936, and may well have originated on this tour. It has a rough picturesqueness, but as an animal drawing, and in delicacy of touch, is a good deal inferior to a comparable pencil study of donkeys by Morland. Ibbetson's watercolours of Wales have considerable documentary importance for, unlike most watercolourists of the period, he was keenly interested in the people of the country, their conditions of life, costume, work and customs. So we get among his drawings such subjects as *The Blind Harper of Conway, Cyfarthva Ironworks, Coal Staithe on the River Tawe, Women Spinning*, and *A Drawnet at Tenby*—to quote only a few of those reproduced by Miss Clay in her book. Ibbetson went on for some few years making use of his Welsh material, and the National Museum of Wales has two watercolour versions of the same subject, *Llangollen and Dinas Bran*, both signed and dated, one 1794 ($13 \times 18\frac{1}{2}$ inches) and the other 1796 ($13\frac{1}{2} \times 20$ inches). Both are done from the same viewpoint, but they differ in the figures, and the earlier drawing is the softer and better of the two, with beautiful greys in the distance. The colour of the 1796 version is harder and brighter and it contains a much more elaborate group of cattle and figures. This is perhaps one of the *Nine Views in Wales*, exhibited by Ibbetson at the Academy in 1796. After that year Welsh subjects occur only rarely among Ibbetson's exhibits.

In November 1794, disaster fell upon Ibbetson, who was then living at Paddington. His wife died, leaving him with three children. The loss afflicted him severely, he took to drink, and the next few years were a very bad period for him. He was never, however, without patrons, such as Lord Mansfield, who employed him on decorations at Ken Wood; Sir

George and Lady Beaumont, who 'more or less adopted' his daughter; William Roscoe of Liverpool, Lady Balcarres, and George Thomson of Edinburgh. In 1798 Ibbetson moved to Liverpool where he worked for a dealer, Thomas Vernon, who contracted to pay his debts but neglected to do so. Ibbetson never returned to London, though he continued to exhibit there. He soon discovered the Lake District and early in the new century was settled at Ambleside, where in 1801 he had the good fortune to marry Bella Thompson, whose father was a weaver in that place. The Thompson family seems to have been respected and intelligent, and Bella, though she was only eighteen at her marriage, proved a very sensible woman, who made her husband an admirable wife. This marriage was, indeed, the saving of Ibbetson, and through his wife's influence his last years were useful and productive. From Ambleside they moved in 1802 to Troutbeck, which remained the home of the family until 1805. In that year they moved once more—to Masham, in Yorkshire, which Ibbetson had previously visited to execute commissions for a local squire, William Danby. At Masham the painter remained—sociable, kindhearted and much respected—until on October 13, 1817, he died.

Ibbetson's output was about equally divided between oils and watercolours, and I am inclined to prefer him in the former medium. In watercolour he often used the vignette convention in which the subject is as it were aerially suspended in the centre of the paper with the sides and corners left blank. This may be pretty enough when done on a small scale as decoration at the end of a chapter, or below a poem, in a book. But when used, as Ibbetson used it, for quite large drawings, it has a very awkward and unconvincing effect. Moreover his oils have a pleasant richness of quality which his watercolours lack. Nevertheless the latter are often very attractive; their figures—with characteristic little black dots for eyes—are well-grouped, lively and (though there is not much individual characterization in them) observed from life. For despite the fact that Benjamin West called him the Berghem of England, Ibbetson drew the inspiration of the peasant figures which fill his drawings much more from dwelling among English country folk as one of themselves than from the canvases of earlier painters. A charming example (291), in a slightly sentimental mood, of his work is *The Sale of the Pet Lamb* ($8\frac{7}{12} \times 12\frac{2}{3}$ inches,) in the Victoria and Albert Museum. It shows, in the central foreground, two little girls in white holding their lamb, while a third, in pink, kneels by it with clasped hands raised beseechingly to a butcher's man in a blue apron who stands by his horse. Behind him, and further to the left, are a cottage and trees, done chiefly in Indian ink wash. In the middle distance to the right a man in a blue coat, mounted on a white horse, talks to a man and woman—presumably the children's parents. There are grey hills and clouds beyond. The foreground is darkish. Another very good example—and a more straightforward observation from life—is a farmyard scene, measuring $10\frac{5}{8} \times 15\frac{7}{8}$ inches, in Mr H. C. Green's collection. It is in pen and watercolour and is dated 1793. In the left foreground is a goat suckling two kids. A man in a pink coat mounts a horse which is held by a boy whose coat is of a pleasantly contrasting blue. Farther back stand the farmer and his wife (290). A pretty series of 12 small watercolours, each $2\frac{1}{2} \times 3$ inches, representing the history of an oak tree, from the acorn up to the various uses to which the timber is put by man, belongs to Mr L. G. Duke. Occasionally preliminary sketches in pencil, or in monochrome wash, are to be found, but these are not so common as with some other artists.

Very little is known about Peter La Cave (or Le Cave) though he was a prolific artist,* whose watercolour groups of peasants, horses, cattle and so forth are among the first things the collector is likely to come across. His name is obviously French, and since he is recorded by Ibbetson to have understood Dutch it is plausible to connect him, as Long did, with a family of Dutch artists of the name who were of French extraction. He was working in England at least from 1789 to 1816, and exhibited two Devonshire views at the Royal Academy in 1801. He appears to have been indigent and probably disreputable, as there is record of his having been in gaol at Wilton in 1811 (though it is only fair to add that the bill of indictment for felony then brought against him was returned *ignoramus* by the Grand Jury) and that he deserted his wife. I suspect that he sometimes allowed other people to sign his work, as there is a watercolour, apparently by him, but signed 'J. R. Morris, 1806', in the Victoria and Albert Museum, and I have two much-damaged drawings in each of which the artist's signature has been altered into 'John Thos. Gower 1802', but, probably owing to the way they have faded, the original 'La Cave' underneath is now quite easily visible. La Cave seems to have had connections with both Ibbetson and Morland, and according to the report in *The Examiner* quoted by Long, 'with [Morland] La Cave lived many years as professional assistant'. La Cave occasionally painted in oils, but the great bulk of his work is in watercolour or more rarely pencil.

La Cave's watercolours vary very little in subject, except that early in his career he did some topographical subjects, of which Miss Paul reproduces two in her article already cited—*A View of Great Malvern*, 1789 (in the Malvern Public Library) and *Abingdon*, 1790 (in Mr H. C. Green's collection). The latter, with its foreground figures of horseman and capering dog and cattle watering, foreshadows somewhat La Cave's later and more familiar manner (292). In that, such incidents form the main point of the pictures, which represent subjects such as loaded donkeys crossing a ford, a cart being driven home, a gipsy encampment, or a group of cattle or goats, tended by a country girl who sits by a rock. These watercolours fall noticeably into two types—with comparatively large figures and with small ones. It is perhaps worth noting that I cannot recall seeing one of the latter type signed, as the former frequently are. Whether this has any significance I do not know, but it seems difficult to suppose that the two types are not the work of the same artist. The figures and animals in La Cave's drawings are outlined in pen, attractively grouped and often prettily coloured. They have, however, very little relation to real life, being a mere picturesque formula. The backgrounds are somewhat conventionally and weakly, but still prettily, done with the brush, and consist usually of a church, or a farm, with a few trees or bushes and a distant blue hillside. There is often a very obvious break in construction between the foreground and the distance. Curiously enough La Cave sometimes shows a quite unexpected richness and strength in his pencil drawings. Dawson Turner possessed a volume of them (La Cave had some sort of connection, apparently, with Norwich). These were chiefly drawings of cattle and horses, and Cotman in one of his letters to Turner (written in 1804) expresses his admiration for them. He was, indeed, probably influenced by them to some extent. This volume I came across in the nineteen-thirties, when it was being broken up by a dealer in the Tottenham Court Road and sold at fifteen shillings a

* See 'P. La Cave, Landscape Painter', by Basil S. Long. *Walker's Quarterly*, July 1922. 'Peter La Cave' (chiefly an extract from *The Examiner*, August 4, 1811), by Basil S. Long. *Walker's Monthly*, August 1929. 'Peter La Cave', by Frances Paul. *Apollo*, December 1947.

page. I bought half-a-dozen pages, which carry three beautifully soft and sensitive pencil drawings—an old woman with a basket, a shepherd boy, and a woman holding a large fish. There is also a highly spirited and free pencil and wash sketch of a carter with his cart and horses and dog, besides a number of more conventional groups of peasants with donkeys, horses and sheep. I have occasionally come across pencil drawings by La Cave from other sources—but they are not nearly so common as his pretty, but weak and conventional, watercolours (293 and 294).

Two foreign artists who spent a few years in England were the Swiss, Johann Conrad Gessner (1764–1826), here from 1796 to 1804, and the Brandenburgher, Heinrich Wilhelm Schweickhardt (1746–1797), who settled in London in 1786 and stayed till his death. Gessner painted watercolours, with horses as a chief feature, in a rather harsh, strongly coloured, but not ineffective style, of which the Victoria and Albert Museum has examples. Schweickhardt's drawings are chiefly of cattle, but in my experience usually in black, or black and red, chalk. In full watercolour I have seen only one example, which came from Dr Percy's collection.

A mere mention must suffice for George Holmes, who is said to have worked both in Ireland and England, and exhibited at the Royal Academy from 1799 to 1802. He specialized in watercolour groups of cattle and peasants in landscape, but these were not of much distinction. He also did topographical views in grey or blue monochrome. I have some Irish sketches dated in 1796 and 1797, and the British Museum has (amongst other drawings of his) a watercolour of an Irish scene dated 1804, but whether he worked before or after these dates I do not know.

The two or three drawings I have seen by Mrs Amelia Noel (exhibiting 1795–1804) were little landscapes with small rustic figures, so perhaps she too deserves a place here. Farington, in his diary for April 8, 1805, tells how this poor lady, who supported her four children by teaching painting and drawing, came to him and 'represented that it was of great consequence to her to have a picture in the Exhibition, as her scholars judged of her ability in the Art from that circumstance'.

Another artist of whom a brief mention must suffice is John Renton, who exhibited from 1799 to 1841, chiefly at the Royal Academy and the British Institution. He was principally an oil-painter, but he used watercolour also, perhaps only for private purposes. Mr L. G. Duke has a number of very skilful drawings in the medium by him, and I have seen others. Renton's headquarters were always in London—his first address was in Hoxton—but he included a good many Lake District subjects in his exhibits. He made—both there and by the Thames—some charming and sensitive studies, in pencil and watercolour, of country girls and lads, which are sympathetically observed from life. He also did some watercolour landscapes which show the influence sometimes of J. S. Cotman, sometimes of John Varley. I have, however, only seen sketches or studies by Renton, never finished exhibition pieces in watercolour (287).

James Ward, RA (1769–1859), was an artist of remarkable talents, as engraver, draughtsman, and painter both in oils and watercolour, who has seldom been given his due except perhaps in the first of these capacities. Watercolours with him were on the whole a byproduct, but he used the medium fairly often, and at times with a distinction which entitles him to very honourable mention in this book, though one could hardly class him among

the great watercolourists. He was born on October 23, 1769,* the younger son of James and Rachel Ward. His father, manager to a wholesale fruiterer and cider merchant in Thames Street, took increasingly to drink, and even before he lost his employment the family was in poor circumstances. Young James was taken from school at seven years old and when he was nine was washing bottles at a warehouse for four shillings a week, working from six in the morning to eight or nine at night. He began to draw, nevertheless, and when he was twelve was apprenticed to the engraver and pastellist J. R. Smith, who did not treat him well and used him merely as an errand boy. His elder brother William, himself afterwards an eminent engraver, was already apprenticed to Smith, and when he finished his time managed to take young James away with him. As his brother's apprentice James worked from 1783 to 1791, going to live with him, probably from about 1785 to 1787, at Kensal Green, which was then quite rural. He acquired during this period much skill as an engraver, and also began to paint—being inspired thereto by his admiration for George Morland, who on September 22, 1786, became his brother-in-law by marrying James's sister Ann. A month later William married Morland's sister Maria.

As a painter James Ward at first modelled himself closely on Morland, though he had no actual instruction from him, and Ward's early works have often passed as by Morland. He was ambitious to make painting his real profession, but did so only against the advice and opposition of many artists who wished him to stick to engraving. This annoyed him so much that he began to refuse commissions for engraving, even to the extent of £2,000 in a single year, though he was practically without work as a painter. Some commissions began to come to him, about 1797 and 1798, for portraits of cattle and horses, of which he eventually did many, and it was as a painter that he became ARA in 1807 and RA in 1811. His first painting had been exhibited (at the Society of Artists) in 1790, and at the Academy he showed, between 1792 and 1855, no less than 298 exhibits. His total contributions to exhibitions in his lifetime numbered 400. Nevertheless, and in spite of an early appointment, in 1794, as Painter and Engraver to the Prince of Wales, his life was far from one of unbroken prosperity. He had his triumphs, but also very great disappointments—he wasted six years over a huge allegorical picture commemorating Wellington's victory at Waterloo, and the end of his life saw him left far behind by the taste of the day. He had, moreover, many financial troubles, principally caused by his eldest son being mentally afflicted and his third son a wastrel. Happily the second son, George Raphael (1798–1878), who became an engraver of note, was a more reliable character and proved a stalwart support to his father in his middle and old age. Ward's first wife, Emma (her maiden name was Ward, but she was no relation), whom he had married apparently about the year 1795, died in 1819, and in 1828 he married her cousin Charlotte Fritche. About a year later he left the house in Newman Street which had been his home since 1799, and lived the rest of his days at Cheshunt, where on November 16, 1859, he died. He was a man of rugged, independent, and strongly religious character.

Today Ward's paintings—notably the *Bulls Fighting, St Donat's Castle*, deliberately modelled upon Rubens, in the Victoria and Albert Museum, and the *Gordale Scar* and *Cattle in Regent's Park* at the Tate Gallery—are probably more widely admired than at any

* See W. Shaw Sparrow, *A Book of Sporting Painters*, Lane, 1931, where the correct date is given. See also C. Reginald Grundy, '*James Ward, RA*', Connoisseur, 1909.

time since they were painted. But his drawings and watercolours, though they are begin-
ning to attract attention, are still too little known. Ward drew constantly and in every sort
of medium—chalk, pen, pencil, wash of various kinds, and watercolour. He was not always
a very easy, or even a correct draughtsman, but he was an extremely observant one, whose
work is often forceful and full of rugged character. He did enormous numbers of draw-
ings, and nearly always signed them, sometimes with his full name, sometimes with
initials, sometimes with a monogram of all the letters in J. Ward. Usually he added RA,
and sometimes the date, to his signature. Like Chinnery and Hills he often annotated his
sketches in shorthand. He frequently gave the name of the place, but not so often the date,
and he had an irritating habit of writing 'August 22' or some such day, without the year,
so that his drawings are of less value than they might be in helping the student to trace
Ward's sketching trips. These are not easy to date. He was in the Isle of Thanet about
1797 (see W. Shaw Sparrow *loc. cit.*); and Grundy identifies some further tours. In 1801,
painting cattle for Boydell and the Agricultural Society, Ward was in Berkshire, Wiltshire,
Dorset, Somerset, Devon, Cornwall and Bedfordshire; and in 1802 he was in Wales and
the border counties for three months, bringing back 581 sketches from nature. He visited
Scotland in 1805 (with Lord Somerville at Melrose) and in 1811. From inscriptions on
drawings at the British Museum or in my own collection or elsewhere it is clear that Ward
was in Wales (Barmouth) in September 1807, Dorset (Isle of Portland) and also Wiltshire
(see the *Chiseldon* at Manchester) in August 1822, Wales (Abergavenny) in September 1829,
and Suffolk (Bury St Edmunds) in 1833. These are all the definite identifications of both
place and date that I have—though no doubt others could be added to them.

Ward has sometimes seemed to me a sort of artistic Cobbett, observing with sharp eyes
and noting down with pen, pencil, chalk, wash, or watercolour every curious or picturesque
object or personality which he saw on his travels through the English countryside. He
clearly had the keenest interest in old buildings, farm labourers, gamekeepers, country
folk of all sorts, horses, cattle, pigs, birds, carts, boats, farm-work, and even such small
objects as milk-pans and jugs—all these were recorded by him and form a valuable and
realistic commentary on country life in the early nineteenth century. He also made many
studies of landscape, mountain and cloud forms, trees (which he drew with great beauty),
and so forth. Sometimes one gets in his more careful and elaborate drawings a curious dis-
proportion in the size of distant objects—for example sheep grazing in a far meadow—
which may have been a deliberate mannerism, since it is to be noticed occasionally in the
landscapes of Rubens, upon whom at one time Ward modelled his landscape style. Ward
drew particularly well with the pen, using it with a firm and incisive touch which could
give great life and movement to a drawing. He could also be extremely delicate and
poetical, as in a little watercolour sketch of birches by a stream, or in a black chalk study
of willows, which has almost the sombrely evocative quality of one of Cotman's last tree
studies in the same medium. In watercolour his colour is sometimes a trifle acid in its
blueish greens, but at other times it has something of the creamy richness of Girtin, by
whom he was certainly influenced and whom he may have known through George
Morland, whom Girtin knew to some extent. There is a copy of a Girtin watercolour by
Ward in the British Museum, and the National Museum of Wales has a small Girtinesque
landscape. Sometimes Ward could be surprisingly modern, as in a little watercolour of

hill scenery, which I have, in which a few simple, horizontal or arching, areas of flat colour build up a drawing which might almost be by the late Sir Charles Holmes (295, 297, and 298).

The formal finished watercolour landscape Ward did only comparatively seldom. His finest thing of the kind is probably *Chiseldon, near Marlborough* ($10\frac{1}{4} \times 14\frac{7}{8}$ inches), which is in the Whitworth Gallery, Manchester, and was seen at Burlington House in 1934 and at the RBA in 1948 (296). It shows a rough track leading from the centre foreground up and away towards a village in the left distance, while to the right of it is a blue-green valley in which are trees and a white farm with red roof. This drawing contains some beautiful pen-work, and is attractively rich in colour. Incidentally the sheep in the valley—in accordance with the peculiarity or trick to which I have already drawn attention—are larger than they should be. There are also good watercolour landscapes by Ward in the British and Victoria and Albert Museums. But it was in his sketches and slighter drawings, including some casual watercolour portraits of gamekeepers and labourers, that his acute record of country life and character is chiefly to be found.

In some of his work—though scarcely I think in his watercolours—Ward comes into the class of sporting artists. Not many such painters of the generations covered by this book—those born before 1785—used watercolour very much. Philip Reinagle, RA (1749–1833), did so occasionally—there is a fox hunting watercolour by him at South Kensington and I have also seen occasional shooting subjects of his. Samuel Howitt (1756*–1822), however, did so regularly, though he also painted in oils, and etched. A member of an old Nottinghamshire Quaker family, Howitt was originally a gentleman devotee of field sports, living at Chigwell, Essex, and only took to art professionally when money difficulties forced him to do so. He exhibited occasionally between 1783 and 1815, showing first at the Academy in 1784. He illustrated a number of sporting or zoological works, including Captain T. Williamson's *Oriental Field Sports*, 1807, working in this case from Williamson's own sketches, for he himself never visited India. Preliminary drawings for these plates exist (there are two in the British Museum and I have two more), and Binyon, in his catalogue of the Museum's English drawings, expressed the view that they were Williamson's original sketches. In this I think he was wrong, for it seems to me clear that these drawings, free and rough as they are, are quite characteristic of Howitt, who probably made them from Williamson's originals, as an intermediate stage in the preparation of the plates.

Howitt married Rowlandson's sister, and his early watercolours, done in the 'eighties and 'nineties, are very close to Rowlandson in style, particularly to a rather precise stiff type of early Rowlandson. These early drawings, with pen outlines and coloured in watercolour, include a number of hunting and other sporting subjects, in which his first-hand acquaintance with sport was a great asset to him, and of which there are examples at the British Museum and at South Kensington (301). He also did charming landscapes with rustic figures, which are again very Rowlandsonian. Some of these watercolours were done in the Isle of Wight and are dated 1791, for example one in the Victoria and Albert Museum, and another in my own collection. The latter, which measures 9×13 inches,

* Mr L. G. Duke tells me that the late G. E. Kendall discovered in the registers of St James's Church, Piccadilly, that Howitt was born in 1756. The date usually given in books of reference is *circa* 1765. I do not know that Mr Kendall ever published this correction.

is a view along the cliff tops with a chine opening in the foreground. Its edges are grown with bushes. In the right-hand corner are a girl carrying a rake over her shoulder, a boy and a capering dog. The outlines are in pen and the colouring is mostly in light soft tones—reddish for the bushes on the near side of the chine, with various greys and blues for the rocks of the cliffs and the distant fields along their tops. This drawing, incidentally, does not show the sharp dog's toothing, or hedgehog, effect which Howitt often used for foliage. On the whole the effect of such drawings is strongly Rowlandsonian (300). He is said to have done caricatures also in Rowlandson's style, but I do not think I have seen any. Howitt's later watercolours, especially his smaller drawings of animals, of which he did a great many, are usually (at least) done without pen, the great bulk of the drawing being executed with the brush, though in some cases there is some underlying pencil visible. They vary a good deal in quality, but at their best can be very skilful and charming, the pose of the creature being lifelike and the background often consisting of a pretty suggestion of landscape. Often Howitt notes at the bottom of such a drawing whether it was done from life, sometimes mentioning the place at which the specimen was seen—for instance the menagerie at the Tower of London—and the name of the species. He was particularly good at deer, which he drew with special delicacy, but he also did many monkeys, cattle, birds, fish and so forth (299).

With the Alken family of sporting artists (for which see W. Shaw Sparrow, who gives a family tree in *A Book of Sporting Painters*, Lane, 1931) watercolour of a kind was a frequent medium. The ramifications of this clan are intricate, but happily need not trouble us greatly here since most of them belong to generations later than those with which we are concerned. Samuel Alken the Elder (1756–1815) was architect and engraver but only very doubtfully (on Shaw Sparrow's showing) a painter, though works have often been attributed to him, probably in error. Two of his sons, however, call for brief mention, Samuel the younger (1784–*circa* 1825), and Henry Thomas (1785–1851), who signed H. Alken and is by far the most important of the family. He was trained as a miniature painter, and this probably was one of the causes of his tight, precise style of drawing. He specialized above all in hunting scenes, and was himself known in Leicestershire as a rider to hounds. The drawings of his best, or second, period,* from about 1819 to 1831, are, in essence, careful pencil drawings more or less coloured. Sometimes he adopted the very ugly and inartistic device of colouring only the riders, the horses and the hounds, and of leaving the rest in pencil. In others (for example several in the British Museum) there is a pale wash of some sort over the whole picture, but the riders and their animals are more strongly coloured than the rest. Yet there is never any warmth, richness or modelling in the colour, which is purely superficial in effect. Personally I find prints after Alken much more attractive than his original drawings, of which a quite good example is the British Museum's *Charging a Flight of Rails—Near as a Toucher* (9½ × 12 inches). This is carefully drawn in soft

* In the introduction to the catalogue at Messrs Ellis and Smith's exhibition of original drawings by Henry Alken, 1949, Mr J. Gilbey Ellis has set out a division of his work into three periods. During the first period, 1809 to 1819, there is little pencil visible, though the result is essentially drawing, not painting. The aim is usually humorous (302). It seems to me that in this period Alken's figures are a trifle reminiscent of J. A. Atkinson and the landscape settings remind me of Howitt. In the second period, 1819 to 1831, Alken's drawings are, as stated above, careful pencil drawings more or less coloured. In the third period, from 1831 up to about 1840, he produced elaborate and often crowded watercolour compositions of sporting scenes, without obvious pencil work and sometimes done over an etched outline, which are more or less in imitation of oil-paintings. These are less humorous or satiric than his early work. After 1840 his powers declined greatly. Messrs Ellis and Smith's catalogue contains reproductions of drawings of all three main periods.

pencil, and very artificially washed in colour with the riders, horses and hounds much too bright for the background, which is only faintly coloured (303).

A curious and sometimes attractive byway in which certain artists began to earn their livings, partly or more rarely wholly, in the last quarter of the eighteenth century, was the trade of painting the portraits of prize cattle, horses, sheep, pigs and the like. It concerns us hardly at all here, for it was carried on almost entirely in oil-paintings and engravings. I have, however, seen a few primitive examples in watercolour. The British Museum has a large watercolour ($15\frac{1}{2} \times 19\frac{7}{8}$ inches), of a black and white bull in a landscape by a certain J. Hornsey, who worked about 1795–1797, and also did topographical drawings, chiefly of Yorkshire, which were engraved in the *Copper-plate Magazine*. It no doubt made a handsome decoration in the farmhouse for which it was intended. In the late Lord Northbrook's most interesting collection of cattle pictures (chiefly prints) now at the Rothamsted Agricultural Research Station, Harpenden, there are also a few watercolours, but of much less artistic merit than the prints. Otherwise I do not remember seeing any cattle portraits in watercolour, though no doubt others exist.

The marine watercolourists are a very different matter, for they formed a vigorous and prolific school in the second half of the eighteenth century, and though there were among them many pedestrian or crude journeymen performers, there were also several of much talent and charm, though scarcely of genius. To a writer they present the difficulty that it is almost impossible to convey in words the slight stylistic differences which separate the work of one from that of another. This is perhaps the reason why there is, so far as I know, no book about the English marine draughtsmen, though there has recently appeared a useful short account of the whole school of British marine painting, by Mr Oliver Warner,* in which the watercolourists have their place. They are, nevertheless, well worth a book of their own, if someone will do the necessary research. In this place they must receive, I fear, but brief and perfunctory treatment.

The roots of English marine drawing stretch back into the seventeenth century and in particular to the work of the two William Van de Veldes, father and son, who as noted in Chapter I settled in this country about 1675, and of whom the younger died in 1707. There were native painters of ships, such as Isaac Sailmaker (1633–1721), and the Jerseyman Peter Monamy (*circa* 1670–1749), who bridged the change from the seventeenth to the eighteenth century, but I do not know of any drawings firmly attributable to either of them; the *Old East India Wharf* in the Victoria and Albert Museum, long given to Monamy, is now tentatively transferred to Samuel Scott. Shipping drawings of the early eighteenth century are neither common nor important, but it may be worth noting that I have twice seen large signed and dated drawings of the period enclosed in rather elaborate decorative and allegorical borders. One was a big watercolour (unfortunately I did not note the size) which I saw about 1947 in a shop at Cambridge. It represented shipping, competently drawn, and the border decoration contained mermen and other allegorical figures with bulrushes at the side and, in a panel at the bottom, the inscription 'By Edmund Bush Anno Dni 1715-16'. A similar piece, but in monochrome, is a view of Gibraltar, $21\frac{1}{8} \times 28\frac{3}{8}$ inches, in the National Maritime Museum. It is signed and dated 'Willkes Page Anno Domni 1718', and it too has an elaborate border—of figures, garlands, cannon, etc. Either

* *An Introduction to British Marine Painting,* by Oliver Warner. 1948. Batsford. 21*s*.

by itself would be scarcely worth mentioning, but the occurrence of two similar ambitious maritime drawings, each similarly signed by a different and otherwise unknown artist, and dated within a couple of years of each other, seems a curious coincidence, which may indicate that there was a fashion for such things.

A good number of the early marine painters had professional interests, other than art, in the sea. Isaac Sailmaker, to whom reference has been made, no doubt drew his name from his trade. Charles Brooking (1723–1759), a talented painter who died before he fulfilled the expectations he had aroused, was brought up in the dockyard at Deptford. Most of the few drawings of his I know are in monochrome (304), as are those of Francis Swaine (exhibiting from 1762; died 1782). Swaine usually signed his work, 'F. Swaine'. A good example is the National Maritime Museum's *A Lugger Close-hauled in a Breeze* ($10\frac{3}{8} \times 15\frac{7}{8}$ inches), in which a crimped pen-line is effectively used for forming the crests of waves (305). This particular effect, however, is by no means general in Swaine's work. I do not know that he followed any sea-trade apart from his painting, but a contemporary of his, John Hood (exhibiting 1762–1771), was a shipwright working at Limehouse. He sometimes signed his drawings, which I have only seen in Indian ink, with his whole name and sometimes with the initials 'I.H.'. Some of his stiff and crude portraits of ships are at Greenwich. Other shipwrights were William Anderson and John Cleveley the younger (of both of whom more in a few moments); and the latter's twin brother Robert was a caulker. Nicholas Pocock (who is dealt with at some length in Chapter XI) was a merchant captain, and Dominic Serres (to whom also I shall revert) was a French seaman. George Tobin (1768–1838), a rather clumsy amateur, was a naval officer who rose to the rank of Rear-Admiral. So evidently marine painting was in many instances a secondary activity, arising out of the artists' contacts, through their trade or profession, with the sea.

Samuel Scott (*c.* 1710–1772) has already been discussed, as a topographer of the Thames valley, in Chapter II, and I do not propose to write of him here, since I know no watercolours (or indeed other drawings) certainly by him which are primarily concerned with ships or the sea. It is true that the National Maritime Museum has a large number of sketches, many of them much in the manner of Van de Velde, of ships and shipping, all taken from the same album. They are very freely and loosely and imaginatively drawn, on blue (or more rarely grey) paper, in various mediums—including black and white chalk, pen and wash, and pencil. Unfortunately, however, their attribution to Scott is only tentative.

Not much younger than Scott was Dominic Serres, RA (1722–1793), a good number of whose drawings are known. He was born at Auch, Gascony, apparently of educated people, but ran away to sea, and about 1758 was serving on a Spanish ship when he was taken prisoner by the English and brought to this country, where he remained for the rest of his life. After his release from imprisonment he opened a small shop, first on London Bridge and then in Piccadilly, for the sale of his pictures, which were chiefly sea-pieces but included some landscapes, too. He also lived for a while in Northamptonshire. Charles Brooking is said to have assisted him, but this can only have been for a short while immediately after Serres's arrival in England. He began to exhibit (at the Society of Artists) in 1761 and in 1768 was a foundation member of the Royal Academy. He was, as Edwards reports, a good linguist, 'but, what is still more to his praise, he was a very honest and

inoffensive man, though in his manners *un peu du Gascon*'. His exhibits at the Society of Artists, the Free Society, and the Academy numbered in all 134. Serres's drawings vary considerably. The National Maritime Museum (in which he is not well represented as a draughtsman) has an Indian ink monochrome, with heavy black pen outlines, *Capt. Macbride in the Artois taking two Dutch privateers* ($10\frac{5}{8} \times 14\frac{3}{4}$ inches). Like many of his drawings it is signed with initials.* Sir Robert Witt has an extremely Van de Velde-ish group of ships in pen and watercolour, signed 'D.S. 1792', which with its red, white and blue flags makes a very pretty effect. I have also seen Van de Velde-like monochromes of a softer, more misty and poetical, type. But Serres's most characteristic drawings are watercolours, with a rather thick pen outline, in which a soft creamy blue is the prevailing hint. They can be quite attractive, though the touch of the pen is sometimes a bit heavy and clumsy. A younger son, Dominic M. Serres, exhibited nine landscapes at the Academy between 1778 and 1804 and taught drawing. There are some of his watercolours, which are quite showy and decorative landscapes, at the Victoria and Albert Museum.

More important, however, than the younger Dominic, was the eldest son, John Thomas Serres (1759–1825), a talented marine artist who was ruined by the extravagance and dishonesty of his wife Olive (*née* Wilmot), who claimed to be a daughter of the Duke of Cumberland and took to herself the title of Princess. As a young man J. T. Serres taught drawing at the Maritime School in Paradise Row, Chelsea, an institution which was founded in 1779 and lasted till 1787. He began to exhibit at the Royal Academy in 1776, and in 1793 succeeded his father as marine painter to the King. He was then also appointed marine draughtsman to the Admiralty, which often employed him to make sketches of enemy harbours, allotted him a ship for the duty, and paid him £100 a month while he was on this work. There are examples of his watercolours, which are drawn with a firm and fairly fluent pen and tinted in colour, in many museums and private collections, and at Greenwich he is far better represented than his father. A pretty example there is *A Scene on the Thames with Peter boats and figures* ($8\frac{1}{2} \times 13$ inches), with pleasant loose penline and soft colouring. It is signed (like most of J. T. Serres's work) and dated 1790. Also at Greenwich is *The Loss of the Lady Hobart on 28 June 1803*, signed and dated 1803 and measuring $18 \times 26\frac{1}{4}$ inches. It shows two boatloads of survivors (their faces with little black dots for features, rather in the manner of Ibbetson) tossed on an angry sea. The *Lady Hobart* is half-sunk to the right, while in the distance to the left is an iceberg. The boats and the waves make an effective curve, and the soft reds and other colours of the seamen's clothes are a pleasant break in the general grey-to-green-to-yellowish range of the sea and sky. Possibly this drawing has faded somewhat (the engraving made by Joseph Jeakes† in 1804 is much brighter in colour) but it certainly shows Serres to have been a very competent performer. Another example at the National Maritime Museum is reproduced as figure 307. He also worked occasionally in pen and Indian ink monochrome and in pencil.

The brothers John (1747–1786) and Robert (1747–1809) Cleveley were two of the most successful and accomplished marine draughtsmen of the later half of the eighteenth century. They were the twin sons of John Cleveley senior, a shipwright, of Deptford, who was

* In initialling his drawings Serres occasionally wrote a long S, but usually the more ordinary form of the letter, as in figure 306.
† Joseph Jeakes was also a draughtsman. I have a small rather formal monochrome landscape by him. He exhibited at the Royal Academy eleven times between 1796 and 1809. According to information given me by his great-nephew, the Rev J. M. Jeakes, he died about 1829.

himself also a painter. John and Robert were both brought up in the shipyards at Dept-ford. There was another brother, James, who was a ship's carpenter, sailed with Captain Cook on the *Resolution*, and then made some drawings which were worked up into water-colours by his brother John. Both John and Robert painted in oils as well as in water-colours.

John Cleveley, junior, while working at Deptford as a young man, attracted the atten-tion of Paul Sandby (see Chapter III), who was the drawing master at the Royal Military Academy, Woolwich. Sandby gave him lessons in watercolour. It was perhaps owing to Sandby's teaching that John Cleveley was not entirely (though he was principally) a marine painter, but did some topographical drawings also. I have three small examples of the kind in pen and monochrome wash, one of which represents a view in Ireland and another a view in Portugal; they are very much in the Sandby tradition of careful topo-graphy. He began to exhibit at the Free Society of Artists in 1767 and at the Royal Academy in 1770. In 1772 he went as draughtsman with Sir Joseph Banks's expedition to the Hebrides, Orkneys and Iceland. In 1773 he was draughtsman on the expedition led by Captain Constantine John Phipps (afterwards Lord Mulgrave) to discover a northern route to India, which however only got to the northward of Spitzbergen and then was forced to return. There are three rather pale and formal watercolours of ships surrounded with ice-floes, done by Cleveley as a result of this voyage, in the British Museum. Only one of these is dated—with the year 1774—and this is true of another drawing relating to this voyage which is in the Victoria and Albert Museum, so these finished watercolours were clearly worked up from sketches after Cleveley's return home. He is said in the *D.N.B.* to have used the signature 'Jnᵒ Cleveley Jun' until 1782 (presumably about the time of his father's death), but I do not think this was quite invariable, and I refer below to a drawing dated 1779 in which the Junior is omitted.

John Cleveley at his best was a suave and agreeable, though not notably forceful, watercolourist. A good example of his work is *Two-deckers making for Gibraltar* ($22 \times 31\frac{1}{4}$ inches), signed 'Jnᵒ Cleveley Delinᵗ 1779', in the National Maritime Museum. It shows ships in a long line approaching the Straits over a choppy sea, which is treated in a way much superior to the ordinary perfunctory formulae of the marine artist. The waves here have real variety and individuality of shape (308). Cleveley, however, was capable of more commonplace work, as in his rendering of the sea in a monochrome, apparently representing *Drake Island, Plymouth*, which is also at Greenwich.

Robert Cleveley (1747–1809) was, like his brother, an agreeable painter of sea-pieces, including especially naval battles. There is no record of his having had lessons from Sandby—but perhaps he received instruction at second hand from him through John. Very little, I fancy, is known of Robert personally. He exhibited from 1767 to 1806, chiefly at the Free Society and the Royal Academy. He was sometimes described as 'of the Navy', but does not seem to have held a commission. Many of his works were engraved. He held the appointments of marine draughtsman to the Duke of Clarence and marine painter to the Prince of Wales. There are a number of watercolours by him at Greenwich, and some monochromes which are marked with sharp delicate touches of the pen, rather in the manner of some of Van de Velde's drawings. As good examples of his watercolours may be cited two from the Greenwich collection: *The Occupation of Rhode Island*, 9 *Dec.* 1776, signed

and dated 1777, 17⅝×26¼ inches (309), which makes pleasant distant effect of a long coast-line against which ships are sending great bursts of white smoke that rises to mingle with the clouds above; and *A Frigate Taking in Stores*, signed and dated 1791, 30×53 inches. In the latter the smaller ships in the distance are very softly and charmingly done, but the figures in the boat are rather stilted. Robert Cleveley seems to have liked working on this (for watercolour) colossal scale, for in 1949 Messrs Walker showed me two drawings almost identical in size with that last mentioned. One, signed and dated 1796, represented ships off the Needles; the other (and more attractive), signed and dated 1791, was apparently the *View of Billingsgate at High Water*, which was shown at the Academy in 1792. It is a view up-stream towards Old London Bridge (as it then was, without the houses on it), with a glimpse of Fishmongers' Hall through the masts and sails of the ships that line the river bank on that side. Part of another ship comes into the picture from the left, and there is a rowing-boat in the centre of the foreground. All the vessels are crowded with figures somewhat in the manner of Dayes. The colour is a little weak, but on the whole the drawing is a most interesting, and agreeably effective, record of a busy river scene.

To my mind one of the most pleasing of the marine watercolourists was William Anderson (1757–1837), a Scot by birth and originally a shipwright by trade. He came south to London and became a close friend of Julius Caesar Ibbetson. He worked in oils as well as in watercolours and exhibited from 1787 to 1834, sending 45 pictures to the Academy between 1787 and 1814, which was the last year he showed there. The charm of Anderson's best drawings lies in the fact that they show the formal vision of the eighteenth century without the crudeness, or naivety, of many of the eighteenth century ship painters. He specialized in river and harbour scenes with shipping, and there is often a bit of quay or riverbank in the foreground on which stand, say, a couple of sailors—one in a red coat and the other in a blue—chatting or hauling a rope. His colours are very pretty, the detail of his ships is (I am told) accurate, and his drawings, calm in spirit, are often delightfully suffused with light. His skies, especially, can be effectively luminous (311). There are examples of his work at Greenwich, South Kensington and the British Museum, and in most collections. His watercolours are usually signed and dated, but not so (in my experience) his occasional monochromes. Anderson was a clever sketcher of figures— sailors sitting at a table, horses and carts, and so forth—in pen, pencil or wash, and once at a bookseller's I came across a large album of such spirited scraps, of which I was able to acquire a few. In his watercolours Anderson very often made effective use of the long narrow blue streamers which floated from the masts of eighteenth-century ships and of which the proper name is pendants (pronounced pennants, for some reason best known to the Navy).

An artist of much the same type, though of less charm and accomplishment, was Samuel Atkins. His dates of birth and death are not known, but he exhibited 18 pictures at the Royal Academy between 1787 and 1808. From 1796 to 1804 he was in the East Indies. He too painted in both oil and watercolour. His larger watercolours can be a little stiff and unconvincing in arrangement, but on a small scale—say 5½×8 inches—he was quite pretty and graceful. I have, amongst other drawings by him, a small landscape, but it is mannered in conception and very poor in execution. He usually signed 'Atkins', very often on a piece of wood floating in the sea. A favourable example of his work on a rather larger scale (13½×18⅝ inches) is reproduced as figure 310.

A whole host of minor shipping watercolourists existed, and one comes across examples of their work from time to time. A very assiduous hack performer was Thomas Buttersworth, by whom the National Maritime Museum has a number of showy but stiff and essentially commonplace watercolours of naval battles, dated between 1797 and 1810, though the events depicted are often somewhat earlier, for example the loss of the *Royal George* in 1782. Buttersworth's touch is rather hard and his figures poor. He was particularly fond of a line of flags of a strong blue strung out squarely across the picture. Another prolific performer—at any rate there are many prints after him—was Robert Dodd (1748–1816), but a watercolour of his at Greenwich, dated 1797, is a feeble thing. Also at Greenwich is an example, dated 1791, of another poor and stiff artist, John W. Edy; nor is there much to be said for J. Livesay who worked in the Portsmouth area about 1800 and is represented in the same museum. John Christian Schetky (1778–1874), who was born in Edinburgh and was a pupil of Alexander Nasmyth, had rather more reputation, but his finished work (e.g. *H.M.S. Active . . . working out of Portsmouth Harbour*, circa 1819, to be seen at Greenwich) is prim and weak, though with some gay touches of colour. His slighter sketches, which are not always marine, are often more pleasing. Some further names may be given, of which I myself have examples: Thomas Naylor, working 1788–1795, a heavy-handed imitator of Atkins; F. J. de la Cour, who in a watercolour of ships at sea, dated 1806, is still firmly in the eighteenth century tradition, with curly, pleasantly formalized, waves; and J. Emery, exhibiting 1801–1817, whose sepia monochrome dated 1813 seems to be striving ineffectually after Cotman.

A much more accomplished artist than any of those mentioned in the last paragraph was Samuel Owen (1768 or 9–1857). He exhibited only from 1794 to 1810, first at the Academy and then with the Associated Artists in Water-Colours, and apparently retired from active participation in his profession many years before his death. He supplied drawings which were engraved by W. B. Cooke in *The Thames*, 1811, and a few others for the *Picturesque Tour of the River Thames*, published by William Westall and himself in 1828. Though not invariably restricted to marine and shipping subjects, it was nevertheless chiefly these which Owen drew, but he had not the precise formality of the professional marine artists of the eighteenth century. He was, indeed, very much an artist of the early nineteenth century, when marine painting ceased to be a self-sufficient trade of its own, and became increasingly an occasional branch of landscape-painting with a more atmospheric, romantic, and picturesque approach which aimed rather at interesting the lover of art than at a seamanlike exactness. A good example of Owen's work signed and dated 1808 ($8\frac{7}{8} \times 13$ inches), in Mr L. G. Duke's collection, shows a fishing boat tossed on the crest of a wave as it puts off from shore (312). The sea is a rich blue-green with milky patches of foam. Other boats are in the distance, and there is a strong leaden-grey sky with a lighter patch in the centre. The drawing is akin more to Francia—a landscape painter who did occasional sea-pieces—than to a marine artist such as Anderson (though there were only about ten years between Anderson and Owen in age)—and seems to forecast such early Victorian watercolourists of the sea as Charles Bentley and George Chambers. Another drawing which I have noted as a good example of Owen is *Boats Becalmed* ($8 \times 11\frac{1}{8}$ inches) in the National Museum of Wales, signed and dated January 1804. It is a study of fishing boats in Indian ink wash with some colour—red-brown on the sails, red on the

small flags, and so on. The effect is very agreeable and fairly broad. Both the British Museum and the Victoria and Albert contain examples of Owen's work—with which these brief notes on the marine watercolourists may end.

We saw, in Chapter I of this book, how John White in the sixteenth century made drawings of birds and other creatures. And at the end of Chapter II mention was made of a few artists who made more or less factual watercolour drawings of plants or birds in the second and third quarters of the eighteenth century—notably G. D. Ehret, George Edwards, Charles Collins, Isaac Spackman and Peter Paillou. These, however, were by no means the only naturalist draughtsmen of that or the immediately succeeding period. The great growth of interest in the various branches of natural history during the eighteenth century, stirred largely by the work and writings of Linnaeus in Sweden, and exemplified here by such events as the foundation of the Linnean Society of London in 1788, the beginning of the publication of Sowerby and Smith's *English Botany* in 1790, and of Curtis's *Botanical Magazine* in 1781, meant that natural history drawing became a recognized if limited field of professional activity. Exploration too gave the scientific draughtsman an opportunity, and the British Museum (Natural History) has collections of such work done on Captain Cook's three voyages to Australia. From Cook's first voyage of 1768–1771 there are large watercolours of plants and various kinds of animals by a young Scottish draughtsman, Sydney Parkinson (1745?–1771), who died at Cape Town on the way home. From Cook's second journey, 1772–1775, there are large drawings of birds, a few mammals and other animals by Johann Georg Adam Forster, commonly known as George Forster (1754–1794), who belonged to a Yorkshire family which had settled in Polish Prussia after the execution of Charles I. He accompanied the expedition as assistant to his father, the naturalist Johann Reinhold Forster. George Forster's work was poor, the colour blotchily put on, and the settings, where attempted, crude with perfunctorily formal vegetation. From Cook's third voyage, of 1776–1780, the museum has 115 drawings of birds, mammals (e.g. a walrus), fish, crustaceans, etc., by William W. Ellis, of whom nothing is known. They are mostly in rather scratchy pen and Indian ink, with pale watercolour washes, most of the birds being drawn in the early eighteenth century convention of a colossal bird perched upon a very small tree-stump. Of these three draughtsmen Parkinson is, artistically, by far the most notable, and his best work is in his fine series of botanical drawings. These are on large sheets of paper (e.g. $18\frac{3}{4} \times 11\frac{1}{2}$ inches), and are sometimes in clear colour without much pencil (for the more delicate plants), but at other times (for the more coarsely textured species) in opaque, but not heavy, pigment (314). Some of Parkinson's last drawings were finished after his death by other artists.

These are by no means the only things of the kind in the Natural History Museum, which is very rich in scientific drawings. So far as botany is concerned, the high-water mark is probably the work of an Austrian, Ferdinand Lucas Bauer (1760–1826). His large and very handsome watercolours of Australian plants (e.g. $21 \times 14\frac{1}{4}$ inches) are chiefly in clear colour with some use of gum (apparently) for strengthening the shadows (315). The Museum also has some drawings of Australian animals by him. Ferdinand Bauer was born at Feldsberg in Austria, and died in Vienna. His connection with this country began in 1786 when John Sibthorp (1758–1796), who was then in Vienna, engaged him to accompany him as draughtsman on his first journey to Greece, and Bauer's chief fame is as the

illustrator of Sibthorp's posthumous *Flora Graeca*, the original drawings for which are at Oxford, together with others of animals. He did a certain amount of topographical work also, both in Greece and in England. The late G. C. Druce had 131 'sepia sketches' of places in Greece visited by Bauer and Sibthorp (see G. C. Druce, *The Flora of Oxfordshire*, 1927, page C). I have three largish signed sepia and Indian ink views, carefully but rather stiffly and formally drawn, of Instow, in Devon, with which the Sibthorps had family connections. The largest of these measures $13\frac{1}{2} \times 21\frac{1}{2}$ inches. His brother Franz Andreas Bauer, FRS (1758–1840), came to England in 1788 and two years later settled at Kew, where for 30 years he was employed by Sir Joseph Banks as draughtsman at the Royal Botanic Gardens. He was also botanic painter to George III. A large collection of his drawings of Kew plants is in the Natural History Museum. They are on large sheets (e.g. $20\frac{1}{2} \times 14\frac{1}{2}$ inches), and chiefly in clear colour, sometimes with a little opaque colour also. Some only partly finished examples allow one to observe his method of work which seems to have been, first to draw the plant carefully and delicately in pencil; then, apparently, to colour the outline; and last to add the general colours.

Not more than passing mention can be made of other such botanical watercolourists as Frederick P. Nodder (exhibiting 1773–1788; died about 1800?), who in 1788 was described as 'botanical painter to her Majesty'; John Miller, originally Johann Sebastian Muller (1715–1790), a native of Nuremberg who settled in England in 1744, and his son John Frederick Miller, who accompanied Banks and Solander to Iceland in 1772 as draughtsman; and Peter Brown (exhibiting 1766–1791), who was Botanical Painter to the Prince of Wales. I have seen very competent work by all of these. It is often highly decorative too, though its prime object was always scientific and it was therefore essentially distinct from, for example, the purely decorative flower arrangements of such an artist as Mary Moser (1744–1819), afterwards Mrs Lloyd, a foundation member of the Royal Academy, specimens of whose work are in the Victoria and Albert Museum, and whose aim was entirely artistic (313). A very early example of her watercolours, signed and dated 1759, belongs to the Royal Society of Arts, which awarded it a prize in that year. Perhaps a mere mention may be made of James Bolton (1758–1799), a self-instructed artist-naturalist who lived near Halifax. His rather crude, but well observed, drawings of British ferns and horsetails, mostly in Indian ink but a few of them in colour, once belonged to Sir Joseph Banks and are now in the Natural History Museum. A few of them have dates varying from 1776 to 1790. Another name is that of Simon Taylor, who worked in the sixties and seventies of the century.

We have not yet done with the botanical artists, and among the treasures of the Natural History Museum are the original drawings made by James Sowerby (1757–1822) for *English Botany* (36 volumes, 1790–1814), for which Sir James Edward Smith wrote the text. Sowerby was one of the most eminent of English artist-naturalists, and he illustrated many works beside this one. He was, moreover, the founder of a dynasty, and at least five of his sons or grandsons achieved distinction in this field. His illustrations to *English Botany* are probably the most lucid, informative and comprehensive delineations of the British flora ever done and they had a very wide influence on the developmentof English natural history. The plates have great charm, both of line and of colour, but the originals are disappointing as watercolours, since it was Sowerby's custom to colour only small sections of

his drawings (which are in delicate pencil)—half a leaf, for example, with a short bit of stem, and, say, one flower in an umbel—merely as guidance for the hand-tinting of the engravings (316). Fully coloured plant drawings by Sowerby do, however, exist.

Also of importance was Sydenham Teak Edwards* (1769?–1819), son of a school-master at Abergavenny. His work varies a good deal in quality, and my impression is that his flower drawings were better than his bird drawings, which can be wooden and unpleasing in colour. I have a drawing on vellum by him of two pipits, which has just these faults, though there is an attempt to show the birds in a natural background. As a botanical artist (which is his chief fame) he was a protegé of William Curtis (1746–1799), for whom he made nearly 1,700 drawings for the *Botanical Magazine* alone, besides others for the *Flora Londinensis* and other publications. Edwards left the *Botanical Magazine* in 1815 and started the rival *Botanical Register*. One may study Edward's botanical drawings in the library at Kew Gardens, and some of them—for instance a particularly dainty *Aster fruticulosus*, reproduced as plate 2,286 in the *Botanical Magazine*—are charming (317).

Not plants and birds alone occupied the naturalist-draughtsmen of the second half of the eighteenth century. The beauty, curiosity and interest of the insect world also em-ployed them. Entomologists of that period called themselves 'Aurelians'—from the Latin *Aurelia*, meaning a chrysalis—and Moses Harris (1731–*circa* 1785), secretary from 1762 to 1766 of an Aurelian Society (the second society of that name), called the book on butter-flies and moths which he published in 1766 *The Aurelian*.† For this he wrote the text and drew and engraved the illustrations. A volume of his original drawings (some of which were reproduced by Mr N. D. Riley in a King Penguin *Some British Moths* in 1944) is in the British Museum (Natural History). They are bound with the sheets of a later edition, but differ considerably from the published plates. They cannot have been done for the original edition, since some of them are dated 1785. I suspect them to have been a set specially drawn for some friend or patron. In these drawings Harris shows the adult insect, caterpillar, chrysalis and food-plant, grouped artificially and with curious variation of scale. More than one species is given on each plate. The insects are much more skifully drawn than the plants. In spite of the slightly naive artificiality of the arrangement—which is nevertheless decoratively effective—the quality of the drawing and colouring of the individual insect is very high—even brilliant. The attitudes in flight are particularly well caught, and Harris's use of body-colour is admirably suited to the rendering of the sheen and velvety quality of butterflies and moths. The drawings measure about $12\frac{3}{4} \times 8\frac{3}{4}$ inches each, and most of them are signed. A few carry the date 1785, but rather oddly, the date has been erased from some others. Harris illustrated a number of other books of natural history, but so far as I am aware his only surviving original drawings are these (319).

A second watercolourist of insects was John Abbot, who has escaped the compilers of most English books of reference—though Samuel Redgrave, in his *Dictionary of Artists of the British School*, jumbles him up with John White Abbott. John Abbot‡ (*b.* 1751–*d.* be-

* See O. Stapf, 'The *Botanical Magazine*: Its History and Mission'. *Journal of the Royal Horticultural Society*. Vol. LI. Part I. 1926.
† This, with its later editions, is clearly a book of great bibliographical complexity, a matter which I do not propose to discuss here.
‡ See Anna Stowell Bassett, 'Some Georgia Records of John Abbot, Naturalist', *The Auk*, Lancaster, Pennsylvania. April 1938; also C. L. Remington in *The Lepidopterists' News*, Cambridge, Massachusetts, March 1948, consisting chiefly of Abbot's own account of his early years. I owe these references to Mr A. C. Townsend.

tween 1839 and 1845) was born in Bennet Street, St James's, London, the son of an attorney who owned some good pictures and a collection of prints. The boy soon became interested in insects and also had some drawing lessons from Jacob Bonneau (exhibiting 1765–1784). In 1770 young Abbot showed 'two drawings of butterflies and insects' as an honorary exhibitor with the Society of Artists, his address being given as Poland Street. He was articled to his father, but not caring for the law sailed for America in 1773, going first to Virginia and later, in 1776, to Georgia, where apparently he remained for the rest of his life. His *Natural History of the Rarer Lepidopterous Insects of Georgia*, 2 volumes, folio, edited by J. E. Smith, was published simultaneously in English and French in 1797. The Natural History Museum has seventeen volumes of Abbot's original watercolours of Georgian insects, carrying dates varying from 1792 to 1804. They include moths, butterflies, beetles, grasshoppers, spiders and other groups. In rendering his insects Abbot used clear colour with a beautifully soft touch. Those drawings which include also the insects' food plants show that he was on the whole rather less sympathetic in his colouring of flowers, though some of these too are very well done. Within his narrow limits he was a very sensitive and accomplished craftsman (320).

Many names could be added to these brief notes on the artist-naturalists who used watercolour—but enough has perhaps been said to indicate how important a field of employment was offered to watercolourists by the illustration of the world's rapidly expanding knowledge of natural history. If a final name is to be given it must be that of a very remarkable artist—Thomas Bewick (1753–1828). He, however, comes only secondarily into our subject, for his chief greatness lay in wood-engraving, which art he revived and completely transformed. A Northumbrian, born at Ovingham on the Tyne, he made Newcastle his headquarters. The little tail-pieces with which he adorned the innumerable publications which he illustrated, notably his *General History of Quadrupeds* (1790), and his *History of British Birds* (1797–1804), are on the whole a greater artistic achievement than the delineations of the birds and animals themselves. These tail-pieces show much observation of country life and an acute, often humorous, gift of comment and incident. The British Museum is fortunate in possessing a long series of Bewick's drawings, many of which, both designs for tail-pieces and studies of birds or mammals, are in watercolour over Indian ink. Others are in Indian ink alone or in pencil. They were all given to the nation by the artist's daughter, Miss Isabella Bewick, in 1882. In general the bird-drawings —which are quite small, say 3×4 inches—are disappointing, though some, such for example as the quail, blue tit, robin, curlew and dotterel, are neat and pleasing, and there are some very skilful watercolour drawings of single feathers. On the whole, however, I prefer the designs for the tail-pieces—and these tiny watercolour versions of the familiar wood-engravings are in their way delightful. Such vignettes as the man fording a stream with his cows; the lads skating; the old woman attacked by geese; the angler wading with bent rod in a river; the man asleep under a bush; the snowman; and the horse and cart running away while a boy falls out behind; give an intimate picture of English country life as Bewick saw it. Certain others—the old man looking at the tombstone, the suicide dangling from a tree, or the bird-nesting boy falling into a stream as the bough on which he is climbing breaks—illustrate the occasional grim streak in Bewick's humour. But his watercolours have nothing like the distinction of his wood-engravings. A few of his bird-

drawings are on a rather larger scale, such as the starling ($7\frac{3}{4} \times 9\frac{7}{8}$ inches), which Sir Robert Witt lent to the British Exhibition in 1934 (318). Thomas's brother, John Bewick (1760–1795), worked with him as an engraver. The British Museum has some of his drawings also, including a number of rather infantile topographical watercolours of no great importance. A bird-artist less eminent than Thomas Bewick was William Hayes. Presumably he was also rather older—certainly he was earlier in manner. A good deal of his work was engraved, but the only original drawing of his I remember is a signed example in Mr L. G. Duke's collection.

Last, in this chapter, comes portraiture in watercolour, a subject with which I propose to deal shortly, though it would be possible to enlarge on it at very great length, for almost every artist has made a portrait at some time or other, and most of them have done so in watercolour. Here I shall write of only a few of those later artists who made a regular practice of drawing watercolour portraits. Miniatures, which are a special study in themselves, will be excluded, and so will pastel portraits, such as those of John Russell, J. R. Smith, and H. D. Hamilton, and pencil portraits, such as those of the younger George Dance.

The most notable portraitist in watercolour of the late eighteenth century was John Downman,* ARA (1750–1824), of whom some account has been given, in connection with his landscape drawings and his visit to Italy, in Chapter V. He was born probably at Ruabon in Wales (though many books of reference say he was born in Devon), the son of an attorney. He came to London as a youth and studied under Benjamin West and from 1769 at the Royal Academy. He exhibited first in 1768 at the Free Society of Artists, and from 1769 to 1819 sent 333 exhibits to the Royal Academy, of which he became an Associate in 1795, but never reached full membership. After his Italian trip of from 1773 to 1774 or 5 he returned to England and was practising as a portraitist at Cambridge in 1777–8. He then came back to London, remaining there till 1804, when he moved to East Malling, in Kent. In 1806 he visited Plymouth and in 1807 and 1808 worked in Exeter, next year returning to London. About 1817 he settled at Chester and died at Wrexham in 1824.† His finished portraiture is represented in most art museums, and he left also large numbers of preliminary sketches of his sitters. Finished examples are sometimes quite large, the watercolour of the Duchess of Devonshire, signed and dated 1787, which the Duke of Devonshire lent to the British Exhibition in 1934, measured $38\frac{1}{2} \times 25\frac{1}{2}$ inches; but his most characteristic portraits are ovals measuring say $8 \times 6\frac{1}{2}$ inches. These especially it is that give the impression of being miniatures on a large scale, though in fact they are softer in touch and outline than most miniatures. Downman's portrait watercolours are very much done to a formula, and there is often a touch of insipidity about them, but he could do a handsome young man, or a delicately pretty girl, with great charm and refinement. The more rugged types did not so often come within his range—though his sitters included Nelson. His favourite medium of black chalk and stump combined with watercolour enabled him to achieve a very soft, suave, and velvety quality, and his colours, particularly his delicate blues, are often extremely pretty. Dr Eric Millar tells me that Downman often applied the red of his faces on the back of the thin paper on which he

* See 'John Downman, ARA', by G. C. Williamson. 1907.
† The dates of Downman's life are variously given in books of reference. Those which I have given agree with the addresses quoted by Graves in his *Royal Academy Exhibitors*.

worked, so that the colour showed softly through. Yet the most beautiful drawing of his that I have seen is not in colour but in black chalk. This is the head of a girl lying asleep on her pillow, her face seen almost in profile and her hair stretching back from her brow. This deeply sensitive sketch is in Mr A. P. Oppé's collection. It measures $10\frac{3}{4} \times 9\frac{1}{2}$ inches.

The chief documents of Downman's career are the albums in which he mounted his 'first studies' for portraits. The main facts about these are set forth by Mr Edward Croft-Murray in an article in the *British Museum Quarterly*, September 1940. Downman, Mr Croft-Murray tells us, originally arranged these albums more or less chronologically into four series, each containing from four to eight albums. The first series, of eight volumes, was sold first by Downman's daughter, and dispersed; volumes 1 and 3 being now in the Fitz-william Museum. Later, but probably before 1825, Miss Downman (afterwards Mrs Benjamin) sold series ii-iv to George Neville, afterwards Neville Grenville, Dean of Windsor, and these are the so-called 'Butleigh Court Sketch-books'. They later passed to Lady Longmore, from whom in 1936 the Fitzwilliam Museum acquired Series ii. Series iii now belongs to Dr Eric Millar, who has a fine collection of Downman's work. The British Museum bought five of the six volumes in Series iv. Volume 5 of the series belongs to Mrs Ralph Neville. It will be seen, therefore, that a very large proportion of Downman's often wonderfully fresh and delicate preliminary portrait sketches is available for study by those interested (322).

Another of the distinctive portrait-watercolourists of the turn of the century was Henry Edridge, ARA (1769–1821), who was also a landscape draughtsman with a pleasantly natural style in watercolour. He was a Londoner born at Paddington, and as a boy was apprenticed to the engraver William Pether. He became a student at the Royal Academy, where he began to exhibit miniatures in 1786. In 1789 he made the acquaintance of Thomas Hearne (see Chapter IV), who became his close friend. The influence of Hearne's style is to be seen, I think, pretty clearly in the technique of Edridge's portraits. As a por-traitist he had considerable employment, but it was not until 1820, the year before his death, that the Royal Academy elected him an Associate. This official recognition seems curiously belated when we remember that Edridge showed 260 exhibits at the Academy, and never exhibited elsewhere. He visited Normandy in 1817 and 1819, when (as already mentioned, see Chapter IX) he originated a style of picturesque semi-architectural water-colour which was imitated by Samuel Prout. Edridge was one of the Monro circle, and when he died was buried at Bushey. His style of portraiture was somewhat formal, and he specialized in rather small full-length or three-quarter length drawings—measuring, say, 10 to 13 by 7 to 9 inches—the subject being posed in a landscape. Occasionally, as with mili-tary officers standing with drawn sword, he worked on a slightly larger scale. In general effect his portraits are not far removed from monochrome, little colour being used except on the face, which is carefully stippled and tinted, and hands. The remainder of the draw-ing is in a painstaking and intricate combination of pencil, wash, and touches of pen. A par-ticularly charming example of Edridge's work was the full length, $12\frac{1}{4} \times 8\frac{5}{8}$ inches, of Princess Mary,* daughter of King George III, lent by King George V from Windsor Castle in 1934 to the British Exhibition at Burlington House. It showed the Princess standing on a

* Now identified as Princess Sophia. See figure 322.

terrace, one arm resting on a stone wall over which she has thrown her cloak or shawl, with a wooded park landscape in the background (321).

Highly affected and artificial, but not without a certain charm, are the drawings of Adam Buck (1759–1833), an Irishman, born at Cork, who lived most of his life in London but also worked in Dublin. He is best known by engravings, done about the first decade of the nineteenth century, after his drawings of young ladies in high-waisted flowing white dresses and low-heeled slippers, sometimes dancing with a tambourine in hand. His drawing are, I think, rare, and the few that I know include a couple of book-illustrations in the British Museum, and the entirely typical pencil and watercolour portrait (or perhaps fancy subject) of a young mother seated book in hand while her little girl leans eagerly on her knees. This (323) belongs to the Victoria and Albert Museum. It is signed and dated 1808, and was engraved in the same year with the legend

> Mamma, don't make me beg in vain;
> Pray read that Pretty Book again.

This is a naïvely pleasing work, though the high finish which the artist has given to the faces, and the accentuation of eyes and mouth, upset the balance and give a rather hard and inartistic effect when examined at all closely. A later example, which I found in a second-hand shop in the King's Road, Chelsea, a good many years ago, represents a little girl in a low-necked white frock, with blue silk sash, long pantalettes, and black slippers, who stands in a conventional park-land setting suggested in grey wash. It is signed and dated 1821, and measures about $7\frac{1}{2} \times 6$ inches. According to an inscription on the back of the frame the child is 'Mary Burgh, aged 3 years and $\frac{1}{2}$, June 1821'. Another mother and child, rather like that already described, but dated 1822, is also in the Victoria and Albert Museum. The sitters are 'Lady Louth and her daughter'.

Everyone who has prowled about for a number of years, either collecting or observing English drawings, must have accumulated notes of many examples of English watercolour portraitists. My own personal miscellany of the kind includes the following names:

John Taylor (1739–1838) who, Samuel Redgrave tells us, was known as 'Old Taylor'. He was a pupil of Francis Hayman at the St Martin's Lane Academy. I presume he was the 'John Taylor 1774' who signed a primly charming oval watercolour ($7\frac{1}{2} \times 6$ inches) of a young lady, with blue ribbon in her dark hair, who sits sketching by a tree (324). I have seen no other work of his. W. Wellings (exhibited only in 1793), by whom I have a full-length watercolour ($8\frac{1}{4} \times 6$ inches) of *Mrs Billington as Mandane in the Opera of 'Artaxerxes'*. This is a stiffly artificial little drawing, showing the lady with elaborately looped skirt and long blue cloak, much curled grey hair, and a lofty head-dress of ostrich plumes and so forth (325). A similar theatrical portrait by Wellings is in the Victoria and Albert Museum. William Mineard Bennett (1778?–1858), who signed and dated 1814 a rather fruity little watercolour ($6\frac{5}{8} \times 5\frac{1}{2}$ inches) of a florid, not-so-young young man, with curly hair (326).

Bennett was a native of Exeter, a miniature painter and portraitist in oils and watercolours. Later in life he settled in Paris and was decorated by Louis Philippe, but in 1844 returned to Exeter to spend there his last years. He was a pupil of Sir Thomas Lawrence, PRA (1769–1830), who as a boy did portraits in body-colour—but not, I think, in clear watercolour. Apart from his practice as a portrait painter in oils, Lawrence in his

adult years did many portrait drawings, often slight but very graceful, in red and black chalk and other mediums—though again, I believe, not in watercolour (327). These had a wide influence on early nineteenth century portrait-drawing, as one may see in the work of such an artist as Josiah Slater, who flourished between about 1806 and 1833. He used light tints of watercolour on the faces, and sometimes other parts, of his portraits, which were usually slightly drawn in pencil or fine black chalk. He drew the likenesses of the sons of the Iron Duke as children (still in the possession of the present Duke of Wellington) and also made portrait drawings of the members of Grillon's Club. His drawings are not uncommon and presumably he had a large practice (328). Whether he was a pupil of Lawrence or not, I do not know.

Also to some extent in the Lawrence tradition was James Green (1771–1834), who specialized in watercolour portraits in the earlier part of his career but later worked chiefly in oils. In 1808 he was treasurer of the Associated Society of Artists in Water-Colours. The British Museum has a portrait—influenced by both Lawrence and Edridge—of a youngish lady seated, which is delicately tinted in watercolour (330). The use of blue shadows round the eyes, which this drawing shows, is, so Mr Edward Croft-Murray tells me, characteristic of Green's work—which I myself do not know well, the only example in my own collection being an amusing small watercolour of a lady taking a bath.

These disconnected notes on watercolour portraitists might be continued almost indefinitely. The subject is one which could probably in itself supply the material for a book. Yet here only one last name can be given, that of Alfred Edward Chalon, RA (1780–1860; see also p. 228), who, though he lived twenty years in the eighteenth century, afterwards became the complete Early Victorian artist, painting, amongst other things, a charming portrait of the young Queen which was reproduced on many early issues of Colonial postage stamps. His caricature, or semi-caricature, portraits of singers and actors are full of wit and high spirits (331); he also did a large number of serious watercolour portraits which show not only careful rendering of the faces, but a good deal of delicate technical brilliance in the painting of the costumes and other accessories. With A. E. Chalon we may say good-bye to this branch of our subject, for from his later work the last influence of the eighteenth century has quite disappeared (329).

The Old Water-Colour Society

AN EVENT which greatly affected the development of English watercolour during the nineteenth century took place on April 22, 1805. This was the opening, in two rooms at 20 Lower Brook Street, of the first exhibition to consist entirely of watercolours—275 of them, all by the sixteen members of a newly-founded body which then called itself the Society of Painters in Water-Colours. The exhibition, which lasted until June 8, was a great success, and launched the Society upon a career which, though it has had its vicissitudes, especially in the early years, still continues. At present, indeed, the Society maintains a very high standard of accomplishment on rather conservative lines. This body has known several names. From 1805 to 1812 it was 'The Society of Painters in Water-Colours'. From 1813 to 1820 it was reconstituted as 'The Society of Painters in Oil and Water Colours'. It then reverted to its original title and to the practice of showing only watercolours; and in 1881 it became, what it now is, 'The Royal Society of Painters in Water Colours'. It is commonly known as 'The Old Water-Colour Society' to distinguish it from 'The New Society [now the Royal Institute] of Painters in Water-Colours', founded in 1832. The story of the Old Society has been admirably and very fully told in J. L. Roget's two volumes, published in 1891, a work to which every subsequent writer on this subject has cause to be indebted.

The chief motive for the foundation of the Society was dissatisfaction with the condition in which watercolours were seen at other exhibitions. Drawings had been shown at exhibitions (including from 1769 those of the Royal Academy) ever since the Society of Artists began operations in 1760, but the draughtsmen and watercolourists felt that they were regarded very much as poor relations of the oil-painters, more especially as at the Academy they were excluded from 'the Great Room' at Somerset House, where the chief pictures were hung, and shown only in rooms where they were seen in company with the inferior oils. Though there was a steady private demand for drawings and watercolours by collectors and connoisseurs, the watercolourists desired to have a platform of their own from which to attract to better advantage the attention of a wider public. This was a very natural, and even laudable, desire, but it entailed the danger that some artists might attempt to make their watercolours compete with oil-paintings not merely in popularity but also in kind. Indeed it became the besetting sin of much nineteenth-century watercolour art that it was either too large for the medium (as was, for instance, so much of Copley Fielding's work) or that it emulated the depth and richness of oil-paint and so lost much of its own freshness and individual character. The very adoption of the phrase 'painters in water-colours' in the title of the Society was perhaps a warning

of danger, since the traditional usage had been—and to some degree still is—to speak, in this connection, not of paintings but of drawings.

The originator of the idea of forming such a Society seems to have been William Frederick Wells (1762–1836) who, about 1801, discussed the idea first with Samuel Shelley (1750–1808), and later with Shelley's friends Robert Hills (1769–1844) and William Henry Pyne (1769–1843). These four were the prime movers in the scheme, and by 1804 they had succeeded in interesting in it six others, all (except perhaps the youngest of them) artists of position, practising watercolour more or less regularly, and not members of the Academy. These six were Nicholas Pocock (1740–1821), Francis Nicholson (1753–1844), John Varley (1778–1842), Cornelius Varley (1781–1873), John Claude Nattes (1765?–1822) and William Sawrey Gilpin (1762–1843), and the ten artists met on November 30, 1804. They then formally constituted themselves a society, electing Gilpin president, Shelley treasurer, and Hills secretary. A further six members—George Barret, junior (1767?–1842), Joshua Cristall (1767?–1847), John Glover (1767–1849), William Havell (1782–1857), James Holworthy (1781–1841) and Stephen Francis Rigaud (1777–1861)—were soon elected and made up the sixteen who contributed to the first exhibition, and whose work forms the subject of the present chapter. As the reader will have noticed they were, in age at least, a very various lot, some in their early twenties and one over sixty.

Of these certainly the most obscure figure, so far as our present-day knowledge goes, is the President, William Sawrey Gilpin. He was the son of Sawrey Gilpin, RA (1733–1807), the animal painter, whose drawings in pencil and pen (or sometimes both) and more rarely in wash or watercolour (for example nice free studies of cows in reddish-brown against a blue background) are familiar to collectors, and the nephew of the Rev William Gilpin, the apostle of the picturesque, of whom something is said in Chapter XII. W. S. Gilpin was a drawing master in good practice and Roget says that he achieved his election as president 'more by his connection with art than by his ability as a draughtsman', and adds that he was so much outdone by other exhibitors that he resigned the presidency in 1806, and took a post as a military drawing master first at Great Marlow (under William Alexander and William Delamotte) and later at Sandhurst. He exhibited with the Society up to 1815, showing eighty-five drawings in all. Eventually he became a landscape gardener. It may be very true that Gilpin was outshone by many of the other exhibitors, who included a number of extremely able men, but it is unlikely that such artists as Pocock, Hills, Cristall and Varley would have chosen an incompetent to preside over them. I have long suspected that W. S. Gilpin's work might be more interesting than the oblivion into which he has fallen suggests, but he is not an easy artist to track out, for he is unrepresented in the Victoria and Albert Museum and though there are two drawings of his in the British Museum they were not until recently catalogued under his name, nor do I recollect seeing him in any other public collection. I have, however, at various times found some ten not very important watercolours by him. Though most of these are signed, none is dated, but that which appears to be the earliest, *Scenery in the Grounds of Downton*, a finished watercolour measuring $12 \times 16\frac{1}{4}$ inches, must belong to the eighteenth century— say, about 1790 (333). In the manner it comes nearest to the landscapes of Nicholas Pocock. One or two others suggest that, also probably early in his career, Gilpin was

influenced by his uncle William, at any rate in mountain landscapes, in which the trick of posing two small figures in the foreground gazing at the view is copied almost exactly. Other drawings—e.g. a stream with overspreading tree and buildings on the far side, or a bridge over a mountain torrent—seem more individual and show indications of a characteristic palette (already evident in the Downton drawing just quoted) in which a greenish-grey and a dull pinkish brick-red have a leading part. Some apparently early nineteenth century sketches seem to show the influence of Girtin and Edridge (334). Recently I was shown a privately owned sketch-book, chiefly of coast scenes round Folkestone and Dover, which had 'W. S. Gilpin' pencilled lightly inside the cover. This has since been firmly attributed to Constable, on the strength of certain studies of waves and sky (see C. H. Peacock, 'A Constable Sketch Book' in *New Writing and Daylight*, Hogarth Press, 1945); but the cliff studies appear to me to be much nearer to (though admittedly rather better than) what we know of W. S. Gilpin's watercolours, and I believe the book may quite possibly be his—more especially since, as Mr Carl Winter has ascertained, Gilpin exhibited nine watercolours of subjects at Folkestone and Dover in the years 1805-6-7 at the Water-Colour Society. Very likely his later finished drawings (which would be those he exhibited) were less good than his sketches, but he may yet turn out to be an artist of higher rank than is generally thought.

Samuel Shelley,* the treasurer, was primarily a miniature-painter, and as such he chiefly holds his place in the history of art; but he also painted 'fancy subjects' in watercolour, and it was in respect of these that he took his place in the newly-formed society. His themes were often taken from the poets. The Victoria and Albert Museum possesses one of his contributions to the exhibition of 1805, a watercolour measuring $22\frac{3}{8} \times 15\frac{3}{8}$ inches, *Memory Gathering the Flowers Mowed Down by Time*, and another drawing of almost the same size, *The Huntress*. It is interesting, for purposes of study, that in Shelley's sketchbooks, also in the possession of the Museum, are several studies for these two finished drawings, which may stand here as examples of his watercolour work. They are, it must be confessed, insipid things, and though they aim at richness of colour their woolliness, especially in the treatment of foliage, prevents their attaining any real strength in this respect, nor is their drawing good. The first shows Memory—a young lady in white and pale blue robes, and flowing brown ringlets—kneeling under an arch formed by Time and his scythe, who in his turn is overarched by inward-leaning trees. Time's back and shoulders, which are clumsily drawn, are nude save for a red thong and a wisp of black cloth, and his hair and beard are white. The flowers he is mowing down are large cultivated roses, which somehow or other have transplanted themselves into the wild. *The Huntress* is an even more artificial and unconvincing affair—showing, in a woodland setting, a lady in a blue dress and wide white hat perched on a white horse, while near her is a man on foot, wearing a brown suit and carrying a staff, horn, etc., at whose side runs a most unlifelike dog. Collectors of drawings, who do not insist on full watercolour, sometimes find portrait studies by Shelley in a size rather larger than miniature, and these are of much finer quality than the large finished drawings just described. One such study of three girls (332), freely washed in grey-brown monochrome over pencil, has long given me much pleasure and seems to have something of the strong blocking in of the main lines

* See 'Samuel Shelley', by Randall Davies. *Old Watercolour Society's Club*. Vol. XI. 1934.

of the composition which one associates with the pen and wash drawings of Romney. Shelley, who was born in Whitechapel, lived finally at 6 George Street, Hanover Square, where he had as neighbours Robert Hills at number 8 and W. H. Pyne at number 10. He was a successful man in his profession generally, but watercolour was not his main occupation.

By contrast Robert Hills,* the third original office bearer in the society, is one of the most familiar figures in the school. His watercolours are frequently seen, and are among the first which the beginner learns to recognize when he becomes interested in the art. This is not to be wondered at since, between 1805 and his death in 1844, Hills showed no less than 600 works at the Water-Colour Society alone. He produced also occasional oil-paintings and did many etchings of animals, but with these we are not here concerned. Hills was a Londoner, born at Islington in 1769, but London was then still a comparatively small town, with country sights and sounds within reach of an easy walk for anyone whose tastes lay that way—as Hills's certainly did. He was a careful and loving observer of lanes and farmyards, and a most sensitive draughtsman of animals—especially domesticated animals, though also deer. Of his training we know that he had some lessons from J. A. Gresse and in 1788 became a student at the Academy; but presumably his skill in rendering animals came from his own predilection and powers of observation. His early work often has a beautiful silvery quality, particularly when he is not using the full range of colour, as for example in a drawing in the Victoria and Albert Museum which represents a melancholy-looking horse, standing with a storm blowing round him, rendered chiefly in washes of grey, or in a drawing of a bull in a shed, which Mr L. G. Duke has. His best period was before or not much after 1810, and in late life his work became, through over-elaboration, intolerably woolly in texture and often unpleasantly red and hot in colour. But at his best Hills is a delightful artist, and a typical fine example of his work gives a glimpse of pastoral England such as still happily survives, almost unchanged, in many parts of the land today. It may, for instance, show a stretch of lane, curving with subtly arranged sinuosity away between elms and past a timbered farm, while a boy drives a small herd of cattle towards the spectator. There is a beautiful clarity of atmosphere, and a striking illusion of space, so that one seems to be looking into a hollow cone. The colour is fresh and clean, the cattle are well grouped and their movement is admirably suggested. Of a slightly different type is a very remarkable *Village Snow Scene* in the collection of Mr Thomas Girtin. In this the view is seen from the depths of a barn in which are grouped villagers, with a horse, dog, donkey and so on, while beyond through the open doors is the village street with the snow falling thickly and people, head-down to avoid being blinded by it, making their ways home.

An interesting matter of practice is recorded about Hills—his custom of making preliminary miniature versions of his watercolours. Roget (vol. II, p. 28) states: 'For his more elaborately composed drawings, Hills was also in the habit of making small studies in colour, which he called his "models". . . . They exhibit a freshness and sometimes possess a silvery quality of colour, which the artist lost in his large and more elaborate drawings.' Very small watercolours of this type sometimes occur. One such, which I have, measures $3\frac{1}{4} \times 4\frac{1}{2}$ inches. Since Hills also made preliminary studies in the field, chiefly in grey wash

* See 'Robert Hills, Watercolour Painter and Etcher', by Basil S. Long, *Walker's Quarterly*, 1923. Also 'Robert Hills', by I. A. Williams, *Burlington Magazine*, February 1945.

or in a favourite combination of two washes, silver-grey for the background and yellowish-brown for the foreground and for trees in the middle distance, it seems possible that one might—with luck—be able to bring together three stages of a Hills subject—the preliminary sketch, the 'model', and the finished drawing measuring perhaps 10 × 15 inches. Hills's preliminary drawings can be delightful, especially his pencil studies of animals, his country children in watercolour (e.g. in Sir Robert Witt's collection), his sheets of details of ploughs and other farm implements, and his grey wash sketches of timbered farm buildings, which are extremely delicate. Such drawings often occur mounted on sheets of stiff grey paper, which usually bear the stamp J.G. inside a horizontal ellipse. These initials are those of John Garle, FSA, one of the trustees appointed under the artist's will. Many of Hills's drawings, too, are annotated in shorthand—a habit which he shared with James Ward and George Chinnery. Hills travelled widely in Britain, and in July and August 1815 he toured Holland and Belgium, and published an account of the tour, illustrated by himself, in the following year. Sir Bruce Ingram has a most interesting and pleasing series of ninety-three of the original drawings made during this tour, including several of the neighbourhood of Waterloo done little more than a month after the battle. A final point to be noticed about Hills is that he frequently drew animals in landscapes by other artists, particularly G. F. Robson (335, 336 and 337).

The originator of the Water-Colour Society, William Frederick Wells,* is not today a very well-known figure as a watercolourist—indeed, he is chiefly familiar for the series of soft-ground etchings which he and John Laporte did after drawings by Gainsborough. He was one of the few early artists who travelled in Northern Europe, where he visited Norway and Sweden. He was a close friend of Turner, and suggested to him the idea of the *Liber Studiorum*, the first four drawings of which were done at Wells's house at Knockholt in Kent. During the last twenty years of his life (he died in 1836) he was professor of drawing at Addiscombe College. I have seen very few of his watercolours apart from the three examples in the Victoria and Albert Museum. Of these the largest is a conventional romantic landscape, *The Dawn—a Ruined Castle above a River*, painted in 1807, with the castle standing on the top of a hill and cows watering at a pool—a somewhat Glover-like composition. It is so faded, and consequently red, as to give one very little idea of its original colour but it at least shows an individual way of doing foliage with a peculiar long, dark, narrow brush stroke—a mannerism which should help one to recognize other work by Wells. It is certainly evident, but in a slightly modified form, in another of the Museum's examples, *Egton Bridge, near Whitby, Yorkshire*, which is dated as late as 1829. This is a quite unfaded drawing and gives a better idea of Wells's colour, which however I do not find very attractive. The picture represents a broad blue-green prospect of meadows and trees, falling away from the spectator. In the middle distance a row of cottages leads away downhill, and in the foreground are groups of children rather crudely drawn and over brightly coloured (338). An earlier work, dated 1806, shows only slight beginnings of the foliage treatment I have here noted as characteristic.

The name of William Henry Pyne (1769–1843), another of the founders of the Society, is rather better known, though his fame is probably more for his etchings of groups of rustic and other figures, animals, and so on in his *Microcosm*, a work designed to aid other

* See 'William Frederick Wells', by Basil S. Long. *Old Water-Colour Society's Club*. Vol. XIII. 1936.

artists. The original pen or pencil drawings for some of these are in the British Museum. His work in this kind is a little in the manner of Rowlandson, but much less free or spontaneous, though Pyne was certainly an able figure draughtsman, and figures play an important part in some of his watercolours such as a large skating scene which once belonged to Mr Duke. Pyne is recorded as having been a good-natured man, much given to gossip (he was the author or part-author, under the pseudonym Ephraim Hardcastle, of two publications, *Walnuts and Wine* and *The Somerset House Gazette*), but not assiduous in his art or resolute in pursuing his projects. Watercolours by him are not very common and I have never formed a very clear idea of his style. The subjects are often cottage or other interiors, with figures somewhat in the manner of Morland or Rowlandson (340), pretty rather feeble things; or groups of cottages (e.g. three of the four examples in the Victoria and Albert Museum's catalogue). Mr H. C. Green has one of the best of the latter type (339), a view of a building (apparently a mill-house) with moss-grown thatch. It is signed and dated 1803, and measures 13×19 inches. Of the Pynes at South Kensington, one is a pretty but not exciting little *Landscape with Church and Cottages* in the same Dayes tradition as many early drawings of Turner and Girtin. It is almost entirely in blue, with a yellowish glow in the sky, and here and there lights washed in with fawn. The outlines are in pen. The scene is a view down a hollow winding lane, along which a man drives a flock of sheep. To the right is a church on a hill, with houses below the slope, to the left is a bank crowned with trees. The drawing is signed but not dated. A very different, presumably rather later, drawing is *Fishermen's Houses by the Thames at Battersea*, signed and dated 1806, which has much more colour—e.g. in the brown and pink houses and the patches of blue in the sky. It is influenced by Girtin, but is more finicky and less vigorous than his work. In later life Pyne was more a writer than a painter or draughtsman.

Of the Society's original members the senior was Nicholas Pocock,* who was born in 1740 and might well have been treated in an earlier chapter of this book. He was the son of a Bristol merchant, who died when Nicholas was but a youth and left him the care of his mother and brothers. He went to sea and by 1767 was commanding a ship, bound for South Carolina. *The Dictionary of National Biography* states that six volumes of his sea journals, illustrated by drawings in Indian ink, belonged to his grandsons, the watercolourists George and Alfred Fripp. One such log, that of the *Snow Minerva* on her trip to the West Indies in 1776, was included in one of the two sales of Pocock's works at Hodgson's in 1913. A very large number of sketches of Pocock origin came upon the market through those sales, but some of these are probably by members of his family, though others are certainly his own. In 1780 Pocock sent a sea-piece in oils to the Academy, where it arrived too late for exhibition but attracted the attention of Reynolds, who advised him to 'unite landscape to ship painting'. This advice he took, and a typical finished watercolour by Pocock often combines both elements. An excellent example, which was exhibited at the Fine Art Society in January 1946, was a large view† measuring about 16½×24 inches, of Bristol, seen lying to the left, and beyond the far end, of a receding stretch of river, on which, in the middle distance, rides a masted ship. In the right foreground is a group of children playing, done on a fairly large scale, and behind them a red

* See 'Nicholas Pocock', by Randall Davies. *Old Water-Colour Society's Club*. Vol. V. 1928.
† Now in the possession of Messrs F. T. Sabin, Park House, Rutland Gate, S.W.7, by whose courtesy I reproduce it as figure 342.

ensign hangs from a ship standing in the stocks. In the far distance looms a church, and on the river bank to the left are scattered groups of houses whose rather pale red (seen also in the flag) agreeably varies the general blue-green tone of the picture as a whole. This drawing seemed still fairly fresh, but these elaborate compositions of Pocock's are often very badly faded. The combination of topographical and nautical interest is typical of him, and ships in the Avon at Bristol often gave him his subjects.

Sometimes, however, Pocock omitted the nautical interest, and produced unadulterated landscape or topography. In the exhibition held at Bristol in honour of the bicentenary of his birth there was a very beautiful and free study of a waterfall, lent by Mr Oppé, who owns a number of Pocock sketches; and examples of a series of views in South Wales, where he must have made a tour, occasionally turn up. These are rather roughly done, but in pleasant rich tones of brown and green and grey-blue. This series is, in my experience, usually numbered in one corner by the artist, and mounted (presumably also by him) on a grey and white wash mount, inscribed with the name of the place. One which I have represents the *View from Lord Vernon's Towards Aberavon*. Another fairly free and effective watercolour by Pocock—but not in the same series—shows the inside of a quarry, with a cart and two horses and a group of yokels having a meal, and is marked by some attractive pale buff and orange-yellow washes on the rock faces. (343); it is a drawing which makes one think of early Turner until the clue to the real authorship is seized. His slighter sketches, sometimes of Mediterranean scenes, are occasionally very poetical, with creamily rich washes of blue and grey. Nor, in these notes on Pocock's watercolours, must his charming small informal portraits of children be omitted. One warning should be added. There are things which, at a first glance, may appear to the unwary eye to be watercolours of shipping subjects by Pocock. They are, indeed, I believe, his work, but they are only partly in watercolour, being also partly etched (in the outlines) and partly aquatinted. Presumably Pocock did these in order to be able to supply quickly a demand for a popular decorative subject.

Certainly the next artist on our list, Francis Nicholson (1753–1844),* at one time— apparently in the 1780's—adopted a similar method of multiplying his picturesque Yorkshire views for sale to visitors 'during the spaw season' at Scarborough. He himself thus described the process: 'For Scarborough I manufactured an incredible number of drawings. My process was by etching on a soft ground the different views of the place, from which were taken impressions with blacklead. This produced outlines so perfectly like those done by the pencil, that it was impossible to discover any difference. This was nearly half of the work, and in the long days of summer I finished them at the rate of six daily.' Presumably many of these hybrid productions are still masquerading as original drawings by Nicholson—and they are only one of the traps that lie in the path of collectors, for he was extensively 'faked' even in his lifetime and Roget reports that 'Nicholson once saw in a shop window in Maddox Street a copy of a drawing of his of the Dripping Rock at Knaresborough, which he preferred to his own work'—an unusually candid confession for an artist to make. Here it may be convenient to note that another watercolourist who adopted, at least occasionally, the practice of doing a watercolour upon the basis of a soft

* See B. S. Long, 'Francis Nicholson, Painter and Lithographer', *Walker's Quarterly*, No. 14, 1924, also Randall Davies, 'Francis Nicholson, Some Family Letters and Papers'. *Old Water-Colour Society's Club*. Vol. VIII. 1931.

ground etching was John Laporte (1761–1839), who has already been mentioned among the followers of Sandby. I have such an example of his handiwork, but it should deceive no one, for there is no attempt to disguise the nature of the etched lines, which are lightly washed in watercolours. In this connection, too, it may be recalled that Blake also used a hybrid process at times.

Nicholson was a Yorkshireman by birth, born at Pickering. He had his artistic training chiefly from artists at York and Scarborough, and most of his early professional career centred upon Whitby, Knaresborough, Harrogate, Scarborough and Ripon. It is thought that John Pearson (1777–1813?), by whom there is a watercolour of Durham in the Victoria and Albert Museum, may have been a pupil of Nicholson in his Yorkshire period. He did not finally settle in London until 1803—though he had visited it often before then. On the first occasion, apparently some time in the 'seventies, he had some lessons from the German painter, Conrad Martin Metz (1755–1827), who himself deserves a small place in a book on English watercolour for his pastoral-mythological figure subjects, drawn in pen with a highly mannered elegance, washed in grey and very lightly tinted with other colours (341). His style had no effect on that of Nicholson, who was essentially a landscape painter though he sometimes added figures that were adequately drawn, but not much more. In the 'eighties Nicholson renewed his acquaintance with London, and began to build up there a *clientele* for his Yorkshire views, and at the end of the century he stayed there, and later at Wimbledon, with his friends, or patrons, Sir Henry and Lady Tuite, with whom he toured in the Lake District and elsewhere. Nicholson was extremely successful as a purveyor of picturesque views, not only of Yorkshire (which is the subject of most of his earlier and better work) but also of Wales, the Lake District, Somerset, North Devon and the Highlands of Scotland. A few foreign views which he exhibited were (presumably in all cases) from sketches by others. One of those whose foreign subjects he thus copied was the only daughter of Sir Richard Hoare, first baronet of Stourhead. She married Sir Thomas Dyke Acland in 1785. He died in 1795 and in 1796 she married Captain the Hon Matthew Fortescue, RN. She died in 1841. Her only son by her first marriage is briefly mentioned in Chapter XII. According to Randall Davies she was Nicholson's most successful pupil and lifelong friend, and many works by her and by Nicholson are at Killerton. Nicholson was a man of considerable ingenuity and technical resource, and invented a method of 'stopping out the lights' in his watercolours by touching them, at successive stages, with a composition of beeswax, turpentine and flake white, which was subsequently removed with turpentine or spirits of wine. I have never, however, cared greatly for his work, with its overstressed patches of high light, and its general lack of crispness—a failing which is very evident in the usual spongy or woolly texture of his trees and of the waterfalls of which he was especially fond. His colour, too, is not generally pleasing, and relies too much on a rather sickly yellowish green—though it is only fair to add that, in spite of the attention which he paid to the lasting powers of his colours, he has often suffered greatly from the fading of his work, especially when he used, in his skies, a mixture of Indian red and indigo. A series of views of Sir Richard Colt Hoare's house and grounds at Stourhead in Wiltshire, most of which are in the British Museum, shows what Nicholson's colour is like when it retains its freshness, and some of the softer effects are indeed very pretty. But the subjects of this series—among which are several

very able interiors—are scarcely typical. Nicholson last exhibited at the Water-Colour Society in 1815, and during the remainder of his long life was largely withdrawn from professional practice. Several members of his family were also artists. These included his only son Alfred (originally in the Navy), his daughters Sophia (Mrs William Ayrton) and Marianne (Mrs Thomas Crofton Croker) and his nephew George (344 and 345).

Much more sympathetic, to me, is the work of Joshua Cristall (1767?–1847),* a watercolourist who, like certain others, suffers in public estimation from the fact that he is represented in public galleries by rather laboured, highly finished, works which are far less aesthetically satisfying than his watercolour sketches and other less formal drawings, some of which show a very fresh and delightful vision. Indeed Cristall is one of those painters whose small watercolour notes of things seen—clumps of trees, for instance, against wind-blown sky—are sometimes mistaken for Constable's, an error made the easier by their often being so temptingly initialled 'J.C.' Nevertheless, though the mythological or sentimentally rustic themes—the cottage girl spinning by her door, for instance—in which Cristall specialized are at variance with current taste, and so keep his finished pictures from general appreciation today, there are other completed works of his with more unaffected subjects, as we now think, which are easy to admire. There is, in particular, his large *The Fishmarket on the Beach, Hastings,* in the Victoria and Albert Museum (probably the picture exhibited at the Water-Colour Society in 1808) which shows admirably his skill in the grouping of many figures into a composition.

Cristall had exhibited little before the Water-Colour Society began, though he was then 38. But he had had a hard start, with little schooling, and his father, a Scottish sea-captain, had been firm in giving no encouragement to his artistic impulses. Before he eventually became a student at the Academy, he had worked successively in a London china shop, a Shropshire china works, as a copying clerk, and as a printer. By 1805 he had some reputation, it would seem, among his fellow watercolourists, but can scarcely have been known to the general public. Nor was he ever—though his work was treated with respect and he was President of the Society in 1816 and 1819, and again from 1821 to 1831—successful financially. His life, in fact, was a constant struggle, whether he lived in London or, as he did from 1823 to 1841, at Goodrich on the Wye.

In his way Cristall was a very genuine artist. His cottage maids, as finally offered to the public, were no doubt a little sentimentalized; but they, and their kin, were all originally observed from the life, and were not mere studio properties. Among his sketches are many studies of country folk in pencil or pen, sometimes touched with a few washes of colour, and inscribed with the date and place. The two best works of his I remember seeing were large watercolour studies, one a full length of a peasant girl shading her eyes, the other of the head of an old woman, which Mr L. G. Duke lent to the British Art exhibition at Burlington House in 1934. That of the girl, dated 1812, had great charm (347) and that of the old woman, dated 1810 and inscribed *Winkfield near Windsor,* suggested both feeling and understanding of character. An apt example of Cristall's methods came to my notice in February 1946, when a charming watercolour of a girl seated on a low stone wall by a well, and holding one finger-tip shyly to her lips, passed through the hands of Messrs

* See Randall Davies, 'Joshua Cristall'. *Old Water-Colour Society's Club.* Vol. IV. 1927.

Colnaghi.* It was signed and dated 1810, and the figure was almost exactly a replica, identical in size, of a pencil drawing in my possession which is inscribed 'Hastings 1807'. The only important difference, save the added setting and accessories, is the position of the further arm. But in the pencil drawing the girl is a very raw, awkward fishergirl, patently observed from life, whereas in the watercolour she has been just a bit tidied up and smoothed out. The shoes are the same, but they look a little better kept, the dress is the same but just a trifle better in quality, the hair is less tousled, the nose a good deal more delicate in shape and so on. The changes are slight, but they combine to raise the child, as it were, a peg or two in the social scale—in token of which she has been given a black poke-bonnet which the fisher child probably never owned. There is also the point to be noted that this pair of drawings shows that the dates on Cristall's finished water-colours are not necessarily those at which he actually saw their subjects (348 and 349).

Cristall was a late starter. The earliest drawing of his I have seen† is a little pencil study of mountains between Bangor and Capel Curig dated 1802, and there are other Welsh drawings dated 1803. These show a pleasantly warm and sensitive use of pencil, but lack the strength of his later drawing of mountains. In 1805 he visited the Lake District and he was there again in 1818 when he also went to the Scottish Highlands and did some admirably sure and simple pen drawings of mountains and trees. In 1807 he was, as we have seen, working near Hastings, and in 1810 he was at Windsor. Later trips, before he settled at Goodrich, were to Wales in 1820 and 1821. He used a characteristic range of colour, in which mauve-pink, clear yellowish green and grey-blue, and a purplish chocolate-brown occur frequently. Sometimes, in his round-contoured flat planes of colour, he seems to show the influence of Cotman. Cristall did fine work until late in his career; for example, some Welsh landscape sketches in watercolour done in 1831 and 1832 are striking and individual things (346).

It was probably the great success of the Water-Colour Society's first exhibition in 1805 which led John Glover (1767–1849)‡ to settle in London, for previously he had been a provincial artist, only occasionally coming to town, though he exhibited pictures at the Academy in 1795, 1799, 1801, 1803 and 1804. The son of poor parents, he was born at Houghton-on-the-Hill, near Leicester, and though club-footed worked in the fields as a boy. He had a deep love of the country and is said to have possessed remarkable power over birds. At 19 he became writing master in the school at Appleby in Leicestershire, and also took to making drawings of gentlemen's houses. On his occasional visits to London he had eight lessons from William Payne and one from 'Smith'—presumably 'Warwick' Smith. Not much, if any, sign of either of their styles is to be seen in Glover's mature work. As Long points out there is some evidence of Payne's influence in two of Glover's early drawings in the British Museum. In 1794 he set up as a drawing master at Lichfield and, meeting with considerable success, stayed there for about eleven years. One of his pupils there was Henry Salt (1780–1827), who afterwards travelled—and drew—in India, Abyssinia and Egypt. Presumably it must have been at Lichfield also that James Holworthy (1781–1841) was his pupil. As we have seen, Holworthy, like his master, was an original member of the Water-Colour Society, but there is little to be said of his work—so

* It is now in the collection of Mr J. Leslie Wright.
† But Randall Davies, *loc. cit.*, reproduces a rather immature watercolour of St Michael's Mount, signed and dated 1794.
‡ See B. S. Long, 'John Glover'. *Walker's Quarterly.* April 1924.

far as I know it—save that it is competent, and closely modelled on that of his master. I have seen some sketch-books of his, containing pretty little monochrome exercises in Glover's manner. Indeed a close fidelity to their teacher's work is generally shown by Glover's pupils, such as his son William Glover (exhibited 1813–1833). Henry C. Allport, who in 1808 was teaching drawing at Birmingham, and in 1818 became a member of the Water-Colour Society, was another pupil of the Lichfield period. George Pickering (1794?–1857), who closely imitated Glover, was presumably also a pupil. Since the facts are not, so far as I know, elsewhere recorded, it may be well to note here that in February 1943, at a dealer's in London, I saw a sketch-book full of drawings, the first being a view of Offa's Dyke in pencil and watercolour, by one William Fernyhough, who according to an inscription written in the book by 'his attached friend William Turner' (which William Turner?) was 'born at Lichfield and died young' and was 'a favourite pupil of Glover'. The inscription stated that some of the pencil outlines had been tinted by the said Turner to preserve them. These drawings were very Gloverish in lighting and subject, but with harder outlines, and I thought them possibly by the same hand as three Glover-like monochromes which I already had. A full watercolour, which I also have, and which has 'Wm. Fernyhough' pencilled on the back, does not suggest Glover's influence, except perhaps in the lighting. Another artist who occasionally imitated Glover both in general composition and in the treatment of foliage was J. Robertson (exhibiting 1815–1836) who is said to have been a drunken drawing master. His drawings are very common, and at first sight taking. The Glover influence appears in only a few of them, but their authorship is given away by the two or three curiously unreal patches of high light which invariably mark this man's work. His more usual style is firmly outlined in pen and washed in brown monochrome—sometimes also in colour. He repeats his properties, especially a cottage at the end of a single-span bridge, again and again. At one time these drawings were thought (on the strength of an inscription on one of them) to be by R. R. Reinagle, RA (1775–1862), who also was a scallywag, but I think the evidence for Robertson is overwhelming. His drawings, by the way, often bear the forged signature of David Cox (see p. 16 for this group of forgeries) (352 and 353).

To return, however, to Glover himself. From the start of the Society he was a copious exhibitor up to 1832, both there (until 1817) and at other exhibitions, including a series of annual one-man shows starting in 1820, at which he showed oils as well as drawings. To judge from his subjects, he must have toured widely in the British Isles; he visited France in 1814 and Switzerland in 1815, and travelled in other Continental countries including Italy. In 1831 he settled, with his family, in Tasmania and stayed there till his death. In his watercolours, which he seldom signed, he was a strong mannerist, with a very distinctive way of rendering foliage by means of a 'split brush'—by which I take it is meant that he twisted the hairs of his brush into two or more small points, which enabled him to produce the little twisted parallel touches which are the hall-mark of his work and that of his imitators. These are certainly very effective for suggesting bushes, and also for rendering the glint of light across a wooded hillside. No doubt the gratification of learning the trick was well worth the £2 2s. a lesson which Glover at one time charged. His lighting, too, coming across the picture between the foreground and the distance, and often filling the intervening space with very brilliant effects of sun on mist, is charac-

teristic. A type of subject he much loved has a dark foreground with trees, dropping back with a figure or two on the brow of the hill (his figures are good and cleverly placed) into a deep, sunlit valley, the far side of which is made up of a wooded hill crowned by a castle. Or the middle distance may be not a valley, but a lake or a river. He did cattle well—though not so well as Hills—and was fond of decorating his foregrounds—both in his watercolours and oils—with the huge leaves of the butter-bur. Glover often worked very agreeably in monochrome, and he was a good sketcher—a pencil drawing of a man asleep is admirable. His watercolours were coloured over a groundwork of Indian ink, with Indian red and indigo for the skies and—like many drawings in which indigo was used—are often badly faded (350 and 351).

Another of the original members who, like Cristall and Glover, had exhibited little before the foundation of the Society was George Barret (1767 or 8–1842), son of the George Barret who was a foundation member of the Academy and in his day a very fashionable landscape painter. The elder Barret, who died in 1784, left his widow and children destitute—as did the younger Barret leave his nearly sixty years after. The latter seems to have been a very likeable man, too modest to charge high prices for his drawings, of which he produced a great many, exhibiting nearly six hundred with the Society. Like his father he lived in the Paddington district—then largely rural—where for a time Cristall was a neighbour. He exhibited views of Wales and of the Thames valley, but more and more as time went on he specialized in poetically idealized landscapes, often of sunsets, sunrises or other effects of glowing light, and in classical compositions upon Claudian lines. These later works suggest a comparison with the drawings of Francis Oliver Finch (1802–1862) and with some of the imaginative classical subjects of John Varley and Havell. Barret liked, in his later years, rich fruity colours, with much purple and orange, and he believed that watercolours would not fade if they were put on thickly. It is a fact, I believe, that his work has, on the whole, retained its colour well. He was a skilled artist, but I do not, personally, find his more elaborate work very congenial. It seems to me to aim at qualities better realized in oil paint. However one occasionally sees rather simply drawn and coloured tree studies, done by Barret comparatively early in his career, which are pleasing in a direct way, and his small watercolours, observed without dramatization, can be charming—for example, a little view of blue mountains seen through a receding sequence of yellow-brown-dark green in a foreground of rocks and pine-trees, which is signed with initials. It is not typical of Barret as we think of him in public picture galleries—but I prefer it to many of his more 'important' works. In 1950 the Leger Galleries showed a series of 36 small views of Isle of Wight scenery, chiefly blue, grey, and brown in effect, which were fresh and sincere in an unostentatious way. There are also monochrome landscapes by Barret which have style and are rather like Cristall in line (354 and 355).

Of the five remaining original members of the Water-Colour Society Stephen Francis Rigaud (1777–1861) was the only son of John Francis Rigaud, RA (1742–1810), a historical painter of French-Italian origin. The younger Rigaud first exhibited at the Academy in 1797, and as a watercolourist specialized in religious subjects, such as *Satan Discovered in the Bower of Adam and Eve*, *Martha and Mary* and *Sin and Death*. He sometimes also took subjects from literature, and the Victoria and Albert Museum possesses his *Telemachus*

Discovering the Priest of Apollo, which he exhibited with the Society in 1809. It is a pretentious and heavy-handed work, which makes no appeal to the taste of today.

Rigaud is not a prominent figure in the history of English watercolour; nor, strictly on his artistic merits, would it be necessary to say much about another original exhibitor, John Claude Nattes (1765?–1822), an assiduous topographical draughtsman whose views were engraved in a number of publications. Most of such coloured drawings of his as I have seen contain passages of body colour, and have often faded unequally, so that they are marred by unpleasant hot red patches. He did a vast number of drawings in pen and ink, sometimes with and sometimes without Indian ink wash. These have a coarse boldness of touch which is characteristic but not often attractive (356). I have occasionally seen whole albums of such drawings—for example one consisting entirely of views of the gardens at Stowe, and another of old inns, country houses and so forth in the Boulogne and Abbeville area. He did a number of Italian views early in his career, but whether he actually visited Italy or not I do not know. Nor do I know whether he was English or French by birth. He referred to himself as 'Monsieur Nattes' but that may well have been a bit of play-acting on his part. He was not long a member of the Society, for in 1807 he was expelled when it was found that a large proportion of his exhibits that year were not really by him but by other artists. Nattes was not only draughtsman and drawing-master, but also a mounter of drawings and I fancy a dealer. Quite the most pleasing thing I know about him is the charming engraved label which he pasted on to the back of drawings which are not, I think, always his own work—though some are. It represents a terrace, with a wooded park and temple beyond, and in a panel above there is the following inscription:

'Monsieur Nattes No. 41, Charles Street, Westminster, Pupil of Mr Dean, respectfully acquaints the Nobility & Gentry that he teaches Drawing in the manner of that celebrated Master, on moderate terms—he also teaches Perspective so very essential in taking Local Views—

'Monsieur Nattes likewise continues to decorate Drawings & Prints in the most elegant manner, has a very superior method of fixing or binding drawings, in Chalks or Lead, to prevent them from being Effaced.'*

The 'Mr Dean' mentioned in this legend is Hugh Primrose Dean (died about 1784), somewhat pompously known as 'The Irish Claude', who was Nattes's master. He, too, seems to have been a bit of a rogue (in spite of a period as a Methodist preacher) and Edward Edwards records that in 1780, about a year after Dean's return from Italy, whither he had been sent by Lord Palmerston, he showed, as his own, some black chalk drawings which were actually by an Italian. This fact seems to reveal a whole series of difficulties for the attributor, for in Lord Warwick's sale in 1936 there were two black chalk drawings of Italian scenes rather in the style of Wilson, but stiffer, one at least of which was signed on the mount 'Dean Delin'. These were obviously mounted by Nattes (his characteristic mount is white, greenish or cream with one gold line and several black ones),† with his label on the back. Are these the genuine work of Dean, or of the Italian?

* The mingling of the functions of the artist and the shopkeeper craftsman, shown by this label, may not have been uncommon in the late 18th and early 19th centuries. Another printed label, that of John Hippisley Green (sculptor and painter, exhibited 1775–1820), of which I have a copy on the back of one of (presumably) his drawings, reads: 'J. H. Green, Drawing Master, No. 1, Wells Street, Oxford Street.—Drawing Materials &c.' Green exhibited from 1 Wells Street from 1800–1817.

† Nattes also sometimes used a plain black mount with the title and signature written on it in white.

Anyhow, I think it was this style of drawing which Nattes advertised himself as teaching, and similar black chalk drawings, rather like a cross between Wilson and the French artist Pillement (who was for a time in England), on Nattes's mount and with his label, may be tentatively ascribed to him. One such, which I have, belonged to Paul Sandby. There are other types of drawing which I have seen attributed to Nattes, but I do not know upon what evidence.

The remaining three exhibitors belonged to the youngest generation of watercolourists—the two Varleys, John who was 26 at the time of the 1805 exhibition and Cornelius who was 23, and William Havell* who also was 23. The last was one of the fourteen children of Luke Havell, a drawing-master of Reading, and was the nephew and cousin respectively of the well-known engravers Daniel and Robert Havell, who in 1812 published a series of *Picturesque Views on the River Thames* after William's drawings. It is with the scenery of the Thames that Havell's name is principally associated—with vistas of the shining river seen between the green opulence of the trees in full foliage. But in fact his range of subject was much wider than that. He was in Wales in 1802, and in 1803 with Benjamin Barker, and in 1807 he went to Westmorland where he stayed two years. A view of Windermere dated 1811 is in the British Museum and seems to render the Lake District very much in terms of the Thames valley. In 1816 he went to China with Lord Amherst's embassy, but left it the following year for India, where he remained until 1825. He visited Italy in 1827. During his later years he was in monetary difficulties. He died in 1857. A fine example of his early work is the *Kilgerran Castle* (probably that shown at the Water-Colour Society in 1806) in the Victoria and Albert Museum, a view which looks along the shining water of the river Teifi towards the castle standing darkly on the cliff in the distance (357). This is a composition of some grandeur, though the castle itself is a little theatrical. It owes a good deal to Girtin, or perhaps Francia, especially as regards the massing of the dark cliff forms, between which the yellow sunset light in the sky gleams down on, and is reflected in, the luminous waters of the river. This light and the red and blue coats of two figures in a boat add a touch of brighter colour to a subject treated chiefly in dark tones of brown, purple-grey and green.

Havell is a respectable figure in the English watercolour school. John Varley† was a great deal more than that. He is indeed one of the most brilliant and attractive—and also one of the most disappointing—artists, and his name is among those best known to the general public. He was extremely prolific, constantly in debt and producing a stream of drawings to pay his debts. The result is that much of his work, though very skilful, is mechanical in inspiration and repetitive in subject, and that the difference between a first-rate Varley and a commonplace one is very wide. John Varley, the eldest of five brothers, was born at Hackney on August 17, 1778. His father Richard Varley came from Lincolnshire, and his mother was a descendant of Oliver Cromwell, whose daughter Bridget married General Fleetwood—hence the second name of William Fleetwood Varley (1785–1856) who like his elder brothers John and Cornelius was a watercolourist, though of less importance. W. F. Varley's mountainous landscapes are able but not highly distinguished. His career was cut short by the shock of being nearly burnt to death in a fire at Oxford, from which

* See 'William Havell', by Adrian Bury. *Connoisseur*, December 1949.
† See *John Varley of the 'Old Society'* , by Adrian Bury. Lewis. £5 5s.

he never recovered, and he seems to have done no work during the last thirty-five or so years of his life. John was originally apprenticed—at thirteen—to a silversmith, but after his father's death in 1791 he was allowed his desire of becoming a painter. He worked for a while with a portrait-painter, and at about 15 or 16 became pupil and assistant to Joseph Charles Barrow, a topographical draughtsman and drawing-master. Louis Francia (see p. 103) was an assistant at the same time. Barrow's drawings sometimes occur, and show him to have been a minor follower in the Sandby tradition, with a rather stiff and wooden style. His best work consists of views of Strawberry Hill done for Horace Walpole.

In 1796 John Varley, while sketching in Hornsey Wood, made the acquaintance of John Preston Neale (1780–1847),* later an accomplished if rather unimaginative topographical watercolourist, a great many of whose views of country houses, churches and so forth were engraved as illustrations to publications, and who exhibited at the Academy, the Water-Colour Society and elsewhere (358). He contributed many illustrations of London and its environs, and also of certain other parts of England, to Britton and Brayley's *Beauties of England and Wales*. Neale and Varley struck up a friendship, and made many sketching expeditions to Hoxton, Tottenham, Stoke Newington and other then still more or less rural places round London. An early expedition farther afield was to Peterborough with J. C. Barrow. In 1799 or 1800 Dr Thomas Monro (see p. 247), at whose house in Adelphi Terrace Varley also worked, took him to Fetcham to sketch. The country within easy reach of London remained one of the inspirations of his work, but a much stronger impetus came from his early visits to Wales, the first of which seems to have been in 1798 or 1799, in company with George Arnald (1763–1841), a painter who later became an ARA and was spoken of by J. T. Smith in the same breath as Turner, but who is today almost completely forgotten. I have seen a number of drawings of various kinds, and in varying styles, by Arnald, but have no clear idea of his use of watercolour. A watercolour of Rhayader Bridge, which looks like an inferior Nicholson but is signed John Varley on the back and must I think—against all appearances—be by him, may well date from this first Welsh trip. Perhaps on the same tour, Varley was also in company with James Baynes (1766–1837), a successful drawing master and watercolourist who did many Welsh views and was fond (if I may judge from the few specimens of his work I have seen, for example one in the Whitworth Institute at Manchester) of timbered farmhouses—sometimes drawn slightly in the manner of Girtin (359). There is a rather hard and showy *Moonlight View of Allington Castle, Kent*, dated 1825, by Baynes, in the Victoria and Albert Museum.

Varley made further Welsh tours in 1800 (apparently) and in 1802 (when he was accompanied by his brother Cornelius, and met Cristall, Havell and other artists in North Wales). In 1803 he visited Yorkshire and Northumberland, and a view of Knaresborough Castle, in Mr L. G. Duke's collection, a pleasant soft drawing in greys and blues with touches of fawn, somewhat reminiscent of Girtin by whom he had no doubt been influenced through contact at Monro's, belongs to this year (360). These tours made up the bulk of Varley's travel in search of material, and they, and especially his memories of Welsh mountain scenery, remained his chief stock-in-trade for the remainder of his very

* Roget, however, says Neale was about 7 years Varley's senior—if so he would have been born about 1771.

busy and productive life. It is perhaps no wonder that the inspiration often wore pretty thin in his later work. Physically John Varley was a big man of great strength—and certainly he needed it, for his life was one of Herculean activity. He claimed to have worked fourteen hours a day for forty years, and he also played hard, boxing with his pupils and filling his house with friends. At one time he earned £3,000 a year, but was always in debt, and so frequently under arrest for it that he said that he felt that something was wrong if he were not arrested once or twice a month. To secure his release he sold large numbers of drawings to dealers. Yet he was a happy man. 'All these troubles,' he said, 'are necessary to me; if it were not for my troubles I should burst with joy.' Among his non-professional interests was astrology. In 1819 he met William Blake and became his close friend until Blake's death in 1827. As a teacher he had a very wide influence and importance, for his pupils, who generally lived in his house, included John Linnell, William Mulready, W. H. Hunt, F. O. Finch, William Turner of Oxford, and Samuel Palmer—as also, to a rather less extent, David Cox, Peter De Wint, and Copley Fielding. On some of these he exercised a strong temporary influence. For example, there are watercolours, presumably early, by David Cox which are almost purely Varley, such as the *Dolbadern Castle* (which might almost be a typical Varley) and the magnificent *Pembroke Castle*, both in the late Sir Hickman Bacon's collection, and another drawing in the Whitworth Institute, Manchester.

If much of Varley's work was repetitive and mechanical it also displayed great technical dexterity, and there are certain of his drawings which have real grandeur and a peculiar quality of glowing romantic imagination. Such are *Sunrise from the Top of Snowdon*, signed and dated 1804, which Mr Oppé lent to the British Exhibition in 1934, and two remarkable drawings in the Victoria and Albert Museum, *Afterglow* ($11\frac{1}{8} \times 17\frac{1}{4}$ inches), and a large unfinished view of Snowdon ($14\frac{7}{8} \times 18\frac{3}{4}$ inches). *Afterglow** depicts a half distant view of two craggy peaks, the nearer of them crowned with two castles, set against a sky in which the last hues of orange and red sink into deepening shades of grey. On the near side of the two hills a line of black rounded trees runs across the picture, while nearer still is a lake which catches the last gleams of light. A dark foreground draws across the lower edge of the composition a line which is broken by the figure of a man in a deep red coat and by the shape of a boat, which are outlined against the water. The whole picture conveys a wonderful sense of light glowing within darkness, though in composition it is a little like a stage setting composed of upright planes silhouetted one in front of the other. Of these three drawings the unfinished Snowdon, brilliant as it is, is the least satisfying, it has more of stylistic mannerism than the others, and there is in its strong colour and sharp outlines a touch of that hardness which can mar Varley's work (362). Incidentally, it illustrates the problems which work of the Varley school often presents, for I have a watercolour which is simply a variation upon the same subject, seen from a slightly different level, and with the valley in the middle distance filled in with a lake. This is a highly accomplished drawing, but inartistic in the extreme and most unpleasing in colour, and I can only think that it is the work of one of Varley's pupils, who had been given the Snowdon drawing as a theme to embroider upon and vary, or perhaps a variant of it (by Varley himself) to copy. Probably a great deal that is called by John Varley's name,

* Though generally accepted as Varley's this drawing is catalogued by the museum as 'Attributed to him'.

and at first sight may seem to be by him, is in fact, could one but prove it, by his pupils or imitators. I have heard it suggested, for example, that a certain rather soft and fuzzy type of Varleyish watercolour may be by Tobias Young (died 1824), a Southampton artist whose low-toned watercolours, sometimes signed, of cottages on commons, with sheep grazing, and suchlike subjects, have a certain broad effectiveness. Again, I have two brown monochromes, the first of which I did not doubt until I acquired the second and observed how much more delicate and subtle were its gradations of tone, how much freer the shapes into which the brush had guided the wash. Both are possibly by Varley. One (361) certainly is (it is inscribed on the back 'By John Varley, given to me by Mrs Palmer, 1867', and I like to imagine that 'Mrs Palmer' was the widow of Samuel Palmer), but the other may, I think, be a pupil's work.

Even when Varley is repeating himself, his arrangements of his stock properties can often be—if one does not take too severe a view of the matter—delightful. The distant mountain, shining lake in middle distance, tree (often rendered in a convention of a single tapering trunk, leaning at its tip towards the centre of the picture, and clothed towards the top with far too few boughs and far too few and large leaves) in one corner, and rocks, with or without pensive travellers surveying the whole, in the foreground, can be very effective as Varley renders them in his rich glowing colours. His Thames-side views are less dramatic, but often agreeable in their calm way, and he did a number of topographical views of buildings and streets—but these I find less interesting. In technique he experimented constantly. Sometimes he varnished a drawing all over (as Gainsborough did on occasion, to simulate the effect of oils) and I have a tiny watercolour of a church among trees, done on the back of one of the Water-Colour Society's cards for 1821, in this manner. Often, in order to get added depth and glow he would put gum over his dark passages—but this has a nasty habit of catching the light unless looked at from the right angle. Another technical trick which he tried (from about 1837 onwards, as Cosmo Monkhouse states in the *Dictionary of National Biography*) was to paint on a very thin rough greyish paper laid down on white card, and to scratch through the paper with a knife and expose the card for the lights. These late drawings are often brownish-purple in general effect and—though they cannot compare in directness of inspiration with the best of his early work—I sometimes like them. Even to the end of his career John Varley's hand retained its skill, its control over an almost unequalled box of tricks.

Cornelius Varley* (1781–1873) was a far less prolific, on the whole a less technically skilful, and certainly a less widely known, watercolourist than his elder brother. He was trained originally, under an uncle, as a watchmaker and maker of instruments, and throughout his life devoted much of his time to scientific pursuits, particularly the making of lenses and telescopes. It is therefore only natural that his artistic output was less than John's. He was nevertheless a very pleasant artist, who used broad clean washes of colour with charming effect. He did many Welsh landscapes (there are a number in the Victoria and Albert Museum) and also a good many classical subjects. His monochromes can be delightful; they sometimes have classical figures delicately put in in pencil, and show a gift for the effective contrast of light and shade; there is often something Cotmanesque about them—as also about his pencil drawings. An admirable example of his water-

* See 'Cornelius Varley', by B. S. Long. *Old Water-Colour Society's Club*. Vol. 14. 1937.

colour is the *Beddgelert Bridge* ($11\frac{3}{4} \times 17\frac{7}{8}$ inches), in the Victoria and Albert Museum, a drawing notable for the fresh and lucid qualities of its washes of ochre, red-brown and grey on the bridge and buildings, and of blue in the sky, with small figures neatly and vividly touched in. One often hears a picture called 'harmonious', but this one seems rather—in colour—melodious and rippling (363).

Cornelius Varley was an original member of an institution which must have a brief mention here, since almost every collector must have come across its productions at some time or other—the Sketching Society, which was founded in 1808 and lasted until 1851.* Prominent among its founders were the brothers J. J. and A. E. Chalon, both of whom later became RA's, and its membership, which was limited to eight, also included at various times H. P. Bone, Thomas Uwins, Joshua Cristall, Francis Stevens, William Turner of Oxford and others. Its official title was 'The Society for the Study of Epic and Pastoral Design', and it held weekly meetings at the members' houses in rotation, from October to April each year. The host of the evening provided materials and set a subject, which the members drew from 6 to 10, after which a supper of bread, cheese and beer was served and the drawings were criticized. They were usually in sepia and they remained the property of the host. Not all the members were chosen from the Water-Colour Society, though many of them were so, including John James Chalon (1778–1854), who was principally a landscape painter—though not invariably, as a drawing in the British Museum, *The Silhouette* (364), bears witness. It is not, however, typical of his work. His more interesting brother, Alfred Edward Chalon (1780–1860), was not a member of the Water-Colour Society. He is briefly noticed in Chapter X. The brothers Chalon, who were members of the Sketching Society throughout its existence, were born in Geneva of French descent, and apparently were not connected with Henry Barnard Chalon (1771?–1849), painter of animals and sporting subjects, who was of Dutch origin. I remember seeing a couple of portraits of dogs by him in gouache—so perhaps he is entitled to the briefest of mentions in this book.

Artists who worked in watercolour were 'as plentiful as blackberries' in the early nineteenth century, and it will be impossible to deal in detail with all those who were associated with even the early years of the old Water-Colour Society. Cotman, Cox and De Wint were frequent exhibitors; so was Samuel Prout; and among others who belonged to the Society were many more to whom reference is made in other chapters of this book. An artist of some talent, who is, however, not so mentioned, was Edmund Dorell (1778–1857), a member from 1809 to 1812. His work does not seem to be very common today, but there are a few of his watercolours in the Victoria and Albert Museum, and Mr H. C. Green has a striking signed example, *Swansea from the Road to Briton Ferry* ($11\frac{3}{4} \times 16\frac{3}{4}$ inches). This has a rich blue and grey sky with low-toned, but not dark, foreground, and good recession and distance, though the touch is a little woolly. A few lines, too, may be added about Ramsay Richard Reinagle (1775–1862) who became an associate of the society in 1805 and a member in 1806. He was a son of Philip Reinagle, RA, and was extremely precocious since he began to exhibit at the Royal Academy in 1788, when he was only 13.

* See Mr Hesketh Hubbard's article 'The Society for the Study of Epic and Pastoral Design' in The Old Water-Colour Society's Club's twenty-fourth annual volume, 1946.

As a watercolourist he was fond of mountain and lake scenes and Italian landscapes. He had considerable ability, as examples at the Victoria and Albert Museum show, but I have never seen anything by him which seemed to me really interesting or original. He did many drawings, figure subjects as well as landscapes, in pencil and in crayon. He became ARA in 1814 and RA in 1823, but disgraced himself in 1848 by exhibiting another man's painting as his own and had to resign from the Academy. From the Water-Colour Society, of which he was president from 1808, he resigned in 1812 (i.e. before its reorganization in 1813), having exhibited 62 drawings there. A mere mention must be enough for Frederick Christian Lewis (1779–1856), best known as an engraver, and his brother George Robert Lewis (1782–1781), both of them landscape watercolourists of talent and occasional exhibitors with the society, though not members.

A Note on Amateurs

FROM THE beginning amateurs have figured notably in the history of English water-colour, often using the medium with distinction, and occasionally having an important share in its artistic development. Francis Place in the seventeenth century and William Taverner in the mid-eighteenth century were amateurs, and they had many distinguished successors. For sound reasons the part played by the amateur was indeed much greater before about the middle of the nineteenth century than it has been since, because, particularly in the eighteenth century, there were many men and women who were highly cultivated, were interested in the arts, and acquired considerable skill in them, particularly in watercolour, but who, because of their rank, were debarred from following art as a profession. A member of the nobility, or of the landed gentry, even (though to a less degree) a professional man such as a parson or a doctor, would in that age have considered it beneath his dignity to make drawings for money or—even more—to perform the semi-menial task (as it then seemed) of giving drawing lessons. The gentleman's part, in the eighteenth century view, was to patronize art, or, if he himself was talented in that way, to practise it purely as an intelligent and aesthetic recreation. The work of certain amateurs is well known, but others, often of considerable ability, are continually coming to light, and on the whole too little attention has, I believe, been paid to amateur work. Frequently, when the authorship of some skilful, but unattributable, drawing is in question, the answer must be, if it could only be proved, what the late Randall Davies used to call 'the D.A.'—the Distinguished Amateur. And in this connection it is worth noting that amateur drawings are, as a general rule, a little old-fashioned. Amateurs have not usually spent their daily life in close contact and discussion with their fellow-artists and they tend to produce drawings which seem stylistically one generation earlier than the work of professionals of the same age. This obviously cannot be an absolute rule, but it is, I think, an observation of fairly wide application.

A few of these amateurs were assiduous practitioners, whose work was constantly before the public even if they did not take money for it. There was a well-established practice by which amateur caricaturists had their work etched—and no doubt in certain cases redrawn—by professionals, and they probably drew no emolument from its publication. Such a man as Henry William Bunbury (1750–1811) produced a mass of published work and, even though most of it was etched, or otherwise reproduced, by other artists, it seems strange to our modern way of looking at things that he should have received nothing for it. He was the second son of a Suffolk parson baronet, Sir William Bunbury, and the baronetcy (which still exists) eventually passed to his own second son, Sir Henry Edward

230

Bunbury (1778–1860), soldier and military historian. A large number of drawings, apparently of Bunbury family provenance, bear faked signatures of H. W. Bunbury, written in ink or pencil in a round cursive hand (see p. 16). In some cases I think the drawings themselves are genuinely by H. W. Bunbury, others are certainly not by him but perhaps by members of this family—including Sir Henry Bunbury, for I have a slight pencil sketch, much in his father's manner, which is signed on the back 'H. E. Bunbury. Sept. 1814'.

H. W. Bunbury was educated at Westminster and St Catherine's College, Cambridge, and in 1771 he married Catherine Horneck, whom Goldsmith called 'Little Comedy'. Mr Croft-Murray has drawings by Bunbury of Miss Horneck as Sebastian and Miss Wynne as Viola in an amateur production of *Twelfth Night* at Wynnstay—a great centre of amateur theatricals for which he designed the invitation cards and Paul Sandby the scenery (367). Before his marriage Bunbury had visited France and Italy, and had studied drawing at Rome. His great year, as an artist, was 1787, when there were published his two delicious strip cartoons, or shallow friezes of delightfully comic figures, *A Long Minuet, as Danced at Bath* and *The Propagation of a Lie*. Also in 1787 was published the first edition of his well-known book *An Academy for Grown Horsemen*, by Geoffrey Gambado. After the death of his wife he retired, in 1798, to Keswick, where in 1811 he died. Bunbury was a very pleasant caricaturist, full of broad good-natured humour, and quite without malice. He avoided political subjects, and drew fat dons being blown about by the wind, odd-looking clergymen at dinner, clumsy horsemen and their uncouth steeds, barbers shaving their customers, and stout citizens out on an angling party (incidentally, he would have revelled in the humour of the late Harry Tate's *Fishing* sketch). Two particularly delightful fishing subjects (one of which was etched and not improved by Rowlandson) belong to Mr L. G. Duke (366). Bunbury worked in all sorts of medium —pencil, pen and wash, watercolours, even oils. He had nothing like Rowlandson's power or fluency of draughtsmanship, but his individual figures are full of life, even though their drawing is often weak and though he had no great gift of combining them into a composition. He was not always a comic draughtsman, but also drew rustic maidens or other sentimental subjects, or illustrations of Shakespearean themes such as his *Florizel and Autolycus Changing Garments* in the Victoria and Albert Museum. This ($13\frac{3}{4} \times 17\frac{5}{8}$ inches) may stand as a favourable example of his more polished and elegant drawings. In such figure subjects he was often very pretty, especially as regards colour, and one sometimes comes across little scraps by him—such as a sketch, dated 1786, of a lady in a pale blue hooped dress and wide hat—which are delicate and charming, if lacking in professional finish and assurance, for Bunbury remained essentially an amateur in his drawing. One of his pieces for which I have especial affection is a watercolour, in brown and red and a little olive green, of *Little Red Riding Hood*—and none the less because the wolf is the most ludicrous and friendly beast imaginable. His caricature work to some extent influenced that of George Moutard Woodward (see p. 142), a squire's son, who perhaps began as an amateur, but eventually practised professionally. Bunbury's figure subjects I find greatly preferable to such examples as I have seen of those of the celebrated Lady Diana Beauclerk (1734–1808), daughter of the third Duke of Marlborough, wife of Johnson's friend Topham Beauclerk, and the subject of one of the great man's least charitable

remarks. Her work was greatly admired by Horace Walpole, who owned several examples; and a large and ambitious specimen of her watercolours can be seen in the Victoria and Albert Museum, a *Group of Gipsies and Female Rustics* ($27\frac{1}{2} \times 35\frac{1}{2}$ inches). I find it somewhat pretentious and vapid (369). There are some pretty little watercolour cherubs and single figures which I have heard tentatively attributed to Lady Diana, but I do not know that their authorship has been established. A vigorous and highly talented amateur caricaturist was George Townshend, fourth Viscount and first Marquis Townshend (1724–1807), but so far as I know he drew only in pen and Indian ink, and did not use watercolour (368).

Among amateur draughtsmen of figure subjects must also be mentioned William Locke of Norbury (1767–1847), whose father, also William Locke (1732–1810), was a collector and amateur artist too. The younger Locke was a pupil and friend of Henry Fuseli, who dedicated his lectures on painting to him, and whose influence is sometimes seen in Locke's drawings. These are not common, but there is a spirited example, *Gamblers Disputing* ($7\frac{3}{8} \times 10\frac{3}{8}$ inches), done when he was about 18 in pen and ink with some washes of colour (365), at the Victoria and Albert Museum, which acquired in 1947 a number of others in various mediums (pen, pencil, red chalk, etc.) by gift from the late Dr Annette Benson. The Ashmolean also has an example; and in the British Museum there is a pencil drawing, with touches of watercolour, of two women dancing, and the head of one of them strongly recalls Fuseli. Mr L. G. Duke has a pen drawing of two women with a child and a toy horse and cart, which is signed and dated 'Wm. Locke Aug. 1784'.

Another amateur who occasionally did caricatures was Coplestone Warre Bampfylde* (1720–1791), a country gentleman of Hestercombe in Somerset. He made a series of humorous illustrations for Christopher Anstey's poem, 'An Election Ball', 1776; one of them was used as the frontispiece of the poem, and the whole series was etched, on a smaller scale, by William Hassel, to illustrate Anstey's Latin *Ad C. W. Bampfylde, Arm: Epistola Poetica Familiaris*, 1776. They are quite amusing, but I think must have been improved a good deal by the engraver; at any rate, the only caricature drawing by Bampfylde which I have seen, in pen and watercolour, is a much poorer production. Bampfylde, however, was more than an amateur caricaturist, he was well known as an amateur landscape painter and exhibited between 1763 and 1783 at the Society of Artists, the Free Society of Artists, and the Royal Academy. There is an example of his landscape watercolours at the Victoria and Albert Museum,† and I have seen a dozen others (some of which I now have) at various times. The artist who influenced him most was Paul Sandby. A formal, rather stilted, topographical view is *Milbourn St Andrew's, the Seat of Edmund Morton Pleydell Esq*—showing a plain stone house, with trees and rookery to the left, garden and cottages to the right, and in front park-land with cows, sheep, deer, horses, and a groom riding and leading another horse ($11 \times 24\frac{3}{4}$ inches). This is in clear colour and pen, and is perhaps nearer to Grimm than to Sandby. But the example of Sandby is overpoweringly evident in Bampfylde's imaginative landscapes, which sometimes have a good deal of body-colour in them, especially in the lights, e.g. a coast scene, with castle

* See Ralph Edwards, 'C. W. Bampfylde', *Apollo*, XI. 113. 1930.

† In 1949 this museum acquired also a large album of drawings in watercolour, wash, pen, etc., chiefly by Bampfylde, which still stand in need of study. They include watercolours of Stourhead, and also some of Bampfylde's etchings. Mr L. G. Duke also has a Stourhead view, reproduced here as figure 370.

on a cliff and a man driving a pack-horse in the foreground, which is signed and dated 1772 (371). A similar Claude-cum-Sandby coast scene of 1773 seems to be in clear colour, and so is a large romantic landscape, again of 1773, a view of a lake with mountain and ruined temple behind and, to the left, a wayfaring family. In this drawing ($13\frac{3}{8} \times 17\frac{3}{4}$ inches) the outlines are partly in pen and partly in black crayon. It is really quite an imposing minor work. In 1780 Bampfylde seems to have done a tour in the north. *A View of Grasmere and Holm [Helm] Crag between Ambleside and Dunmailrayse* is dated August 1780, and a *View from the 3 mile stone of the Vale of Lonsdale and Hornby Castle on the road from Lancaster to Hornby*, though undated, may well have been done on the same trip. These two drawings, and especially the first, show that Bampfylde was able to use the natural scene for something better than the prim topography of his *Milbourn St Andrew's*. Some of his work was engraved by Vivares and others. I have an extra soft corner in my heart for Bampfylde because his name is among the subscribers to the two volumes of *Poems, Lyric and Pastoral*, by my great-great-grandfather, Edward Williams (Iolo Morganwg), which after long delays were published in 1794, when Bampfylde had been dead three years. The presumptive date of his birth I owe to the kindness of the Rev R. Llewellyn Lewis, Vicar of Kingston St Mary, Taunton, who tells me that Bampfylde was baptized there on April 21, 1720.

Much more important, and of much greater influence, though as an artist he was extremely restricted in range, was the Rev William Gilpin (1724–1804), who through his tours and other writings illustrated by himself became one of the chief influences upon popular taste at the end of the eighteenth century.* He was born at Scaleby Castle, near Carlisle, and Sawrey Gilpin, RA, was his younger brother. William was educated at schools at Carlisle and St Bees, and at Queen's College, Oxford. In 1746 he was ordained, and became a curate at Irthington. His first book was a life of his collateral ancestor Bernard Gilpin, published in 1753, which he undertook in order to pay off a debt contracted at Oxford. He was for a short time a curate in London, but soon took over a boys' school at Cheam, Surrey, which he ran for some thirty years, showing himself something of an educational reformer. During the summer holidays he went on sketching tours—to East Anglia in 1769 and 1773; to the Wye and South Wales in 1770 and 1782; to the S.E. coast in 1774; and in 1776 to Cumberland, Westmorland, and the Highlands. His first artistic publication was an *Essay on Prints* in 1768. In 1777 he became vicar of Boldre in the New Forest, where he remained until his death, and showed himself a very remarkable and progressive parish priest, devoting whatever he made from his books to improvements in the parish. His long series of self-illustrated writings began in 1782 with *Observations on the River Wye, and Several Parts of South Wales, etc., relative chiefly to Picturesque Beauty; made in the Summer of 1770*. The fifteen oval plates of the first edition are in a mixture of etching and aquatint after drawings by the author. They were the work of 'a young man, a relative of mine', who may have been William Sawrey Gilpin, then aged 20 (see p. 212). They were apparently not considered satisfactory, for plates were done afresh, entirely in aquatint, for the second edition, 1789, by the engraver Jukes. Personally, however, I prefer the original plates, in which the etched lines reproduce effectively those lively touches of the reed pen that are so characteristic of Gilpin's original work. I cannot pretend to find

* See W. D. Templeman, 'The Life and Work of William Gilpin'. University of Illinois Press, Urbana, Illinois, 1939. $3.

Gilpin's aesthetic meditations on the English landscape readable—they seem to me often prosy and sometimes obscure—but they had great influence in their time, and the plates are, in their way, pleasing. In spite of Gilpin's use, in his title, of the hybrid phrase 'picturesque beauty', it is clear that he recognized the distinction drawn at that time between the beautiful and the picturesque, and there is a curious passage in which he contrasts the picturesque qualities of cows and horses, deciding that 'in a *picturesque light* the cow has undoubtedly the advantage, and is in every way better suited to receive the graces of the pencil', and adding that 'cows are commonly the most picturesque in the months of April and May, when the old hair is coming off'.

Gilpin drawings are not rare, but I cannot recall ever having seen one in full colour*—though I have seen what appear to be copies or imitations of his work in colour. He always, in my experience, worked in Indian ink, sometimes on a yellow foundation (as in a drawing which came from Lord Warwick's sale in 1936), and often over a loose outline in pencil. His drawings very frequently measure about $7\frac{1}{4} \times 11$ inches, but may on occasion be either much larger or smaller. Nearly always a very distinctive use of the reed pen is a feature of his work, the pen strokes being used interruptedly to strengthen and accent, say, the outline of a hill, to put in figures of men surveying the scene (usually two men, one short and one tall, together, or sometimes a group of three, two standing and one sitting), or to sketch the trunk and boughs of trees—in which he used a free, sickle-shaped, down and up, stroke for the secondary branches. Gilpin's pen-work, once you have seen it, is quite unmistakable, and so is his handwriting which one sometimes finds on the back of, or attached on a separate sheet to, his drawings, in a paragraph of explanation and exposition. His subjects were often imaginary—from an inscription accompanying one in the Victoria and Albert Museum we learn that a certain mountain in it 'may be supposed to be a peculiar feature of the country'—and he often insisted that his drawings were not to be taken as 'portraits'. On one quite trivial little drawing which I have, the original of one of his illustrations to his Lakeland tour, are written the following instructions to his engraver, which show how little Gilpin cared for the details even of an actual scene: 'This is a view on Ullswater towards Patterdale. On the left Martindale fell falls with an abrupt step into the water. On the right two woody promontories pursue each other. But as the view is meant rather to explain the country, than to give an exact portrait of it, Mr Smith need not be closely confined to my lines. But it shd be etched so as to present the same parts to the right and left, which in the 2 first drawings yt were sent is not material.'

Such were Gilpin's principles—or some of them—and within the narrowly limited range of his style and method he often achieved effects of great delicacy. His mountain scenes, with mist diffusing itself through the whole middle distance of the picture, are sometimes admirable, and show a deep feeling for the romantic poetry of landscape. Mr H. C. Green has a remarkable series of first-rate examples of Gilpin's work. Two sales of his drawings were held, one on May 6, 1802, the other shortly after his death in 1804. They raised £1,200 and £1,600 respectively, which was used to endow the village school which Gilpin founded at Boldre to counteract the laxity of a community that lived largely by poaching in the New Forest. Whether the blind-stamped initials, W.G., which are often found on his drawings mean necessarily that they have come from one of these sales,

* Mr L. G. Duke has two coloured drawings by Gilpin. See also Addenda.

I do not know. But one such stamped drawing, which I have, is annotated on the back 'Sale 6 May 1802'. I think it possible that Gilpin was to some extent influenced by Alexander Cozens, and he may have experimented in Cozens's method of inspiration by blot (see p. 38). At any rate there is one Gilpin drawing in my collection, rather rough looking and clumsy, but stamped with his initials, which is inscribed on the back 'A Blot D°——'. In another drawing Gilpin has tried the trick of gumming the shadows to get depth, but I think this was exceptional with him (372 and 373).

A good many amateurs, like Gilpin, seem to have worked entirely, or at least principally, in monochrome. For example, the few drawings I have seen by John Skippe (1741–1812), a Herefordshire man who was educated at Merton College, Oxford, travelled in Italy, and studied landscape under C. J. Vernet, have been so (374). He learnt drawing from J. B. Malchair (see p. 90), whose Oxford pupils included several other eminent amateurs, notably Lord Aylesford, Sir George Beaumont, and Dr William Crotch. Of these three the first, Heneage Finch, fourth Earl of Aylesford (1751–1812), was an artist of much sensitiveness and distinction who, though he did not restrict himself invariably to monochrome, often did so, and in any event used an extremely limited range of colours, of which brown, bistre, grey, and a pale brick-red were the chief (375 and 376). He was at school at Westminster and before succeeding to the earldom in 1777 sat in the House of Commons. Five drawings in blackish-brown wash over pencil, which are in an album chiefly of drawings by Malchair in the British Museum, show Aylesford still much under Malchair's influence, and must be early works. He was an etcher of talent, and an exhibitor at the Royal Academy from 1786 to 1790. To judge from the subjects of some of his drawings he must have visited the Continent (I have a drawing inscribed 'Sancerre'), but he seldom dated his work. Indeed the only dated example I remember seeing is a view of the Wrekin done in the year of his death. His work is especially well represented in the collections of Mr Oppé and Mr Duke, and there were examples in Lord Warwick's sale at Sotheby's in 1936. Aylesford's drawings, though generally slight, show delicacy of taste, and a very agreeable loose touch, both with the pen and with the brush. He drew mountain scenes, castles on hills, other buildings, and trees, the foreground being in brown and the distance, if not all in grey, often with characteristic mottled grey shadows. If there is a building in the drawing its roof is often the occasion for introducing a passage in Aylesford's favourite pale red. He seemed to know just when to leave a sketch without spoiling its effectiveness, and did not mind leaving the outer parts of the paper bare. A slight, but to my eye very pretty, watercolour by him indicates with much economy of effort a stretch of slow-flowing river, with open ground in front and on the far bank a pink-roofed summer-house and a wood. The scene is suggested with admirable effortlessness. It is on a paper which Aylesford was fond of using and which has curious irregular wrinkles and scratch-like markings upon its surface. There are, however, great risks in attributing drawings (as I have attributed this one) to Aylesford, for it is clear that other members of his family worked in his style and continued to do so for many years after his death. In an album I recently found examples to the point, including two drawings by a younger brother, the Rev and Hon Daniel Finch, Prebendary of Gloucester (1757–1840), who was the sixth son of the third Earl and was also a pupil of Malchair. In method and palette these drawings are indistinguishable from the work of the fourth Earl, though they are perhaps a

little weaker and less certain in effect. In the same album were drawings by three members of the related Legge family. Of these Heneage Legge (1747–1827) is represented by a black and white chalk landscape rather in the manner of Wilson: he was a grandson of the first Earl of Dartmouth and a great-grandson of the first Earl of Aylesford; but two daughters of the third Earl of Dartmouth—Lady Barbara Maria Legge, who married Francis Newdegate in 1820, and died in 1840, and Lady Charlotte Legge, who in 1816 married George Neville (who afterwards took the surname Grenville), Master of Magdalene College, Cambridge, and Dean of Windsor, and did not die until 1877—show very distinct Aylesford influence, the former in a Claudeian composition, the latter in a rather good, solid, drawing of part of Pembroke Castle. And I strongly suspect that there were others.

The Rev William Bree (1753?–1822) was Rector of Allesley, which is only a few miles distant from Packington Park, Lord Aylesford's home. Sir Bruce Ingram acquired in 1949 two albums of pen and wash, pencil, or watercolour views of Maxstoke Priory, a ruin in the same vicinity and a subject which Aylesford drew. Bree's drawings, two of which are dated 1805 and 1806, are certainly influenced by Aylesford, and also to a less degree by Grimm, Rooker and perhaps Nattes. The watercolours, which are highly accomplished, are chiefly in soft, low, tones of grey and green, and the rendering of the stone of the building is notably well done, both in quality and colour.

Sir George Howland Beaumont (1753–1827) as the friend and patron of Constable, as one of the principal founders and benefactors of the National Gallery, and as the friend of Wordsworth, Coleridge and Scott, is a familiar figure in the history of English art and literature. He was born at Dunmow in Essex, which continued to be his country home until the end of the century. The beautiful belfried and gabled house in which he lived still stands on the outskirts of the town, near where the road branches off to Great Bardfield. He succeeded to his baronetcy in 1762, and was educated at Eton, where he was taught drawing by Alexander Cozens, and at New College, Oxford, where, as already mentioned, he was a pupil of J. B. Malchair. In 1778 he married and in 1782 and 1783 visited Switzerland and Italy with his wife. In 1819, 1821 and 1822 he was again on the Continent (whether he made one long tour, or two short ones, is not clear), visiting Holland, Germany, Switzerland and Italy. He was a member of Parliament from 1790 to 1796, and in 1800 began, with George Dance, RA, to rebuild Coleorton Hall, in Leicestershire, the house with which his name is most closely associated, and where Constable, Wordsworth, and many other celebrities stayed with him. Though he exhibited 36 pictures at the Royal Academy between 1779 and 1825, Beaumont's work as an artist is little known, chiefly because the great bulk of it is, or was lately, still in the hands of the family. The British Museum has a few drawings, Mr Leonard Duke has an album of sketches,* and I have come across others at various times, but on the whole students know little of his pictures. In 1938, however, an exhibition of 39 paintings and 131 drawings was held at Leicester, and not only did the introduction to the catalogue, written by Mr A. C. Sewter, add certain facts to those recorded in, for example, the *Dictionary of National Biography*, but for the first time there was an opportunity of judging something of Beaumont's stature as an artist. The exhibition was selected from the 120 oil painitngs and over

* Another album passed through a London sale-room in 1949, when it was bought by Mr F. R. Meatyard, of Museum Street.

2,000 drawings preserved at Coleorton, and showed Beaumont to be an artist with a strong sense of the dramatic qualities of landscape, though sometimes failing to achieve proper solidity for his mountain and other masses, and with a restricted range of colour. The chief obvious influences were those of Claude and Wilson. As regards the drawings, only a few were in colour, most of them being in pencil or pen-and-ink and wash, or in pencil alone. After an interval of twelve years I cannot pretend to criticize these exhibits in detail, but Mr Sewter, who examined the whole of the Coleorton collection, in his useful introduction noted the influence of Alexander and J. R. Cozens, Gainsborough, Warwick Smith, Girtin, Hearne, Rembrandt and Magnasco. Yet in spite of this Mr Sewter is perfectly right in claiming individuality for Beaumont—once you have got to know him, he is, in my limited experience, a recognizable draughtsman. Even in the handful of his drawings which are available to me as I write, some of the influences noted by Mr Sewter are evident. A small, rather insipidly pretty, watercolour of a thatched cottage, signed and dated 1794 on the back, is strongly reminiscent of Hearne. A pencil study of ruins, trees, etc., dated 1810, owes much to Gainsborough and to Wilson, and another, a haymaking scene, which probably belongs to the same year, besides owing an evident debt to Gainsborough, is influenced also, I think, by Constable (or perhaps the young Constable was influenced by him?) and Crome, especially in the treatment of the trees. Rather strong patches of high light, achieved by leaving the paper blank, are characteristic of many of Beaumont's wash drawings, for instance, a pencil and sepia view looking over Grasmere to Helm Crag, dated September 9, 1807 (the Wordsworths had visited him the previous winter, and he was probably repaying the compliment), and another mountain and lake scene, in pencil with brown wash for the foreground and blue-grey for the distance (377 and 378).

Neither Aylesford nor Beaumont—nor so far as my very slight knowledge of him goes, Skippe*—shows in his work much of the influence of Malchair, but with another pupil, or perhaps disciple would be a better word, William Crotch (1775–1847), it is often evident. Crotch being, like Malchair, both musician and artist, and being moreover not a mere transient undergraduate at Oxford but for many years a resident there, was no doubt closer to him temperamentally and longer under his influence than the others. Under his formal tuition Crotch cannot have been for very long, for in 1797, when it is said he first came to know Malchair intimately, the latter was already losing his eyesight. In 1798 he handed over his teaching practice to William Delamotte, and the next year made his last drawing. (See A. P. Oppé. 'J. B. Malchair of Oxford', *Burlington Magazine*, August 1943.) William Crotch was an extraordinary and very likeable character. He was born at Norwich, the son of a musical carpenter, and his early aptitude for music was such that Dr Burney read a paper about him to the Royal Society. In 1779 (when he was 4) he came to London with his mother and—seated on her knee—performed at the organ and piano as 'the Musical Child'—surely the most infantile of infant prodigies. In 1786 he was in Cambridge studying music and two years later settled in Oxford, and must soon have made his first acquaintance with Malchair, since in 1789 he was engaged to play a concerto at the music room where Malchair was leader of the band. In 1790—being then 15—

* I know even less of the drawings (which no doubt exist) of another of Malchair's amateur pupils, Oldfield Bowles (1739–1810), of North Aston, Oxfordshire.

he was appointed organist of Christ Church, a post which he held till 1807 or 1808. Contemporaneously he held several other organists' posts in Oxford, and in 1797 became professor of music. In 1799 he took his Mus.Doc. At Oxford he lectured, composed, and sketched, publishing two sets of etchings in 1809. About 1810 he moved to London, where he continued his successful musical career, and in 1822 became the first Principal of the Royal Academy of Music. During his later years he lived at Kensington Gravel Pits, but his death occurred at Taunton, where he was staying with his son.

Dr Crotch's watercolours show great talent, and he occasionally painted in oils.* The larger drawings clearly proclaim their amateur origin, for they have a certain awkwardness and heaviness of touch. But his smaller sketches are often delightful, so much so, indeed, that on at least two occasions lately drawings masquerading—in the very best company—as Constables have been proved to be by Crotch. The Malchair influence is apparent in the strong underpainting of slightly diagonal strokes of dark grey or black (probably Indian ink) and sometimes in the trick of rendering foliage by means of a peppering of small dark blotches. A charming example ($10\frac{1}{4} \times 14\frac{3}{4}$ inches) of Crotch, in which these marks of style are seen, is *Holywell Mill, Oxford*, a drawing signed on the back (like most of Crotch's work) and dated July 11, 1803, 7 a.m. Only two colours are used over the Indian ink foundation—a soft pale green for the grass and trees and a brown for the roof of the mill (379). The thing is seen with the same simplicity and freshness which appear in some of Malchair's glimpses of Oxford nooks and corners. The meadow, the mill, the trees, the punt moored in the mill-stream, make up a sincere and unpretentious drawing, of an agreeable early morning pearly-grey general effect. An extremely pleasing group of drawings was that made at Heathfield, Sussex, where the Crotch family must have stayed in August, 1811. These are chiefly studies of trees in parkland, and are mostly in pale colours—green, grey, blue—over an Indian ink foundation, but one or two are in stronger, more opaque, colour. One especially delicious example, rather different from the others, is a perspective along a classical colonnade outside a house, at the end of which a lady in white holds up a small child in her arms, while a brown dog lies by the house door. All looks sunny and fine, but a note on the back tells us that there is 'thunder about'. It also says that the figures represent 'Mamma, Kitty and Badger'—a characteristic note, for they are far too slightly suggested to be recognizable. But Crotch loved to note small, artistically irrelevant, facts on the back of his drawings—such as the identity of a figure which is a mere dot in the landscape, or the tune which a group of country folk sang. Another series of drawings—larger and bolder than those just mentioned—was done in Dovedale on August 26, 1802, and is of special interest, from the point of view of method, in that Crotch did one drawing every half-hour. A few of the series are missing, but from the numbers it is clear that he adhered to this scheme of half-hour intervals at least from 12 noon to 4.30 p.m. The drawings are fairly large (one measures 13×20 inches) and in full colour, so it is unlikely that more than an outline in black chalk was done at the time. Probably the colour was added afterwards. This group owes a great deal to Malchair's monochrome Welsh landscapes, especially in the treatment of cliffs and rocky slopes. It is perhaps worth noting that Crotch was a great copyist—he made copies

* See 'William Crotch, Musician and Painter', by Hilda Barron. *Country Life*, January 30, 1948. The illustrations are a landscape and a supposed self-portrait in oils, and four watercolours from an album of late (1832–42) examples of his drawings.

of drawings by Malchair, and even of Malchair's copies of other artists, and he sometimes copied his own sketches forty years after their original date. For example, I have a rather strong black monochrome of *The Wairs near Oxford, April* 28, 1801, 8 *a.m.*, and a copy of it in colour made by Crotch in 1842. Other drawings are collaborations with William Delamotte. Within his limits Crotch is an artist whom it is pleasant to know (380).

Another amateur who, though his style is unmistakable, often appears under an *alias* is Thomas Sunderland (1744–1823), for his drawings are often disfigured by the forged signature of Paul Sandby (see p. 16 for this group of forgeries). They have also masqueraded as D. M. Serres and even Rowlandson. Sunderland's work is, however, now pretty well known to museum officials, collectors, and the more knowledgeable dealers. The following biographical facts were mostly given me in 1937 by the artist's great-grandson (and Randall Davies's nephew), Mr Richard Sunderland, who at that time kept a picture shop in Westbourne Street, near Sloane Square, and since they are not found in the more usual books of reference, it may be valuable to print them here at length*:

Thomas Sunderland was born at Whittington Hall, near Kirkby Lonsdale, on November 3, 1744. He was the son of John Sunderland and Mary, daughter of Thomas Rawlinson of Whittington Hall. On the death of his father in 1782 he sold Whittington and bought (or built) Littlecroft, Ulverston. He was a pioneer of the iron ore industry in Furness, and on the threatened invasion of England by Napoleon he formed the Ulverston Volunteer Corps (1803–1806). He was a Deputy Lieutenant of the County of Lancashire. He travelled much in Britain and on the Continent. Views of Scotland, Wales, Ireland, the Lakes, Italy, Spain, Switzerland and the Rhineland are mentioned in the catalogue of his work sold in 1919. On July 4, 1823, he died, aged 79, and was buried in St Mary's churchyard, Ulverston. He married Anne, daughter of William Dickson of Beckbank, Cumberland, and left a son and three daughters. Littlecroft eventually became the County Hotel, and was burnt in 1912; the Ulverston Post Office now stands on the site. Thomas Sunderland's sister, Judith, married Edward Gregge-Hopwood of Hopwood Hall, near Bury, a house which is the subject of some of Sunderland's drawings. It is now the home of the Manchester Golf Club.

Fully coloured drawings by Sunderland are rare. There were half-a-dozen examples in the Randall Davies sale in 1947, but they were rather commonplace things and lacked the delicacy of Sunderland's best drawings, which are in his habitual medium of blue-grey monochrome, sometimes ranging into pale blue in the sky and into a browner tint in the foreground. The outlines are drawn either in pen or pencil—often both occur in one drawing—and sometimes he used more than one coloured ink, black, brown, and occasionally (as for the roof of a hut in the most elaborate drawing of his I know, inscribed *The Austrian Barriers at the Castle of Ehrenberg. T.S.* 1795) dull red. Evidently he loved castles perched on rocky summits for, in addition to the two such castles in the drawing just mentioned, there is a similar building in Sunderland's *Castle of Segovia, Spain.* By far his best work, however, is in his views of the Lake District, which he interpreted with real understanding and love. A patch of cliff, with bushes growing in its crannies, dropping down to the waters of a lake, or a view of distant fells over a valley of woodland and

* See also Randall Davies, 'Thomas Sunderland. Some Family Notes,' *Old Water-Colour Society's Club.* Vol. XX. 1942. For information about Sunderland I have also to thank Miss Margaret Pilkington, of the Whitworth Gallery, Manchester, and Messrs Colnaghi.

meadow, seems to have stirred his nature to really effective expression, as in a very beautiful distant view of Rydal Hall, full of subtle gradations of grey in the sun-and-cloud dappled fell-side, which succeeds admirably in confining a large expanse of view on a comparatively small piece of paper. I remember the thrill with which, one early spring day, I walked up a narrow stone-walled lane above Ambleside and suddenly realized that I was on the very spot on which Sunderland had made this drawing 150 years before. From a reference in Farington's diary we know that Sunderland knew Farington, and he may have been his pupil. He was probably also a pupil of Alexander or John Robert Cozens, or both. The influence of the latter is evident in Sunderland's work, and the catalogue of prints and drawings by or belonging to Sunderland, sold at Sotheby's on July 14, 1919, contains one drawing by Alexander Cozens (381 and 382).

An artist whose drawings I have seen wrongly attributed to Sunderland was a certain E. Becker (I do not know his Christian name) who was I presume also an amateur—though he is a very vague figure, and may have been a minor professional. His identification we owe to the researches of Mr A. P. Oppé, who has succeeded in establishing Becker as the author of three groups of drawings—all in monochrome. There are, first, some rather stiff and careful views of Rome in pen and wash, which suggest that possibly Becker may have been a pupil of Richard Cooper. They are usually mounted on sheets of grey paper with the name of the place written below the drawing, but the name is also generally written rather faintly in ink on the drawing itself. I take it these are the earliest of Becker's drawings—perhaps done about 1780. Second comes a type of rather free pen and wash Lake District landscapes, and it is these which I have seen called Sunderland. They are attractive, but the pen line is flaccid and less sure than Sunderland's and they are certainly not by him. They must be a good deal later than the Roman drawings, and, besides having the place-names written on them in ink, are sometimes annotated with scribled notes of colour, etc., which seem to comprise, as well as English words, others in French and German (384). These drawings have slight similarity to Downman's Lake District sketches. Thirdly, there are some similar, but more nervous, pen and wash drawings of the Thames Valley (383), of which the late firm of Parsons in the Brompton Road had a number, and which Mr Oppé has also identified as by Becker. These are Becker's best productions. Whether this artist was in any way connected with Ferdinand Becker, an artist who died at Bath in March 1825, I do not know. As I have said, he may or may not have been an amateur, but he is worth noting here for the similarity of his work to Sunderland's.

Also to be noted in connection with amateur watercolours of the Lake District are those of Amos Green and his wife. Amos Green (1735–1807), who was born at Halesowen, was himself a professional painter, especially of flowers, but the landscape watercolours which he did late in life after he settled in the north of England were things rather apart from his professional work. He was fond of woodland scenes and waterfalls, often in brown monochrome, sometimes in rather pale colour, with tender green and primrose yellow foliage. He was specially good at putting in such detail as bracken in the foreground and in suggesting the species of the trees in a drawing—but there remains something amateurish about his work of this kind. His wife, whom he married in 1796, was a Miss Harriet Lister of York—presumably the 'Miss Lister' who exhibited a single landscape at the Academy in 1784. She must have been an amateur pupil of Amos Green's, and much of her work

is indistinguishable from his (385 and 386). Several albums in which her sketches and his were bound up together, sometimes with an illustrated title page, turned up recently, and most of them were, I am afraid, broken up. A great many of the drawings were initialled A.G. or H.G., but even so it was difficult to detect much difference, though the lady shows special aptitude for certain effects, such as soft light upon distant mountains. The drawings in these albums were done on tours of the Lake District, Wales, Scotland and elsewhere. There are also a number of more ambitious separately mounted watercolours by Mrs Green, which show a good sense of mountainous landscape, and demonstrate once more that the talented amateur was often quite the equal of the average professional. The other point they illustrate is how very near the pupil could often get to the master—a point always to be remembered in attributing unsigned drawings. It is a chastening thought that though we know the names of the professional masters, those of the amateur pupils are generally forgotten—and sometimes a drawing signed with an unfamiliar name gives one a jolt. A year or two ago I found a monochrome drawing inscribed on the mount *Castle Acre, Charlotte St Asaph*—but if that name were not there nobody would hesitate to accept the drawing as a typical example of Thomas Hearne. One must presume it, however, to be by Lady St Asaph, even though no other by her is known. And yet may it not perhaps be by Hearne after all, for did not the stupid Princess in *The Rose and the Ring* put 'Angelica fecit' at the bottom of sketches she never drew, and may not other great ladies have done the same? To revert for a moment to the North Country amateurs, another name to be noted is that of Edward Swinburne (1765–1829 or later), uncle of the poet. Some of his drawings were engraved in Surtees's *History of Durham*, volume IV, 1840, and one of these, the original Turnerish brown monochrome drawing of the view of High Force, is sensitive and deft.

Another amateur, of whom I know nothing but his name and what is revealed by his work, was Charles Annesley, who worked in the first, second, and third decades of the nineteenth century. A drawing inscribed Llanberis, 1809, is in the National Museum of Wales. He sometimes signed with a monogram of his initials. He drew alpine scenes, Italian cities outlined against the sky, and occasionallly an English or Welsh view, with skill and in a recognizable style (387). His outlines are in pen, or occasionally pencil, and he often uses sharp, narrowly elongated, looping to indicate foliage. His drawings are mostly in blue, grey, and pinkish brown, with pink for the roofs of buildings. He may have been a parson, but I am not sure that a drawing, which I have, inscribed 'The Rev C. Annesley' is really by the same hand. One of Annesley's drawings is a copy after Sir Thomas Dyke Acland (1787–1871), an amateur certain of whose sketches were copied, no doubt with some freedom, by Nicholson.

Possibly the amateur who came nearest in style to his professional master was John White Abbott (1763–1851), of whom Mr Oppé has given an important account in the Walpole Society's thirteenth volume (1925). He was born at Exeter, and his whole life was spent there, or in that neighbourhood, save for a possible early visit to London, and in 1791 a journey to Scotland, the Lakes, and Lancashire, and perhaps also Yorkshire and Derbyshire. He practised as an apothecary and surgeon and, probably in 1825, inherited the estate of Fordlands (the subject of many of his drawings) from an uncle. As an artist he was a pupil of Francis Towne, and exhibited oil-paintings at the Royal Academy from

1793 to 1805 and again in 1810 and 1822. Some of these earned high contemporary praise. He never sold a picture, and never exhibited a drawing—and it is his drawings which, since the acquisition, by gift from members of the family, of a number of examples by the Victoria and Albert Museum in 1923 and 1924, have made his name familiar to modern ears. Abbott's work is sometimes almost indistinguishable from that of Towne, but seen in quantity Abbott's individuality makes itself felt. He is Towne without the grandeur, the noble sculptured form, the brilliance and rich depths of colour, that are seen in Towne's finest work. At the same time Abbott has the simplicity, good manners, and charm of the cultivated country gentleman—and his work is extremely neat and often very pretty indeed. Mr Oppé describes and reproduces an Exeter view of 1796 which is in watercolour without any pen, but this is an exceptional work. Abbott's drawings are almost invariably outlined in pen, always very neatly, though at some moments more freely handled than at others. It is in the drawing of trees that his freest pen-work occurs, and I think that he felt that certain species called for looser handling than others—not being content like so many artists with using a mere generalized formula for a tree. Sometimes the washes are in monochrome, sometimes in flat smooth areas of deliciously clear colour based, like the pen-work, on Towne's practice in his English landscapes. Abbott usually introduced a few figures, sometimes classical, but at other times rustic, a woodman, or a drover with his pack-horse. He was often very happy when an area of smooth sunlit cliff or hill is contrasted with broken ground or trees in the foreground; the rocks, rippling waters and willow-clad banks of the Teign furnished him with many grateful subjects; and so did Dawlish Warren and the City of Exeter itself. But it was as an interpreter of trees and woodlands that he was at his best (388 and 389).

Some relation to the almost oriental simplified formality of the Towne School is suggested by the work of another West Country amateur, John Baverstock Knight (1785–1859),* who was a squire and land-surveyor in Dorset, living for many years at West Lodge, Piddlehinton. I do not know, however, that any actual connection with Towne has ever been established. The Victoria and Albert Museum has a fine series of his drawings, which vary a good deal in style. His pen work is sometimes rather stilted, especially in his more precise topographical views, but it could be quite dashing at other times. A particularly beautiful example is *View looking down to Lodore and Borrowdale*, in pen and ink and grey wash—which relates stylistically somewhat to the north country amateur drawings discussed a few pages back (390). But Knight is, in this drawing, freer than Sunderland, much more certain than Becker, and more distinguished mentally than either of them. He visited many parts of the British Isles (including Ireland) and also travelled on the Continent. It is recorded that from the age of 23 he rose daily at five and worked at painting from six to nine before devoting the rest of the day to business and sport. He exhibited at the Royal Academy in 1818 and 1819. He copied pictures by old masters and he worked in oils as well as watercolour, painting full-length portraits and sporting pictures. He was two years younger than David Cox but, being an amateur, his drawings are like those of an earlier generation and belong more to the eighteenth than the nineteenth century tradition.

To these notes on two West Country amateurs may be added a brief reference to a

* See 'John Baverstock Knight', by D. S. MacColl. *Burlington Magazine*. May 1919.

group of pleasant, if minor, brown and grey monochrome drawings, with pen outline, of places in the Dawlish area, which are not very far, in style, from some of Baverstock Knight's work. A long series of these belonged, some twenty years ago, to the late Mr George Suckling, the bookseller, of Garrick Street. He informed me that he had acquired them from the Hoare family of Luscombe, Dawlish, as the work of Sir Richard Colt Hoare (1758–1838). Sir Richard was well known both as a patron of the arts and as an amateur artist, and for a long time I did not question this attribution. But eventually I became suspicious, since they do not square entirely with other drawings undoubtedly his which I have seen (for example the large album of pen and sepia wash views done in Tuscany in 1789, now in the Victoria and Albert Museum) and which, though bolder, are at the same time harder and less sensitive than these sketches. Recently, however, I saw in the National Museum of Wales a series of monochrome drawings by Peter Richard Hoare (1772–1849), of Kelsey Park, Beckenham, Kent, a younger brother of Sir Richard, and these were clearly by the same hand as the Dawlish drawings. To him, I think, must also be given the authorship of the watercolour *Coast scene*, attributed to Prince Hoare (see p. 123) in the Victoria and Albert Museum catalogue (edition 1927), since it is clearly signed 'P. R. Hoare, 1789', and is certainly not beyond the powers of a clever boy of 17. It is not very like his much later monochromes, but the passage of more than twenty years would easily account for this (391 and 392).

A vast number of other amateurs might be mentioned in this chapter, and there are some who must. Edward Hawke Locker (1777–1849), the father of Frederick Locker-Lampson, was a topographical watercolourist whose views of houses were, to judge by the examples I have seen, fully up to the average professional standard of the time (393). The Rev Robert Hurrell Froude (1771–1859), also the father of a distinguished son—the historian James Anthony Froude—was a softly poetical sketcher of picturesque village streets, ruins, and landscapes, both in monochrome (in which he is agreeable) and in colour (394). Other clergymen were the Rev Joseph Wilkinson (working about 1810), who made stiff, feebly coloured watercolours of the Lake District (395) and of Norfolk, some of which were published as engravings; the Rev John Eagles,* who in 1824 was a candidate for associateship of the Old Water-Colour Society, but was rejected on the ground that amateurs were not eligible—I have seen at least one example of his work which was rich in colour and bold; the Rev John Gardnor† (1728?–1808), for many years Vicar of Battersea, who did quite able and handsome watercolours of Rhineland castles and so forth, the figures in which are said to be by a professional (396); and—to bring the list of clerics to an end—John Fisher, Bishop of Salisbury (1748–1825), Constable's patron. I had been on the track of Bishop Fisher ever since I saw an album of pretty but amateurishly drawn views, coloured in nice greys, blues and greens, inscribed 'D. Fisher from her affectionate father'. It connected itself with the Bishop, who is recorded to have been an amateur artist, by the fact that the localities included both East Anglia and the West Country. Later I found some Italian views (397) by the same hand and dated 1785 and 1786, in which years Bishop Fisher was in Italy. I was therefore delighted when a bundle of

* Mr L. G. Duke tells me he thinks that Eagles influenced Muller.

† Redgrave gives his Christian name as James, but Colonel M. H. Grant, 'The Old English Landscape Painters' (1926), p. 81, corrects this to John. Col Grant also states that, before ordination, Gardnor kept a drawing academy in Kensington Square. He seems therefore originally to have been a professional artist.

drawings, bearing his name, turned up in 1944 at Hodgson's and confirmed my detective work. The Bishop was, however, a poor draughtsman, though his colour is pretty. A much more accomplished namesake was Sir George Bulteel Fisher (1764–1834), a distinguished gunner, who was Commandant at Woolwich when he died. He served in many parts of the world and was one of the few early English artists to make watercolours (one such is among those in the Victoria and Albert Museum) of Canada. Some of Sir George Fisher's most pleasing drawings are views over the Thames at Charlton and elsewhere near Greenwich and Woolwich (398). He had a beautiful and poetical sense of light fresh colour, and was one of those artists who tend to construct their pictures, not in one unbroken recession from front to back, but in a series of a few superimposed vertical planes, like stage scenery. Drawing was part of the regular training of the army officer, but few officers attained Fisher's artistic level. He sometimes did watercolours of shipping. Another military draughtsman, and a competent one in the topographical tradition, was Colonel W. Gravatt, who is represented in the British Museum by four drawings, which include views in the West Indies (412). He worked about 1790 and used both clear and opaque colour. He was a friend of Paul Sandby and a Fellow of the Royal Society.

A few other figures, in an age in which watercolour was a widespread non-professional accomplishment among the leisured and other educated classes, call for mention. One, who seems to have escaped the usual books of reference, was Sir James Steuart (or Stewart), fifth baronet of Allan Bank, Berwickshire, who was born at Rome in 1779 and died at Edinburgh in 1849. According to the *Complete Baronetage*, his full Christian names were John James, and he succeeded his father in 1817. The only critical reference I know to him is Mr W. G. Constable's article on an album of his drawings and etchings, belonging to the Avery Memorial Library, Columbia University, published in the *Print-Collector's Quarterly* for April, 1942. His drawings occasionally occur (I have picked up sixteen at various times) but are seldom recognized. They are well worth acquiring, for he was a spirited draughtsman. He specialized in battle scenes—cavalry slashing at each other madly—somewhat in the manner of Borgognone, in mounted figures in medieval costume, and in other equestrian subjects, drawn with freedom, style, and sometimes considerable elegance. They are often in pen and monochrome, but also occasionally in colour. He also did slight watercolour sketches of places—Charing Cross and Glamis Castle for instance—and those which are most loosely touched in are the most effective. In 1947 I saw a Steuart on sale as by Constantin Guys—and really it took one a minute or two's thought to correct the attribution (399 and 400).

Another who calls for mention is Francis Grose (1731?–1791), who must, as a draughtsman, be classed as an amateur, though he had some training at Shipley's drawing school and used his drawings as illustrations for his antiquarian publications. He must stand here as the representative of the eighteenth century amateur draughtsmen of antiquities.* His father was a Swiss jeweller who lived at Richmond in Surrey†, and gave his son a good education. Francis Grose exhibited drawings at the Society of Artists and the Royal Academy between 1767 and 1777, and made many tours sketching old castles, churches,

* Others were Joseph Windham (1739–1810) and Thomas Rackett (1757–1841), the latter a pupil of Paul Sandby and of Theodosius Forrest.

† By a coincidence Augustin Heckel, a German jeweller, retired to Richmond, and drew local views, some of which were engraved.

towns, and so forth. His home, for much of his life, was at Wandsworth, and from 1755 to 1763 he held the post of Richmond Herald. He then became paymaster and adjutant of the Hampshire Militia, and later was captain and adjutant of the Surrey Militia. He was a large fat man with a good-natured, pig-like, face and was reputed 'an inimitable boon-companion.' He drew caricatures and was himself caricatured by Sandby (probably) and others. The first edition of his *Antiquities of England and Wales* appeared in four volumes folio, between 1773 and 1787. In 1789 he toured Scotland, when some too much quoted verses were addressed to him by Burns, and his *Antiquities of Scotland*, two volumes, 4to, were published in 1789–91. In May 1791, in the course of a visit to Ireland, he died of an apoplectic fit while dining at the house of Nathaniel Hone in Dublin, and the *Antiquities of Ireland* appeared posthumously, two volumes, 4to, 1791–1795. Grose relied mostly on his own drawings for his illustrations, but he occasionally used drawings by other amateurs which (in at least one instance that I know of) he appears to have redrawn himself for the engraver. His drawings vary extraordinarily in quality, which is perhaps partly due to the fact that his servant Thomas Cockings was also an artist and seems to have helped him— though whether he was better or worse than his master I do not know. Generally Grose's drawing, which is usually in pen, is extremely poor, and relies on very perfunctory formulae for foliage, the tiling of roofs, fences and so forth. His human and animal figures are often ludicrously bad. Yet he had an eye for a picturesque scene and a pretty sense of clean fresh colour. Mr Duke has a view of Rochester which is far above Grose's usual standard in accomplishment, and I have three Isle of Wight watercolours, one of which is dated August 2, 1772, which show him in a mood of pure landscape (401). One, a view from near Cowes towards Hurst Castle, seems to show the unexpected influence of Taverner in its quiet and simple rendering of a wide stretch of land and water. These three water-colours came from a volume of drawings by Grose which was in Sir Thomas Phillipps's library (Phillipps MS. 24232). The work of another peripatetic antiquary, James Moore, which is in itself very feeble, is of interest for the eminent artists by whom it was redrawn, and it is referred to in the chapter on Dayes, Girtin and Turner. One who was antiquary and amateur artist, as well as naturalist and poet, was George Keate, FRS (1729–1797). He exhibited between 1766 and 1789, thirty times as an honorary exhibitor at the Royal Academy, and six times with the Society of Artists. His exhibits included many views of English and foreign towns. He was fond of the landscape entirely in gouache, and there is an attractive unsigned example in this medium, a pearly and luminous view of the bridge at Avignon, at the Victoria and Albert Museum. It is very noticeably more accomplished than two signed Kentish views which I saw at a dealer's two or three years ago.

Almost every group or section of the English watercolour school had its amateurs. In East Anglia, for instance, there was George Frost of Ipswich (1754–1821), an admirer of Gainsborough and a friend of Constable, to whom (as 'early examples') are sometimes falsely attributed the best of Frost's black chalk drawings of trees, farmhouses, churches and the like. They are also occasionally called Gainsborough by too optimistic owners— but as Frost they have considerable merit, though they are very unequal, and his houses have a curious lack of solidity which usually gives them away. Mr L. G. Duke tells me that Frost himself taught other amateurs and that some 'Frosts' are in fact by his pupils. Frost worked a good deal in watercolour, doing many views of boats, and waterside

buildings, on the Orwell. A couple of able studies of a small boy in a blue coat are perhaps the best watercolours of his that I have seen—but on the whole I do not greatly care for his use of the medium, in which he was fond of an unpleasant purplish red (402 and 403). In quite another milieu there was J. S. Hayward,* who was an early friend of Joshua Cristall and is recorded as having been present on March 23, 1803, at a meeting of the sketching club with which Girtin had been associated. The meeting was presided over by J. S. Cotman, and others present included J. Varley and P. S. Munn. The subject for the evening was taken from Ossian. Hayward was later connected with the Sketching Society described on p. 228, and seems at one time to have acted as secretary of it. His watercolours, especially harbour scenes in the neighbourhood of Plymouth, show him to have been a rather weak draughtsman, but with a pleasant command of rich, cheesy-textured, colour which owes something both to Girtin and Cotman, and perhaps also to the early drawings of Samuel Prout. His monochrome washes have much richness (407).

An end must, however, be put to this enumeration, so let the chapter conclude with two amateurs of special note in the history of British watercolour. The first is Charles Gore, of whom some account is to be found in Mr C. F. Bell's introduction to the Walpole Society's XXIIIrd volume, 1935, a volume which is devoted entirely to the work of J. R. Cozens. Charles Gore was born on December 5, 1729, and was a Lincolnshire landowner who married a Yorkshire heiress. He was fond of the sea and of ships, and for some time made his headquarters at Southampton. In 1773 the health of his wife led to his wintering in Lisbon, and thence he and his family, having been given a passage in a British frigate, went on to Italy, reaching Lerici in 1774. On the way he made drawings at Gibraltar and Minorca. Mr Bell states that the dating of his drawings is confusing, but he visited Rome, Naples and Florence—where his youngest daughter was married to Lord Cowper on June 2, 1775—Corsica, Nice, Marseilles, Leghorn and other places. In 1777 he spent April and May in Sicily in company with the antiquary Richard Payne Knight and the German painter Philipp Hackert. There he made drawings which were afterwards copied and improved by J. R. Cozens, who was then in Italy and must have been known to Gore by then, but who was not, in Mr Bell's opinion, one of the Sicilian party. Payne Knight's diary of the tour was translated into German by Goethe, who knew Gore and has described his friendship with Hackert. Gore was back in England by 1781, when he made a number of watercolours in Sussex and became a member of the Dilettanti Society, but after that he lived again for a while at Florence. From 1791 until his death in 1807 he lived at Weimar as a member of the Ducal Court. There are 27 drawings by him in the British Museum and there are (or were) about 1,000 at Weimar. A few are in private collections. He was a highly skilled marine draughtsman, and about a quarter of his drawings are of the sea and shipping. Others are of ruins and Mr Bell has borne testimony to the value, as records, of those representing Greek remains in Sicily. The Sussex watercolours which he did in 1781 are long panoramas, rather slight and not carried very far, but done with a certain freedom and reminding me more of some of Paul Sandby's unfinished drawings of Windsor than of anything else. They include views of Battle Abbey, Brighton, and Arundel. The most important of those which I have seen of

* Hayward's Christian names were John Samuel (see Victoria and Albert Museum, departments of E.I.D. and of Paintings, *Accessions* 1939, 1950). Mr Brian Reade kindly points out to me that from references in Mr Oppé's article in *The Connoisseur*, December 1923, and in S. D. Kitson's *Life of J. S. Cotman*, 1937, it is clear that Hayward was born about 1779 and died in 1821.

this group represents Arundel Castle and town ($7\frac{7}{8} \times 24$ inches), with the waters of the river occupying the whole foreground, and a windmill to the left. It is delicately done, chiefly in yellowish green, with greys and pinks for the buildings and roofs (404 and 405).*

Somewhat akin to Gore, though less skilful in the representation of ships, was Thomas Mitchell, Assistant Surveyor of the Navy, of whose work the British Museum has a good many examples in Indian ink. They are mostly views of Plymouth and other ports. An unfinished view of Westminster Bridge in 1789 ($11\frac{1}{8} \times 19$ inches), taken from the Lambeth shore, with men unloading a barge in the foreground, has a genuine suggestion of Samuel Scott about it (406). Mitchell exhibited as an amateur between 1763 and 1789, first at the Free Society of Artists and later at the Royal Academy.

Lastly we come to one who, though not primarily as an artist, was a person of very considerable importance in the history of English watercolour, Dr Thomas Monro (1759–1833),† who was the third (and not the last) of a line of doctors of Scottish origin who specialized in the study of madness and each of whom was physician to Bethlem Hospital. A strong artistic bent also came out in several generations of the Monro family, and what gives Thomas Monro his special importance was the encouragement and, if not actual teaching, at least the opportunity of self-improvement in the art which he afforded to many of the most able of the young watercolourists of the last few years of the eighteenth century and the early part of the nineteenth, above all Girtin and Turner. In the spring of 1794 (see C. F. Bell, Walpole Society, Volume XXVII, p. 100) Dr Monro moved from Bedford Square to 8 Adelphi Terrace, which was the scene of his celebrated 'academy' where during the winter months Girtin, Turner, John Varley and others used, for a small fee and supper, to copy, and compose variations upon, drawings by Gainsborough, Hearne (Monro's favourite artist), and especially J. R. Cozens (who during his final years of insanity was under Monro's care). Other drawings which were used as copies at these sessions were outlines by John Henderson the elder (1764–1843), another skilled amateur and patron, who also lived in Adelphi Terrace. He was the father of Charles Cooper Henderson, the amateur sporting artist. There are a number of John Henderson's water-colours and other drawings in the British Museum, and others are occasionally to be found in dealers' portfolios. They are often in grey or blue monochrome (like the Turner-Girtin products of the Monro school) but are more woolly in texture than the best things of their kind (408). In particular Henderson seems to have had some share in the series of blue-grey drawings of shipping subjects at Dover, some of which are in the Turner bequest at the British Museum. The whole problem of the Monro school drawings is, however, one of very great difficulty, as will be gathered by reading what has been written by the late A. J. Finberg (*Life of Turner*, 1939, pp. 36–40) and by Mr C. F. Bell (Walpole Society, Volumes V, XXIII, XXVII). Every book on watercolour contains some account of the Monro Academy, but some at least of the statements made must be mistaken. Certainly the remark quoted by Randall Davies (*Chats on Old English Drawings*, 1923, p. 127) as made by Turner to David Roberts, 'Girtin and I have often walked to Bushey and back to make drawings for good Dr Monro at half-a-crown apiece and a supper', must be apocryphal; for Monro's first country house was at Fetcham, and he did not move to Bushey until about

* See also Oliver Warner, 'Charles Gore, friend of Goethe', *Apollo*, November 1949.
† See W. Foxley Norris, DD, Dean of York, a descendant of Monro's, in *Old Water-Colour Society's Club*, Volume II, 1925.

1805 (see *Dictionary of National Biography*), when Girtin was dead and Turner already an RA.

As an artist Monro was the pupil of John Laporte (see p. 61), but, at any rate in his most characteristic work, he shows little of Laporte's influence, but rather that of Gainsborough, whom as a young man he knew (409). The most familiar of his drawings are bold studies of trees, rocks, mountains —and more rarely buildings—done in Indian ink wash, sometimes combined with chalk or charcoal. W. Foxley Norris, Monro's great-grandson, stated, on the evidence of one who had watched Monro at work, that 'in some of the sketches the outline was added with a stick of dry Indian ink while the paper was still wet'. Occasionally (according to Foxley Norris) figures cut out of white paper, were gummed on the drawings and then treated with wash or crayon. Monro's studies are often extremely bold and effective, and according to Randall Davies they were thought to be by Hoppner (who did rather similar landscape sketches and was in fact a friend of Monro's) until in 1922 a volume of them with Monro's name was sold at Hodgson's among books from Cassiobury Park. Since then a great deal of Monro material has come on the market at various times, including many of these studies in black, and also certain more Hearne-like drawings of cottages, etc., which may be Monro's, as also may an occasional coloured drawing. But there is as a rule so much work by younger members of this family mixed up with these lots that attribution is difficult. It is to be noted, however, that certain drawings which are almost indistinguishable from Monro's bear the signature of another celebrated amateur, Lady Farnborough (1762–1837), and are certainly by her. She was the daughter of Sir Abraham Hume, and in 1793 married Charles Long, who was knighted in 1820 and created Baron Farnborough in 1826. According to Roget she was Girtin's favourite pupil. Lady Farnborough was a highly talented, if unoriginal, artist, who worked also in pencil (somewhat in the style of Edridge), chalk, and watercolour. The Longs lived at Bromley Hill Place in Kent, and that neighbourhood is the subject of many of Lady Farnborough's drawings (410 and 411).

There is an incidental thought which occurs to me, upon reading through this chapter, and that is how small a part women have played in the development of watercolour in England. Among the amateurs, at least, one might have expected to find many skilful women practitioners, since so very many young ladies have had lessons in the medium. Yet, in fact, hardly any of the better amateurs were women—Lady Diana Beauclerk, Mrs Amos Green, and Lady Farnborough, who was much the most accomplished of the three, being almost the only ones mentioned in this book. No doubt there were some others, such as Lady Mordaunt (c.1778–1842). She was Mary Ann, elder daughter of William Holbeach, and in 1807 married Sir Charles Mordaunt, Bart. Mr Oppé, in his catalogue of the earlier English drawings at Windsor, published this year (1951), gives brief particulars of her career and reproduces an example of her skill. A collection of her drawings was sold in 1950, and it included some attractive views of old buildings in pen or pencil and sepia wash. Yet even allowing for Lady Mordaunt, who until lately was scarcely known, and a few others, and remembering also such able professionals as Mary Moser and one or two more, the total contribution of women to watercolour art up to the first half of the nineteenth century seems curiously unimpressive.

ADDENDA

p. 7. See A. M. Hind, *Wenceslaus Hollar and his views of London and Westminster in the Seventeenth Century*, 1922; and J. Urzidil, *Hollar, a Czech Emigré in England*, 1942. Also, I. A. Williams, 'Hollar: a Discovery', *Connoisseur*, November 1933.

p. 22. The date of George Lambert's birth is usually given as 1710. But Vertue's statement in September 1722 that Lambert was then 'aged 22' makes it clear that he was born about 1700. See *Walpole Society*, Volume XXII (Vertue III), 1933-4, p. 6. I have to thank Mr L. G. Duke for pointing this out to me.

p. 32. Dr G. R. de Beer kindly points out to me that in the summer of 1773 Banks was in Wales with Solander, Lightfoot and Charles Blagden (see Edward Smith, *The Life of Sir Joseph Banks*, 1911, p. 37). P. Sandby is not mentioned, but this may be the tour referred to by his son.

p. 33. P. Sandby's *Gate of Coverham Abbey* (fig. 56) was certainly the original (perhaps through a print) of the design on one of the trial plates, 1773, for the dinner and dessert service commissioned from Josiah Wedgwood by the Empress Catherine of Russia in 1774. See number 252 in Messrs Wedgwood's catalogue of 'Early Wedgwood Pottery exhibited at 34 Wigmore Street', 1951.

p. 56. G. Robertson's patron was William Beckford of Somerley Hall, historian of Jamaica. Elsewhere (as lower on this page) the Beckford references are to William Beckford, author of *Vathek*.

p. 67. See also Brinsley Ford, *The Drawings of Richard Wilson*. Faber, 1951, 27s. 6d.

p. 72. The very large collection of drawings of Alexander Runciman, belonging to the National Gallery of Scotland, Edinburgh, includes, beside many figure drawings, some views of Edinburgh and the neighbourhood in pen and slight watercolour or monochrome. There are also drawings of Rome. I have to thank Mr Ellis Waterhouse for showing them to me.

p. 121. See also Nicholas Powell, *The Drawings of Henry Fuseli*. Faber, 1951, 25s.

p. 123. Mr Nicholas Powell kindly draws my attention to an article 'John Brown, the Draughtsman', by J. M. Grey, in the *Magazine of Art*, July 1889.

p. 134. In 1951 I was shown a large watercolour, a scene from *The Tempest*, completely in the manner of Richard Westall. It was signed 'G. F. Joseph 1795'. George Frederick Joseph (1764-1846) was afterwards a portrait-painter and became ARA in 1813.

pp. 147-8. George Shepheard is not to be confused with George Shepherd, a topographical watercolourist who exhibited from 1800 to 1830.

p. 149. For David Allan see 'An Eighteenth Century Illustrator', *Times Literary Supplement*, May 4, 1951. Also, T. Crouther Gordon, *David Allan of Alloa*. Published by the author, Clackmannan, 1951, 30s. Dr Gordon makes it clear that Allan was in Rome from 1764 to 1777, but came home several times during that period.

p. 154. Since the proofs of this book were passed for press, the Colman Galleries at the Castle Museum, Norwich, have been opened to the public.

p. 233. The details of William Gilpin's sketching tours given on this page, though agreeing with those in the *Dictionary of National Biography*, are apparently wrong in several particulars. The right dates of the tours seem to have been: East Anglia, 1769; the Wye and South Wales, 1770; Cumberland and Westmorland, 1772; North Wales, 1773; South-East Coast 1774; the Highlands, 1776. According to Templeman the tour in Western England took place before 1778.

pp. 234-5. Mr H. C. Green has an example of Gilpin's work in colour. It is also clear, from an inscription in a volume in Mr Green's collection, that Gilpin's stamped initials on a drawing do not mean that it was necessarily in one of the sales of his work.

Chapter XII. William Day, an honorary exhibitor at the Royal Academy from 1782 to 1801, might be added to this chapter. There are examples of his watercolours in the Victoria and Albert Museum, and in the collections of the Rev Francis Smythe and Mr Hesketh Hubbard. The latter in 1951 came across a large and varied group of Day's drawings, signed and unsigned, in various media, of which I also was able to acquire a few. At his best Day was highly accomplished. He worked in Wales, Derbyshire, and at Lymington, amongst other places. Some drawings are dated as late as 1805. They are, however, so diverse in style as to make one wonder whether they are all by one hand.

THE PLATES

PLATE I

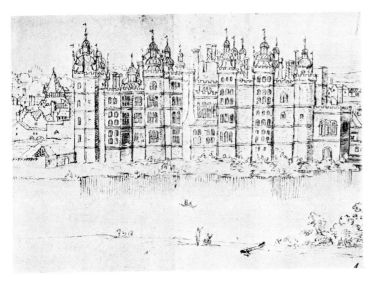

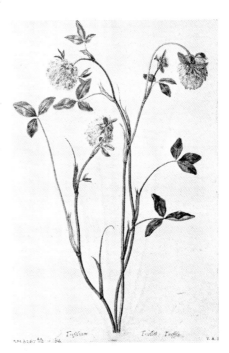

1. ANTHONIS VAN DEN WYNGAERDE. *Richmond Palace*. Detail from drawing of 8×35½ inches. Pen with some watercolour.
Bodleian Library, Oxford

2. JACQUES LE MOYNE DE MORGUES. *Purple Clover*. 10⅞×7½ inches.
Victoria and Albert Museum

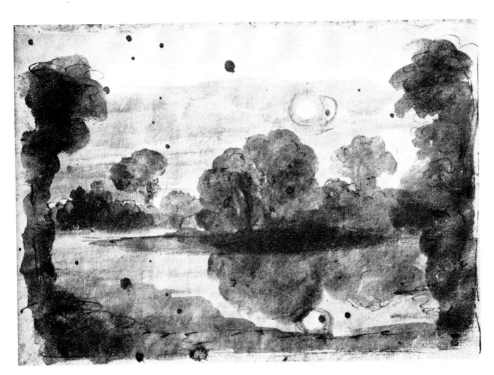

3. INIGO JONES. *Night*. Design for *Luminalia* (? by Davenant). 6⅜×8¾ inches. Pen and black ink washed with dark grey. Ex Coll. Lord Burlington.
Trustees of the Chatsworth Settlement

PLATE II

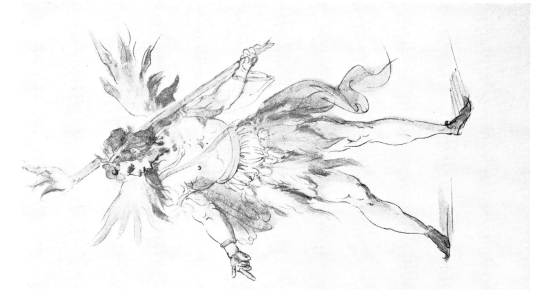

5. INIGO JONES. *A Page like a Fiery Spirit.* $11\frac{3}{8} \times 6\frac{1}{4}$ inches. Costume design for T. Campion's *The Lords Maske*, 1613. Ex Coll. Lord Burlington. Trustees of the Chatsworth Settlement

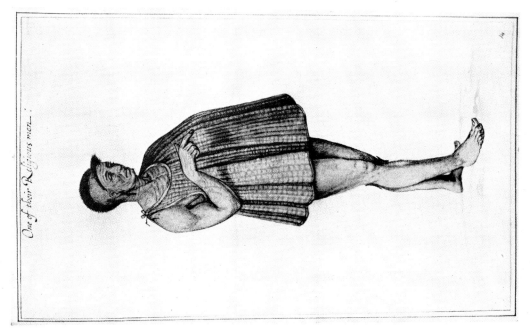

One of their Religious men.

4. JOHN WHITE. *One of their Religious Men.* $10\frac{3}{8} \times 6$ inches. British Museum

PLATE III

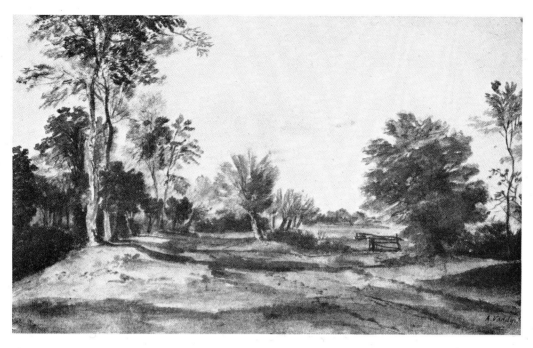

6. SIR ANTHONY VAN DYCK. *A Path among Meadows.* $9\frac{5}{8} \times 15\frac{5}{8}$ inches. Water-colour and body colour on grey paper. Signed. Ex Coll. Bouverie, Wellesley and Malcolm. British Museum

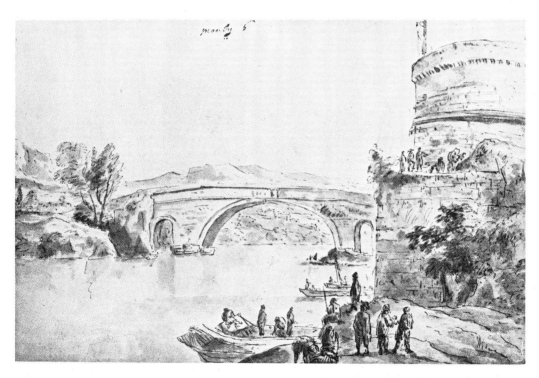

7. THOMAS MANBY. *Ponte Lucano, near Tivoli.* $9\frac{1}{4} \times 14\frac{1}{2}$ inches. Inscribed 'Manby 6'. Pen and grey wash. Ex Coll. P. A. Fraser

PLATE IV

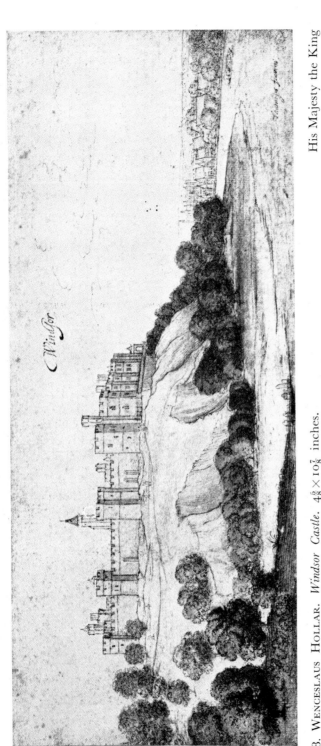

8. WENCESLAUS HOLLAR. *Windsor Castle.* $4\frac{5}{8} \times 10\frac{7}{8}$ inches.

His Majesty the King

9. WENCESLAUS HOLLAR. *West Part of Southwark toward Westminster.* $5\frac{1}{8} \times 12\frac{1}{8}$ inches. Pen over pencil. Drawing for part of Hollar's 'Long Birds-eye View', engraved 1647. Shows Globe and Bear Garden Theatres. Ex Coll. P. A. Fraser.

PLATE V

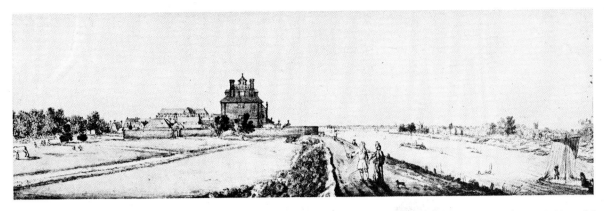

10. FRANCIS PLACE. '*Peterborough House Lambeth and the Strand as they apeard from Mill Bank A° 1683.*' $6\frac{3}{8} \times 18\frac{1}{4}$ inches. Inscribed and dated by the artist. Ex Coll. P. A. Fraser.　　　Victoria and Albert Museum

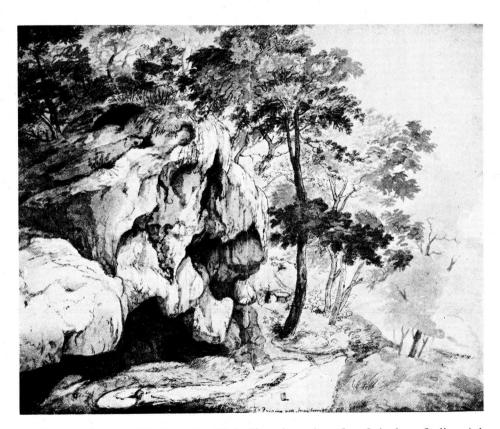

11. FRANCIS PLACE. *The Dropping Well, Knaresborough.* $12\frac{7}{8} \times 16$ inches. Indian ink wash and pen. Inscribed by the artist and initialled.　　　British Museum

PLATE VI

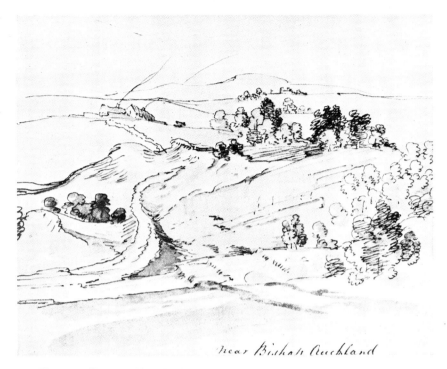

12. FRANCIS PLACE. *Near Bishop Auckland.* $5\frac{3}{4} \times 7\frac{1}{2}$ inches. Pen and brown wash. Inscribed on the back by the artist. The inscription on the front has been added later. Ex Coll. P. A. Fraser

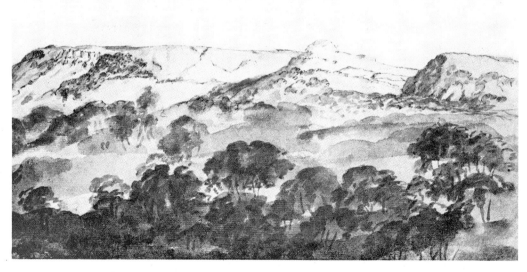

13. FRANCIS PLACE. *Hills with Limestone Cliff.* $6\frac{1}{8} \times 9\frac{1}{4}$ inches. Pen and brown wash.
York City Art Gallery

PLATE VII

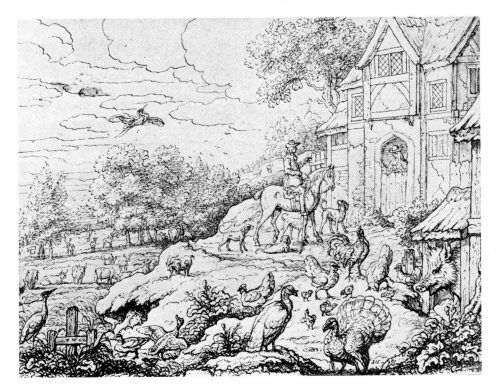

14. FRANCIS BARLOW. *Farmyard, with Figures and Landscape Background.* 7⅜×9⅝ inches.
Pen and Indian ink. Victoria and Albert Museum

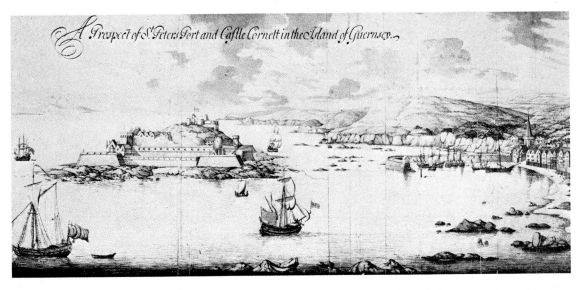

15. THOMAS PHILLIPS. *A Prospect of St Peter's Port and Castle Cornett in the Island of Guernsey.* 19⅞×41⅛ inches.
From a survey dated 1680. National Maritime Museum

PLATE VIII

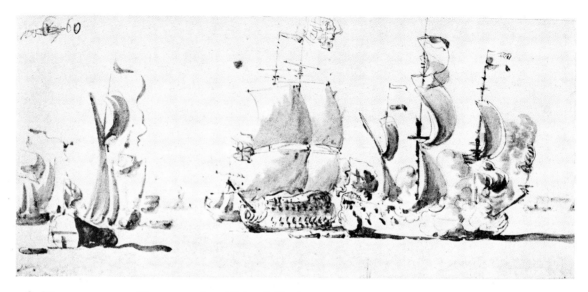

16. WILLIAM VAN DE VELDE, senior. *Visit of Charles II to the Tiger, August 1681.* $5\frac{3}{4} \times 13$ inches. Pencil and grey wash. Number 60 of a series of at least 86 drawings done on this occasion.

National Maritime Museum

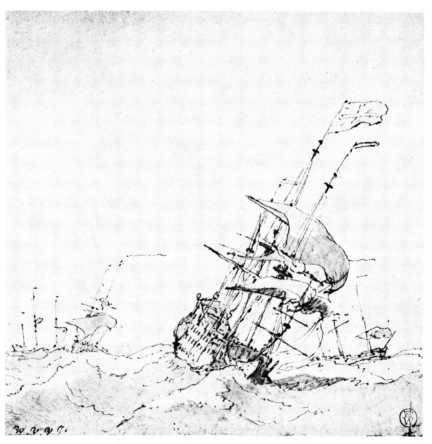

17. WILLIAM VAN DE VELDE, junior. *An English Flagship scudding in a Heavy Sea.* $5\frac{7}{8} \times 6\frac{1}{8}$ inches. Pen and brown ink with grey wash. Signed with initials. Ex Coll. Lord Warwick. National Maritime Museum

PLATE IX

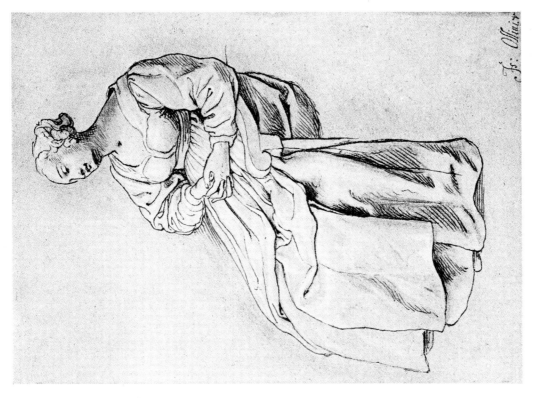

19. Isaac Oliver. *A Woman with Braided Hair.* $7\frac{5}{8} \times 5\frac{1}{4}$ inches.
Signed. Pen, grey wash and white chalk.
Mr A. P. Oppé

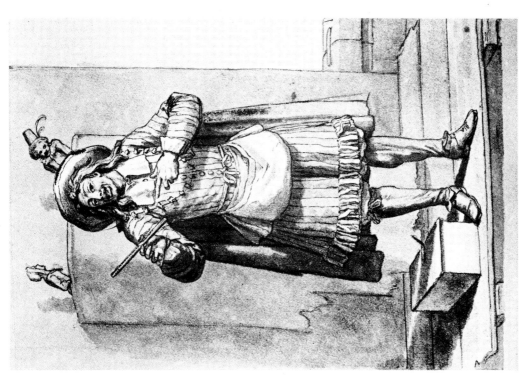

18. Marcellus Laroon, senior. *The Marionette Showman.*
$10\frac{3}{4} \times 7\frac{1}{4}$ inches.
British Museum

PLATE X

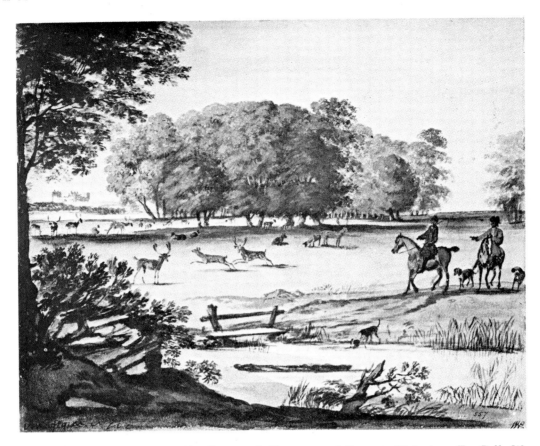

20. PETER TILLEMANS. *View of a Park, with Huntsmen and Deer.* 7×8¾ inches. Ex Coll. W. Esdaile.
Victoria and Albert Museum

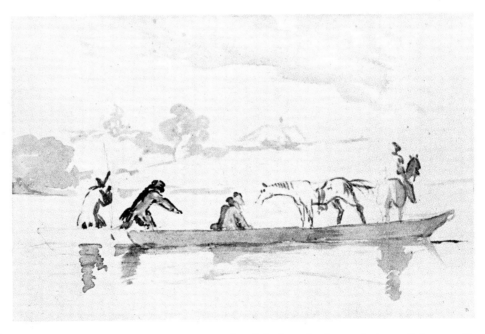

21. PETER TILLEMANS. *A Horse Ferry.* 5⅞×9⅜ inches. Sepia wash over slight pencil. Inscribed with artist's name on mount. Ex Coll. J. Richardson, junior.

PLATE XI

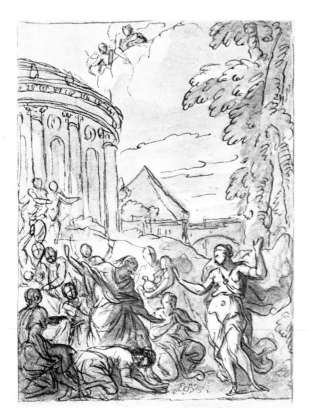

22. Sir James Thornhill. *Classical Design with Temple.* 7¼×5⅝ inches. Pen, pencil and grey wash.

23. John Devoto. *Portrait of Matthew Buckinger.* 10⅛×6½ inches. Signed.

Mr E. Croft-Murray

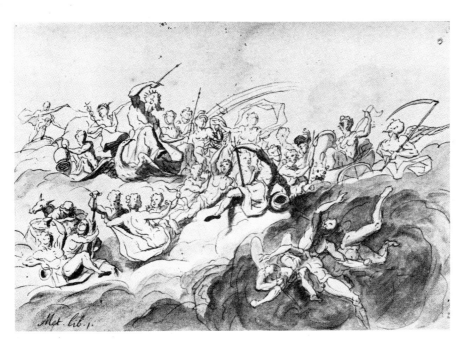

24. Thomas Carwitham. *Illustration to Ovid's Metamorphoses.* 7×10⅝ inches. Pen and sepia wash. Inscribed on back with artist's name.

PLATE XII

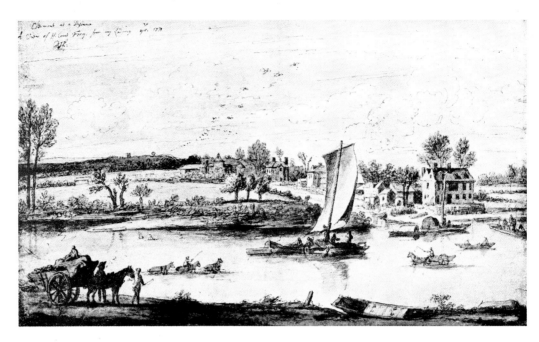

25. SIR JAMES THORNHILL. *View of Hampton Court Ferry*. 11 × 18½ inches. Inscribed and initialled by the artist and dated 1731. Pen and sepia wash. Ex Coll. W. Esdaile.

Whitworth Art Gallery, Manchester

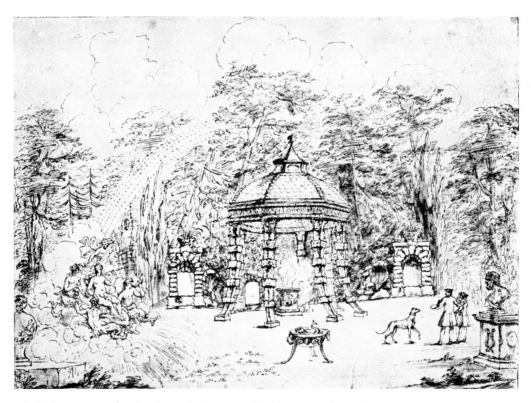

26. WILLIAM KENT. *View in Pope's Garden at Twickenham*. 11⅜ × 15⅝ inches. Pen and sepia wash. Formerly attributed to A. Pope.

British Museum

PLATE XIII

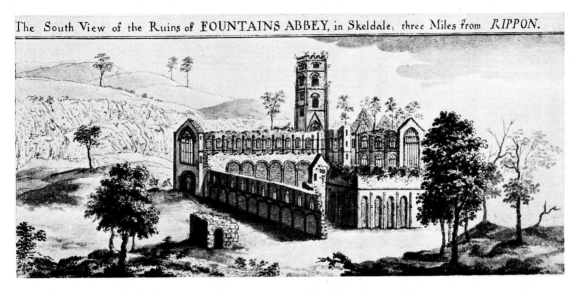

The South View of the Ruins of FOUNTAINS ABBEY, in Skeldale, three Miles from *RIPPON*.

27. SAMUEL BUCK. *The South View of the Ruins of Fountains Abbey.* $6\frac{1}{8} \times 13\frac{3}{4}$ inches. Pen and Indian ink. With spurious signature. Engraved 1726.

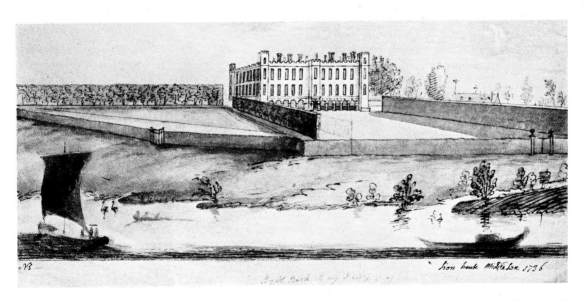

28. NATHANIEL BUCK. *Sion House, Middlesex.* $5\frac{3}{4} \times 13\frac{7}{8}$ inches. Pen with grey and brown wash. Signed with initials and dated 1736. Engraved 1737.　　　　　　　　　　　　Duke of Northumberland

PLATE XIV

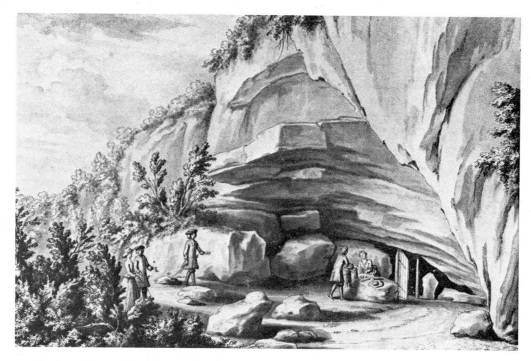

29. BERNARD LENS. *The Entrance into Ochie Hole.* 8⅛ × 12½ inches. Pen and Indian ink.

Mr. L. G. Duke

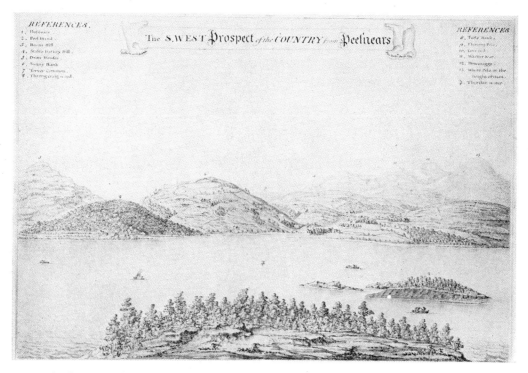

30. STEPHEN PENN. *View over Coniston.* 13⅛ × 19¼ inches. Signed and dated 1732.

PLATE XV

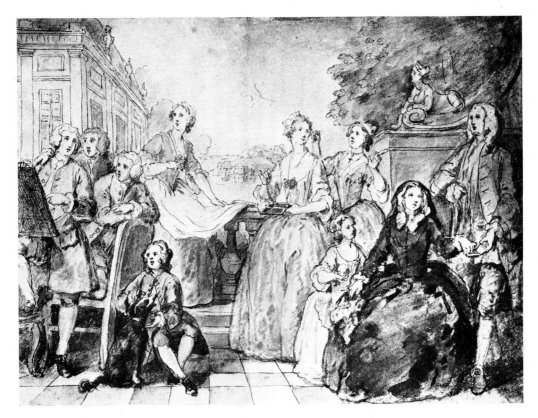

31. WILLIAM HOGARTH. *Study for a Portrait Group.* 12¾ × 17¼ inches. Pen and ink over red chalk, washed with Indian ink and watercolour. Ex Coll. W. Russell and Cheney.

British Museum

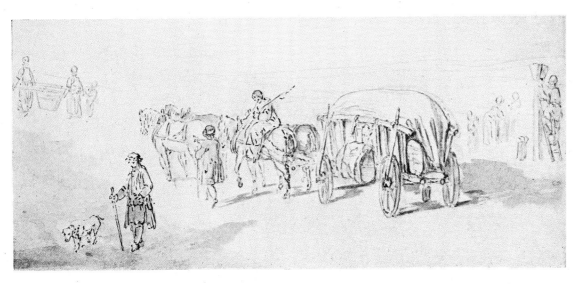

32. MARCELLUS LAROON, junior. *A Waggon and Figures on a Road.* 5⅜ × 12⅜ inches. Pen, pencil and grey wash.

Sir Bruce Ingram

PLATE XVI

33. SAMUEL SCOTT. *Twickenham Church.* $10\frac{1}{8} \times 19\frac{3}{8}$ inches.

Sir Bruce Ingram

PLATE XVII

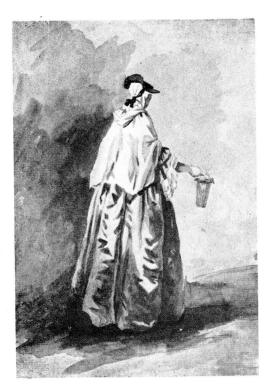

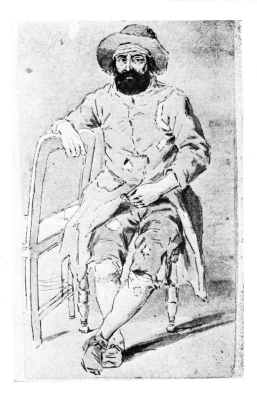

34. SAMUEL SCOTT. *A Lady in a Billowing Skirt.*
$9\frac{1}{2} \times 6$ inches. Ex Coll. Horace Walpole.
Mr A. P. Oppé

35. LOUIS PIERRE BOITARD. *A Ragged Man.*
$7\frac{3}{4} \times 5\frac{3}{4}$ inches. From an album of drawings
by Boitard. Ex Coll. L. G. Duke

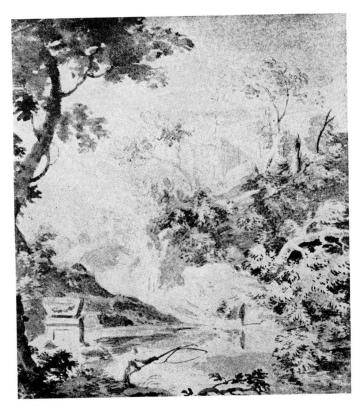

36. WILLIAM TAVERNER. *Classical Landscape with Fisherman.*
$12\frac{7}{8} \times 11\frac{1}{4}$ inches. Indian ink. Ex Coll. N. Smith and R. Davies

PLATE XVIII

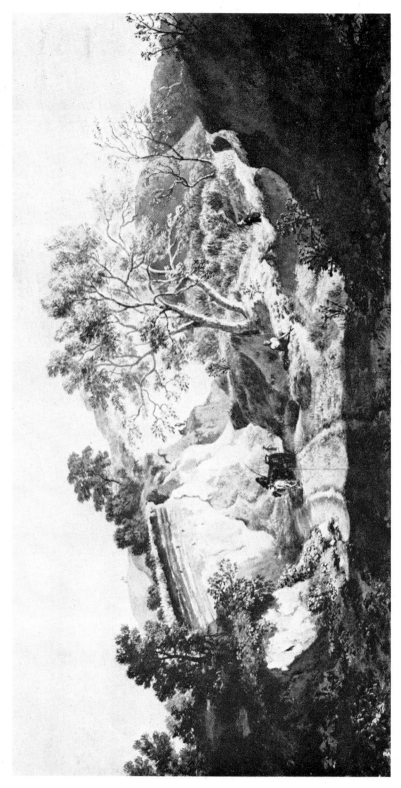

37. William Taverner. *Sand Pits, Woolwich*. 14¼×27⅝ inches. Body colour. Ex Coll. P. Sandby and Percy.　　British Museum

PLATE XIX

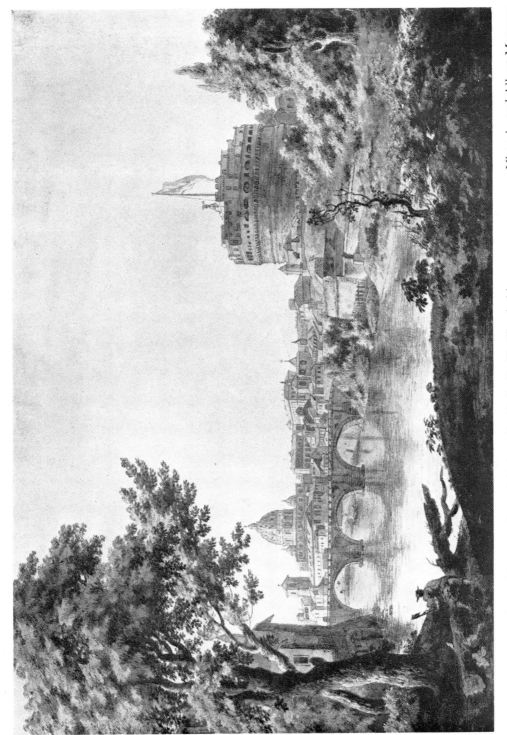

38. John Skelton. *View of Rome.* $14\frac{9}{16} \times 20\frac{7}{8}$ inches. Ex Coll. Sir H. Theobald.

Victoria and Albert Museum

PLATE XX

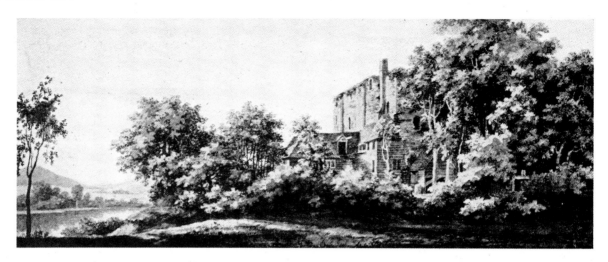

39. John Skelton. *The Castle, Canterbury.* $8\frac{1}{4} \times 21\frac{1}{4}$ inches. British Museum

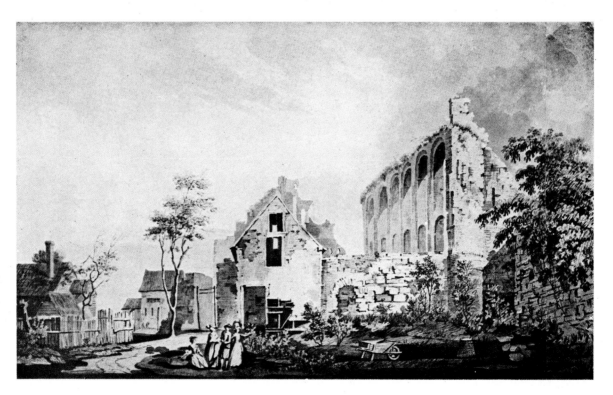

40. Theodosius Forrest. *St Botolph's Priory, Colchester.* $13\frac{1}{2} \times 21\frac{7}{8}$ inches. British Museum

PLATE XXI

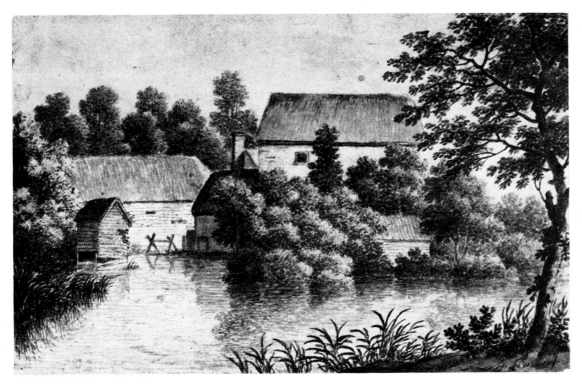

41. GEORGE LAMBERT. *A Mill-Pool.* $7\frac{7}{8} \times 12\frac{1}{2}$ inches. Signed or inscribed. Mr L. G. Duke

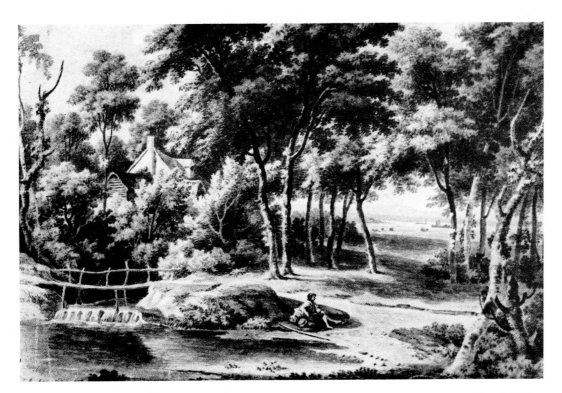

42. GEORGE LAMBERT. *A Woody Landscape.* $9\frac{5}{16} \times 14\frac{1}{8}$ inches. Signed. Mr L. G. Duke

PLATE XXII

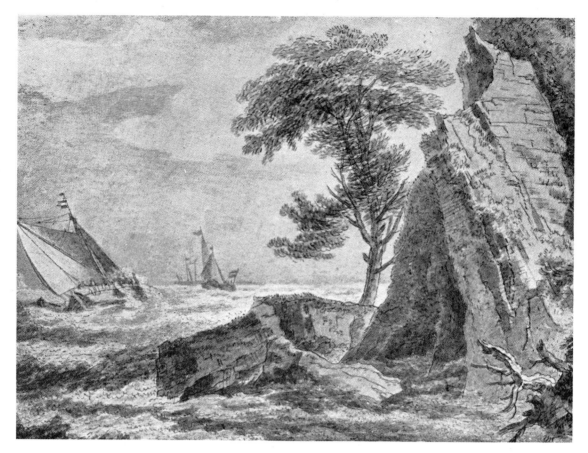

43. François Vivarès. *Ships by a Rocky Shore.* $8\frac{1}{4} \times 11\frac{1}{4}$ inches. Ex Coll. T. Churchyard? and Barlow family.

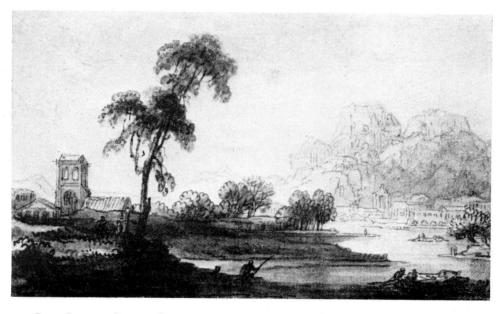

44. John Baptist Claude Chatelain. *Classical Landscape.* $3\frac{1}{4} \times 5\frac{5}{8}$ inches. Mr A. P. Oppé

PLATE XXIII

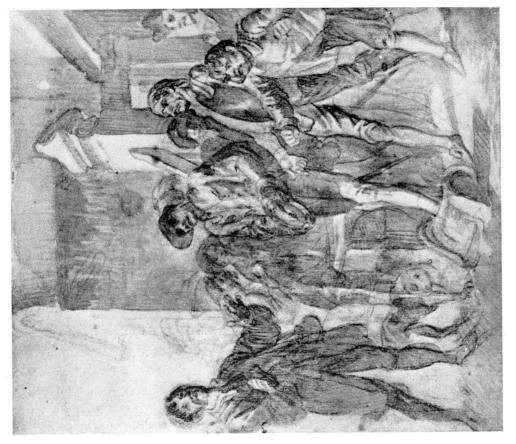

46. FRANCIS HAYMAN, R.A. *Illustration to Don Quixote.* $8\frac{1}{4} \times 6\frac{7}{8}$ inches. Pencil and brown wash. Study for a finished drawing which is in the British Museum

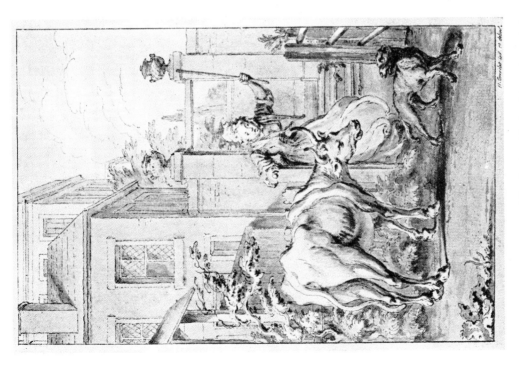

45. HUBERT GRAVELOT. *The Cookmaid, the Turnspit, and the Ox* (Gay's 'Fables'). $6\frac{7}{8} \times 4\frac{3}{8}$ inches. Indian ink and pen. British Museum
Signed. Engraved 1738.

PLATE XXIV

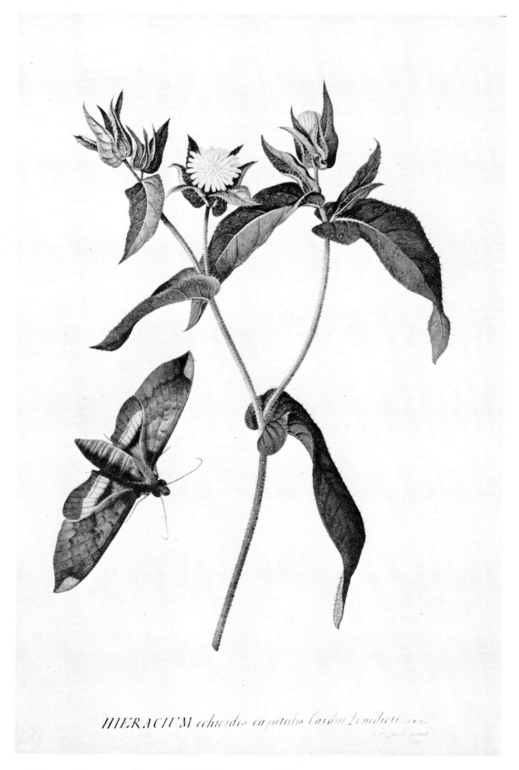

HIERACIUM echioides capitulis Cardui Benedicti ...

47. GEORG DIONYSIUS EHRET. *Bristly Ox-tongue and Hawk Moth.* 19¼ × 13¾ inches. Body colour and watercolour. Signed and dated 1756.

PLATE XXV

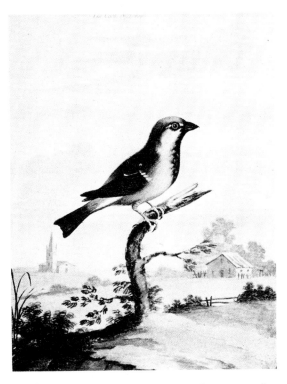

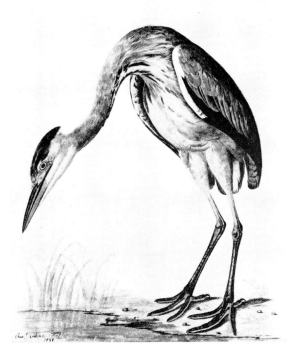

48. GEORGE EDWARDS. *The Cock Sparrow.* $11\frac{1}{8} \times$ 8¾ inches. Body colour.

49. CHARLES COLLINS. *A Heron over a Pool.* $18 \times 14\frac{1}{4}$ inches. Body colour and watercolour. Signed and dated 1737.

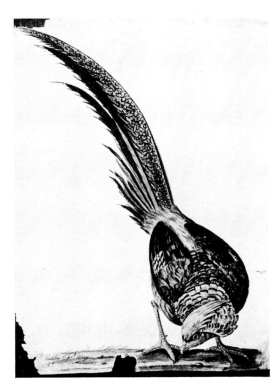

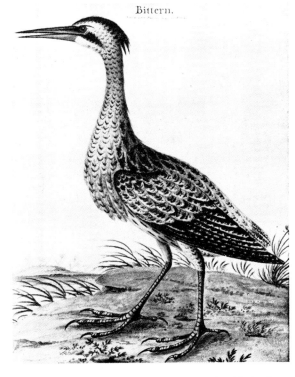

50. PETER PAILLOU. *A Golden Pheasant.* $20 \times$ $14\frac{5}{8}$ inches. Body colour. Signed and dated 1745. Mr A. P. Oppé

51. ISAAC SPACKMAN. *A Bittern.* $10\frac{7}{8} \times 8\frac{3}{4}$ inches. Signed. Ex Coll. E. Hudson.

PLATE XXVI

52. THOMAS SANDBY, R.A. *Old Somerset House, the Garden or River Front.* 20⅞ × 29½ inches. Inscribed 'T. Sandby fecit' on the back. His Majesty the King, Windsor Castle

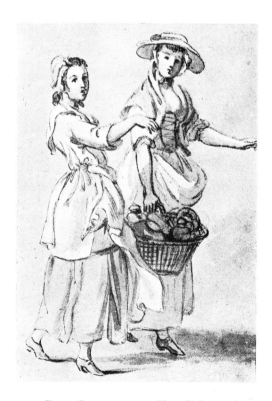

53. PAUL SANDBY, R.A. *Two Girls carrying a Basket.* 6⅜ × 4⅝ inches. Pencil and pen, and reddish-brown wash.

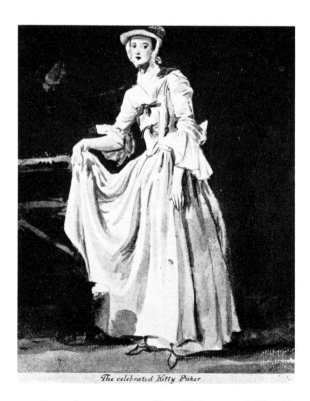

54. PAUL SANDBY, R.A. *Kitty Fisher as a Milkmaid.* 6⅜ × 5⅜ inches.
His Majesty the King, Windsor Castle

PLATE XXVII

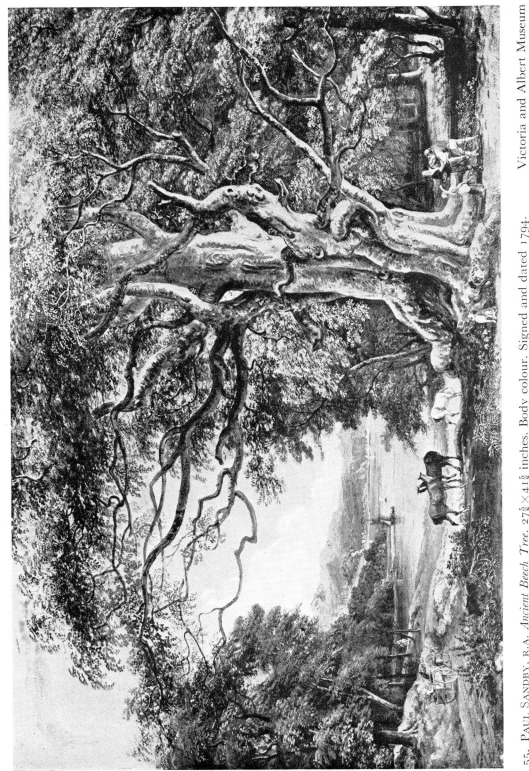

55. PAUL SANDBY, R.A. *Ancient Beech Tree.* $27\frac{5}{8} \times 41\frac{5}{8}$ inches. Body colour. Signed and dated 1794.

Victoria and Albert Museum

PLATE XXVIII

56. Paul Sandby, r.a. *Gate of Coverham Abbey, in Coverdale, near Middleham, Yorkshire.*
$10\frac{3}{8} \times 15\frac{1}{4}$ inches. Watercolour and body colour. British Museum

57. Paul Sandby, r.a. *Castle and Stream.* $9\frac{1}{2} \times 11\frac{3}{4}$ inches. Inscribed on original
mount as P. Sandby's by T. Sandby. British Museum

PLATE XXIX

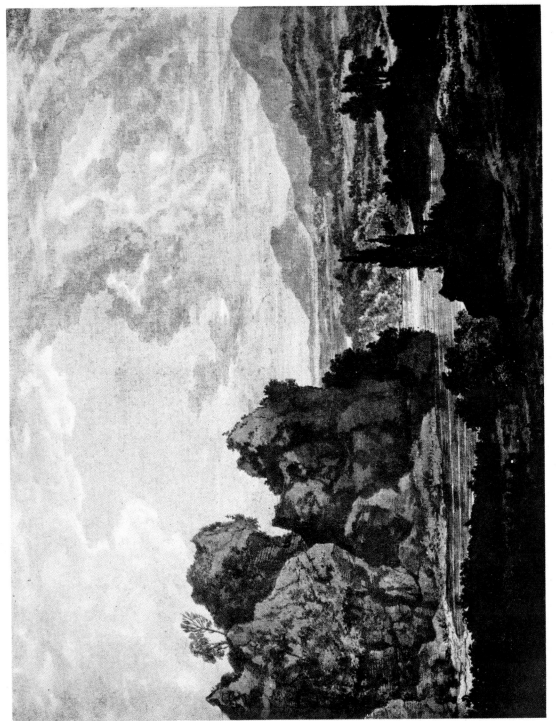

58. ALEXANDER COZENS. *A Classical Landscape.* $17\frac{1}{2} \times 22$ inches. Grey wash on varnished paper.

Mr A. P. Oppé

PLATE XXX

59. ALEXANDER COZENS. *The Cloud.* $8\frac{1}{2} \times 12$ inches. Grey and black washes on thin India paper.
Ex Coll. Praed. Mr A. P. Oppé

60. ALEXANDER COZENS. *Dead Trees in a Landscape.*
$6\frac{1}{8} \times 7\frac{3}{4}$ inches. Brown wash on toned paper. Ex
Coll. Sir H. Theobald. Mr A. P. Oppé

61. ALEXANDER COZENS. *Mountainous Landscape with River.*
3×5 inches. Pen and brown ink with black and grey wash.
Numbered 23 by the artist.

PLATE XXXI

62. SAMUEL WALE, R.A. *Hampton Court.* $3\frac{1}{4} \times 5\frac{5}{8}$ inches. Pen and blackish-grey wash. Engraved in R. Dodsley, 'London and its Environs Described', 1761.

63. ANTHONY DEVIS. *Near St Martha's.* $5\frac{3}{8} \times 8$ inches. Inscribed by the artist and signed with monogram.

64. ANTHONY DEVIS. *Landscape with Church and Cattle.* $11\frac{3}{4} \times 16\frac{7}{8}$ inches. Watercolour with crayon. Signed and dated 1772. Victoria and Albert Museum

PLATE XXXII

65. JOHN JOSHUA KIRBY. *A View of St Alban's Abbey.* 13¼×22 inches. Signed with monogram and dated 1767. British Museum

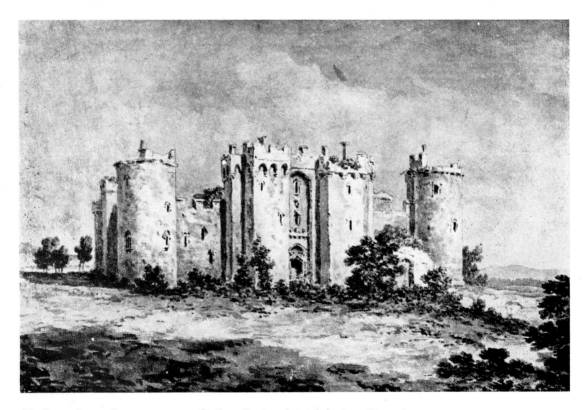

66. JOHN INIGO RICHARDS, R.A. *Bodiam Castle.* 9⅝ × 14⅜ inches. Signed.

PLATE XXXIII

67. John Inigo Richards, r.a. *Sewardstone, Essex.* $5\frac{5}{8} \times 8\frac{1}{4}$ inches. Mr A. P. Oppé

68. George Barret, senior, r.a. *Landscape with River and Figures.* $14\frac{3}{4} \times 21\frac{1}{4}$ inches. Signed (or inscribed?) and dated 1782. Ex Coll. W. Smith. Victoria and Albert Museum

PLATE XXXIV

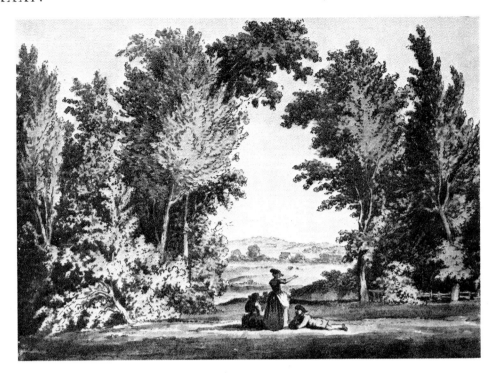

69. SAMUEL HIERONYMUS GRIMM. *Between Chiswick and Brentford.* $5\frac{7}{8} \times 8$ inches. Signed and dated 1774. Mr L. G. Duke

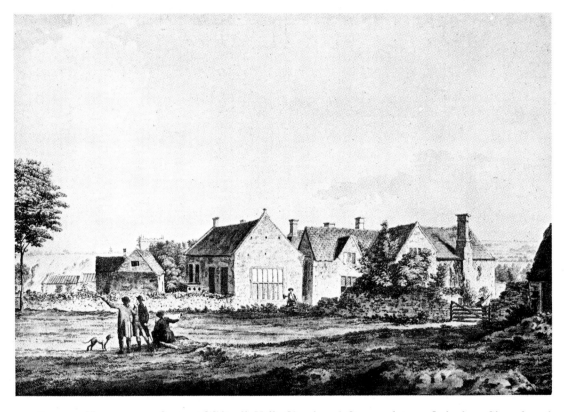

70. SAMUEL HIERONYMUS GRIMM. *Whitwell Hall, Church and Crag.* $14\frac{1}{4} \times 20\frac{7}{16}$ inches. Signed and dated 1785. Victoria and Albert Museum

PLATE XXXV

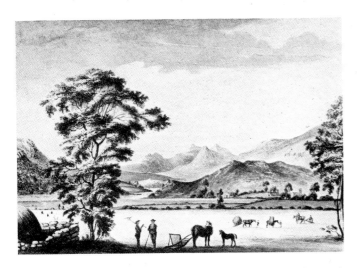

71. MOSES GRIFFITH. *Snowdon from Capel Curig.* 11⅞ × 17⅛
inches. Engraved in Vol. II, Pennant's 'A Tour in Wales'.
1784. Ex Coll. T. Pennant. Walker's Galleries

72. JOHN WEBBER, R.A. *Near Dolgelly.* 13¼ × 18¼ inches.
Signed and dated 1790. Victoria and Albert Museum

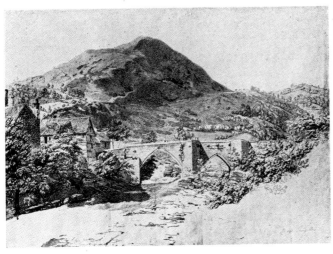

73. JOHN ALEXANDER GRESSE. *Llangollen Bridge.* 14⅞ × 21
inches. Unfinished. Victoria and Albert Museum

PLATE XXXVI

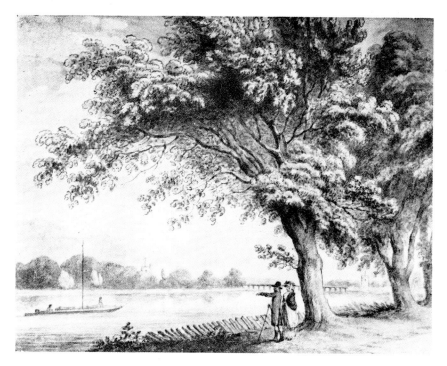

74. EDWARD EDWARDS, A.R.A. *Barn Elms*, 1793. $9\frac{1}{2} \times 11\frac{3}{4}$ inches. Signed with initials.

Mr L. G. Duke

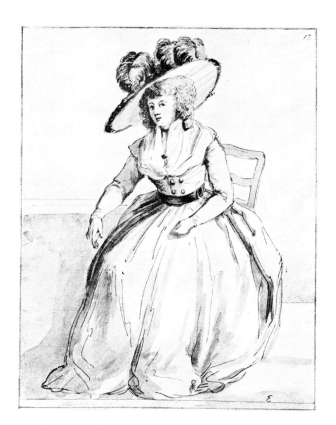

75. EDWARD EDWARDS, A.R.A. *A Lady Seated*. $8\frac{7}{8} \times 7\frac{3}{8}$ inches. Signed with single initial. From the artist's sale, 1808.

Mr Ralph Edwards

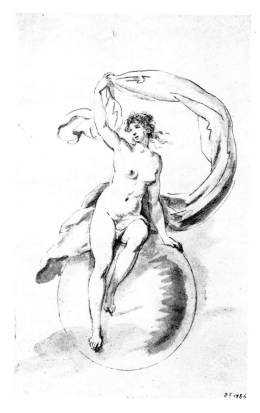

76. EDWARD EDWARDS, A.R.A. *Nude Figure seated on a Globe*. $9\frac{1}{4} \times 6$ inches. Pen and Indian ink wash. Signed with initials and dated 1786.

PLATE XXXVII

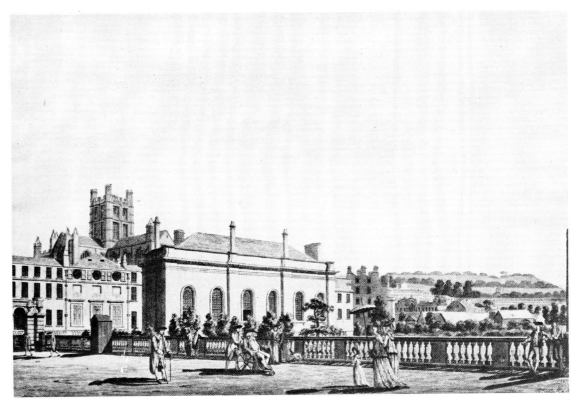

77. THOMAS MALTON, junior. *North Parade, Bath.* 13 × 18⅞ inches. Signed and dated 1777. Ex Coll.
W. Smith. Victoria and Albert Museum

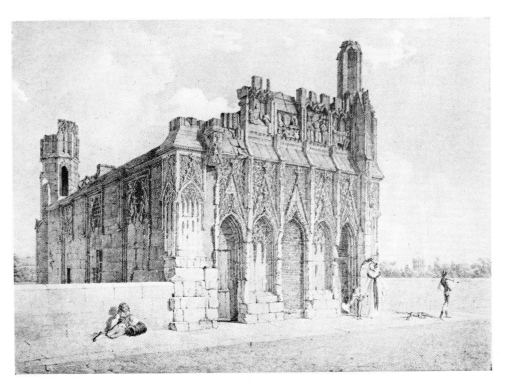

78. THOMAS RICHARD UNDERWOOD. *Chapel on Wakefield Bridge.* 10 × 14¼ inches. Inscribed
with title and dated 1794 in an old hand. Mr Thomas Girtin

PLATE XXXVIII

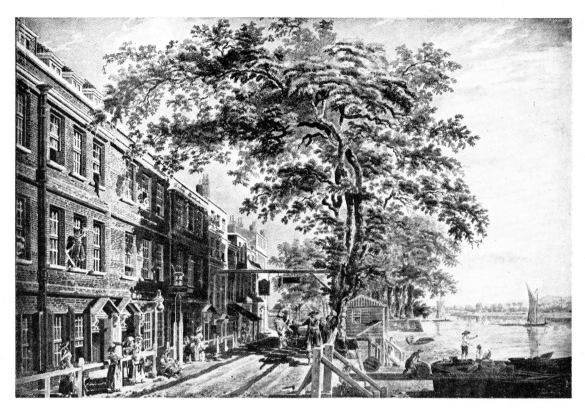

79. JAMES MILLER. *Cheyne Walk, Chelsea.* 16⅛ × 24⅞ inches. Signed and dated 1776.
Victoria and Albert Museum

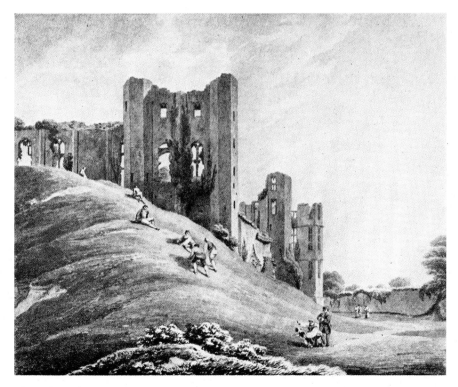

80. MICHAEL 'ANGELO' ROOKER. *Kenilworth Castle.* 9 × 11 inches. Signed.
Grey monochrome.

PLATE XXXIX

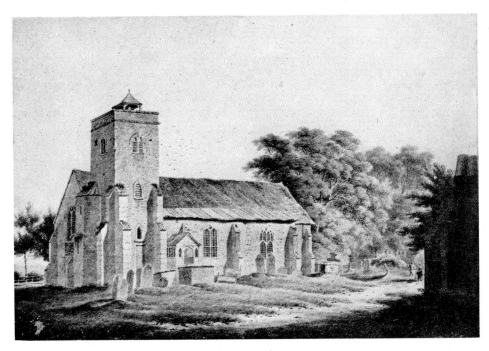

81. Joseph Powell. *Willesden Church.* $14\frac{1}{2} \times 20\frac{7}{8}$ inches. Signed.

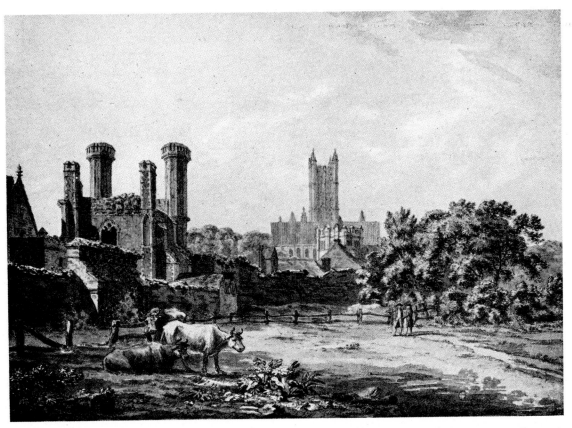

82. Benjamin Thomas Pouncy. *Canterbury Cathedral from St Austin's.* $15\frac{3}{4} \times 21$ inches. Signed in full and
with monogram and dated 1782. Whitworth Art Gallery, Manchester

PLATE XL

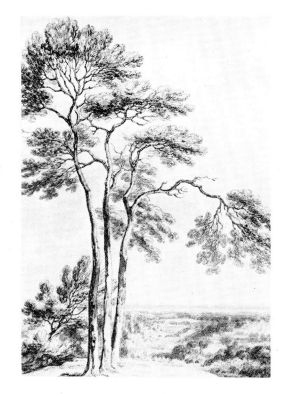

83. THOMAS HEARNE. *Trees in a Landscape.* $10\frac{3}{8} \times 7\frac{5}{8}$ ins. Pen and grey wash. Ex Coll. Miss Burney.
Sir Bruce Ingram

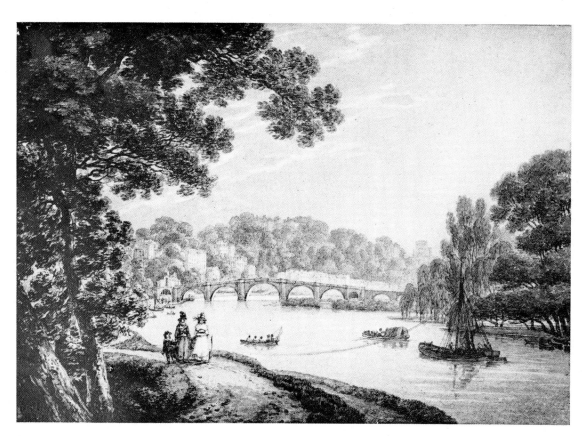

84. THOMAS HEARNE. *Richmond, Surrey.* $7\frac{1}{2} \times 10\frac{5}{8}$ inches. Signed and dated 1770.
Victoria and Albert Museum

PLATE XLI

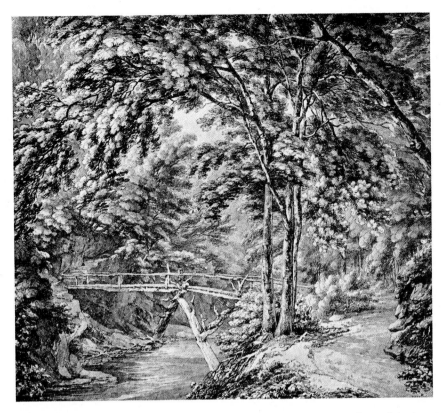

85. THOMAS HEARNE. *Wooded Glen at Downton, Herefordshire.* $12\frac{5}{8} \times 13\frac{3}{4}$ inches.
Indian ink and sepia. Signed. Victoria and Albert Museum

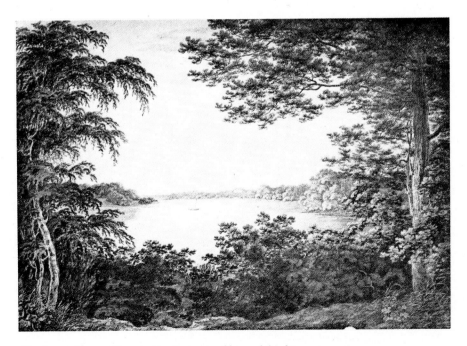

86. JOHN EMES. *View in Cumberland.* $16\frac{1}{4} \times 23\frac{1}{2}$ inches.
 Whitworth Art Gallery, Manchester

PLATE XLII

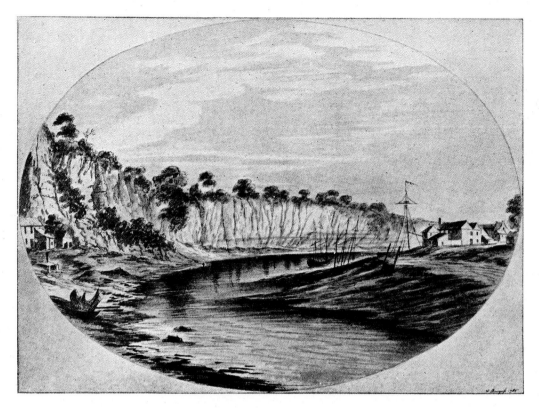

87. WILLIAM BURGESS. *The River Wye at Chepstow.* 10 × 14⅜ inches. Signed and dated 1785.

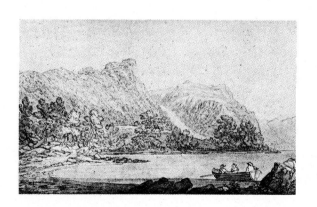

88. JOSEPH FARINGTON, R.A. *Bowness.* 4¾ × 7¾ inches. Signed and dated 1780. Pen and grey wash.

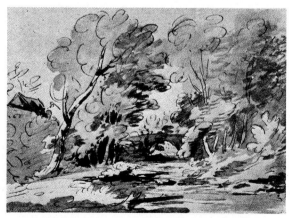

89. JOSEPH FARINGTON, R.A. *Wooded Stream with Bridge.* 5⅛ × 7¼ inches. Pen and Indian ink wash. From the Farington Sale 1921. Ex Coll. M. Hardie

PLATE XLIII

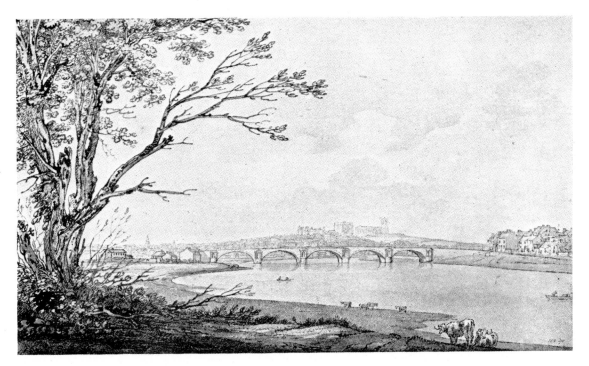

90. JOSEPH FARINGTON, R.A. *Lancaster.* 9 × 15⅜ inches. Pen, pencil and Indian ink. Signed.
Victoria and Albert Museum

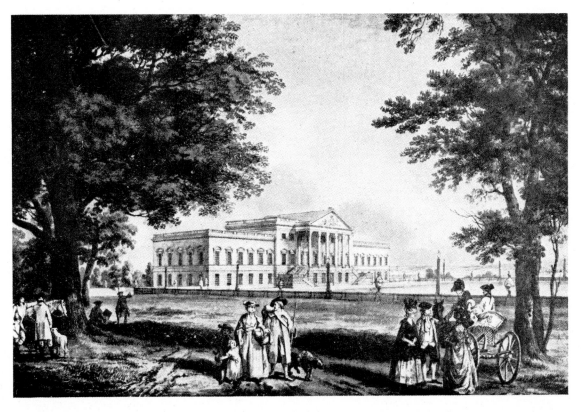

91. GEORGE ROBERTSON. *View of Wanstead House, Essex.* 11 $\frac{7}{16}$ × 17 $\frac{7}{16}$ inches. Pen and blackish-grey
wash. Engraved 1781. Victoria and Albert Museum

PLATE XLIV

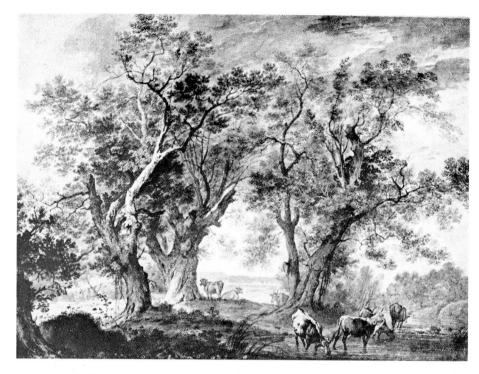

92. GEORGE ROBERTSON. *Landscape with Cattle drinking at a Pool.* $11\frac{1}{2} \times 15\frac{7}{8}$ inches.
Victoria and Albert Museum

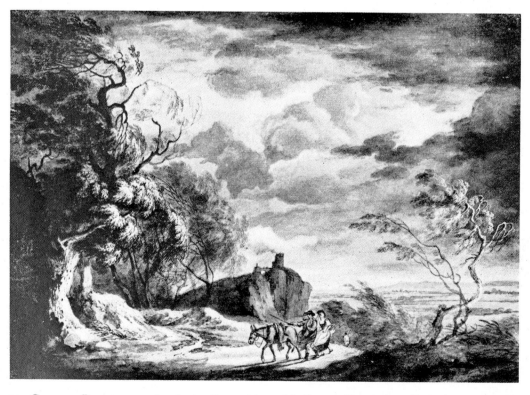

93. GEORGE ROBERTSON. *Landscape Composition with Stormy Sky.* $11\frac{3}{8} \times 16\frac{1}{4}$ inches. Ex Coll.
J. Moore. Ashmolean Museum, Oxford

PLATE XLV

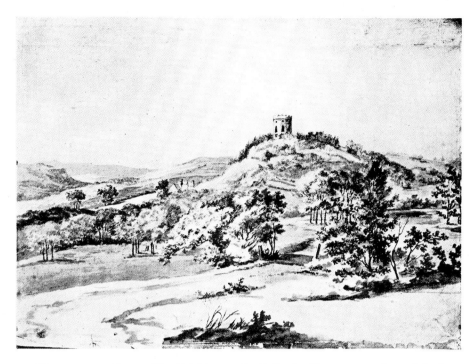

94. HENDRIK DE CORT. *The Belvidere at Gnoll Castle, Glamorgan.* 13¾ × 19⅜ inches. Inscribed on the back. Pencil and Indian ink wash.

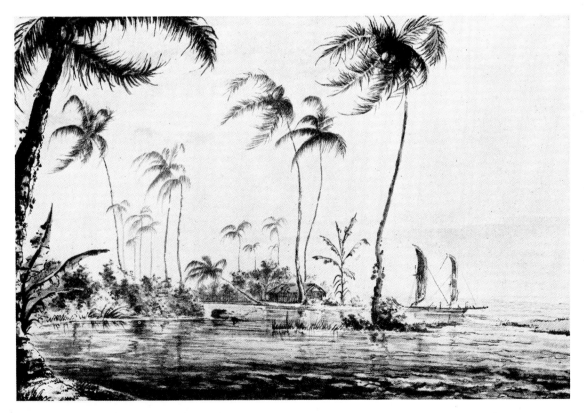

95. WILLIAM HODGES, R.A. *View in the Island of Otaheite.* 14¼ × 21¼ inches. Indian ink and some water-colour. Signed on the back and dated 1773. Ex Coll. A. Trotter and J. Percy.　　British Museum

PLATE XLVI

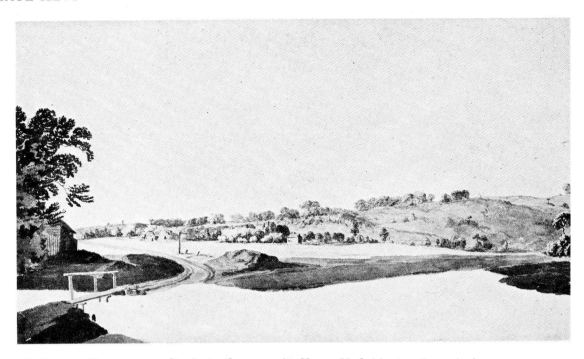

96. THOMAS DANIELL, R.A. *Sketch of a Common, with Houses*. Unfinished. $11\frac{7}{8} \times 21$ inches.
Victoria and Albert Museum

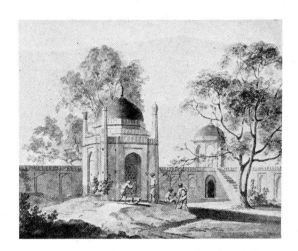

97. THOMAS DANIELL, R.A. *Part of the Tomb of Nawaub Assuph Khan at Rajmehal (Behar)*. $14\frac{3}{4} \times 18\frac{5}{8}$ inches. Study for aquatint.
Walker's Galleries

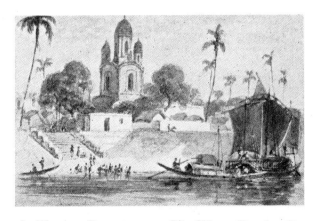

98. WILLIAM DANIELL, R.A. *The Chitpore Pagoda*. $4\frac{3}{8} \times 6\frac{7}{8}$ inches.
Walker's Galleries

PLATE XLVII

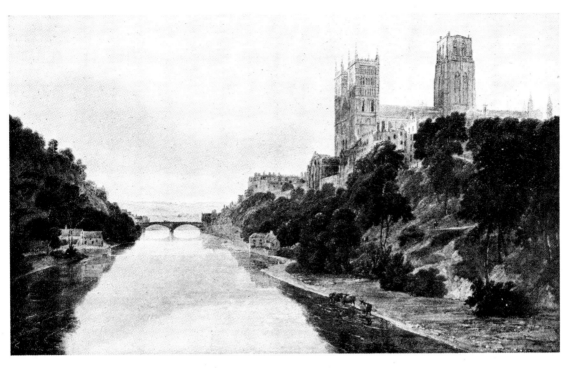

99. WILLIAM DANIELL, R.A. *Durham Cathedral.* 15¾ × 25⅝ inches. Signed and dated 1805.
Victoria and Albert Museum

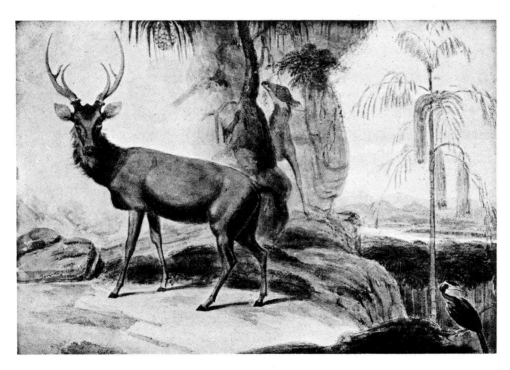

100. SAMUEL DANIELL. *Deer and Birds in a Tropical Landscape.* 12⅜ × 17⅞ inches.
Victoria and Albert Museum

PLATE XLVIII

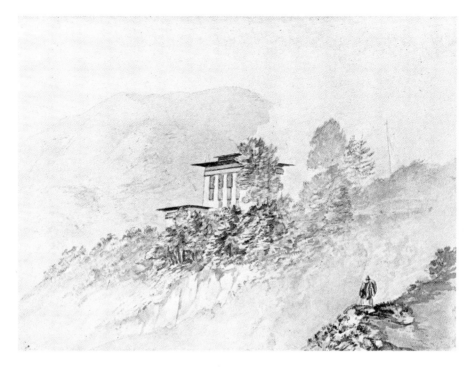

101. SAMUEL DAVIS. *The Rajah's Villa, Wandecky, in the Hills above Tacissudon, in Bootan.* $10\frac{3}{8} \times 14\frac{1}{4}$ inches. Signed. Inscribed with title on back of mount.

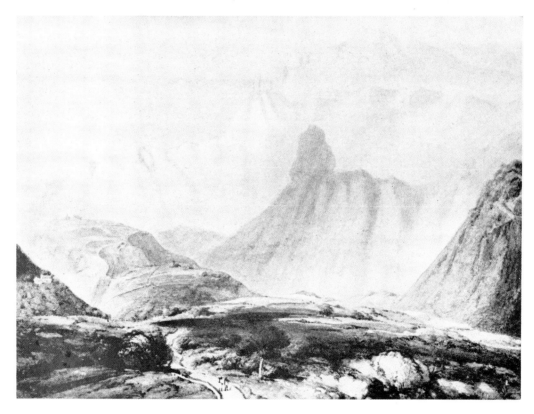

102. WILLIAM WESTALL, A.R.A. *St Helena—Lot and his Daughters.* $12\frac{1}{2} \times 17\frac{1}{4}$ inches. Signed and dated 1804. Mr H. C. Green

PLATE XLIX

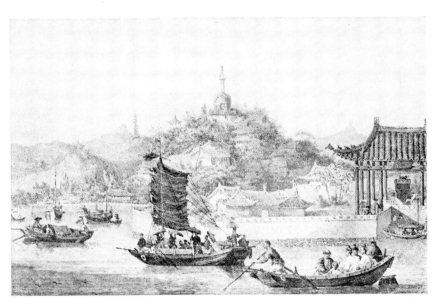

103. WILLIAM ALEXANDER. *Emperor of China's Gardens, Imperial Palace, Pekin.*
$9\frac{1}{4} \times 14$ inches. Signed. Victoria and Albert Museum

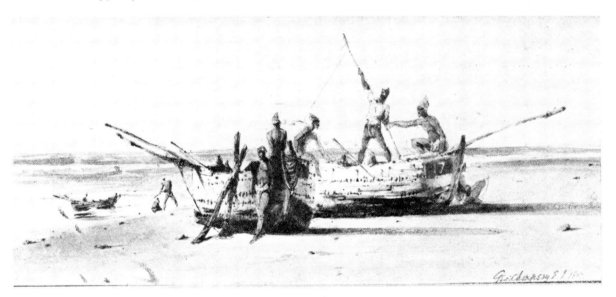

104. GEORGE CHINNERY. *Indian Beach with Boats and Figures.* $5\frac{1}{4} \times 12$ inches. Signed and dated 1807.
Mr. L. G. Duke

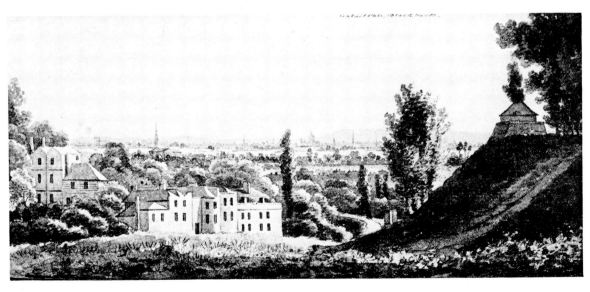

105. GEORGE HERIOT. *Conduit Vale, Blackheath.* $4\frac{3}{8} \times 10$ inches. In one of the artist's sketchbooks.
Sir Bruce Ingram

PLATE L

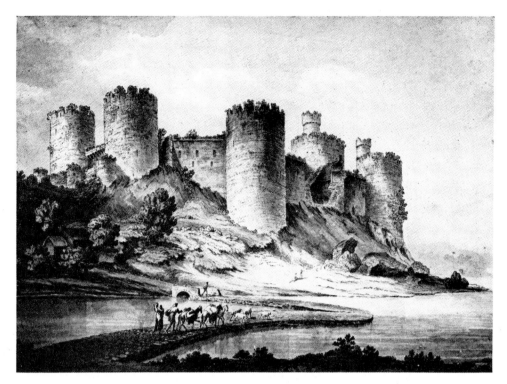

106. LIEUTENANT-GENERAL ARCHIBALD ROBERTSON. *Conway Castle.* $14\frac{5}{8} \times 20\frac{7}{8}$ inches. Pen and Indian ink. National Museum of Wales

107. WILLIAM GREEN. *View on Ullswater.* $8\frac{1}{2} \times 12$ inches. Signed on back of mount and dated 1806.

PLATE LI

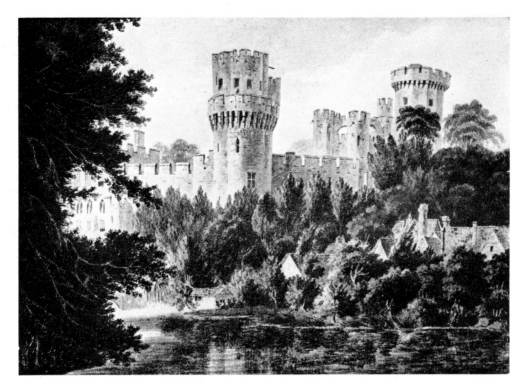

108. J. ROE. *S.E. View of Warwick Castle from the River.* 13×18⅜ inches. Engraved 1812.
Victoria and Albert Museum

109. JOHN MARTEN, senior. *Clifford Castle, Herefordshire.* 5⅝×9 inches. Signed twice with initials.

PLATE LII

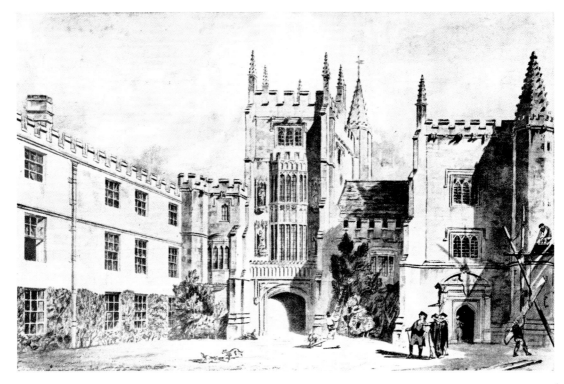

110. Daniel Harris. *The Original Entrance to the Cloisters at Magdalen College, Oxford.* $11\frac{1}{2} \times 17\frac{3}{4}$ inches. Signed with initials. Engraved by I. Taylor for 'Oxford Almanack', 1787. Mr E. Croft-Murray

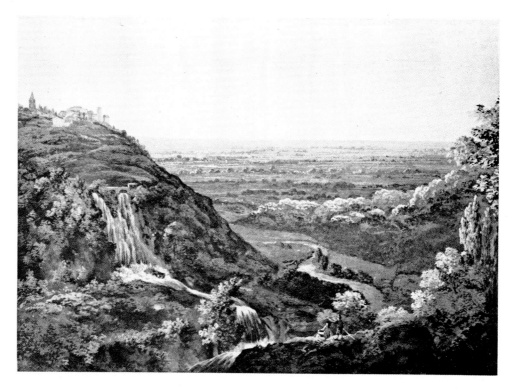

111. John Laporte. *An Italian Landscape.* $12\frac{5}{8} \times 17\frac{1}{2}$ inches. Signed on mount and dated 1790. Gouache.

PLATE LIII

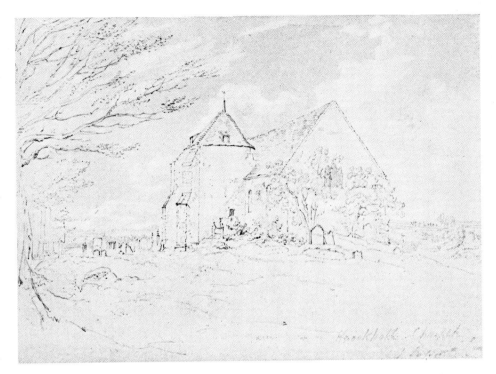

112. JOHN LAPORTE. *Knockholt Church.* 7¾ × 10½ inches. Pencil with blue wash in sky. Signed.

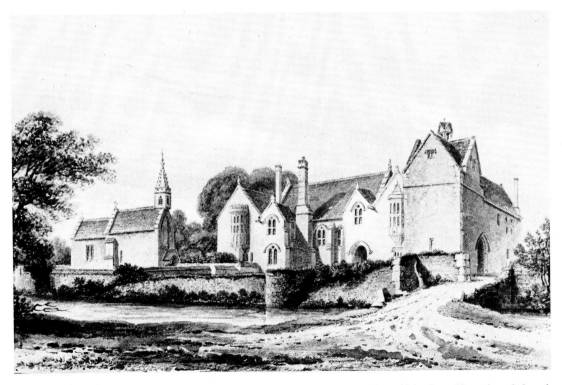

113. JOHN BUCKLER. *North-West View of Great Chalfield, Wiltshire.* 10¾ × 16¾ inches. Signed and dated 1823. British Museum

PLATE LIV

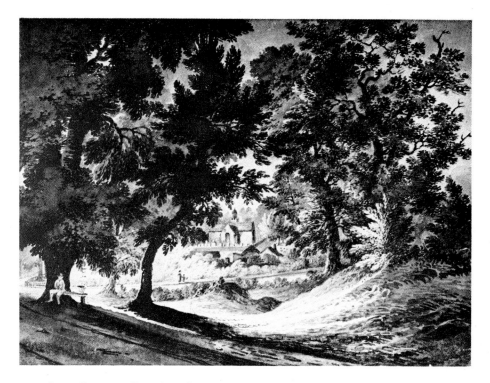

114. JAMES BOURNE. *Petersham, Surrey.* $10\frac{7}{8} \times 14\frac{7}{8}$ inches. Sepia wash with slight pencil. Signed on the back.

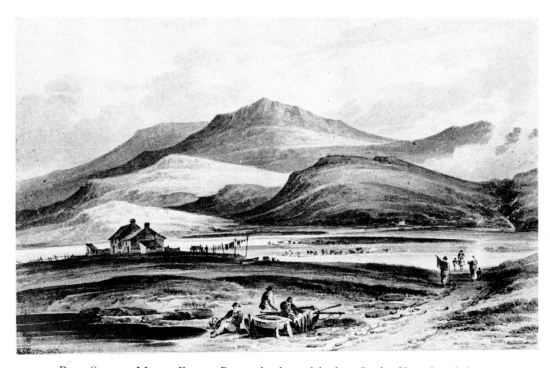

115. PAUL SANDBY MUNN. *Ferry at Barmouth.* $9\frac{1}{2} \times 15\frac{1}{2}$ inches. Sepia. Signed and dated 1827.

PLATE LV

117. PAUL SANDBY MUNN. *A Waterfall.* $10\frac{1}{4} \times 6\frac{5}{8}$ inches. Dark brown wash. Signed and dated 1814.

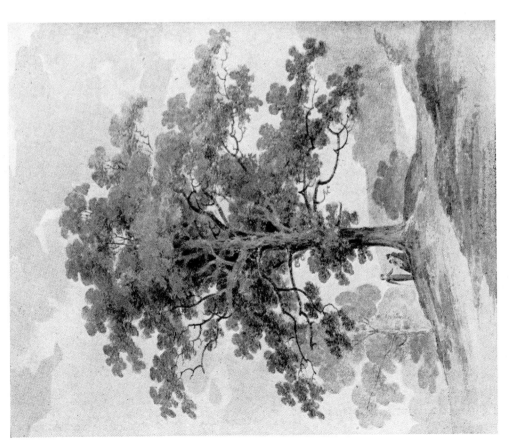

116. PAUL SANDBY MUNN. *Two Ladies and a Child under an Oak.* $12\frac{1}{4} \times 10$ inches. Signed with initials and dated 1805.

PLATE LVI

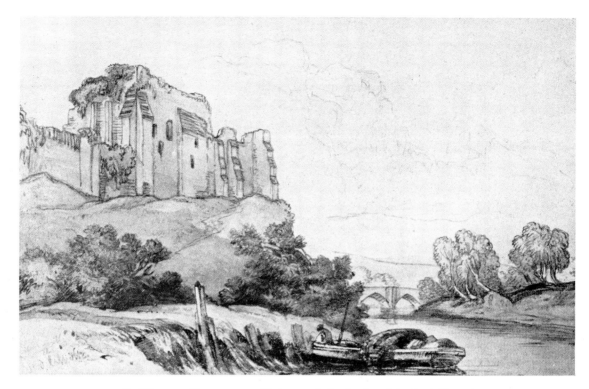

118. WILLIAM DELAMOTTE. *Cockermouth Castle*. 6×9⅝ inches. Signed.

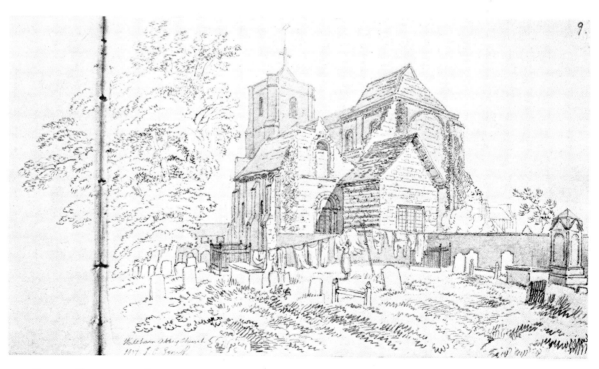

119. JOSEPH CLARENDON SMITH. *Waltham Abbey Church*. 6¼×11 inches. Pencil with grey and brown wash. Signed and dated 1807. In a sketchbook. Victoria and Albert Museum

PLATE LVII

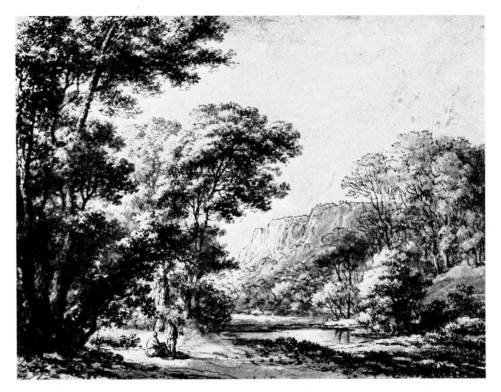

120. ALEXANDER NASMYTH. *The Hill of Kinoul near Kinfauns.* 6⅞×9 inches. Pen with black-to-grey wash. Inscribed with title and signed with initials.

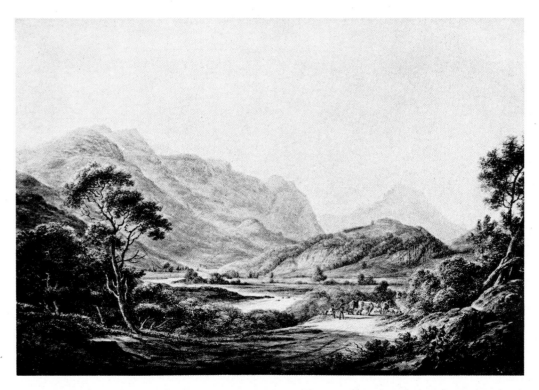

121. ANDREW WILSON. *A Highland Valley.* 16½×24½ inches. Signed and dated 1799 on back of mount.

PLATE LVIII

122. PATRICK GIBSON. *View in Lambeth Marsh, Surrey.*
11 × 9½ inches. Indian ink and pen. Signed and dated 1805.

123. HUGH WILLIAM WILLIAMS. *A Bridge in the Hills.* 7¼ × 10⅛ inches. Brownish-grey wash.
Signed on back of mount.

PLATE LIX

124. Hugh William Williams. *A Stormy Landscape.* 15⅛ × 20 inches. Signed and dated 1801.

PLATE LX

125. RICHARD WILSON, R.A. *Villa Borghesi.* $11\frac{1}{4} \times 16\frac{3}{8}$ inches. Signed with initials, dated 1754, and numbered 3: Black chalk and stump, heightened with white. Lord Dartmouth

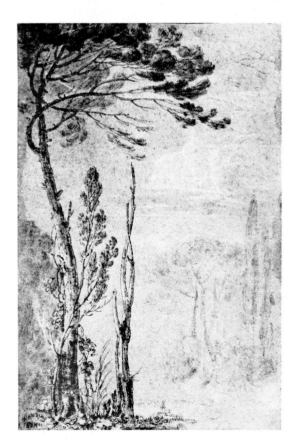

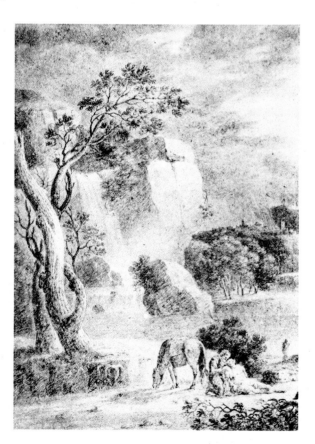

126. RICHARD WILSON, R.A. *Tall Trees: the Vale of Baiae.* $15\frac{3}{4} \times 10\frac{1}{2}$ inches. Black chalk and wash, heightened with white. Ex Coll. B. Booth.
 Mr Brinsley Ford

127. ROBERT CRONE. *The Good Samaritan.* $15\frac{1}{2} \times 11\frac{1}{4}$ inches. Signed with initials. Black and white chalk on brown paper. A fragment from a larger drawing. Another version exists.

PLATE LXI

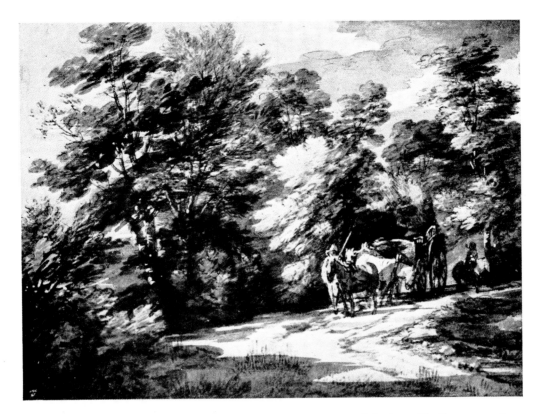

128. THOMAS GAINSBOROUGH, R.A. *A Woodland Road.* 9⅜ × 12½ inches. Chalk, watercolour and Indian ink, touched with white. British Museum

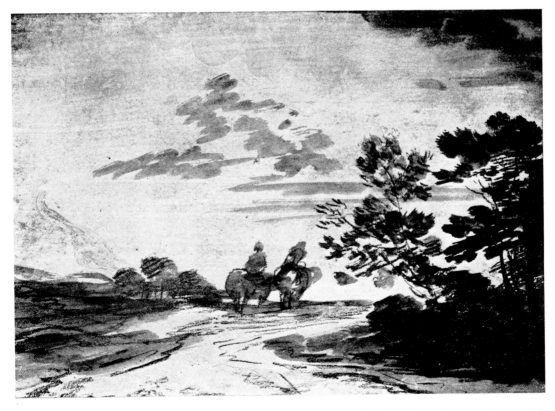

129. THOMAS GAINSBOROUGH, R.A. *Travelling West.* 8¼ × 11½ inches. Chalk and watercolour, with body colour in sky. Ex Coll. A. Kay. British Museum

PLATE LXII

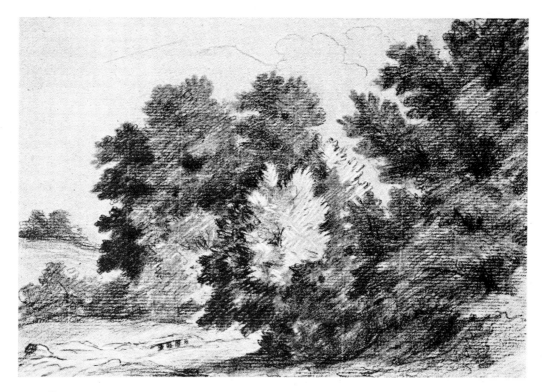

130. JOHN HOPPNER, R.A. *Landscape with Trees.* $7 \times 10\frac{3}{8}$ inches. Black chalk over faint wash, heightened with white, on blue paper. British Museum

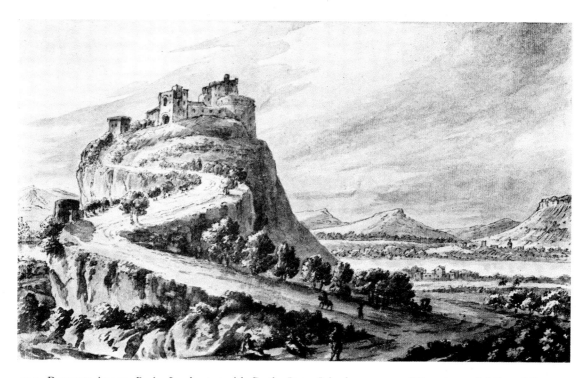

131. ROBERT ADAM. *Rocky Landscape, with Castle.* $8 \times 12\frac{3}{4}$ inches. Victoria and Albert Museum

PLATE LXIII

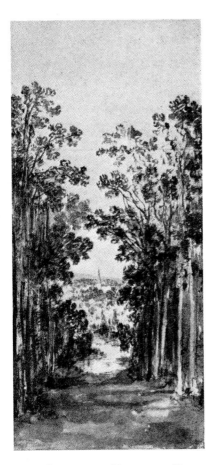

132. Nicholas Thomas Dall, A.R.A. *View of Hackfall in Yorkshire (Cacklington Church).* $13\frac{5}{8} \times 6\frac{1}{4}$ inches. Signed and dated 1766.

Mr A. P. Oppé

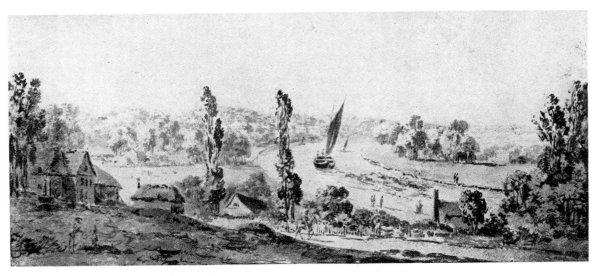

133. Nicholas Thomas Dall, A.R.A. *View up the Thames from Richmond Hill.* $8\frac{1}{4} \times 18\frac{3}{8}$ inches. Indian ink wash over slight pencil. Signed on mount and dated 1774. Ex Coll. L. G. Duke.

PLATE LXIV

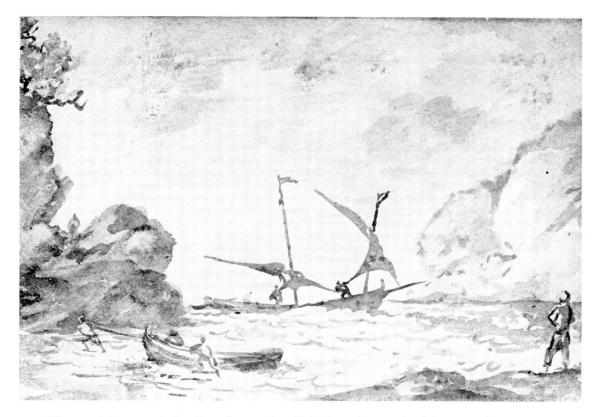

134. WILLIAM MARLOW. *Italian Coast Scene.* $10\frac{5}{8} \times 16\frac{1}{4}$ inches. Grey wash with traces of pencil. Versions in oil and watercolour exist.

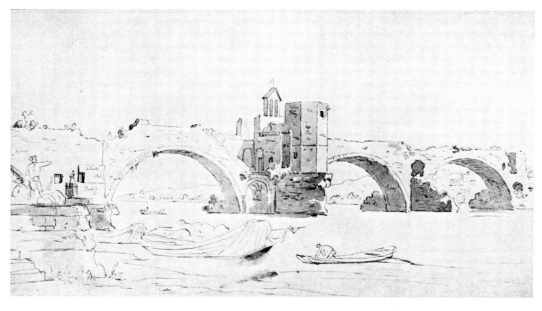

135. WILLIAM MARLOW. *The Bridge at Avignon.* $8\frac{3}{4} \times 16\frac{3}{4}$ inches. Pen and dark grey wash. An oil version is reproduced in Col. M. H. Grant's *The Old English Landscape Painters*.

PLATE LXV

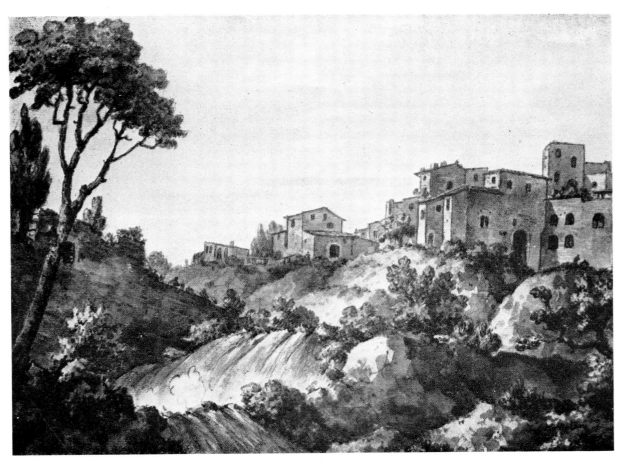

136. WILLIAM MARLOW. *Tivoli*. $10\frac{3}{8} \times 14\frac{3}{4}$ inches. Signed. Mr Thomas Girtin

PLATE LXVI

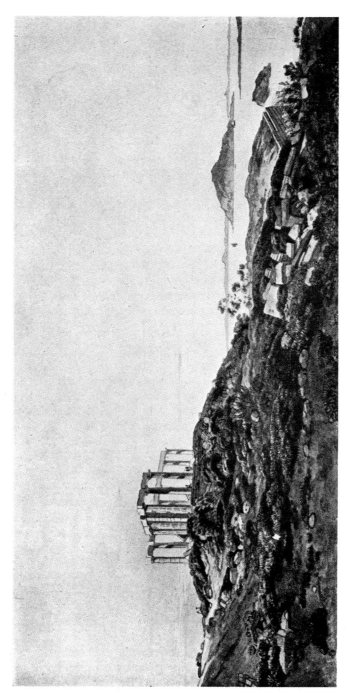

137. WILLIAM PARS, A.R.A. *Temple of Athene at Sunium.* $9\frac{1}{4} \times 18\frac{5}{8}$ inches. Engraved by P. Sandby 1779, and by Byrne in 'Ionian Antiquities', Vol. II, 1797.

PLATE LXVII

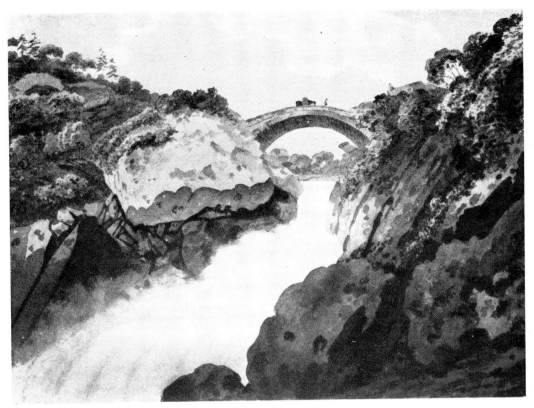

138. WILLIAM PARS, A.R.A. *On the Tessin, near Poleggio.* $9\frac{3}{4} \times 13\frac{3}{4}$ inches. Mr A. P. Oppé

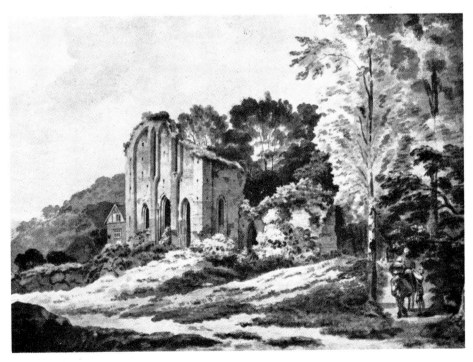

139. WILLIAM PARS, A.R.A. *Valle Crucis.* $10 \times 14\frac{1}{4}$ inches. Ex Coll. Dr J. Percy.
Mr A. P. Oppé

PLATE LXVIII

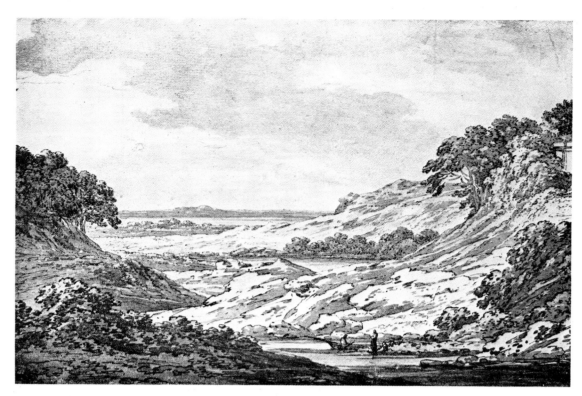

140. RICHARD COOPER, junior. *Rocky Landscape.* 13 × 19½ inches.　　Victoria and Albert Museum

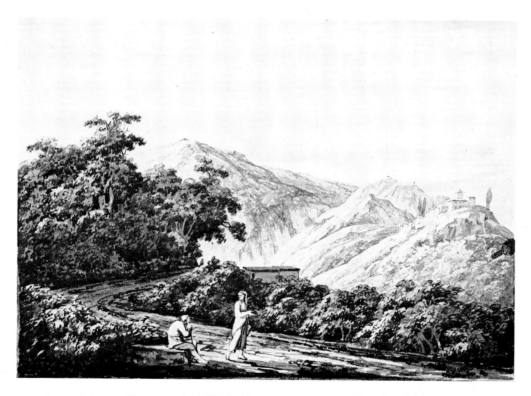

141. JACOB MORE. *View near the Mill, looking toward Licenza: Horace's Villa on the left.* 11¼ × 15⅞ inches.

PLATE LXIX

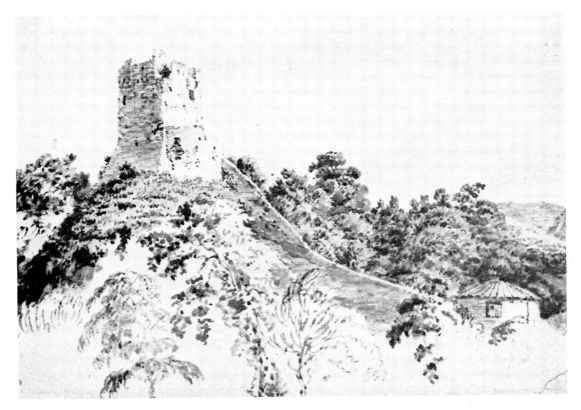

142. Joseph Wright, a.r.a., of Derby. *Nice, December 15* [1773]. $9\frac{1}{2} \times 13\frac{5}{8}$ inches. Grey wash.
Mr A. P. Oppé

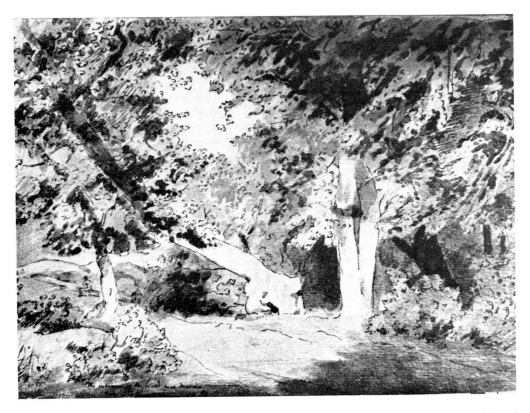

143. John Downman, a.r.a. *The Entrance of the Wood near Marino.* $10\frac{1}{8} \times 14\frac{1}{4}$ inches. Signed with initials, dated 1774, and inscribed 'done in a camera obscura'. Mr A. P. Oppé

PLATE LXX

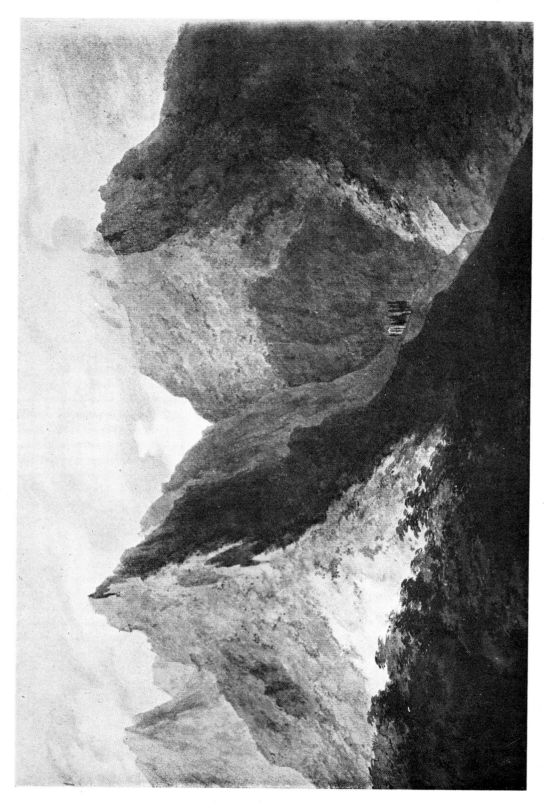

144. JOHN ROBERT COZENS. *View in the Island of Elba.* $14\frac{1}{2} \times 21\frac{1}{8}$ inches. Signed and dated 178[?]. Ex Coll. W. Smith.
Victoria and Albert Museum

PLATE LXXI

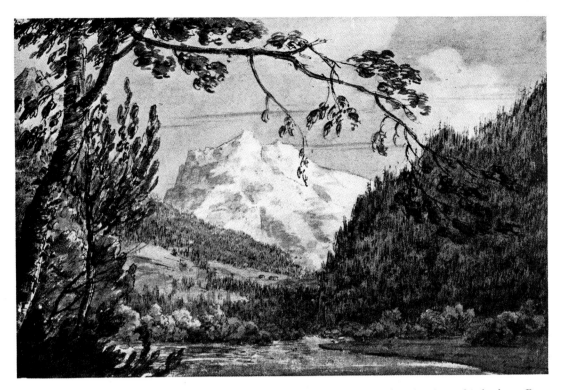

145. John Robert Cozens. *View between Lauterbrunnen and Grindelwald.* $9\frac{1}{8} \times 13\frac{11}{12}$ inches. Pen, tinted. Dated 1776. Ex Coll. Dyce.　　　　　　　　　　Victoria and Albert Museum

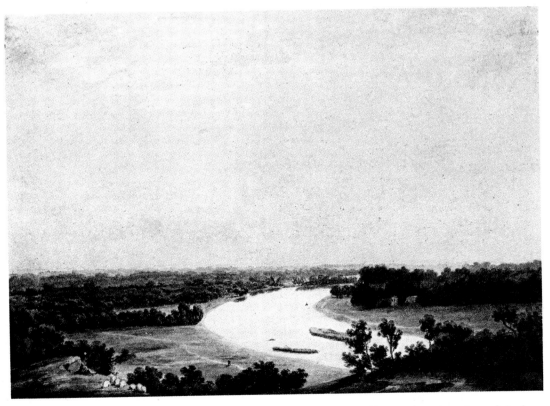

146. John Robert Cozens. *The Thames from Richmond Hill, looking south-west.* $14\frac{1}{4} \times 20\frac{5}{8}$ inches.
Mr. E. Croft-Murray

PLATE LXXII

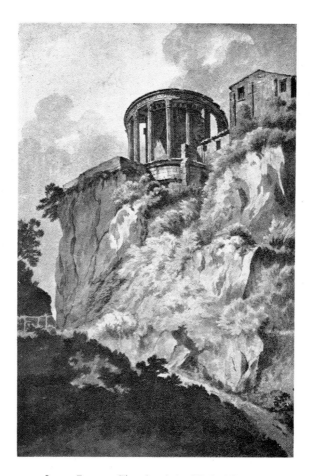

147. JOHN SMITH. *Temple of the Sibyl, Tivoli.* 20⅝ ×
13 inches. Ex Coll. Lord Warwick.
 National Gallery of Canada, Ottawa

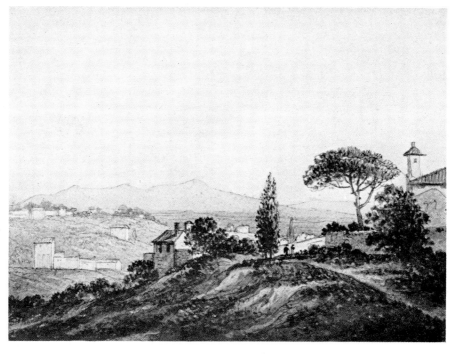

148. JOHN SMITH. *View towards Porta Pia towards Tivoli.* 8¼ × 11⅜ inches. Inscribed
by artist and signed on the back of the mount.

PLATE LXXIII

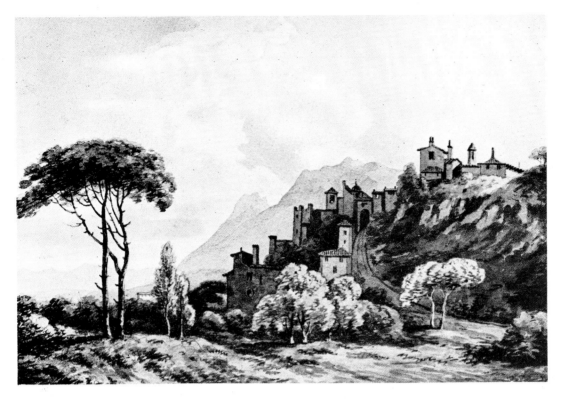

149. JOHN SMITH. *Terracina*. $6\frac{5}{8} \times 9\frac{3}{4}$ inches. Ex Coll. Trevelyan. Victoria and Albert Museum

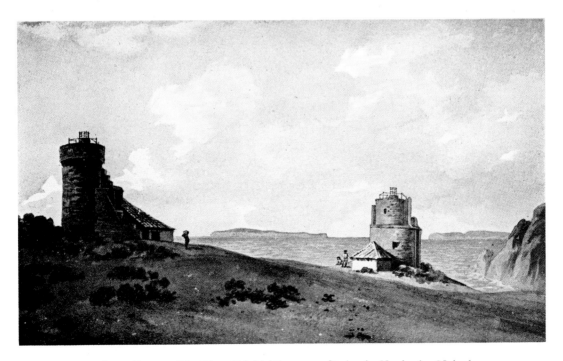

150. JOHN SMITH. *The Two Old Lighthouses on St Anne's Head*. $5\frac{1}{8} \times 8\frac{3}{4}$ inches.

PLATE LXXIV

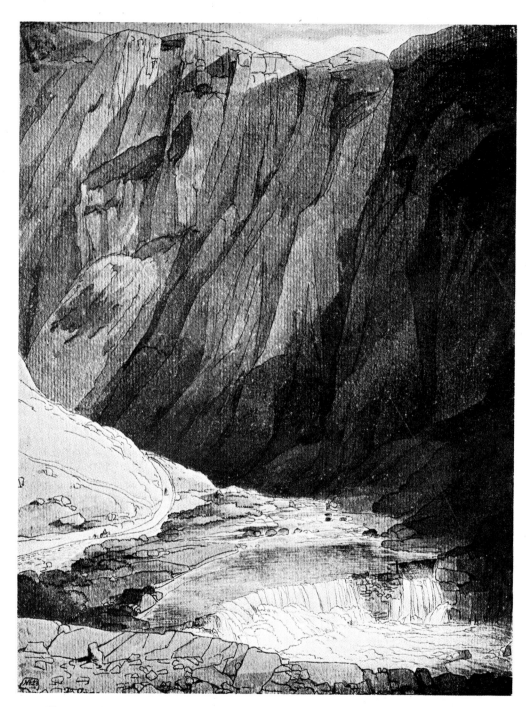

151. Francis Towne. *The Salmon Leap, from Pont Aberglaslyn.* 11 × 8½ inches. Signed and dated 1777. Ex Coll. J. H. Merivale. Mr A. P. Oppé

PLATE LXXV

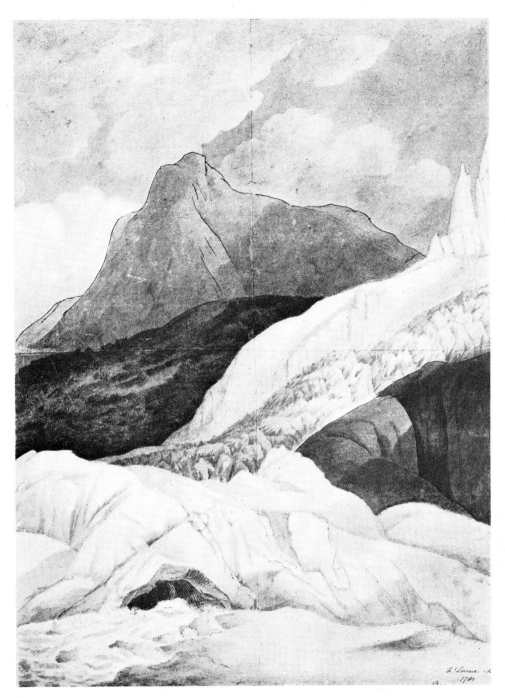

152. FRANCIS TOWNE. *The Source of the Arveiron: Mont Blanc in the background.* $16\frac{3}{4} \times 12\frac{1}{4}$ inches. Signed and dated 1781. Victoria and Albert Museum

PLATE LXXVI

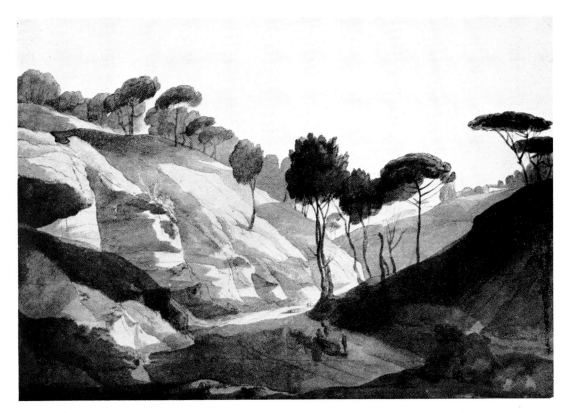

153. FRANCIS TOWNE. *Sta Maria a Monte, Naples.* 12 $\frac{5}{16}$ × 18 $\frac{1}{4}$ inches. Signed, inscribed and dated 1781. Ex Coll. Merivale. Mr L. G. Duke

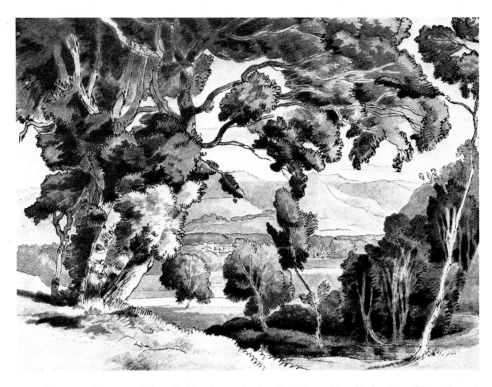

154. FRANCIS TOWNE. *View looking towards the Appenines.* 6 $\frac{1}{4}$ × 8 $\frac{1}{2}$ inches. Signed and dated 1781, back and front.

PLATE LXXVII

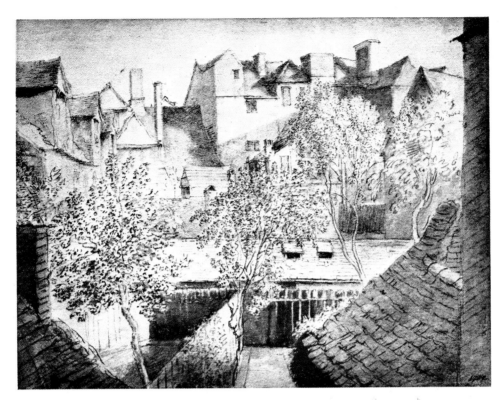

155. JOHN BAPTIST MALCHAIR. *St Barnabas, Oxford*. 10½ × 13¾ inches. Inscribed and
dated 1782 on the back by the artist. Ashmolean Museum, Oxford

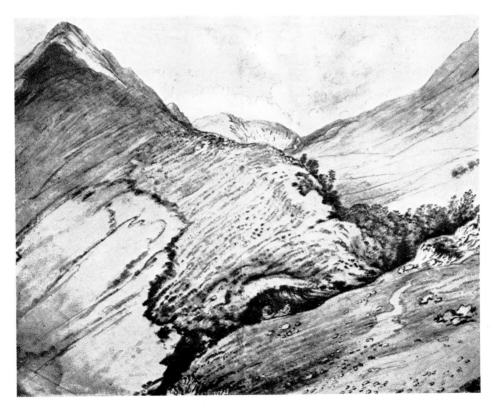

156. JOHN BAPTIST MALCHAIR. *Moel y Fridd*. 16¾ × 20¾ inches. Pencil and grey wash.
Inscribed and dated 1795 on the back by the artist. Ex Coll. W. Crotch.
 Mr L. G. Duke

PLATE LXXVIII

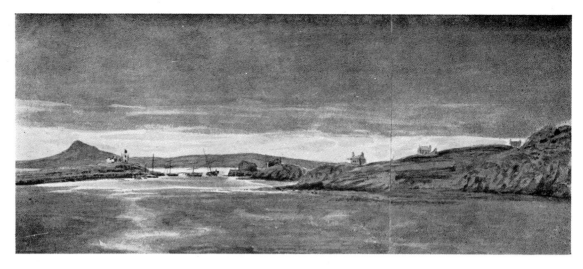

157. REV. WILLIAM HENRY BARNARD. *Holyhead Harbour.* $9\frac{1}{2} \times 22\frac{1}{2}$ inches. Inscribed on the mount by the artist and dated 1795.

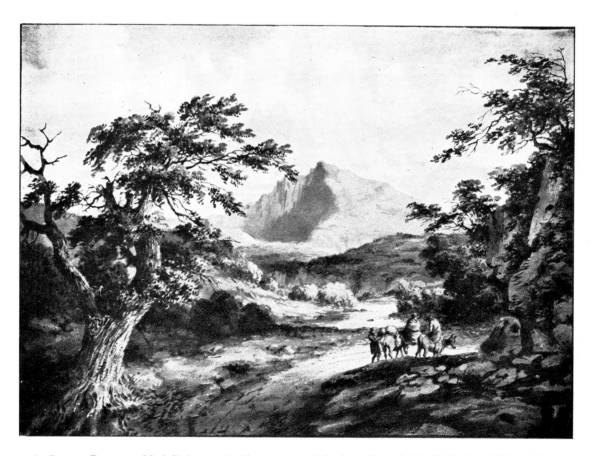

158. JOSEPH BARBER. *Moel Shabot on the Llugwy.* 13×18 inches. Signed. Ex Coll. Lord Warwick.

PLATE LXXIX

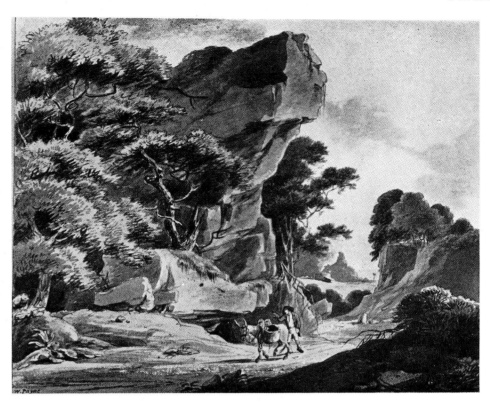

159. WILLIAM PAYNE. *Landscape with Man Driving Donkey.* $7\frac{3}{4} \times 9\frac{7}{8}$ inches. Signed. Miss H. E. Williams

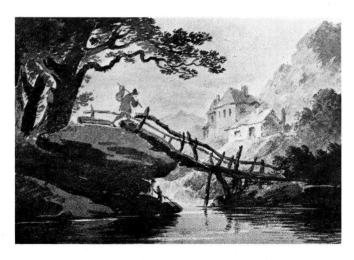

160. WILLIAM PAYNE. *A Rustic Bridge.* $6\frac{3}{4} \times 9\frac{5}{8}$ inches. Blue and grey wash..

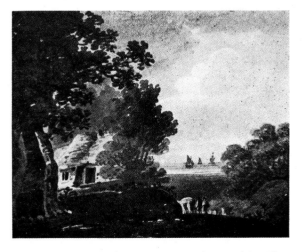

161. JOHN HENRY CAMPBELL. *Landscape with a View of the Sea.* $5\frac{1}{4} \times 6\frac{5}{8}$ inches. Signed.

PLATE LXXX

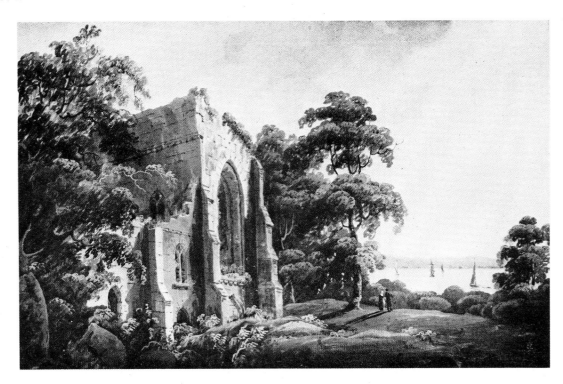

162. Thomas Walmsley. *West End of Netley Abbey*. $10\frac{3}{8} \times 16$ inches. Body colour.

Victoria and Albert Museum

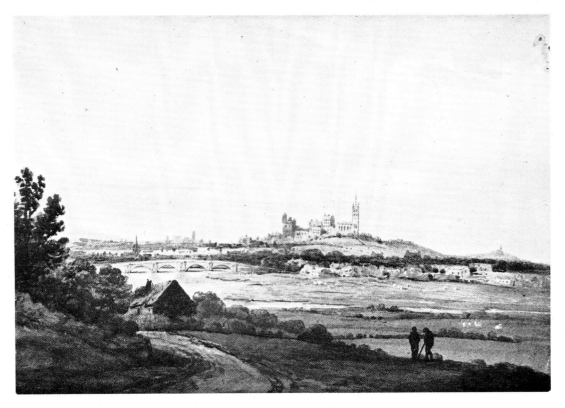

163. Richard Sasse. *View of Lancaster*. $8\frac{3}{32} \times 12\frac{1}{16}$ inches. Signed and dated 1801.

Victoria and Albert Museum

PLATE LXXXI

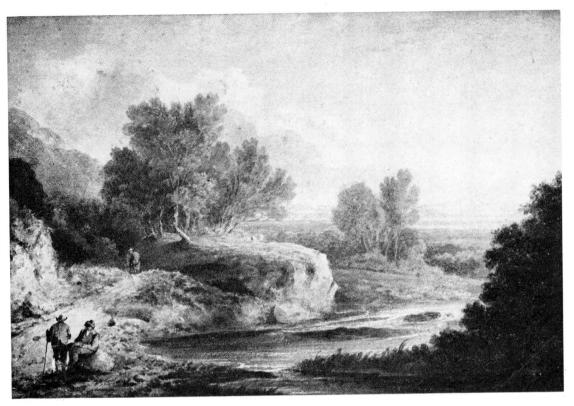

164. THOMAS BARKER. *River Scene with Figures.* $17\frac{3}{4} \times 25\frac{1}{2}$ inches. Victoria and Albert Museum

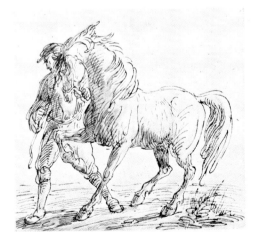

165. THOMAS BARKER. *Boy Driving Sheep.* $4 \times 6\frac{3}{4}$ inches. Pen and sepia.

166. THOMAS BARKER. *Man Leading Horse.* $10 \times 8\frac{1}{2}$ inches. Blank top of paper omitted. Pen and sepia.

PLATE LXXXII

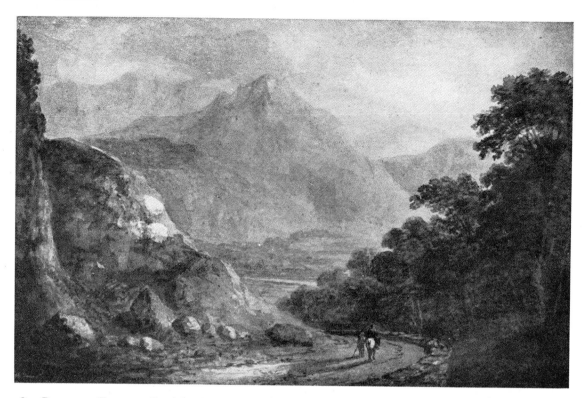

167. BENJAMIN BARKER. *Road Leading to Pont Aberglaslyn: View looking into the Vale of Festiniog, North Wales.* 9¾ × 15 inches. Inscribed on back and dated 1804. Victoria and Albert Museum

168. J. WEST. *Caldicot Castle, Monmouthshire.* 11¾ × 16½ inches. Inscribed on back of mount and signed.

PLATE LXXXIII

169. EDWARD DAYES. *Buckingham House, St James's Park.* $15\frac{1}{2} \times 25\frac{1}{2}$ inches. Signed and dated 1790.
Engraved 1793. Victoria and Albert Museum

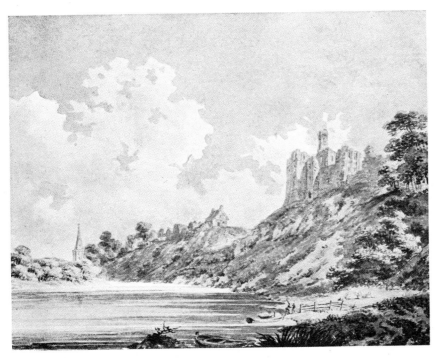

170. EDWARD DAYES. *Warkworth Castle, Northumberland.* $6\frac{5}{8} \times 8\frac{5}{8}$ inches.
Signed and dated 1793.

PLATE LXXXIV

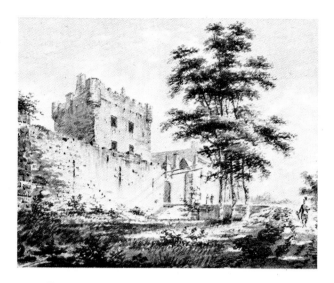

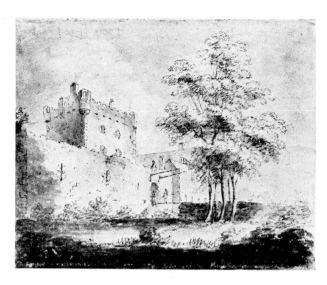

171. Edward Dayes after James Moore. *Cawdor Castle near Nairn.* 6½×8½ inches. Signed and dated 1792 by both artists. Engraved 1798. *Cf.* fig. 172.

Ashmolean Museum, Oxford

172. James Moore. *Cawdor Castle near Nairn.* 7⅛×9 inches. Pencil with grey and blue wash. Signed and dated 1792. *Cf.* fig. 171.

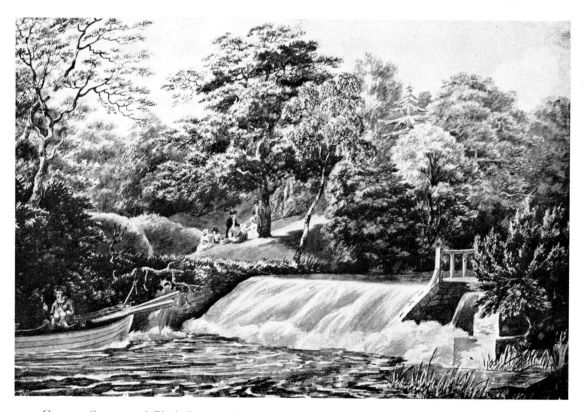

173. George Samuel. *A Picnic Party.* 13 11/16 × 20½ inches.

Victoria and Albert Museum

PLATE LXXXV

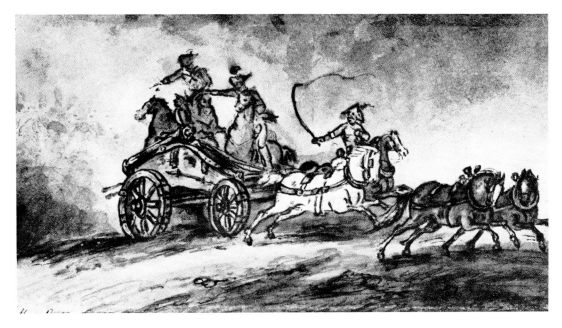

174. SIR ROBERT KER PORTER. *A Gun Horse Team.* $4\frac{7}{16} \times 7\frac{7}{8}$ inches. Signed. Ex Coll. Mrs F. B. Haines. Victoria and Albert Museum

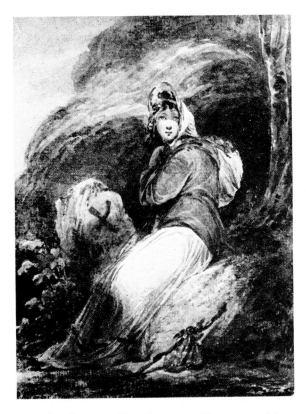

175. SIR ROBERT KER PORTER. *Woman seated by a Milestone.* $6\frac{1}{4} \times 4\frac{3}{4}$ inches. Signed and dated 1798.

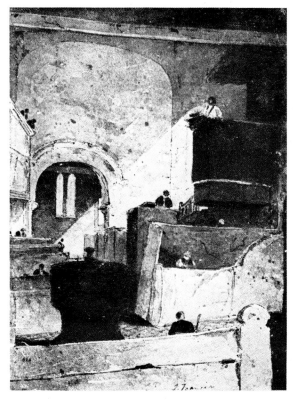

176. FRANÇOIS LOUIS THOMAS FRANCIA. *Interior of a Church.* $9\frac{3}{4} \times 7\frac{3}{8}$ inches. Sepia. Signed or inscribed. Victoria and Albert Museum

PLATE LXXXVI

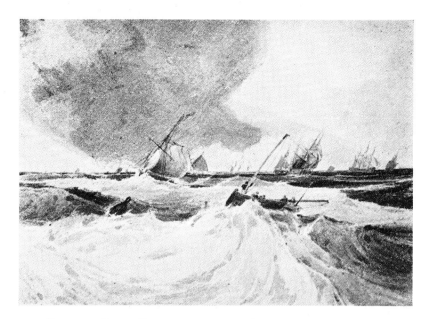

177. FRANÇOIS LOUIS THOMAS FRANCIA. *Transports Returning from Spain, February 1809, beating into St Helen's Roads.* $11\frac{1}{4} \times 15\frac{3}{4}$ inches. Ex Coll. S. Redgrave and J. Percy. British Museum

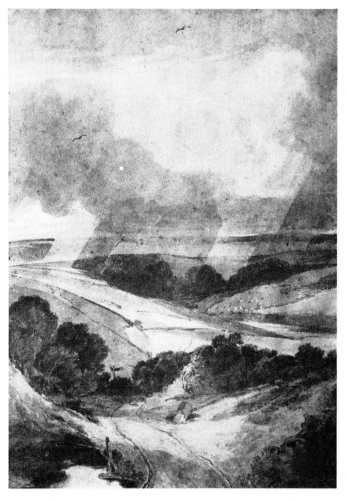

178. FRANÇOIS LOUIS THOMAS FRANCIA. *Mousehold Heath.* $12\frac{1}{2} \times 9\frac{3}{16}$ inches. Signed and dated 1808. Mr L. G. Duke

PLATE LXXXVII

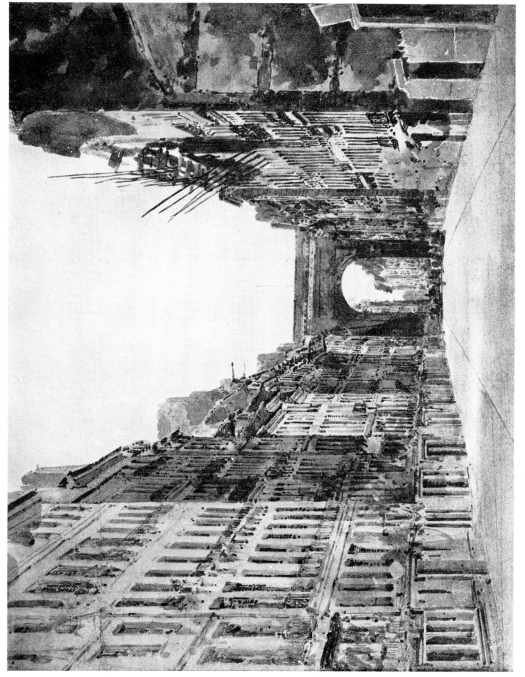

179. Thomas Girtin. *La Rue St Denis, Paris.* $15\frac{1}{2} \times 18\frac{3}{4}$ inches. Ex Coll. Sir J. Knowles and Sir Hickman Bacon.
Sir Edmund Bacon

PLATE LXXXVIII

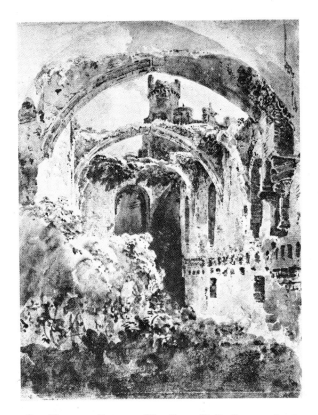

180. THOMAS GIRTIN. *The Great Hall, Conway Castle.*
14½ × 11½ inches. British Museum

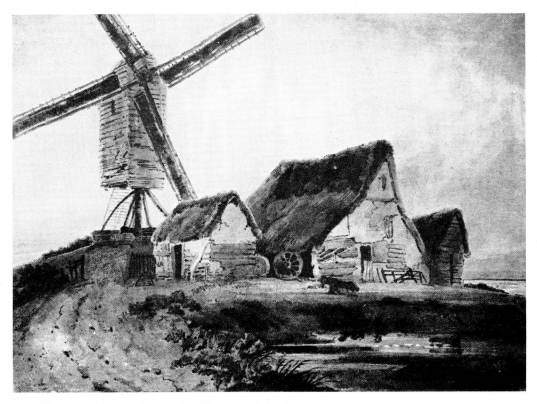

181. THOMAS GIRTIN. *Stanstead Mill.* 17 × 23½ inches. Sir Edmund Bacon

PLATE LXXXIX

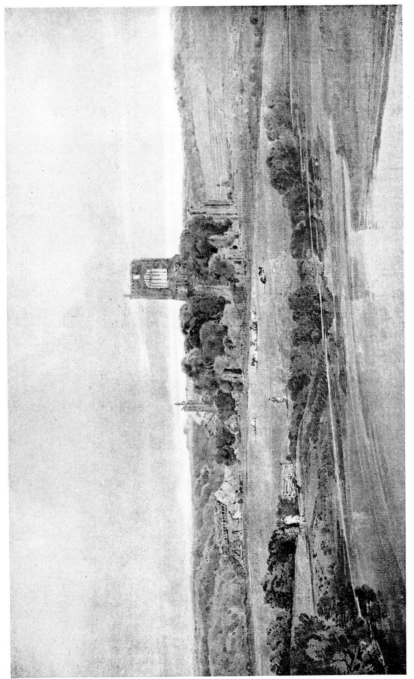

182. Thomas Girtin. *Kirkstall Abbey, Yorkshire—Evening.* $12 \times 20\frac{1}{8}$ inches. Ex Coll. T. C. Girtin.
Victoria and Albert Museum

PLATE XC

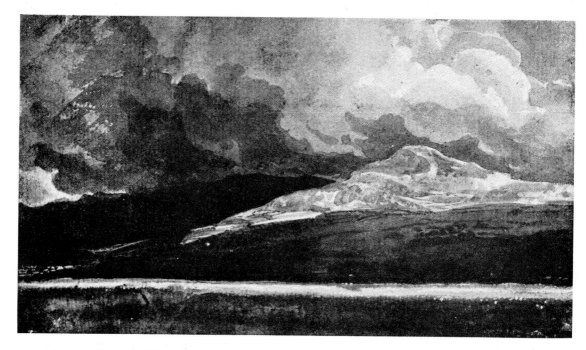

183. THOMAS GIRTIN. *Hills and Stream.* $6 \times 10\frac{1}{8}$ inches. Ex Coll. Chambers Hall. British Museum

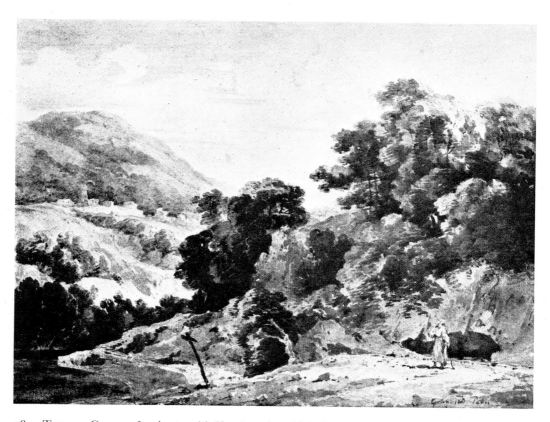

184. THOMAS GIRTIN. *Landscape with Hermit.* $13\frac{1}{8} \times 18\frac{3}{4}$ inches. Signed and dated 1801. Based on an etching by H. Swanevelt. Victoria and Albert Museum

PLATE XCI

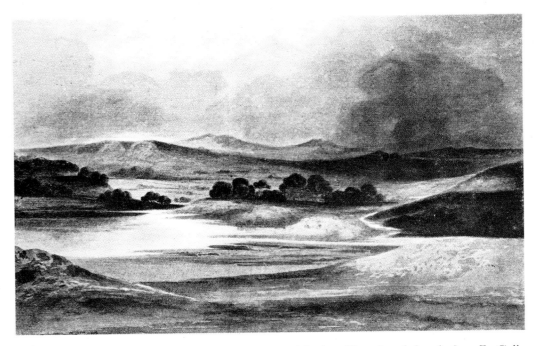

185. WILLIAM PEARSON. *Mountains and Lake.* 12 × 19½ inches. Signed and dated 1802. Ex Coll.
J. Percy. British Museum

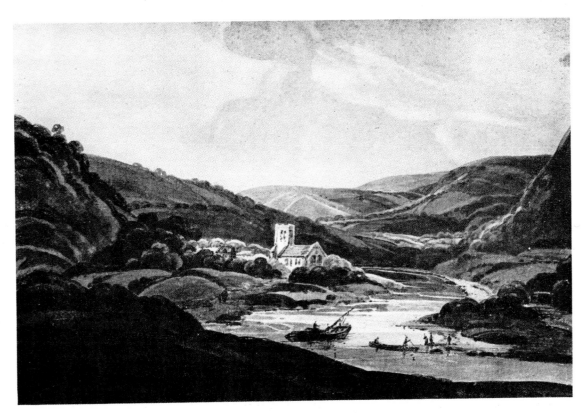

186. FRANZ JOSEPH MANSKIRSCH. *Village Church by River.* 10½ × 15⅞ inches.
 Whitworth Art Gallery, Manchester

PLATE XCII

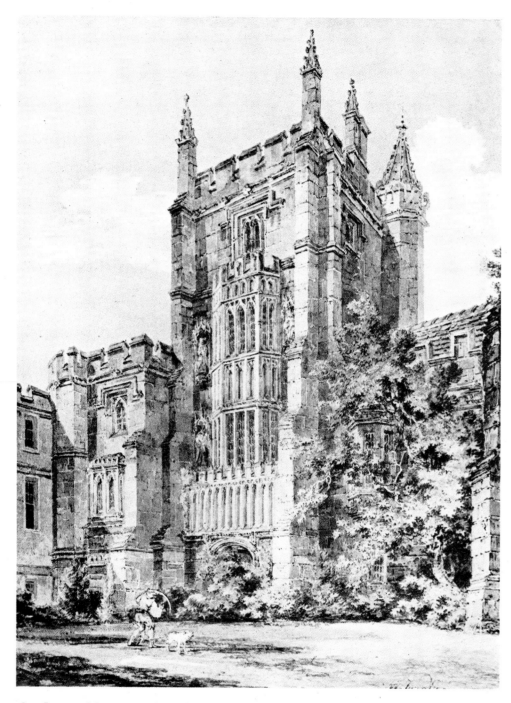

187. JOSEPH MALLORD WILLIAM TURNER, R.A. *The Founder's Tower, Magdalen College, Oxford.* $10\frac{1}{2} \times 8\frac{3}{8}$ inches. Signed.
British Museum

PLATE XCIII

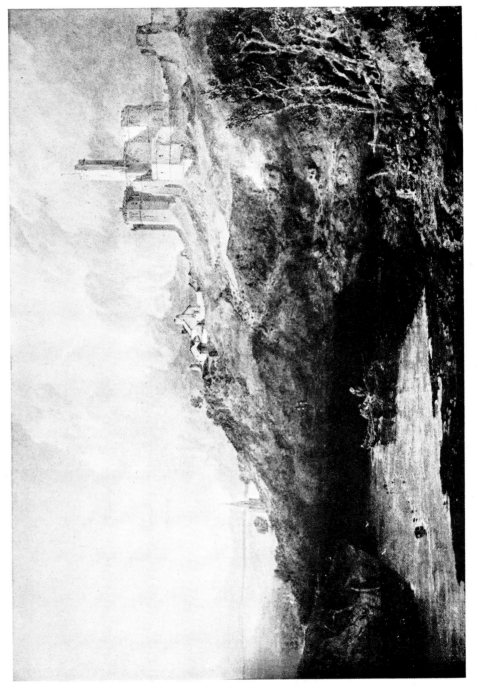

188. Joseph Mallord William Turner, r.a. *Warkworth Castle, Northumberland.* 20½×29½ inches. Exhibited at the R.A. in 1799. Ex. Coll. Ellison. Victoria and Albert Museum

PLATE XCIV

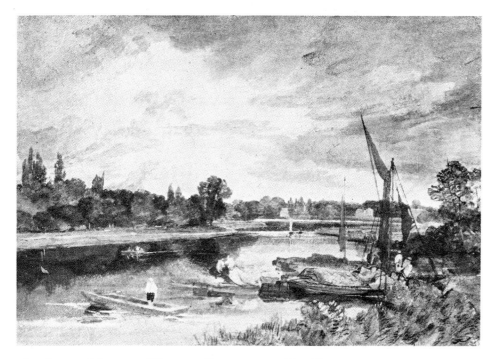

189. JOSEPH MALLORD WILLIAM TURNER, R.A. *The Thames near Windsor.* $10\frac{1}{8} \times 14\frac{1}{2}$ inches. British Museum

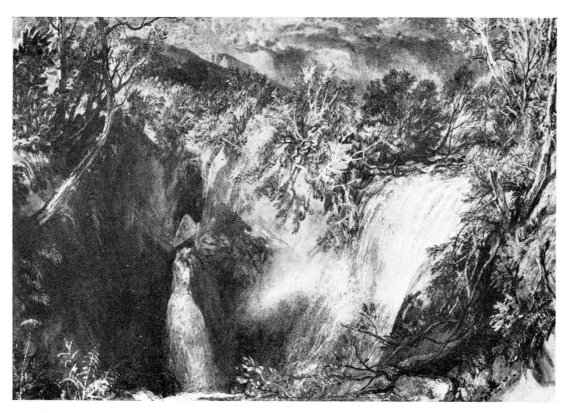

190. JOSEPH MALLORD WILLIAM TURNER, R.A. *Weathercote Cave, near Ingleton.* $11\frac{5}{8} \times 16\frac{3}{4}$ inches.
British Museum

PLATE XCV

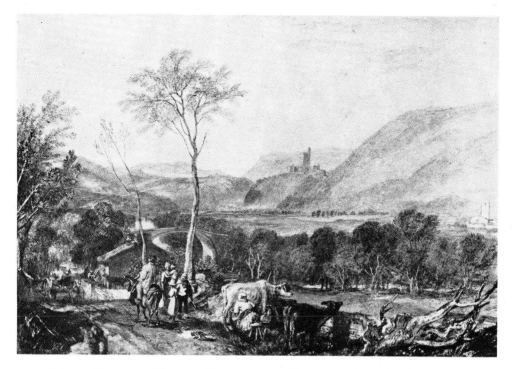

191. JOSEPH MALLORD WILLIAM TURNER, R.A. *Hornby Castle, Lancashire, from Tatham Church.* $11\frac{1}{2} \times 16\frac{1}{2}$ inches. Engraved 1823. Ex Coll. Sheepshanks.

Victoria and Albert Museum

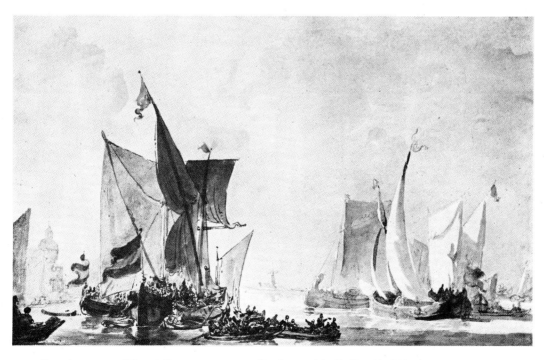

192. SIR AUGUSTUS WALL CALLCOTT, R.A. *Seapiece, with (? Dutch) Shipping.* $12\frac{3}{4} \times 20\frac{3}{8}$ inches. Sepia.

Victoria and Albert Museum

PLATE XCVI

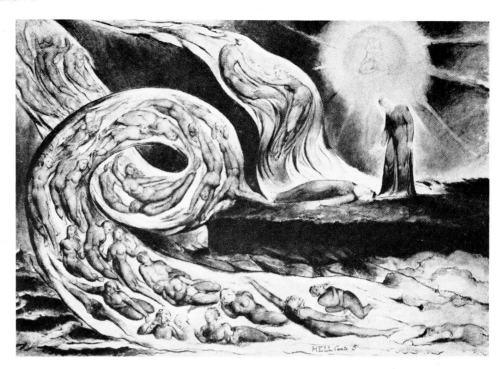

193. WILLIAM BLAKE. *The Whirlwind of Lovers (Inferno. Canto v.). c.* 14½×20½ inches.
Ex Coll. J. Linnell. Birmingham City Art Gallery

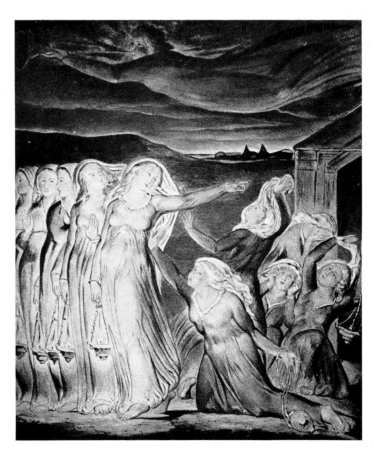

194. WILLIAM BLAKE. *The Ten Virgins.* 15¾×13 inches. Ex Coll.
T. Butts. Tate Gallery

PLATE XCVII

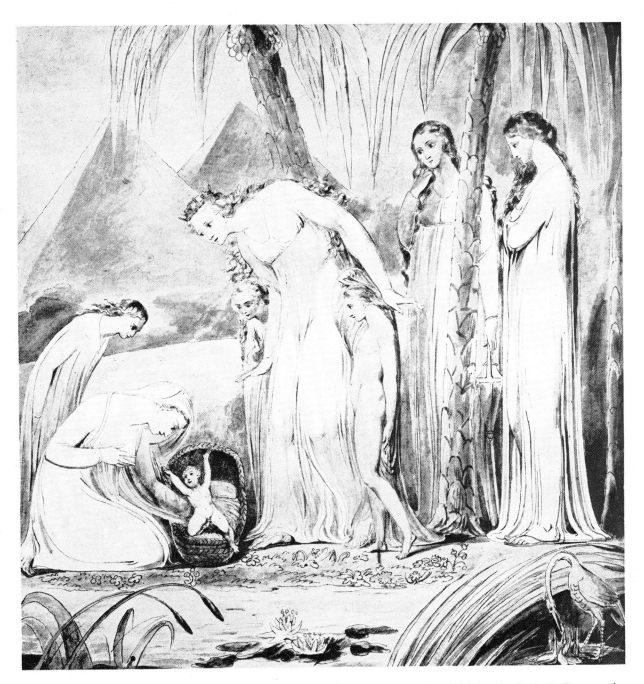

195. WILLIAM BLAKE. *The Finding of Moses*. 12⅝ × 12¾ inches. Signed with initials. Ex Coll. T. Butts and
W. Graham Robertson. Victoria and Albert Museum

PLATE XCVIII

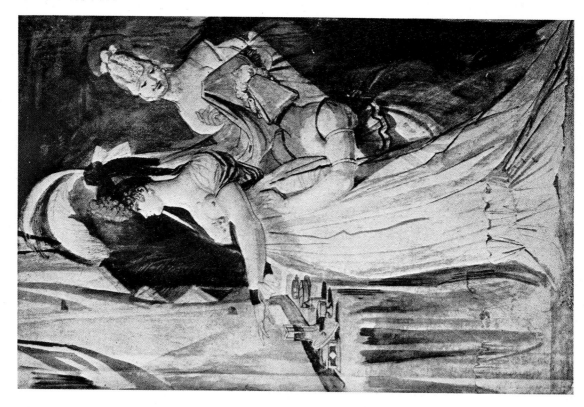

197. HENRY FUSELI, R.A. *The Dressing Table.* 17½ × 11½ inches.
Pencil and wash with some colour.
Mr Brinsley Ford

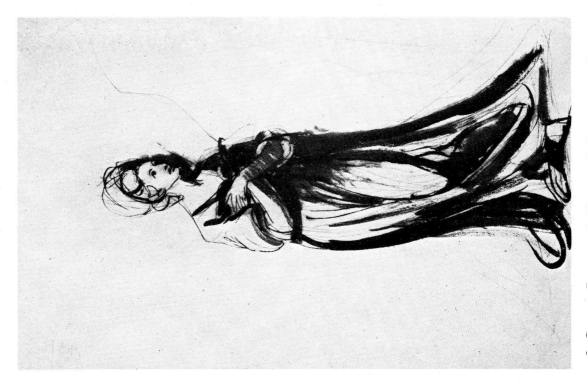

196. GEORGE ROMNEY. *A Woman with Folded Arms.* 18¾ × 11½
inches. Pen and ink wash. Ex Coll. Miss Romney; H. Horne
and Sir E. Marsh.
Mr Brinsley Ford

PLATE XCIX

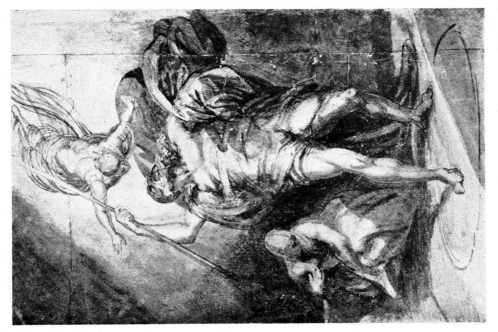

199. JOHN BROWN. *The Magician.* 12½×8⅛ inches. Signed with initials. Pen, pencil, brown and grey wash and white.

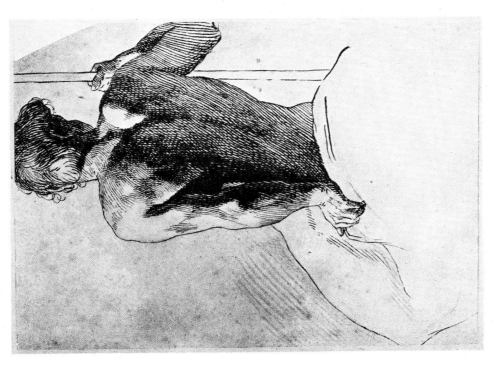

198. JAMES BARRY, R.A. *A Nude Horseman.* 17⅞×12⅛ inches. Pen and black chalk on paper stained with ? oil.

PLATE C

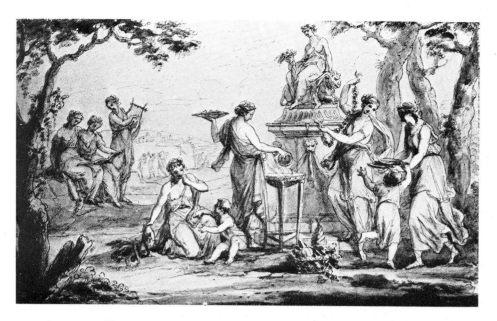

200. ANGELICA KAUFFMANN, R.A. *A Sacrifice to Ceres.* $8 \times 13\frac{1}{4}$ inches. Pen and sepia wash. British Museum

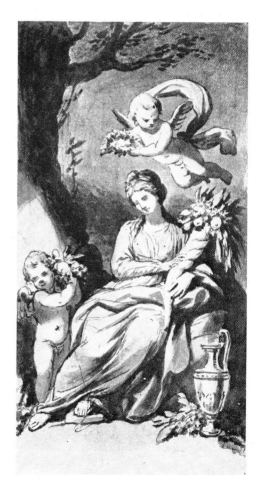

201. BIAGIO REBECCA, A.R.A. *Plenty.* $9\frac{1}{2} \times$ 5 inches. British Museum

PLATE CI

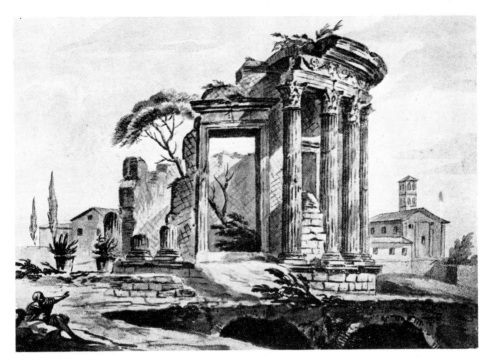

202. Antonio Pietro Zucchi, a.r.a. *The Temple of the Sibyl, Tivoli.* $10\frac{1}{4} \times 14\frac{3}{4}$ inches. Sepia, Indian ink, and touches of watercolour. Ex Coll. Cracherode.

British Museum

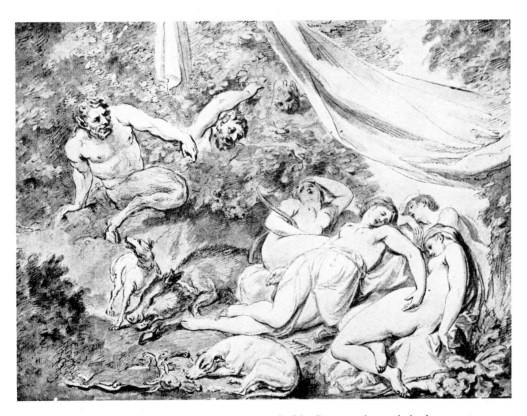

203. Giovanni Battista Cipriani. *Nymphs surprised by Satyrs.* $12\frac{1}{2} \times 17\frac{1}{16}$ inches.

Victoria and Albert Museum

PLATE CII

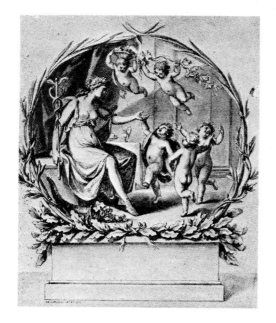

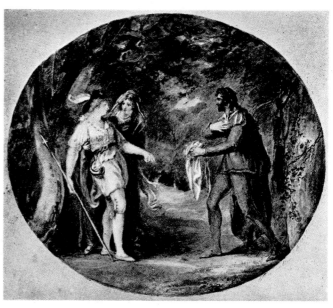

204. GIOVANNI BATTISTA CIPRIANI, R.A. *Ticket for the Ball at the Mansion House, April 17, 1775.* $8\frac{5}{8} \times 7\frac{1}{4}$ inches. Pen and Indian ink wash. Signed. Engraved by Bartolozzi 1775.

205. WILLIAM HAMILTON, R.A. *Illustration to 'As You Like It'.* $8\frac{3}{8} \times 9\frac{7}{8}$ inches. Signed and dated 1796. Ex Coll. J. M. W. Turner? British Museum

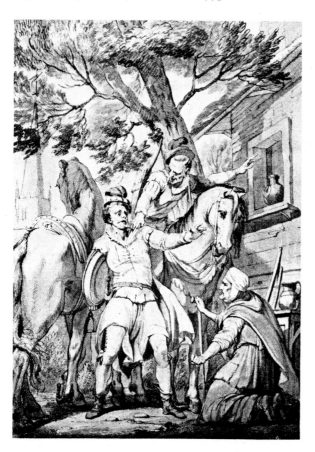

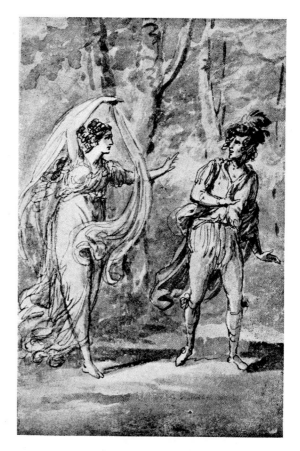

206. JOHN HAMILTON MORTIMER, A.R.A. *The Sompnour, the Devil, and the Widow.* $8\frac{1}{8} \times 5\frac{7}{8}$ inches. Ex Coll. W. Smith. Victoria and Albert Museum

207. THOMAS STOWERS. *Figures in a Wood.* $4\frac{3}{4} \times 3$ inches. Pen and Indian ink wash. Inscribed with the artist's name. Ex Coll. Stowers family.

PLATE CIII

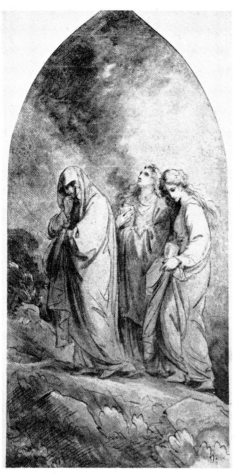

208. BENJAMIN WEST, P.R.A. *The Three Marys*. 16¼ × 8¼ inches. Signed and dated 1783. Design for window, St George's Chapel, Windsor. Presumably exhibited at R.A. 1783. Ex Coll. Sir R. Witt.

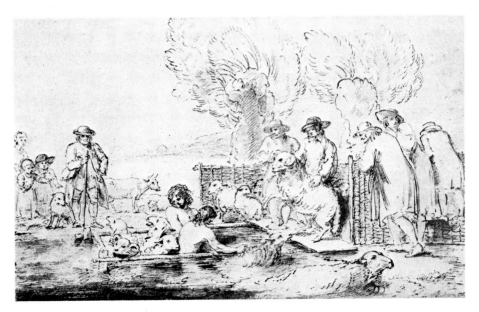

209. BENJAMIN WEST, P.R.A. *Sheep Washing*. 12 × 19¾ inches. Signed and dated 1783. Victoria and Albert Museum

PLATE CIV

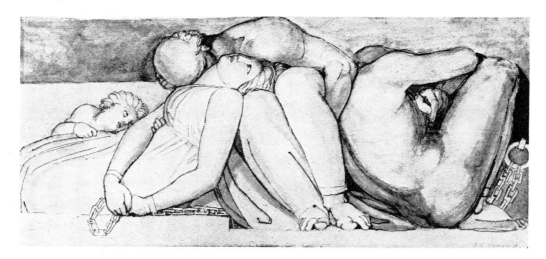

210. JOHN FLAXMAN, R.A. *Deliver the Captives; one of the Acts of Mercy.* 5¾ × 13 inches. Pen with
Indian ink and sepia wash. Signed. Engraved by F. C. Lewis. British Museum

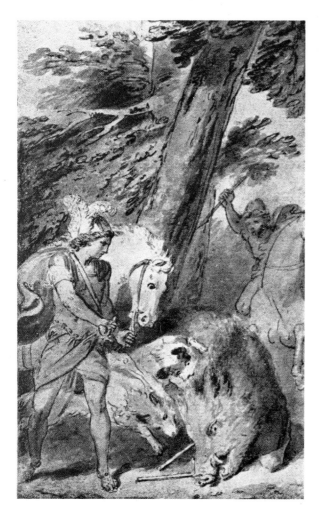

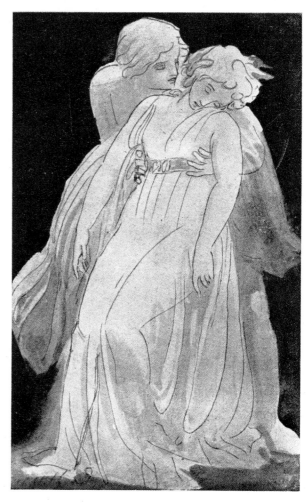

211. THOMAS STOTHARD, R.A. *Illustration to Whitehead's
'Atys and Adrastus'.* 4¾ × 2⅞ inches. Pen and grey-brown
wash. Engraved in *Lady's Poetical Magazine*, 1781.

212. THOMAS STOTHARD, R.A. *Solicitude.* 7⅞ × 4⅜ inches.
Pen and brownish-black wash. With spurious signa-
ture. Ex Coll. Lady Callcott.

PLATE CV

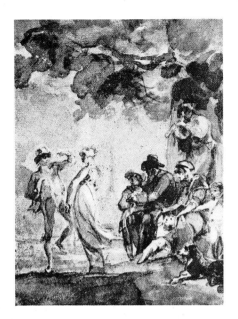

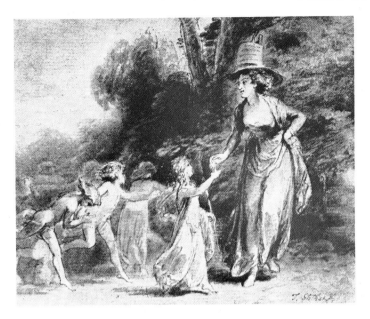

213. THOMAS STOTHARD, R.A. *Illustration to 'The Deserted Village'*. $6\frac{3}{4} \times 5\frac{1}{8}$ inches. Pencil and grey wash touched with sepia. Ex Coll. H. Horne and Sir E. Marsh.　　　Mr H. C. Green

214. THOMAS STOTHARD, R.A. *Titania and the Fairies*. $4\frac{3}{4} \times 6$ inches. With spurious signature. Ex Coll. Lady Callcott.
Mrs Ralph Keene

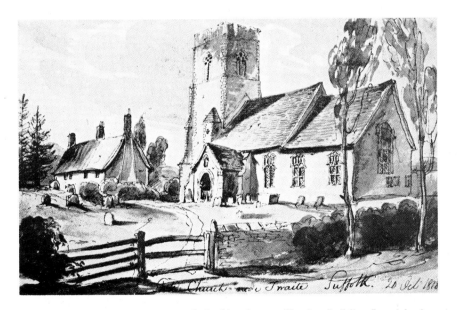

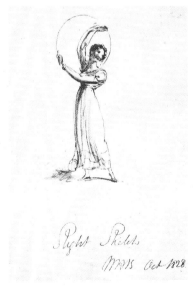

215. WILLIAM HENRY BROOKE. *Stoke Church, near Twaite, Suffolk*. $4\frac{7}{8} \times 7\frac{1}{2}$ inches. Inscribed by the artist and dated 1818.

216. WILLIAM HENRY BROOKE. *A Dancer*. $6\frac{1}{4} \times 4\frac{1}{4}$ inches. Signed with initials and dated 1828.

PLATE CVI

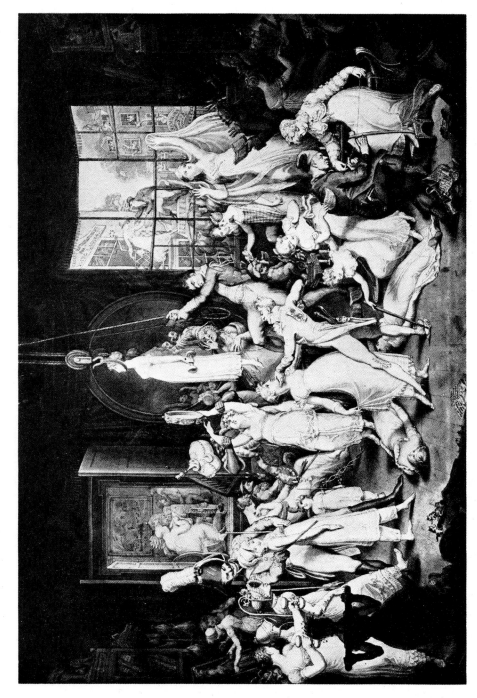

PLATE CVII

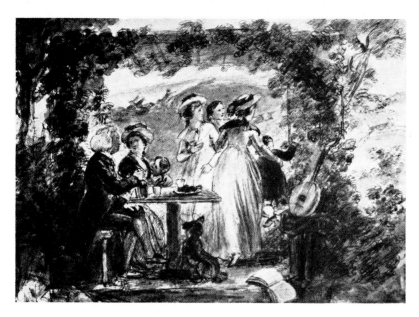

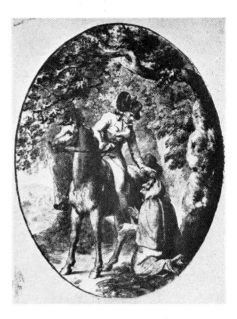

218. JOHN MASEY WRIGHT. *Illustration to 'The Vicar of Wakefield'.* 9×13 inches. Mr H. C. Green

219. RICHARD CORBOULD. *Illustration to 'Ferdinand, Count Fathom' by T. Smollett.* $3\frac{1}{4}\times2\frac{5}{8}$ inches.
Victoria and Albert Museum

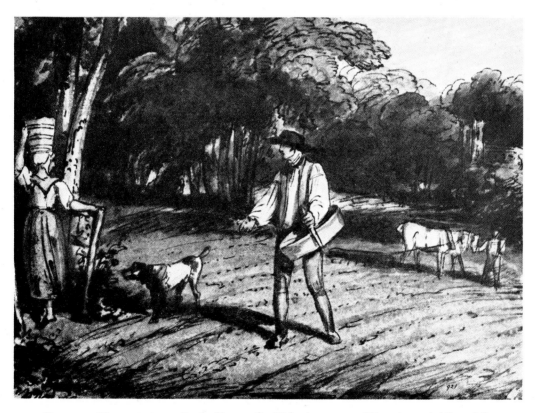

220. RICHARD WESTALL, R.A. *Rustic Figures.* $6\times8\frac{1}{2}$ inches. Victoria and Albert Museum

PLATE CVIII

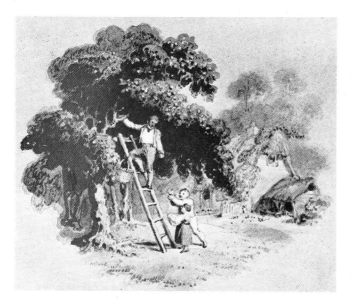

221. RICHARD WESTALL, R.A. *Picking Apples (vignette)*. 5⅞×7⅛ inches.

222. WILLIAM MARSHALL CRAIG *Vignette for Title Page of Cowper's Poems, Vol. II.* 8⅞×5½ inches. (Portions blank save for signature not shown.) Signed and dated 1813. Pen and Indian ink wash. Engraved.

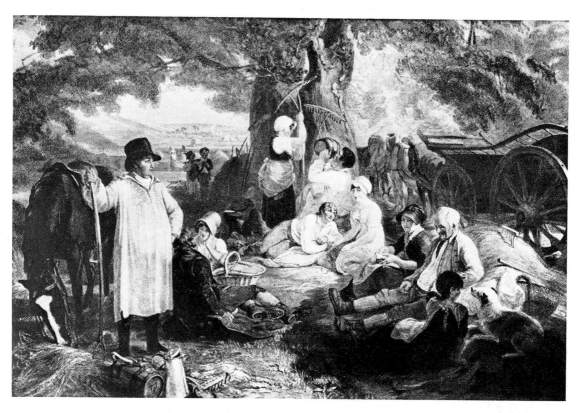

223. THOMAS UNWINS, R.A. *Haymakers at Dinner.* 18⅞×27⅝ inches. Signed. Probably exhibited at Old Water-Colour Society, 1812. Ex Coll. W. Smith. Victoria and Albert Museum

PLATE CIX

224. JOHN AUGUSTUS ATKINSON. *Two French Officers taken by a British Soldier.* 8¾×11 inches. Aquatinted by Dubourg, 1817. Mr H. C. Green

225. JOHN AUGUSTUS ATKINSON. *The Poet.* 9¼×6¾ inches. Aquatinted by E. Orme, 1819.
 Mr Gilbert Davis

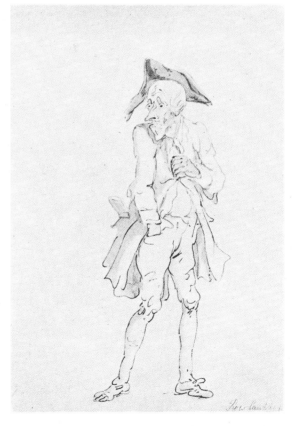

226. THOMAS ROWLANDSON. *A Grub-Street Poet.* 9⅞×7⅛ inches. Pen and water-colour. Ex Coll. T. Churchyard? and Barlow family.

PLATE CX

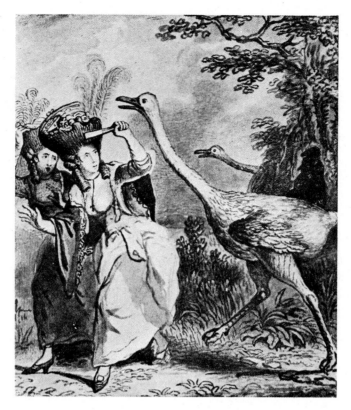

227. JOHN COLLET. *The Feathered Fair in a Fright.* $6\frac{7}{8} \times 6\frac{1}{8}$ inches. Engraved *c.*1777.

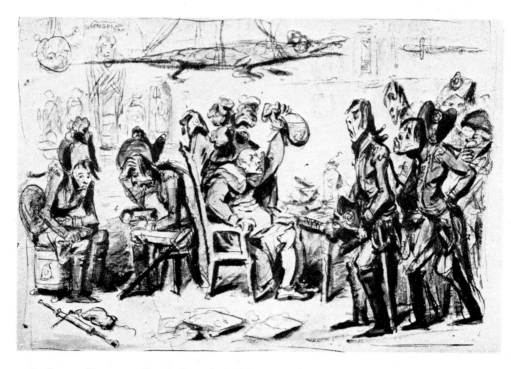

228. JAMES GILLRAY. *French Generals Retiring on account of their Health.* $12\frac{1}{4} \times 15\frac{3}{4}$ inches. Dated 1799. Etched with variations. British Museum

PLATE CXI

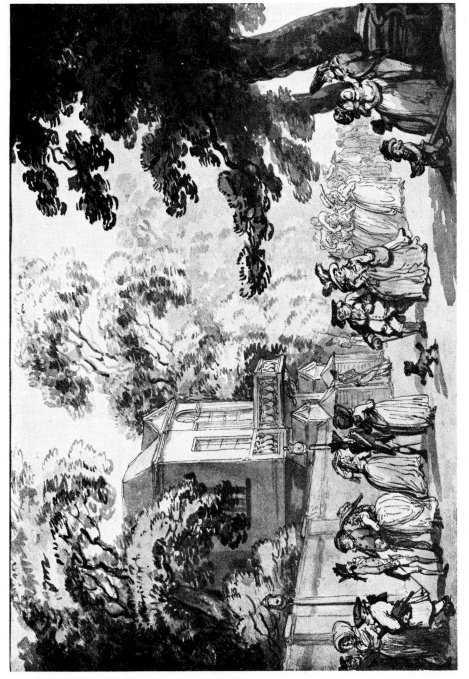

229. Thomas Rowlandson. *Entrance to Spring Gardens.* $13\frac{1}{4} \times 18\frac{9}{16}$ inches. Ex Coll. Desmond Coke.
Victoria and Albert Museum

PLATE CXII

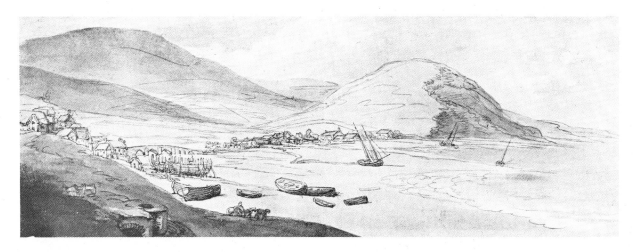

230. THOMAS ROWLANDSON. *The Mouths of the Rheidol and Ystwyth at Aberystwyth.* 6 $\frac{3}{32}$ × 18 $\frac{9}{16}$ inches. Ex Coll. Desmond Coke. Victoria and Albert Museum

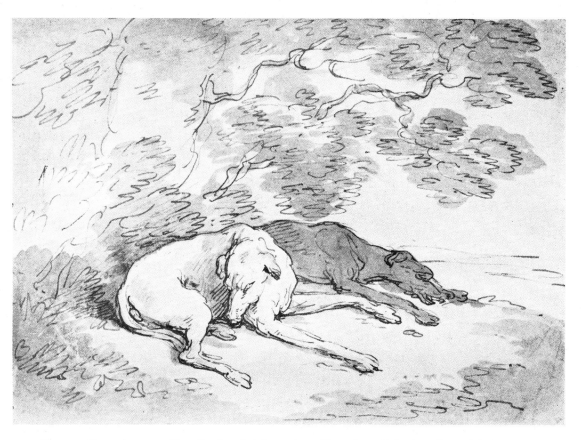

231. THOMAS ROWLANDSON. *Two Greyhounds lying under a Tree.* 7 $\frac{1}{8}$ × 9 $\frac{13}{16}$ inches. Pen with grey and pale brown washes. Mr L. G. Duke

PLATE CXIII

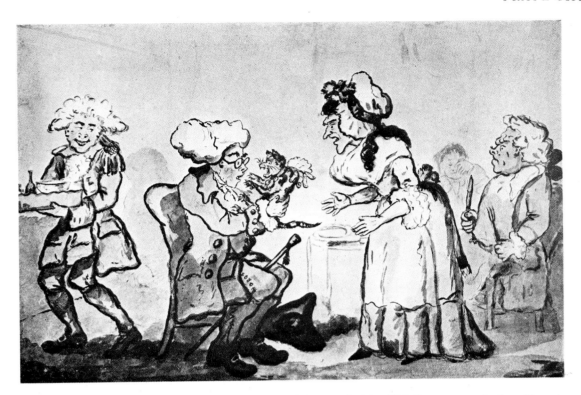

232. GEORGE MOUTARD WOODWARD. *A Favourite Cat choaked with a Fish Bone.* 12 × 19 inches. Signed and dated 1790 on mount.

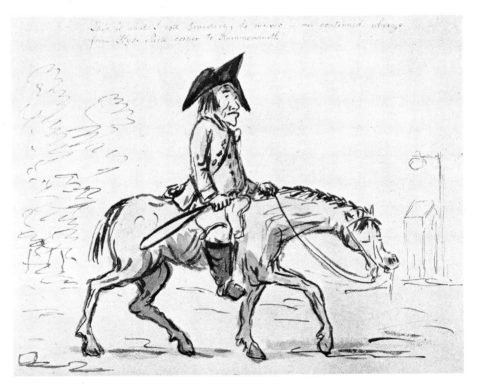

233. GEORGE MOUTARD WOODWARD. *A Whistler!!* 7½ × 10 inches. Inscribed by artist. Engraved by Rowlandson, 1799.

PLATE CXIV

234. JOHN NIXON. *A Reading from 'Jane Shore'.* $7\frac{1}{2} \times 9\frac{3}{4}$ inches. Signed and dated 1788.
British Museum

235. ISAAC CRUIKSHANK. *The Sailor's Sweetheart.*
$11\frac{1}{2} \times 8\frac{7}{8}$ inches. British Museum

PLATE CXV

236. ROBERT DIGHTON. *A Windy Day—Scene outside the Shop of Bowles, the Printseller, in St Paul's Church-yard.* $12\frac{5}{8} \times 9\frac{5}{8}$ inches. Victoria and Albert Museum

237. JOHN BOYNE. *A Meeting of Connoisseurs.* $16\frac{1}{4} \times 21\frac{7}{8}$ inches. Signed. Engraved 1807.
Victoria and Albert Museum

PLATE CXVI

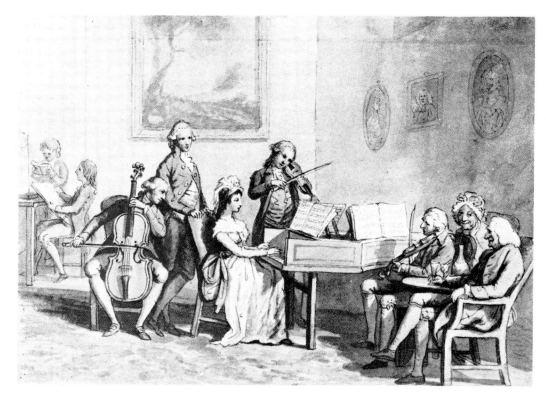

238. Samuel Collings. *Drawing-room Music.* 11¾×17 inches. Walker's Galleries

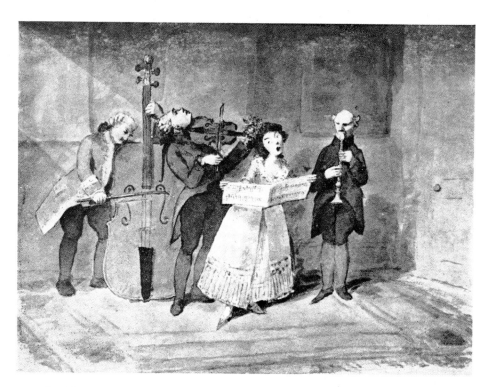

239. Sir Nathaniel Dance Holland, R.A. *or* George Dance, junior, R.A. *Conquering a Chromatic Passage.* 6⅝×8½ inches. Mr L. G. Duke

PLATE CXVII

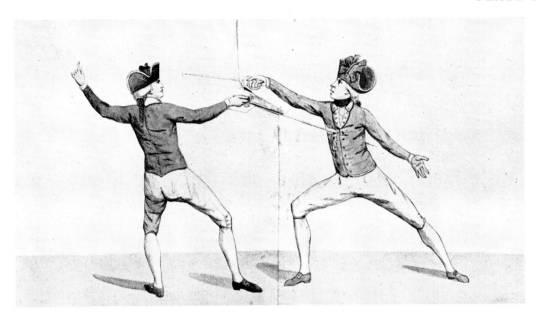

240. JAMES ROBERTS. *A Duel.* $6\frac{1}{4} \times 10\frac{3}{4}$ inches. Signed 'Drawn from the life by James Roberts. 1779'.

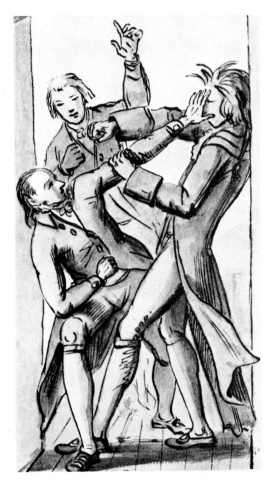

241. GEORGE SHEPHEARD. *Men Fighting in a Doorway.* $8\frac{3}{8} \times 6$ inches. Inscribed on back in the artist's hand 'Haughton Field and Shepheard'.

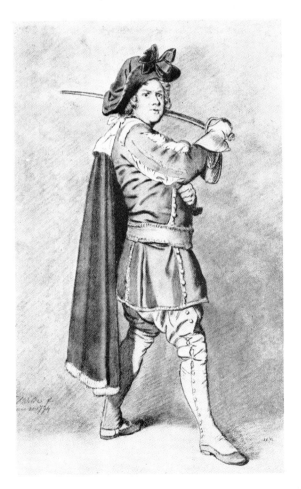

242. SAMUEL DE WILDE. *G. D. Harley as Kent in 'King Lear'.* 14×9 inches. Signed and dated 1794. Victoria and Albert Museum

PLATE CXVIII

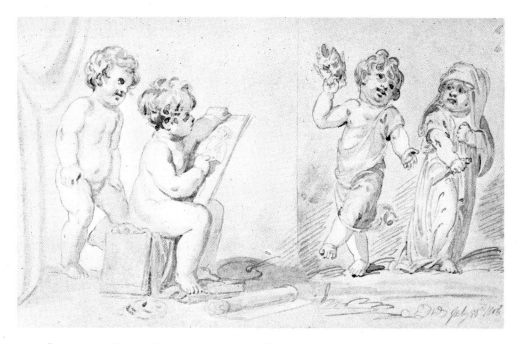

243. Samuel de Wilde. *Painting, Comedy and Tragedy.* $8\frac{1}{4} \times 12\frac{7}{8}$ inches. Signed with initials and dated 1806.

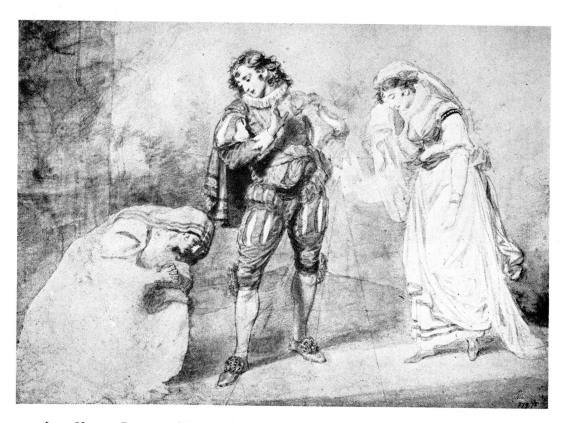

244. John Hodges Benwell. *Pierre du Terrail, Chevalier de Bayard.* $9 \times 12\frac{1}{2}$ inches.

Victoria and Albert Museum

PLATE CXIX

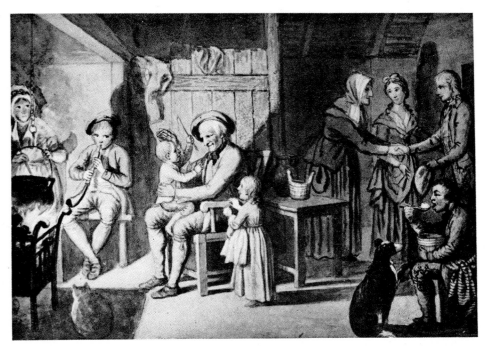

245. DAVID ALLAN. *Scottish Domestic Scene.* 12 7/16 × 18 inches. Glasgow Art Gallery

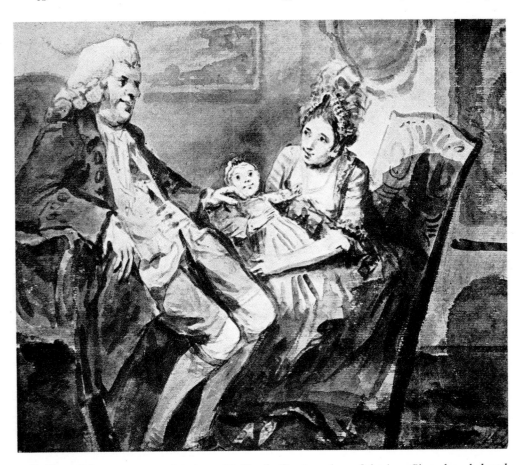

246. ELIAS MARTIN, A.R.A. *Interior, with Family Group.* 10½ × 11¾ inches. Signed and dated
1771. Victoria and Albert Museum

PLATE CXX

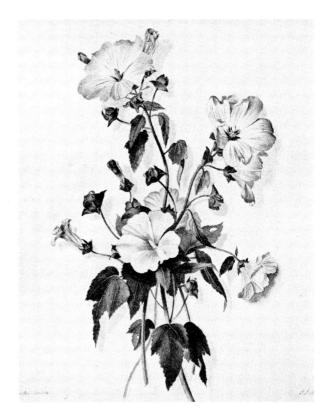

247. JAMES SILLETT. *Garden Mallows*. $16\frac{1}{2} \times 12\frac{1}{4}$ inches.
Signed with initials and dated 1803. Ex Coll. J. Reeve.
British Museum

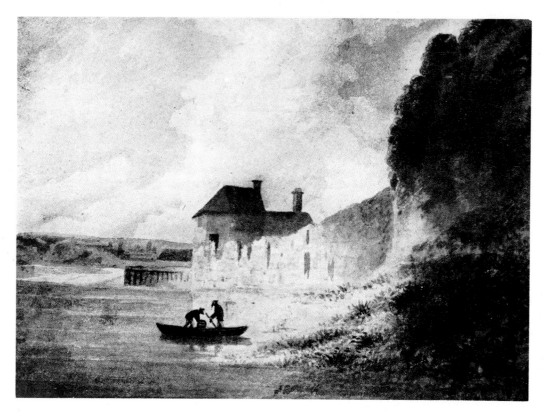

248. ROBERT LADBROOKE. *Old Wall at Carrow Abbey*. $6\frac{1}{8} \times 8\frac{1}{2}$ inches. Ex Coll. J. Reeve.
British Museum

PLATE CXXI

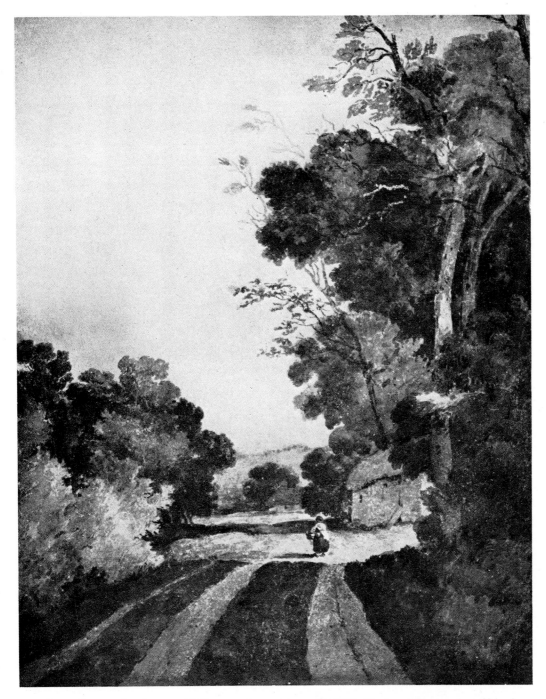

249. JOHN CROME. *Landscape, with Cottages*. Sometimes called *The Shadowed Road*. 20½ × 16¾ inches.
Victoria and Albert Museum

PLATE CXXII

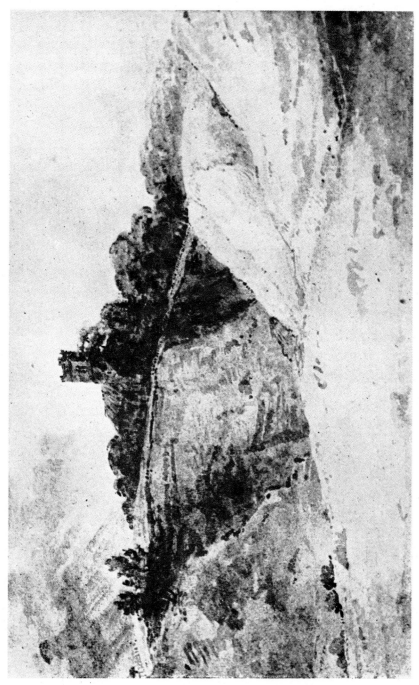

250. JOHN CROME. *Whitlingham.* $10\frac{7}{8} \times 17\frac{1}{2}$ inches. Grey-brown monochrome. Colman Collection, Castle Museum, Norwich

PLATE CXXIII

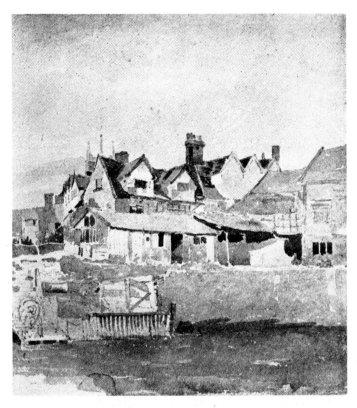

251. JOHN THIRTLE. *St Miles, Norwich.* $10\frac{1}{4} \times 9\frac{1}{4}$ inches. Ex
Coll. J. Reeve. British Museum

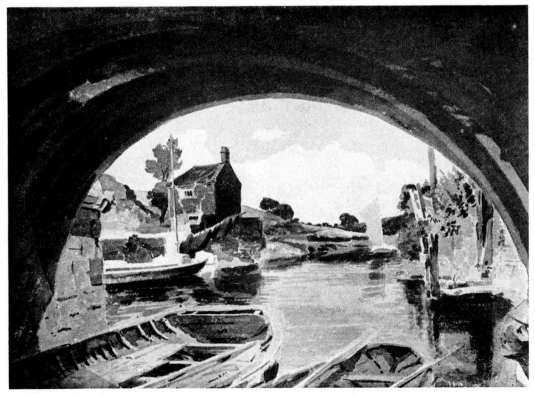

252. JOHN THIRTLE. *Under Bishop Bridge.* $11\frac{3}{8} \times 15\frac{1}{2}$ inches. Ex Coll. J. Reeve. British Museum

PLATE CXXIV

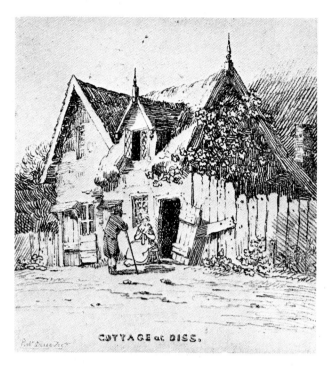

253. ROBERT DIXON. *Cottage at Diss.* $8\frac{7}{8} \times 7$ inches. Soft-ground etching signed and dated 1810. *Cf.* 254.

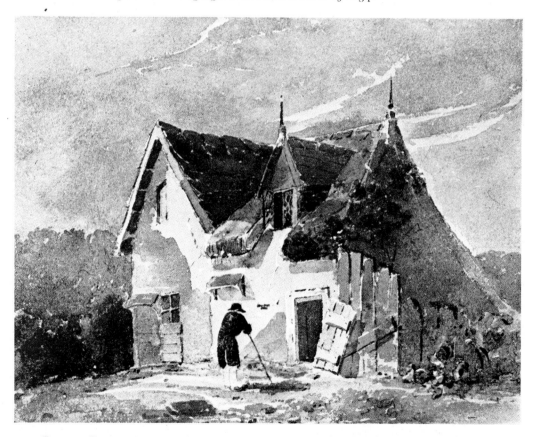

254. ROBERT DIXON. *Cottage at Diss.* $6\frac{5}{8} \times 8\frac{5}{8}$ inches. Watercolour study for 253.

PLATE CXXV

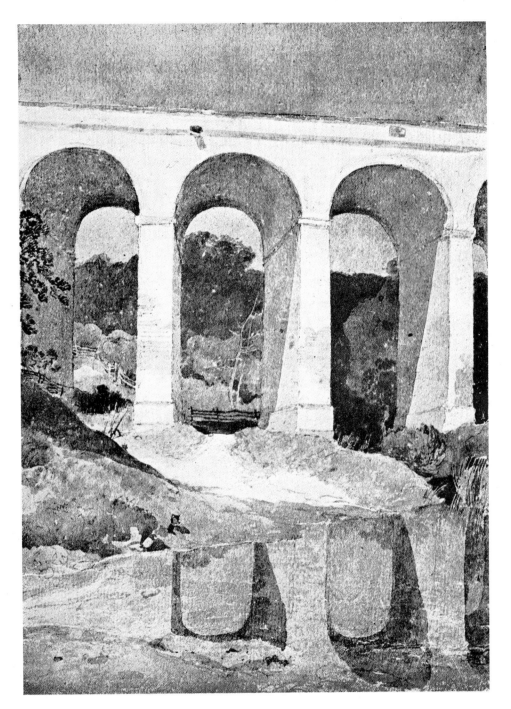

255. JOHN SELL COTMAN. *Chirk Aqueduct*. 12 $\frac{7}{16}$ × 9 $\frac{1}{8}$ inches. Victoria and Albert Museum

PLATE CXXVI

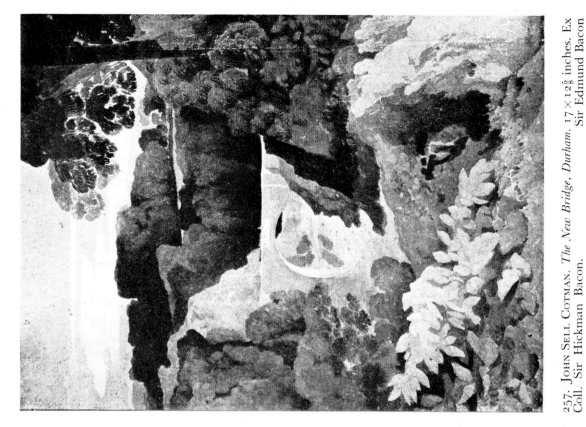

257. JOHN SELL COTMAN. *The New Bridge, Durham.* 17 × 12⅝ inches. Ex Coll. Sir Hickman Bacon. Sir Edmund Bacon

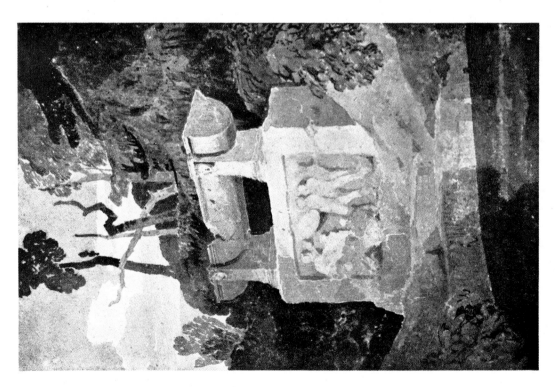

256. JOHN SELL COTMAN. *A Sarcophagus in a Pleasure Ground.* 13 × 8⅞ inches. Ex Coll. Dawson Turner. British Museum

PLATE CXXVII

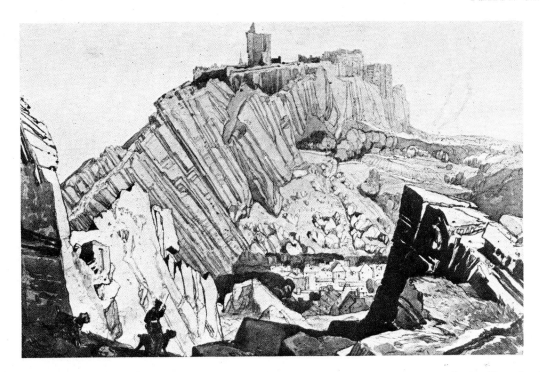

258. JOHN SELL COTMAN. *Domfront: Looking to the South-east.* $15\frac{15}{16} \times 10\frac{3}{16}$ inches. Sepia. Signed. Ex Coll. W. Gurney. Mr Martin Hardie

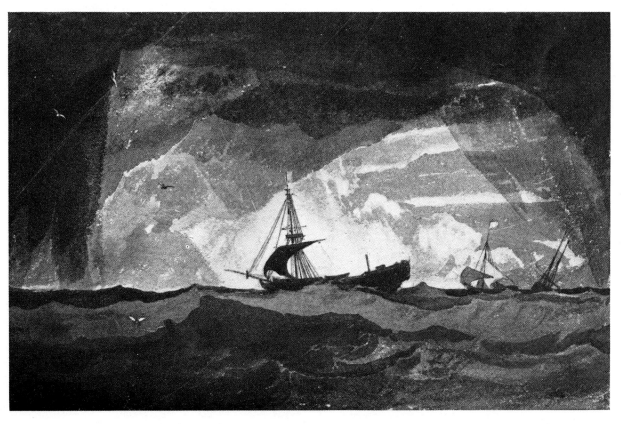

259. JOHN SELL COTMAN. *A Dismasted Brig.* $7\frac{3}{4} \times 12\frac{1}{8}$ inches. Ex Coll. J. Reeve. British Museum

PLATE CXXVIII

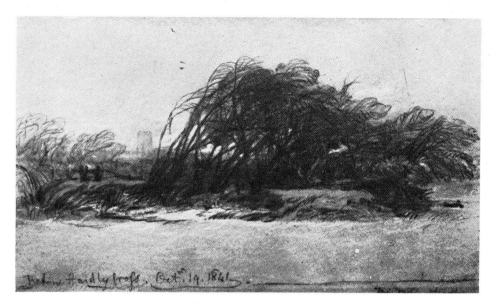

260. JOHN SELL COTMAN. *The World Afloat.* $8\frac{3}{4} \times 14\frac{1}{4}$ inches. Black chalk. Inscribed by the artist and dated 1841. Ex Coll. J. Reeve.

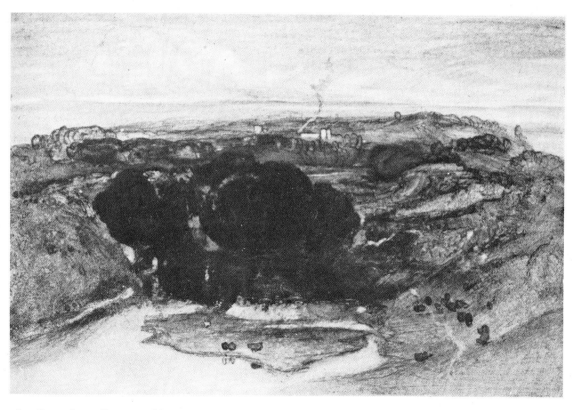

261. JOHN SELL COTMAN. *The Lake.* $7\frac{1}{16} \times 10\frac{9}{16}$ inches. Victoria and Albert Museum

PLATE CXXIX

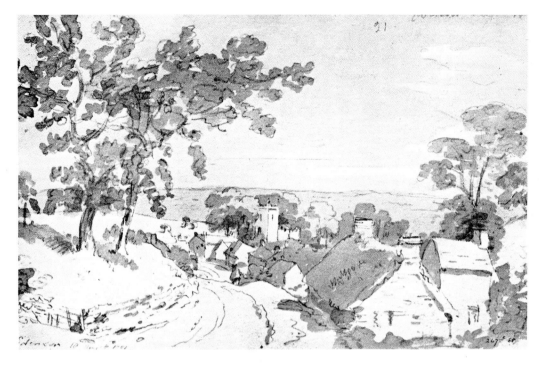

262. JOHN CONSTABLE, R.A. *Edensor*. $6\frac{7}{8} \times 10\frac{3}{8}$ inches. Pencil and Indian ink wash. Dated 1801. Ex Coll. Miss I. Constable. Victoria and Albert Museum

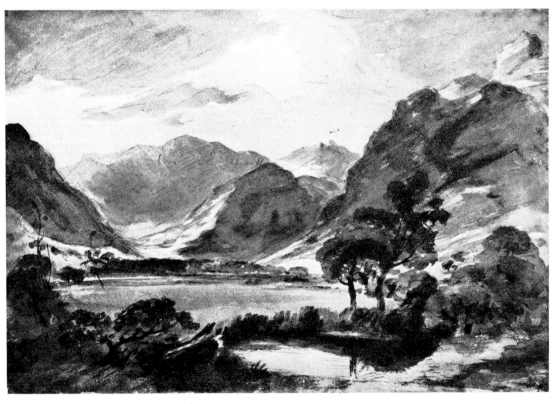

263. JOHN CONSTABLE, R.A. *Mountain Scene, Langdale*. $13\frac{1}{2} \times 19$ inches. Pencil and Indian ink wash. Dated 1806. Ex Coll. Miss I. Constable. Victoria and Albert Museum

PLATE CXXX

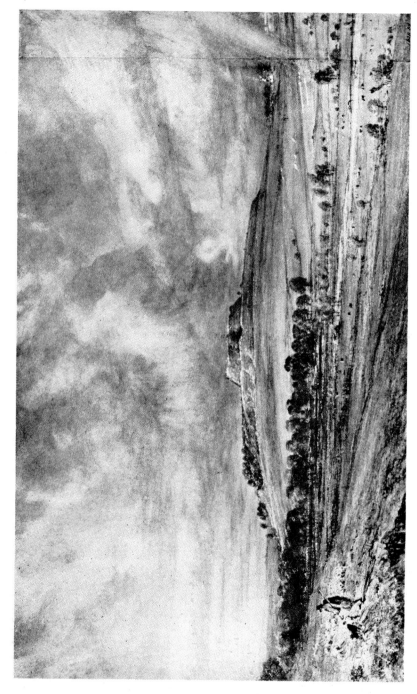

264. JOHN CONSTABLE, R.A. *Old Sarum.* $11\frac{1}{2} \times 19$ inches. Presumably the drawing exhibited at the R.A. 1834. Ex Coll. Miss I. Constable. Victoria and Albert Museum

PLATE CXXXI

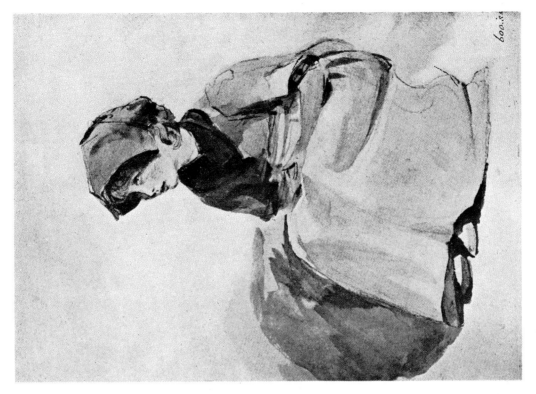

266. JOHN CONSTABLE, R.A. *Rustic Girl Seated.* $7\frac{3}{8} \times 5\frac{1}{4}$ inches. Ex Coll. Miss I. Constable.
Victoria and Albert Museum

265. JOHN CONSTABLE, R.A. *East Bergholt Church, with Elm Trees. View from the West.* $12 \times 7\frac{3}{4}$ inches. Black chalk. Dated 1812. Ex Coll. Miss I. Constable.
Victoria and Albert Museum

PLATE CXXXII

267. JOHN CONSTABLE, R.A. *Landscape Study*. $8\frac{3}{8} \times 7\frac{1}{8}$ inches. Ex Coll. Miss I. Constable.
Victoria and Albert Museum

PLATE CXXXIII

268. AGOSTINO AGLIO. *Landscape, probably on the South Coast.* 7¾×11 inches. Signed and dated 1829 on the back.

269. JOHN HARDEN. *A Family Party, about* 1822. Approximately 8×10 inches. Sepia.
Miss A. L. Mather

PLATE CXXXIV

270. CHARLES BARBER. *Interior of a Church.* 13¼ × 18¼ inches. Signed and dated 1816.
Mr H. C. Green

271. DAVID COX. *Windsor Castle.* 6¾ × 10¼ inches. Sepia. Ex Coll. J. Orrock.
Victoria and Albert Museum

PLATE CXXXV

272. David Cox. *Between Pont Aberglaslyn and Festiniog.* $7\frac{3}{4} \times 10\frac{1}{4}$ inches. Signed. Ex Coll.
J. Henderson. British Museum

273. David Cox. *Snowdon Range.* $10\frac{3}{4} \times 14\frac{3}{8}$ inches. Signed and dated 1833. Ex Coll.
J. Henderson. British Museum

PLATE CXXXVI

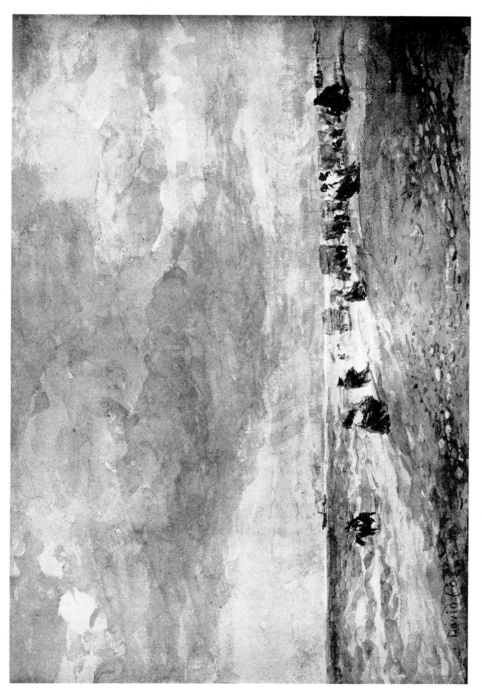

274. DAVID COX. *Rhyl Sands*. 10 $\frac{5}{16}$ × 14 $\frac{1}{4}$ inches. Signed.

Victoria and Albert Museum

PLATE CXXXVII

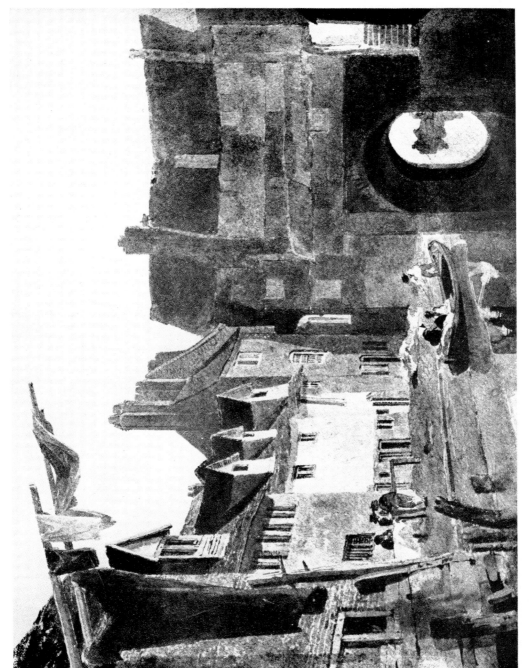

275. Peter De Wint. *Old Houses on the High Bridge, Lincoln.* $15\frac{5}{8} \times 20\frac{3}{8}$ inches. Victoria and Albert Museum

PLATE CXXXVIII

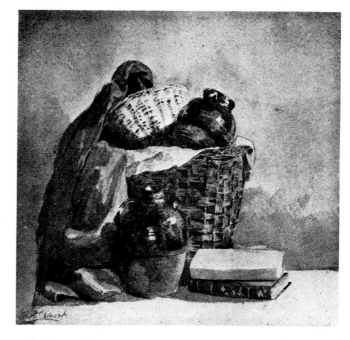

276. PETER DE WINT. *Still Life.* $8\frac{7}{8} \times 9\frac{5}{8}$ inches. Signed or inscribed. British Museum

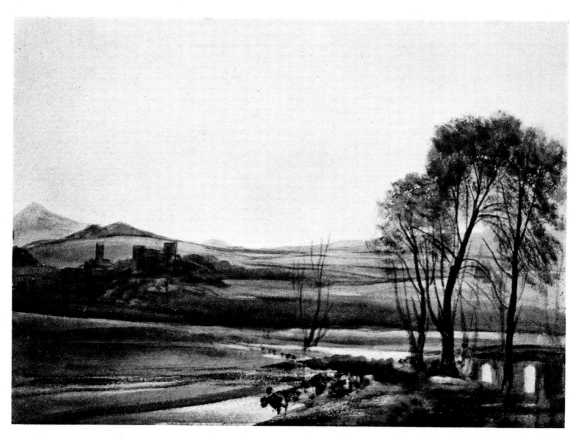

277. PETER DE WINT. *Clee Hills.* 15×21 inches. Ex Coll. Sir Hickman Bacon. Sir Edmund Bacon

PLATE CXXXIX

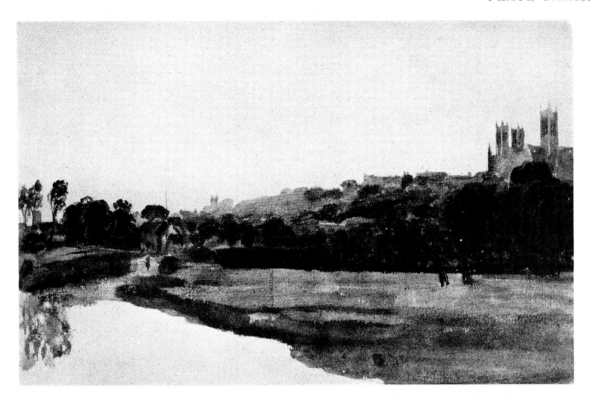

278. PETER DE WINT. *Lincoln from the River.* $12\frac{1}{2} \times 19\frac{1}{4}$ inches. Ex Coll. Sir Hickman Bacon.

Sir Edmund Bacon

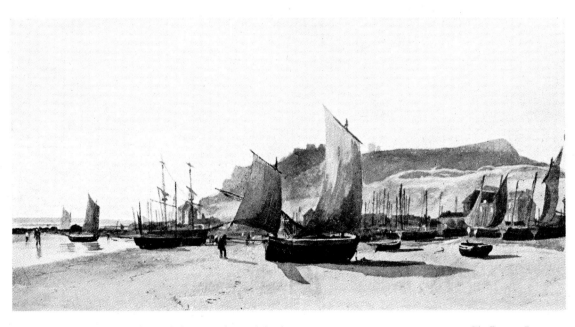

279. SAMUEL PROUT. *A Beach Scene.* $11\frac{3}{8} \times 19\frac{1}{2}$ inches.　　　　　　　　　Sir Bruce Ingram

PLATE CXL

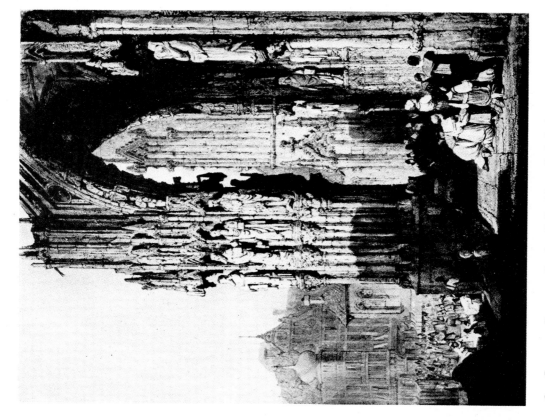

281. Samuel Prout. *Porch of Ratisbon Cathedral.* $25\frac{3}{4} \times 18\frac{1}{4}$ inches.
Signed. Ex Coll. Ellison. Victoria and Albert Museum

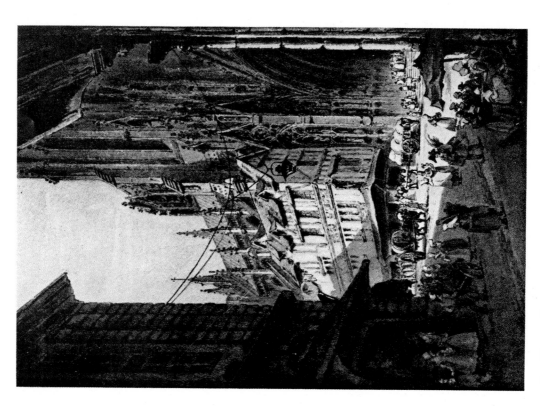

280. Henry Edridge, A.R.A. *South Portal, Rouen Cathedral, from the
Place de la Calende.* $15\frac{5}{8} \times 10\frac{5}{8}$ inches. Ex Coll. J. E. Taylor.
Victoria and Albert Museum

PLATE CXLI

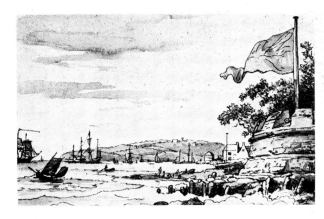

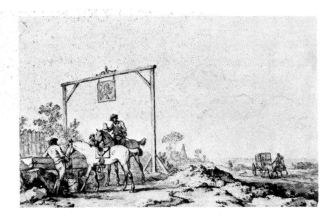

282. PHILIP JAMES DE LOUTHERBOURG, R.A. *West Cowes.*
5 × 7¾ inches. Pen and sepia, washed with Indian ink.
Ex Coll. White. British Museum

283. PHILIP JAMES DE LOUTHERBOURG, R.A. *Men Watering Horses by an Inn Sign.* 7⅞ × 12 inches. Pencil and sepia.
 Mr L. G. Duke

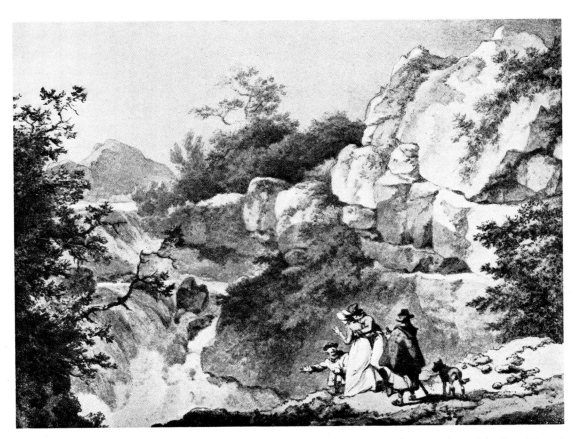

284. PHILIP JAMES DE LOUTHERBOURG, R.A. *Cataract on the Llugwy, near Conway.* 9½ × 12¼ inches. Signed.
Engraved 1808. Victoria and Albert Museum

PLATE CXLII

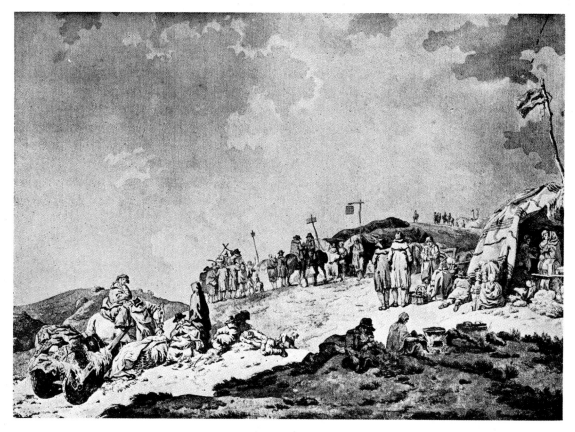

285. FRANCIS WHEATLEY, R.A. *Donnybrook Fair.* 15 1/32 × 21 5/16 inches. Signed, and dated 1783.
Victoria and Albert Museum

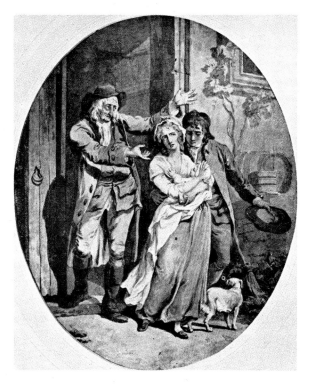

286. FRANCIS WHEATLEY, R.A. *The Dismissal.* 13 3/8 ×
11 1/4 inches. Signed, and dated 1786. Ex Coll. W.
Smith. Victoria and Albert Museum

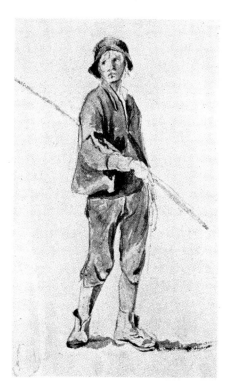

287. JOHN RENTON. *Boy with Fishing
Rod.* 9 7/8 × 6 inches. Dated 1807 on the
back. Ex Coll. L. G. Duke

PLATE CXLIII

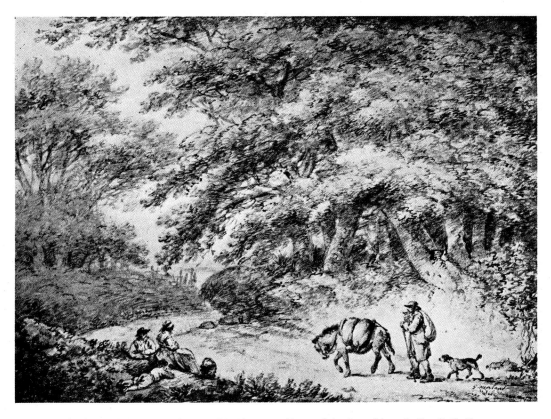

288. GEORGE MORLAND. *Landscape with Figures.* $9\frac{11}{16} \times 13\frac{2}{3}$ inches. Signed. Ex Coll. Dyce.
Victoria and Albert Museum

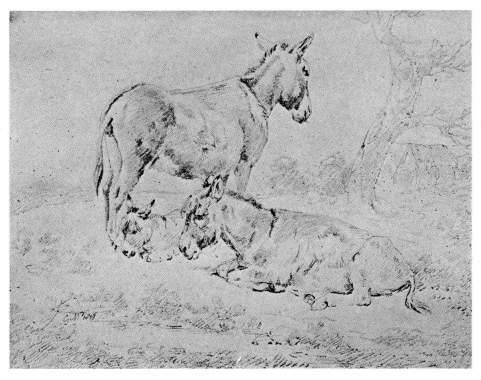

289. GEORGE MORLAND. *Donkeys.* $7\frac{5}{8} \times 10\frac{3}{4}$ inches. Pencil. Signed and dated 'G.Md. 1801'.

PLATE CXLIV

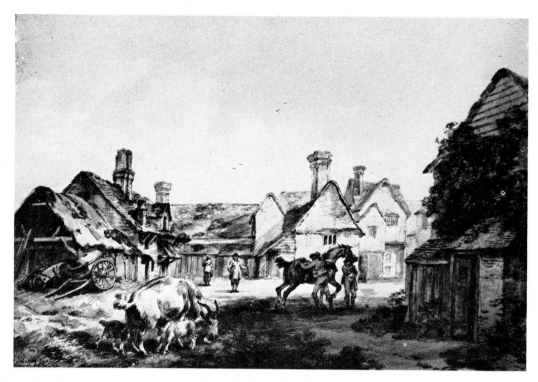

290. JULIUS CAESAR IBBETSON. *A Farmyard Scene.* $10\frac{5}{8} \times 15\frac{7}{8}$ inches. Signed and dated 1793.
Mr H. C. Green

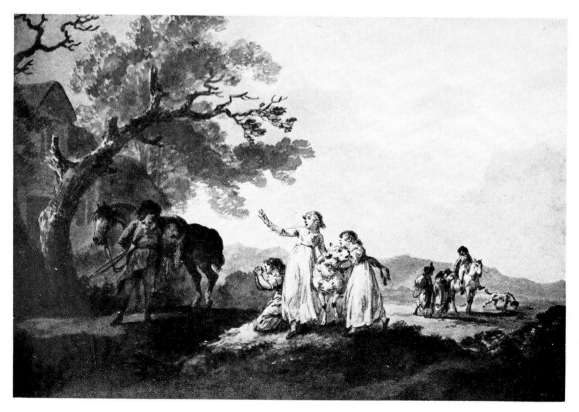

291. JULIUS CAESAR IBBETSON. *The Sale of the Pet Lamb.* $8\frac{7}{12} \times 12\frac{2}{3}$ inches.
Victoria and Albert Museum

PLATE CXLV

293. PETER LA CAVE. *Boy in a Smock.* 9 × 4¾ inches.
Pencil. Ex Coll. Dawson Turner

292. PETER LA CAVE. *Abingdon.* 8⅛ × 11¾ inches. Signed and dated 1790.
Mr H. C. Green

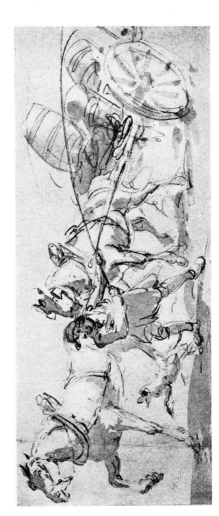

294. PETER LA CAVE. *Man with Cart and Two Horses.* 4¾ × 10⅛ inches. Pencil and
bluish-grey wash. Ex Coll. Dawson Turner

PLATE CXLVI

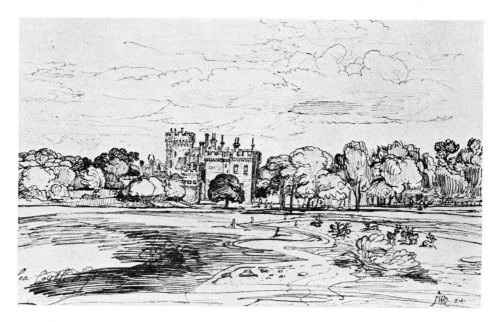

295. JAMES WARD, R.A. *Lea Castle.* $8\frac{5}{8} \times 14\frac{5}{8}$ inches. Pen. Signed with monogram and dated 1814. Ex Coll. Mrs E. M. Ward

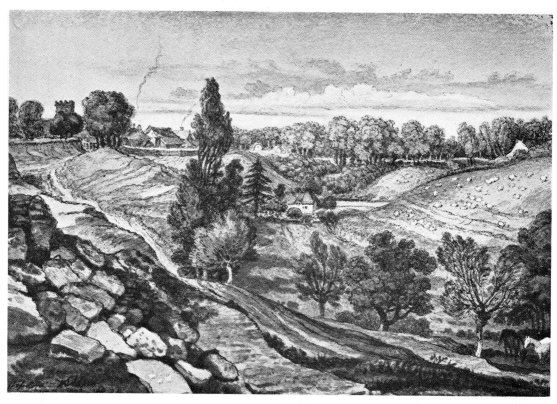

296. JAMES WARD, R.A. *Chiseldon, near Marlborough.* $10\frac{1}{4} \times 14\frac{7}{8}$ inches. Signed and dated 1822.
Whitworth Art Gallery, Manchester

PLATE CXLVII

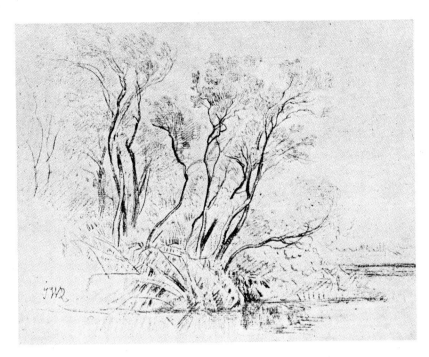

297. JAMES WARD, R.A. *Trees by a Stream.* 10×13 inches. Black and white chalk. Signed with monogram.

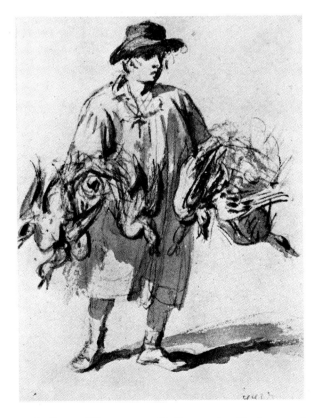

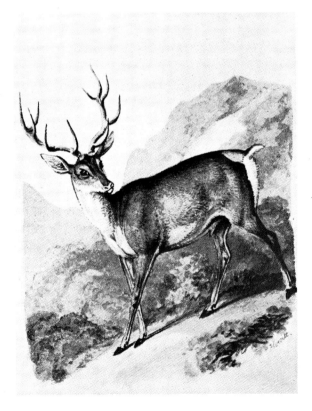

298. JAMES WARD, R.A. *Rustic carrying Ducks.* 7×4⅝ inches. Pencil and grey-brown wash. Signed with monogram.

299. SAMUEL HOWITT. *A Stag (Red Deer?)* 8¾×5¾ inches. Signed.

PLATE CXLVIII

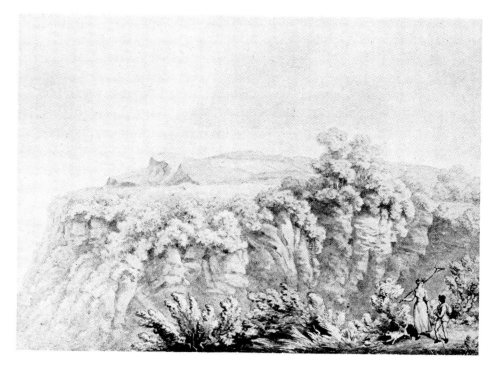

300. SAMUEL HOWITT. *Cliff-tops, presumably in the Isle of Wight.* 9 × 13 inches. Signed and dated 1791.

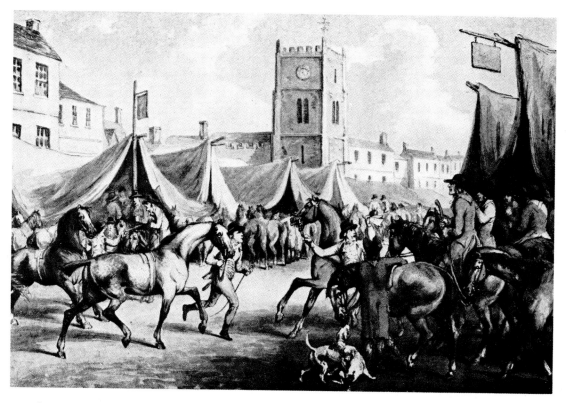

301. SAMUEL HOWITT. *A Country Horse Fair.* 10¼ × 14¾ inches. Signed and dated 1793.

Victoria and Albert Museum

PLATE CXLIX

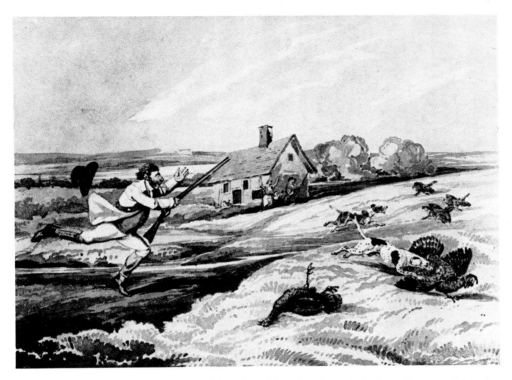

302. HENRY ALKEN. *The Miseries of Shooting.* Plate I. $7\frac{3}{8} \times 10\frac{1}{2}$ inches. Engraved by the
artist 1816. H.R.H. The Duke of Gloucester

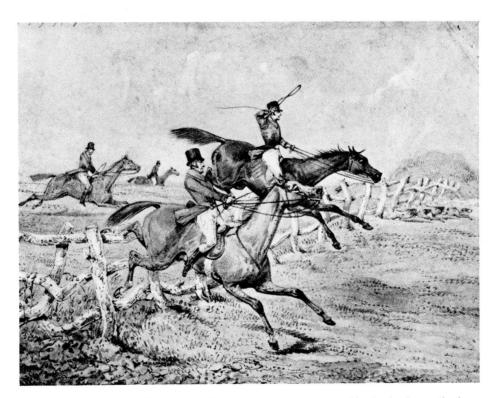

303. HENRY ALKEN. '*Charging a Flight of Rails, near as a Toucher.*' $9\frac{1}{2} \times 12$ inches.
British Museum

PLATE CL

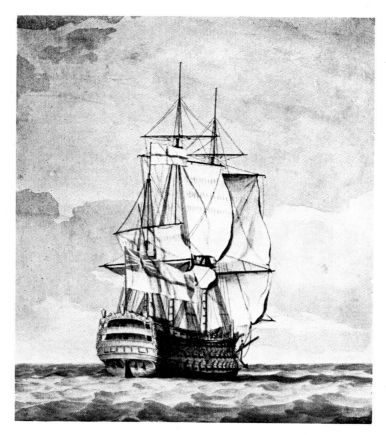

304. CHARLES BROOKING. *English Line of Battle Ship.* 12⅝ × 12 inches.
Indian ink. Victoria and Albert Museum

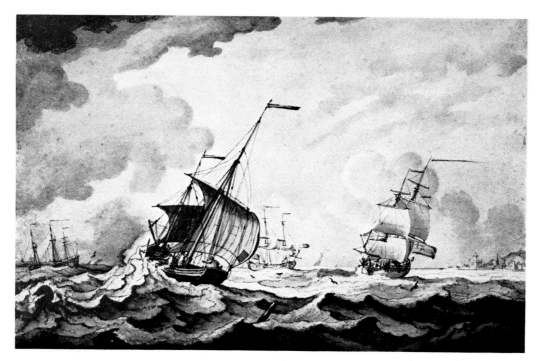

305. FRANCIS SWAINE. *A Lugger close-hauled in a Breeze.* 10⅜ × 15⅞ inches. Pen and brown wash.
National Maritime Museum

PLATE CLI

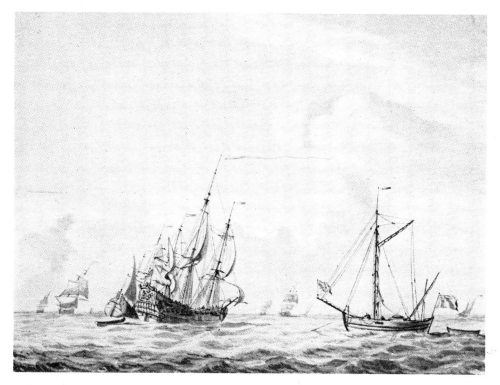

306. DOMINIC SERRES, R.A. *Shipping at Sea.* 7 × 9¾ inches. Signed with initials on mount and dated 1784. Sir Bruce Ingram

307. JOHN THOMAS SERRES. *View of the Island of Procida, near Naples.* 10¾ × 17 inches. Signed 'Giov. T. Serres, 1791'. National Maritime Museum

PLATE CLII

308. JOHN CLEVELEY, junior. *Two-deckers making for Gibraltar.* 22×31¼ inches. Signed and dated 1779.
National Maritime Museum

309. ROBERT CLEVELEY. *The Occupation of Rhode Island, 9 December, 1776.* 17⅝×26¼ inches. Signed and dated 1777.
National Maritime Museum

PLATE CLIII

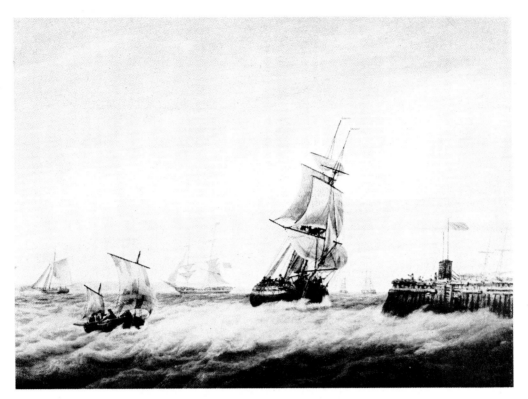

310. SAMUEL ATKINS. *Shipping by a Pier.* $13\frac{1}{2} \times 18\frac{5}{8}$ inches. Signed.

Messrs P. and D. Colnaghi

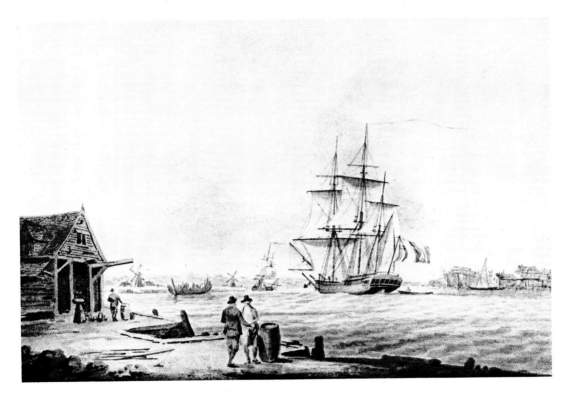

311. WILLIAM ANDERSON. *Shipping in an Estuary.* 8×12 inches. Signed and dated 1793.

PLATE CLIV

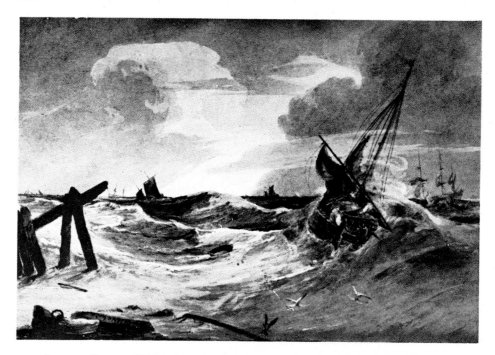

312. Samuel Owen. *Fishing Boats Putting Off.* 8⅞ × 13 inches. Signed and dated 1808.
Mr L. G. Duke

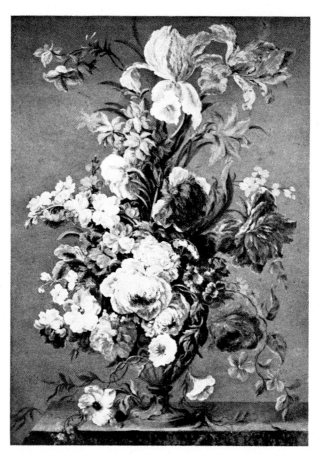

313. Mary Moser, r.a. *Vase of Flowers.* 24 × 17½ inches.
Tempera. Dated 1764. Ex Coll. Queen Charlotte.
Victoria and Albert Museum

PLATE CLV

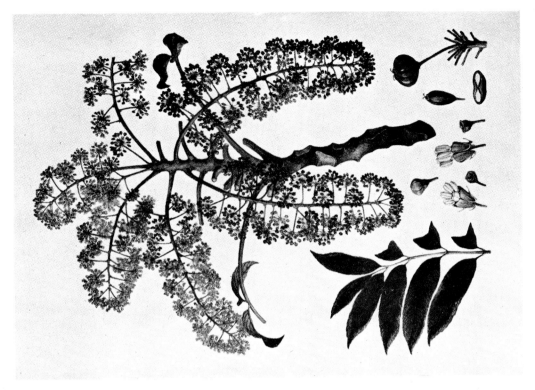

315. FERDINAND LUCAS BAUER. *Mackinlaya macrosciadia.* 20¾×14 inches. Ex Coll. Banks. British Museum (Natural History)

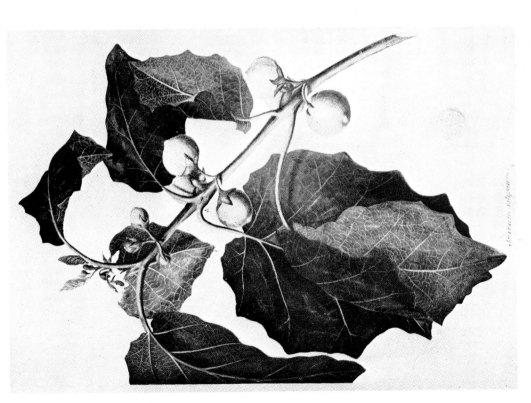

314. SYDNEY PARKINSON. *Solanum latifolium.* 18⅜×11¼ inches. Signed and dated 1769. Ex Coll. Banks. British Museum (Natural History)

PLATE CLVI

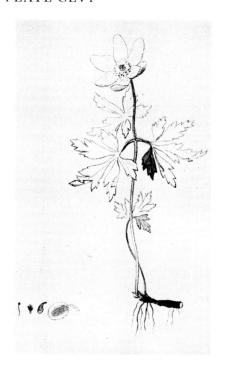

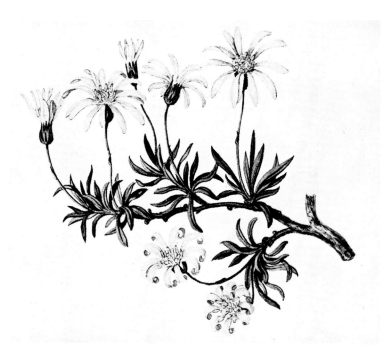

316. JAMES SOWERBY. *Anemone nem-orosa*. $12\frac{1}{2} \times 7\frac{7}{8}$ inches. Pen and pencil with touches of colour. Engraved in 'English Botany', Plate 355, 1796. British Museum (Natural History)

317. SYDENHAM EDWARDS. *Aster fruticulosus*. Size of portion shown *c.* $4\frac{1}{10} \times 4\frac{3}{4}$ inches. Engraved, Plate 2286, *Curtis's Botanical Magazine*, 1821. Royal Botanic Gardens, Kew

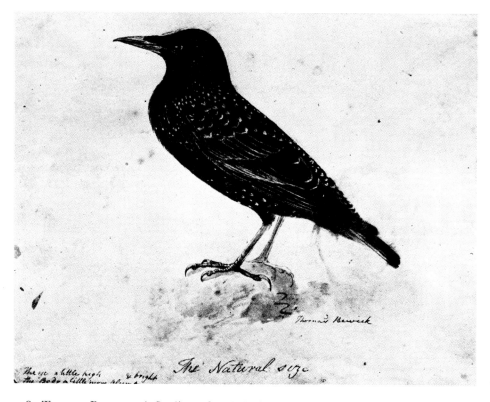

318. THOMAS BEWICK. *A Starling*. $7\frac{3}{4} \times 9\frac{7}{8}$ inches. Signed. Sir Robert Witt

PLATE CLVII

320. JOHN ABBOT. *Marbled Oak Moth.* $11\frac{7}{8} \times 9\frac{1}{8}$ inches. Ex Coll. J. Francillon. British Museum (Natural History)

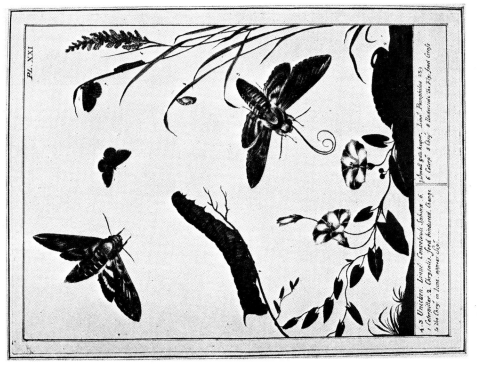

319. MOSES HARRIS. *Illustration for 'The Aurelian'.* $12\frac{3}{4} \times 8\frac{3}{4}$ inches. Signed and dated 1785. Ex Coll. Rothschild. British Museum (Natural History)

PLATE CLVIII

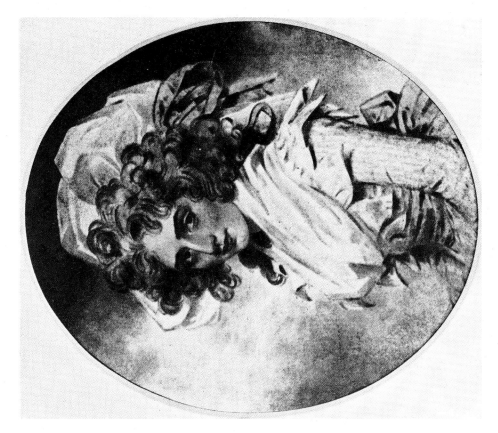

322. JOHN DOWNMAN, A.R.A. *Mrs Siddons.* $8 \times 6\frac{3}{4}$ inches. Annotated by the artist and dated 1787. National Portrait Gallery

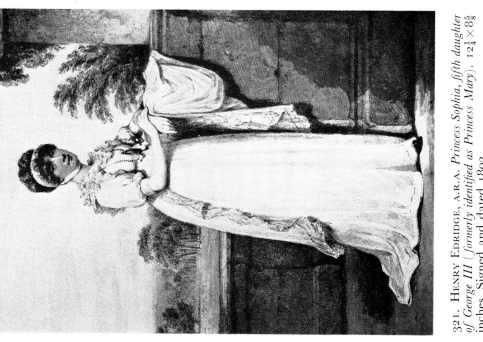

321. HENRY EDRIDGE, A.R.A. *Princess Sophia, fifth daughter of George III (formerly identified as Princess Mary).* $12\frac{1}{4} \times 8\frac{5}{8}$ inches. Signed and dated 1802.
His Majesty the King, Windsor Castle

PLATE CLIX

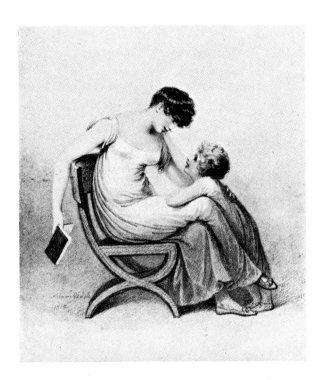

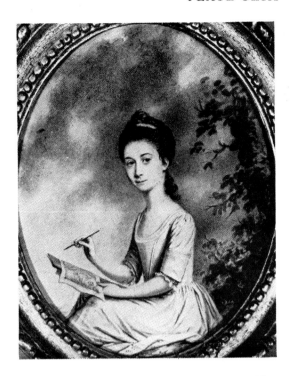

323. ADAM BUCK. *Mother and Child.* $9\frac{3}{8} \times 7\frac{11}{16}$ inches. Signed and dated 1808. Engraved by M. N. Bate, 1808. Victoria and Albert Museum

324. JOHN TAYLOR. *A Young Lady Sketching.* $7\frac{1}{2} \times 6$ inches. Signed and dated 1774.
 Mrs Ralph Keene

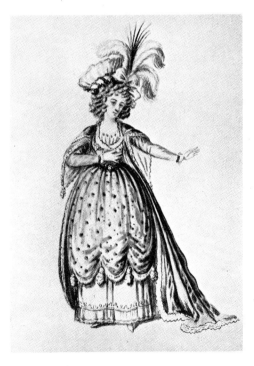

325. WILLIAM WELLINGS. *Mrs Billington as Mandane in the Opera 'Artaxerxes'.* $8\frac{1}{4} \times 6$ inches. Signed on the back.

326. WILLIAM MINEARD BENNETT. *A Young Man with Auburn Hair.* $6\frac{5}{8} \times 5\frac{1}{2}$ inches. Signed and dated 1814.

PLATE CLX

327. SIR THOMAS LAWRENCE, P.R.A. *Herman Wolff.* 19×16 inches. Red and black chalk. Ex Coll. Keightley. Mr E. Croft-Murray

328. JOSIAH SLATER. *Lady with a Blue Scarf.* $11\frac{5}{8}\times9\frac{7}{8}$ inches. Chalk and watercolour. Signed and dated 1816.

329. ALFRED EDWARD CHALON, R.A. *Lord Lytton in Fancy Dress.* $17\frac{1}{2}\times13$ inches. Ex Coll. G. H. Lane. National Portrait Gallery

330. JAMES GREEN. *Portrait of a Lady.* $15\times12\frac{1}{4}$ inches. British Museum

PLATE CLXI

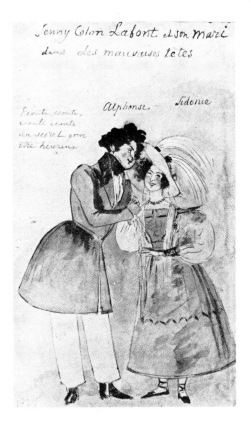

331. ALFRED EDWARD CHALON, R.A.
'*Jenny Colon Lafont et son Mari*.' $15\frac{1}{4} \times 9\frac{1}{4}$
inches. Inscribed by the artist and dated
1829. British Museum

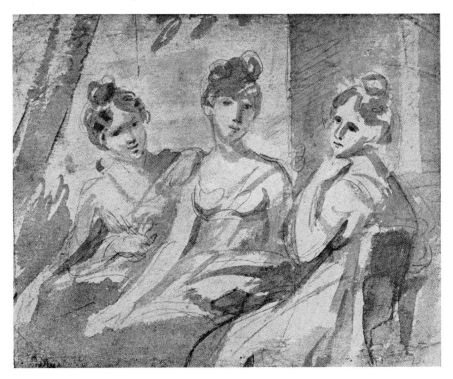

332. SAMUEL SHELLEY. *Three Girls Seated*. $7 \times 8\frac{3}{4}$ inches. Greyish-brown wash
and pencil. Inscribed 'Shelley'.

PLATE CLXII

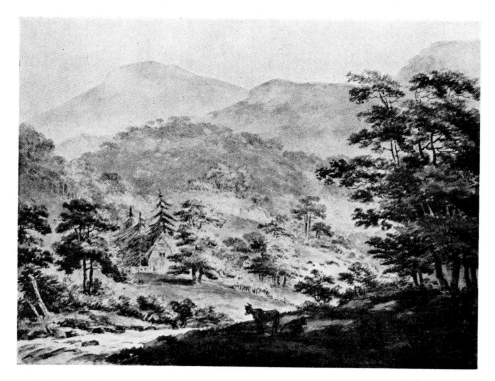

333. WILLIAM SAWREY GILPIN. *Scenery in the Grounds of Downton.* 12 × 16¼ inches. Signed. Title inscribed on back of mount.

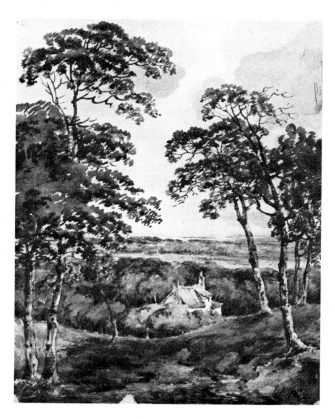

334. WILLIAM SAWREY GILPIN. *A Woody Landscape.* 12½ × 10½ inches. Signed with initials on front and in full on back. Ex Coll. Burrard family.

PLATE CLXIII

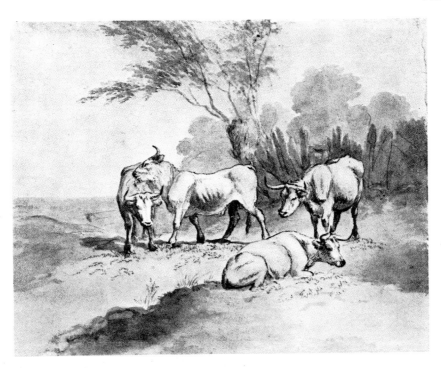

335. ROBERT HILLS. *Study of Longhorn Cattle.* 12×15 inches. Pencil with brown and grey wash.

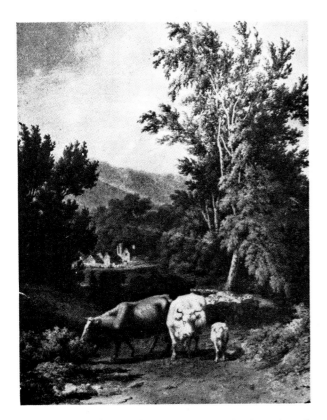

336. ROBERT HILLS. *Landscape with Cattle.* 17×12¼ inches. Signed and dated 1811. Walker's Galleries

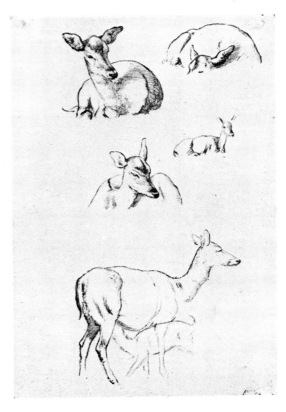

337. ROBERT HILLS. *Studies of Deer.* 9⅛×6½ inches. Pencil. Ex Coll. J. Garle.

PLATE CLXIV

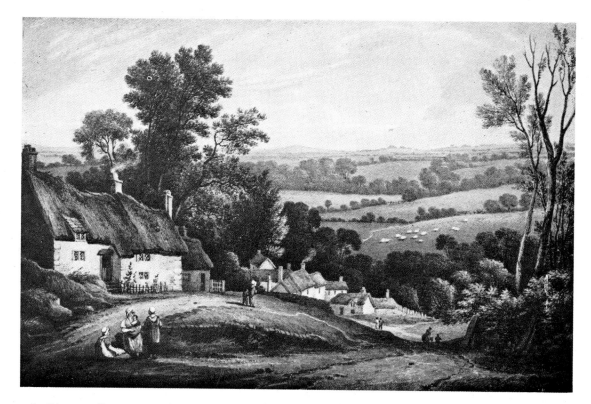

338. WILLIAM FREDERICK WELLS. *Village of Egton Bridge, near Whitby, Yorkshire.* 11 × 16⅞ inches. Signed. Dated 1829 on back. Victoria and Albert Museum

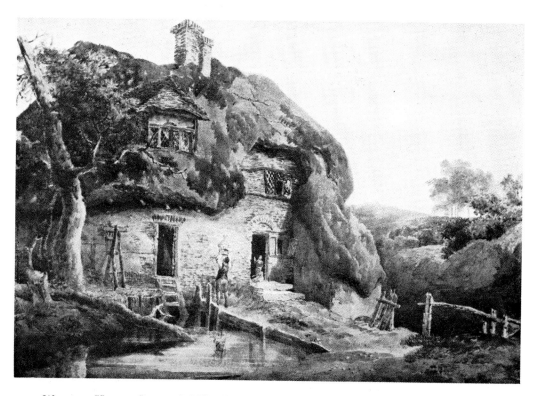

339. WILLIAM HENRY PYNE. *A Mill House.* 13 × 19 inches. Signed and dated 1803.
Mr H. C. Green

PLATE CLXV

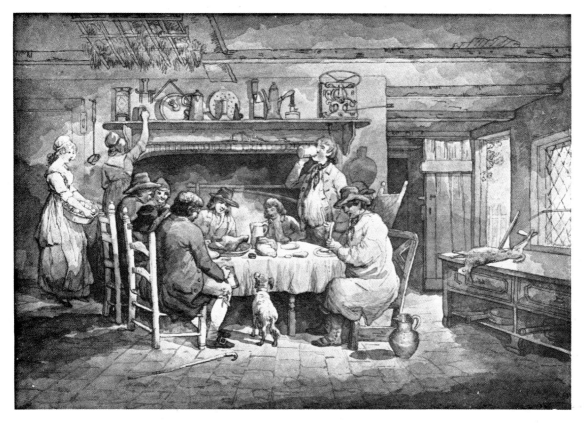

340. WILLIAM HENRY PYNE. *A Farmhouse Kitchen.* $7\frac{5}{8} \times 10\frac{1}{2}$ inches. Signed and dated 1796.

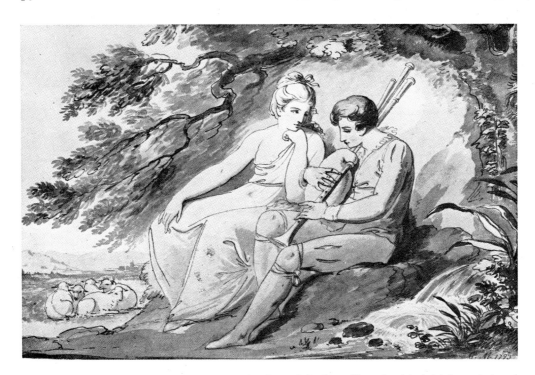

341. CONRAD MARTIN METZ. *A Pastoral.* $9\frac{1}{4} \times 14\frac{1}{4}$ inches. Signed with initials and dated 1793.

PLATE CLXVI

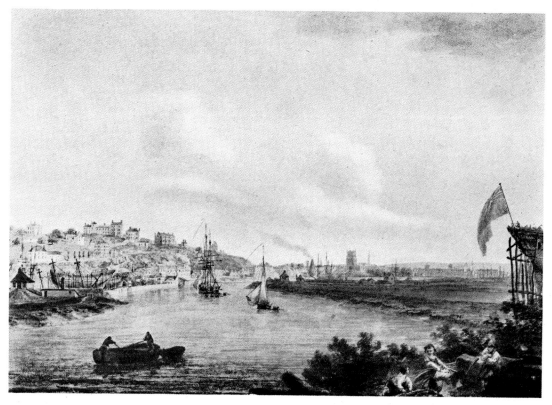

342. NICHOLAS POCOCK. *View of Bristol.* 16½ × 24 inches. Signed.　　　Messrs F. T. Sabin

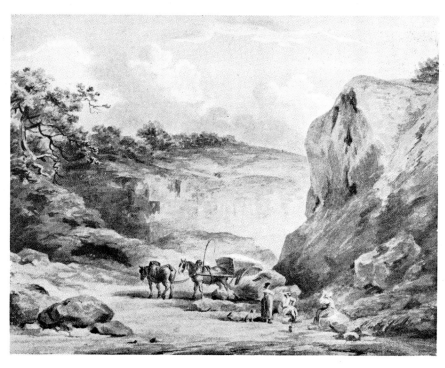

343. NICHOLAS POCOCK. *Scene in a Quarry.* 10½ × 13½ inches.

PLATE CLXVII

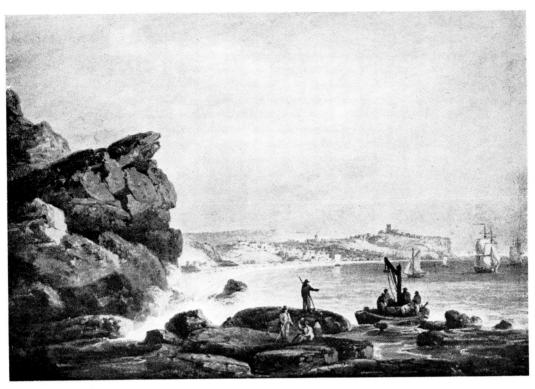

344. Francis Nicholson. *Scarborough.* $13\frac{5}{8} \times 19\frac{7}{8}$ inches. Victoria and Albert Museum

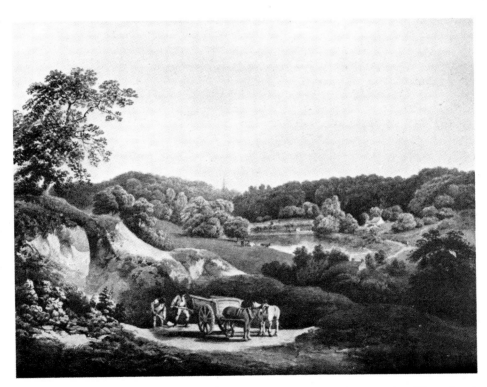

345. Francis Nicholson. *Stourhead.* $15\frac{3}{4} \times 21\frac{1}{2}$ inches. One of a long series of Stourhead views. British Museum

PLATE CLXVIII

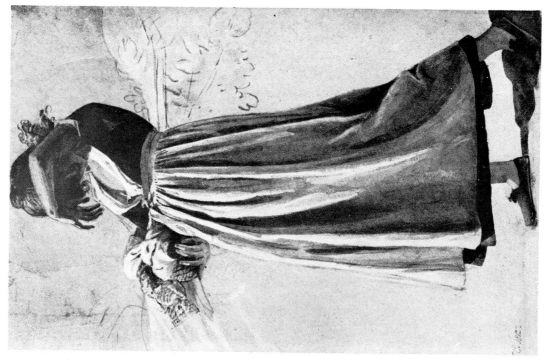

347. Joshua Cristall. *Study of a Peasant Girl shading her eyes.*
16⅜ × 10⅞ inches. Signed with initials and dated 1812.
Mr L. G. Duke

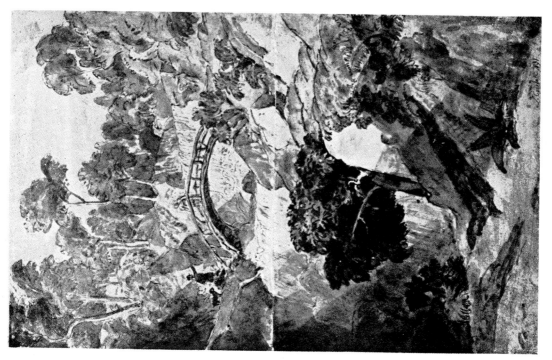

346. Joshua Cristall. *Waterfall at Llandoga, Monmouthshire.*
14⅛ × 9 inches. Signed and dated 1831.

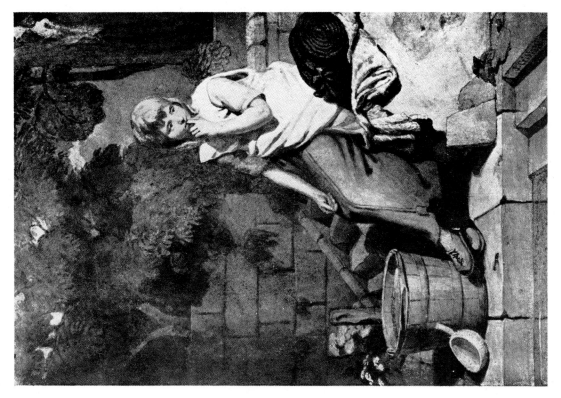

PLATE CLXIX

349. JOSHUA CRISTALL. *Girl Seated by a Well.* 12½×8¼ inches.
Signed and dated 1810. Mr J. Leslie Wright

348. JOSHUA CRISTALL. *Girl Seated by a Well.* 8⅞×6½ inches. Pencil.
Study for Fig. 349. Signed and dated 1807.

PLATE CLXX

350. JOHN GLOVER. *Cader Idris.* $11\frac{1}{4} \times 16\frac{1}{2}$ inches.

351. JOHN GLOVER. *Valle Crucis Abbey.* $11 \times 17\frac{1}{2}$ inches. Grey and blue wash.

Victoria and Albert Museum

PLATE CLXXI

352. J. ROBERTSON. *Landscape in the style of Glover.* $7\frac{1}{4} \times 10\frac{1}{8}$ inches.

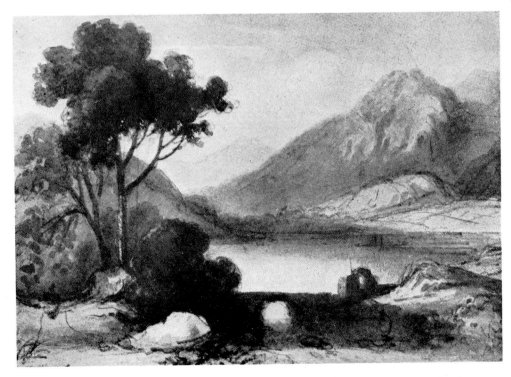

353. J. ROBERTSON. *Mountainous Landscape with Lake and Bridge.* $6\frac{1}{2} \times 9\frac{3}{8}$ inches.

PLATE CLXXII

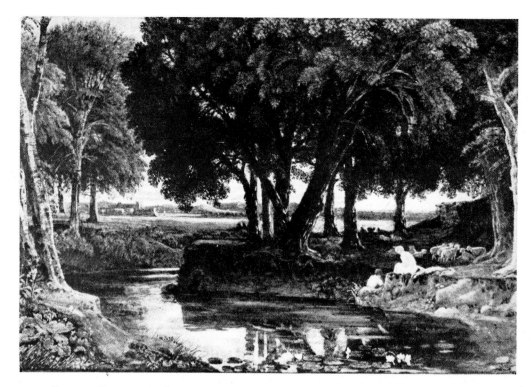

354. GEORGE BARRET, junior. *The Close of Day.* 14×20¼ inches. Signed and dated 1829.
Mr J. Leslie Wright

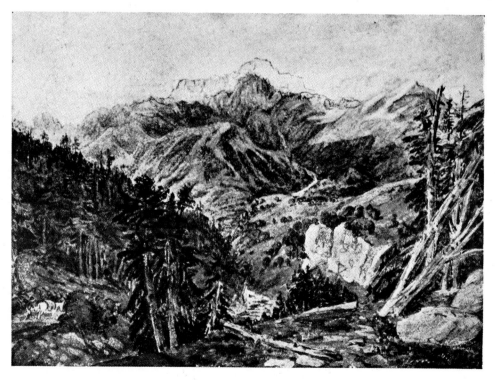

355. GEORGE BARRET, junior. *A Mountain Landscape.* 5¾×7⅞ inches. Signed with initials and dated 1810 (or 1819?).

PLATE CLXXIII

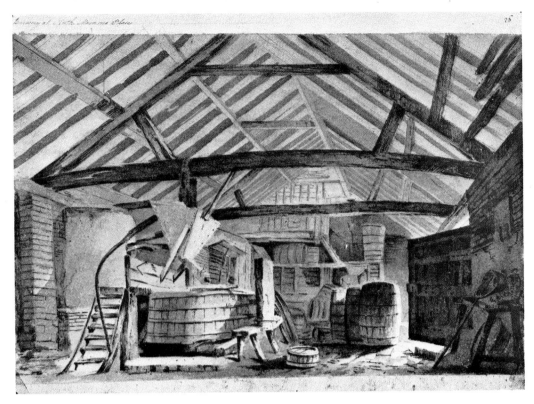

356. JOHN CLAUDE NATTES. *Brewery at North Mimms Place.* 8½ × 12⅞ inches. Pen and Indian ink. Numbered 26. From a series of drawings by Nattes.

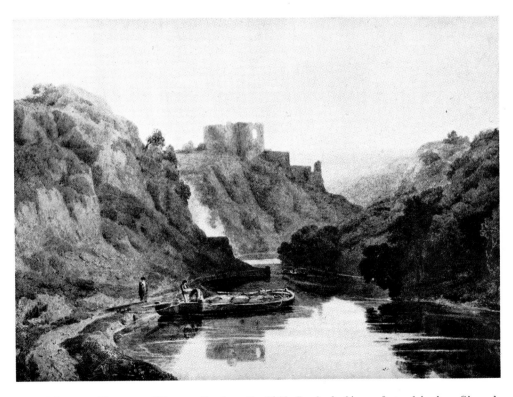

357. WILLIAM HAVELL. *Kilgerran Castle on the Teifi, Pembrokeshire.* 19⅜ × 27½ inches. Signed. Probably exhibited at O.W.C.S. 1806. Victoria and Albert Museum

PLATE CLXXIV

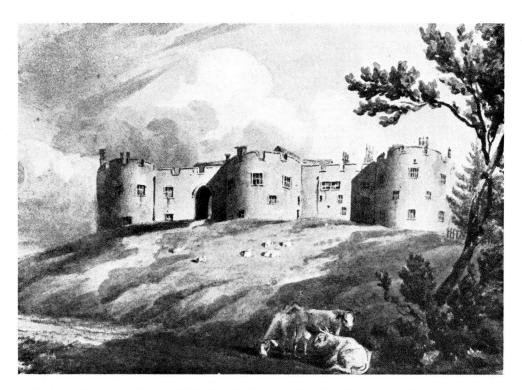

358. John Preston Neale. *Chirk Castle, Denbighshire.* $6\frac{1}{8} \times 8\frac{3}{4}$ inches. Signed and dated [1815?].

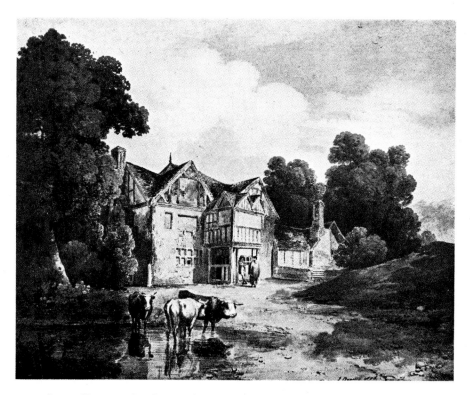

359. James Baynes. *Landscape with Inn and Figures.* $15\frac{1}{2} \times 19\frac{3}{4}$ inches. Signed and dated 1806. Whitworth Art Gallery, Manchester

PLATE CLXXV

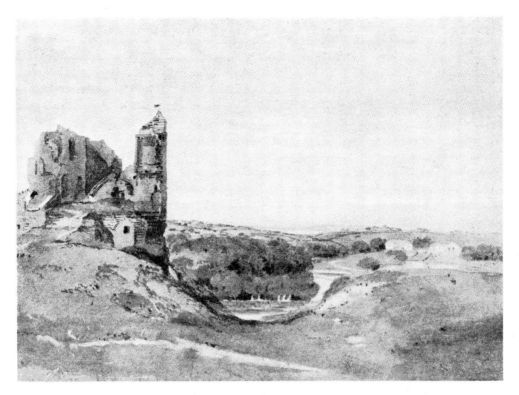

360. JOHN VARLEY. *Knaresborough Castle.* $10\frac{7}{16} \times 14\frac{1}{2}$ inches. Signed on the back and dated 1803. Mr L. G. Duke

361. JOHN VARLEY. *Landscape Composition in Monochrome.* $5 \times 9\frac{5}{8}$ inches. Sepia. Inscribed on back 'By John Varley given to me by Mrs Palmer 1867'.

PLATE CLXXVI

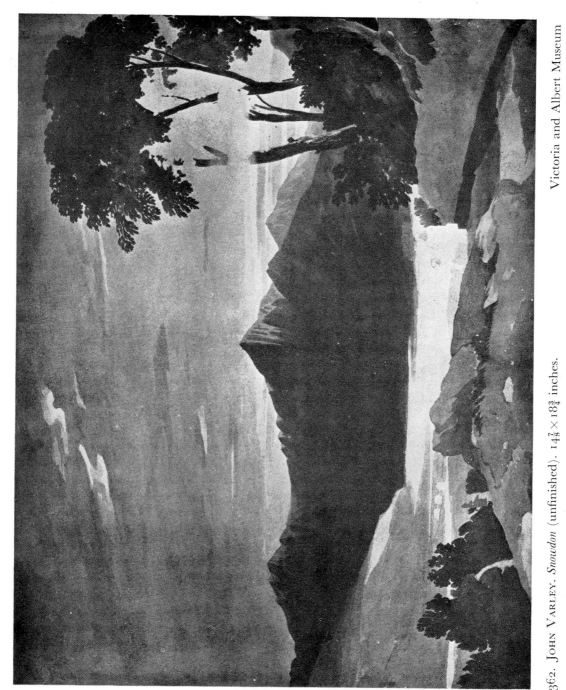

362. JOHN VARLEY. *Snowdon* (unfinished). $14\frac{7}{8} \times 18\frac{3}{4}$ inches.

Victoria and Albert Museum

PLATE CLXXVII

363. CORNELIUS VARLEY. *Beddgelert Bridge.* $11\frac{3}{4} \times 17\frac{7}{8}$ inches. Victoria and Albert Museum

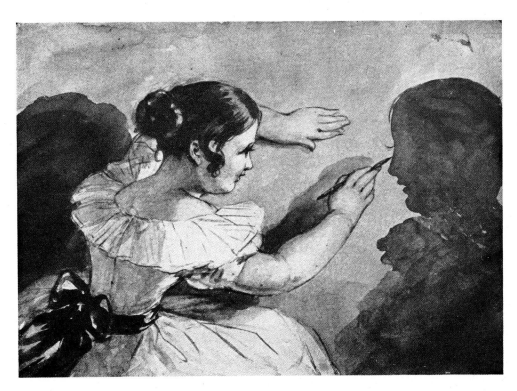

364. JOHN JAMES CHALON, R.A. *The Silhouette.* $12\frac{1}{2} \times 17\frac{1}{4}$ inches. Pinkish-brown wash.
British Museum

PLATE CLXXVIII

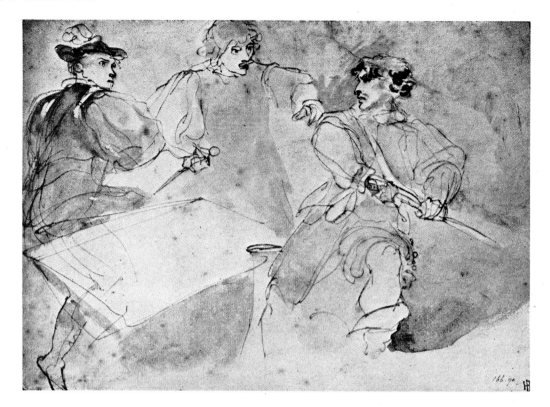

365. WILLIAM LOCKE. *Gamblers Disputing.* $7\frac{7}{8} \times 10\frac{3}{4}$ inches. Ink with light washes of colour. According to a contemporary inscription on the back, this was drawn by Locke about 1785. Ex Coll. H. Reveley. Victoria and Albert Museum

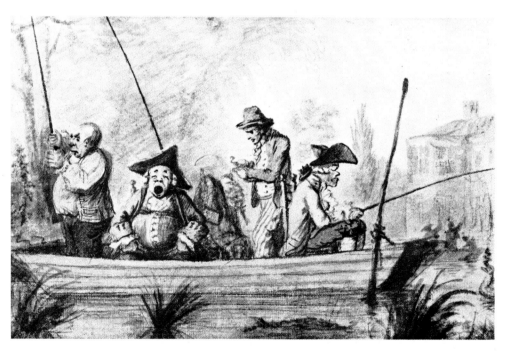

366. HENRY WILLIAM BUNBURY. *Patience in a Punt.* $8\frac{3}{4} \times 11\frac{1}{4}$ inches. Etched by Rowlandson.
Mr L. G. Duke

PLATE CLXXIX

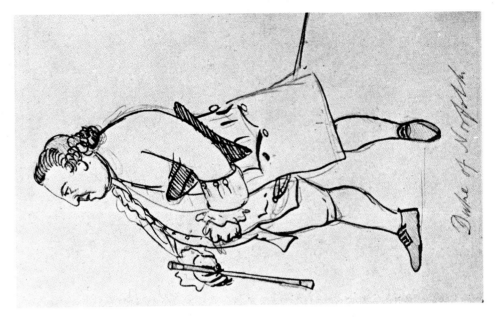

368. GEORGE, 1ST MARQUIS TOWNSHEND. *The Duke of Norfolk.* $8\frac{7}{8} \times 5\frac{3}{4}$ inches. Pen and slight pencil. Ex Coll. L. G. Duke.

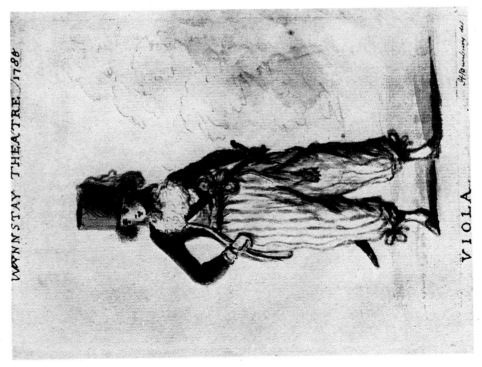

367. HENRY WILLIAM BUNBURY. *Miss Wynne as Viola.* $7\frac{3}{4} \times 5\frac{5}{8}$ inches. Signed and dated 1785. Mr E. Croft-Murray

PLATE CLXXX

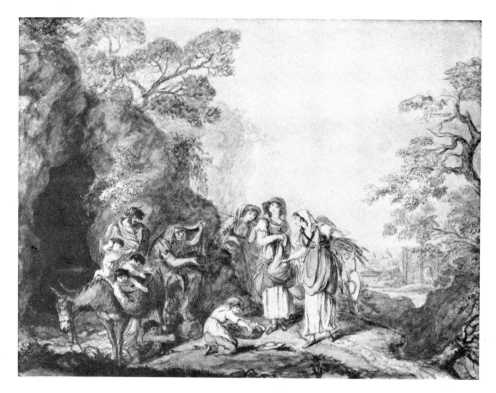

369. LADY DIANA BEAUCLERK. *Group of Gypsies and Female Rustics.* 27½×35½ inches.
Victoria and Albert Museum

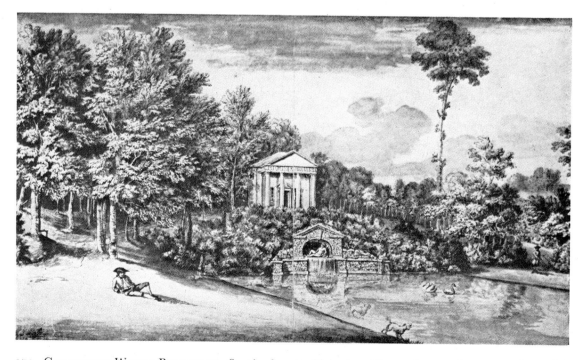

370. COPLESTONE WARRE BAMPFYLDE. *Stourhead.* 11×18½ inches. Watercolour and pen, touched with
body colour. Signed with initials and dated 1753. Mr L. G. Duke

PLATE CLXXXI

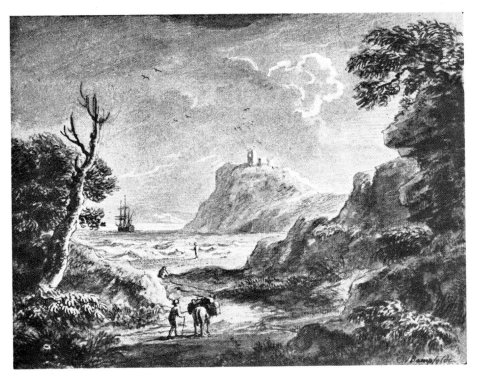

371. Coplestone Warre Bampfylde. *A Romantic Landscape.* 9 × 12 inches. Body colour. Signed and dated 1772.

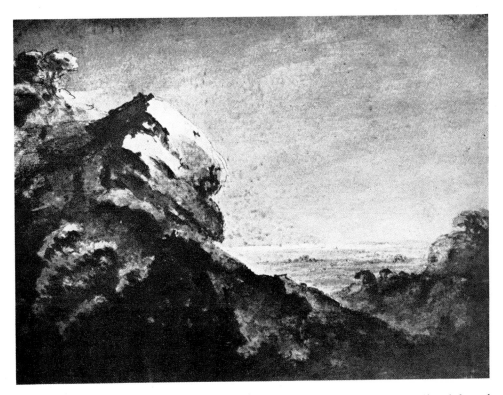

372. Rev William Gilpin. *A Rock like a Lion's Head.* 10½ × 14⅜ inches. Indian ink and reddish-brown wash, with touches of pen and pencil. Stamped with the artist's initials.

PLATE CLXXXII

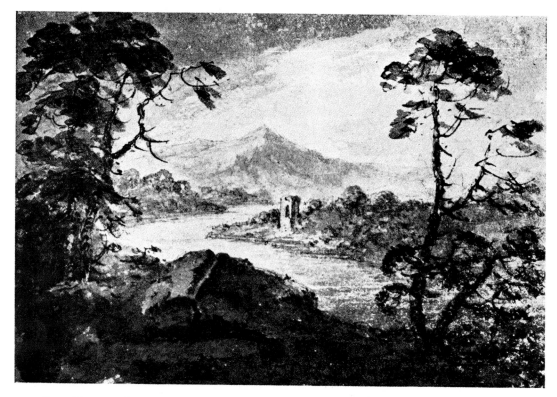

373. REV WILLIAM GILPIN. *Picturesque Landscape with River and Mountain.* $7\frac{1}{2} \times 10\frac{7}{8}$ inches. Stamped with the artist's initials. Pen with Indian ink and pale brown washes.

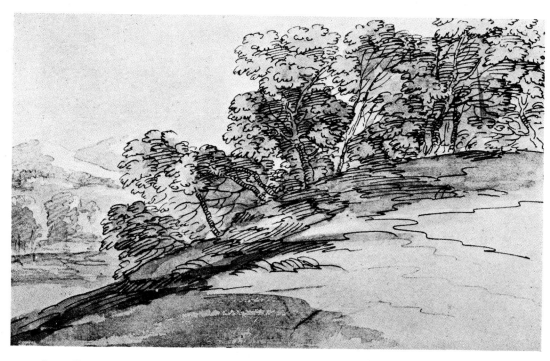

374. JOHN SKIPPE. *Group of Trees on Rising Ground.* $7\frac{5}{8} \times 12$ inches. Pen and sepia.

Victoria and Albert Museum

PLATE CLXXXIII

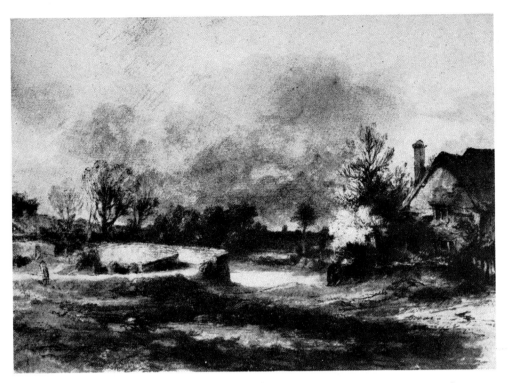

375. LORD AYLESFORD. *An English Landscape.* $8\frac{1}{4} \times 11\frac{1}{4}$ inches. Pen and watercolour.
Mr A. P. Oppé

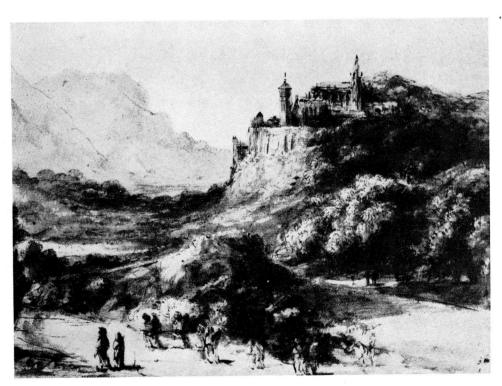

376. LORD AYLESFORD. *A Continental Landscape with Figures of Monks.* $8\frac{1}{4} \times 11$ inches.
Pen and brown wash. Mr A. P. Oppé

PLATE CLXXXIV

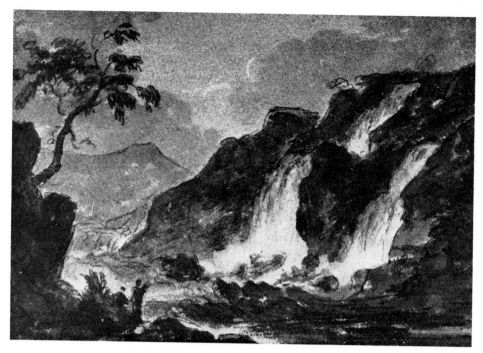

377. Sir George Howland Beaumont. *Landscape with Cascades.* $9\frac{1}{8} \times 13\frac{3}{8}$ inches. Black chalk and Indian ink wash heightened with white. Dated 1805. From a collection of Beaumont's drawings given by Lady Beaumont, 1827. Mr L. G. Duke

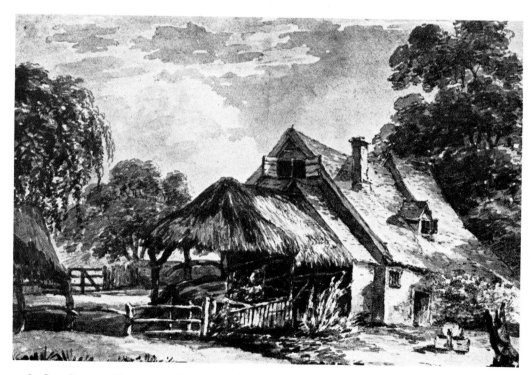

378. Sir George Howland Beaumont. *Bucklesham Mill, Suffolk.* $5\frac{1}{2} \times 8\frac{1}{4}$ inches. Pencil and grey wash. Dated 1798. From a collection of Beaumont's drawings given by Lady Beaumont, 1827.

Mr L. G. Duke

PLATE CLXXXV

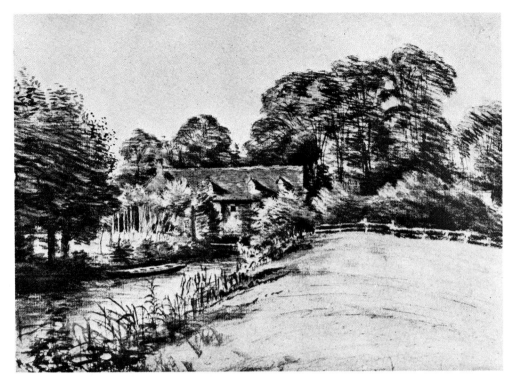

379. WILLIAM CROTCH. '*Holywell Mill, Oxford, July* 11, 7 *a.m.*' 10¼ × 14¾ inches. Signed etc. on back and dated 1803.

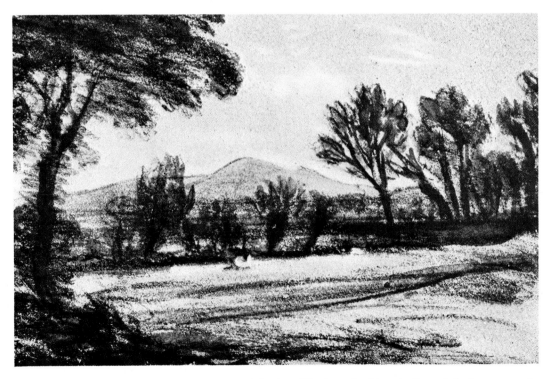

380. WILLIAM CROTCH. *High Curley.* 5⅞ × 9⅛ inches. Black and white chalk and dark grey wash. Inscribed on back by Crotch 'Montagna di Ercole vulgo High Curley' etc.

PLATE CLXXXVI

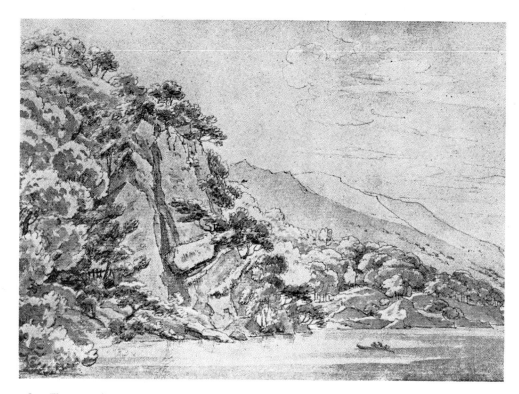

381. THOMAS SUNDERLAND. *Stybarrow Crag, Ullswater.* 9 × 13 inches. Pencil with grey and blue wash. Title inscribed on back by the artist.

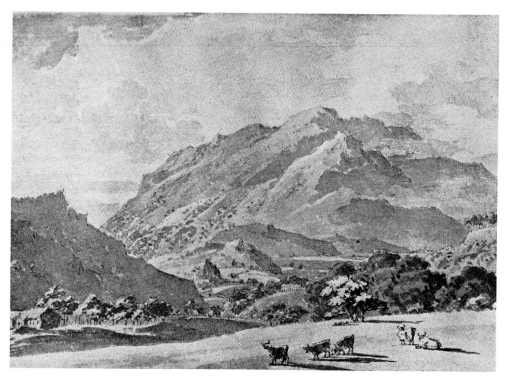

382. THOMAS SUNDERLAND. *Rydal Hall and Rydal Head.* 9⅛ × 13¼ inches. Pen and pencil, with grey and blue wash. Title inscribed on mount by the artist.

PLATE CLXXXVII

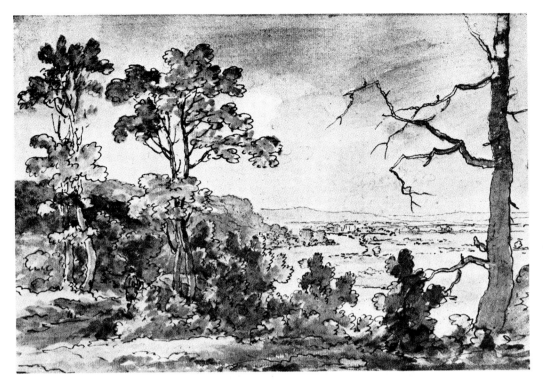

383. E. Becker. *A View, probably in the Thames Valley.* $7\frac{3}{4} \times 11\frac{3}{4}$ inches. Pen and brownish-grey wash.

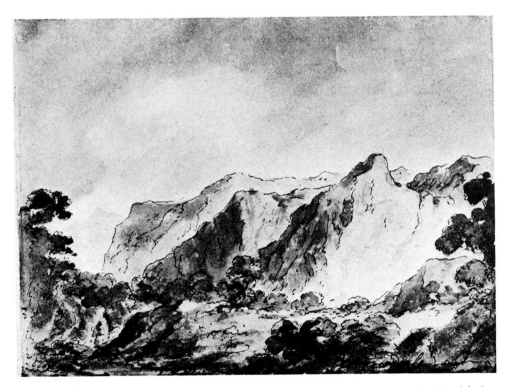

384. E. Becker. *Borrowdale.* $5\frac{3}{4} \times 7\frac{1}{2}$ inches. Pen and grey wash. Inscribed with title by the artist.

PLATE CLXXXVIII

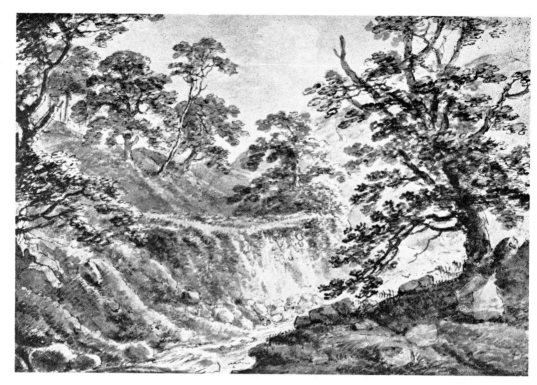

385. Amos Green. *A North-Country Beck.* $8\frac{7}{8} \times 12\frac{3}{4}$ inches. Dated 1802. Inscribed with the artist's initials by his widow.

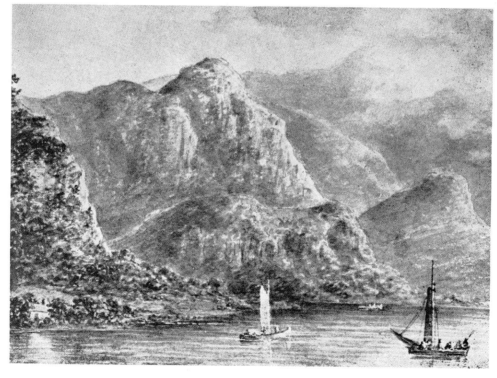

386. Mrs Amos Green (Harriet Lister). '*Study in a Boat near Lowdoor, of effects on the Lake of Derwentwater.*' $4\frac{1}{2} \times 7\frac{3}{4}$ inches. Inscribed on back with title, dated 1802, and signed 'H.G.'

PLATE CLXXXIX

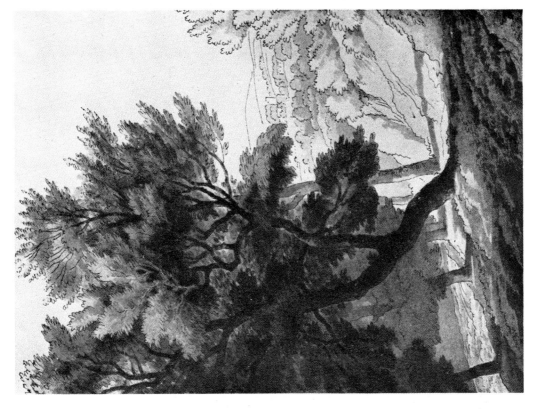

388. John White Abbott. *On the Teign.* $10\frac{1}{4} \times 7\frac{1}{2}$ inches. Pen and blackish-grey wash. Title inscribed on mount.

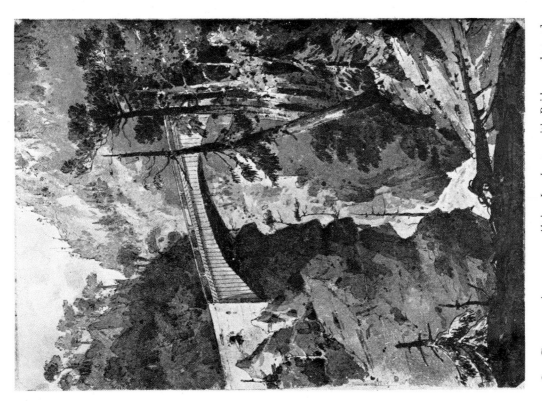

387. Charles Annesley. *Alpine Landscape with Bridge.* $14\frac{1}{2} \times 10\frac{3}{8}$ inches. Pen with brown ink and grey, blue, and pinkish-brown washes. Signed with monogram.

PLATE CXC

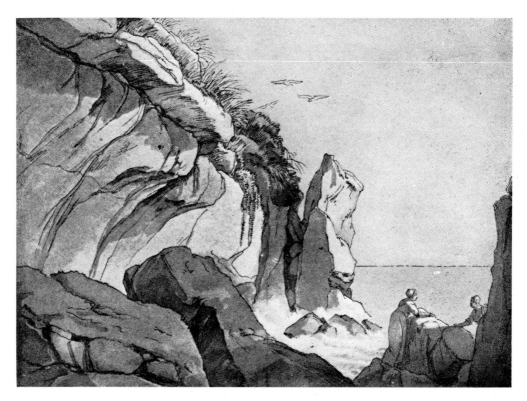

389. JOHN WHITE ABBOTT. *The Warren.* 7⅞ × 10½ inches. Pen and brownish-grey wash. Dated 1811 on back by artist. Title inscribed on mount.

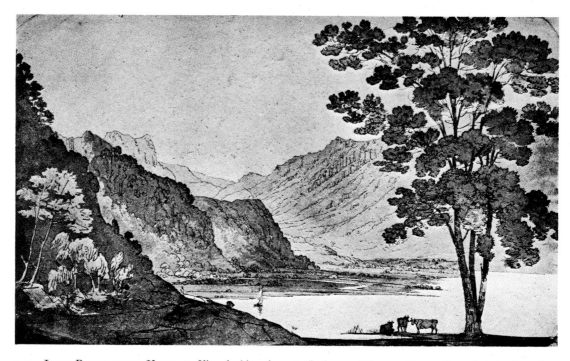

390. JOHN BAVERSTOCK KNIGHT. *View looking down to Lodore and Borrowdale.* 10 15/16 × 18 5/16 inches. Pen washes of various greys. Signed with initials.

Victoria and Albert Museum

PLATE CXCI

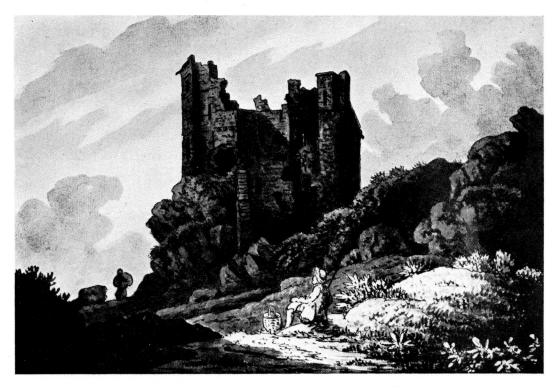

391. SIR RICHARD COLT HOARE. '*East View of Roch Castle in Pembrokeshire, 18 June, 1793.*' $7\frac{1}{2} \times 11\frac{1}{2}$ inches. Pen and sepia. Inscribed with title and signed.

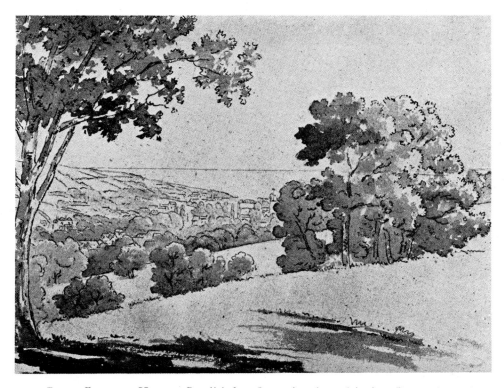

392. PETER RICHARD HOARE. *Dawlish from Luscombe.* $7\frac{1}{8} \times 10\frac{1}{4}$ inches. Pen and purplish-grey wash. Previously attributed to Sir R. C. Hoare.

PLATE CXCII

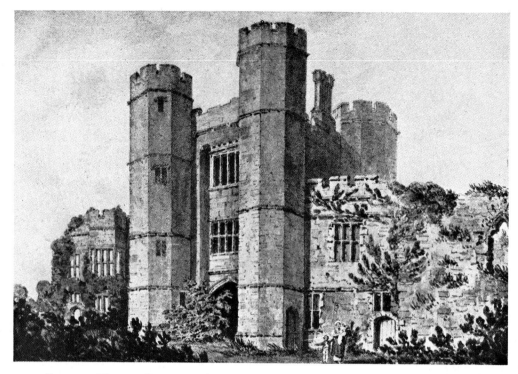

393. EDWARD HAWKE LOCKER. *Titchfield House, near Fareham, Hampshire.* $6\frac{1}{8} \times 8\frac{5}{8}$ inches. Dated 1803 on the back. Victoria and Albert Museum

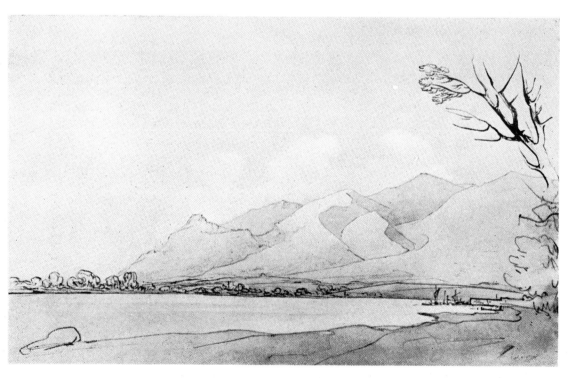

394. REV ROBERT HURRELL FROUDE. *Water and Hills.* $8\frac{1}{4} \times 13$ inches.

PLATE CXCIII

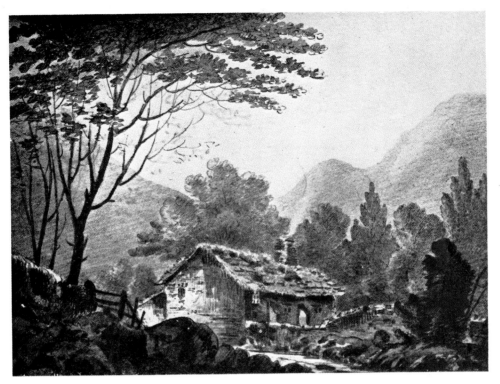

395. REV JOSEPH WILKINSON. *Ormathwaite Cottage, Underskiddaw.* 7×9¾ inches.
Victoria and Albert Museum

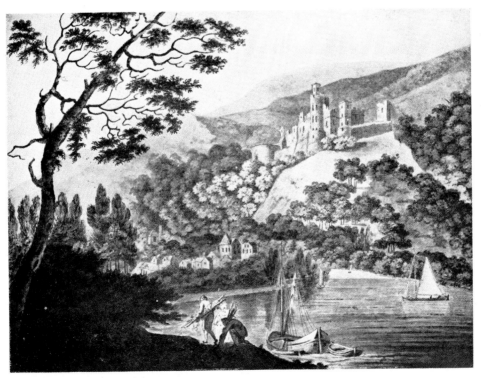

396. REV J. GARDNOR. *Capelle Castle on the Rhine.* 13¾×17¾ inches. Engraved as Plate XIX in 'Views taken on or near the River Rhine', 1788.
Victoria and Albert Museum

PLATE CXCIV

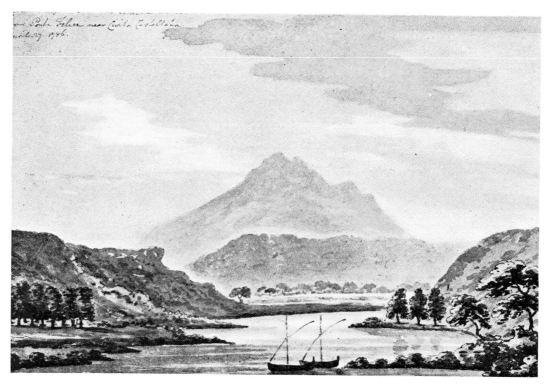

397. JOHN FISHER, BISHOP OF SALISBURY. *A View of the Tiber and Soracte, taken from the Ponte Felice near Civita Castellana.* $5\frac{3}{4} \times 8\frac{3}{4}$ inches. Inscribed by artist and dated 1786.

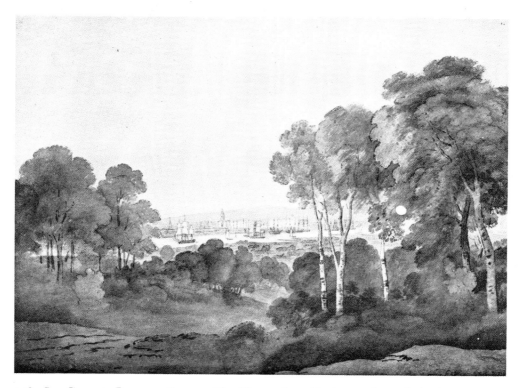

398. SIR GEORGE BULTEEL FISHER. *The Thames from Charlton.* $17\frac{1}{2} \times 25\frac{1}{16}$ inches.
Victoria and Albert Museum

PLATE CXCV

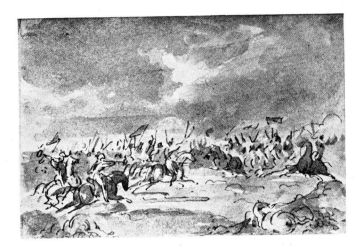

399. Sir James Steuart. *A Cavalry Action.* $4\frac{1}{2} \times 6\frac{5}{8}$ inches.

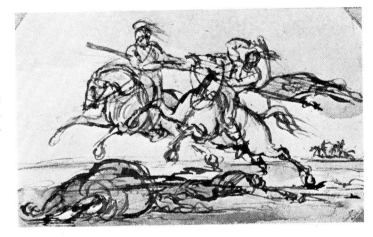

400. Sir James Steuart. *Two Horsemen Fighting.* $3\frac{5}{8} \times 6$ inches. Pen, pencil and sepia wash. Signed (or inscribed) with initials.

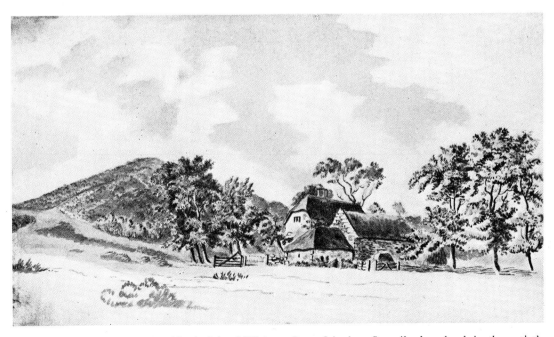

401. Francis Grose. *A Farm in the Isle of Wight.* $10\frac{1}{4} \times 17\frac{3}{4}$ inches. Inscribed on back in the artist's hand. Ex Coll. Sir T. Phillipps.

PLATE CXCVI

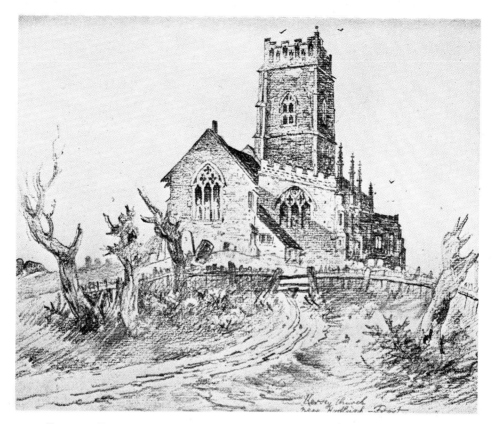

402. GEORGE FROST. *Kersey Church, near Hadleigh.* 9⅜ × 12⅛ inches. Black chalk. Inscribed with title and artist's surname. Ex Coll. T. Churchyard? and Barlow family.

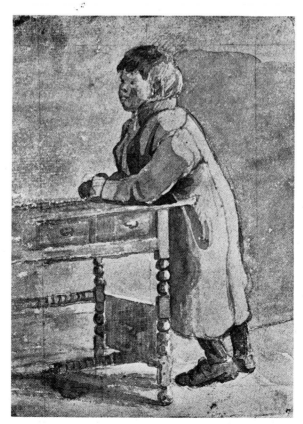

403. GEORGE FROST. *Boy Leaning on a Table.* 10 × 7⅝ inches. Inscribed on back 'Frost'. Ex Coll. T. Churchyard? and Barlow family.

PLATE CXCVII

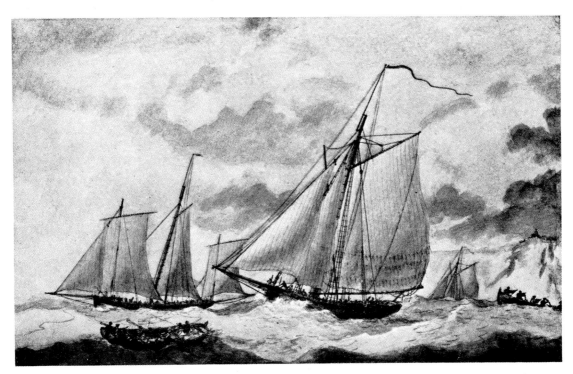

404. CHARLES GORE. *Armed Boats off the English Coast.* $11\frac{1}{8} \times 17\frac{3}{4}$ inches. Signed and dated 1794. Ex Coll. R. Payne Knight. British Museum

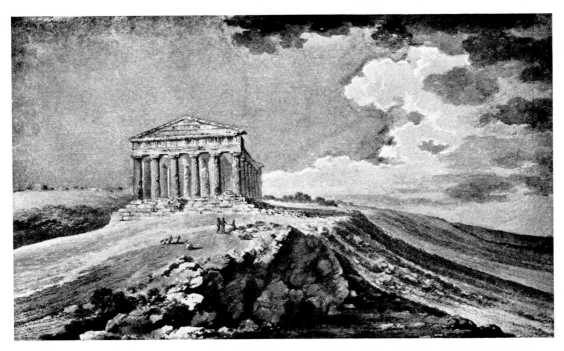

405. CHARLES GORE. *Temple of Concord at Agrigentum, Sicily.* $9\frac{7}{8} \times 17\frac{1}{8}$ inches. Ex Coll. R. Payne Knight. British Museum

PLATE CXCVIII

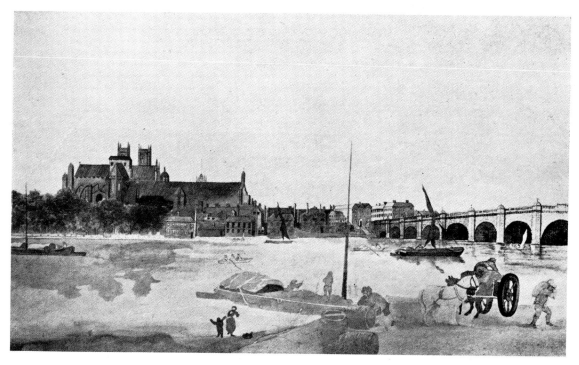

406. THOMAS MITCHELL. *Westminster Bridge in* 1789. $11\frac{1}{8} \times 19$ inches. Indian ink. British Museum

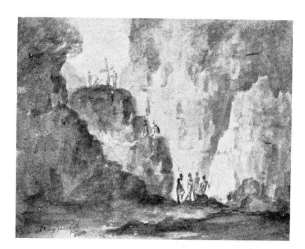

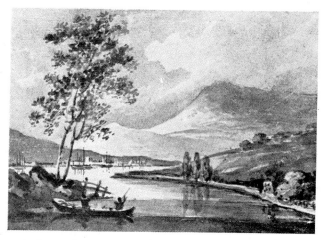

407. J. S. HAYWARD. *A Religious Ceremony among Rocks.* $3\frac{1}{2} \times 4\frac{5}{8}$ inches. Signed and dated 1800.

408. JOHN HENDERSON. *River and Mountains.* $5 \times 6\frac{7}{8}$ inches. Grey and blue wash. Signed or inscribed, and dated 1801.

PLATE CXCIX

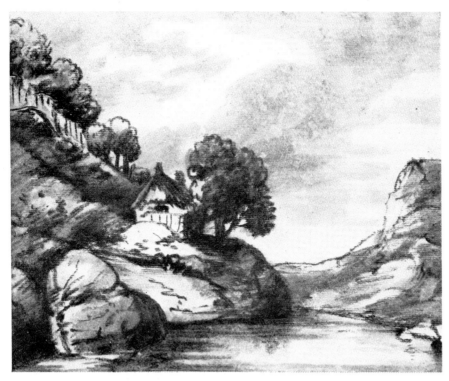

409. DR THOMAS MONRO. *Cottage by a Rocky Shore.* $8 \times 10\frac{1}{8}$ inches. Indian ink stick and wash.

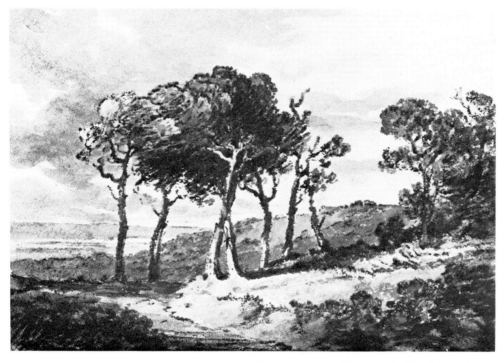

410. AMELIA LONG, LADY FARNBOROUGH. *Ashburnham.* $9 \times 12\frac{7}{8}$ inches. Indian ink stick and wash. Signed 'A.L.'

PLATE CC

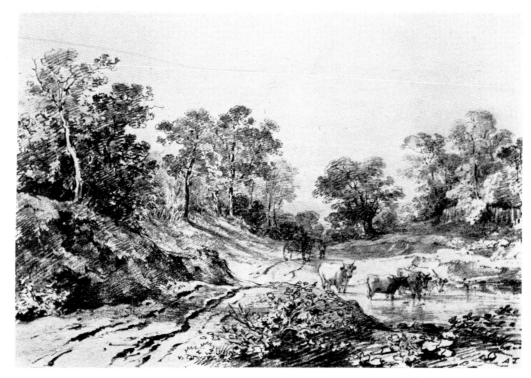

411. AMELIA LONG, LADY FARNBOROUGH. *A Country Road between Trees.* $11\frac{1}{4} \times 16\frac{3}{4}$ inches. Charcoal and crayons. Signed 'A.F.' Victoria and Albert Museum

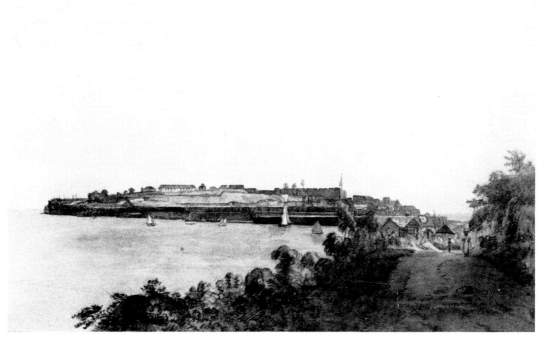

412. COLONEL W. GRAVATT. *Fort Edward, Jamaica.* $11\frac{5}{8} \times 18\frac{5}{8}$ inches. Signed with initials.
British Museum

Mead, Dr, 26
Meatyard, F. R., 236
Mengs, Raphael, 122
Merivale, C. H., 87
Merivale, John, 87
Merivale, the Misses, 88
Metz, Conrad Martin, 218, Fig. 341
Michelangelo, 117, 122
Michell, Mathew, 141
Middiman, S., 86, 93
Miles, Ann (Mrs Cotman), 161
Military drawing, 2, 29, 31, 58, 63-4, 175, 212, 244
Millar, Dr Eric, 207-8
Miller, James, 50. Fig. 79
Miller, John, 204
Miller, John Frederick, 204
Miller, Philip, 26
Milton, John, 123, 134, 148
Minn, H., 90
Mitchell, Sir Andrew, 122
Mitchell, Thomas, 247. Fig. 406
Modern Language Association of America, Publications of, 133
Monamy, Peter, 197
Monkhouse, Cosmo, 227
Monro, Dr Thomas, 49, 53, 62, 71-2, 80, 82, 97, 101, 104, 109, 113, 157, 159, 179, 208, 225, *247-8*. Fig. 409
Monstrelet, 130
Montagu, Duke of, 31
Monthly Magazine, 29
Moore, James, 56, *99-100*, 101, 245. Figs. 171 and 172
Moore, Sir John, 103
Moore, Thomas, 133
Mordaunt, Sir Charles and Lady, 248
More, Jacob, 76-8. Fig. 141
Morland, George Charles, 101, 108, 136, 142, 184, *187-8*, 189, 191, 193-4, 216. Figs. 288 and 289
Morland, Henry Robert, 187
Morland, Maria (Mrs W. Ward), 187-8, 193
Morning Post, 80
Morris, J. R., 191
Morritt, John, 159
Morse, Mr and Mrs E., 120
Mortimer, John Hamilton, 117, 121, *126-7*, 129, 131, 133, 138, 141, 146, 186. Fig. 206
Moser, G. M., 117
Moser, Mary (Mrs Lloyd), *204*, 248. Fig. 313
Mottram, R. H., 152
Mounts and Mounters, 41, 42, 73, 124, 215, 223
Mulgrave, Lord, 200
Muller, Johann Sebastian, 204
Muller, W. J., 175, 243
Mulready, William, 226
Munn, Paul Sandby, 16, 31, *63*, 102, 156, 158-9, 246. Figs. 115-117
Munn, William and James, 158
Muntz, John Henry, 48

Narraway, John, 109
Nash, Frederick, 50
Nasmyth, Alexander, 64-5. Fig. 120
National Gallery, 25, 179, 188, 236
National Gallery of Canada, 85
National Gallery of Scotland, 64-5. See also *Addenda*
National Library of Wales, 86
National Maritime Museum, 10, 11, 94, 197-202
National Museum of Wales (Cardiff), 9, 40, 52, 60, 68, 165, 189, 194, 202, 241, 243
National Portrait Gallery, 31
Nattes, John Claude, 212, *223-4*, 236. Fig. 356
Natural history drawings, 3-4, 8, 11, 12, 25-8, 47, 196, 203-7
Naylor, Thomas, 202
Neale, John Preston, 225. Fig. 358
Nelson, Admiral Lord, 207
Neville, Mrs Ralph, 208
Neville Grenville, George, 208, 236
Newdegate, Francis, 236
Newton, Francis Milner, 40
New Water-Colour Society (Royal Institute), 52, 211
New Writing and Daylight, 213
New York Public Library, 60
Nicholson, Alfred, 219
Nicholson, Francis, 8, 61, 95-6, 212, *217-19*, 225, 241. Figs. 344 and 345
Nicholson, George, 219
Nicholson, Marianne (Mrs Croker), 219
Nicholson, Sophia (Mrs Ayrton), 219
Ninham, Henry, 151
Ninham, John, 151-2
Nixon, James, 143
Nixon, John, 137, *143-4*. Fig. 234
Nodder, Frederick Polydore, 204
Noel, Mrs Amelia, 192
Nollekens, Joseph, 116, 166
Norden, John, 2
Norfolk and Norwich Society of Artists, 153
Norris, Christopher, 23
Norris, W. Foxley, 247-8
North, Brownlow, 137
Northbrook, Lord, 197
Northcote, James, 123
Northumberland, Duchess of, 73
Northumberland, Duke of, 16, 69
Northwick, Lord, 84
Norton, Peter and family, 158
Norwich, Castle Museum, 50, 152, 155-7, 161. See also *Addenda*
Norwich School, 151-165
Norwich Society of Artists, 152-3, 155
Notes and Queries, 58
Novelist's Magazine, 129-30
Noyes, Alfred, 61
Noyes, Robert, 61
Nuneham, Lord, 31

O

Old Water-Colour Society (R.W.S.), see Water-Colour

Old Water-Colour Society's Club Publications, 83, 101, 178, 182, 213, 215-7, 219, 227-8, 239, 247

Oliver, Isaac, 12. Fig. 19

Onslow, Earl of, 11

Oppé, A. P., 12, 13, 19-22, 28-39, 53, 68, 71-2, 74-5, 78-9, 81-2, 84-8, 101-2, 127, 137-8, 140-1, 157, 165, 172, 177, 208, 217, 226, 235, 237, 240-2, 246, 248

Oram, Henry, 69

Oram, William, 69

Ossian, 246

Ottley, William Young, 123

Ovid, 14

Owen, Samuel, 202-3. Fig. 312

Oxoniensia, 90

P

Page, Willkes, 197-8

Paillou, Peter, *28*, 203. Fig. 50

Palgrave, Sir Francis and Lady, 164

Palmer, Samuel, 119, 133, 226-7

Palmerston, Lord, 75, 223

Panoramas, 103, 105

Park, T., 128

Parkinson, Sydney, 203. Fig. 314

Parkyns, George Isham, 99

Pars, Henry, 74, 87, 117

Pars, William, *74-6*, 77, 87. Figs. 137-139

Parsons, Messrs, 27, 240

Paul, Miss F., 191

Pavière, Sydney H., 41-2

Payne, Sir Ralph, 52

Payne, William, *93-4*, 220. Figs. 159 and 160

Peacock, C. H., 213

Pearson, John, 218

Pearson, William, 107-8. Fig. 185

Pembroke, Lord, 4

Penn, Stephen, 19. Fig. 30

Penn, William, 9

Pennant, David, 46-7

Pennant, Thomas, 28, 46-7

Pepys, Samuel, 11

Percy, Dr J., 76, 124, 192

Pérignon, Nicholas, 44

Perry, J. M., 94

Persia, British artist in, 103

Peter the Great, 35

Pether, William, 97, 208

Philip II of Spain, 2

Phillipps, Sir Thomas, 245

Phillips, Thomas, 11. Fig. 15

Phipps, Capt John Constantine (Lord Mulgrave), 200

Pickering, George, 221

Picturesque, the, 33, 233-4

Pilkington, Miss M., 239

Pillement, J., 224

Pine, John, 36, 76

Pine, Robert Edge, 126

Piranesi, 101

Place, Francis, 6, *8-10*, 11, 32, 230. Figs. 10-13

Pleydell, Edmund Morton, 232

Plimer, J. (pupil of Wilson), 68

Plymouth, Earl of, 175

Pocock, Nicholas, 144, 198, 212, *216-7*. Figs. 342 and 343

Poetical Magazine (see also Ackerman), 130

Pope, Alexander (poet), 131

Pope, Alexander (miniaturist), 186

Pope, Mrs Alexander, 186

Porter, Anna Maria and Jane, 103

Porter, Sir Robert Ker, 102-3. Figs. 174 and 175

Portland, Duchess of, 26

Portrait drawings, 9, 48, 65, 78, 123, 126, 142, 145-6, 155-6, 158, 207-10, 213

Pouncy, Benjamin Thomas, 48, 51, *52*. Fig. 82

Poussin, N. and G., 5, 22, 34, 174

Powell, Joseph (often called John), 51-2. Fig. 81

Powell, Nicholas, *Addenda*

Praed, Sergeant W. M., 37

Preston, Harris Art Gallery, 42

Price, Robert, *22*, 90

Price, Sir Uvedale, 22

Princess Royal, 102

Prins, J. H., 51

Print-Collector's Quarterly, 244

Prout, Samuel, 163, 174, *182*, 208, 228, 246. Figs. 279 and 281

Pryde, James, 112

Pugin, Augustus Charles, *50*, 140

Puttick and Simpson, Messrs, 55

Pye, J., 100

Pyne, William Henry, 94, 212, 214, *215-6*. Figs. 339 and 340

R

Rackett, Thomas, 244

Ragg (or Agg), Maria (Mrs Cox), 173

Raleigh, Sir Walter, 2, 3

Ramsay, Allan, 69

Ramsden, E. H., 29

Random and Stainbrook, 94

Raphael, 117, 131

Rawlinson, Thomas, 239

Reade, Brian, 246

Rebecca, Biagio, 124. Fig. 201

Redgrave, G. R., 172, 178-9

Redgrave, Samuel, 205, 209

Reeve, James, 152, 154-6

Reinagle, Philip, 195, 228

Reinagle, Ramsay Richard, 221, *228-9*

Rembrandt, 237

Remington, C. L., 205

Renton, John, 192. Fig. 287

Repton, Humphry, 50-1

Revett, Nicholas, 74-5